THE ART OF SEEING

SEVENTH EDITION

THE ART OF SEEING

SEVENTH EDITION

Paul Zelanski • Mary Pat Fisher

Library of Congress Cataloging-in-Publication Data is available upon request from the Library of Congress

Editor-in-Chief: Sarah Touborg Senior Editor: Amber Mackey Editorial Assistant: Carla Worner Director of Marketing: Brandy Dawson Executive Marketing Manager: Marissa Feliberty

Credits and acknowledgments borrowed from other sources and reproduced, with permission, in this textbook appear on pages 534 and 549.

Copyright © 2007, 2005, 2002, 1999, 1994, 1991, 1988 Paul Zelanski and Mary Pat Fisher

Published by Pearson Education, Inc., Upper Saddle River, New Jersey, 07458. Pearson Prentice Hall. All rights reserved. Printed in China. This publication is protected by Copyright and permission should be obtained from the publisher prior to any prohibited reproduction, storage in a retrieval system, or transmission in any form or by any means, electronic, mechanical, photocopying, recording, or likewise. For information regarding permission(s), write to: Rights and Permissions Department.

Pearson Prentice Hall™ is a trademark of Pearson Education, Inc. **Pearson®** is a registered trademark of Pearson plc. Prentice Hall® is a registered trademark of Pearson Education, Inc.

Pearson Education LTD. Pearson Education Singapore, Pte. Ltd Pearson Education North Asia Ltd

Pearson Education, Canada, Ltd Pearson Educación de Mexico, S.A. de C.V. Pearson Education-Japan Pearson Education Malaysia, Pte. Ltd

This book was designed and produced by Laurence King Publishing Ltd, London www.laurenceking.co.uk

Every effort has been made to contact the copyright holders, but should there be any errors or omissions, Laurence King Publishing Ltd would be pleased to insert the appropriate acknowledgment in any subsequent printing of this publication.

Front cover: Janet Cummings Good, Lunar Moth and Morning Glory from the "Petals and Wings" series, 2005. Epson archival print, printed on an Epson 7600 printer with Ultra Chrome ink on Enhanced Matte paper, $23 \times 33\%$ ins $(58.4 \times 85 \text{ cm})$. Artist's collection.

Frontispiece: Gus Mazzocca, Haitian Dance Fantasy "Petwo": Portrait of Ann *Mazzocca*, 2005. Digital/screen print, 30×40 ins (76.2 \times 101.6 cm). Artist's collection.

Contents

PREFACE 9

PART 1 Learning to See 11

1 Understanding Art 12

WHAT IS ART? 13

THE CREATIVE IMPULSE 13

TYPES OF ART 14

Two- and Three-Dimensional Art 15
Representational and Nonrepresentational Art 17
Artists on Art: Georgia O'Keeffe on Abstraction 22
Fine and Applied Arts 24
Public and Private Art 27
Art Issues: Censorship of Offensive Art 30

CONTENT 33

Sociopolitical Content 34 Power and Propaganda 37 Spiritual Purposes 40 Inner Experiences 41 Beauty 48

CRITICAL OPINION 48

Art Issues: Race and Gender Criticism 52

LASTING GREATNESS IN ART 54

2 Visual Elements 58

LINE 59

Seeing Line 59

The World Seen: Islamic Calligraphy 62
Implied Line 65
Descriptive Line 67
Expressive Qualities of Line 70
Directional Line 70

SHAPE AND FORM 73

Degrees of Three-Dimensionality 73

Characteristics of Three-Dimensional Form 77

Artists on Art: Henry Moore on Form and Space 80
Two-Dimensional Illusion of Form 83
Shapes 85

Artists on Art: Arshile Gorky on Art Elements
Conveying Life's Intensity 88

SPACE 93

Three-Dimensional Art in Space 93 Two-Dimensional Space 97 Scale 108 Spatial Illusion 111

TEXTURE 113

Actual Texture 114 Simulated Texture 116

VALUE AND LIGHT 119

Local and Interpretive Values 120
Lighting 122
Reflections 127
Artists on Art: Leonardo da Vinci on
Chiaroscuro 128
Light as a Medium 131

COLOR 134

A Vocabulary of Color 134

Natural and Applied Color 138

Local, Atmospheric, and Interpretive Color 141

Emotional Effects of Color 142

Warm and Cool Colors 145

Advancing and Receding Colors 148

Color Combinations 148

Interaction of Color 152

Artists on Art: Josef Albers on Seeing Colors 157

Limited and Open Palette 158

TIME 161

Actual Movement 161
Illusion of Movement 164
 Artists on Art: Auguste Rodin on The Illusion of Movement 166
The Captured Moment 168
Change Through Time 169

3 Organizing Principles of Design 170

REPETITION 171

VARIETY 175

RHYTHM 181

BALANCE 183

COMPOSITIONAL UNITY 186

EMPHASIS 189

ECONOMY 193

PROPORTION 195

RELATIONSHIP TO THE ENVIRONMENT 198 Artists on Art: Wassily Kandinsky on Underlying Harmony 200

PART 2

Two-Dimensional Media and Methods 205

4 Drawing 206

APPROACHES TO DRAWING 206

DRY MEDIA 209

Graphite Pencil 209

Silverpoint 210

Charcoal 210

Chalk 213

Pastel 214

Crayon 215

LIQUID MEDIA 216

Pen and Ink 216

Brush and Ink 216

The World Seen: Chinese Landscape Paintings 217

5 Painting 220

APPROACHES TO PAINTING 221

PAINT MEDIA 224

Encaustic 224

Fresco 225

Tempera 228

Oil 231

Art Issues: Cleaning and Restoring Paintings 232

Watercolor 237

Gouache 239

The World Seen: Tibetan Sand Paintings 240

Synthetics 242

Collage 244

Mosaic 246

MIXED MEDIA 248

6 Printmaking 249

APPROACHES TO PRINTMAKING 251

PRINTMAKING PROCESSES 252

Relief 252

Artists on Art: Stephen Alcorn on The Art of the

Color Linocut 255

Intaglio 258

Planographic 264

Stencil 267

Photocopy and Fax Art 268

MIXED PRINT MEDIA 270

7 Graphic Design 272

THE GRAPHIC DESIGNER AND VISUAL IDEAS 273

Artists on Art: Peter Good on The Art of Graphic

Design 274

TYPOGRAPHY 276

ILLUSTRATION 279

8 Photography and Filmmaking 283

PHOTOGRAPHY 284

Artists on Art: Edward Weston on Photography as a

Way of Seeing 294

Digital Photography 296

Creative Use of Digital Imaging 297

FILM 300

TELEVISION AND VIDEO 307

Art Issues: Mixing Art and Politics: The Films of

Leni Riefenstahl 308

9 Digital Art 313

THE COMPUTER AS A DRAWING MEDIUM 314

THE COMPUTER AS A PAINTING MEDIUM 315
Artists on Art: Janet Cummings Good Compares
Computer to Other Media 318

THE COMPUTER IN THREE-DIMENSIONAL ART 319

VIDEO GRAPHICS 320

VIRTUAL REALITY 322

THE COMPUTER AS A UNIQUE ART MEDIUM 323

INTERACTIVE ART IN CYBERSPACE 325

Art Issues: Art Websites 326

PART 3

Three-Dimensional Media and Methods 329

10 Sculpture 330

PLANNING SCULPTURES 331

CARVING 333

Artists on Art: Michelangelo Buonarroti on Marble-Quarrying 335 The World Seen: Benin Ivory Carvings 336

MODELING 337

CASTING 340

Artists on Art: Benvenuto Cellini on A Near-Disastrous Casting 341

ASSEMBLING 343

EARTHWORKS 346

Art Issues: Preserving Ephemeral Materials 348

11 Crafts 352

CLAY 353

The World Seen: Chinese Porcelains 355 Artists on Art: Paula Winokur on Working in Clay 356

METAL 358

The World Seen: Precious Metalwork from Tsarist Russia 360 WOOD 361

Artists on Art: George Nakashima on A Feeling for Wood 362

GLASS 364

FIBERS 369

The World Seen: Persian Carpets 371

12 Product and Clothing Design 374

INDUSTRIAL DESIGN 375

CLOTHING DESIGN 380

The World Seen: Saris of India 384

13 Architecture 386

ARCHITECTS' UNIQUE CONCERNS 387

FUNCTION 389

The World Seen: The Hidden Temples of Angkor 390

STRUCTURE 398

The World Seen: Moorish Arches and Domes 404

14 Designed Settings 413

INTERIOR DESIGN 414

ENVIRONMENTAL DESIGN 417

The World Seen: Japanese Stone Gardens 422

AESTHETICS IN THE PERFORMING ARTS 424

PART 4 Art in Time 431

15 Historical Styles in Western Art 432

ART MOVEMENTS 433

THE BEGINNINGS OF WESTERN ART 433

Prehistoric 433

Aegean 439

Mesopotamian 439

Art Issues: Looting of Art Treasures 440

Egyptian 443

ART OF ANCIENT CULTURES 444

Greek 444

Roman 446

Early Christian and Byzantine 446

MEDIEVAL ART 448

Early Medieval 448

Romanesque 452

Gothic 452

Late Gothic 454

RENAISSANCE ART 454

Early Renaissance in Italy 455

Art Issues: The Camera Obscura:

A Trade Secret? 456

High Renaissance in Italy 458

Northern Renaissance 462

Art Issues: Protecting Famous Artworks 464

Mannerism 467

BAROQUE ART 468

Southern Baroque 468

Northern Baroque 472

Rococo 472

EIGHTEENTH- AND EARLY NINETEENTH-

CENTURY ART 472

Neoclassicism 473

Romanticism 475

LATER NINETEENTH-CENTURY ART 476

Realism 476

Impressionism 479

Post-Impressionism 479

Artists on Art: Paul Gauguin on Cross-Cultural

Borrowings 480

TWENTIETH-CENTURY ART 483

Expressionism 485

Fauvism 485

Cubism 487

Futurism 487

Abstract and Nonobjective Art 487

Dada 488

Surrealism 490

Traditional Realism 490

Abstract Expressionism 490

Post-Painterly Abstraction 491

Pop Art 494

Minimalism 494

Technological Art 495

Conceptual Art 496

Earthworks 497

Performance Art 498

Installations 498

New Realism 500

The Craft Object 500

Neoexpressionism 503

Post-modernism 505

Widening of the Mainstream 505

Artists on Art: Deborah Muirhead on Art as Ancestral

Exploration 506

Art Issues: Art as Investment 510

16 Understanding Art on All Levels 514

PICASSO'S GUERNICA 515

RODIN'S GATES OF HELL 520

MICHELANGELO'S SISTINE CHAPEL CEILING 524

FRANK GEHRY'S GUGGENHEIM MUSEUM IN BILBAO 530

NOTES 534

GLOSSARY/ PRONUNCIATION GUIDE 537

ARTISTS' PRONUNCIATION GUIDE 547

CREDITS 549

INDEX 551

TIMELINE

30,000 B. C. - A. D. 2000 436

TABLES

35,000 B. C. - A. D. 500 Prehistoric to Roman 434

500-1500 Early Christian to Gothic 450

1425-1640 Early Renaissance to Southern Baroque 466

1500-1800 Northern Renaissance to Rococo 469

1750–1950 Neoclassicism to Surrealism 477

1945–2000+ Into the Twenty-First Century 502

MAPS

The Prehistoric and Ancient World 435

Europe in the Early Twelfth Century 450

Renaissance Italy 466

Northern Europe in the mid-Seventeenth Century 469

Europe in the mid-Nineteenth Century 477

The World in the Late Twentieth Century 502

Preface

We are very pleased to be able to offer this seventh edition of *The Art of Seeing*, for its features will bring readers even closer than before to an informed understanding of the fine and applied arts of the world. The scope of this understanding has been updated and extended in various ways.

NEW FEATURES OF THIS EDITION

Over sixty new images have been added to this edition, most of them in color, so that the reproductions approximate as faithfully as possible the experience of actually viewing the works. They include new examples of art from contemporary culture, such as the chalk drawings of Julian Beever. Other new images include pieces of graphic design, industrial design, murals, video art, computer art, interiors, light installations, crafts, furniture, and even the Singapore skyline. Women artists continue to be well represented throughout the book, including numerous new images.

Digital art has become an integral part of the contemporary art scene, so its coverage has been expanded and updated throughout the book as well as in the chapter devoted to digital art. Digital photography is rapidly overtaking film, and its processes and artistic pros and cons are discussed in detail in Chapter 8.

Art issues continue to make news. We have updated the "Art Issues" box on "Censorship of Offensive Art" in Chapter 1, adding recent highly controversial exhibits in Buenos Aires and Moscow. Phenomenal prices have been paid for paintings on auction, so the latest examples of the world's most expensive art have been illustrated and discussed in the "Art Issues" box on "Art as Investment" in Chapter 15. Another new "Art Issues" box entitled "Art Websites" has been added to Chapter 9 exploring art websites from gallery and museum sites to artists' individual sites.

A groundbreaking piece of architecture—Frank O. Gehry's Guggenheim Bilbao—is analyzed in depth in Chapter 16. Its origins in the city's revitalization plans, the planning stages with digital and physical modeling, and the aesthetic experience of the finished work, which has become a globally recognized icon of post-modernism, are considered, and illustrations and discussions of aspects of the work are woven throughout the text.

To help readers grasp how artists feel about making art, we have added many new quotations from working artists in this edition, from digital artist David Em to ceramist Toshiko Takaezu. A new "Artists on Art" box in Chapter 9 features Janet Cummings Good, whose work appears on the cover, comparing computer to traditional media.

To clarify points discussed in the text, new line drawings have been added: Three-point perspective, Golden Mean proportion, geodesic dome, and ziggurat structure.

THE NATURE OF THIS BOOK

As always, we have taken considerable pain in *The Art of Seeing* to make art come to life. The language we use is vigorous and down-to-earth, with many quotations from the artists themselves to help explain what they were trying to do. There are also numerous "Artists on Art" boxes throughout the book, distinguished by bluetinted headings, featuring more lengthy passages in which major artists speak about their work in general, giving students valuable insights into art from the artists' points of view.

Carefully chosen artworks are illustrated and described at the beginning of each chapter. These vignettes display works that are in some way emblematic of the entire topic to be discussed.

Many illustrations are accompanied by discursive captions that augment the text discussions by giving related information about the content and context of the work. Some include interesting quotations from the artists about what they were attempting to do, thus deepening understanding of the work at hand.

There are many pedagogical aids in *The Art of Seeing*. Each chapter begins with a helpful list of "Key Concepts" to help readers mentally organize the material that follows. Unfamiliar words are carefully defined where they are first used, and those that are again defined in an extensive illustrated glossary at the end of the book are printed in bold face. Pronunciation aids are provided for words in the glossary that may be unfamiliar to students. There is also a guide in the back to the artists' names that are difficult to pronounce.

Artworks reproduced in *The Art of Seeing* provide a stimulating and exciting visual gallery. The illustrations

for each concept are clearly related to the text and carefully described. There are some 619 illustrations, 394 of them in color, many reproduced at full-page size. They are taken from all the visual arts, from painting and sculpture to clothing and industrial design. Use of such a global variety of illustrations from both fine and applied arts, old and new, allows us to broaden tastes in art and to demonstrate the underlying principles, elements, and issues in art, no matter what form it takes.

In Chapter 15, which traces the development of Western art, the discussion is enhanced by maps and timelines. The six maps show the regions where major trends in Western art developed and indicate key artistic centers, with insets of important buildings and monuments. Each map is accompanied by a timeline giving a global historical context to the evolution of Western art, up to the twenty-first century.

Special feature boxes entitled "The World Seen" are included in many chapters. Each examines an art form that has been highly developed in a particular time and place, such as the brush and ink paintings of Sung China, the precious metalwork of Tsarist Russia, the ivory work of the kingdom of Benin, the hidden temples of Angkor in Cambodia, and the traditional gold-embroidered saris that have entered the realm of high fashion in India. The social and cultural factors that led to these heights are examined along with the exceptional skillfulness of the artists. These "The World Seen" boxes are distinguished from the running text by their green-tinted headings.

In the special feature boxes on "Art Issues" we have attempted to explore many areas of controversy in the art world. These "Art Issues" boxes are distinguished from the running text by their brown-tinted headings.

ITS ORGANIZATION

Part 1 of *The Art of Seeing* lays the foundation for understanding the aesthetic aspects of a work of art. In Chapter 1, we develop an initial vocabulary and an intellectual framework for considering artworks: The creative impulse, the varying forms and content of its manifestation, critical opinion of the results, and, with time, the recognition of the greatness of some works. Chapter 2 is devoted to extensive analysis of the visual elements with which the artist works: Line, shapes, form, space, texture, light, color, and time. Chapter 3 covers the subtle organizing principles by which these elements are used in a work of art.

The next two parts of the book approach art through the materials and techniques used by the artists. By revealing the difficulties of each method, we hope to enhance appreciation of the artists' accomplishments. Part 2 covers two-dimensional techniques and media: Drawing, painting, printmaking, graphic design, photography, photocopy, fax, film, television, video, and digital art. Part 3 covers three-dimensional media: Sculpture, crafts, industrial design, clothing design, architecture, interior design, environmental design, and the performing arts.

Part 4 approaches art as it exists in time. We first offer a concise approach to historical styles in Western art. The major movements, from prehistoric to contemporary, are covered, with an illustrated timeline on pages 436–37 as an aid to understanding how the distinctly different aesthetic movements are related in time. In addition, six maps show close-ups of particular periods so that one can see where the major artists of the time were working, in the context of major world events.

The final chapter is a unique, in-depth examination of four works of art, including their evolution in time. It approximates the actual experience of encountering a work of art, drawing on all levels of appreciation developed in the book.

ACKNOWLEDGMENTS

Many people have willingly helped us to revise and update The Art of Seeing, particularly Gus Mazzoca, Janet Cummings Good, Karen Cassyd-Lent, and Ruth Zelanski. Our reviewers for this edition have been very helpful with comments that guided our revisions. We would like to express our special gratitude to Randall Rhodes at Frostburg State University, Alberto Meza at Miami-Dade College, Nancy H. McDonald at Roane State Community College, Douglas M. Williams at Montgomery College, and Jane Edberg at Gavilan College. At Prentice Hall, Sarah Touborg, Amber Mackey, Brandy Dawson and Marissa Feliberty have been supportive, and the brilliant and dedicated staff at Laurence King Publishing—especially Melanie White, Kara Hattersley-Smith, Susie May, Susannah Jayes, and Nick Newton—have worked hard as always to help improve the content, organization, design, and production of The Art of Seeing. Annette Zelanski has been as always generous with her help and loving support. The second author also wishes to acknowledge the inspiration and support of her revered teacher, Baba Virsa Singh.

We feel that the improvements in this seventh edition will be very helpful to all those who seek an educated, sharpened sense of art appreciation. Our own appreciation grows each time we approach this book.

Paul Zelanski Mary Pat Fisher PART

1

Learning to See

Zagarenski, 1895 (detail of Figure 9.6). AN ENCOUNTER WITH a work of art can be deeply satisfying, provocative, or disturbing. With training, we can begin to recognize the ideas, feelings, and historical context of works of art, and the elements and principles of design that are the artist's aesthetic tools.

Understanding Art

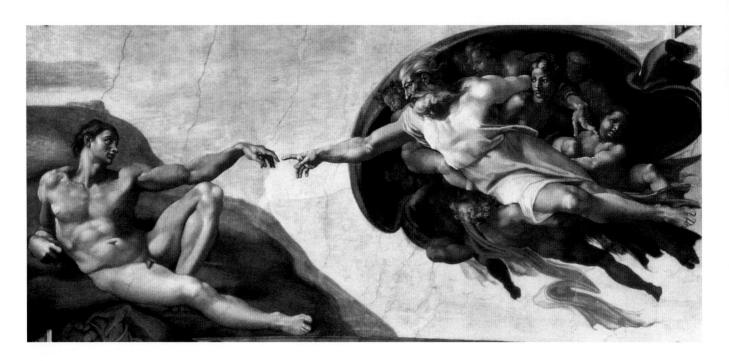

■ KEY CONCEPTS

Why create art?

What form does art take and why?

The difference between the fine and applied arts

Creating art for public and private use

Understanding the emotions, ideas, symbols, stories, and spiritual connotations behind art

Criticism and art

Lasting greatness

1.1 Michelangelo Buonarroti, Sistine Chapel ceiling (detail, post-restoration), *Creation of Adam*, 1510. Fresco. Vatican Museums and Galleries, Rome.

IN ONE OF the world's most famous images, a powerful male figure symbolizing God, attended by angels and perhaps bringing Eve, the legendary first woman, reaches from heaven to earth and imparts life into the first human. The excitement of Michelangelo's *Creation of Adam* (1.1) is centered on the moment when God's finger sends the spark of life into previously inert matter.

Similarly, artists of all times and places have set their hands to the raw material of the planet and produced from it new and dynamic works of art, greatly enriching our human experience. This chapter takes an overview of artistic creation. First we will look at attempts to define art and will note the universal impulse to create art. Then we will survey the general categories and content of artwork. At the end of the chapter, we will consider how the artist's creations are judged by others and how aesthetic greatness may transcend the artist's own times. These topics provide an initial framework for understanding art.

What is Art?

The Oxford English Dictionary offers many definitions of art, including the summary statement: "the skillful production of the beautiful in visible forms." At the same time, it notes that this usage of the word "art" cannot be found in any English dictionary before 1880 and that even when it did appear it was used primarily with reference to painting. Few cultures have a word corresponding to this definition, for the skillful production of things is entirely interwoven with life itself, often for religious or functional purposes, rather than some rarefied pursuit of beauty for its own sake.

Thomas Hoving, former Director of the Metropolitan Museum of Art in New York, offers a contemporary definition that makes reference neither to skill nor beauty: "Art happens when anyone in the world takes any kind of material and fashions it into a deliberate statement."1 This definition of the word "art" as used by contemporary artists and writers about art has been stretched to encompass extremely varied human creations, and its boundaries are continually being expanded. However, even Hoving's extremely broad definition does not cover all the ground, for it suggests the idea of art as personal expression—an endeavor that is largely unique to recent Western culture. In many non-Western or tribal cultures, the concept of art as a separate creative activity divorced from religious, functional, or governmental purposes does not occur.

The Creative Impulse

The impulse to create art is so strong that artworks have appeared in all cultures, from the earliest days of our species. Tens of thousands of years ago, our Paleolithic ancestors were apparently painting with red ocher, shaping ritual objects, and fashioning simple necklaces out of animal bones and teeth. Even weapons and sewing needles had decorations scratched onto them.

A tiny bust of a woman (1.2) carved perhaps 24,000 years ago illustrates the care with which artists have worked throughout history. This piece is only $1\frac{1}{4}$ inches (3 cm) high, and yet the material has been carefully sculpted into a woman's likeness, including details of her

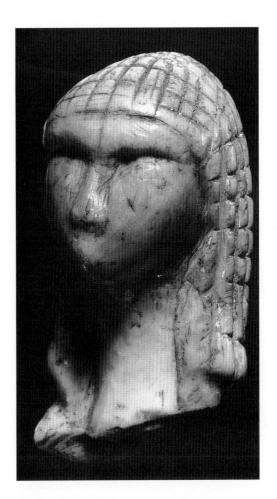

1.2 Woman from Brassempouy, Grotte du Pape, Brassempouy, Landes, France, c. 22,000 в.с. Ivory, height 1¹/₄ ins (3 cm). Musée des Antiquités Nationales, St. Germain-en-Laye, France.

hairstyle. Why did someone lavish such attention on a very small piece of ivory? It was sculpted long before recorded history, so we can only speculate as to what its function may have been or what it meant to its creator.

Even today, if we question artists about their feelings and ideas, with the contemporary assumption that art is a means of personal expression, we find that some cannot easily explain why they create art. For them, it is an inner calling. Whether or not the work sells, an artist is compelled to create it. Rembrandt van Rijn, the seventeenth-century Dutch painter, fell out of favor and was forced to give up his fine things, declare himself bankrupt, and live a life of poverty. Nonetheless he continued painting and at that time produced some of his very best work, such as his haunting Self-Portrait (1.3). Auguste Renoir, the French Impressionist painter (see pages 188-89), developed arthritis, which was so painful that he could not hold a brush. Instead he had a brush strapped to his hand, and he continued painting. What unconsciously touches us in the artist's work is perhaps in part the

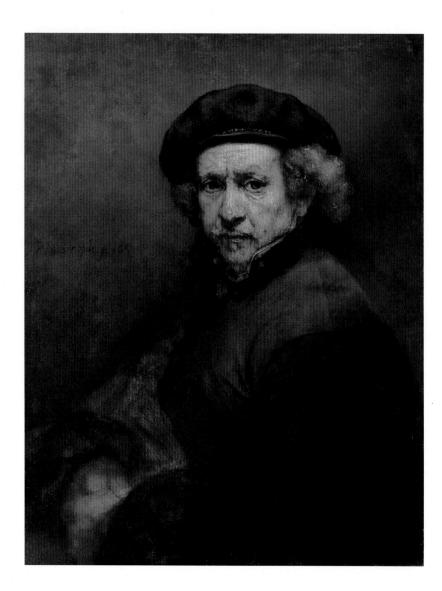

1.3 Rembrandt van Rijn, Self-Portrait, c. 1660. Oil on canvas, 33×26 ins (84×66 cm). National Gallery of Art, Washington, D.C. Andrew W. Mellon Collection. From young manhood to old age, Rembrandt created over one hundred self-portraits, apparently using himself as a model for probing character studies.

passionate commitment from which it is born. To be sure, there are others for whom artmaking is a profession, a craft at which they have become skillful and which provides a way of making a living.

The question is not so much why people make art but why some people don't. From a very early age, we begin trying to shape materials in our environment into artistic creations. This effort usually continues unless it is stifled by those who try to teach us the "right" way to make art or those who insist that we color within the lines of somebody else's drawing. We may compare our creations unfavorably with more skillful works and give up our attempts at making art.

Training and practice are usually necessary to make the hands create what the mind can imagine. In many cases, the creation of a work of art is meticulously planned and executed. But there may also be an element of spontaneity and serendipity in some kinds of artistic expression. Creating something new requires a certain originality of thought. To create is to develop something from one's own imagination, bringing something into being which would not evolve in the natural course of things. This imagination has deep wellsprings which may lie beneath conscious thought. When some artists are working they may enter a state of intense concentration in which they may fail to notice the passage of time or the stiffness of their bodies. In this meditation-like altered state of consciousness, visual ideas may evolve without intellectual struggle, once a foundation of skills and design sensitivities has been developed. The chance to experience this direct communion with a deeper level of reality is at least part of the urge to create—and it invites others to share in the experience.

Types of Art

In speaking of art, we commonly use general descriptions that refer to its two- or three-dimensionality, to its degree of realism, to its usefulness or

sheer aesthetic quality, and to its intended audience, whether public or private. We will examine these categories here. We may also categorize a work according to its historical period or style, but this subject will be taken up in detail in Chapter 15.

TWO- AND THREE-DIMENSIONAL ART

Three-dimensional works have spatial depth as well as height and width. Degrees of three-dimensionality are discussed in Chapter 2. Two-dimensional works, by contrast, are developed on a flat plane without depth (though the surface may be somewhat built up with paint). Both types of art are shown in Figure 1.4, a scene from a museum exhibit. Claes Oldenburg's Soft Saxophone is three-dimensional. Visitors to the exhibit could walk around the soft sculpture, puzzling over its contours. Is it like a balloon being deflated to

near-nothingness? Or is it in the process of being inflated? The museum guard standing nearby is also a three-dimensional sculpture, Duane Hanson's Museum Guard, a fiberglass and polyester cast of a real human being, dressed in guard's clothing. Hanson's human sculptures are so lifelike that viewers often mistake them for real people.

On the wall are hung two two-dimensional paintings. In Wayne Thiebaud's Bikini a woman stares straight out at us, her body language and the starkness of the painted background emphasizing the direct visual confrontation. Tom Wesselmann's Still Life gives presence on a grand scale to items of American pop culture, almost like icons of the times: cigarettes, canned food, Midwestern corn, and the seascape seen through the window. These pictures are painted larger than life in a way that makes them appear almost more

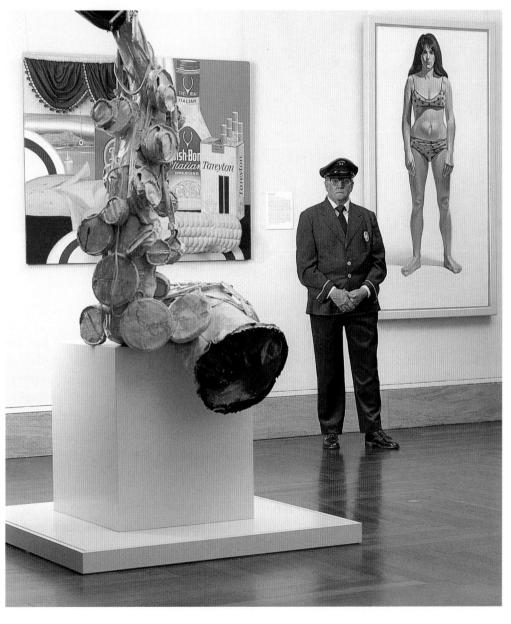

1.4 Duane Hanson, Museum Guard, 1975. Polyester, fiberglass, oil, and vinyl, $69 \times 21 \times 13$ ins $(175.3 \times 53.3 \times 33 \text{ cm});$ Claes Oldenburg, Soft Saxophone: Scale B, 1992. Canvas, wood, clothes line, dacron, resin, and latex paint, $69 \times 35 \times 36$ ins (175.3 × 89 imes 91.4 cm). On long-term loan from the Hall Family Foundation; Tom Wesselmann, Still Life no. 24, 1962. Acrylic polymer on board, fabric curtain, $48 \times 59\% \times \%$ ins (122 \times 152.1 \times 20 cm); Wayne Thiebaud, Bikini, 1964. Oil on canvas, $72 \times 35\%$ ins (182.9 \times 91.1 cm). Parker-Grant Gallery installation, 1994. The Nelson-Atkins Museum of Art, Kansas City, Missouri. Photo by E. G. Schempf.

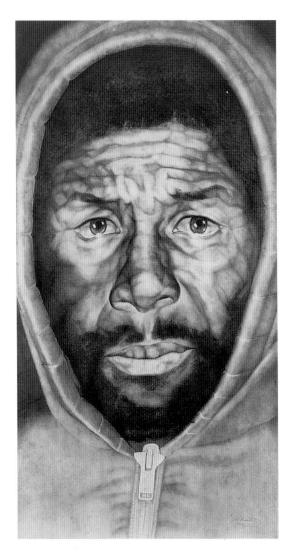

1.5 Susumu Kinoshita, A Man Staring, 1994. $74\% \times 39\%$ ins (190 \times 100 cm). Courtesy of the artist.

real than a photograph. Thus, as this exhibit shows, whether art exists in rarefied two-dimensional space or in the three-dimensional world we experience, it is equally capable of engaging our attention.

It is important to note that, to be fully appreciated, art must be experienced in person. From a reproduction in a book or slide or website, you cannot perceive the textures, the way strokes were applied, the smells, the sounds, the fullness of its three-dimensionality, the surrounding environment, or even the scale of the work. If you were to see Susumu Kinoshita's *A Man Staring* in a reproduction (as in Figure 1.5), you might assume that it is approximately life-sized; to see this small reproduction is to examine it from a somewhat detached, psychologically "safe" distance. But if you

To experience fully any work of art, we must see the work itself. Skillful reproductions, such as those in this book, will whet your appetite. But actually to eat the meal, you must experience the original. And you must give it time. When you do have the opportunity to see original works of art, they may be placed among many others in a museum. How can you possibly digest them all at once?

The Italian art historian Federico Zeri gives this advice:

It is better to understand a single painting rather than to see thousands quickly without understanding anything. For many, visiting an exhibition is like running a race: thirty seconds for the Victory of Samothrace [15.13], fifteen seconds for Manet's Olympia, etc. Look at the tourists' faces; they are terrorized. You have to grasp the vocabulary, the grammar of each work. And that takes time.2

REPRESENTATIONAL AND NONREPRESENTATIONAL ART

When art attempts to represent what we see in the world around us, it is called representational or figurative work. Within this category there are many degrees of realism.

The Dutch artist Rachel Ruysch's Still Life with Fruit and a Vase of Flowers (1.7) is a good example of realism —the accurate depiction of the visible world. Ruysch's father was a botanist, and she painted rare flowers, leaves, and fruits in such a realistic, naturalistic way that even a butterfly has seemingly entered the picture to drink from them. Of course, what looks like a casual, asymmetrical arrangement has been carefully planned by the artist for balance and emphasis, with light falling principally on the white flower in the center, as the rest of the composition recedes into shadows. But the exuberance of the painting, with its lush colors, curving stems, and great variety of forms and textures, does not call attention to its careful execution. So popular were her flower paintings that Ruysch (1664-1750) was summoned to Germany as a court painter, and thus became the first internationally recognized woman artist.

A step removed from this realism is **idealization** transforming the real world into one that approximates one's ideas of perfection. If you look ahead at the Classical Greek sculpture of a spear bearer in Figure 2.28, you can see that the man's head is more than humanly perfect: the eyes, nose, mouth, and hair have a smoothness and symmetry that are not seen in real human beings. Similarly, Peter Paul Rubens's Landscape with Rainbow (1.8) offers a romanticized picture of country life. Everyone seems healthy and

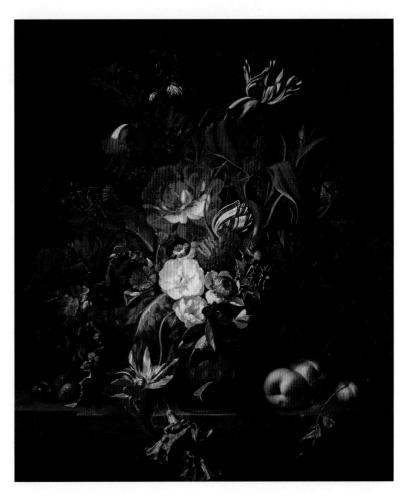

1.7 Rachel Ruysch, Still Life with Fruit and a Vase of Flowers, $39 \times 32\%$ ins (99×83 cm). The Fitzwilliam Museum, Cambridge, UK.

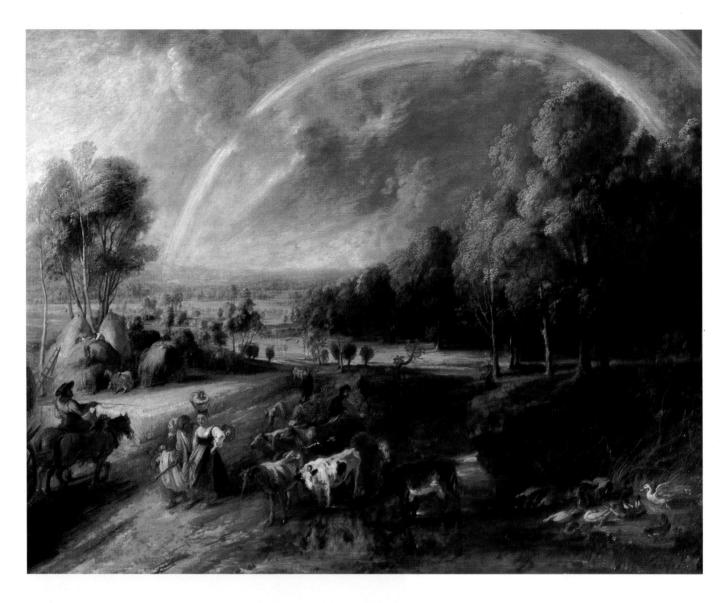

1.8 Peter Paul Rubens, Landscape with Rainbow, c. 1635. Panel, $37\frac{1}{4} \times 48\frac{1}{2}$ ins (94.6 \times 123.2 cm). Alte Pinakothek, Munich. Himself of aristocratic background, Rubens romanticized the life of the peasantry and celebrated in this painting the pleasures of the moment within the ever-changing natural environment.

happy, even the animals, and the sun's appearance after a shower of rain floods the scene with light, bringing out a double rainbow in the sky. The pastoral idyll expresses Rubens's own apparent pleasure with his life in the Flanders countryside.

Another kind of shift from absolute realism is **stylization**—emphasizing design rather than exact representation when working with natural forms. Diego Rivera's *Flower Day* (**1.9**) stylizes human figures into massive forms. The simplified outlines turn arms and garments into interlocking blocks of color, shaded at the edges for a monumental three-dimensional effect. The seated local women and the flower carrier are thus transformed into sacred statues honoring the abundance of the earth.

A somewhat different approach to figurative art is

called abstraction—extracting the essence of real objects rather than faithfully representing their surface appearance. A series of trees by Dutch artist Piet Mondrian illustrates the process of increasing abstraction. The first one shown, Tree II (1.10), is a fairly representational depiction of what appears to be an old apple tree, with riotous interplay among the lines of the main branches and the secondary suckers that shoot upward from them. In the second, The Gray Tree (1.11), Mondrian has in effect pruned away the suckers, leaving only the branches that form a rhythmic series of arcs, echoing and counterbalancing the strong leftward arc of the main trunk. Mondrian also develops interest in the shapes of the spaces between the branches by painting them as if they had textures of their own. In the third, most abstract, tree image,

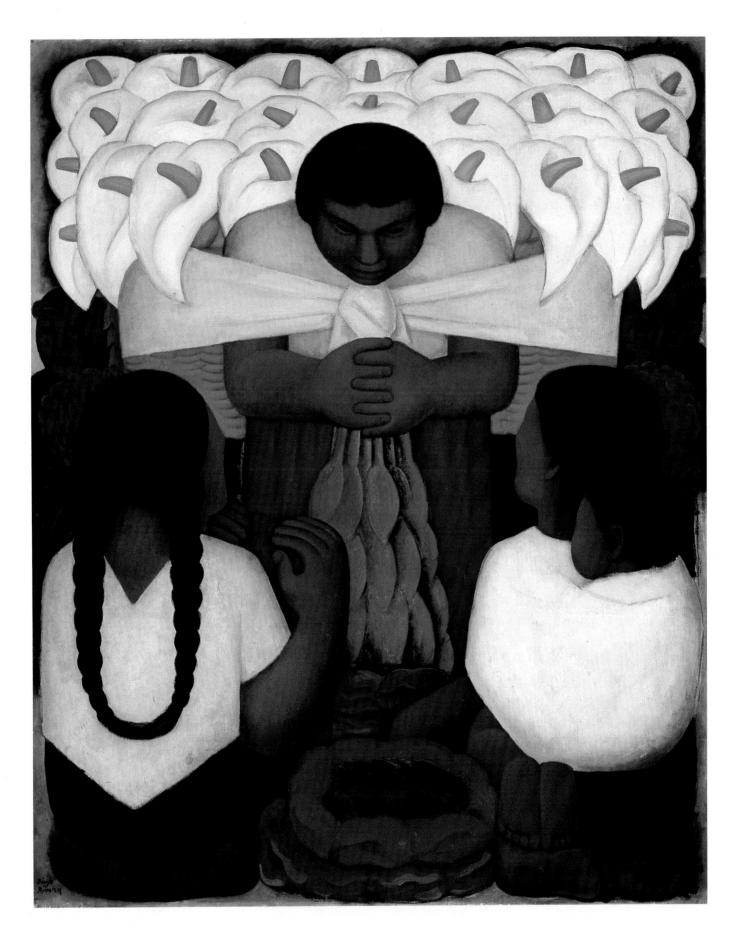

1.9 Diego Rivera, *Flower Day*, 1925. Encaustic on canvas, 4 ft 10 ins \times 3 ft 11½ ins (1.47 \times 1.20 m). Los Angeles County Museum of Art, Los Angeles, California. County Funds.

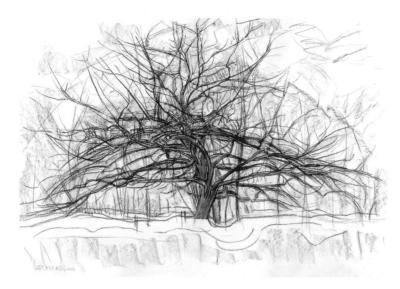

1.10 Piet Mondrian, *Tree: Study for The Gray Tree*, 1911. Black crayon on paper, 23×34^{1} /s ins (58.4 \times 86.5 cm). Collection of the Gemeentemuseum Den Haag, The Netherlands. © 2007 Mondrian/Holtzman Trust c/o HCR International, Warrenton, VA.

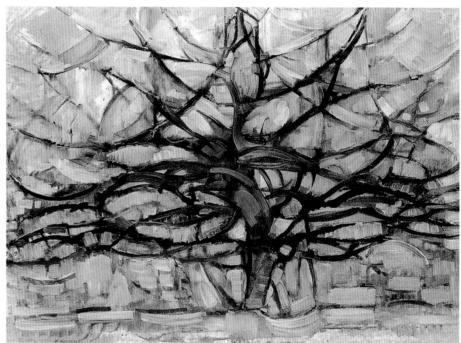

1.11 Piet Mondrian, *The Gray Tree*, 1911. Oil on canvas, $31\frac{1}{2} \times 42\frac{7}{8}$ ins (79.7 \times 109.1 cm). Collection of the Gemeentemuseum Den Haag, The Netherlands. © 2007 Mondrian/Holtzman Trust c/o HCR International, Warrenton, VA.

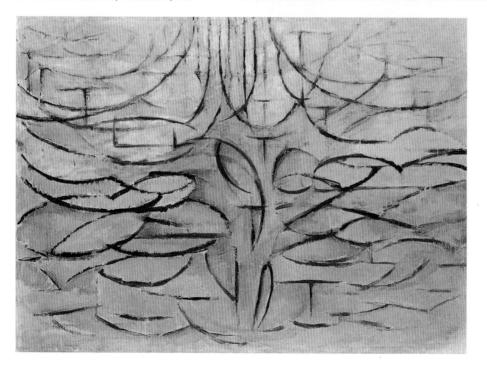

1.12 Piet Mondrian, Flowering Apple Tree, 1912. Oil on canvas, 31 × 42% ins (78.5 × 107.5 cm). Collection of the Gemeentemuseum Den Haag, The Netherlands. © 2007 Mondrian/Holtzman Trust c/o HCR International, Warrenton, VA. Mondrian wrote of a "nostalgia for the universal" and probed beneath the surface of things gives delight, their inwardness gives life," he once wrote.

1.13 Piet Mondrian, Composition (B) en Bleu, Jaune et Blanc, 1936 (Composition (B) in Blue, Yellow, and White, 1936). Oil on canvas, $17\frac{1}{8} \times 13\frac{1}{4}$ ins $(43.5 \times 33.5$ cm). Kunstmuseum, Basel. Emannuel Hoffman Foundation. © 2007 Mondrian/Holtzman Trust c/o HCR International, Warrenton, VA.

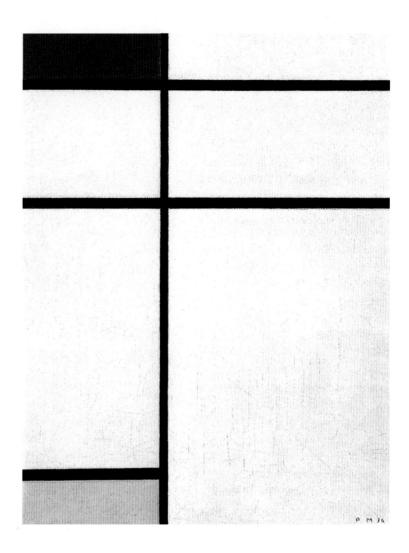

Flowering Apple Tree (1.12), the thickness of trunk and branches is also pared away, leaving only the interaction of arcing lines and the spaces between them. Here Mondrian has reduced the visual essence of a tree as lines in space to its bare bones.

The opposite extreme from realism is **nonobjective** or nonrepresentational work, in which no reference at all is made to objects from the physical world. Here one sees only pure elements of design—lines, shapes or forms, space, textures, colors.

Using Piet Mondrian again as our example, ultimately his reductionist approach led to utterly non-representational paintings such as *Composition in Blue, Yellow, and White* (1.13). Here, all reference to the three-dimensional world was eliminated. Stripping away any objective imagery, to which people would bring their own individual associations, he strove for universal imagery by confining himself to the bare bones of visual experience: lines, colors, and shapes.

Even then he limited his choice of shapes to just one purely geometric shape: the rectangle. He treated the flat plane of the canvas as the two-dimensional space that it is. The serenity of aesthetic balance among the parts of the composition had spiritual implications, he felt, signifying order in the universe. Mondrian hoped that such nonrepresentational art would be spiritually satisfying to its viewers.

The less representational a work is, the more we must bring to it if we are to appreciate it. In Mondrian's more abstract trees, we have to use our memories of trees to interpret the images. We are also asked to become intellectually involved in discovering relationships between lines and spaces. When all figurative imagery is deleted, our response no longer has any base in our experiences of the physical world. Instead, we can explore the work as we would explore virgin territory. Indeed, nonobjective art has historically been used in many cultures to suggest spiritual realities that lie beyond form.

ARTISTS ON ART

Georgia O'Keeffe on Abstraction

GEORGIA O'KEEFFE (1887-1986), an austere, strong-minded woman who painted until her death at the age of ninety-nine, is considered one of the greatest American artists of the twentieth century. She is particularly famous for her large abstractions of flowers, as shown in Lily-White with Black (1.14), animal bones, mysterious organic forms, and landscapes of the New Mexico desert, where she spent her later years as a nearrecluse. For her, painting was a way of communicating about experiences and sensations that could not be expressed in any other way. And, although she had studied and practiced previous artists' methods, she was also determined to use her skills to communicate in a different way. She explains in her letters:

"It was in the fall of 1915 that I first had the idea that what I had been taught was of little value to me except for the use of my materials as a language—charcoal, pencil, pen and ink, watercolor, pastel, and oil. I had become fluent with them when I was so young that they were simply

another language that I handled easily. But what to say with them? I had been taught to work like others, and after careful thinking I decided that I wasn't going to spend my life doing what had already been done. ... I decided I was a very stupid fool not to at last paint as I wanted to and say what I wanted to when I painted."

Among her letters are these comments:

"The large White Flower with the golden heart is something I have to say about White—quite different from what White has been meaning to me. Whether the flower or the color is the focus I do not know. I do know that the flower is painted large to convey to you my experience of the flower—and what is my experience of the flower if it is not color?

I know I cannot paint a flower. I cannot paint the sun on the desert on a bright summer morning but maybe in terms of paint color I can convey to you my experience of the flower or the experience that makes

the flower significant to me at that particular time.

Color is one of the great things in the world that makes life worth living to me and as I have come to think of painting it is my effort to create an equivalent with paint color for the world—life as I see it."

November 1, 1930

"From experiences of one kind or another shapes and colors come to me very clearly—sometimes I start in very realistic fashion and as I go on from one painting after another of the same thing it becomes simplified till it can be nothing but abstract—but for me it is my reason for painting it I suppose.

At the moment I am very annoyed—I have the shapes—on yellow scratch paper—in my mind for over a year—and I cannot see the color for them—I've drawn them again—and again—it is from something I have heard again and again till I hear it in the wind—but I cannot get the color for it—only shapes."⁶

April 22, 1957

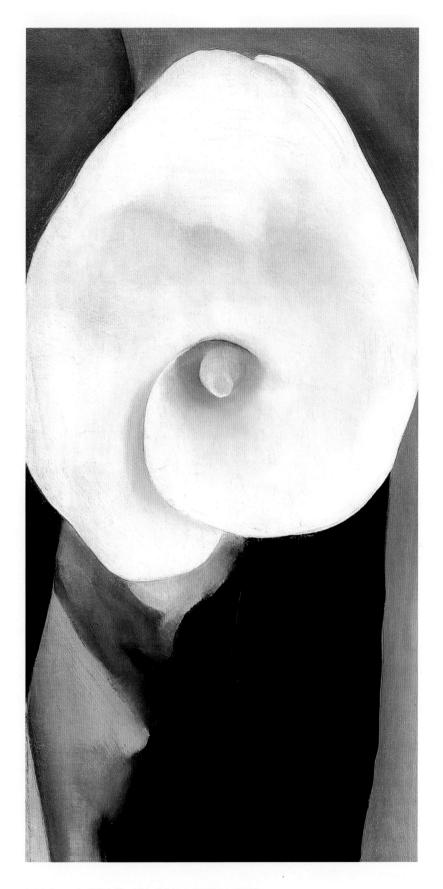

1.14 Georgia O'Keeffe, *Lily—White with Black*, 1927. Oil on board, 12×6 ins (30.5×15.2 cm). Estate of Georgia O'Keeffe.

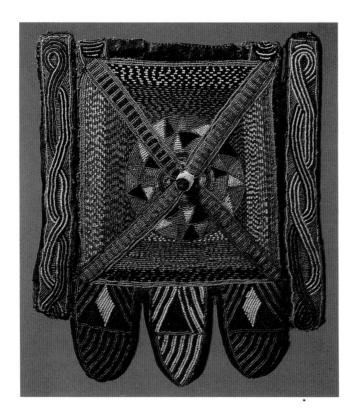

1.15 Yoruba diviner's bag.

The Yoruba divination bag, used for future-fore-telling sacred objects (1.15), incorporates many common motifs for the intangible dimensions of life, including swirling circles within circles, the four directions of the universe, and intertwined lines.

FINE AND APPLIED ARTS

In addition to dimensionality and realism, another distinction that can be made among works of art is whether they were originally intended as objects to be looked at or as objects to be used. In the Western tradition of the past several centuries, the fine arts, such as drawing, painting, printmaking, and sculpture, involve the production of works to be seen and experienced primarily on an aesthetic rather than a practical level. Pieces of fine art may evoke emotional, intellectual, sensual, political, or spiritual responses in us. Those who love the fine arts feel that these responses are very valuable, perhaps especially so in a highly materialistic world, for they expand our awareness of the great richness of life itself. Auguste Rodin, the nineteenthcentury sculptor whose work The Gates of Hell we explore in depth in Chapter 16, offered a passionate challenge to artists—and to those who are touched by their works: "The main thing is to be moved, to love, to hope, to tremble, to live."7

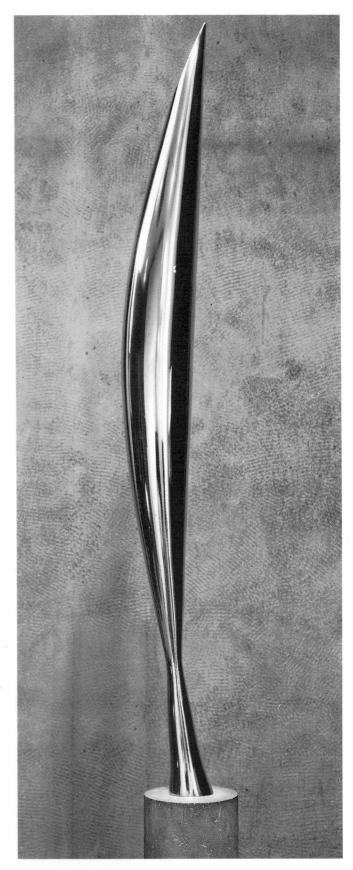

1.16 Constantin Brancusi, *Bird in Space*, 1928. Bronze (unique cast), $54 \times 8\frac{1}{2} \times 6\frac{1}{2}$ ins (137.2 \times 21.6 \times 16.5 cm). Museum of Modern Art (MOMA), New York. Anonymous donation.

1.17 Lucy Lewis, water jar, 1979. Ceramic, height 6 ins (15 cm).

Constantin Brancusi's elegant *Bird in Space* (1.16) has no utilitarian function whatsoever. It is solely "art for art's sake," a highly refined suggestion of that ephemeral moment when a bird in flight catches the light. Indeed, the effect captured Brancusi's imagination, and between 1910 and the early 1950s he created a series of twenty-eight similar birds in bronze and marble, explaining that "The Bird has fascinated me and will not release me." It is based on the Romanian legend of Maiastra, a magical golden bird whose feathers shone like the sun, illuminating the darkness. When struck by light that brings out their highly polished surface, Brancusi's bronze birds become radiant, light-giving sources, formless points of light in the immensity of space. Brancusi said:

As a child, I used to dream that I was flying among trees and up into the sky. I have always remembered this dream and for forty-five years

I have made birds. It is not the bird that I want to express but the gift, the taking off, the *élan* God is everywhere. One is God when one forgets oneself and if one is humble and makes the gift of oneself, there is God in your work One lady in New York felt that and, kneeling, wept before one of my Birds.⁹

Unlike the nonfunctional appeals of the fine arts, the first purpose of the **applied arts** is to serve some useful function. Traditional basket-makers, furniture-makers, potters, and weavers around the world create objects to hold things, to sit upon, to cover the body. But many craftspeople have not been content solely to do the bare minimum of work to create functional objects. Everywhere, their creative urge has burst the confines of functionality, leading to infinite variations in design. Lucy Lewis, a traditional potter from Acoma Pueblo in New Mexico, used the chewed end of a yucca cactus spine to paint the fine lines of an elaborate design on the surface of her water jar (1.17). But the jar's main purpose is to hold water. Until recently, the

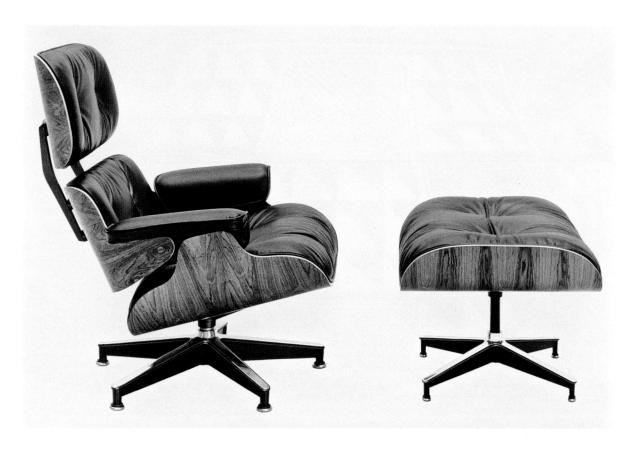

1.18 Charles and Ray Eames, lounge chair and ottoman, 1946. Museum of Modern Art (MOMA), New York. Charles and Ray Eames brought a strongly democratic spirit and a perennial interest in experimentation to bear upon mass-produced furniture, hoping to uplift society through affordable but high-quality industrial design.

people of Acoma, which may be the oldest continually inhabited city in the United States, still followed the old ways, carrying water for drinking, cooking, and washing up to their adobe homes from natural rock cisterns on the cliff walls below. The forms of their water jars were therefore designed to prevent spilling and to balance readily on the carrier's head. The pots also had to be light in weight, so Acoma ware is some of the world's thinnest-walled pottery. Interestingly, the languages of most Native American peoples do not include a word or term that means "fine art"; although they traditionally created pottery, basketry, and woven materials with a highly sophisticated sense of design, they used these pieces simply as part of their everyday lives.

The applied art of pottery-making is one of the **crafts**, the making of useful objects by hand. Other applied art disciplines are similarly functional. **Graphic designers** create advertisements, fabrics, layouts for books and magazines, logos for corporate identification, and so on; **industrial designers** shape the mass-produced objects used by high-tech societies, from cars, telephones, and computer workstations to household furniture. If these designs are successful, their aesthetic

and functional appeal is long lasting. Innovative chairs designed in the 1940s and 1950s by the industrial designer Charles Eames and his sculptress wife Ray (1.18) in the effort to bring good design into everyday life are still popular today. Other applied arts include clothing design, interior design, and environmental design.

Having made this Western distinction between the fine and applied arts, we must note that the boundary between them is blurred. Art for art's sake is a category that exists only in certain cultures; until recent centuries in European cultures, and still today in non-industrialized societies, artistic production has been either an aspect of spiritual and ritual practice or a functional endeavor. Certain works had functions when they were created that are now overlooked by those who consider them solely as fine arts. The sculptures and stained-glass windows of Gothic cathedrals were functional in the sense that they were designed to teach and inspire people of the Christian faith.

Many functional pieces have been made with the accent on their visual appeal rather than their functional qualities. The fine porcelain stemcup shown in Figure 1.19 is so beautifully designed that we cannot

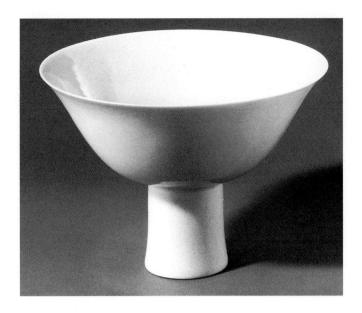

1.19 Stemcup, Ch'ing dynasty, Ch'ien Lung reign, 1736–39. Porcelain, 3% ins (9.8 cm) high. Yale University Art Gallery, New Haven, Connecticut. Gift of Dr. Yale Kneeland, Jr., B.A. 1922.

consider it simply as a functional piece. It is equally a work of fine art, created for those who could afford to surround themselves with costly beauty, even in the functional furnishings of their homes.

Another reason for the blurring of the distinction between fine and applied arts is that the artistic sophistication of many functional pieces and the time and skill involved in handmade crafts are increasingly appreciated by people in today's industrial societies. The everyday pottery of people who still follow their culture's traditional lifeways, along with many other examples of applied design, are now included in major museum collections, as objects both of cultural significance and of pure visual delight.

PUBLIC AND PRIVATE ART

Some art is intended chiefly for private use or enjoyment; some for the public at large. Private works are of a scale and character that invite intimate participation, though they may secondarily be displayed in museums as well. In a traditional Japanese home, the *tokonoma* alcove, like the one shown in Figure 1.20, is a quiet spot for private contemplation, usually decorated only by a single scroll painting and a vase with flowers, whose natural beauty is thought to humble anything created by humans. Originally set aside for the worship of ancestors, the alcove still invites contemplation of the sacred in the midst of ordinary life.

By contrast, governments and public institutions

have long commissioned art on a grand scale as public statements. Rome's Arch of Constantine (1.21) was designed to glorify Constantine's victory over his greatest rival, a victory that made him absolute ruler of the Roman Empire. Its surface is decorated with a series of reliefs used to honor the emperor, though some were actually plundered from monuments to earlier rulers. The massiveness of the arch is a symbol of the emperor's public stature.

In all cultures, religious institutions have been major patrons of artists, commissioning paintings and sculptures to help tell the story of their tradition to the masses and inspire them with the same beliefs. Much of our greatest architecture has been created in the service of centralized governments and religious bodies, who had the power or commanded the devotion to raise the large sums of money needed for monumental projects.

Business corporations and multinational conglomerates are now also centers of wealth and power. In recent years, they have become patrons of the arts as well. They buy and display large paintings and sculptures, partly to impress their clients and partly as good investments, for the commercial gallery and auction-house system has fostered a vigorous market in art as a financial commodity.

The increasing appreciation of art as investment has raised new issues for public consumers of art, such as museums, municipalities, and governments. One is the issue of censorship of art that is considered offensive

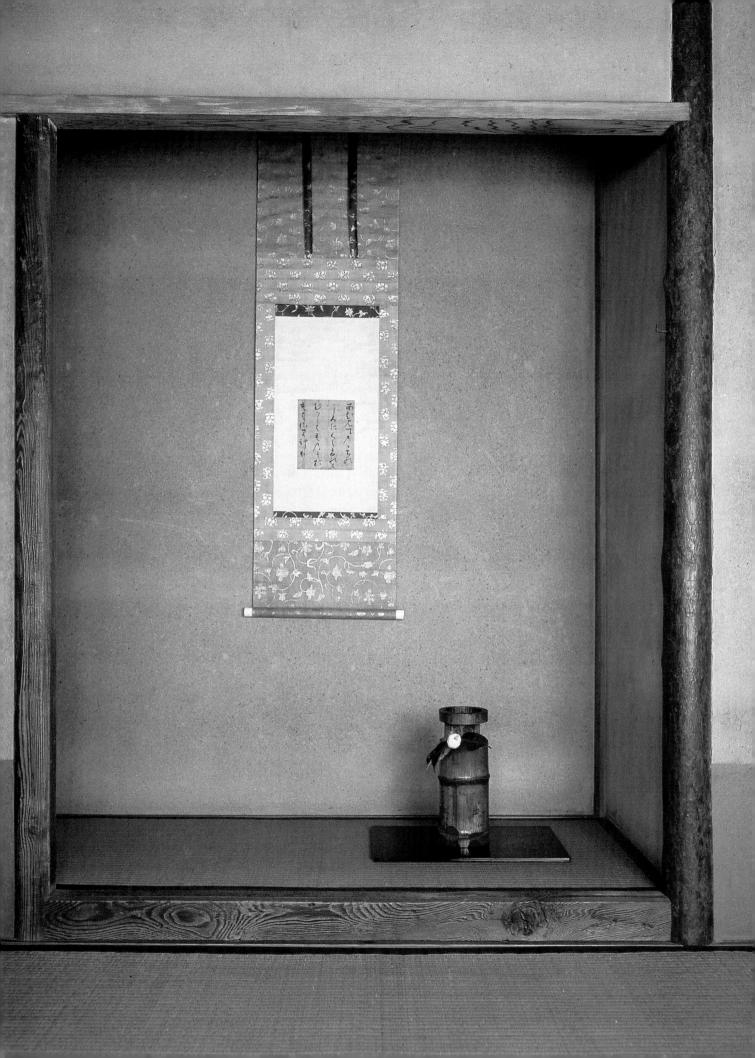

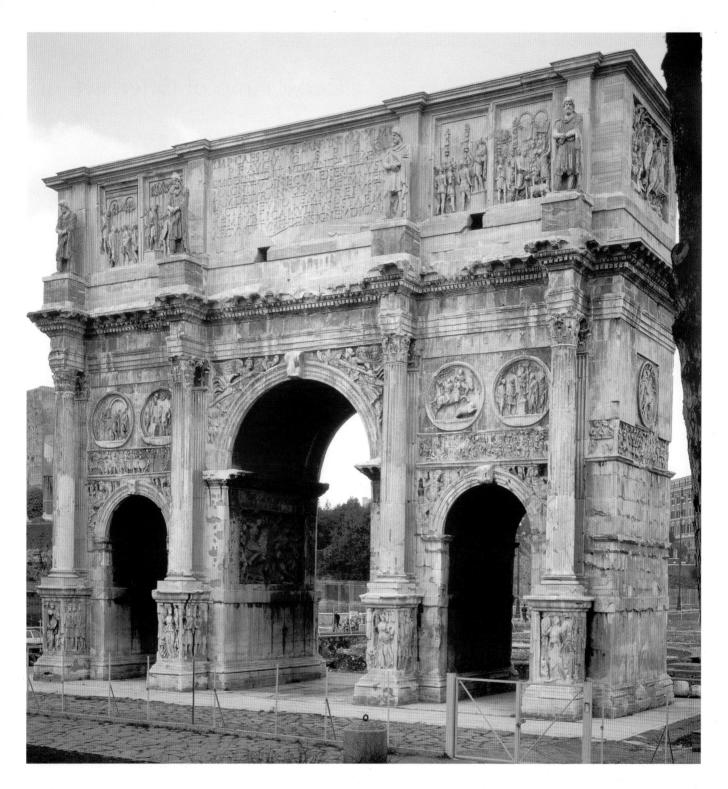

1.20 (opposite) Tokonoma alcove in a private home, Japan.

1.21 (above) Arch of Constantine, Rome, A.D. 312–315.

(see pages 30–1). Other issues raised in this area will be examined later in a box on Art as Investment (see pages 510–11).

People feel that when public money is used for the purchase of art—as when it is used for any other purpose—they have a right to express their disapproval, whether on the grounds that they do not like the art or that they consider it simply a waste of money. The purchase of the American artist Barnett Newman's *Voice of Fire* (1.24) by the National Gallery of Canada for the equivalent of US\$1.5 million raised a howl of protest. Some objected to spending two-thirds of the Gallery's annual acquisitions budget on a work by a non-Canadian artist. Others did not place such

Censorship of Offensive Art

DOES THE PURSUIT of art require complete freedom of expression for all artists? Should limits be drawn as to what is acceptable in publicly displayed art or publicly funded art?

These questions came to the fore in 1990 in the United States when funding by the National Endowment for the Arts for a traveling exhibition of sexually explicit photographs by Robert Mapplethorpe became the subject of intense debate and even an obscenity court case. It was filed against the director of the Contemporary Art Center in Cincinnati. Jurors were shown only the seven most controversial photographs from the exhibit. They were asked to determine whether they met all three criteria of obscenity, as defined in a landmark US Supreme Court ruling from 1973. The Supreme Court had ruled that a work is obscene if it depicts sexuality "in a patently offensive way," if "the average person, applying contemporary community standards" finds that it appeals to "prurient interest," and if it "lacks serious literary, artistic, political, or scientific value."10

None of the jurors had any background in art appreciation and they did not like the pictures. Nevertheless, they acquitted the director after ten days of expert testimonies designed to prove that Mapplethorpe's work did indeed have serious artistic value and therefore should not be judged legally obscene. The director of the Cleveland Museum of Art argued that the photographs were metaphoric "images of rejection, aggression, anxiety." The director of the Walker Art Center in Minneapolis told the jury:

"I recognize that they are difficult. I recognize that they are confrontational. I recognize that they tell us things maybe we would rather not hear. But they do shine lights in some rather dark corners of the human psyche. And they symbolize, in disturbing, eloquent fashion, an attitude. And they do reflect an attitude that is not necessarily limited to the artist."

One of the jurors later said, "We learned that art doesn't have to be pretty." Nevertheless, the potential for funding for art on the edge to be withdrawn continues to hang over the heads of artists and museums.

In 1999, the mayor of New York threatened to withdraw the city's financial support of the Brooklyn Museum of Art, evict it from its premises, and replace its governing board because of its exhibition of the work of ninety-two young British artists, entitled "Sensation." The works included slices of animals in formaldehyde-filled cases, a portrait of a child abuser and murderer made of small children's hand-prints, and statues of children with genitalia where their faces should be. The mayor termed it "sick stuff," and pointed to a work by Chris Ofili, The Holy Virgin Mary (1.22), as being particularly offensive to people of Roman Catholic faith. Ofili's black Madonna is ornamented with cutouts of buttocks and lumps of elephant dung. The resulting controversies involving use of public funds, vested interests, religion, race, moral sensitivities, animal rights, freedom of expression, and mixing of aesthetics and politics notwithstanding, the exhibition was held, and record crowds queued up to see it.

In 2005, Buenos Aires was rocked by controversy over a retrospective of the anti-religious, explicitly sexual, and politically satirical works of Leon Ferrari. The archbishop of the city declared the exhibition blasphemous, and the cultural center, staff, and artist received threats of violence. After the exhibit was closed by a judge to avoid hurting people's religious sentiments, the cultural center and city hall won their appeal to re-open it, on the basis of the artist's right to free expression. The cultural secretary of Buenos Aires observed, "The exhibition may be provocative, but nobody was obliged to see it."13 In fact, because of the scandal, some 70,000 people came to see the exhibition.

Moscow witnessed violent protests over an exhibition of the work of forty Russian artists exploring religion in Russian life. Held at the Sakharov Museum and Public Center in 2003, the exhibit was entitled "Caution! Religion." The exhibition was vandalized by Orthodox fundamentalists and the organizers were brought to trial in 2005 on charges of provoking religious hatred. Mobs of fundamentalists built altars for prayer vigils in the courthouse corridors during the trial and shouted anti-Semitic epithets at the defendants. The court demanded that the artists submit statements explaining why they had created their works; one artist had to defend her depiction of Adam and Eve as naked. Psychologists and art historians called by the prosecution said that they detested contemporary art and felt that it should not be shown in public museums. Despite outcries by the international intellectual community, the organizers were

found guilty and fined 100,000 rubles (\$3,600) apiece. Demands that the artworks should be destroyed were not upheld by the court, however.

Censorship of art has long been an issue. Michelangelo's monumental painting at the end wall of the Sistine Chapel, The Last Judgment (detail in Figure 1.23), was violently attacked in the sixteenth century shortly after it was painted. In the Council of Trent, Roman Catholic Church officials had ruled that sacred images must adhere closely to scriptural descriptions, lest any viewer be misled. Critics felt that Michelangelo had taken too much artistic license. His angels did not have wings, for instance, and the angels blowing trumpets announcing the apocalypse were all grouped together, rather than at the four corners of the earth in accordance with scripture. The most controversial aspect of the work was the voluptuous nudity of the figures, which prompted one critic to refer to Michelangelo as "that inventor of filthiness." People tried physically to attack *The Last Judgment*. So as to save the masterpiece, two succeeding popes ordered that the naked figures should be overpainted with loincloths to cover their genitals and breasts; the bits of clothing now seen (5.16) did not exist in Michelangelo's original work (1.23).

More recently, in 1937 Nazi Germany confiscated over 16,000 pieces of modern German art of all sorts, burned much of it in a huge fire, and exhibited some of the rest with the label "Degenerate Art." At the opening of the exhibit, the president of the Reich Chamber of Visual Arts explained:

"We now stand in an exhibition that contains only a fraction of what was bought with the hard-earned savings of the German people and exhibited as art by a large number of museums all over Germany. All around us you see the monstrous offspring of insanity, impudence, ineptitude, and sheer degeneracy. What this exhibition offers inspires horror and disgust in us all."¹⁵

Among the works confiscated from German museums were fifty-seven paintings by Wassily Kandinsky, whose delicate explanations of spiritual harmony in art are quoted in a special feature box on pages 200–01.

Questions arise: What are the ramifications of institutional censorship of artistic creation? Can art be dangerous for social health? Can censorship of art be dangerous for social health? If there should be limits, who should define them? Should the depiction of violence, sexism, racism, or sacrilege be censored, or only overt depictions of sexuality?

1.22 Chris Ofili, *The Holy Virgin Mary*, 1996. Paper collage, oil, glitter, polyester resin, map pins, and elephant dung on linen, 96×72 ins (244 \times 183 cm). Courtesy of the Saatchi Collection.

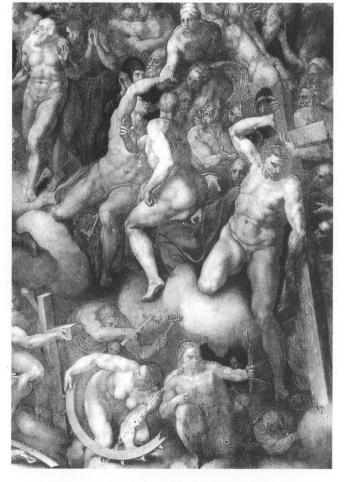

1.23 Michelangelo Buonarroti, the *Last Judgment* (detail), end wall of the Sistine Chapel, old print of the original.

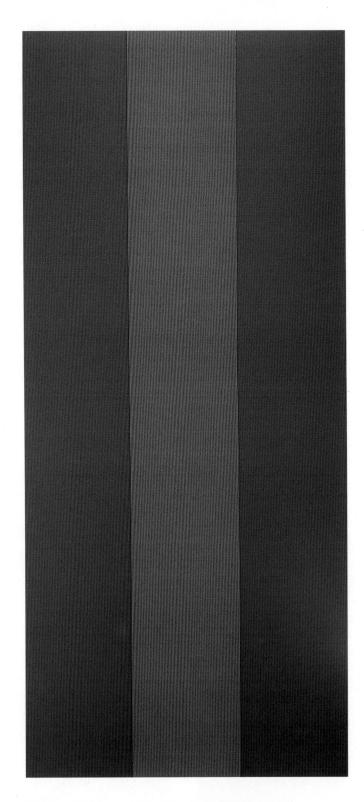

1.24 Barnett Newman, *Voice of Fire*, 1967. Acrylic on canvas, 17 ft 10 ins \times 8 ft (5.44 \times 2.44 m). The National Gallery of Canada, Ottawa. Collection Annalee Newman, New York.

high value on modern, nonrepresentational paintings. A pig farmer, who was then Chairman of the Canadian House of Commons Cultural Affairs Committee, said he could have created the same 18-foot-high (5.5-m) red stripe on blue ground himself, "given two cans of paint, a roller, and about ten minutes." ¹⁶

The Gallery director defended the decision to buy the work of a US artist, affirming that "Art is universal; it knows no boundaries, and artists know no boundaries." The Head of Collections and Research at the National Gallery explained the aesthetic reasons for the purchase:

1.25 Daniel Libeskind, Model for the World Trade Center, New York, 2002.

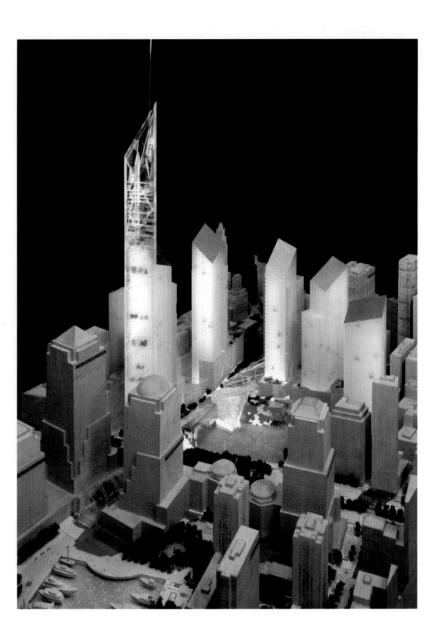

In the spacious, sunlit gallery where the work is presently installed, *Voice of Fire*'s soaring height strengthened by the deep cadmium red center between darker blue sides is for many visitors an exhilarating affirmation of their being wholly in the world and in a special space where art and architecture complement each other.¹⁸

As you study the material and examples in this book, you can begin to develop informed opinions about art that may have been unfamiliar to you.

Content

One way of beginning to understand what is going on in a work of art is to try to grasp its **content**—its meaning, including the subject-matter (what it is or

represents), and the emotions, ideas, symbols, stories, or spiritual connotations it suggests.

Americans struggling to cope with the emotional aftermath of September 11, 2001, considered how the World Trade Center should be rebuilt. Should there be more grand towers symbolizing national greatness in the face of threat? Should there be disjointed structures suggesting chaos? Towers that look as though they are swaying in the air? Standard post-modern urban architecture? All such proposals were rejected in favor of a design that reflects the continuing idea of loss: Daniel Libeskind's design featuring a park in a deep pit at Ground Zero, exposing the subterranean wall that held back the Hudson River after the buildings were attacked. This pit, surrounded by tall buildings that will cause it to be totally in shadow every year on September 11, will be a lasting metaphor for the deep wound in the national psyche (1.25).

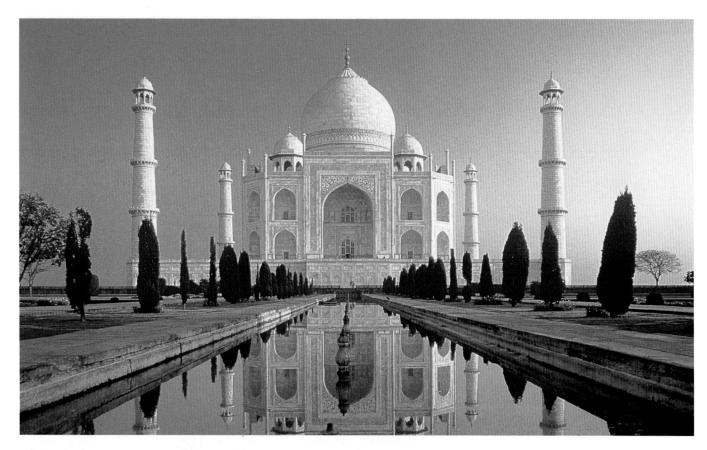

1.26 Taj Mahal, front view with pool in foreground.

The content of a work of art is not a fixed entity captured within a frame. It is shifting, evanescent, personal. It changes depending on who is looking at the artwork, and what emotions and experiences they bring to the act of viewing. Wayne Thiebaud's Bikini (1.4) may elicit quite different responses from men and from women, as their gaze meets hers. Among the range of possibilities, she might be seen as an object of men's desire or as a self-determining human being. Viewers' emotions and experiences are in turn deeply influenced by their cultural context, by the ways and beliefs of the society in which they learned how to interpret the world. Reactions to a depiction of a nude woman, for instance, will differ profoundly in cultures where women are expected to be heavily clothed and in cultures where nudity is socially acceptable.

Content is also influenced by the context of the artist's life, culture, and historical setting. Visitors to the beautiful Taj Mahal (1.26) find it especially poignant when they learn that it was built by the emperor Shah Jahan to immortalize his beloved wife, Mumtaz Mahal, and that she had been his constant companion, even in battle, until she died while giving birth to their fourteenth child. One's appreciation of the intention behind this monument to his life

partner is tragically heightened when one learns that the emperor was later imprisoned by his son and could thereafter see the Taj Mahal only from his prison window, from which he gazed at it for the rest of his life.

Some works are so powerful that we can respond to them directly, without knowing anything of the artist's personal life or of the cultural or historical context. We don't think of Rembrandt as a period artist; we know him as one of the greatest artists of all time. Hundreds of years after his self-portrait was painted in 1660 (1.3), that face, executed with such compelling truth, such strength in design, and such technical skill, looks out at us from the darkness with an appeal that is timeless.

SOCIOPOLITICAL CONTENT

Many artworks have been created to record something in the political or social environment, to inform the public, or to preserve an event for history. Studied from a sociopolitical point of view, art can be seen as providing information about the cultural and social background of its time. Vera Mukhina's *Machine Tractor Driver and Collective Farm Girl* (1.27) offers a vivid insight into the idealism of early twentieth-century communism in Russia, with its hopeful vision that men

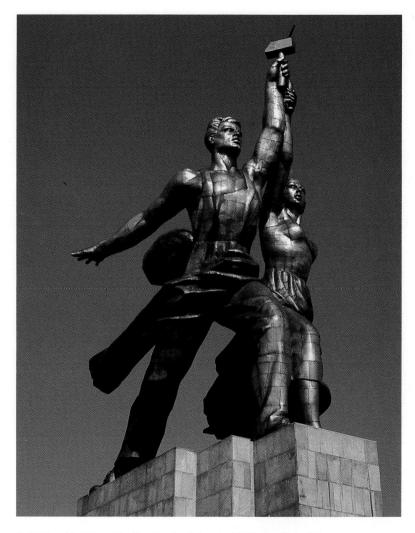

1.27 Vera Mukhina, *Machine Tractor Driver and Collective Farm Girl*, undated, Moscow.

and women of all classes would work side by side for the common good and so create a new, egalitarian society.

In contrast with this message in support of government policies, some art is created as social criticism. Sometimes the message is blatant, immediately apparent; sometimes it is subtle and complex. W. Eugene Smith's photograph *Tomoko in a Bath* (1.28) is part of a series illustrating industrial pollution in Minamata, Japan. Tomoko is a victim of mercury poisoning; her mother is giving her a bath. The scene—dramatized by composition and lighting—is one of the most powerful photographs ever taken. It may evoke a strange mixture of feelings, from horror at the effects of pollution to compassion for the tenderness with which Tomoko's mother is holding and looking at her daughter. The pose and expression of great love in the midst of tragedy may remind some of Michelangelo's *Pietà* (15.27).

The political intent of some art may be to soothe rather than to inflame passions. The Vietnam War

deeply divided the people of the United States. There was a desire to create a memorial to those who died fighting the war, but how could this be done in a way that did not antagonize either the relatives of the deceased or the opponents of the war? In an open competition, the winning solution was created by a young architecture student, Maya Lin. Her Vietnam Veterans' Memorial in Washington, D.C. (1.29) is a very quiet but nonetheless profoundly moving statement about the deaths of Americans in the war. Elegantly and starkly simple, it consists of an angled wall of polished black granite, incised with the names of all the Americans who died in the conflict, and then tapering down to disappear into the earth. Lin explains:

Many earlier war memorials were propagandized statements about the victor, the issues, the politics, and not about the people who served and died. I felt a memorial should be honest about

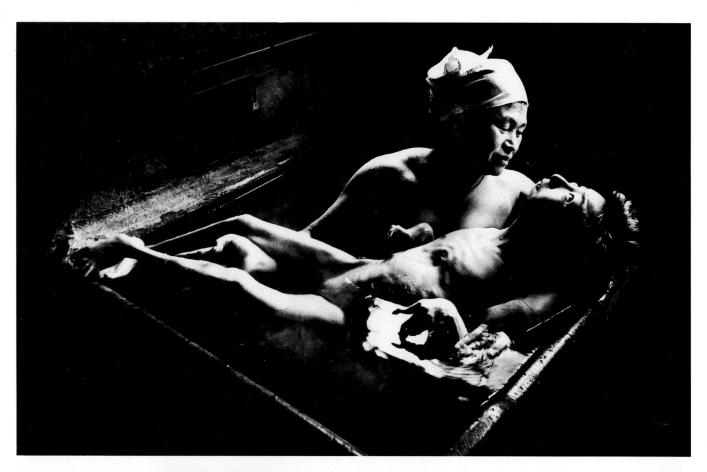

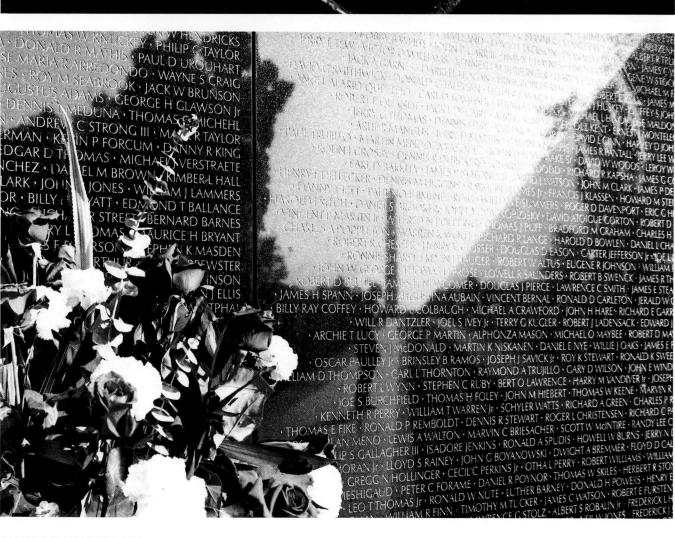

1.28 (opposite) W. Eugene Smith, *Tomoko in a Bath*, 1972. Photograph. © 1972 Aileen & W. Eugene Smith.

1.29 (opposite, below) Maya Ying Lin, Vietnam Veterans' Memorial, Washington, D.C., 1982–4. Black granite, length 250 ft (76.2 m).

the reality of war and be for the people who gave their lives I didn't want a static object that people would just look at, but something they could relate to as on a journey, or passage, that would bring each to his own conclusions I didn't visualize heavy physical objects implanted in the earth; instead it was as if the blackbrown earth were polished and made into an interface between the sunny world and the quiet, dark world beyond, that we can't enter. 19

POWER AND PROPAGANDA

Another way in which artists' skills and creativity have been engaged is in the creation of works that allow the person or group who paid for them to gain prestige. Certainly this was an intention behind the commissioning of many monumental pieces, such as Louis XIV's colossal palace at Versailles (1.30). A huge corps of architects, interior designers, sculptors, painters, and landscape artists worked for almost half a century to create not only the largest and grandest palace the world had ever seen, surrounded by an immense and elaborate park, but also an entire city for government officials, courtiers, servants, and the military. Their buildings radiate along avenues that intersect in the king's bedroom, symbolizing the vast wealth and power of the absolute monarch.

Mingled with a show of wealth is the desire to impress the public with one's good taste in art. Today corporations often choose for this purpose large, nonobjective paintings and sculptures. These can suggest a sophisticated, contemporary corporate image, and they have no subject matter that would offend

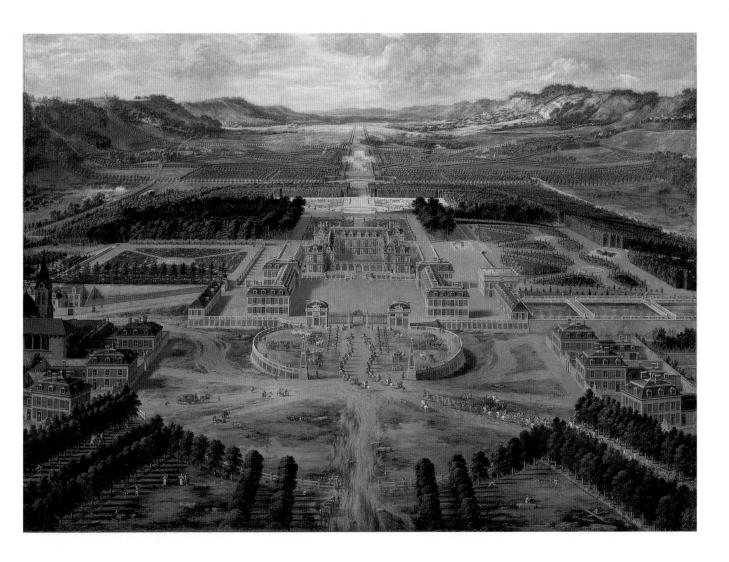

1.30 Pierre Patel, View of the Castle and the Gardens of Versailles, Catch of the Avenue of Paris, 1688. Oil on canvas, 45×63 ins (115 \times 161 cm). Musées Nationaux, Paris.

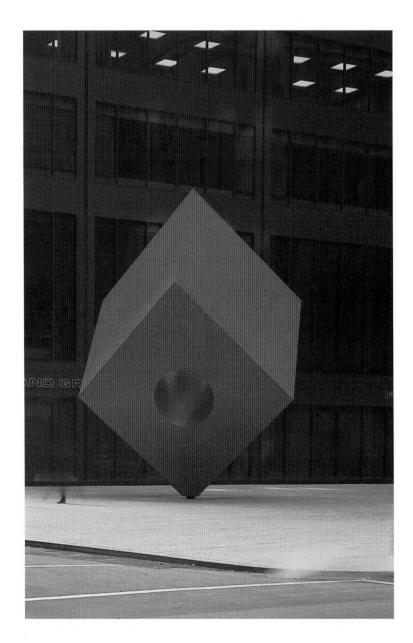

1.31 Isamu Noguchi, *Red Cube*, 1968. Red painted steel. Marine Midland Plaza, New York.

anyone. But it takes wealth and a certain daring to commission monumental modern sculpture to occupy expensive urban real estate. The point of using valuable Manhattan ground-level space for a huge cube resting precariously on one corner (1.31) may escape the uninitiated, but the choice of this sculpture by Isamu Noguchi was a signal to those who know something about art that the bank that commissioned it was imaginative, forward-looking, and prestigious.

Patronage plays a major part not only in financing but also in determining the content of commissioned artworks. Governments like to project positive self-concepts, presenting a proud image to both citizens and visitors. Public architecture is often commissioned with this intention. Moshe Safdie's

Vancouver Library Square (1.32) was intended as the central symbol of the city of Vancouver, as well as a place for learning, public gatherings, and civic office work. Vancouver citizens were offered the chance to vote for their choice of the designs of three architectural firms. A solid majority—70 percent—chose Safdie's design, which wraps a curving, freestanding wall around a semicircular structure containing small reading nooks, which in turn embraces a cube containing the library stacks. The voters preferred it because it was "most memorable and different."

The same artistic skills that can express civic pride can also be used coercively. The advertising executives who commission graphic designers are skillful at tapping into consumers' pride to convince them to

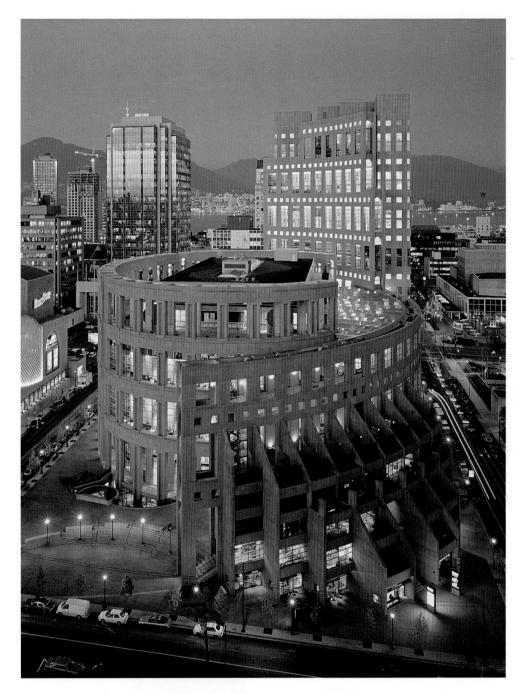

1.32 Moshe Safdie, Vancouver Library Square, Vancouver, British Columbia, opened May 1995. Photo by T. Hursley.

buy products. Advertisements for expensive cars often speak to people's aspirations to wealth and good taste; ads for clothing often manipulate people's desire to exert sex appeal. Adolf Hitler had a clear sense of the tremendous impact of media propaganda and used it extensively and ultimately with tragic effect, to build popular support for his regime. Ludwig Hohlwein's poster commissioned for the Nazi regime (1.33) presents such a powerful visual image that the mere words "Und du?" ("And you?") convey the aggressive

challenge to the civilian to become part of the war machine. We are shown only the storm-trooper's masculine features, nothing of his individuality; he becomes an abstraction for the idea of the German Soldier, a superhumanly strong man with the power of the group and the group's history behind him. The angle from which he is shown makes us look up at him, and the deliberate mingling of hero worship, intimidation, and brooding power is characteristic of the totalitarian values of the Nazi regime.

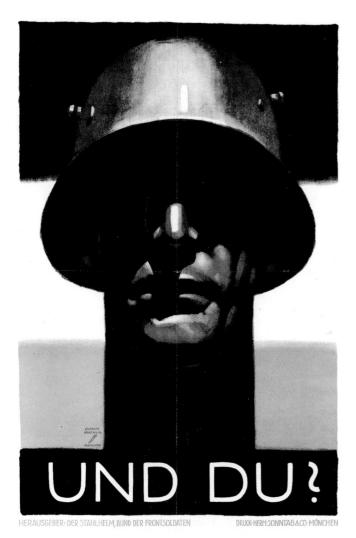

1.33 Ludwig Hohlwein, poster, c. 1943. Library of Congress, Washington, D.C. Poster Collection.

SPIRITUAL PURPOSES

Much of the world's art has been created to serve spiritual functions, whether to inspire or educate the populace or to evoke or appease deities. In the process, the person commissioning or creating the work may expect worldly adulation or spiritual blessings. The Baroque sculptor and architect Gian Lorenzo Bernini was commissioned by the Roman Catholic Cardinal Cornaro to build an intimate and ornate chapel honoring himself and his family. As its altarpiece, Bernini created a lifesized sculpture of *The Ecstasy of St. Teresa* (1.34). It illustrates the story in which the saint is speared by an angel in a vision, leaving her "completely afire with love of God." Because the work is so skillfully and dramatically executed, it brings both honor to the patron and inspiration to the viewer.

Art created for spiritual purposes is of course deeply embedded in the spiritual understandings of the particular culture. Michelangelo's depiction of God in the Creation of Adam (1.1) is shaped by Judeo-Christian understanding of God as a male Person, separate from His creation. People from cultures that regard the Ultimate Power as formless, or as female, would be puzzled by this depiction of God. Some Hindus, for instance, use images of a dancing Lord Shiva (1.35) to evoke awareness of the all-pervading Power that is continually creating and destroying the cosmos. Ganapathi Stapati, Principal of the College of Architecture and Sculpture in Mahabalipuram, explains:

It is all part of the scientific and spiritual tradition we have been brought up in. It is complex and difficult to explain in English, but I will try. We believe there is a spirit in all things, and through sculpture we express in form the beauty of that spirit. The smallest unit is the atom. Ultimately atoms are united in form—in physical objects—but they also exist in space. Within us there is an inner space in which atoms vibrate, and these vibrations are our feelings. When we

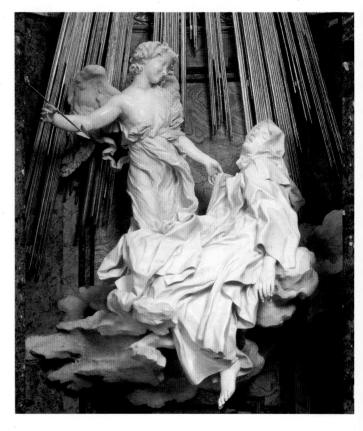

1.34 Gian Lorenzo Bernini, *The Ecstasy of St. Teresa*, 1645–52. Marble, stucco, and gilt bronze, lifesize. Cornaro Chapel, Church of Santa Maria della Vittoria, Rome.

Bernini, deeply imbued with Christian piety, has masterfully carved marble into a highly realistic visual expression of the mystic's inner experience of spiritual rapture.

see fine art, we vibrate to it—we are moved. When we create art through the discipline of our tradition, we create forms which mirror the vibrations within us Ours is not a realistic art, but in our sculptures we can give expression to the eternal spirit and, through symbols, to even the most subtle aspects of Hindu philosophy.²¹

The symbolic imagery in spiritual art may be understood only by people of that culture, or only by an initiated few, or perhaps only by the artist herself or himself. In Australian aboriginal culture, the unseen world—the Dreaming—is understood as the ground of existence and the abode of powerful ancestral beings. Only the elders are initiated into the secrets of this world, but they are authorized to depict it symbolically. On a superficial level, these paintings, such as *Burrowing Skink Dreaming at Parikirlangu*, supervised by Darby Jampijimpa (1.36), are aerial views of the sacred

landscapes, but they are said to have many more levels of interpretation understood only by the elders.

INNER EXPERIENCES

Rather than taking images or events outside themselves as their subjects, many artists have explored their own interior worlds. One aspect of this inner world is the capacity for fantasy—for imagining things that have never been seen, as in Paul Klee's *Twittering Machine* (1.37). Despite the delicate playfulness of this painting, Klee spoke about the act of artistic creation very seriously. For him, it seemed to be a way of approaching the unseen and the creator of all realms, both seen and unseen. In his *Creative Credo* he asserted that "visible reality is merely an isolated phenomenon latently outnumbered by other realities." He approached his materials with no preconceived subject-matter, allowing unconscious understandings to guide his hand. "My hand is entirely the implement of

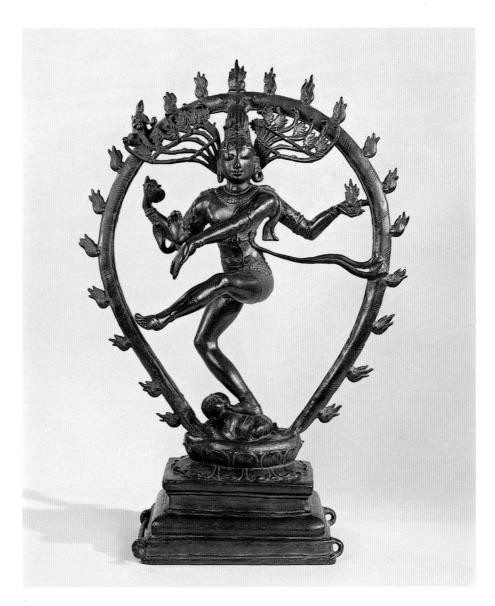

1.35 Nataraja (Shiva as Lord of the Dance), from Madras Presidency, eleventh century A.D. Bronze casting, height 3 ft (91.44 cm). Victoria and Albert Museum, London. Statues of the "Dancing Shiva" depict an understanding of life and death as a dance. Lord Shiva is the god of a cosmos in perpetual flux, with death and destruction part of the process of purification, rebirth, and renewal.

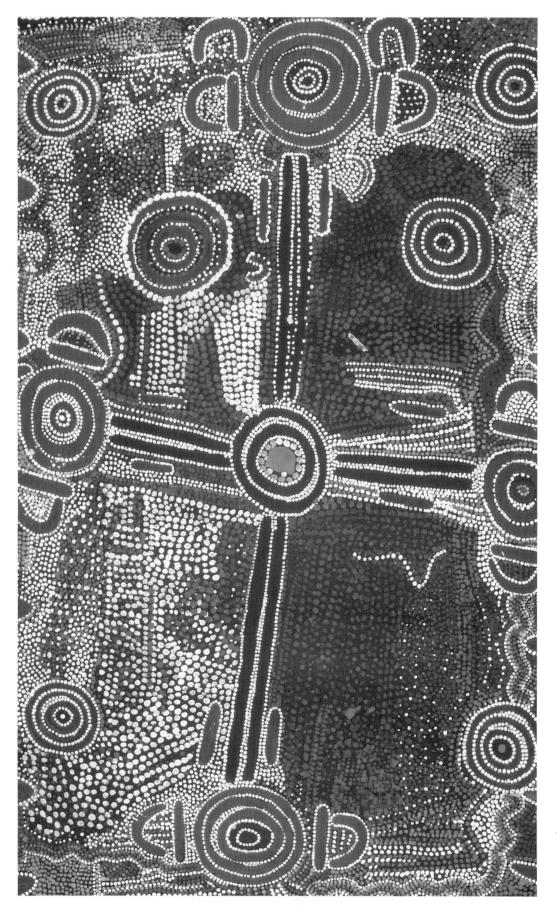

1.36 (left)
Darby Jampijimpa,
Burrowing Skink Dreaming
at Parikirlangu, 1986.
Acrylic on canvas,
57¼ × 37 ins
(145.3 × 94.2 cm).
© Asia Society Galleries
and South Australia
Museum.

1.37 (opposite) Paul Klee, Twittering Machine (Zwitscher-Maschine), 1922. Watercolor and pen and ink on oil transfer drawing on paper, mounted on cardboard, 25½ × 19 ins (63.8 × 48.1 cm). Collection Museum of Modern Art (MOMA), New York. Purchase 564.1939.

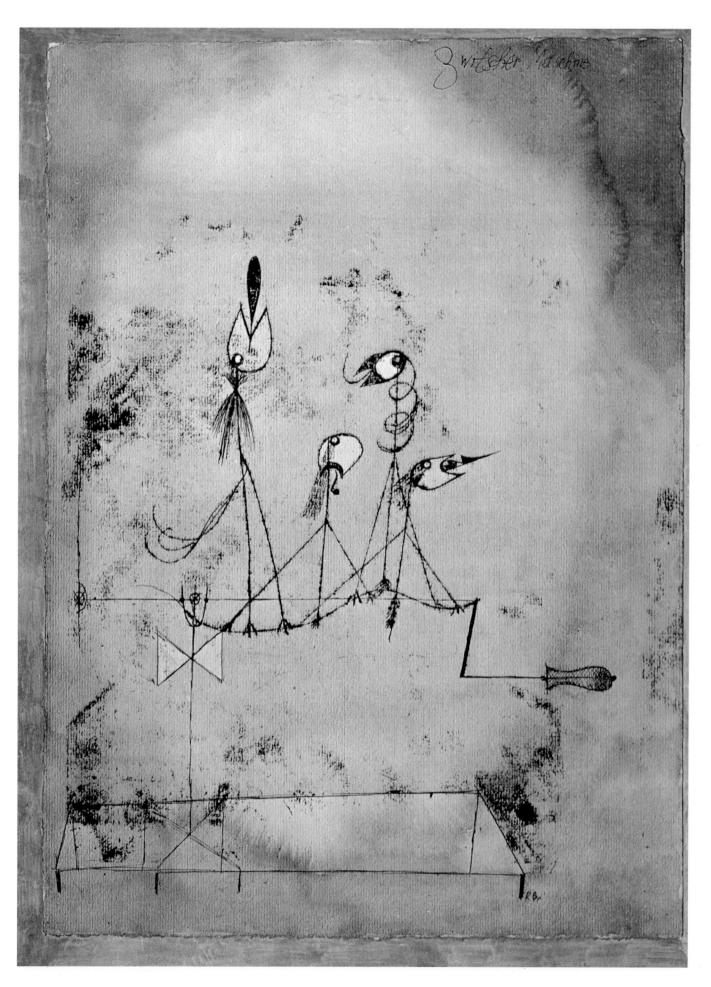

a distant sphere,"²² he explained. "What artist does not yearn to dwell near the mind, or heart, of creation itself, that prime mover of events in time and space?"²³

Another artist who delved into the unconscious to bring forth fantastic images was Henri Rousseau. A retired Parisian customs collector, he painted exotic landscapes and creatures that he had never seen, as in The Dream (1.38). The narrative within the painting suggests the illogical happenings and inventive landscapes we experience in our dreams. Rousseau was a naive artist, one who had never been trained in the principles and techniques of art. For instance, the lighting in The Dream does not seem to come from the direction of the moon; Rousseau placed highlights and shadows where he wanted them, rather than where they would logically fall. Unencumbered by ideas of the way things "should" look or be represented, he was highly successful in entering the uncharted territory of the subconscious. Be that as it may, we respond to Rousseau's images on some level beneath conscious thought. Rousseau's untaught, natural sense of design and his detailed treatment of mysteriously juxtaposed figures give a haunting power to these landscapes of the soul.

Often artworks refer to cultural symbols for inner experience, which are best understood by people from that particular culture. For Korean women, "wrapping the bundle" is an expression that means packing up one's things and leaving the family, perhaps to avoid tension, perhaps to live with another person. To a Korean, the sight of a bundle of possessions evokes personal responses to change, impermanence, and uprooting of one's life, as poignantly suggested in Soo-ja Kim's installation piece *Deductive Object* (1.39). Kim explains:

We are wrapped in cotton cloth at birth, we wear it until we die, and traditionally we are wrapped in it for burial. Especially in Korea, we use cloth as a symbolic material on important occasions such as coming of age ceremonies, weddings, funerals, and rites for ancestors. Therefore cloth is thought

1.38 Henri Rousseau, *The Dream*, 1910. Oil on canvas, 6ft $8\frac{1}{2}$ ins \times 9ft $9\frac{1}{2}$ ins (2.045 \times 2.985 m). Collection Museum of Modern Art (MOMA), New York. Gift of Nelson A. Rockefeller. 252.1954.

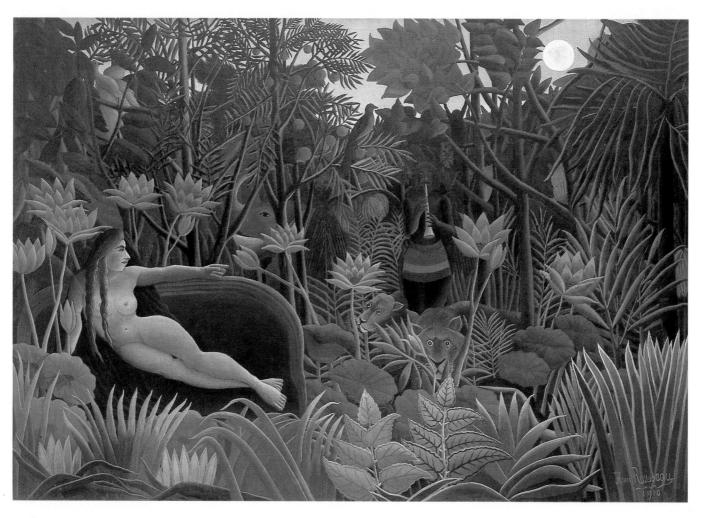

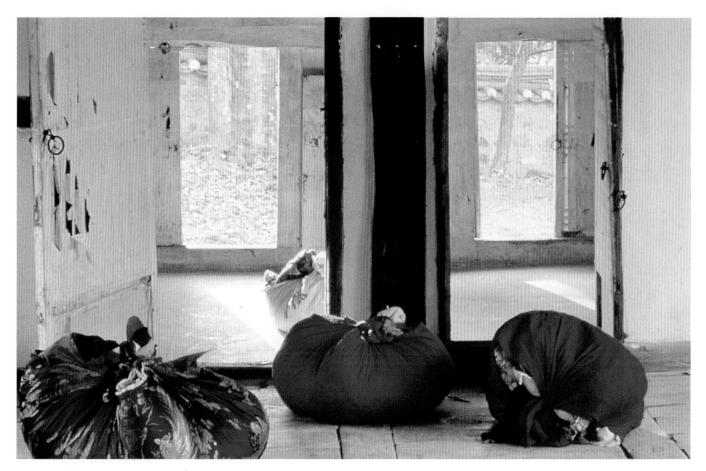

1.39 Soo-ja Kim, Deductive Object, Yangdong village, South Korea, 1994. Used clothes and used bedcovers.

to be more than a material, being identified with the body—that is, as a container for the spirit. When a person dies, his family burns the clothes and sheets he has used. This may have the symbolic meaning of sending his body and spirit to the sky, the world of the dead.²⁴

Inner experiences may also be depicted directly, as it were, without the use of any imagery from the outer world. Mark Rothko's subject-matter was sheer emotion, beyond form. His sublime nonobjective paintings, such as *Green on Blue* (1.40), offer large, hovering, soft-edged fields of color for quiet contemplation. People often respond to them with powerful emotion, as was Rothko's intention. He said:

I am interested only in expressing the basic human emotions—tragedy, ecstasy, doom, and so on—and the fact that lots of people break down and cry when confronted with my pictures shows that I *communicate* with those basic human emotions. The people who weep before my pictures are having the same religious experience I had when I painted them. And if you ... are moved only by their color relationships, then you miss the point.²⁵

In some cases, artists draw their imagery from external realities but project their own state of mind onto them. Some quality inside the artist finds its counterpart in the outer world, revealing inner truths. One who worked in this way was Vincent van Gogh (1853-90). Inwardly intense, he had to place himself in an asylum for protection during his periodic mental disorders. Ultimately he took his own life. His The Starry Night (1.41) reflects a dynamic vision of nature as ever-changing, in continuous motion. The sky boils with swirling energy patterns; the hills roll like waves; the trees writhe upward like flames. The houses in the village seem dwarfed by the cosmic drama, with the possible exception of the church spire. It is clear that, to see this pastoral landscape thus, van Gogh must have been highly sensitive and seething with inner energy.

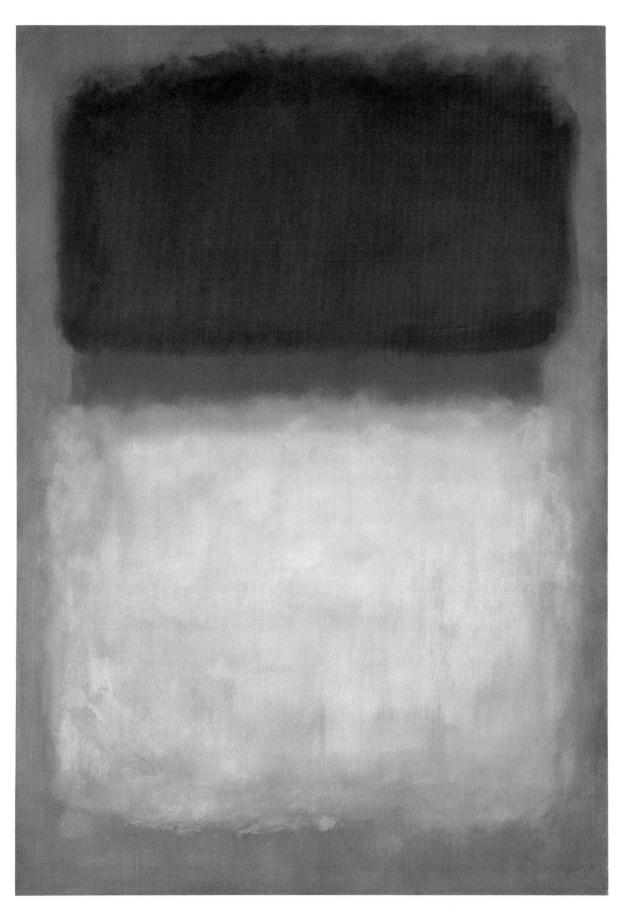

1.40 Mark Rothko, *Green on Blue*, 1956. Oil on canvas, 7 ft $5\frac{3}{4}$ ins \times 5 ft $3\frac{1}{4}$ ins (2.28 \times 1.61 m). University of Arizona Museum of Art, Tucson, Arizona. Gift of Edward J. Gallagher, Jr.

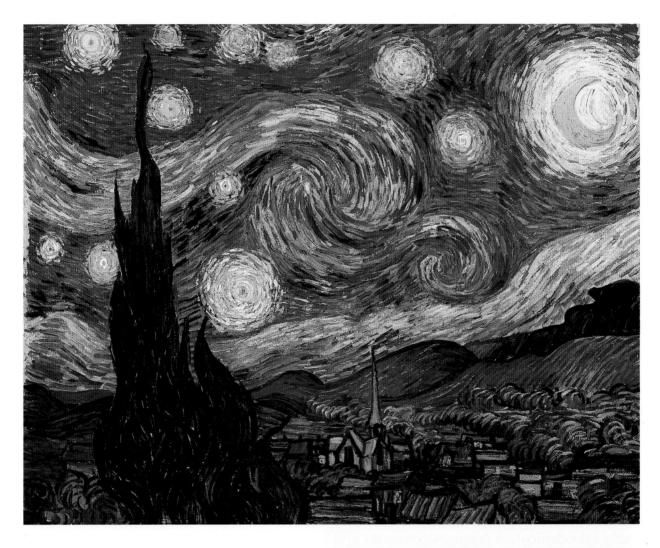

1.41 Vincent van Gogh, *The Starry Night*, 1889. Oil on canvas, $29 \times 36\frac{1}{4}$ ins $(73.7 \times 92.1 \text{ cm})$. Museum of Modern Art (MOMA), New York. Acquired through the Lillie P. Bliss Bequest. 472.19.

Personal spirituality without reference to a particular religious tradition permeates much of contemporary artistic creation. Without theology, without historical references, such direct experiences of mystical dimensions of life are difficult to express, either in words or in images. George Chaplin uses color as a nonverbal expression of spirituality, in paintings such as *Da Kara* (1.42). He explains:

Color is both the subject and object of my paintings and I celebrate it for its emotional and spiritual impact. Each work develops as an intuitive and sensory experience through subtle transitions of varying amounts of color.²⁶

1.42 George Chaplin, *Da Kara*, 2003. Oil on canvas,60 \times 68 inches (152.4 \times 172.7 cm). Artist's collection.

BEAUTY

Many artists have created art in the pursuit of beauty. There may be some narrative content, or expression of feelings or ideas, or some political context, but the emphasis in such cases is to create forms that are the most beautiful creations of human hands. Ideals of beauty are culturally influenced, but elegance of form often transcends culture to appeal to people everywhere.

Perhaps the world's most dramatic example of this impulse to create beauty is the Taj Mahal (1.26). The Mughal Emperor Shah Jahan's desire was to immortalize his wife's memory in a mausoleum of matchless beauty. For twenty-two years, the greatest masons and 20,000 laborers worked under his direction to execute his ideal. Their materials were pure white marble, sandstone, and precious stones gathered from as far afield as Persia, Mesopotamia, Tibet, and Sri Lanka. Across the exquisite surfaces are sculpted verses from the Qur'an, and inlays of diamond, lapis lazuli, sapphire, carnelian, turquoise, agate, coral, garnet, onyx, and amethyst to create flowers of subtly varying colors. The regal symmetry of the great mausoleum and the towers that flank it, like ladiesin-waiting surrounding a lovely princess, is beautifully echoed in a long reflecting pool.

To increase understanding and appreciation of such aesthetic triumphs, Chapter 2 of this book will explore the elements of design, which are the visible characteristics of matter: line, shape and form, space, texture, light and dark, color, and movement or change through time. Artists study these characteristics and use them quite consciously to achieve their ends. Chapter 3 will look at the principles of design—how a work is organized for a unified and engaging effect. The principles of design we will be exploring include repetition, variety and contrast, rhythm, balance, compositional unity, emphasis, economy, proportion, and relationship to the surrounding environment. Then Parts 2 and 3 of the book will explore two- and three-dimensional media and their methods, revealing the difficulties as well as the potential of each medium.

Critical Opinion

Art does not exist in a vacuum. The mood of the times and the opinion of the professionals in art appreciation, such as art critics and museum curators, have a telling effect on our response to works of art. There are no absolute guidelines for judging quality in art. People tend to respond negatively to anything unfamiliar, but what was originally shocking and unprecedented may in time become quite familiar and acceptable. In the early 1960s, the average person thought Jackson Pollock was a fraud or a trickster, because he presented his works done with flung or dripped paint as serious art (1.43). But the critics declared Pollock a serious artist, worthy of being studied and collected. Nonobjective art such as Pollock's "allover" dripped compositions and Barnett Newman's *Voice of Fire* (1.24) became highly respectable and also began to attract high prices.

Critical tastes have changed dramatically over time. Some artists who were praised to the skies in art magazines ten years ago are almost unknown today. When the French Impressionists such as Monet, Renoir, and Seurat began their experiments with depicting the play of light and how it determined what they saw, they were utterly rejected by the reigning French Academy. At one point, a bankrupt dealer tried to sell van Gogh's canvases in bundles of ten for 50 centimes to one franc per bundle. Today the works of the Impressionists and Post-Impressionists are considered so valuable that only the very wealthiest collectors can afford them. Van Gogh's *Portrait of Dr. Gachet* was sold in 1990 for US\$82.5 million.

Referring to a painting by Auguste Renoir (see his work in Figure 3.28), a critic once wrote, "Evidently, the models spent several days under water." A painting by the Post-Impressionist Paul Cézanne (1.44) was at first dismissed as "a few palette scrapings," but is now in the collection of the Philadelphia Museum of Art.

While the Impressionists were struggling to survive, the President of the Society of French Artists, William Bouguereau, controlled admission to the official salon and thus access to sales and commissions. He favored a painting style called "enhancement," in which ordinary human defects are deleted in favor of idealized beauty, and figures are set off against a dark background and organized according to traditional formulas for composition, as in *Nymphs and Satyr* (1.45). Bouguereau himself had abandoned his earlier work portraying death and suffering, for, as he explained, "I soon found that the horrible, the frenzied, the heroic does not pay, and as the public of today prefers Venuses and Cupids and I paint to please the public, it is to Venus and Cupid I chiefly devote myself."²⁹

But as Impressionism and later contemporary movements gradually took hold, accustoming viewers to more offbeat and abstract effects, Bouguereau's work lost favor.

1.43 Jackson Pollock, *Number 1, 1948*, 1948. Oil and enamel on unprimed canvas, 5 ft 8 ins \times 8 ft 8 ins (1.73 \times 2.64 m). Museum of Modern Art (MOMA), New York. Purchase. 77.1950. From 1947 onward, Jackson Pollock used the radical process of pouring or dripping paint onto large canvases laid on the floor, thus creating "allover" compositions without imagery. When examined at their full size, their complex surfaces seem to burst with inner energy.

For a long time, it was considered too contrived and romanticized to be taken seriously. In recent years, however, some critics have reassessed this opinion: Bouguereau's work is being shown again at certain museums, and realistic figurative work has come back into vogue.

Today there are varying models for judging art. One is a **formalist** approach. From this perspective, the chief focus is on how the artist manipulates elements of design, as we will be exploring in Chapter 2, organizes them according to unifying principles, as we will be exploring in Chapter 3, and wields particular media, to be explored in Chapters 4 to 14.

A second critical perspective is **expressivist**. In this paradigm, emphasis falls on the ability of the art to communicate feelings and ideas. Qualities such as originality, intensity, and sincerity are given greater weight than technique and design qualities. Thus in recent times a new appreciation has grown around the work of untrained "outsider" and "folk" artists, and work that deals more in communicating concepts than

in creating objects. You will find examples of such work throughout this book, as well as in discussions of specific art movements in Chapter 15.

A third perspective is instrumentalist. Here one analyzes art primarily on the basis of how it fulfills some religious, political, or social purpose. This is not a new approach; around the globe and throughout most of history, most art has been created to serve some functional purpose such as education or healing rather than to exist on its own as art for art's sake. Today this approach has come back into vogue with the creation of art designed to provoke political or social responses, such as concerned awareness of environmental problems. It is also involved in a new appreciation of art created by oppressed members of society, including women and racial or cultural minorities, for to accord critical recognition to this art serves the social purpose of ending their exclusion from the mainstream of the art world (see pages 52-3). Throughout this book, we will be looking at examples of art by women,

1.44 Paul Cézanne, *Mont Sainte-Victoire seen from Les Lauves*, 1902–4. Oil on canvas, $27\frac{1}{2} \times 35\frac{1}{4}$ ins (69.8 \times 89.5 cm). Philadelphia Museum of Art, George W. Elkins Collection. *Cézanne had an overriding interest in visual representations of the solid structures of things.*

multicultural art, and art created for specific functional goals. In addition, Chapter 15 discusses appreciation of women's art and multicultural art historically as a relatively new Western phenomenon.

The same work of art can thus be judged from very different points of view. Consider three quite different contemporary interpretations of *mantle* (1.47), Ann Hamilton's enigmatic installation at the Miami Art Museum. It consisted of approximately 60,000 flowers, eleven shortwave radios, and a seated woman stitching woolen coats. Lorie Mertes, Associate Curator at the museum, responded to the sensory experience and possible symbolic meaning of the installation:

The word "mantle" means to cloak and cover, and Hamilton's *mantle* certainly entailed total sensory envelopment: the scent of flowers, the blanket of sound, and the coats themselves. But the exhibition also made one aware of time and its passage—another kind of blanket. Time's immediate passing was measured by the presence

of attendants and their labor-intensive task of manually mending the coats; time as extinguished was suggested by the flowers in their various stages of bloom and decay; and, finally, time as eternal was captured in the disembodied voices emanating from the flowers, which would shortly die.

Joan Simon, an art historian, took an historical point of view of the same work:

It could almost be seen as an interpretation of a 17th-century Dutch painting: a precisely rendered architectural interior; a *vanitas*, or allegorical still life with flowers as symbols of the fragility of life; a woman immersed in her thoughts and handiwork bathed in a warm light from a candle or a window.

Tami Katz-Freiman, an art critic, brought an awareness of the sociocultural environment to her understanding of the work:

1.45 William Bouguereau, *Nymphs and Satyr*, 1873. Oil on canvas, 8 ft 6 ins \times 5 ft 11 ins (2.59 \times 1.8 m). Sterling and Francine Clark Art Institute, Williamstown, Massachusetts.

During the late nineteenth century, William Bouguereau was one of the wealthiest and most powerful of French painters, since he pandered to the tastes of the bourgeoisie and was continually assured of state patronage. His critical reputation has nonetheless seen great oscillations.

Race and Gender Criticism

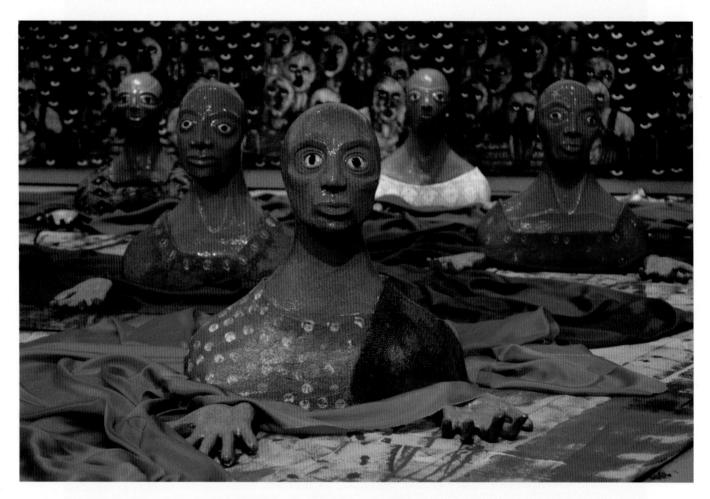

1.46 Imna Arroyo, Ancestors of the Passage: A Healing Journey through the Middle Passage, 2005. Mixed media installation, heads with hands $19 \times 8 \times 9\%$ ins ($48.3 \times 20.3 \times 24.1$ cm), background collagraph prints on paper 49×90 ins (124.5×228.6 cm), overall dimensions variable. Exhibited at Widener Gallery, Trinity College, Hartford, Connecticut, January–March 2005.

AT PRESENT, ART is undergoing intense scrutiny on the basis of criteria that are new to art criticism. At issue is the extent to which women artists and artists of color have been marginalized by the white, male-dominated Western art establishment and their humanity trivialized or oppressed through art.

One problem has been racial and gender stereotyping, rather than recognition of the full humanity of those without political power.

Women have often been depicted as

seductive sex objects rather than as complete and independent individuals. From the 1970s onward, some women artists have themselves begun creating art about the female body, not as an object but as a subject. To redefine their own sexuality, they have explored the female body in images, celebrated its links with nature and natural processes, and documented its abuses.

Another issue is the low value placed on the work of women and people of color. In the art market

centered in New York, it has been difficult for many such artists to be accepted or taken seriously. Women have rarely been acknowledged as fine artists—as painters or sculptors or printmakers, for instance. And traditional crafts which they have mastered, such as quiltmaking, have not been recognized as valuable art until recent years. In 1997, a prominent show of contemporary artists at the Museum of Modern Art in New York included only three white women, one woman of color,

and no men of color, out of a total of seventy-one artists. If the work of women or people of color is shown, it may be specifically as "feminist" or "black" art, rather than simply as art, or it may be shown only in alternative spaces, such as cooperative galleries. Daryl Chin asserts:

"The art world, so tied to an ideology of a market economy, reflects the sociopolitical consciousness of that ideology. And that ideology maintains a hierarchy of stratification, with minority artists lacking a definable place within the structure ... If the majority fails to recognize the exclusionary tactics now being practiced, then the realm of aesthetics is no longer imaginary; it is downright pathological." 31

One could argue that the art of disempowered peoples should be judged by the same aesthetic standards as the art of the powerful. But it can also be argued that the criticism of art is based on aesthetic

principles developed in the mainstream of Western culture. How then to judge quality in works that are not part of that tradition?

One solution is to try to evaluate work in terms of its own intentions. Consider the work of Imna Arroyo. She is a Puerto Rican artist whose work self-consciously reflects her African-Caribbean heritage and also her indigenous Taino ancestry. Although much of her work investigates the role of women in those cultures, Ancestors of the Passage: A Healing Journey through the Middle Passage (1.46) has different intentions. She explains:

"My imagery reflects both my physical and spiritual world. I use both two- and three-dimensional forms to resurrect the ancestors from their watery graves and give voice to the millions of people who died as a result of greed, disease, and inhuman treatment during the Atlantic slave trade. Ancestors of the Passage is an affirmation of the

memory of this loss. Only half of the slave ship cargo of 40 million to 90 million people, kidnapped from their homeland, survived. The Ancestors of the Passage is an important artwork for me because it has informed me of my richer African heritage and allows me to bear witness and to acknowledge the great loss. At the same time, I want the viewer to become aware of the great gifts brought forth by the ancestors who survived and to honor their legacy. As human beings we continue to witness atrocities and yet forget them all too quickly."32

If this work is to be judged in its own terms, we should not ask, "Is it well-designed or skillfully made?" but rather, "Does it touch us, reach out to us, educate us, remind us of a horrible page in human history?"

The serious consideration of multicultural and women's art is challenging and broadening critical tastes in art, which are in any case ever-changing rather than static.

1.47 Ann Hamilton, *mantle*, installation view, Miami Art Museum, April 2–June 7, 1998. Sixty thousand cut flowers on a table 48 ft (14.6 m) long, eleven shortwave radio receivers broadcasting garbled voices, and a static, seated woman stitching woolen coats before a 10 ft (3 m) high window. Photo by Thibault Jeanson.

Hamilton's site-specific work could be seen as referring to the social, cultural, and economic climate of southern Florida. Located between the Americas, Miami is a center of the import-export business and a focal point of immigration. As an Israeli who moved to Miami a few years ago, I couldn't help thinking of the flowers—an allusion to the city's multimillion-dollar wholesale flower industry—as an embodiment of the cultures that make up the city's social texture.³⁰

Lasting Greatness in Art

Throughout this book, you will be gaining critical faculties that will help you to judge the form and content of artworks. By the end of the book, you should be able to analyze a work of art from many perspectives and thus come to some conclusions about its worth and meaning. In the last chapter, we will be looking in depth at three artworks that have been considered great through the centuries, and also a newer work, which is loved by some and vigorously opposed by others. We will also be examining aspects of these key works at relevant points throughout the book. Here we will look briefly at the circumstances under which they were created, and how all have been enmeshed in some kind of controversy.

One of these featured works is Michelangelo Buonarroti's Sistine Chapel ceiling (1.48). Early in the sixteenth century, Pope Julius II commissioned him to

paint the Twelve Apostles and some simple decorations on the Vatican Palace Chapel ceiling. Michelangelo later wrote that he convinced the pope that if he limited himself to this idea, the result would be "a poor thing." The pope thus gave him carte blanche to create whatever he thought best. The result was an extraordinarily complex project: to paint in fresco the Christian story of humanity's beginnings. It is considered one of the world's greatest art treasures. Nevertheless, Michelangelo was soon under criticism from counterreformers in the Roman Catholic Church. In a backlash against Renaissance humanism, the Counter-Reformation attempted to reestablish the Church's voice of authority, as opposed to the voice of individual reason, which was subject to potential errors. Art commissioned for Church purposes was included in restrictions outlined by the Council of Trent in 1563. As indicated in the Censorship feature box (pages 30-1), Michelangelo's work was criticized for its inventive and metaphorical spiritual approach, for the artist had not used biblical descriptions literally. Michelangelo was a very wealthy artist, but his letters indicate that he had continually to remind his patrons, including the pope and the Church, to pay him.

In recent years, the Sistine Chapel ceiling has again been at the center of a raging controversy. This time the issue is its radical restoration, which some people feel has ruined this great work. The issues

^{1.48} (opposite) Michelangelo, ceiling of the Sistine Chapel (after cleaning 1989), 1508–12. Fresco 45 \times 128 ft (13.7 \times 39 m). Vatican Palace, Rome.

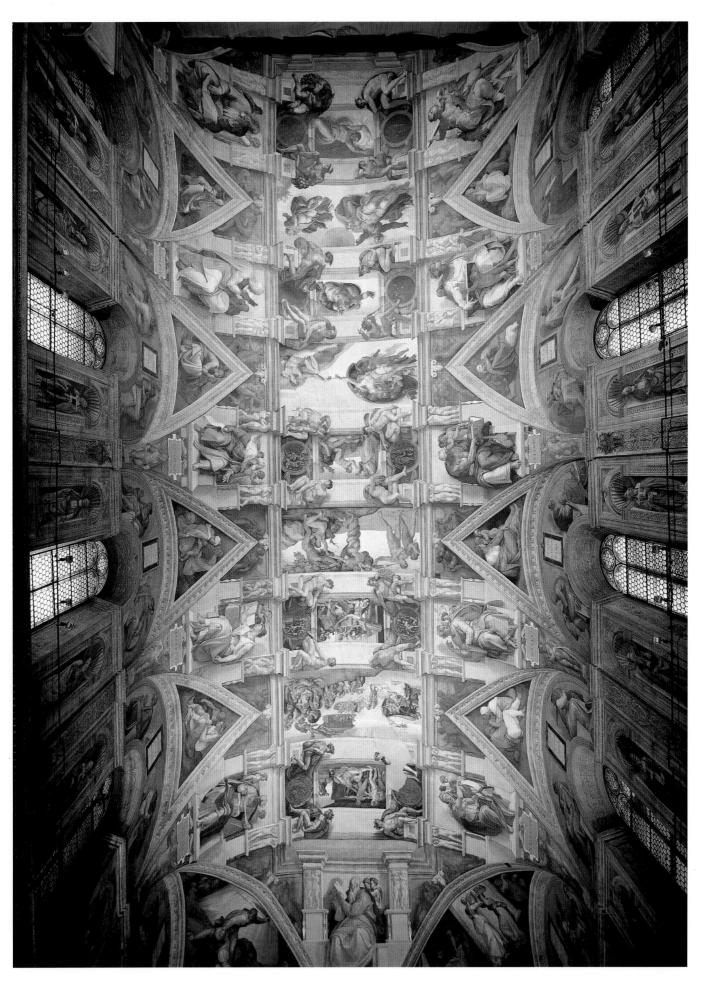

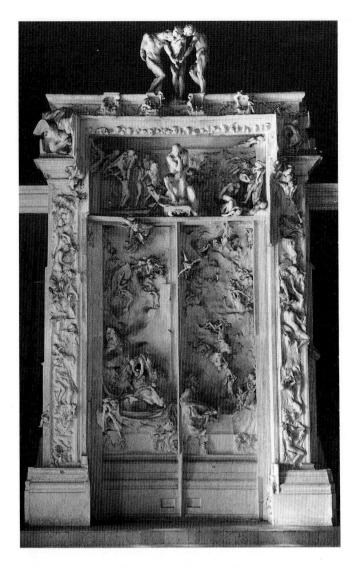

1.49 Auguste Rodin, *The Gates of Hell*. Plaster. Photographed in 1917. Musée Rodin, Paris.

involved in restoration of famous artworks will be examined in an Art Issues box in Chapter 5, as well as in the last chapter.

Just as Michelangelo had trouble in collecting the money owed to him for this work, so did the nineteenth-century French sculptor Auguste Rodin, artist of the monumental *The Gates of Hell*, explored in the last chapter of the book. He also had difficulty in dictating how his work should be displayed, and it was hard for him to convince his patrons that his aesthetic sensitivities rather than their ideas should shape the sculptures they commissioned. Many of his projects remained unfinished. *The Gates of Hell* (1.49) was commissioned for a proposed museum which was never built; the plaster molds that Rodin created for the Gates (as shown here) were not cast into bronze, as he had planned, until after he had died (see Figure 2.22).

Pablo Picasso's monumental twentieth-century painting *Guernica* (1.50) was also a commissioned piece. During the Spanish Civil War, Picasso was a loyalist, an anti-fascist, living in exile in France. He was asked in January 1937 by the Spanish government in exile to paint a commemorative piece about the war for the 1937 World's Fair in Paris. He had not yet begun when, in April 1937, the ancient city of Guernica in northern Spain was destroyed by German bombers acting to support General Franco. There was no strategic reason to bomb Guernica; it was just a rehearsal to test the new military technique of saturation bombing. Most of Guernica was reduced to rubble; many civilians were killed. When Picasso heard the news, he

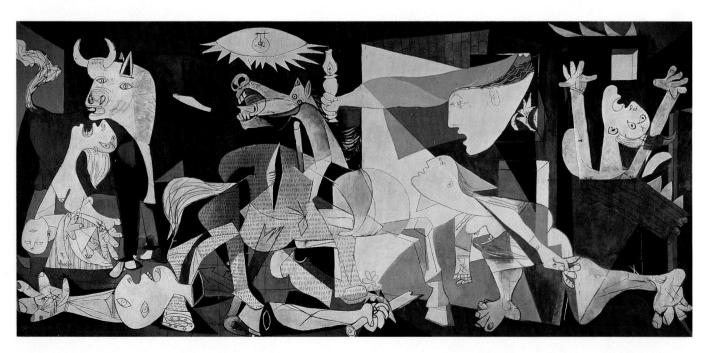

1.50 Pablo Picasso, Guernica, 1937. Oil on canvas, 11 ft $5\frac{1}{2}$ ins \times 25 ft $5\frac{1}{4}$ ins (3.49 \times 7.75 m). Reina Sofia Museum of Modern Art, Madrid.

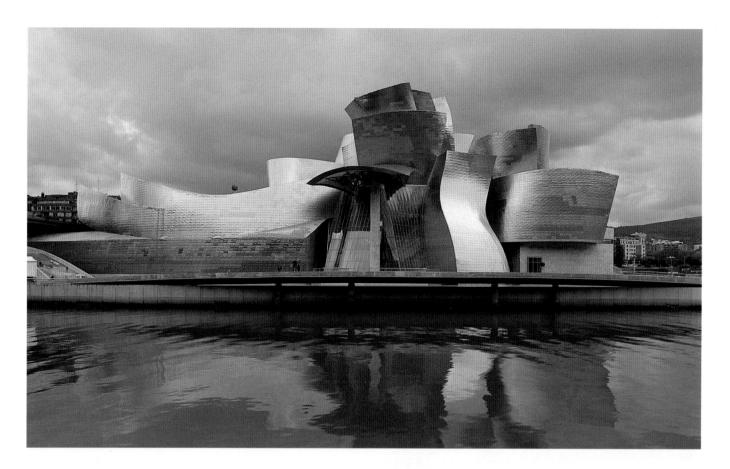

1.51 Frank Gehry, Guggenheim Museum, 1997. Bilbao, Spain. Guggenheim Foundation.

began to work on the huge and profound painting, expressing his anguish over this atrocity. As soon as the painting was finished, it was put on display at the Spanish Pavilion in Paris. Picasso may have intended that the work would incite protest against modern warfare in general. Franco's supporters interpreted the painting in a specific political sense, and they recommended that the painting should be removed from the Pavilion as "an anti-social and ridiculous picture, wholly inadequate for the wholesome mentality of the proletariat." Picasso himself had it transferred to the Museum of Modern Art in New York to protect it.

The final key work to be examined will be architect Frank Gehry's Guggenheim Museum in Bilbao (1.51). Its imaginative contours and gleaming surfaces have been extremely successful in bringing positive attention to a city that had previously been notorious for its high crime rate and bad weather. It seems to have achieved its high goal: to create a building that in itself is a stunning architectural showpiece and also to showcase some of the great art of the world.

Great artistic creation, rooted in the immediate context, nonetheless manages to communicate something to spectators centuries later. People in Vancouver readily compare Moshe Safdie's Library Square (1.32) to the Roman Colosseum because, after 2,000 years, the Colosseum is still well known and impressive, even in ruins. Picasso's Guernica was provoked by, and refers to, a war about which most people now living know nothing, yet the painting still stirs us today. The cries of those opposing the radical restoration of the Sistine Chapel ceiling are anguished precisely because they recognize the work as a great and irreplaceable work of art. What is communicated by great works varies—be it anger, compassion, spiritual inspiration, or elegance of form—but what all great works have in common is their ability to fascinate us over the ages.

Visual Elements

■ KEY CONCEPTS

Discerning and understanding line
Art in two and three dimensions
How artists use space
The use of texture to evoke a response
The relationship between light and dark
Understanding how color works
How artists convey movement

2.1 Gentile da Fabriano, *The Adoration of the Magi*, 1423. Tempera on wood panel, 9 ft 11 ins \times 9 ft 3 ins (3.02 \times 2.82 m). Galleria degli Uffizi, Florence.

THE MAJOR SURVIVING work of Gentile da Fabriano (c. 1370–1427) is *The Adoration of the Magi* (2.1), which brilliantly uses elements of design to evoke the adoration of Jesus by the faithful. Progressive frames of action illustrate the journey of the Magi to Bethlehem to find the infant Jesus, culminating in the moment when the first of the Three Kings kneels in adoration before the Christ Child, who touches his head in blessing.

Extreme size differences in the figures tell a visual story of action that happened in the distance and in the past, leading to action very close to the viewer in the present. The rich textures of the kings' garments, the golden haloes and ornaments, the shining coats of the sleek horses, and the costly blue of Mary's gown create the impression of a very special event. The artist also uses eye-catching reds to lead our attention along a diagonal to and from the Holy Family. Thus Gentile has carefully employed form, space, color, texture, and time in creating this beautiful painting.

The elements of design with which artists work are the observable properties of matter: line, shape and form, space, texture, value (lights and darks) and lighting, color, and time. Although these elements are unified in effective works of art, in this chapter we will isolate and deal with one at a time to train our eye to see them and to understand how artists use them.

Line

A mark or area that is significantly longer than it is wide may be perceived as a line. In the world around us, we can see trees and grass, legs and telephone posts as lines if we learn to apply the mental abstraction "line" to the world of real things. A tree bare of its leaves can be perceived as a medley of lines, as Mondrian noted in his tree abstractions (1.10–1.12). The sections that follow will develop the ability to discern lines in artworks and to understand the aesthetic functions they serve.

2.2 Sami Efendi, *Levha* in *Celi Sülüs*, 1872. Private collection, London. "May Allah help you in all matters."

2.3 John Alcorn, *The Scarlet Letter*, 1980. Exxon Corporation, for Public Broadcasting Great Performances.

SEEING LINE

It is easiest to see lines in works that are primarily linear and two-dimensional, such as the lovely piece of calligraphy shown in Figure 2.2. Calligraphy is the art of fine writing, so highly developed in Arabic cultures, Japan, and China that some pieces are meant first as art and only secondarily as figures to be read. Many pieces of Arabic calligraphy were designed to be hung or used on tilework, to be seen at a distance, so that great attention was paid to the effects of lines and their composition. Arabic characters are usually set down in straight lines, but the master calligrapher Sami Efendi worked the strokes into a flowing circular pattern to enhance their beauty and the unity of the design. When lines are made with a flat-pointed instrument, such as the reed pen used here, their thickness grows and diminishes as the lines swing through curves.

Lines may be seen in unworked as well as worked areas of a design. In John Alcorn's drawing (2.3) to represent Hawthorne's novel *The Scarlet Letter* for

2.4 Door panels, parish church, Urnes, Norway, c. 1050–70. Carved wood.

television audiences, we can see not only black lines on white but also white lines defined by black-inked areas. Notice how gracefully Alcorn handles the rapid transitions from the white of the background to the white lines defining the hair, leading us to see the former as **negative**, or unfilled, space, and the latter as **positive**, or filled, space.

Even more subtly, we perceive lines along **edges** where two areas treated differently meet. Along the left side of Hester Prynne's face, as we see it, there is a strong white line belonging to and describing her profile; the black of her hair shadows is pushed behind it in space. On the right side of her face there is a strong edge belonging to the black of her hair, with her face appearing to be behind it in space.

In three-dimensional works, we may find lines that are incised, raised, or applied to forms. In the eleventh-century Norwegian door panels (2.4), some superb but now unknown craftsman has carved wood into complex patterns of lines. These patterns continually shift from elongated animals to serpents to plant vines. They are carved in such a linear fashion that what we perceive at first is a maze of interlacing lines rather than distinct objects.

Edges may be "read," or interpreted, as lines in three-dimensional works as well as in two-dimensional works. Part of the effectiveness of Barnett Newman's Broken Obelisk (2.5) lies in the sharp edges where flat planes meet, creating **contour** lines that emphasize the form and define its three-dimensionality (2.6).

In some three-dimensional pieces, entire areas are so thin in relation to their length that they are seen as lines. In Eva Hesse's *Hang-up* (2.7), the frame on the wall is seen as an outline, but one containing only emptiness, while the thin wire projecting forward in an eccentric loop forms a highly expressive line. It suggests the feeling of not fitting in, of breaking away like a mutation from a meaningless base but still being attached to it, and thus unsure of its own identity. Hesse speaks of such sculptures as embodying the "absurdity" and "contradictions" of her life. When she was aged two, she barely escaped being sent to a German concentration camp. Later in life, her parents divorced, her mother committed suicide, her husband left her, and her father died. Feeling unable to fulfill the multiple demands of being a woman, wife, housekeeper, and artist, Hesse declared: "I cannot even be myself." Along with these personal hardships, Hesse struggled as a young female artist in New York, trying to develop new directions in an art world dominated by men. How can an artist express something that has not been articulated before? If she is insecure, she will feel absurd in comparison with mainstream standards. Hesse has conveyed all these feelings merely by means of two lines.

2.6 Lines formed by the edges of *Broken Obelisk*.

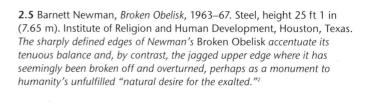

2.7 Eva Hesse, *Hang-up*, 1965–66. Acrylic on cloth over wood and steel. 5 ft 10 ins \times 6 ft 9 ins \times 6 ft 6 ins (1.82 \times 2.13 \times 1.98 m). Art Institute of Chicago, Chicago, Illinois. Through prior gifts of Arthur Keating and Mr and Mrs Edward Marns, 1988.130.

THE WORLD SEEN

Islamic Calligraphy

ONE OF THE most revered uses of line has been the writing of the sacred revelations which were received by the Prophet Muhammad and preserved as the Holy Qur'an. Islam generally prohibits representational work in public art, to avoid any tendencies toward idol worship. Allah (God) is the One Source of all Creation, to whom all worship is due, but Allah is "the Light of heavens and earth," so subtle as to be imperceptible by human sight, and therefore cannot be depicted. Artisans thus turned to developing beautiful calligraphic styles, especially for presenting the sacred Word of Allah. They also created repeating vegetal and geometric designs to give an impression of the eternity and harmony of the cosmic Creation. Thus written and ornamented, passages from the Holy Qur'an have been inscribed on many surfaces, from gloriously illuminated manuscripts to tilework in mosques.

The Prophet Muhammad is said to have stated: "Allah is Beautiful and loves beauty," and "Allah is pleased that when you do anything, you do it excellently." Thus fine craftsmanship was given great impetus as Islam spread across West and East Asia, North Africa, and Spain, and loving attention given to ornamentation, even of utilitarian, everyday objects. Exquisite work was carried

out in many media, including calligraphy, miniature painting, ceramics, mosaic, metalwork, glass, fibers, woodcarving, garden design, and architecture. In calligraphy, not only the beautiful writing but also the preparation of the reed pens and inks was undertaken with great care. Traditionally, the calligrapher uses a reed pen cut at an angle. When moved across the paper, it makes a thick line on downstrokes and a thin line on upstrokes.

Many different calligraphic styles have evolved, for the basic script used for writing Arabic, the language of the holy revelations, is extremely flexible. Its combination of vertical strokes and lower rounded characters offers scope for dynamic design contrasts. There are seventeen basic letter forms, plus eleven more created by the addition of dots above or below certain letters. Most of the writing styles give an impression of dynamic movement from right to left, the direction in which Arabic is written and read. Pages of the Holy Qur'an are often divided into grid patterns and intricately illuminated, lending further sophistication to the designs.

Calligraphers study for years with masters of the art, repeating particular traditional styles again and again until they can use them so perfectly that the line appears dynamic rather than labored. The example shown here (2.8) is from Cairo. It was commissioned by the commander-in-chief who later became ruler, Baybars al-Jashnagir, and was probably illuminated by the master calligrapher Muhammad ibn Mubadir Abu Bakr, known as "Sandal." He has used two different styles of calligraphy—a Kufic script of exaggerated angularity for the top and bottom lines, which state that this is volume VII of the Holy Qur'an, and a flowing cursive script for the central inscription, which attests to the scripture's holiness and purity. The lines of calligraphy have been created with great care, for two precisely parallel lines were drawn to encase the negative white space, which is then defined by the surrounding colored arabesque designs. The geometric patterns provide a beautiful counterpoint to the central cursive inscription.

For centuries, rulers have commissioned such beautiful line work as a way of receiving the blessings of Allah. As the art of calligraphy has been applied to beautiful copying of the beautiful Words of God, and passed down from generation to generation of masters, reverence for the Word has been a unifying factor within the varied global Muslim community.

2.8 Left half of the double frontispiece to volume VII of the Qur'ān of Baybars al-Jashnagir, 1304–6. $18\frac{1}{2}\times12\frac{1}{2}$ ins (47 \times 32 cm). Add. 22406, f.v. 871318. British Library, London.

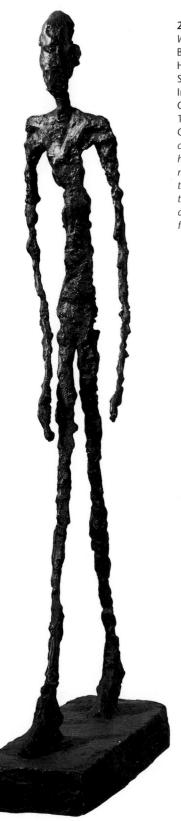

2.9 Alberto Giacometti, Walking Man, c.1947–49.
Bronze, height 27 ins (69 cm).
Hirshhorn Museum and
Sculpture Garden, Smithsonian
Institution, Washington, D.C.
Gift of Joseph H. Hirshhorn,
1966.

Giacometti's anxious efforts to capture the nature of being led him again and again into nearnothingness when he attempted to portray human figures. Only the base of the statue gives his attenuated linear figure some footing in this world.

The human figure is sometimes handled as abstract lines in space, a perception that is carried to an extreme in the attenuated figures of Alberto Giacometti, such as Walking Man (2.9). This reduction of a human to something less than a skeleton can be seen as a statement about the isolation and loneliness of the individual in modern civilization. Giacometti himself insisted that his focus lay not so much on the gaunt figure as on the vast, empty space that surrounds and presses in on it. It is hard to grasp this perspective when looking at a photograph, but in actuality, the small scale of the battered figure—only 27 inches (69 cm) high—does make the space surrounding it seem even greater.

Earthworks—those large-scale environmentaltering projects in which the surface of the earth becomes the artist's canvas—sometimes create

2.10 Christo and Jeanne-Claude, *Running Fence, Sonoma and Marin Counties*, California, 1972–76, erected 1976. Nylon fabric, steel poles, cable, 18 ft \times 24½ miles (5.5 m \times 40 km). © Christo and Jeanne-Claude 1976. Photograph © Jeanne-Claude 1993.

immense lines that can best be seen from a distance. From near by, Running Fence (2.10) by Christo and Jeanne-Claude appeared as a great fabric curtain, 18 feet (5.5 m) high. Its even more memorable aspect was the beautiful line it created over 24½ miles (40km) of northern Californian countryside, until it ultimately disappeared into the Pacific Ocean. To erect this temporary structure for only two weeks in 1976, Christo, Jeanne-Claude, and a large crew of engineers and lawyers spent three years threading their way through public hearings and legal battles; they were also required to produce a 265-page environmental impact statement. These struggles with a disbelieving society are part of Christo and Jeanne-Claude's art form; the temporary end-product is not the only goal. The line of the fence was only one of the visual elements in the design. Its existence also called attention to the contours and features of the land. Speaking of the ranchers who gave their support to Christo and Jeanne-Claude

in obtaining the permits for the erection of the structure and who were sorry when, as intended, it was taken down and all traces of it removed, Christo and Jeanne-Claude were pleased that "they can find that a part of *Running Fence* is their cows, and the sky, and the hills and the barns and the people."³

IMPLIED LINE

Some lines are not physically created; they are merely suggested by the artist. Our mind, with its penchant for trying to read order into the messages from the senses, does the rest, perceiving lines where there are none. Part of the visual excitement of the ad for *Harper's Magazine* (2.11) by the Beggarstaffs (a farsighted but short-lived British design studio around the turn of the twentieth century) is the filling in of lines that have been left out. Just enough information is given for us to see the well-known figure of a Beefeater in his distinctive uniform. The illusion works

2.11 William Nicholson and James Pryde, called the Beggarstaff Brothers, poster for *Harper's Magazine*, 1895. Victoria and Albert Museum, London.

particularly well along the right side of his lower tunic, where an edge is suggested by very slight upward swings of the dark bands.

Implied lines may project beyond the work itself. In many two-dimensional works, the artist asks us to make assumptions about what "happens" beyond the edges of the picture. For this we need to be given enough information to draw inferences based on our experiences of the physical world. Geometric figures are perhaps easiest to predict. Shown part of a square or a circle, we may automatically fill in the rest with our imagination. In *Fox-Trot A* (2.12), Piet Mondrian shows us a cropped segment of a linear image that by implication extends beyond the picture area. The challenge he sets for us is to determine how much larger the uncropped "original" would be. We automatically assume that the left vertical and the horizontal will continue as straight lines and intersect just beyond the

2.13 Thorn Puller (Spinario), 1st century B.C. Bronze, height 28¾ ins (73 cm). Capitoline Museums, Rome.

2.14 Ellsworth Kelly, *Apples*, 1949. Pencil, $17\% \times 22\%$ ins (43.5 \times 56.2 cm). New York, Museum of Modern Art (MoMA). Gift of John S. Newberry, by exchange.

picture. But what about the two verticals? Will they be joined by a crosspiece above the top? The only clue that the cropped segment shown may be part of a hypothetical series of rectangles—like a multi-paned window—is the crossing of the two lines at lower right. The suggestion that the figure doesn't end here leads the mind outward to imagine a much larger series of lines that cannot be seen at all.

In addition to drawing the viewer into participating in a work, implied lines are often used for compositional ends. **Eyelines**—the implied lines along which a subject's eyes appear to be looking—are a common device for directing the viewer's eye or pulling a composition together. Usually eyelines occur between figures, as in Bouguereau's *Nymphs and Satyr* (1.45), in which each person in the circle is looking at someone who is looking at someone else, so tying them all together. But in the Hellenistic bronze *Thorn Puller* (**2.13**), we follow the "line" between the youth's eyes and his own foot, for his concentration is so clearly fixed on his foot that our

eyes go in the same direction. His limbs are also arranged to form lines that lead our eye toward the foot. Our attention is often drawn to points where many lines intersect. If our eye then strays to examine the figure as a whole, the lines of the body carry us around in a circle to arrive back at the same point.

DESCRIPTIVE LINE

Decorative line is that which provides surface embell-ishments, such as the A on Hester Prynne's dress (2.3). By contrast, line that is **descriptive** tells us the physical nature of the object we are seeing and how it exists in space.

In *Apples* (2.14), Ellsworth Kelly's seemingly simple pencil line is purely descriptive. With the barest of means, his line tells us to read certain unfilled areas as nine apples, each having a somewhat different form but still quite recognizable as apples. We can see and almost feel their volume. Line is used here as **contour** line—an imaginary line defining the outer boundaries

2.15 Albrecht Dürer, *Head of an Apostle*, 1508. Brush on paper, $12\frac{1}{2} \times 8\frac{1}{3}$ ins (31.7 \times 21.2 cm). Graphische Sammlung Albertina, Vienna.

2.16 Arnold Bittleman, *Martyred Flowers*, c. 1957. Pen and ink, $26 \times 38\frac{3}{4}$ ins (66×98 cm). Fogg Art Museum, Harvard University, Cambridge, Massachusetts.

of an object but not its internal modeling, color, shading, or texture. Not only do the contour lines allow us to "see" the apples; they also describe the space around them. We can infer from these brilliantly arranged lines that the apples occupy three-dimensional space of a certain depth and that they are sitting on some flat surface that we cannot actually see.

Lines may be used in two-dimensional work to describe three-dimensional form—to create the illusion that a figure's mass, or solid content, occupies a certain volume in space and has a certain visual weight. In *Head of an Apostle* by the German artist Albrecht Dürer (2.15), the head appears to have continually varying contours, to be fully rounded in spatial volume, and to have convincing weightiness. Dürer achieved this extremely detailed depiction of a venerable, beetle-browed head largely by highly skillful use of line. Drawn close together, dark parallel lines (hatch-

ing) and crossed parallel lines (cross-hatching) suggest shadows where contours curve away from the light. Where the lines seem to loop in visually incomplete ovals around an axis, they imply the contours of the unseen back side of the form.

Many small lines placed close together may also be used to suggest texture. In Arnold Bittleman's *Martyred Flowers* (2.16), we readily perceive textural effects even though we cannot be sure what forms are being described. The title refers to flowers; yet in places the textures appear feathery, wing-like. Although there is an impression of explosion and destruction, each line has been placed with great care. Where many are juxtaposed, dark areas develop that create a mysterious undulation in space. Note that variations in thickness and spacing of lines create a range of degrees of darkness, or value, with many shades of gray.

2.17 Gebrüder Thonet, Reclining rocking chair with adjustable back, c.1880. Steam-bent beechwood and cane, $30\frac{1}{2} \times 27\frac{1}{2} \times 68\frac{1}{2}$ ins (77.5 \times 70 \times 174 cm). Museum of Modern Art (MOMA) New York. Phyllis B. Lambert Fund and Gift of the Four Seasons.

EXPRESSIVE QUALITIES OF LINE

As our eyes move along a line, "reading" it, our visual perception system seems to interpret our eye movements as characterizing the line itself. If a line creates sharp peaks, the eye cannot scan it easily. Its progress is constantly interrupted, giving us a rather uneasy feeling. A line without sharp angles or curves can be read quickly and easily, but if there are breaks in it, they slow the scanning process. Such characteristics of lines tend to make us assign emotional qualities to them. Artists use this tendency to control our emotional response to a work. For example, sharply angled lines may be used to evoke feelings of excitement, anger, danger, or chaos. A relatively flat line may be used to give a sense of calmness. A wide line that can be read quickly may be used to suggest bold strength, directness. A gently curving line may be used to suggest unhurried pleasure.

The reclining rocking chair by the Austrian firm of Thonet (2.17) suggests visually, by its long, flowing lines, the restful feeling that one expects to experience when lying in the chair. As the lines flow through lengthened curves, it is difficult to follow a single line. Rather, we are drawn visually into the abstract expressive quality of the lines: the sense of languid movement. In the mid-nineteenth century, Michael Thonet

had perfected a process of steaming and bending wood that allowed the creation of these plant-like lines and greatly reduced the need for structural joints in furniture. Many of his graceful bentwood furniture designs have continued in production to this day.

Expressive lines in two-dimensional art often have a **gestural** quality. That is, they directly reveal the artist's arm at work, transferring expressive gestures into marks on a surface. In some cases, the gesture may involve the entire body. Cuc Nguyen's calligraphy of the word "Buddha" (**2.18**) is grounded in years of spiritual practice as a Buddhist nun, making it possible for her to steady and concentrate her mind and direct all her energy into making the mark. Such a powerful and quick line does not just come from motions of the hand and fingers; it rises through the artist's feet, solar plexus, heart, lungs, shoulders, arm, hand—all focused on a single moving point.

DIRECTIONAL LINE

Lines may also be used by artists to steer the eye in a certain direction. In the poster for a luxury train by the French poster designer A. M. Cassandre (2.19), our eye is directed from the bottom to the top of the poster. We are placed squarely on top of the rail that is perpendicular to the bottom edge of the poster. Our eye races

2.18 Cuc Nguyen, "Buddha," 2000. Calligraphy handwritten with Chinese ink and brush on handmade rice fiber paper. Although the linear qualities of this calligraphy are striking in themselves, the information conveyed is also notable, if one understands it. The main word is "Buddha," while the four smaller words on the left convey the artist's religious name, which means "the daughter of Buddha, calm and wise." The small oval seal above the word Buddha is her artist's pen name, meaning "the mind and heart are as purified as ice."

2.19 A. M. Cassandre, poster, 1927. Colored lithograph, $41\% \times 29\%$ ins (105 \times 75 cm). Victoria and Albert Museum, London.

along the rail to the point where all the rails converge and disappear on the horizon. The immediate impression is that of speed and elegance in covering great distances. These directional lines lead us effortlessly to our destination, as the poster suggests the train will do—and even beyond, to the North Star (the name of the train).

Shape and Form

Throughout this book, we will be using the word **shape** to refer to defined two-dimensional areas. As we use the term, a shape is flat. We will reserve the word **form** for three-dimensional areas, also called "volume" or "mass." But flat shapes may appear on the surface of three-dimensional forms, and two-dimensional works may create on a flat surface the illusion of forms.

DEGREES OF THREE-DIMENSIONALITY

Within the category of three-dimensional art there are various degrees of three-dimensionality. The flattest works approach two-dimensionality: in these an image is developed outward or inward from a two-dimensional ground. These are called **reliefs**. In a **low relief** (or "bas relief"), figures exist on nearly the same plane as the background, almost as in a drawing, but are carved with enough depth for shadows to appear on surfaces where the light is blocked. In the low-relief Moon House post used to support a roof beam by the Kwashkan Tlingit of the northwest coast of North America (**2.20**), the shadows enhance the drama of the piece, drawing attention to the moon and wolf symbols of the family's membership in the wolf clan. Nevertheless, no area is entirely detached from the ground.

Technically, a work is considered a **high relief** only if at least half of the figures' natural spatial depth projects forward from the background. The fact that far more of the substrate is carved away than in a low relief creates a greater range of light and dark shadows that help to define the forms.

In the sculpted exterior of the Roman sarcophagus, or coffin, shown in Figure **2.21**, some limbs are completely undercut, lifting them away from the background entirely, while other, more shallowly carved figures merge with the background. These variations in depth create a dynamic flow of darks and lights and of projections toward, and recesses from, the viewer.

2.20 House post from the Moon House, Port Mulgrave, Yakutat, c.1916–17. Wood with red, black, and green pigment and nails. Museum of the American Indian, Heye Foundation, New York.

2.21 Sculpted sarcophagus representing Dionysus, the Seasons, and other figures, c. A.D. 220–230. Marble, $35\frac{1}{2} \times 87\frac{3}{4} \times 36\frac{3}{4}$ ins $(90.2 \times 222.9 \times 93.3 \text{ cm})$. Metropolitan Museum of Art, New York. Purchase 1955 Joseph Pulitzer Bequest. The realistic relief-carved figures on this sarcophagus carry attention away from the fact of physical death and toward revelry and the pleasures of each season, as if to ensure the happiness of the departed.

Whether figures are carved or created by attaching materials to a closed backplane, the basic orientation of a relief is the association of three-dimensional figures with a backing. Reliefs are principally designed to be seen straight on; the farther to the side the viewer moves, the less sense the images make.

Another form of three-dimensional art that is designed principally to be seen from the front only is called **frontal** work. Although it is totally freestanding, allowing the viewer to walk all around it or turn it over if it is small, it does not invite viewing from more than one side. Necklaces are typically designed as frontal pieces; the interesting, worked side faces outward, while the back is often minimally worked since it is not designed to be seen. Auguste Rodin's The Gates of Hell (2.22) was not meant to be seen from the back. The artist's concept, never fully implemented, was that people would walk toward it up a flight of stairs, contemplate the agonies of hell as described or imagined in Christian traditions, and then open the doors and walk through, as if confronting their own destiny upon dying. They were to look at the work itself from the front only, facing the distress of its writhing figures.

Three-dimensional art in the **full round** is freestanding and designed to be seen from all sides. When a full-round piece is effective, it often makes people want to walk all the way around it or turn it around in their

hands to discover how it changes. A common device artists use is to pique our curiosity to see what happens out of sight. If a leg disappears around a curve in the piece, we are likely to follow it to find the foot. In *Thorn Puller* (2.13), the curves of the body and the eyeline leading to the foot make us want to move around the sculpture to see what the boy is looking at so fixedly on the sole of his foot, and what his other hand is doing.

The ever-changing quality of three-dimensional works in the full round can barely be imagined from the single, two-dimensional photographs used to represent them. To appreciate a full-round piece completely, one must explore the real thing, from as many angles as possible, for each step and each movement of the head reveals new facets and new relationships among the parts of the piece.

An even fuller degree of three-dimensionality occurs in **walk-through** works, which become part of the environment through which we move. Landscape artists throughout history have planned gardens as walk-through aesthetic experiences. A contemporary version of this experience is available to visitors to the National Geographic Society's central court, in Elyn Zimmerman's *Marabar* (2.23). We are invited to walk among the granite boulders, sensing and perhaps feeling their rough, organic strength and discovering the contrasting extremely smooth textures of the faces of

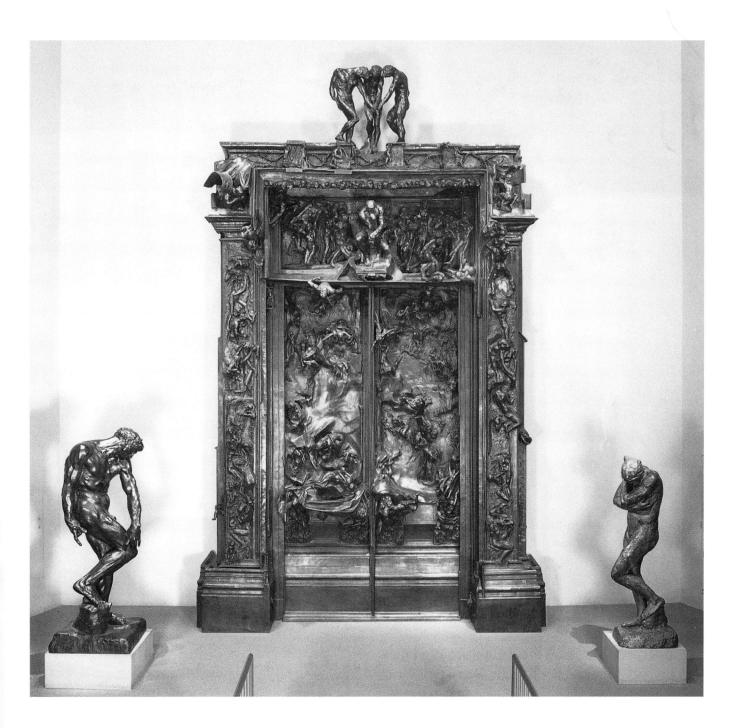

2.22 Auguste Rodin, *The Gates of Hell*, c. 1880. Bronze, 20 ft 10 ins \times 13 ft 3 ins \times 2 ft 9 ins (6.38 \times 4.01 \times 0.83 m). Musée Rodin, Paris. As Adam and Eve cower before the presumed wrath of God's judgment, "The Thinker" seems to brood over the human condition from his position at the intersection of an implied cross.

those boulders that Zimmerman has cut and polished. These polished faces can be seen only from certain angles, so to experience the totality of the work we must walk varying paths through it, exploring what can be seen from many points (2.23).

All effective three-dimensional work subtly defines a certain area as "belonging" to it and to a certain extent influences our movements within this space. Work that surrounds the viewer—such as architecture—is the final step in this control, not only becoming an encompassing structure that we enter but also perhaps surrounding us with a certain psychological atmosphere.

Moshe Safdie's Vancouver Library Square (2.24) creates a rather happy mood among public users of the space. The glass-roofed, six-story "urban room" between the inner glass-walled library and the outer structure places pedestrians and library users in visual relationship to each other, as well as to the structures that surround them. People become part of the architecture, like fellow players in a three-dimensional chess game.

2.24 Moshe Safdie, Vancouver Library Square, Vancouver, British Columbia, completed May 1995, inner promenade. Photo by T. Hursley.

2.23 (opposite) Elyn Zimmerman, *Marabar*, 1984. Plaza and garden sculpture, National Geographic Society, Washington, D.C. Five natural cleft and polished carnelian granite boulders, height 36 to 120 ins (91.4 to 305 cm), surrounding a pool of polished carnelian granite.

CHARACTERISTICS OF THREE-DIMENSIONAL FORM

Artists have approached three-dimensional form in various ways. They may create exterior or interior contours, open or closed forms, and static or dynamic forms.

The surfaces of a three-dimensional work are sometimes called its contours. They may project outward (convex) or inward (concave) relative to the general body of the form. Philip Grausman's monumental *Leucantha* (2.25) exaggerates the inward and outward contours of a woman's head, such as the swelling muscles in the neck and the cleft between lips and nose. Highlighting these strong contours gives the figure an impression of great strength.

Some three-dimensional works have both exterior and interior contours that can be examined. In architecture, the exterior form of a building gives quite a different impression from its interior structure. The lovely flask shown in Figure 2.26 invites us to look at both exterior and interior contours simultaneously. It is made of clear crystal, revealing the concave, pearshaped contour within a similar but convex exterior contour. The interior contour is emphasized and elaborated by the bubbles surrounding it.

A more subtle kind of interior form can only be sensed, rather than seen. Barbara Hepworth, whose work is shown in Figure 2.30, had a loving awareness of unseen interior forms. She wrote:

There is an inside and an outside to every form. When they are in special accord, as for instance a nut in its shell or a child in the womb, or in the structure of shells or crystals, or when one

2.25 Philip Grausman, *Leucantha*, 1993. Cast aluminum, no. 1/3, 9 ft \times 9 ft 10 ins \times 9 ft 10 ins. Photo by Ricardo Barros. Courtesy of Grounds for Sculpture. The majestic head looks neither to the left nor to the right, and like an Egyptian portrait it is designed to be seen from the front or the sides.

2.26 Maurice Marinot, Flask, 1931. Clear crystal glass with bubbles, height $4\frac{7}{2}$ ins (12.4 cm). Victoria and Albert Museum, London.

senses the architecture of bones in the human figure, then I am most drawn to the effect of light. Every shadow cast by the sun from an ever-varying angle reveals the harmony of the inside and the outside.⁴

Another set of distinctions may be made between closed and open forms. Many early Western sculptures were **closed forms** that reflected the raw mass from which they had been carved. The early Egyptian sculpture of *Senmut with Princess Nefrua* (2.27) is developed from a cut stone block which is still quite apparent. To create the heads—particularly that of the child—much of the original block has been removed, yet the overall impression is that of a solid mass. As stonecarving evolved, sculptors learned how to open the forms without losing their structural strength. In the *Spear Bearer* (2.28), the legs are placed apart and the arms are lifted slightly away from the body. Yet to keep the

2.27 Senmut with Princess Nefrua, Thebes, Egypt, c.1450 B.C. Black stone, height 3 ft 4 ins (1.20 m). Egyptian Museum, Berlin.

2.28 After Polyclitus, *Spear Bearer* (Doryphorus), Roman copy after a Greek bronze original of c.450–400 B.C. Marble, height 6 ft 6 ins (1.98 m). National Museum, Naples. Despite tremendous skillfulness in carving marble to resemble the natural contours of the human body, this Roman sculptor had to place a false tree stump behind and a splint at the wrist to support the otherwise free-standing limbs.

limbs from breaking off—as they often did—several props have been maintained.

The development of metal casting allowed fully **open forms**, such as the horse and chariot from ancient Denmark (**2.29**). The slender, open spokes of the wheels and long shaft of the chariot could not be executed in stone, whereas the tensile strength of bronze allows it to be cast into elongated forms without bending or breaking. Bronze casting was a major technological innovation, found from about 3500 B.C. in Mesopotamia and perhaps as early as 3650 B.C. in Thailand.

In the twentieth century, a number of sculptors opened voids through the center of their works. In Barbara Hepworth's *Pendour* (2.30), it is the holes piercing the center of the form that are the focus of attention. These ambiguous voids are accentuated by contrast with the solidity and simplicity of the outer form. Defined by wood painted white, in contrast with the darker exterior, they suggest a quality of tender, hidden purity protected from the outside world.

Finally, we can draw a distinction between static and dynamic forms. **Static** forms appear to be still, unchanging. The pyramid is a supremely static form, for its broad base seems to guarantee an immovable stability. Michael Heizer's *City Complex One* (**2.32**) has an enduring, monumental effect. Like the surrounding mountains, it looks set to remain standing a very long time. Indeed, in contrast to the more temporary nature of many earthworks, this structure was built to last, with

2.29 Horse and Sun Chariot, from Trundholm, Zealand, Denmark, c. 1800–1600 B.C. Bronze, length 23 % ins (59.2 cm). National Museum, Copenhagen.

Many cultures tell the myth that the sun is pulled across the heavens in a chariot, and the development of bronze casting long ago allows us to see this lovely depiction of the myth from ancient Denmark.

2.30 Barbara Hepworth, *Pendour*, 1947–48. Painted wood, $12\frac{1}{8} \times 29\frac{3}{8} \times 9\frac{3}{8}$ ins $(30.6 \times 74.5 \times 23.8 \text{ cm})$. Hirshhorn Museum and Sculpture Garden, Smithsonian Institution, Washington, D.C. Gift of Joseph H. Hirshhorn, 1966.

ARTISTS ON ART

Henry Moore on Form and Space

WHEN HENRY MOORE (1898–1986) was a student at The Royal College of Art in London, he visited the British Museum twice a week to explore the riches of the world's sculptural traditions. The one that spoke to him the most was the sculpture of ancient Mexico, with its powerful closed forms. He also had a lifetime interest in organic forms, such as weather-worn bones and watersmoothed pebbles. From these and other elements, he evolved a distinctive personal sculptural style that was characterized by abstract, rounded contours interwoven with shapely voids, as in his Sheep Piece around which sheep cluster at his homestead (2.31). Whether he was working in stone, wood, or bronze castings, Moore was consistently interested in the interplay between positive form and negative space, and in how a piece looks from all sides:

"Appreciation of sculpture depends upon the ability to respond to form in three dimensions. That is perhaps why sculpture has been described as the most difficult of all arts Many more people are 'formblind' than colour-blind. The child

learning to see first distinguishes only two-dimensional shape; it cannot judge distances, depths. Later, for its personal safety and practical needs, it has to develop (partly by means of touch) the ability to judge roughly three-dimensional distances. But having satisfied the requirements of practical necessity, most people go no farther They do not make the further intellectual and emotional effort needed to comprehend form in its full spatial existence.

"This is what the sculptor must do. He must strive continually to think of, and use, form in its full spatial completeness. He gets the solid shape, as it were, inside his head—he thinks of it, whatever its size, as if he were holding it completely enclosed in the hollow of his hand. He mentally visualises a complex form from all round itself; he knows while he looks at one side what the other side is like; he identifies himself with its centre of gravity, its mass, its weight."

"At one time the holes in my sculpture were made for their own sakes. Because I was trying to become conscious of spaces in the sculpture—I made the hole have a shape in its own right, the solid body was encroached upon, eaten into, and sometimes the form was only the shell holding the hole. Recently I have attempted to make the forms and the spaces (not holes) inseparable, neither being more important than the other."

"If you hold your hand as I am doing now, the shape that those fingers could enclose if I were holding an apple would be different from the shape if I were holding a pear. If you can tell what that is, then you know what space is. That is space and form. You can't understand space without being able to understand form and to understand form you must be able to understand space. If I can really grasp in my mind the shape of your head, I must know what distance there is from your forehead to the back of your head, and I must know what shape the air is between your eyebrows and your nostrils, or down to the cheeks. The idea that space is something new in sculpture is only spoken of by people who can't know what space and form are."7

2.31 Henry Moore, *Sheep Piece*, 1971–72, Hoglands, Hertfordshire. Bronze, length 19ft (5.8 m). Courtesy of the Henry Moore Foundation, Hertfordshire, England.

2.32 Michael Heizer, *City Complex One*, 1972–76, Garden Valley, Nevada. Cement, steel, and earth, 23 ft 6 ins \times 140 ft \times 110 ft (7 \times 43 \times 34 m). Collection of the artist and Virginia Dwan.

concrete and steel reinforcing packed earth. The sense of historical permanence that Heizer's structure evokes is increased by its reference to ancient structures: the rectangular base and sloped sides derived from the mastabas (tombs) of ancient Egypt, and the framing from an ancient Maya ball court at Chichén Itzá.

Dynamic forms are those that appear lively, moving, and changing, even though they are actually stationary. The Art Nouveau movement in applied art often worked with dynamic forms, such as Louis Comfort Tiffany's exquisite *Flower-form Vase* (2.33). From chairs to vases to stair railings, Art Nouveau designs appear to be growing as though they are organic forms. Tiffany's vase exposes the dynamic process by which the glass was blown, pulled, and shaped when in a molten state. Although the end result is hard and fixed, it appears still to be in fluid motion, like a bud in the process of reaching upward and growing outward.

TWO-DIMENSIONAL ILLUSION OF FORM

Many two-dimensional works of art are designed to represent the three-dimensional world, but they exist on a flat plane rather than the three-dimensional world of our experience. Jan Vermeer makes us very aware of this process in his The Art of Painting (2.34). We see the artist—some think it is Vermeer himself—observing a three-dimensional model and translating her form into a two-dimensional painting. The drawing aside of a curtain gives us what appears to be an intimate view into this process. The scene seems to have realistic spatial depth, with the curtain very close to us, the artist somewhat farther, and the model, seen as though over the artist's shoulder, farther away still, against the wall. The impression we have of seeing three-dimensional forms in three-dimensional space is an illusion, for the painting consists of marks on a flat surface, like the painting being started on the artist's easel. Vermeer's skill lies in convincing us that we are seeing figures with mass, volume, and weight, rather than flat shapes.

One of the earliest devices used to suggest threedimensionality is **overlapping**. From our experience in a three-dimensional world, we know that if one thing covers another from our view, it must exist in front of it in space.

In the Hindu painting of Krishna and his lover Radha (2.35), Krishna's right arm crosses in front of his chest and also in front of Radha, slightly obscuring them from view, so we know that his arm is closer to us than the rest of his body, which is almost one with that of his lover. The cows around them are lined up spatially by a series of overlappings, each one's body obscuring part of the next. Thus we know that they exist as forms in three-dimensional space, even

2.35 Radha and Krishna, miniature. Victoria and Albert Museum, London. Radha and Lord Krishna have been painted in such a flat fashion, following Indian tradition, that they almost appear to be a single body, an effect well suited to expressing their intimacy. His arm crossing over her chest places him slightly closer to us in space.

2.34 Jan Vermeer, *The Art of Painting*, c. 1665–70. Oil on canvas, 3 ft $11\frac{1}{4}$ ins \times 3 ft $3\frac{3}{8}$ ins $(1.2 \times 1 \text{ m})$. Kunsthistorisches Museum, Vienna.

2.36 Jean-Auguste-Dominique Ingres, *Two Nudes*, study for *The Golden Age*, 1842. Graphite on paper, $16\% \times 12\%$ ins (41.6 \times 31.4 cm). Fogg Art Museum, Harvard University, Cambridge, Massachusetts.

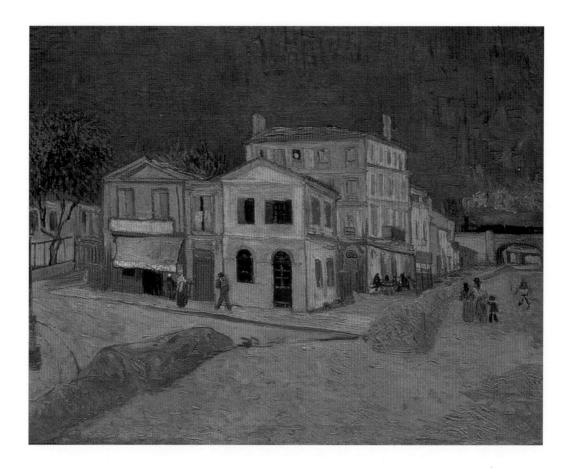

2.37 Vincent van Gogh, *The Yellow House*, 1888. Oil on canvas, 30×37 ins (72×91.5 cm). Van Gogh Museum, Amsterdam, The Netherlands.

though each figure is painted in a solid color, like flat cut-outs in an ideal paradise where not even shadows dim the brilliance of the jewel-like colors.

Another set of devices—shading and modeling of contours—brings out a sense of spatial depth. In the elegantly understated Ingres figure study (2.36) just the slightest indication of shading within the primary contours develops a full-bodied illusion of form, for we understand that the shaded areas exist behind contours which block the light. Curving hatching lines such as those on the woman's left leg suggest that the form is also fully rounded on the side we cannot see. In areas such as the heads, where those lines are not added, the figures read more like reliefs than fully rounded forms.

Another device for giving a two-dimensional surface the appearance of three-dimensional forms is to show more than one side of a form, indicating how it recedes into the distance. If we see only the front wall of a building, we have no idea of the building's depth in space. But if an artist depicts the building from an angle that allows us to see one of the sides as well as the front, we immediately grasp the idea of its form.

Vincent van Gogh's *The Yellow House* (2.37) presents many house forms as simply flat façades, but the two most prominent houses are painted from such an angle that two sides are shown, immediately giving a visual understanding of three-dimensional forms occupying space of a certain depth. The faces of these buildings angle away from each other, and subsequent buildings seem to be smaller and smaller as they recede from the artist's point of view. This approximation of how we actually perceive things in space is called linear perspective, a subject covered in depth later in this chapter in the discussion of space.

SHAPES

In the terminology we are using, shapes are relatively flat areas. In *The Snail* (2.38), for instance, Henri Matisse was working primarily with large shapes that had been painted and then cut and organized into a dynamic composition in which each painted shape touches and is related to the sequence forming the whole. Shapes are particularly noticeable here because they have been physically cut out with clearly defined edges and then glued down. Note that the white

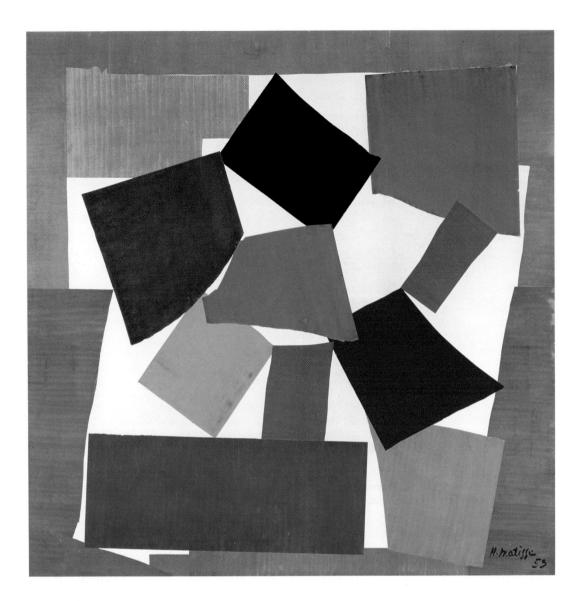

2.38 Henri Matisse, *The Snail*, 1953. Painted, cut, and pasted paper, 9ft $4\frac{3}{4}$ ins \times 9ft 5 ins (2.86 \times 2.87 m). Tate Gallery, London.

Matisse's use of flat colored shapes grew out of his attempts to communicate peacefulness. He explained: "What I dream of is an art of balance, of purity, of tranquility, with no anxious or worrisome subject. ... We are moving toward serenity through the simplification of ideas and form. The ensemble is our only ideal. Details diminish the purity of lines, harm the intensity of emotion."

shapes created between the colored shapes are active and interesting in themselves, and more varied in configuration than the colored patches.

There are a number of general kinds of shapes with which artists have worked. One is the distinctive result of tearing or cutting paper, as in the Matisse. Another is the flattening of objects from the three-dimensional world into two-dimensional shapes.

In his *Hiroshima Series*, # 7: Boy with Kite (2.39), Jacob Lawrence depicts the horror of the atomic bombing by reducing human figures into a series of disjointed, flattened shapes. The deformed shapes of skull-like heads and agonized hands stand out as disembodied

parts of a whole that is no longer unified, that no longer works, as flat and broken as the torn shapes of the kite. We read such a composition from shape to shape across a relatively flat surface in which the only indication of depth is the continual overlapping of one shape by another. In Picasso's *Guernica* (1.50), which also depicts the horrors of war, you can see shapes used in a similar way to convey a feeling of fragmentation, dislocation, and horror. The two similar heads at middle right are painted without any three-dimensional modeling, like flat arrowheads directing our eye to the horror in the skies and the devastation it has wrought on the ground.

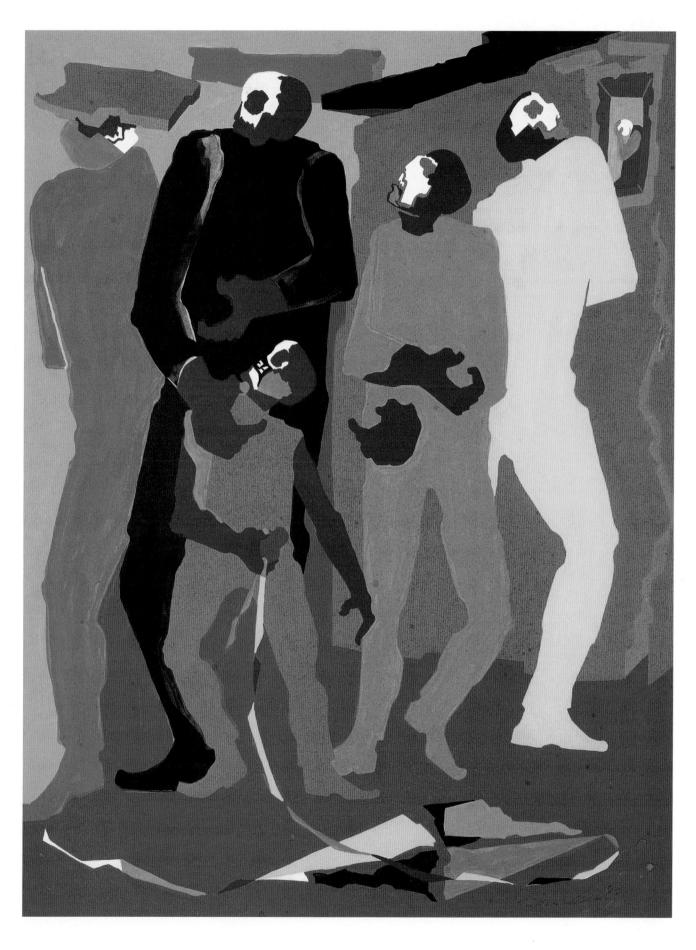

2.39 Jacob Lawrence, *Hiroshima Series*, # 7: Boy with Kite, 1983. Gouache on paper, $23 \times 17\frac{1}{2}$ ins (58.4 \times 44.5 cm). Courtesy of Francine Seders Gallery, Seattle, WA.

ARTISTS ON ART

Arshile Gorky on Art Elements Conveying Life's Intensity

ARSHILE GORKY'S WORK revolves around lines, shapes, and fields of color. At first glance, they may seem fanciful, spontaneous, playful, but his own life and words correct this impression. Born in Armenia in 1904 as Vosdanik Adoian, Gorky experienced the terrible sufferings of the Armenian people. The Turks killed all his grandparents, six uncles, and

three aunts, in some cases before his eyes. His family residence was shelled, and his people were forced to undertake a 150-mile (240-km) death march. That year, 1915, two million Armenians were massacred by the Turks. During a Turkish blockade when he was fifteen, his beloved mother died of starvation in his arms.

In 1920 Gorky emigrated to America, where he faced hunger and poverty but gradually achieved recognition as an artist, only to see some of his best works destroyed in a barn fire. In 1948, his father died, his neck was broken and his painting arm paralyzed in an automobile crash, and his wife left him, taking their two children with her. He

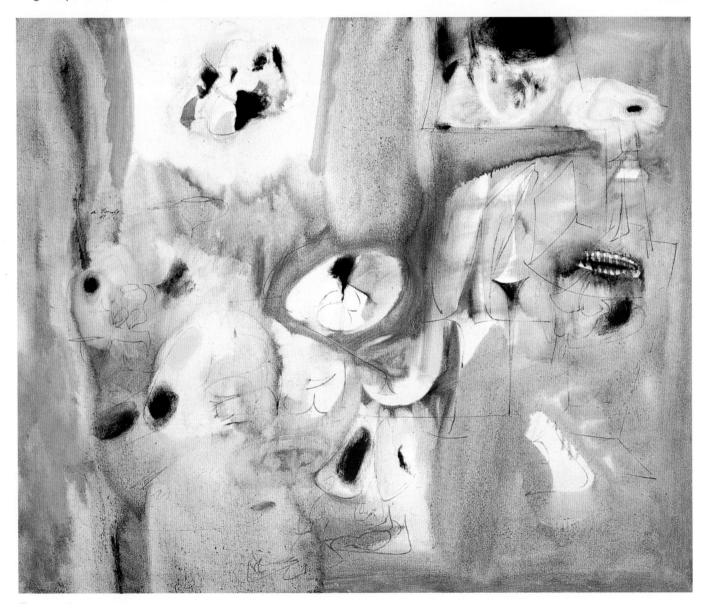

2.40 Arshile Gorky, *Making the Calendar*, 1947. Oil on canvas. The Munson-William-Proctor Institute, Utica, New York. Edward W. Root Bequest.

ended this life of suffering that year by hanging himself. Gorky's words about art therefore ring with the intensity of his personal experience:

"We have been made privy to mankind's evil secrets as well as its glorious achievements. And the living, sensitive, thinking man cannot help but respond with greater than normal intensity. And the remembrance of Armenia's beauty prior to the bloodshed. The art and accomplishments of our unfortunate people. Great art's problem, that is to say my goal, is to enable those who have not experienced certain elements of reality to experience them through the power of my work on their mind and eyes and imagination. To enable them to come as close to realization of reality as possible, simply through my work.

"To be alive is to feel, to be sensitive, and above all to be aware. Art must always remain earnest. Great art contains great topics. What do I mean by great? Not kings, rich men, and clerics, not publicized political scoundrels. I mean love of man, love of nature, love of beauty, love of progress in the well-being of man. Sarcasm has no place in art because it verges on cynicism, which is weakness and the inability to face reality, to master reality.

"The history of our Armenian people has shown us the secret of creativity. The secret is to throw yourself into the water of life again and again, not to hang back, no reservations, risk everything, but, above all, strike out boldly with all you have."9

Abstracted shapes may be so extensively reworked that they begin to lose their representational identity, for everyone except the artist. Arshile Gorky's shapes in *Making the Calendar* (**2.40**) appear to be purely imaginative inventions, but they are derived from a family scene. One of his daughters sits on the left before a window view of the Connecticut countryside. In the center of the painting, there is a dog on the floor in front of a fireplace. To the right, Gorky stands reading a magazine with one hand on the shoulder of his wife, who is rocking their baby in a cradle. Gorky says of such work, "Though the various forms all had specific meaning to me, it is the spectator's privilege to find his own meaning." ¹⁰

Geometric shapes have long been used as a design element in many cultures. The water jar by the pueblo potter Lucy Lewis (1.17) is decorated with black and white triangles within squares, alternating with diamond-like shapes created by lines, woven into squares of the same size. A Liberian gown (2.41) is composed largely of geometric shapes—circles, squares, rectangles, and triangles—whose symmetry is a striking counterpoint to the asymmetrical style of the gown. Although the shapes are worked flat on the cloth, when the gown is worn they will become more three-dimensional as the cloth drapes over the contours of the body.

Shapes can be created in unfilled as well as filled areas of a design. We perceived unworked white shapes in Matisse's *The Snail* (2.38), but they were not the focus of the work. In Helen Frankenthaler's *Mauve District* (**2.42**), an unpainted white area appears as a positive shape that is as important as the painted areas. We are meant to perceive the unworked space as "filled" rather than "empty." Frankenthaler explains:

That area not painted on didn't need paint because it had paint next to it. So it operated as forcefully, and the thing was to decide where to leave it and where to show it and where to say, "This doesn't need another line or another pail of color." In other words, the very ground was part of the medium. Red, blue, against the white of cotton duck or the beige of linen, has the same play in space as the duck. Every square inch of that surface is equally important in depth, shallowness, space, so that it isn't as if background meant the background is a curtain or a drape in front of which there is a table, on which there is a plate, on which there are apples. The apples are as important as the drape, and the drape is as important as the legs of the table.11

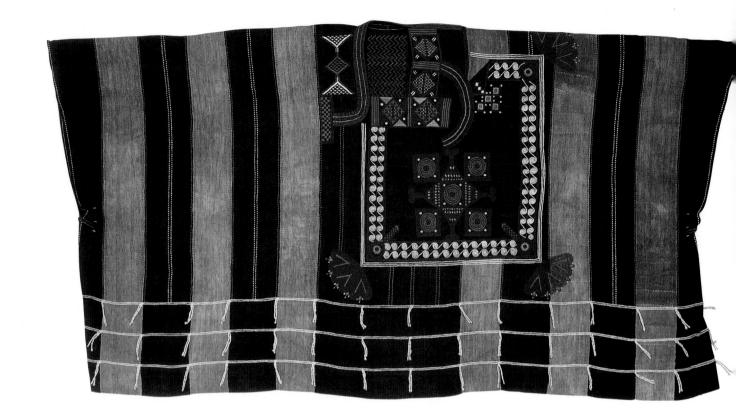

2.41 Gown made by the Mandingo, Liberia. Dyed and woven cotton cloth, decorated with embroidery and appliqué, height $36\frac{1}{2}$ ins (93 cm). British Museum, London.

2.42 Helen Frankenthaler, *Mauve District*, 1966. Synthetic polymer on unprimed canvas, 8 ft 7 ins \times 7 ft 11 ins (2.62 \times 2.41 m). Collection Museum of Modern Art (MOMA), New York. Mrs. Donald B. Strauss Fund.

Helen Frankenthaler was a pioneer in the use of unsized canvas, which so thoroughly absorbed her paint that surface and color, filled and unfilled shapes, seem to coexist on the same plane.

2.43 Odilon Redon, *Orpheus*, after 1903. Pastel, $27\frac{1}{2} \times 22\frac{1}{4}$ ins (70 \times 56.5 cm). Cleveland Museum of Art, Cleveland, Ohio.

2.44 Henryk Tomaszewski, poster for the work of Witold Gombrowicz, 1983. Stedelijk Museum, Amsterdam. Tomaszewski is considered one of the greatest poster artists and teachers of modern Poland, where poster art was highly influential from the end of World War II until the fall of the U.S.S.R. These posters were witty, sarcastic, and full of irony at the country's plight under foreign rule.

The shapes in Frankenthaler's painting are **hard-edged**. That is, their boundaries are clearly distinguished from surrounding areas by contrasts in color along the edges where they meet. The fact that Jacob Lawrence turns body parts into hard-edged shapes in his Hiroshima painting (2.39) forces the eye to focus on the frighteningly erratic outlines of those shapes.

Some artists work instead with **soft-edged** shapes, in which edges are not precisely delineated. In this case, it may be hard to pinpoint where one shape stops

and another begins, but we may still get a sense of the presence of shapes. Odilon Redon, one of the foremost Symbolist painters of the late nineteenth century, created a dream-like atmosphere for *Orpheus* (2.43) by using softly diffused lights and shadows and a barely defined outline for the severed head of Orpheus. The blue cloth is an even more soft-edged shape. Redon, who sought visible expression of the products of the unconscious, saw the mythical head of the dead Orpheus, still singing, as a symbol of art's immortality.

2.45 Alexander Calder, *Cow*, 1929. Wire construction, $6 \% \times 16 \times 4 \%$ ins $(16.5 \times 40.6 \times 10.8$ cm). New York, Museum of Modern Art (MOMA). Gift of Edward M. M. Warburg.

Shapes may also be created to express a certain emotion. In the context of martial law in Poland in 1983, there was no ambiguity about the emotion being expressed by the Polish poster artist Henryk Tomaszewski in his poster advertising an art show (2.44). Prohibited by censorship from showing a "V for victory" hand signal, Tomaszewski presented a foot that clearly bespeaks a defiant, playful freedom. With its slightly bumpy, hairy edges, this shape immediately suggests a down-to-earth populace who will persist in asserting their inner freedom, no matter what restrictions may be imposed by the government that finds artistic expression threatening.

Space

In art, as in life, space is an intangible element. Yet artists work quite consciously with spatial aspects of our existence to achieve the effects they desire. Those we will explore here are the ways in which three-dimensional art controls space, the differing ways space is handled in two-dimensional work, the concept of scale, and the mystery of spatial illusions.

THREE-DIMENSIONAL ART IN SPACE

On the most basic level, three-dimensional art physically occupies space. It has its own very obvious spatial reality—the volume of air it displaces. Less obvious are other ways in which certain works exist in space.

Some works delineate forms in space, shaping the intangible into contoured areas. Alexander Calder's *Cow* (**2.45**) uses wire to create a humorous depiction of a cow's form, with particular emphasis on the udder. The cow's body and udder are actually empty space, but the contour lines created by the wires create the visual impression of voluminous form in that unfilled space, showing us the great rounding of the udder. The sculpture is a small one, enhancing the illusion of form in the unfilled space. If it were large, it would be harder to visualize the form between the lines.

Certain architectural forms define a volume in space by enclosing it. When in ancient Rome people passed through a rectangular portico and entered the hall of the Pantheon (2.46), they must have been overwhelmed by the voluminous space framed by this great domed cylindrical structure. Rising 144 feet (44 m) above the floor, the dome gives way to an even greater expanse of space—the sky itself, framed by a

2.46 Giovanni Paolo Pannini, *Interior of the Pantheon*, c. 1740. Oil on canvas, 4 ft 2½ in (1.28 m) high; 3 ft 3 in (0.99 m) wide. National Gallery of Art, Washington, D.C. Samuel H. Kress Collection. The huge and ingenious dome of the Pantheon allows a view of heavenly space through its "eye," a dramatic glimpse of the eternal that is even more impressive than the statues of various deities in the niches below.

2.47 Joseph Cornell, *The Hotel Eden*, 1945. Assemblage with music box, $15\frac{1}{8} \times 15\frac{1}{8} \times 4\frac{3}{4}$ ins (38.3 \times 39.7 \times 12.1 cm). National Gallery of Canada, Ottawa, Ontario. Copyright © The Joseph and Robert Cassell Memorial Foundation. Photo by Bruce C. Jones, courtesy of Xavier Fourcade, Inc.

Joseph Cornell lived a simple life supporting his mother, grandfather, and invalid brother by working in the Queens, New York, garment industry, while at the same time creating magical worlds from found objects within the confined spaces of his boxed collages.

huge oculus, or "eye," through which the reversed sun poured, illuminating the niches devoted to various gods with its heavenly rays. The recessed coffers in the dome, ingeniously designed to give a visual impression of equal depth, enhance the impression of vast and expanding space. The great interior space was later converted into a Christian church, to serve the same purpose of awing worshipers with the grandeur of the God above, which invisibly fills the space within which we move.

Some sculptures carve out their own small world in a confined space. Joseph Cornell has done many works of this sort, defining an area by means of a glass case and then building up enigmatic compositions within it from **found objects**. In his *The Hotel Eden* (**2.47**), there is a sense of faded Victorian romance—the exotic paper parrot, listings in French, the remains of a poster for what appears to be a large seaside hotel. Beyond these relatively identifiable clues to content, the identity, meanings, and relationships of the found

objects exist in a private fantasy world of the artist. Why the ball? The concentric circles to which the parrot holds a string? The glass of white cylinders? Cornell collected all sorts of objects that delighted him, from marbles and toys to sky charts, and created small scenes with them that tempt the mind beyond its usual frame of reference. Within a space so defined and set apart, everyday objects lose their usual identities and become whatever the artist and the viewers' imaginations perceive them to be.

It is possible for a three-dimensional work to "control" an area larger than it physically occupies. Sculptures with pointed linear projections may seem to activate the space around them, as if the lines continued for some distance into that space. The wing-like structures of the Milwaukee Art Museum's Quadracci Pavilion (2.48) create an impression of dynamic life-energy and movement spreading far into the surrounding space. The building itself is of a certain size, but its presence seems to occupy an even greater volume in space.

2.48 Calatrava Valls, Milwaukee Art Museum, 1994–2001. Milwaukee, Wisconsin.

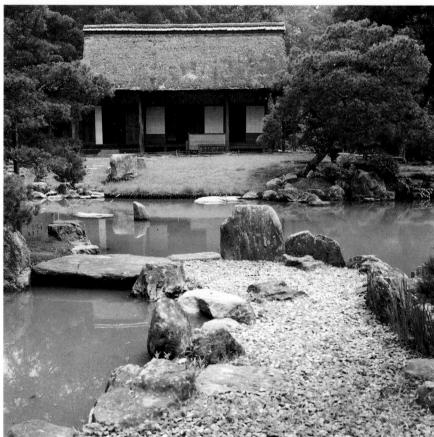

2.49 Garden of Katsura Palace, Kyoto, Japan, Edo period, early 17th century. In classical Japanese gardens, the pace and direction of walking and the aim of one's gaze are very intentionally controlled, maximizing the impact of the garden experience.

It is also possible for three-dimensional art to control us in space. Architecture provides defined rooms, halls, stairways, and ramps that guide our movements. Gardens may also be planned to manipulate people's movements through space, using pathways and barriers. In the Japanese garden shown in Figure 2.49, the way across the pond is defined by a path and then by stepping stones, all carefully arranged to imitate nature. The artistry of Japanese garden design leads us to step in specific places, at a specific pace, so that we are invited to enjoy artfully composed views of the landscape. When these devices work well, we are unaware of being manipulated.

The revolutionary "light-and-space" installation art of James Turrell (b. 1943) is developing ways of totally altering our experience of space. In some of his installations, he uses fields of diffused colored light perceptually to dematerialize ordinary solid rooms. Within these installations, viewers become quite disoriented. Some have fallen to the ground and broken their arms; others have crawled around on the floor because it offers some tactile solidity. Sometimes the spaces seem to expand infinitely; sometimes they seem

alternately to expand and contract. Turrell's intent is not to harm but rather to refer us back to the inner point from which we develop our notions about reality through observing and interpreting our sensations.

TWO-DIMENSIONAL SPACE

The two-dimensional surface is by definition a flat plane. This plane may be referred to as the ground; if a discrete shape is placed on it, it may be called a "figure on a ground," or a figure-ground relationship. In the most direct case of a figure-ground relationship, the ground is unworked and the figure can be clearly distinguished as lying on top of it. In this Australian Aboriginal bark painting (2.50), the painted spirit is the positive figure; the bark on which it is painted is the ground, which seems to lie behind it in space. Since there is a strong contrast in colors between figure and ground, we can discern an edge where they meet and we interpret it as belonging to the figure. However, even in this case, the spatial relationship between figure and ground is not necessarily so straightforward. As a second look at this painting will reveal, the figure is not fully demarcated from the ground by an outline;

2.50 Attributed to Dick Nangulay, *The Lightning Spirit*, 1972, Western Arnhem Land, Northern Territory, Australia. Natural ochers on eucalyptus bark, $14\frac{1}{2} \times 22\frac{1}{2}$ ins (37 × 57 cm). South Australian Government Grant 1972, Art Gallery of South Australia, Adelaide.

2.51 David McNutt, designer, "Master Harold" ... and the boys, 1985. Poster for the Department of Theater Arts, California State University, Los Angeles, California. Courtesy of the artist.

the figure is open, leaving some mystery about where the spirit stops and the surrounding environment begins. Indeed, they may not be entirely separate.

If figure and ground are approximately equal in area, artists can create a figure-ground reversal in which either color can be interpreted as lying on top of the other. Is a checkerboard red on black or black on red? Those of us who are accustomed to reading black type on white paper may initially assume that when we see black and white work, black is the figure and white the ground. The poster for "Master Harold"... and the Boys (2.51) calls this assumption into question, for we can continually flip between seeing the black head of Master Harold as a positive figure and seeing it as the background for a white figure. The white itself alternately reads as the African continent and a white boy's head. In this case, the visual puzzle not only holds our attention but also draws us into the theme of the play: race relations in South Africa.

Two-dimensional picture planes are often treated to

2.52 Muqi, *Six Persimmons*, Southern Song Dynasty, China, late 13th century. Ink on paper, width 14½ ins (37 cm). Daitokuji, Kyoto, Japan.

Unfilled space occupies most of this painting, but it is not empty. According to the mystical Ch'an Buddhism of the time, space is filled with the invisible life force that also permeates all forms. Thus there is an underlying unity to be discovered between the persimmons and the space that surrounds them.

create the impression of space that recedes from the viewer—or sometimes even extends forward. A number of devices have been developed that fool the eye into thinking it is looking into a space that has depth. As illustrations, we will use works that primarily use only one device, though many pieces of three-dimensional art use all of them at once.

One such device is the **placement** of images on the picture plane. In general, we tend to interpret figures that are lower on the picture plane as being closer to us in space. In Muqi's *Six Persimmons* (**2.52**), we do not interpret the fruits as floating in the air. Even though there is no visible surface for them to be sitting on, we perceive them as resting on something because of their placement in relationship to each other. We see the one that is lowest as closest to us, implying a surface that extends at least as far forward as that fruit seems to come. The other persimmons line up behind it at slightly different depths in space, the highest one in the center seeming farther away than the ones to

2.53 Romare Bearden, *She-Ba*, 1970. Collage on composition board, 48×36 ins (122 \times 91 cm). Wadsworth Atheneum, Hartford, Connecticut. The Ella Gallup Summer and Mary Catlin Summer Collection. The flat shapes relate one to the other like offbeat jazz rhythms, for Bearden had great interest in expressing the complex sounds and silences of jazz music visually.

2.54 Pieter Bruegel the Elder, *Hunters in the Snow*, 1565. Oil on canvas, 3 ft 10 ins \times 5 ft 4 ins (1.17 \times 1.62 m). Kunsthistorisches Museum, Vienna. Bruegel places us with the hunters in the foreground, so it is the elevated view of these working men looking across the snowy landscape that we share.

either side. The artist tells us to look from object to object, observing the many subtle ways they differ, including their very slightly differing placement in space.

Another device giving the illusion of spatial depth is overlapping space: the obscuring of images to be interpreted as farther away from us by objects designed to appear closer to us. In Romare Bearden's collage, *She-Ba* (2.53), even though the cut-out shapes are flat and intentionally ambiguous, the obscuring of some parts by others offers clues to their relative positions in space. Across the queen's torso, for instance, overlapping tells us that her scarf is in front of her sleeve, which is in front of her right arm, which is in front of her breasts, which are in front of the other side of her scarf, which is in front of her left arm. The staff is not floating in the air, for part of her hand is in front of it

and there is a suggestion that the ends of her fingers are hidden by it in the back.

A device that adds a tremendous feeling of depth to a two-dimensional painting is **scale change**. In art, the term "scale" refers to relative size. One of the most dramatic examples of the use of scale change is Bruegel's *Hunters in the Snow* (**2.54**). We perceive the hunters on the left as closest to us in space because they are by far the largest of the human figures. The people down on the frozen pond are pushed way back in space because they are so much smaller in comparison. The same kind of rapid scaling down can be traced in the houses and the trees from foreground to distant background. Bruegel makes us feel that we are looking across an immense distance, all the way to another village with a church spire and even beyond that.

Another device used to create the illusion of extremely deep space is **linear perspective**. This technique was refined and translated into precise mathematical terms by Renaissance artists in the fifteenth century. It portrays all parallel horizontal lines of forms that recede from the viewer's position as converging diagonally toward the same **vanishing**

2.55 Anselm Kiefer, *Athanor*, 1983–84. Oil, acrylic, emulsion, shellac, and straw on photograph mounted on canvas, 7 ft $4\frac{1}{2}$ ins \times 12 ft $5\frac{1}{8}$ ins (2.25 \times 3.80 m). Private collection.

point in the distance (in simple **one-point perspective**), determining the changing scale of the forms. As the Post-Impressionist painter Paul Cézanne explained to one of his students,

In an orange, an apple, a bowl, a head, there is a culminating point; and this point is always—in spite of the tremendous effect of light and shade and colorful sensations—the closest to our eye; the edges of the objects recede to a center on our horizon.¹²

Figure **2.56** demonstrates the effect of standing on a railroad track while holding a window before one's eyes. This window represents the **picture plane**—the flat surface on which a two-dimensional work is created. The tracks, which are parallel in actuality but perpendicular to the picture plane, appear on the picture plane as lines drawn toward a single point at a great distance. The horizontal line on which they seem to converge appears as the **horizon line**. Its position is not absolute, but rather depends upon the height from which the viewer is looking.

A dramatic demonstration of this principle can be

2.56 One-point perspective drawing.

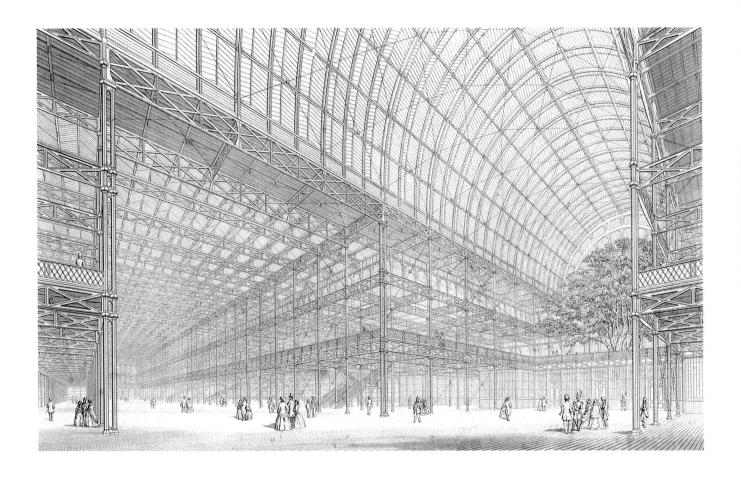

2.57 Joseph Paxton, *The Crystal Palace*, London, 1851. Engraving by R. P. Cuff after W. B. Brounger, $18\frac{1}{4} \times 25\frac{1}{4}$ ins (46.5 \times 64 cm). Drawings Collection, Royal Institute of British Architects, London.

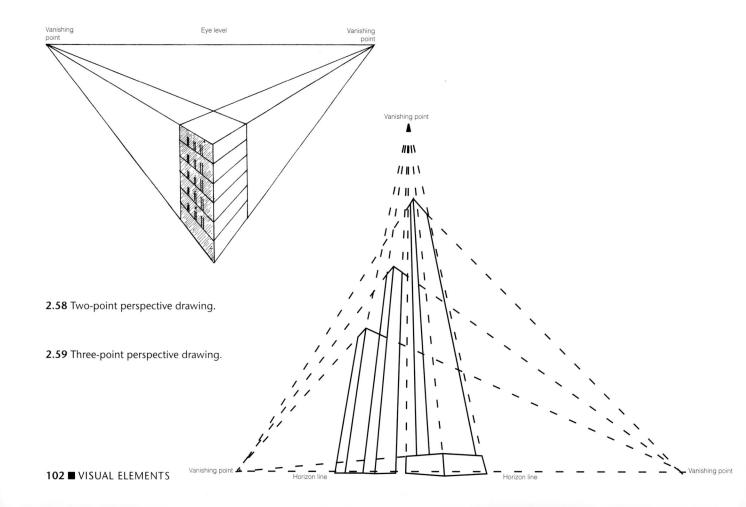

2.60 Berthe Morisot, *View of Paris from the Trocadéro*, 1872. Canvas, 18×32 ins $(46 \times 81 \text{ cm})$. Santa Barbara Museum of Art, Santa Barbara, California. Gift of Mrs. Hugh N. Kirkland.

seen in Anselm Kiefer's *Athanor* (2.55), in which architectural lines rapidly converge toward an eye-level line somewhere beyond the doors of this war-ravaged Third Reich building. The heightened emphasis on the spaciousness of this building makes its emptiness all the more eerie, as if what appeared strong and invincible was actually vulnerable and empty at the core, damaged from the inside out. As is characteristic in Kiefer's work, this feeling is intensely personal, as the artist explores dark and destructive elements in his own psyche and in twentieth-century German history.

When parallel lines appear to diverge toward two different vanishing points (as when we look at the corner of a building or the intersection of two hallways), the visual illusion is known as **two-point perspective** (2.58). The engraving of *The Crystal Palace* shown in Figure 2.57 is rendered in precise two-point perspective. The parallel lines of the hall to the right seem to converge toward one vanishing point, while those in the hall to the left apparently converge toward another, both on the same horizon line. Note that the vertical lines of the supports remain of even width from top to bottom, for they are parallel, rather than perpendicular, to the picture plane.

Depending on the artist's point of view and the forms being represented, there may be more vanishing

points. Tall buildings seen from below, for instance, may be rendered in **three-point perspective**, as in Figure **2.59**, in which parallel lines converge upwardly as well as to either side.

Some artists use linear perspective more freely in ways that remind us of our experience in a three-dimensional world rather than abiding by theories about precisely where and how lines should converge.

Artists may also use atmospheric perspective, by representing the tendency of things in the distance to be less sharply defined in form, hues, and value contrast than forms that are closer to us, because of the effect of atmospheric haze. This device is used naturalistically to push areas back in space, especially when a vast scene is depicted. Berthe Morisot, one of the early Impressionists, painted out of doors. Thus she faithfully recorded this optical phenomenon in her View of Paris from the Trocadéro (2.60). In the foreground figures we can see details of clothing, even though quickly sketched, and the grassy lawn is a rather bright green. Patches of grass at a greater distance are more subdued in hue, and the trees in the middle distance have almost lost their green impression, appearing almost black. Figures at that distance are just dabs of dull color, with no details and little clarity of form, but a few red roofs can still be perceived. In the far

2.61 Edgar Degas, Dancer with a Bouquet, c. 1878. Pastel and wash over black chalk on paper, $15\% \times 19\%$ ins $(40.3 \times 50.3 \text{ cm})$. Museum of Art, Rhode Island School of Design, Providence, Rhode Island. Gift of Mrs. Murray S. Danforth. Even in the artificial world of the ballet, Degas shows us a seemingly informal slice of life, with secondary dancers in slight disarray as the prima ballerina takes a bow.

distance, as observed from her high viewpoint, all objects lose their own colors and are instead suffused with a blue-purple atmospheric haze.

In working two-dimensionally with illusions of three-dimensional space, artists also manipulate the **point of view**. By the angle from which they show us figures, they are telling us exactly where we are placed in spatial relationship to them. The invention of the camera encouraged artists to experiment freely with the points of view they used, rather than rely on conventional frontal views.

Edgar Degas explored unusual points of view in many of his works. In *Dancer with a Bouquet* (2.61), we can barely see the bouquet. What we see instead is the fan of the woman whom Degas has placed between

us and the ballerina, telling us exactly where we are sitting: behind and to the left of the woman with the fan, perhaps in a box slightly above the stage. Degas even makes it very clear where we are looking: down and back across the stage. This precise and unexpected point of view brings us intimately into the scene, as though we were really sitting at the ballet rather than looking at a picture of a ballet.

Don Eddy's Imminent Desire/Distant Longing II (2.62) seems to offer three different views of a natural scene from a single vantage point: looking up, looking straight out, and looking at the plants near the ground. Eddy further controls our viewing position by exaggerating the different angles of view and scale of the images. The lowest panel gives us the impression of

2.62 Don Eddy, *Imminent Desire/Distant Longing II*, 1993. Acrylic on canvas, 6 ft $2\frac{1}{2}$ ins \times 3 ft (1.89 \times .91 m). Nancy Hoffman Gallery, New York.

being very close to the flowers and grass, for their scale is much enlarged, as if one were lying among them and seeing them from very close range. The natural scene in the middle panel is painted in a smaller scale that makes it seem much farther from us. The uppermost panel is painted in such a way that we are placed lying on our back, as it were, looking up at the sky. Today it is easy for viewers to accept this manipulation of viewing angles, for it is commonly used in television and films.

Another relatively recent innovation in points of

view is the aerial view, in which the point of view is above the scene depicted. It takes considerable visual sophistication to interpret such images as horizontal when they are hung on a vertical surface. Janet Cummings Good's Floor Show (2.63) may make sense to you if you are holding this book horizontally. But if you tip it to the vertical, as the picture would be if it were hanging on a wall, you must make a strong mental adjustment to recognize that you are looking down on cats who are lying on a wooden floor instead

2.63 Janet Cummings Good, Floor Show, 1983. Ink drawing, 40×30 ins (101.6×76.2 cm). Collection of the artist. Janet Cummings Good plays with our learned idea that a painting represents an image in front of us, rather than something at our feet, thus creating what seems a humorous balancing act performed by sleeping cats.

of across at cats splayed acrobatically against a wall. In such cases, artists require us to use our model of the world to interpret their creations. We just know from experience that cats sleep on the floor, not on the wall.

We can also examine two-dimensional use of space by considering the extent to which the artist has filled it or left it open. Hieronymus Bosch's *The Carrying of the Cross* (2.64) is so full of people that the canvas seems crowded with degenerate life forms. For this crowd effect, Bosch packed more heads into the picture than could in reality fit bodily into the space. Amid this leering and hateful mob, the serene, resigned face of Jesus carrying the cross (repeated in the veil carried by Saint

Veronica on which his image is said to have appeared) is a striking counterpoint—the image of the divine, unrecognized in the midst of human ugliness.

By contrast, leaving large areas of the picture plane unfilled may be used to create a quiet effect or to draw attention to an image isolated within this emptiness. In Japanese painting, as inspired by Zen Buddhism, the areas left unfilled were considered just as important as the filled areas, for, in simplicity and aloneness, one might discover the underlying oneness of life. The sixteenth-century Japanese artist Hasegawa Tohaku dares to leave two of the large panels of his painted screen (2.65) almost completely unfilled and provides only suggestions of form in the others to create the effect of

2.64 (above) Hieronymus Bosch, *The Carrying of the Cross*, c. 1510. Oil on board, 30×32 ins (76.2×81.3 cm). Musée des Beaux-Arts, Ghent, Belgium.

Bosch was a visionary who was strongly impressed by the human wickedness that fills the world, gruesomely depicted crowding in on the saintly.

2.65 (left) Hasegawa Tohaku (1539–1610), *Pine Trees*, Momoyama period, Japan. Ink on paper, height 5 ft 1 in (1.55 m). Collection Tokyo National Museum, Tokyo.

2.66 (left) Claes Oldenburg, *Stake Hitch*, 1984. Aluminum, steel, urethane foam, 53 ft 6 ins \times 15 ft 2 ins \times 44ft 6ins (16.3 \times 4.6 \times 13.6 m).

Dallas Museum of Art, commissioned to honor John Dabney Murchinson, Sr., for his arts and civic leadership, and presented by his family.

2.67 (below) Hans Holbein, *Jane Small*, c. 1540. Watercolor on vellum, diameter 2% ins (5.3 cm). Victoria and Albert Museum, London.

trees fading into the mist. By a supremely subtle use of contrast, the unfilled areas and the barely seen, washed out tree forms heighten our appreciation of the darkest strokes, and also lead to a feeling of the many merging into the One.

SCALE

We are accustomed to objects that are "lifesized." When an artist presents a familiar form in an unfamiliar size, our interest is often heightened, for the experience is immediately something out of the ordinary.

Vast scale is often used to evoke awe and reverence. But Claes Oldenburg presents mundane objects—such as a clothespin, a lipstick, a hamburger, a baked potato—as colossal monuments to the familiar banalities of our lives, greatly exaggerated in scale. By their great size, these inflated monuments to the ordinary make viewers feel dwarfed. Visitors to the Dallas Museum of Art discover that Stake Hitch (2.66) is so huge that the 20-inch-thick (51-cm) rope runs all the way to the vaulted roof of the gallery and the point of the stake is "hammered through" the floor and can be seen in the basement. Oldenburg sketched and proposed far more monuments than municipalities have dared to build. Approaching the absurdities of modern civilization with humor as a survival tactic, Oldenburg explained his first inspiration:

The first suggestion of a monument came some years ago as I was riding in from the airport. I thought: how nice it would be to have a large rabbit about the size of a skyscraper in midtown.

It would cheer people up seeing its ears from the suburbs. 13

At the other end of the scale of exaggerations are miniatures, artworks that draw us in because they are so much smaller than we would expect. Hans Holbein's miniature portrait of Jane Small (2.67) was actually painted in the same size as it is shown here, requiring extreme delicacy and skill. Imagine how small a brush Holbein must have used to paint the details on the cuffs and neckpiece. Despite the minuscule scale of this meticulous work, it is considered one of the world's great portraits. Precise miniature paintings were very popular as illustrations for medieval

2.68 Attributed to Li Cheng, *Buddhist Temple in the Hills after Rain*, Northern Song Dynasty, China, c. A.D. 940–67. Ink and slight color on silk, 44×22 ins (111.8 \times 55.8 cm). William Rockhill Nelson Gallery of Art, Atkins Museum of Fine Arts, Kansas City, Missouri.

European and Persian manuscripts and as jewelry pieces for sixteenth- through eighteenth-century English aristocrats.

Scale may also be used to make a statement about the relative importance of forms within a work. In

general, larger size symbolizes greater imporance; smaller size symbolizes lesser importance. In *Buddhist Temple in the Hills after Rain* (2.68), as in many early Chinese landscape paintings, the figures of pilgrims are tiny and unobtrusive in comparison with the

2.69 Cimabue, Madonna Enthroned with Angels and Prophets, c. 1280–85. Tempera on wood, 12 ft 6 ins \times 7 ft 4 ins (3.85 \times 2.23 m). Galleria degli Uffizi, Florence.

impressive mountains. In Taoist thought, this scale reflected the importance of humanity in the universe— a barely significant part of the totality, subordinate to nature. By contrast, religious works from the Christian tradition tend to emphasize human forms, especially

those of holy figures. In the large altarpiece *Madonna Enthroned with Angels and Prophets* (**2.69**), the Madonna is larger than life and larger than the angels on either side and the prophets below, a spatial device that speaks of her importance on the throne of heaven.

SPATIAL ILLUSION

One intriguing way in which some artists work with space is to twist it into situations that seem at first glance to work but turn out on closer inspection to be quite impossible, given what we know of the three-dimensional

2.70 William Hogarth, frontispiece to Kirby's *Perspective*, 1753. Engraving, $8^{1/4}\times 6^{3/4}$ ins (20.96 \times 17.15 cm). Victoria and Albert Museum, London.

world. William Hogarth's frontispiece for Kirby's *Perspective* (**2.70**) is a visual game with space as its subject. For instance, the fishing pole held by the man at the far

2.71 M. C. Escher, *Relativity*, 1953. Lithograph, $10\frac{3}{4} \times 11\frac{1}{2}$ ins (27.3 \times 29.2 cm). Print on loan to Gemeentemuseum, The Hague, by the Escher Foundation. © 1990 M. C. Escher Heirs/Cordon Art, Baarn, Netherlands.

right cannot possibly be long enough to reach all the way out to the pond, where it is shown neatly catching a fish. The scale of the sheep rounding the corner at the left is exactly backwards: those farthest away are the largest. To introduce the study of perspective, Hogarth has humorously created a scene full of spatial "mistakes." It may look initially plausible, but the longer you examine it, the more spatial impossibilities you will discover.

The Dutch graphic artist M. C. Escher was fascinated with spatial illusions. In his *Relativity* (2.71),

many surfaces serve three purposes at once—wall, ceiling, and floor—depending on the angle from which the figures approach them. The remarkable staircase to the right has figures walking both on the top and underside of its treads. Each segment is plausible unto itself but becomes spatially impossible when compared to adjoining areas. For Escher, his art was not a game but a serious inquiry into infinity—the point beyond which human concepts of space and time have no meaning.

Texture

The **texture** of a work of art is its surface quality—how it would feel if we touched it. From our experiences in the world, we are quite familiar with a great range of textural qualities: coarse, slimy, bristly, smooth, furry, matted, scratchy, wrinkled, and so on. Our hands are equipped with sensitive nerves for distinguishing textures, and we find sensual joy in feeling certain surfaces. Artists know this, and often use textures as a major influence on our response to a piece.

The sculptor Henry Moore encouraged people to touch his works. His *Reclining Figure* (2.72) makes us want to do so. Its highly polished wood surface

reminds us visually of the smoothness of taut skin and invites caressing. Despite the abstraction of the form, the prominent grain in the elm wood accentuates the visual similarity to a human body by suggesting the curves of muscles.

Some textures are much less inviting, but nonetheless enhance the intended visual impact of a piece. The Batetela mask shown here (2.73) was designed for a shaman's use in exciting crowds with fear of the spirit world. Its several textures are in dramatic contrast to each other, from the hairy, unkempt quality of the beard, to the geometrically precise, incised lines defining the contours of the face, to the furry antennae flopping down over the face like the legs of a dangerous spider. In this context, all these textures become

2.72 Henry Moore, *Reclining Figure*, 1935–36. Elm wood, length 3 ft 6 ins (1.07 m). Wakefield Metropolitan District Council Art Gallery and Museums, Yorkshire, England. Moore's reclining woman expresses physical presence without individuality. Her face is gone, her womb is open, and her abstracted contours are the substrate for the organic surface qualities of the polished wood itself.

2.73 African Batetela mask. Wood, fur, and fiber, length $16\frac{1}{2}$ ins (42 cm). British Museum, London.

alarming yet fascinating. The effect of the mask in motion must have been truly terrifying.

Textures may toy with our curiosity, using it to lure us into spending time with a piece. A natural stream bed is already a play in textures, with the hard, static, water-polished surfaces contrasting with the moving softness of the water itself. Andy Goldsworthy has brought out and increased the textural contrasts in his *Two River Stones Worked around with Curved Sticks* (2.75). The unexpected texture of twigs out of place, inexplicably woven in circles around the stone, is visually intriguing, inviting us to curiously compare and contemplate the textural contrasts between water, twigs, and stone. The twigs remind us of the circular ripples a stone makes when it is thrown into water but are of an entirely different texture.

ACTUAL TEXTURE

The textures with which we are most familiar are those we can feel with our hands: actual textures. Everything has a surface texture, but some textures are more noticeable than others. The Danish rune stone (2.74) is carved as a low relief into rock so grainy that its roughness shows in the photograph. The over-and-under interlacing patterns that wrap around the Christ figure ask to be touched and followed with the fingers,

2.74 Rune Stone, Jelling, Denmark, A.D. 965–86 Granite, height 8ft (2.44 m). The Germanic peoples of first-millennium Europe left permanent inscriptions of their writings, or runes, on stone, and took great trouble to carve them as low reliefs rather than simply incised lines.

2.75 Andy Goldsworthy, Two River Stones Worked around with Curved Sticks (two views), Sun Valley, Idaho, July 28–29, 2001.
©Andy Goldsworthy, from Passage (Abrams, 2004).

almost bringing us into physical contact with the person who carved the stone.

To create an impressive, magical bust of the war-god Kukailimoku (2.76), a Hawaiian artist used several materials with striking actual textures. The feathers of tropical birds create a mysterious texture for the skin, pearl shells make a smooth and shining eye, and sharp dogs' teeth make an impressive array in the mouth. These textural materials may have been used partly because they were plentiful, but to the eyes of those from other cultures, they give a strange, inexplicable quality to the piece.

2.76 (left) Feather god figure, Hawaii, collected on Captain James Cook's third Pacific voyage, 1776–80. Fiber, feathers, dog teeth, pearl shell, height 18¾ ins (48 cm). Institut und Sammlung der Kulturen, Göttingen, Germany.

2.77 Michelle Stuart, *The Pen Argyl Myth*, 1977. Earth and feather from Pen Argyl Quarry, Pennsylvania, rag paper, $13\frac{1}{2} \times 10\frac{1}{2} \times 3\frac{1}{2}$ ins (34.3 × 26.7 × 8.9 cm).

Some actual textures are created rather than used just as they are found. In her "rock books," such as the one shown in Figure 2.77, Michelle Stuart captures the "story of a place" by gathering rocks and dirt there and pounding it into paper, rubbing its surface until it develops a gloss. A series of such "pages" made from diggings at the site are then bound into a "book." The book, in turn, is sealed with a found texture—a feather, a coarse-woven string, a bone. These assemblages bespeak touching the earth, but they do not invite much handling by the viewer because they appear fragile, precious, and even ancient.

SIMULATED TEXTURE

Two-dimensional works often create the visual sensations of textural qualities on a surface that would actually feel quite different if touched. If we touched a print of Mary Azarian's woodcut (2.78) from the alphabet she was commissioned to create for the Vermont public schools, we would feel only the slight coarseness of the paper and the ink across the surface. But visually, what we perceive is the relative smoothness of grass blades, the filmy delicacy of dragonfly wings, and the bumpiness of the toad's skin. None of these textures is described utterly realistically. For

2.79 (opposite) Jean-Auguste-Dominique Ingres, *Portrait of the Princesse de Broglie*, 1853. Oil on canvas, $47\frac{3}{4} \times 35\frac{3}{4}$ ins (121.3 \times 90.8 cm). Metropolitan Museum of Art, New York. Robert Lehmann Collection 1975.

instance, the bumpiness is more hard-edged than the smooth, moist lumps on a real toad. Instead, Azarian uses a visual shorthand that reminds us of these natural textures, if we are familiar with them. These shorthand simulated textures also provide an interesting series of visual contrasts.

In comparison, certain artists have gone to great lengths to capture the visual effects of textures. One of the masters in this respect is Ingres. In his *Portrait of the Princesse de Broglie* (2.79), the facial skin and hair are rather stylized and simplified, in dramatic contrast to the extreme attention to detail in rendering the textures of the fabrics. The lush satiny dress fabric is so

2.78 Mary Azarian, *T is for Toad*, from *A Farmer's Alphabet*, 1981. Two-color woodcut, $12\frac{1}{4} \times 7\frac{1}{2}$ ins (31.1 \times 19 cm). Mary Azarian lives in the Vermont countryside and celebrates its fauna and natural textures in her woodcuts.

2.80 Venus de Milo, c. 150 B.C. Marble, height 6 ft 10 ins (2.08 m). Louvre, Paris.

To carve marble, a sculptor uses a mallet and chisels, but there is no trace of this process in the apparent softness and smoothness of Venus's skin. The only rough marks seen are those from pitting of the surface by erosion.

realistically painted that we can guess exactly how it feels. One clue is the way it reflects the light, a characteristic of smooth and shiny surfaces. We can see that the lace and gold-trimmed throw have very different textures, though they share with the satin the suppleness of fabric. And the information given to our eyes about the chair allows our fingers to imagine the play of the smooth surface and raised brocade across its plump contours.

This same realism in simulated textural effects has occasionally been achieved in three-dimensional works. One of the hardest of materials—marble—has been lovingly sculpted to suggest the feel of human skin in the *Venus de Milo* (2.80) from the Hellenistic period. It looks not only soft but as though it would feel warm to the touch.

When a visual effect is so realistic that it totally fools our perceptions, it is called **trompe l'oeil** (literally, "deceive the eye"). We are fascinated with deception in art. There is probably little innate visual appeal in a golf

2.81 Marilyn Levine, *Two-toned Golf Bag,* 1980. Stoneware with nylon reinforcement, $35 \times 10^{1/2} \times 7$ ins ($89 \times 27 \times 18$ cm).

bag. But the fact that Marilyn Levine has created a lifesized golf bag (2.81) from ceramics makes her piece utterly intriguing. She has carefully studied and captured precisely in the hardness of fired clay the look of pliable worn leather and of metal. If we touched it, the actual feeling of the surface would be shockingly and humorously different from what our mind expects.

Value and Light

Another visual element used quite consciously by artists is **value**, the relative lightness or darkness of an area. Values are most easily perceived when color hues are not present, as in Zheng Xie's ink drawing, *Misty Bamboo on a Distant Mountain* (**2.82**). The bamboo shoots and leaves range from dark black through intermediate tones to faint grays. As we saw in the earlier section on Space, we perceive value contrasts most clearly in areas

closest to us, so the artist uses this device to help us read the fainter plants in the background as being farther from us than the dark plants in the foreground.

The gradations of value from very dark to very light can be represented by means of a **value scale**. The one shown in Figure **2.83** breaks down the variations into ten equal steps, with black at one end and white at the other. In a work such as *Misty Bamboo on a Distant Mountain*, there are actually many more than ten values, but the value scale is a useful tool for seeing value gradations lined up sequentially.

In addition to giving spatial clues, values also help us to perceive the modeling of forms. As light falls on a

2.82 Zheng Xie, *Misty Bamboo on a Distant Mountain*, 1753. Set of four hanging scrolls, ink on paper, $26\% \times 70\%$ ins $(68.2 \times 179.2 \text{ cm})$. The Metropolitan Museum of Art, New York. From the P. Y. and Kinmay W. Tang Family Collection, partial and promised gift of Oscar L. Tang, 1990 (1990.322a–d).

2.84 Gaston Lachaise, *Standing Woman*, 1932. Bronze (cast 1932), $88 \times 41 \% \times 19 \%$ ins (223.6 \times 104.3 \times 48.4 cm). Museum of Modern Art (MOMA), New York. Gift of Abbey Aldrich Rockefeller. Lachaise's powerful Standing Woman has been placed in an outdoor courtyard at the Museum of Modern Art, where the movements of the

courtyard at the Museum of Modern Art, where the movements of the sun and changes in the weather continually alter the highlights and shadows across her body.

three-dimensional object, such as Gaston Lachaise's sculpture *Standing Woman* (2.84), the areas that light strikes most directly are the lightest, showing up as highlights. As contours curve away from the light source in space, the light dims, making the surface appear darker, until it approaches a true black in areas where light is fully blocked. The strong value contrasts on *Standing Woman* help us to grasp the extent to which the form swells out and draws back in space. In this photograph, strong lighting accentuates these contrasts; in more diffuse light, such as an overcast day, the ins and outs of the form would not be so apparent.

LOCAL AND INTERPRETIVE VALUES

The actual lights and shadows we see on real surfaces are called **local values**. Some photographers attempt by techniques of photographing and developing to capture on film the full range of local values, called a **full tonal range** in photography. Katherine Alling has purposely emphasized this value range in her *Feathers* #22 (2.85). She explains:

I chose feathers for their lustrous gradations of black, white, and gray. Photography has the capability to record this full tonal range. In the darkroom I reinforced this potential by preserving the whiteness of the box, the blackness of the major part of the feathers and the delicate gradations of gray in the parts in between. This makes the image realistic. But the artifice of twisting the feathers in a box makes them something out of the ordinary. They are transformed into an abstract image. The result is an equilibrium between the realistic black-white-gray actuality

2.85 Katherine Alling, Feathers # 22, 1984. Toned silver print, 12×9 ins $(30.5 \times 22.9$ cm). Mansfield, Connecticut.

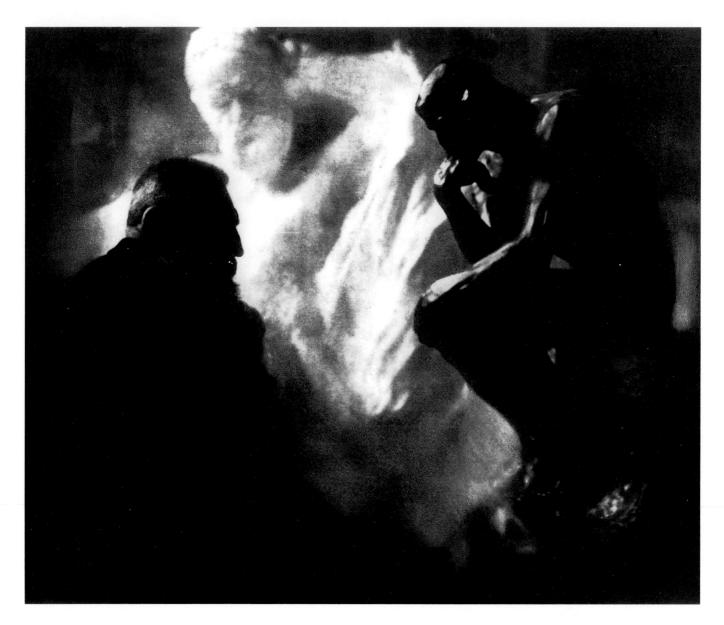

of the feathers in a box and the purity of a unique black-white-gray photographic picture.¹⁴

Many artists have manipulated values for purposes other than reproducing visual realities. When they are not handled realistically, they may be called **interpretive values**. One technique is to reduce the degree to which values gradually change, presenting them as more dramatic contrasts. To turn the sculptor Rodin's famous profile into a massive sculptural form, as if the man himself were a monument chipped from black stone, photographer Edward Steichen arranged for both Rodin and his sculpture *Le Penseur* ("The Thinker") to be in shadow, making them appear similarly strong (**2.86**). Their intense confrontation is set off by the white plaster figure of *Victor Hugo* brooding in the background. There are mid-grays in this photograph, but the main focus is on the stark contrast

2.86 Edward Steichen, *Rodin: The Thinker*, 1902. Photograph. Collection The Gilman Paper Company. *The famous profiles of Rodin and his* Thinker *made it possible for Steichen to present them in shadow with very little visual information.*

of the black forms to the highlights on *Le Penseur* and the light values of the *Hugo*. The drama of this approach is like hitting chords on both ends of a piano keyboard at once, using none of the notes in between.

Another approach to interpretive value is to emphasize one area of the value scale: lights, darks, or mid-tones. Each carries a different emotional quality. Rembrandt used the dark end of the scale in his self-portrait (1.3), with the light of his face barely emerging from the shadows. Graphic designer Milton Glaser has chosen the light end of the scale to represent Monet on a poster (2.87). The choice is appropriate, for the artist emphasized the effects of light in his own work. Here he appears as if in midday light so strong that it has

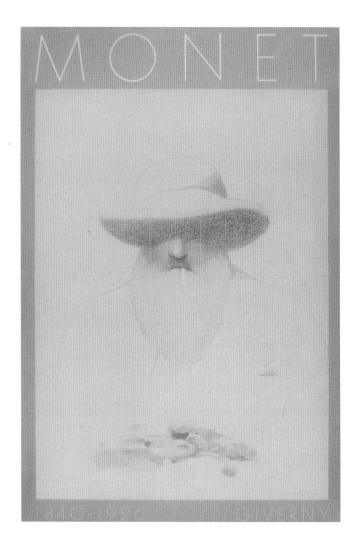

2.87 Milton Glaser, poster for the Monet Museum, Giverny, 1981.

In high contrast works, artists leave out all minor details, turning forms that usually include a range of grays into a dramatic contrast between black and white. The result may be an unrecognizable, seemingly non-objective design. But in the case of the Guggenheim Museum poster (2.88), just enough information is left to allow us to fill in the missing edges of the building's famous spiraling form. Presented in high contrast, it is an intriguing abstraction that calls on us to bring our own knowledge to complete the picture.

LIGHTING

The way a subject is lit—by the sun or by artificial lighting—will affect how we perceive it. In the Persian

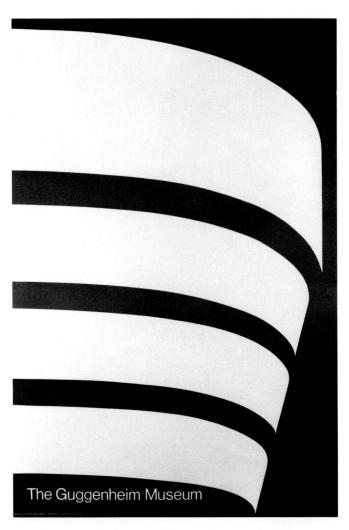

2.88 Malcolm Grear Designers, poster for the Solomon R. Guggenheim Museum, New York, 1970.

miniature painting to illustrate *The Concourse of the Birds* (**2.89**), as in most Persian miniatures, Habib Allah presents a uniformly lit scene with no shadows. This lighting represents no particular time of day, removing it from the realm of the real into the ideal, mystical setting of the parable, which symbolically illustrates the unity of individual souls with the divine. In the *Mantiq at-Tayr* thirty birds undertake a difficult journey in search of the Simurgh, king of the birds, only to discover that they are themselves *si murgh*, which means "thirty birds."

Many works do, however, contain some reference to the ever-changing reality of light. Three-dimensional pieces placed outside in a natural setting—as well as two-dimensional depictions of the natural world—will

2.89 (opposite) Habib Allah, *The Concourse of the Birds*, 1609. Colors, gold, and silver on paper, $10 \times 4^{1}/2$ ins (25.4 \times 11.4 cm). Metropolitan Museum of Art, New York. Fletcher Fund, 1963. *Persian painters eschewed shadows in order to portray paradise.*

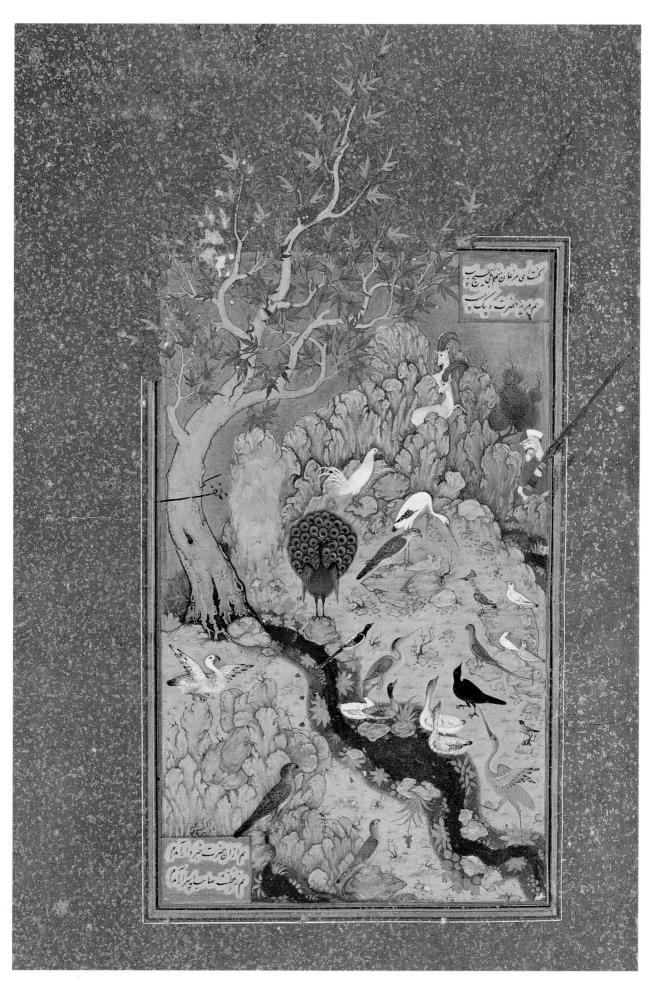

appear quite different when lit from the east at sunrise, overhead at noon, and from the west at sunset. The sun's angle changes during the year, also altering where the highlights and shadows fall. Moonlight brings a very different quality to a scene or piece of sculpture, softening edges and blurring distinctions between forms. And on cloudy days and during rain or snow the character of a piece or scene will be dramatically changed.

From antiquity, humans have used objects placed outside to track-and honor-the movements of the sun, moon, and stars. To do so reveals the predictabilities inherent in an otherwise uncertain existence. The sun will come up again tomorrow, though the point of its rising will have moved slightly. The solstices—the points on the horizon and calendar where this movement turns back on itself—have long had particular significance. A twentieth-century version of the ancient homage to the sun's apparent movements is Nancy Holt's Sun Tunnels (2.90). This consists of four enormous concrete tunnels placed on the Utah desert in such a way that the sun shines directly through two of them for ten days at the winter solstice and through the other two during the summer solstice. At other times, holes drilled into the pipes channel the light of sun, moon, or stars into their shaded centers to create constellations. Looking directly through the appropriate pipe during a solstice (2.91) one sees a shining circle around a circle whose center is the sun. At other times, one sees encircled darkness studded with starlike points of light, a circular sunwashed openness beyond, and the dark circle of the opposite tunnel at its center.

The use of artificial lighting allows controlled

2.90 Nancy Holt, *Sun Tunnels*, 1973–76. Total length 86 ft (26.2 m), tunnels each 18 ft \times 9 ft 4 ins (5.48 \times 2.84 m). Great Basin, Northwest Utah desert, Utah.

rather than changing effects. Sculptors are very careful how their works are lit, for the shape, size, and position of shadows and highlights depend on the placement of lighting.

Even two-dimensional works can be enhanced or destroyed by lighting. Mark Rothko was extremely particular about the way his large luminous paintings (see 1.40) were illuminated when they were shown. He gave these instructions for a retrospective show of his work:

The light, whether natural or artificial, should not be too strong. The pictures have their own inner light and if there is too much light, the color in the picture is washed out and a distortion of their look occurs. The ideal situation would be to hang them in a normally lit room—that is the way they were painted. They should not be over lit or romanticized by spots; this results in distortion of their meaning. They should either be lighted from a great distance or indirectly, by casting lights at the ceiling or the floor. Above all, the entire picture should be evenly lighted and not strongly.¹⁵

During the Renaissance, European painters developed the technique of **chiaroscuro** (Italian for "light and shade")—the depiction in a two-dimensional work of the effects of light and shadow. Values

2.91 Nancy Holt, *Sun Tunnels* (detail). Sunset on summer solstice.

2.92 Caravaggio, *The Conversion of St. Paul*, 1600–2. Oil on canvas, 7 ft $6\frac{1}{2}$ ins \times 5 ft 9 ins (2.29 \times 1.75 m). Cerasi Chapel, S. Maria del Popolo, Rome.

It is reported in the Bible that as Saul was busy persecuting Christians, light flashed from the sky all around him and he fell to the ground, blinded for days. Caravaggio dramatizes this conversion not only by Saul's pose but also by the use of dark and light in his painting. (Saul took the name Paul after his conversion.)

are manipulated for their dramatic effect. In Caravaggio's *The Conversion of St. Paul* (**2.92**) Saul's body gleams with the reflection of the light of God which blinded him. The divine light is emphasized by the surrounding darkness. Rembrandt, the great master of chiaroscuro, portrays himself (1.3) as a softly illuminated form barely emerging from total shadow.

We are quite familiar with the use of artificial lighting to add drama to a city's skyline or friendly warmth and light to the interiors of our homes. Less familiar is the use of artificial colored lights to change the hues as well as the values in an area. A spectacularly theatrical use of colored neon lights appears at the Piazza d'Italia in New Orleans (2.93). A celebration of the

2.93 (opposite) Charles W. Moore and William Hersey, Piazza d'Italia, New Orleans, Louisiana, 1978.

contributions of Italian immigrants, it is like a stage setting for an opera. Flamboyantly sensual, eclectic, and surprising in its architectural forms, it lures visitors to become part of the play. The neon lights throw a great range of colors across the fantastic architecture, for they mix where they overlap, enticing viewers to experience this multi-hued lighting playing across their own bodies.

REFLECTIONS

Another way in which light is used in art is by taking advantage of the fascinating effects of reflections off a smooth surface. Reflected light tends to capture our attention. Anish Kapoor's *Cloud Gate* (2.94) lures visitors to Chicago's Millennium Park to look at themselves, their shadows, sky and clouds, and the forms of the surrounding buildings, reflected and distorted by the polished curving surface of the installation. The surface itself becomes quite active, ever-changing with the movements of spectators and shifts in the weather.

To depict reflections convincingly in two-dimensional works takes great skill. Richard Estes has perfected the art of painting the reflections in artificial surfaces such as chrome and glass so realistically that they appear to be photographs. His *Double Self-Portrait*

2.94 Anish Kapoor, *Cloud Gate*, Millennium Park, Chicago, 2004. Stainless steel, 66×33 ft (20×10 m). Courtesy of the artist, Barbara Gladstone Gallery, Lisson Gallery and Millennium Park, Chicago.

ARTISTS ON ART

Leonardo da Vinci on Chiaroscuro

LEONARDO DA VINCI (1452–1519) was one of the major figures of the Italian High Renaissance. His subtle *Mona Lisa* (2.95) is perhaps the world's most famous painting. The mysterious smile of his model has fascinated viewers for centuries.

Leonardo was an inventor. sculptor, and architect as well as a painter, and he had far-reaching curiosity about all natural phenomena. His intensive studies of human anatomy involved dissection of corpses, from which he created detailed drawings of musculature, bones, and joints. He also wrote extensively on art, anatomy, machinery, and natural history but his voluminous writings were never published during his lifetime. His statements about the use of lights and darks in painting help us to understand why the boundaries of Mona Lisa's facial features are soft and undefined, though undoubtedly the darkened dirty state of the varnish now obscured the original colors of the painting:

"The first intention of the painter is to make a flat surface display a body as if modeled and separated from this plane, and he who most surpasses others in this skill deserves most praise. This accomplishment, with which the science of painting is crowned, arises from light and

shade, or we may say chiaroscuro."

"Shadow is the privation of light. Shadows appear to me to be supremely necessary in perspective, since without them opaque and solid bodies will be ill defined. Those features that are located within their boundaries—and their boundaries themselves—will be ill defined if they do not end against a background of a color different from that of the body. In addition to this, these shadows are in themselves of varying degrees of darkness because they represent the loss of varying quantities of luminous rays, and these I term original shadows, because, being the first shadows, they clothe the bodies to which they are attached. From these original shadows there arise shadowy rays which are transmitted throughout the air, and these are of a quality corresponding to the variety of the original shadows from which they are derived. And on this account I will call these shadows derived shadows, because they have their origins in other shadows."

"Shadow shares the nature of universal things, which are all more powerful at their beginning and become enfeebled towards their end. When I speak about the beginning of every form and quality, discernible or indiscernible, I do not refer to things arising from small beginnings that

become greatly enlarged over a period of time, as will happen with a great oak which has a modest start in a little acorn. Rather, I mean that the oak is strongest at the point at which it arises from the earth, that is to say, where it has its greatest thickness. Corresponding, darkness is the first degree of shadow and light is the last. Therefore, painter, make your shadow darker close to its origin, and at its end show it being transformed into light, that is to say, so that it appears to have no termination."

"That body will exhibit the greatest difference between its shadows and its lights that happens to be seen under the strongest light, like the light of the sun or the light of a fire at night. And this should be little used in painting because the works will remain harsh and disagreeable.

"There will be little difference in the lights and shadows in that body which is situated in a moderate light, and this occurs at the onset of evening or when there is cloud, and such works are sweet and every kind of face acquires grace. Thus in all things extremes are blameworthy. Too much light makes for harshness; too much darkness does not allow us to see. The medium is best."¹⁶

2.95 Leonardo da Vinci, *Mona Lisa*, c. 1503–6. Oil on panel, $30\frac{1}{4}\times21$ ins (76.8 \times 53.3 cm). Louvre, Paris.

2.96 (above) Richard Estes, Double Self-Portrait, 1976. Oil on canvas, 24×36 ins $(60.8 \times 91.5 \text{ cm})$. Museum of Modern Art (MOMA), New York. Mr. and Mrs. Stuart M. Speiser Fund.

2.97 (left) Hoodo (Phoenix Hall), Byodoin Temple, Uji, near Kyoto, Japan, 11th century.

(2.96) is a complex tour de force, photorealistically displaying both the reflections in a restaurant's glass wall of the view across the street—including the artist, who is seen taking the photograph from which this painting was done—and the intermingled details of the interior of the restaurant seen through the same glass. In certain lighting situations, some glass will seem to hold reflections on its surface, but this glass allows both inside and reflected outside to be seen at once, as if the outer world were penetrating the interior. To add to the visual puzzle of figuring out what is inside and what is outside, there is a mirrored surface inside the restaurant, in which a second reflected image of the artist appears.

When we see an object reflected in water, it may seem to lose its grounded position on the earth and instead appear to be floating in space. Such reflections hold great fascination for us, for they draw us into a different world of spatial possibilities. When the water outside the Byodoin Temple (2.97) is as smooth as it is in this photograph, the temple and its reversed image become a totality apparently floating without support in space. The reversed image is visually exciting in itself as a symmetrical counterpart of the actual temple.

2.98 Le Corbusier, interior of the chapel of Notre-Dame-du-Haut, Ronchamp, France, 1950–55.

LIGHT AS A MEDIUM

Light itself may be captured and controlled as an element of design. We humans have always been fascinated by looking at light. It has the power to bring us out of the darkness and to illuminate spaces, both outside and inside us. Artistic presentation of light is of ancient origin. The aesthetic care given to fashioning early clay lamps suggests the reverence and joy with which we regard light.

In medieval Europe, architects of churches used stained-glass windows to great effect, harnessing sunlight passing through colored glass to project religious stories into the interiors as jewel-like hues of light. In addition to their educational function, the stained-glass windows create a suffused color environment which may be conducive to worship of the Unseen. Indeed, mystics of all religions have reported that when they have been touched by the invisible Supreme Force, they have witnessed a great light.

The architect Le Corbusier translated this effect into contemporary terms at Notre-Dame-du-Haut (2.98),

2.99 Jonnie Wilkes, Venom Dub Rigonda, 1996. Laser and cotton T-shirt.

placing bits of stained glass within continually varying window openings. As the light bursts through each of these recesses in the thick walls, it creates a series of focal points in complex mathematical relationships to each other. Within the thickness of the walls, the light of God seems to break through to touch each person physically.

Light itself is an insubstantial medium which cannot be seen, for it is diffused through space. Only when it alights upon some solid, liquid, or vapor is its presence visible. This ephemeral quality is of great interest to many contemporary artists, and considerable experimentation is afoot in the use of light as a medium. Some light artists work with neon or fluorescent tubes of light, some with concentrated laser beams projected onto clouds or solid surfaces, such as Jonnie Wilkes's *Venom Dub Rigonda* (2.99). Here a brilliant star of laser rays becomes visible as it is projected across the dingy surfaces of a nightclub and a T-shirt, creating a striking

contrast between the positive brilliance of the star and the squalor of the urban environment.

Light can be used as having almost palpable presence. Danish artist Olafur Eliasson surrounds viewers with colored lights that continually change, encouraging awareness of sensory and perceptual effects such as after-images that occur in the retina. Eliasson says that works such as *Your Colour Memory* (**2.100**) evoke the experience of "seeing yourself seeing."¹⁷

At the cutting edge of contemporary research into the effects of light is James Turrell. His work delves into what happens when we experience pure colored light in the absence of other sensory clues. In his Ganzfield experiments and installations, viewers are exposed to sequences of colored lights within a white environment. As indicated earlier, they tend to become quite disoriented, for they cannot see any edges upon which to base normal spatial logic; the environment seems to expand infinitely in the presence of blue light and

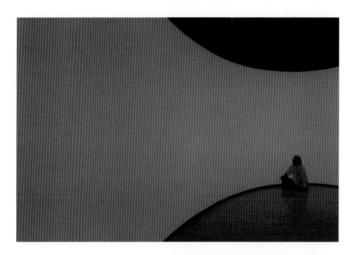

2.100 Olafur Eliasson, Your Colour Memory (three views), installed at Arcadia University Art Gallery, Glenside, Pennsylvania through January 9, 2005. Flourescent lights, control system, projection screen, steel scaffolding, wood, fabric. 10 ft 6 ins \times 17 ft 6 ins \times 29 ft 10 ins $(3.2 \times 5.3 \times 9 \text{ m}).$ Arcadia University Art Gallery, Glenside, Pennsylvania. Collection of Astrup Fearnley Museum, Oslo, Norway.

to press in closer when reds are projected. Ordinary perceptual strategies for understanding the form of the physical environment are of no use when one is confronted by light alone.

Turrell is also building "skyspaces," installations in which his medium is the light of the sky, whose appearance is perceptually altered by strategic use of artificial lighting. In these spaces, Turrell creates rooms with white-painted areas, hidden neon lighting, and an opening that reveals the sky as if it were a solid shape above. The skyspace shown in Figure 2.101, installed at the Scottsdale Museum of Contemporary Art, gives visitors the trance-like feeling of being in an ocean of air. Benches are provided so that they can sit for a long time, letting the light affect their perceptions deeply. Turrell explains that he wants to use light in such a way that "you feel it to be some thing itself, not something with which you illuminate other things, but a celebration of the thingness of light, the material presence, the revelation of light itself." 18

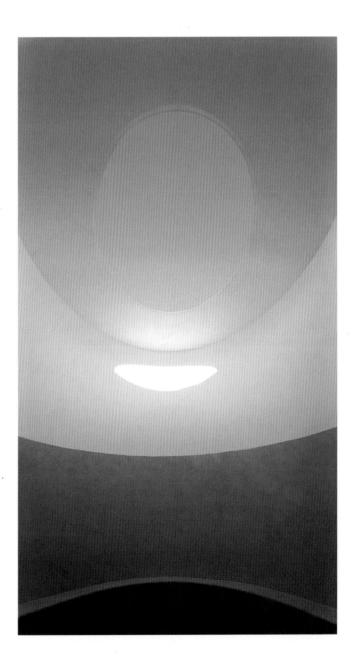

2.101 James Turrell, *Knight Rise*, 2001. Plaster, concrete, and steel, 18 ft (6.25 m) wide. Commissioned by the Scottsdale Public Art Program, Scottsdale, Arizona, USA.

2.102 The visible spectrum.

2.103 Newton's color wheel, from Isaac Newton, *Optice*, 1706. British Library, London.

2.104 Primary and secondary hues in refracted lights.

Color

Color is an immediately obvious aspect of a work of art that clearly impresses itself on our consciousness. In describing any work that strikes a particular color note, we inevitably speak of it as "that red cube" or "one of Picasso's blue paintings." Less obvious are the subtle effects of colors on our visual receptors, emotional state, and our perceptions of space, though these effects are under study by scientists and used consciously by many artists. Color may even affect us spiritually, as the Russian nonobjective painter Wassily Kandinsky wrote:

Color is a power which directly influences the soul. Color is the keyboard, the eyes are the hammers, the soul is the piano with many strings. The artist is the hand which plays, touching one key or another, to cause vibrations in the soul.¹⁹

A VOCABULARY OF COLOR

From Kandinsky's sublime perception we descend to the need to establish a vocabulary for speaking about the colors we perceive. The first point to understand is that what we perceive as the color of an object is actually the reflection of light of a certain wavelength off the surface, as this reflection is received by the retina of the eye and perceived by the brain. It does not "belong" to the object itself. The wavelengths that humans can see (only a tiny fraction of the great spectrum of electromagnetic radiation) are collectively referred to as the **visible spectrum**. As shown schematically in Figure **2.102**, the visible spectrum is the rainbow of colors we see when the white light of the sun passes through a prism that breaks up the wavelengths into seven graduating bands of color.

Centuries ago, Sir Isaac Newton proposed that the ends of this band of hues were so similar that they could be joined, pulling the band into a circular model of color relationships that we now call the **color wheel**. Newton's original proposal is shown in Figure **2.103**. The color wheel demonstrates theoretical relationships among **hues**, the wavelength properties by which we give colors names such as "red," "blue," and so on. In **refracted** (light or "additive") **colors**, there are theoretically three basic hues, from which all other hues can be mixed (**2.104**). These basic hues are called **primary colors**. In refracted colors, the primaries are red, green, and blue-violet. If you examine a color television picture very closely, you will see that it is

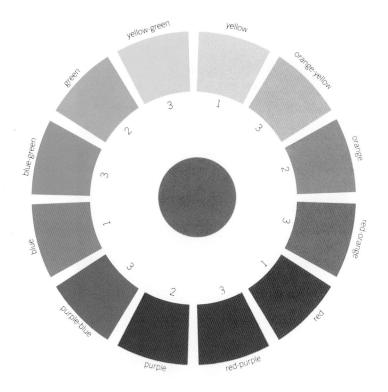

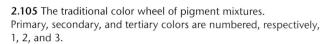

2.106 Primary and secondary hues in reflected pigments.

composed entirely of dots of these three hues. There is no yellow in television transmission. Yellow is one of the **secondary hues** in refracted light mixtures; it is created by mixing red and green light.

This information is hard for many of us to grasp, since the color wheel with which we are more familiar (2.105) shows the relationships between reflected hues. Also called "pigment" or "subtractive" hues, reflected hues are those that result when light is reflected from a pigmented surface that absorbs all wavelengths except those that we see. In this case, the primary hues according to traditional color theory are red, blue, and yellow; the secondaries that can be mixed from them are orange, green, and purple (2.106). If primary and secondary hues are mixed, they form another level of mixtures: tertiary hues, as shown in Figure 2.105. For example, red and purple mixed together make red-purple. Note that there is a circle of gray in the center of the color wheel. If pigments of hues lying opposite each other on the wheel—which are called complementary hues—are mixed in equal amounts, they will theoretically produce a neutral gray. Purple and yellow, for instance, are complementary to each other, as are blue-green and red-orange.

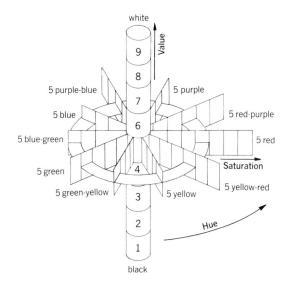

2.107 The color tree illustrating relationships in hue, saturation, and value, here shown at medium value, according to the color theorist Albert Munsell.

2.108 Georgia O'Keeffe, *Abstraction Blue*, 1927. Oil on canvas, $40\frac{1}{4} \times 30$ ins (102.1×76 cm). Museum of Modern Art (MOMA), New York. Acquired through the Helen Acheson Bequest. 1979. Georgia O'Keeffe worked with abstract, sensuous shapes that are defined by their colors. At extremely high values, the edges of the shapes can barely be distinguished.

2.109 Angel de la Guarda, Kuna people, San Blas Islands, Panama. Appliquéd, embroidered cotton *mola* for a blouse. $16\frac{3}{4} \times 19\frac{1}{2}$ ins (42.5 × 49.5 cm), c. 1960. Girard Collection, Museum of International Folk Art, Santa Fe. In equatorial areas, only highly saturated colors hold up against the brilliance of the sun's light, as in this Panamanian panel made for a blouse.

The problem with Newton's model of color relationships—in addition to the open question of whether the two ends of the spectrum can really be joined—is that it accounts for only one characteristic of color: hue. The colors we perceive also differ in two other ways: value and what is called saturation (also known as "chroma" or "intensity"). Value, as we have seen, is a measure of the relative lightness or darkness of a color. It can be conceived as a vertical pole with white at the top and black at the bottom, and increasingly darker grays in between. Value variations in reds, blues, and so on run a similar course from near-white to near-black, with middle-value reds or blues lying at the middle of the pole. These value variations are shown as a three-dimensional model in Figure 2.107. To illustrate the effects of value changes in a hue, Georgia O'Keeffe's Abstraction Blue (2.108) can be seen as a beautiful study in value changes in several hues. At their darkest, the hues of the cloudlike forms are almost black, graduating to pastels that are almost as light as the shape dividing the center of the canvas. At

either end of the value scale, different hues are almost indistinguishable from each other.

The three-dimensional model of color relationships (2.107) also illustrates differences in saturation, which is a measure of the relative brightness and purity of a color. The most highly saturated colors are those that are the pure hue with none of its complementary added. In the angel *mola* piece from the San Blas Islands of Panama (2.109), all colors are used at their highest saturation, creating an extremely brilliant effect.

As more and more of its complementary is added—for instance, as we mix yellow with purple—the color becomes more and more subdued, until, at the center of the vertical axis on this model, it appears as a gray value. As an example of low saturation, Isaac Levitan—a master at manipulating landscapes to evoke human moods—has used the muted colors of a cloudy Russian landscape in *Above Eternal Peace* (2.110) to develop a feeling of the peace of death. Only a hint of sunlight behind the clouds lights the gloom, suggesting heavenly splendor awaiting souls beyond the drab world.

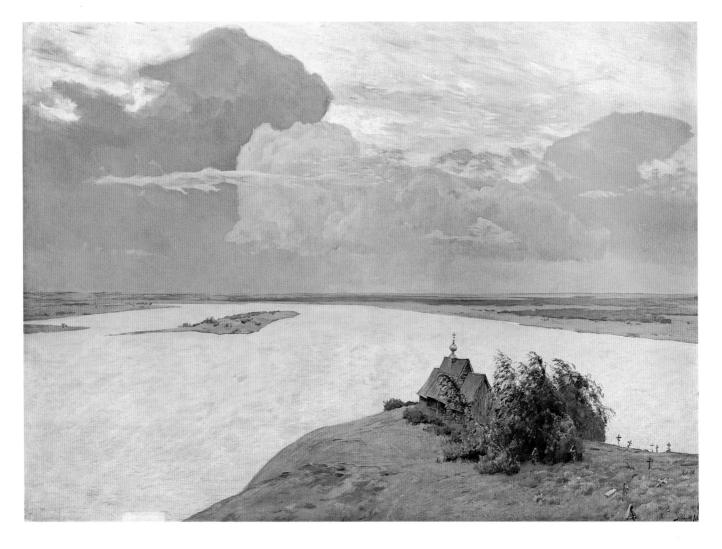

2.110 Isaac Levitan, Above Eternal Peace, 1894. Oil on canvas, 59×81 ins $(150 \times 206 \text{ cm})$. The State Tretyakov Gallery, Moscow.

The three-dimensional model shown in Figure 2.107 was developed by the color theorist Albert Munsell. Munsell found that color relationships could best be explained with a system of five primaries—yellow, green, blue, purple, and red. Therefore, Munsell's complementary colors do not exactly match those of the traditional color wheel shown in Figure 2.105. Munsell's system is now used as a commercial standard for naming and mixing pigments. His models show that the number of equal steps in saturation, from gray to most saturated, varies from one hue to another, red having the most possible steps and yellow the least. The Munsell color tree is therefore asymmetrical.

NATURAL AND APPLIED COLOR

We are surrounded by color in the natural world. Our awareness of its subtleties depends partly on how open our eyes are and partly on where we live. Those who live in snowy areas may become sensitive to the varied hues that can be seen in the "whiteness" of snow, from blue and even green in its shadows to the grayness of "white" flakes seen falling against a pale sky.

Many artists doing three-dimensional work have featured the natural colors in materials rather than covering them with another color. The many hues that lie beneath the bark of wood are often prized by woodworkers. Semi-precious stones may be cut and polished to bring out their colors, and amethyst and citrine quartz crystal clusters are presented as art objects not only because of their unusual crystalline forms but also because of the natural beauty of their translucent colors.

Brass and copper are prized by metalworkers for their own colors, but yet more colors can be brought out in their surfaces by heat treatment. Vladimir Barsukov has applied a torch directly to the surface of copper pieces in his mobile *Joy* (2.111), bringing out a whole spectrum of metallic hues, including yellows, reds, and blues, as differing length of the heating causes differential oxidation of the metal. However, if heat is applied too long, the metal simply turns black.

2.111 Vladimir Barsukov, *Joy*, mobile of copper, approx 16×14 ins $(40.6 \times 35.6$ cm). Artist's collection.

Isamu Noguchi dwells on the natural colors of marble, basalt, and wood in the sculptural composition shown in Figure **2.112**. He writes, "I attempt to respect nature, adding only my own rawness."²⁰

Diametrically opposed to Noguchi's preference for a restrained use of natural colors is the view that color applied to materials intensifies the significance of a work. Many Classical Greek and Roman marble sculptures were originally painted to bring out the details. Medieval wooden sculptures were also painted, as was the Chinese statue of the Bodhisattva (an enlightened being), Guanyin (2.113). Guanyin, like other Chinese divinities, had both male and female qualities, and was at various times considered the Bodhisattva of Mercy and the traditional Chinese mother goddess. The gold suggests a rich and spiritual presence; the red and green excite the eye, in addition to carrying connotations of life, fertility, and good fortune. When colors that are complementary to one another, such as red and green, are juxtaposed, they intensify each other's brilliance. Here this effect is used only sparingly, for the garment is chiefly red trimmed with gold, with a green sash draped here and there like a pathway through the red and gold.

2.112 Isamu Noguchi, (from left to right) *Small Torso*, 1958–62, Greek marble, 13¾ ins (34.9 cm); *Core Piece # 1*, 1974, basalt, 14¼ ins (36 cm); *Core Piece # 2*, 1974, basalt, 15¼ ins (38.7 cm). Photo by Shigeo Anzai. *Basalt is a very hard stone seldom employed by sculptors. But Noguchi so appreciated its natural coloration that he shaped it with the help of diamond-tipped saws and drills.*

2.113 *Guanyin,* Chinese, 11th to early 12th century. Polychromed wood, height 7 ft 11 ins (2.41 m). Nelson Gallery, Atkins Museum, Kansas City, Missouri.

LOCAL, ATMOSPHERIC, AND INTERPRETIVE COLOR

Many of us are taught as children that objects in our world "are" predictable colors: an orange is orange, a tree has a brown trunk and green leaves, the sky is blue, and so on. These perceptions are called local colors. They are the color an object appears if seen from nearby under normal lighting. Often these ideas of what color an object "is" are used to guide color choices in painting. In Gerard David's The Resurrection (2.114), boulders are gray, dirt is brown, and grass is green. Although the values of forms in the distance are generally painted lighter than those in the foreground, the hues are still largely local colors. Christ risen from the tomb clearly dominates the composition, not only because of his central position and upright, frontal stance but also because of the intense red of his cloak, heightened by contrast with the greens that surround it.

A fixed mental model of the world can blind us to its subtle and shifting realities, however, such as in the effects of atmospheric color. The French Impressionists met with tremendous opposition when they trained their minds to perceive the actual colors and forms their eyes were seeing. When Monet painted haystacks, as in Figure 2.115, he discarded the idea that hay is yellow and presented what he actually saw in the cool light of morning. The surprising, scintillating color impressions tend to dematerialize the form. To capture visual truth as nearly as possible, Monet took his canvases outside to paint in natural lighting, from nature, rather than making sketches with color notations and then working inside. He returned again and again to the same field near his home, from summer into winter, painting the ever-changing effects of atmospheric color on the same haystacks.

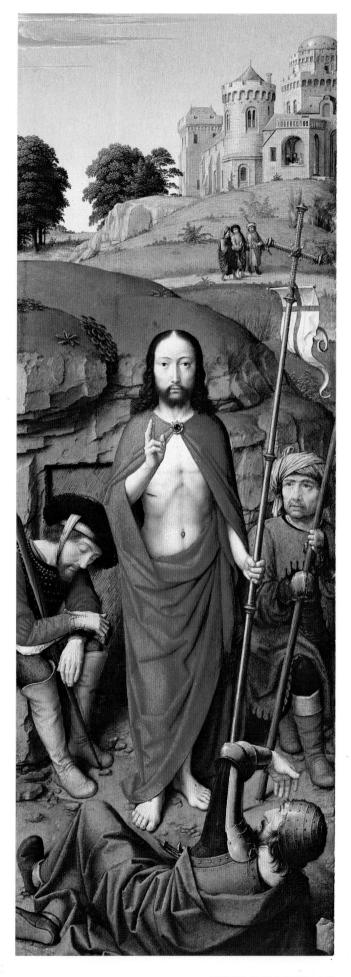

2.114 Gerard David, *The Resurrection* (right-hand panel), c. 1500. Oil on wood, each panel 34×11 ins (86.4 \times 27.9 cm). Metropolitan Museum of Art, New York. Robert Lehmann Collection, 1975. Although the local colors of the landscape are painted in a flat way, in some passages David attains a high degree of realism, as you can see in his careful attention to form and color in the face of the guard at the right.

2.115 Claude Monet, Stacks of Wheat (End of Summer), 1890–91. Oil on canvas, $23\% \times 39\%$ ins (60 \times 100 cm). Art Institute of Chicago, Chicago, Illinois. Potter Palmer Collection 1922.431.

Use of **interpretive color** is somewhat different from either local or atmospheric color. Here color choices are guided by the artist's intent rather than by any external reality. Color is often used interpretively or exaggerated to set the emotional tone for a work. Picasso's *The Old Guitarist* (**2.116**) was painted during his "Blue Period" (1901–4). During these years, he used blues as the predominant colors in his paintings to express the pathos of poverty. In the West, blue is often associated with a feeling of melancholy. If Picasso had used other colors—such as the pinks of his "Pink Period" that followed—the tone of the painting would have been more jovial, but that was not his intent.

EMOTIONAL EFFECTS OF COLOR

Colors affect our moods, and we tend to surround ourselves with the psychological atmosphere we want through our choices of colors in clothing and interior design. Research into the effects of colors suggests that a certain pink has a calming effect on us, for instance, whereas red is stimulating. In addition to these physiological effects, we respond to our culture's color associations. In northern European cultures, white is a symbol of purity. But to the Native American Sioux tribe, white symbolized wisdom and health; and in the Far East white is a symbol of death. As we see in Picasso's *The Old Guitarist* (2.116), blue is associated with sadness in Western cultures; it is also linked with serenity and humanity and is therefore the color often used symbolically for the robes of the Virgin Mary (15.21, 15.26, and 15.34).

While such knowledge is interesting and useful, it does not totally explain the way colors are used expressively in art, for color is only one aspect of the totality to which we respond in a work of art. As an illustration, let us look at three works, all of which feature red as their dominant color. Considered sensitively, each has a different emotional content. In Matisse's *The Red Studio* (2.117), the red is joyous and noisy, and the slight accents of other colors make the red seem boisterous. Matisse intentionally subordinated realism to expression in his use of color, explaining, "What I am after, above all, is

2.116 Pablo Picasso, *The Old Guitarist*, 1903. Oil on panel, $47\frac{3}{4}\times32\frac{1}{2}$ ins (122.9 \times 82.6 cm). Art Institute of Chicago, Chicago, Illinois. Helen Birch Bartlett Memorial Collection, 1926. 253.

2.117 Henri Matisse, *The Red Studio*, Issy-les-Moulineaux, 1911. Oil on canvas, ft $11\frac{1}{4} \times 7$ ft $2\frac{1}{4}$ ins $(1.81 \times 2.19 \text{ m})$. Museum of Modern Art (MOMA), New York. Mrs. Simon Guggenheim Fund. 8.1949. *Matisse used the color red to fill the entire room as an expression of his vibrant, childlike joy in life. One could also find symbolic meaning in his use of red for the artist's studio as the womb of creation. The furniture almost becomes invisible; primary color focus is on the atmosphere of the whole room, with red perhaps expressing intense creativity, and on the colorful products of that creative ferment.*

2.118 Danny Perkins, White Square, 1994. Blown glass, oil paints, $42 \times 16 \times 16$ ins (106.6 \times 40.6 \times 40.6 cm). Courtesy of the artist.

expression ... I am unable to distinguish between the feeling I have for life and my way of expressing it. The whole arrangement of my picture is expressive. The place occupied by figures or objects, the empty spaces around them, the proportions, everything plays a part."²¹

The red of Danny Perkins's *White Square* (2.118) is lush and sensual. This expressive color sensation is enhanced by the sensuous organic curves of the blown glass sculpture and the light passing through it. But even where red appears on a flat area above the white square, the color itself maintains its lusciousness.

By contrast, in Josef Albers's *Homage to the Square: Board Call* (**2.119**), red has an almost cold and intellectual quality. Albers presents reds in such precisely

geometrical gradations, with edges softened by the minimizing of contrast, that his work suggests itself as an object for quiet contemplation. These very different ways of handling the same hue attest to the genius of the artists: that they can make red do whatever they ask, by the way that they use it.

WARM AND COOL COLORS

In addition to—and perhaps linked with—our perceptions of colors as having certain emotional qualities, we also tend to associate degrees of heat or cold with them. Although scientific evidence is inconclusive, we do seem to respond to colors kinesthetically, as though they produced different color sensations in

2.120 (opposite) Interior of Jim and Sandy Howell's home, Washington.

2.119 Josef Albers, *Homage to the Square: Board Call*, Fall 1967. Oil on composition board, 4×4 ft (1.22 \times 1.22 m). Museum of Modern Art (MOMA), New York. The Sidney and Harriet Janis Collection. © 2003, Digital Image, the Museum of Modern Art (MOMA), New York/Scala, Florence. For twenty-five years, Josef Albers used the same format of squares within squares for his experiments with the optical effects of specific color combinations.

our bodies. Some of us intuitively dress in red to feel warmer and blue or green to feel cooler. Such choices of hues seem independent of value differences in the amount of light absorbed or reflected. In general, reds and yellows are considered to be **warm colors**, like those of fire; blues and greens are considered to be **cold**, like icy water.

Consider the visual "temperature" of two interiors. The silvery-blue paleness of Jim and Sandy Howell's living room (2.120) has a feeling so cool and airy that even the red of the wood stove does not seem to give off much warmth. The house is designed to draw in a

tremendous amount of outside light through broad glass walls and a skylit core. This light is of great importance to Jim, a painter who works with very subtle variations of color and light (one of his paintings hangs on the wall). The warmth and brilliance of the light that floods the house are balanced by the quiet coolness of the blues inside. By contrast, the reds of the sitting room shown in Figure **2.121** create an extremely warm effect.

As we have just seen, the amounts in which colors are used and the areas where our attention is focused have a strong effect on our response. When reds,

2.121 David Hicks, sitting room of a house in Oxfordshire, England, 1970s. Courtesy of the artist.

oranges, and yellows are used in small amounts as accents rather than whole environments, they may not create a sense of warmth.

ADVANCING AND RECEDING COLORS

Because of the way our eyes see colors, warm colors tend to expand visually, seeming to come toward the viewer in space, while cool colors contract, seeming to draw back in space. But these effects do not exist in isolation. Look carefully at Ellsworth Kelly's *Spectrum II* (2.122). Because the same amount of color appears in each band, careful observation of our own reactions will give us some clues as to which colors seem visually larger and closer. Does the strip of colors seem to bow in or out at any point? Is this effect continuous, or does it change direction on any of the bands? Now try blocking out the white of the page by placing four strips of some other color around the edges of the reproduction. Does the spatial effect of the colored bands change?

The only rule that is always true in dealing with the elusive subject of color effects is this: *All colors are affected by the colors around them.* Our perception of certain colors as closer or farther depends to a large extent on the colors to either side of them. Colors that are closer to the hue and value of the background will

seem to lie on the same plane as the background; the more that colors differ in value and hue from the background, the more they will appear to come off or recede into it in space, the direction depending on other spatial clues. The effect of contrast between individual colors and the background is complicated in the Ellsworth Kelly painting by the interactions between adjacent colored bands. If you look closely and for some time, you will begin to see that along many edges where colors meet, the light one appears lighter and the dark one darker. Colors affect each other optically by "subtracting" their own hue and value from that of their neighbor.

COLOR COMBINATIONS

Because colors affect each other, in our perception, theorists have noted that the distance between colors on a color wheel has a predictable effect on how harmonious they will be if placed together. Using the traditional color wheel, they have distinguished several common patterns of color combinations, as shown in Figure 2.123. These patterns apply to any sets of colors, and not just the ones shown as illustrations in the figure and the examples that follow. Such orderly relationships do not exhaust the possibilities but provide a basic framework for some designers' color choices.

2.122 Ellsworth Kelly, *Spectrum II*, 1967. Oil on canvas in 13 parts, overall 80×273 ins (203.2×693.4 cm). The Saint Louis Art Museum. Funds given by the Shrenberg Foundation, Inc.

2.123 Color combinations.

2.124 Concrete Architectural Associates, *Le Bed Baroque* at Supperclub Roma, Rome, Italy, June 2002. Le Bed Baroque can accommodate 45 people for dining, dancing or just reclining to admire the ceiling masterpiece and multicoloured lighting.

When only one hue is used, perhaps in different values and saturations and perhaps with small amounts of other colors as accents, the color combination is said to be **monochromatic**. Supperclub Roma (2.124) increases the sensuality of its dining experience by bathing diners in changing monochromatic color schemes. As they lounge on the intimate "Bed Baroque," and perhaps are even given massages by the waitresses, lighting creates all-blue, all-red, or other single-hue environments. All that one sees in these color-charged atmospheres are light to dark values of the same hue, with a halo of near-white light beneath the bed, giving it a floating appearance.

Values of one hue harmonize closely with each other, creating a surrealistically homogeneous effect that may encourage diners to relax from mental over-stimulation in their worldly lives.

Another kind of close harmony occurs when **analogous colors**—hues lying next to each other on the color wheel—are used. Blue and green are analogous colors, with minimal contrasts. Blues and greens predominate in El Greco's *View of Toledo* (**2.125**), interspersed with neutral blacks, whites, and browns. Even the whites are bluish, and the browns are tinged with green.

In contrast with the peaceful coexistence possible between closely related hues, hues that lie opposite

2.125 El Greco, *View of Toledo*, c. 1597. Oil on canvas, 3 ft $11\frac{3}{4}$ ins \times 3 ft $6\frac{3}{4}$ ins (1.21 \times 1.08 m). Metropolitan Museum of Art, New York. Bequest of Mrs. H. O. Havemeyer, 1929. The H. O. Havemeyer Collection.

El Greco was working at the time of the Counter-Reformation, a renewal of the Roman Catholic Church in response to the Protestant movement. Toledo, his adopted home, was a center of Catholic scholarship and mystical spirituality which deeply impressed him. The blue light falling dramatically from the heavens across the green Toledo hills may suggest the blue-green spiritual light often seen by visionaries, as if the entire landscape were bathed in a special spiritual atmosphere.

2.126 Philipp Malyavin, The Whirlwind, 1905. Draft. Oil on canvas, $29\frac{1}{2} \times 47\frac{1}{2}$ ins (75.3 \times 121 cm). Tretyakov Gallery, Moscow. Philipp Malyavin, the son of peasants, used the bright colors of Russian folk art to evoke associations with traditional myths, the everyday and the festive, on one huge canvas which won him the title of Academician.

each other on the color wheel have a jarring or at least exciting effect on the eye when they are juxtaposed. These high-contrast combinations are called complementary color schemes. In the Chinese statue of Guanyin (2.113), the juxtaposition of red and green, which are complementary to each other, creates a sensation of vibrant life. Redon gave his Orpheus (2.43) an enhanced atmosphere of mystical space by juxtaposing purple and yellow where mountains meet sky, creating a sense of vibration between them. Philipp Malyavin's *The Whirlwind* (2.126) depicts the vibrancy of the traditional Russian folk culture with its gaily windblown figures dressed in complementary redoranges and greens. If complementary hues are used next to each other at low saturation or pale values, as in the subtle green in the Banner of Las Navas de Tolosa (2.127), the hue contrast is less obvious but still provides a certain visual excitement.

Another stimulating combination is a **triad color scheme**, in which three colors equally spaced around the color wheel are used together. The yellow, blue, and red of the lovely Ottoman embroidered envelope (2.128)—a container for royal gifts, messages, and

documents—are far enough apart on the color wheel to provide vigorous contrast for each other, but not so far apart that their hues clash.

INTERACTION OF COLOR

The highly contrasting effects of complementary colors juxtaposed may be exactly what an artist desires. When highly saturated complementaries are used in the right amounts next to each other, the interaction between the color sensations in our brain may create some extraordinary optical phenomena. The complementaries may seem to enhance each other's brilliance, the edges between them seem to vibrate, and ghost colors may appear where they meet. Op Art, a movement of the 1960s, used these phenomena extensively in nonobjective, hard-edged, geometrical works that create fascinating illusions in our perceptual apparatus. In Op Artist Richard Anuszkiewicz's Splendor of Red (2.129), the juxtaposition of green and blue lines, and then blue lines alone, with a uniform red ground creates vivid optical illusions that transcend what has actually been painted. The red is the same throughout, but what we perceive is a diamond of very intense red

2.127 Banner of Las Navas de Tolosa, southern Spain, first half of the 13th century. Silk tapestry-weave with gilt parchment, 10 ft 9% ins \times 7 ft 2% ins (3.3 \times 2.2m). Museo de Telas Medievales, Monastery of Santa Maria la Real de Las Huelgas, Burgos, Spain. Patrimonio Nacional.

2.128 Embroidered envelope, Ottoman, 16th century. Velvet with silk, gold and silver wire, $7\frac{1}{2} \times 16\frac{1}{8}$ ins (19 \times 41 cm). Topkapi Sarayi Museum, Istanbul.

2.129 Richard Anuszkiewicz, *Splendor of Red*, 1965. Acrylic on canvas, 6×6 ft (1.83 \times 1.83 m). Yale University Art Gallery, New Haven, Connecticut. Gift of Seymour H. Knox. *Richard Anuszkiewicz was a pupil of Josef Albers (see Figures 2.119 and 2.132) who shared with his famous teacher a strong interest in color perception and became a leader in the Op Art movement.*

popping forward from a less brilliant red diamond against an even less brilliant red. That blue halo around the center diamond occurs solely in our perceptions; it has not been physically painted.

No one can yet state with certainty how these effects happen. Scientists have long tried to determine how we see colors, but only theories are yet available. Color perception seems to involve the one hundred million rods and six and a half million cones in the retina at the back of the eye. The rods and cones are specialized photoreceptive cells that glean information from light striking the retina and pass it along to the brain through a series of nerve fibers. In the brain, almost a third of the gray matter of the cerebral cortex is devoted to integrating the information from the two eyes.

We do not know quite how the brain perceives colors; we do not even know what triggers the information about different hues in the cones. There are light-sensitive pigments in the cones, but we are not certain how they respond to different wavelengths, which correspond to different hues. One of the current theories is that there are three kinds of pigments in the cones: one senses the long wavelengths (reds), one the middle-range wavelengths (greens), and one the short wavelengths (blue-violets). All other colors perceived are mixtures of these primaries in light mixing.

Be this as it may (for there are many other theories), it seems clear that color perception operates by comparison of one colored area with another. For this reason, it is easily "fooled." Consider a simple case of contrast in value. If a medium gray value is seen next to a darker area, it appears light; if the same medium gray is seen against a lighter field, it appears dark. In Figure **2.130**, the central line is actually the same value

2.130 Optical illusion from value contrast.

throughout, but the eye-brain mechanism does not see it that way.

Color perception is not like a camera; it is not a simple registering of information from the outside world. If you were shown a green light in a dark room, you would be able to identify it as green by comparison with the surrounding blackness. But if that same green light were then presented amidst many other green lights, it would be very difficult to select which one had been shown to you first, for there would not be sufficient contrast to judge by.

In addition to effects of contrast, certain optical effects seem to happen when the photoreceptors are fatigued. If we look at one bright hue for a while—overstimulating those photoreceptors—and then look away, we will "see" its complementary hue briefly in an illusion of the same shape. Goethe, who in addition to being a great writer was also a major color theorist, proposed that this illusion arises from an inborn desire for wholeness:

When the eye sees a color it is immediately excited, and it is its nature, spontaneously and of necessity, at once to produce another, which with the original color comprehends the whole chromatic scale. A single color excites, by a specific sensation, the tendency to universality.²²

Whether the explanations are psychological or physiological, the unusual effects known to occur when colors are juxtaposed have led to some interesting artistic experiments. For instance, some artists and color theorists have tried to mix colors optically rather than physically. To "see" colors mixed in Chuck Close's unique *Self-Portrait* (2.131), you must look at it from a great distance. Eugène Delacroix, although using dramatic Romanticist subject-matter and style, was a careful observer of color effects in nature. He thus found that, optically, colors are not solid but fragmented into various hues. In what we quickly perceive as an overall area of red, for instance, there might be small areas that actually look blue or yellow. Applying

2.131 Chuck Close, Self-Portrait, 2000. Screen print, 59×47 ins (149.5 \times 120.5 cm). Museum of Modern Art (MOMA), New York. Gift of Agnes Gund, Jo Carole and Ronald S Lauder. Ronald S Lauder, Donald L Bryant – Leon Black, Michael and Judy Ovitz, Anne Marie and Robert F Shapiro, Leila and Merille Strauss, Doris and Donald Fisher and purchase 215.2000.

ARTISTS ON ART

Josef Albers on Seeing Colors

JOSEF ALBERS (1888–1976) is widely considered the greatest twentieth-century teacher of the use of color in art, as well as being a great colorist himself. Albers created a great number of paintings called *Homage to the Square* (Figures 2.119 and **2.132**). In them he held the composition constant—nesting squares of certain proportions—but altered the color relationship in such a way that each painting has a unique optical effect.

The exercises Albers created for his students at Yale University forced them to recognize the startling optical changes that can be wrought by color interactions. Albers did not begin by teaching the optics of color perception or theories of formal relationships between colors. He began by forcing his students to look carefully at colors, to pay attention to what they were actually seeing rather than what they thought they were seeing. He said:

"In visual perception a color is almost never seen as it really is—as it physically is. This fact makes color the most relative medium in art.

"In order to use color effectively it is necessary to recognize that color deceives continually. The aim of such study is to develop—through experience—by trial and error—an eye for color."

"If one says 'Red' (the name of a color) and there are fifty people listening, it can be expected that there will be fifty reds in their minds. And one can be sure that all these reds will be very different. Even when a certain color is specified which all listeners have seen innumerable times—such as the red of the Coca-

2.132 Joseph Albers, *Equivocal*. Silk-screened print, 11 \times 11 ins (27.9 \times 27.9 cm). From *Homage to the Square: Ten Works by Joseph Albers*. © 1962 Ives Sillman, New Haven, Connecticut. Collection of Margaret Hoener.

Look fixedly at this painting for some time to "see" interesting optical changes along the edges where colors meet.

Cola signs which is the same red all over the country—they will still think of many different reds.

"Even if all the listeners have hundreds of reds in front of them from which to choose the Coca-Cola red, they will again select quite different colors. And no one can be sure that he has found the precise red shade.

"And even if that round red Coca-Cola sign with the white name in the middle is actually shown so that everyone focuses on the same red, each will receive the same projection on his retina, but no one can be sure whether each has the same perception."

"We are able to hear a single tone. But we almost never (that is, without special devices) see a single color unconnected and unrelated to other colors. Colors present themselves in continuous flux, constantly related to changing neighbors and changing conditions."²³

2.134 Georges Seurat, *Seated Model*, 1887. Oil on board, $9\frac{1}{2} \times 6$ ins (24 \times 15.2 cm). Louvre, Paris.

this observation to his canvases, he used **broken col- ors** for areas such as the skin of the horse on the left
and the garments of the horseman on the right in his *Combat of the Giaour and Hassan* (**2.133**), increasing the
dynamism of the color effects.

The Post-Impressionist painter Georges Seurat studied the science of color perception in depth and created a technique called **pointillism**. Using dots of primary and secondary colors in close juxtaposition, he coaxed the eye to mix other colors from them, as in his *Seated Model* (2.134). Seen from a distance, the dots tend to blend into colors other than those of the dots, such as flesh tones and their shadows. The effect suggests scintillating lights, rather than flat pigments.

Color interaction effects depend on the willingness of the viewer to perceive them. You are more likely to see them if you know to look for them or if you simply relax and allow your immediate experiences to register rather than using your brain to override your sensory experiences. Some color interactions happen very quickly and are compellingly "real"; others are more subtle and take time to develop.

LIMITED AND OPEN PALETTE

We leave the complex subject of color with a final measure of ways that artists use color: the range of colors used in a single work of art. An artist who works with an **open palette** draws from the complete range of colors, as Frank Stella does in *Hacilar aceramic la* (2.135). His color choices seem completely unrestrained, in a composition slightly unified by repetition of shapes and lines. At the other extreme is the very **limited palette** used by Picasso in his *A Woman in White* (2.136). The hues Picasso uses are primarily reds and blues, in values so light that they approach white.

In general, there is an obvious difference in emotional impact between the two approaches. A more open palette tends to be busy and exciting, especially when colors are used at full saturation. A more limited palette creates a far more subdued, tranquil emotional

atmosphere, which Picasso used when it suited his expressive purposes. During the same period when he painted the pensive representational *Woman in White*, he also used an open palette for his busier Cubist abstractions.

2.135 Frank Stella, Hacilar aceramic Ia, 2001. Epoxy and spray paint on cast aluminum 31 \times 31 \times 10 ins (78.7 \times 78.7 \times 25.4 cm). Richard Gray Gallery, Chicago and New York.

Frank Stella refused to credit his work with having any expressive content. Its bright hues called attention to the painted sculpture as an object, and that was that. He explained, "My painting is based on the fact that only what can be seen there is there. It really is an object ... you can see the whole idea without any confusion ... what you see is what you see." 14

2.136 Pablo Picasso, *A Woman in White*, 1923. Oil on canvas, $39 \times 30\frac{1}{2}$ ins $(99 \times 77.5 \text{ cm})$. Metropolitan Museum of Art, New York, Rogers Fund 1951; acquired from The Museum of Modern Art (MOMA), Lillie P. Bliss Collection.

Time

Thus far we have been exploring visual elements that exist in space: line, form and shape, texture, value and light, and color. But art exists in time as well as space, and time can be considered an element in itself. Ways in which artists work with time include actual movement, the illusion of movement, capturing a moment in time, and bringing attention to change through time.

ACTUAL MOVEMENT

Some three-dimensional works move through space in time themselves. They are often called **kinetic**

sculpture. Famous examples are the mobiles of Alexander Calder—constructions suspended by a system of wires so that their parts circle around the central point when pushed or moved by air currents. This aspect of the movement of a mobile such as *Lobster Trap and Fish Tail* (2.137) is partly predictable, but the ways in which the individually suspended parts turn around each other and on their own axes are unpredictable. Spatial relationships among the shapes will change continually, as long as the mobile is in motion.

Contemporary kinetic sculpture may be computeranimated at a high level of technical perfection. But perhaps because we have become so accustomed to the sophistication of computer-driven devices, we may

2.137 Alexander Calder, *Lobster Trap and Fish Tail*, 1939. Hanging mobile, painted steel wire and sheet aluminum, about 8 ft 6 ins high \times 9 ft 6 ins diameter (2.6 \times 2.9 m). Museum of Modern Art (MOMA), New York. Commissioned by the Advisory Committee for the stairwell of the Museum. 590.1939.a–d.

Alexander Calder was fascinated by the rotations of the planets around a point and created his mobiles accordingly. He said, "I went to movement for its contrapuntal value." ²⁵

2.138 Jean Tinguely, *Meta-Matic No. 9*, 1959. Motorized kinetic sculpture, height 35½ ins (90.1 cm). Museum of Fine Arts, Houston, Texas. Purchased from funds by Dominique and John de Mevil. *Jean Tinguely created humorous animated machines out of junk parts, including his "Meta-Matic" series, which pretended to draw "Abstract Expressionist" paintings.*

find the bizarre revealed mechanics of Jean Tinguely's *Meta-Matic No. 9* (**2.138**) all the more whimsically appealing. The motor-driven arms of Tinguely's absurd machine clamor like a kitchen appliance as they create a series of scribbles on a small picture ground with colored pens. The product of this playful rattling busyness is a random drawing whose expressionistic quality is reflected in the form of the machine itself.

Change through time is a normal feature of our lives, and some artists explore this feature intentionally in their work. With reference to his *Sublimate (Cloud Cover)* (2.139), Ron Lambert explains:

There are instances when the environment reminds us of our lives, such as the point at the beginning of a rainstorm when you're not sure if you feel the water yet, and even more dramatically in extreme weather when our lives are threatened. In *Sublimate* (*Cloud Cover*) I intend to expose this feeling. I made a rain cloud out of humidifiers, aluminum, and clear vinyl. The mist from the humidifiers condenses against the inside of the vinyl and collects at the bottom where it drips out of small holes, filling a container that resembles a stylized puddle.

2.139 Ron Lambert, Sublimate (Cloud Cover), 2004. Water, vinyl, humidifiers, steel, aluminum, acrylic, size varies. Artist's collection.

Despite the highly constructed appearance of the cloud, the rain-like dripping and the resulting accumulation of water is real, and provide the possibility for the same connection between the physical world and our psyche. By extracting the cloud from its original context and placing it in a gallery, the audience is asked to suspend their automated response and experience a different pace. Art takes time to explore, and even more time to relate with. In my work I aim to exploit the viewer's attention by providing situations which will change while they are being viewed.

As water condenses on the vinyl covering, patterned droplets form. Once enough pressure is formed, the water drips down the inside, erasing the condensed water in its path like a brush

running down paper. Eventually the drop is released from the cloud and at impact the pooled water underneath forms concentric rings which ricochet off the walls of the catch. Action holds our attention, builds up suspension.²⁶

Where water is plentiful, as it is in Rome, it is sometimes used with great abandon to create art that moves and changes through time. An entire river was diverted to feed the Water Organ of the Villa d'Este (2.140), a dynamic environmental sculpture in which water is the medium. The intriguing effects of water in a fountain are organic and serendipitous, as pumps shoot jets into the air and then gravity draws the water back to earth, with wind tossing the spray. As the water falls onto rocks, it is churned and scattered, continuously changing in form.

2.140 Water Organ, Villa d'Este, Tivoli, near Rome, c. 1550.

ILLUSION OF MOVEMENT

In two-dimensional works, and static sculpture, movement cannot happen in real time. It can only be suggested. How to do so was an intellectual and artistic challenge to the French artist Marcel Duchamp. He chose the device of showing a single figure in a

sequence of motions, rather like stop-action photographs, for his famous and controversial *Nude Descending a Staircase* (2.141). Some scientists today feel that this is actually the way time moves: by little jerks, a series of barely different frames, rather than a continuously changing flow. So far we have no way of

2.141 Marcel
Duchamp, *Nude*Descending a Staircase
2, 1912. Oil on
canvas, 58 × 35 ins
(147 × 89 cm).
Philadelphia Museum
of Art. Louise and
Walter Arensberg
Collection.

ARTISTS ON ART

Auguste Rodin on The Illusion of Movement

THE SCULPTOR AUGUSTE RODIN (1840-1917) worked intently with naturally moving living models, creating vigorously realistic sculpture that flew in the face of prevailing French academic traditions. His marvelous Monument to Balzac (2.142), though commissioned by the Society of Men of Letters, was rejected by the Society because it did not coincide with their ideas of what a portrait should look like. Yet his genius in coaxing apparent life into cast metal and sculpted marble is now highly celebrated. The following are excerpts from conversations with his friend Paul Gsell, on the illusion of movement in sculpture:

"I have always sought to give some indication of movement. I have very rarely represented complete repose. I have always endeavored to express the inner feelings by the mobility of the muscles.

"Art cannot exist without life. If a sculptor wishes to interpret joy, sorrow, any passion whatsoever, he will not be able to move us unless he first knows how to make the beings live which he evokes. For how could the joy or the sorrow of an inert object—of a block of stone—affect us? Now, the illusion of life is obtained in our art by good modeling and by movement. These two qualities are like the blood and the breath of all good work."

"Note, first, that movement is the transition from one attitude to another ... You remember how in Dante's Inferno a serpent, coiling itself about

the body of one of the damned, changes into man as the man becomes reptile. The great poet describes this scene so ingeniously that in each of these two beings one follows the struggle between two natures which progressively invade and supplant each other.

"It is, in short, a metamorphosis of this kind that the painter or the sculptor effects in giving movement to his personages. He represents the transition from one pose to another—he indicates how insensibly the first glides into the second. In his work we still see a part of what was and we discover a part of what is to be.

"The sculptor compels, so to speak, the spectator to follow the development of an act in an individual Have you ever attentively examined instantaneous photographs of walking figures? What did you notice? If, in instantaneous photographs, the figures, though taken while moving, seem suddenly fixed in mid-air, it is because, all parts of the body being reproduced exactly at the same twentieth or fortieth of a second, there is no progressive development of movement as there is in art.

"It is the artist who is truthful and it is photography which lies, for in reality time does not stop, and if the artist succeeds in producing the impression of a movement which takes several moments for accomplishment, his work is certainly much less conventional than the scientific image, where time is abruptly suspended."

"Note besides that painters and sculptors, when they unite different phases of an action in the same figure, do not act from reason or from artifice. They are naively expressing what they feel. Their minds and their hands are as if drawn in the direction of the movement, and they translate the development by instinct. Here, as everywhere in the domain of art, sincerity is the only rule."

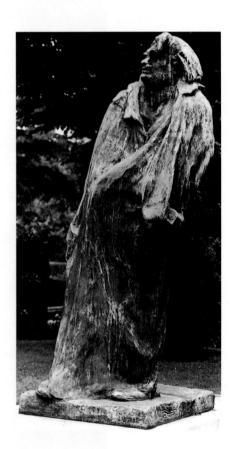

2.142 Auguste Rodin, *Monument to Balzac*, 1897. Bronze, 8 ft $10\frac{1}{4}$ ins \times 3 ft $11\frac{1}{2}$ ins \times 4 ft $2\frac{1}{2}$ ins (2.7 \times 1.2 \times 1.3 m). Musée Rodin, Paris.

2.144 Henri de Toulouse-Lautrec, *Equestrienne (At the Circus Fernando)*, 1887–88. Oil on canvas, 3 ft 3% ins \times 5 ft 3% ins $(1 \times 1.61$ m). Art Institute of Chicago, Chicago, Illinois. Joseph Winterbotham Collection, 1925, 523.

knowing which model of time is true. But when Duchamp painted *Nude Descending*, the European artists who called themselves "Futurists" were insisting that modern art should reflect modern life, which is fast, fragmented, and in constant change. In their *Futurist Manifesto* of 1910, they asserted:

The gesture which we would reproduce on canvas shall no longer be a fixed *moment* in universal dynamism. It shall simply be the *dynamic sensation* itself. Indeed, all things move, all things run, all things are rapidly changing. A profile is never motionless before our eyes, but it constantly appears and disappears. On account of the persistency of an image upon the retina, moving objects constantly multiply themselves; their form changes like rapid vibrations, in their mad career. Thus a running horse has not four legs, but twenty, and their movements are triangular.²⁸

THE CAPTURED MOMENT

Although it is difficult to represent the passage of time in a single two-dimensional image, some images clearly refer to motion by capturing a moment of it in time. In Fragonard's *The Swing* (2.143), we see a young woman being swung by an obliging but naive old cleric at the behest of her hidden admirer, whose lusty gaze she teasingly invites by kicking off her shoe toward him. The sensuous swirling of her clothes, the dynamic positions of her limbs, and the curve of the ropes create a great sense of continuing motion in a fleeting, erotic moment.

With the invention of photography, some artists began selecting and framing their views of life as if seen through the lens of a camera. As we saw in discussing point of view, Degas did so to bring us into the intimacy of the ballet theatre (2.61). Considerably influenced by Degas, Toulouse-Lautrec used a photographic cropped effect to create a sense of motion in his *Equestrienne (At the Circus Fernando)* (2.144). This is what we could see if we were in the ring to the ringmaster's right, watching the horse almost from behind as it galloped around. We could not see much above the dancer's head without raising our glance, so the top of a clown standing on a stool is out of our sight, as is the left side of the clown to the left. Toulouse-Lautrec makes it clear that we are following the horse visually

through time, of which only one moment is shown, and he gives the horse a large open area into which to move, increasing the impression of its movement.

CHANGE THROUGH TIME

All works of art themselves change through time. Usually they deteriorate gradually, some so slowly that the change is barely noticeable. But some are purposely fragile, so that witnessing their decay is part of the art experience itself.

On the other hand, growth is also an essential aspect of life. Andy Goldsworthy has used the slow growth of dwarf trees to create a visual metaphor for human tenacity as well as human fragility. His *Garden of Stones* (2.145) was created for the Memorial Garden of the Museum of Jewish Heritage as a contemplative space, dedicated to the memory of those who survived as well as those who died in the Holocaust. Goldsworthy searched for eighteen large boulders, each of a different character, and carved out a small hollow in each one with a flame torch. In each of the boulders, he planted a dwarf oak tree whose trunk will

slowly grow and fuse with the stone. He says, "Amidst the mass of stone the trees will appear as fragile, vulnerable flickers of life—an expression of hope for the future." Museum officials elaborate:

Garden of Stones reflects the inherent tension between the ephemeral and the timeless, between young and old, and between the unyielding and the pliable. More importantly, it demonstrates how elements of nature can survive in seemingly impossible places. In Jewish tradition, stones are often placed on graves as a sign of remembrance. Here, Goldsworthy brings stone and trees together as a representation of life cycles intertwined. As a living memorial, the garden is a tribute to the hardship, struggle, tenacy, and survival experienced by those who endured the Holocaust. ... The effect of time on humans and nature, a key factor in Goldsworthy's work, is richly present in Garden of Stones, as the sculpture will be viewed, as well as cared for, by future generations.29

2.145 Andy Goldsworthy, *The Garden of Stones*, Harbor view, The Museum of Jewish Heritage, New York, September 16, 2003. Collection of the Museum of the Jewish Heritage—A Living Memorial to the Holocaust, New York.

Organizing Principles of Design

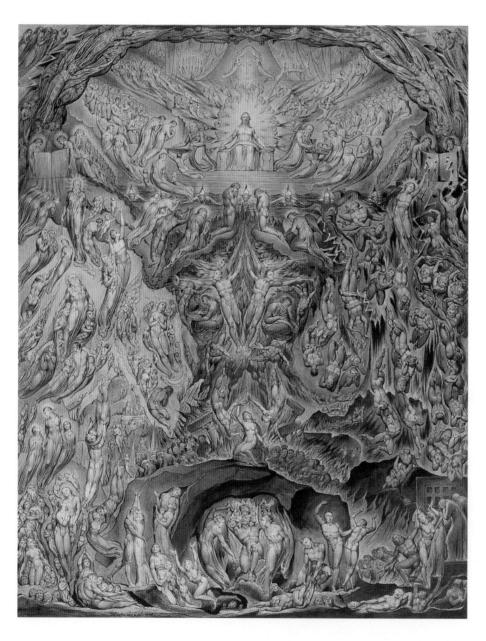

KEY CONCEPTS

Unification of art through repetition

Using visual elements to create rhythm

Using composition to unify the work of art

Organizing a composition through emphasis

Emphasis through economy and proportion

Using the environment to complete the image

3.1 William Blake, The Last Judgment, 1808. Tempera, $19\% \times 15\%$ ins (50.3 \times 40 cm). Petworth House, Sussex, England.

ONE OF THE most dramatic subjects in Christian art is the Last Judgment, in which the dead are resurrected and Jesus, as the agent of God's judgment, determines who is to ascend to heaven and who is to be sent to hell. William Blake's nineteenth-century interpretation (3.1) is highly personal and visionary, but it is nonetheless dramatized and unified by his use of traditional principles of design to organize the many figures.

The central shape in this complex scene is like a chalice, with a radiant enthroned Jesus at its focal point. The contours of this chalice are defined by slight darkening of some of the human figures who are ascending to the

heavenly throne on the left or descending to the flames of hell on the right. The contrast is subtle, but yet it gives structure to this complicated composition. In addition, the figures of the people are drawn in rhythmically similar fashion, with elongated, flowing outlines, and blissful groups on the left are balanced by agonized groups on the right.

As Blake has so skillfully done, artists often try to choose and arrange the visual elements that we examined in Chapter 2 in such a way that there are relationships among them with a certain coherence, or **unity**. If the elements work well in relationship to each other, they create a whole that is greater than the sum of the parts. In trying to determine what holds an effective work together, theorists have distinguished a number of principles that seem to be involved. They include repetition, variety or contrast, rhythm, balance, compositional unity, emphasis, economy, and proportion. Another subtle principle that artists use is the relationship of a work to its environment.

Not all of these principles are emphasized in a single work. And certain artists use them more intuitively

than intellectually, using nonlinear thinking while sketching, planning, and manipulating design elements—until everything feels right. Nevertheless, the principles give us a basis for understanding how art works aesthetically. Often these formal considerations help to express the content of the work and can best be understood when the content as well as the form is taken into account.

Repetition

One of the basic ways that artists have unified their designs is to repeat a single design element, be it a kind of line, shape, form, texture, value, or color. As the viewer's eye travels from one part to another, it sees the similarities, and the brain, preferring order to chaos, readily groups them as like objects. Having learned something about quilt designs from her female relatives, Lucy T. Pettway of Alabama was basically a naive artist who drew on her natural design skills to piece together the quilt she called *Birds in the Air* (3.2). The

3.2 Lucy T. Pettway, *Birds in the Air*, 1981. Cotton and cotton/polyester blend quilt, 79×79 ins $(2 \times 2 \text{ m})$. Collection of the Tinwood Alliance.

3.3 Magdalena Abakanowicz, *Agora* (model), 2005. Cast iron, One hundred figures, each approximately 9 ft tall. Work to be installed in Grant Park, Chicago, 2006.

theme running through the work is repetition of triangles, but of varied sizes, orientations, and colors that form a complex and yet orderly whole.

In three-dimensional work, repetition of a single design element can have a powerful effect. *Agora* (3.3), by Polish sculptor Magdalena Abakanowicz, may have a disturbing emotional impact on viewers, not only because of the headless, limbless quality of the scarred, sinewy figures, but also because they are so tall—9 feet (2.7 m)—and so many (one hundred), all walking seemingly pointlessly toward unknown destinations. The title, *Agora*, is Greek for a town meeting place. The installation is in Chicago. Abakanowicz inscrutably remarks that it "will have to compete with the tension of this extraordinary city in order to be understood." The artist has deleted the heads and arms so that the bodies, "liberated from the face, [are] free to demonstrate, to express things not seen before." What can be

inferred from the postures, the strides, the multiplicity of figures? Abakanowicz, who lived through the violent occupation and war-ravaging of Poland in her childhood, has made of them a herd whose interpretation is left to the viewer.

The repeated figures in Abakanowicz's *Agora* seem to stand alone, despite their similarity. By contrast, in José Clemente Orozco's *Zapatistas* (**3.4**) the similar figures in the peasant army merge into a unified whole. As shown in the diagram (**3.5**), our eye picks out the diagonals of the standing figures and their hats as beats in a single flowing movement to the left, with bayonets as counterthrusts pointing to the drum-like repeated beats of the large hats above. We can see that even if one revolutionary falls, the mass of the others still moves inexorably forward.

Many paintings use repetitions of some design quality to unify complex compositions. If you page through

3.4 José Clemente Orozco, *Zapatistas*, 1931. Oil on canvas, 45 \times 55 ins (114.3 \times 139.7 cm). Museum of Modern Art (MOMA), New York. Given anonymously. 1937.

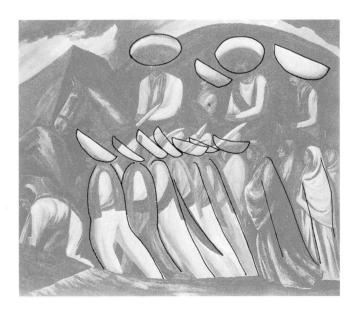

3.5 Repeated figures in *Zapatistas*.

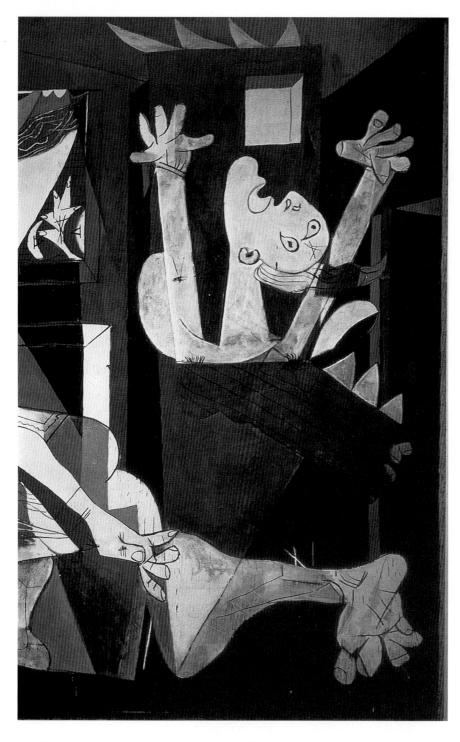

3.6 Pablo Picasso, *Guernica* (detail), 1937. Oil on canvas, 11 ft $5\frac{1}{2}$ ins \times 25 ft $5\frac{1}{4}$ ins (3.49 \times 7.75 m). Reina Sofia Museum of Modern Art. Madrid.

3.7 (opposite) Lance Wyman, logo for XIX Olympiad, 1966. Courtesy of the International Olympic Committee.

the illustrations in this book, you will find numerous examples—some of which are obvious, some quite subtle. Jackson Pollock's drip paintings (1.43) have no unifying element except for the repetition of freely gestured lines of dripped and flung paint, but these in themselves create an all-over compositional effect. Picasso's *Guernica* (1.50) is unified partly by the repetition of pointed shapes, such as flames and the fingers of the figure on the far right (detail shown in **3.6**). Throughout the painting, sharp-pointed shapes appear again and again, not only for unity of design but also to create a sense of danger and one of fragmentation.

In purely decorative works, such as fabric and wall-paper designs, repetition of design elements is often used to build up an all-over **pattern**, a series of images that is repeated in an orderly way. To reflect Mexican design in his logo for the 1968 Olympiad in Mexico (3.7), designer Lance Wyman picked up the Mexican tradition of building up multiple lines to form a pattern. Each letter and number of "Mexico 68" is echoed again and again, forming an optically dynamic pattern. If you look at this compelling design for a while, the pattern seems to pulsate with a life of its own, and new color sensations begin to appear as your eyes try to perceive the repeated lines.

Variety

The companion of repetition is **variety**: change rather than sameness through space and time. Variety often takes the form of subtle variations on the same theme. The triangles in Pettway's *Birds in the Air* (3.2) vary in color and size, and each of Abakanowicz's headless figures is slightly different (3.3). Antoni Gaudí's uncompleted church of the *Sagrada Familia* in Barcelona (3.8) is a fantastic conglomeration of many

architectural styles. Yet it is held together visually by its spires, which vary in form but resemble each other in their tapering upward reach.

Another way in which variety is expressed is through **transitions**, or gradual changes from one state to another. For example, one color may gradually blend into another, a line may change in character, or a form may dissolve into unfilled space. Helen Frankenthaler's woodcut *Essence Mulberry* (3.9) presents a beautiful transition from mulberry to a gray that echoes the gray

3.8 Antoni Gaudí, Church of the Holy Family (Sagrada Familia), Barcelona, 1883–1926. Antoni Gaudí filled Barcelona with exuberant free-form architecture, including the Church of the Holy Family, which remained unfinished after his tragic accidental death.

3.9 Helen Frankenthaler, *Essence Mulberry*, 1977. Woodcut, edition of 46, $40 \times 18\frac{1}{2}$ ins (101.6 \times 46.9 cm).

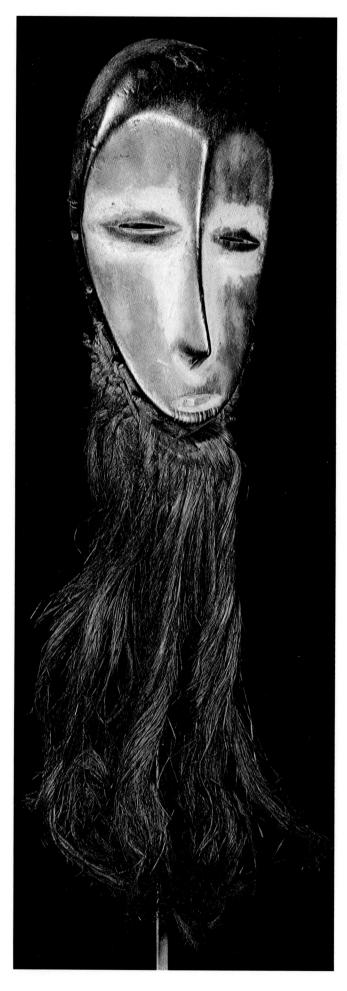

of the ground. She also works with variety in the form of **contrast**—an abrupt change. Here the gradual vertical color change of the upper portion is played against the sudden horizontal of gold on the bottom. Frankenthaler is also working with contrasts in scale and shape, between the hard-edged geometry of the large golden rectangle and the soft-edged amorphous shapes above.

Contrast is often used to enhance our appreciation of both things being compared. The gold and the mulberry hues are so different that each brings out the other's richness by contrast. In a Balega mask (3.10) the rough, random fibers of the beard accentuate the smooth, fast lines of the head. The church of Taivallahti in Helsinki (3.11), excavated from rock as an underground space, calls us to appreciate both the organic roughness of the stone and the elegant refinement of the organ pipes, the earthiness of the walls and the light of the sky brought in beneath the great copper dome. Through a continuing series of contrasts, the stone church wakes up our perceptions and sharpens our awareness of each visual sensation.

Although it might seem logical that highly contrasting passages in a work would disorganize it, detracting from its unity, often the opposite is true. The roughness of the Balega mask beard keeps referring us to the smoothness of the face, tying the two together visually like an egg in a nest. In any work that makes us look from one passage to another and back, it is that act of comparing on the part of the viewer that is the unifying factor. Even if parts seem diametrically opposed to each other, they can be unified in the viewer's mind as two ends of the same continuum. Opposites have a certain unity, complementing each other like black and white, night and day, masculine and feminine.

Artists may also use contrast to create a certain visual tension that adds excitement to a work. There is a fine point up to which things can fight with or pull away from each other as far as they possibly can but still without destroying the unity of the composition. Tintoretto seems to have found this point in his *Leda and the Swan* (3.12). As diagrammed in Figure 3.13, Leda and the observer form strong arcs actively pulling

3.10 Balega mask, Africa. Wood with pigment and fiber, height 8 ins (20.3 cm). Private collection.

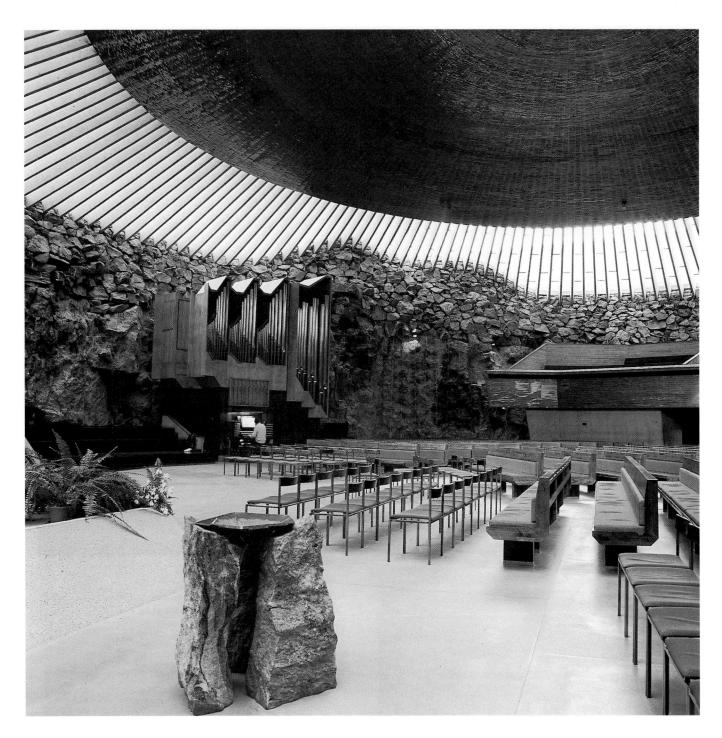

3.11 Timo and Tuomo Suomalainen, interior of Taivallahti church, Helsinki.

away from each other and twisting through space, accentuating Leda's movement toward her lover, Zeus, who has appeared in the form of a swan. Tintoretto worked out his compositions by posing small wax figures in boxes, as if on a stage. He then translated the three-dimensional scene to two dimensions by drawing the figures on a grid placed across the stage and then enlarging them from this grid to the scale of the painting. Not only has he depicted the figures pulling

away from each other; each of the bodies is also twisted in a flowing serpentine movement called serpentinata in Italian, an exaggeration of the figure-posing used in High Renaissance art. First developed by Classical Greek sculptors, the technique involves twisting areas of the body in counterpoised opposition to each other. The twisting movement adds to the dramatic effect. Tintoretto was one of the so-called Mannerist painters, who exaggerated gestures for their theatrical impact.

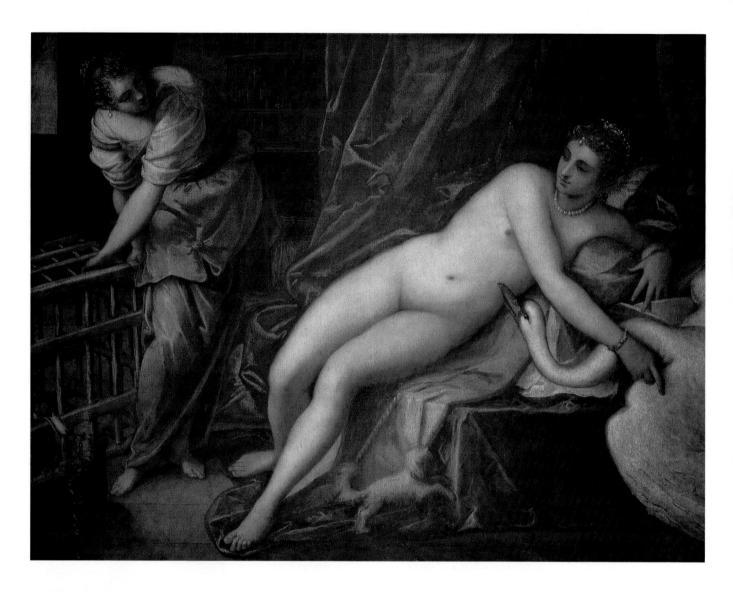

3.12 Jacopo Tintoretto, *Leda and the Swan*, c. 1570–75. Oil on canvas, 5 ft $3\frac{3}{4}$ ins \times 7 ft $1\frac{3}{4}$ ins (1.62 \times 2.18 m). Galleria degli Uffizi, Florence.

3.13 Compositional arcs in Leda and the Swan.

Rhythm

A third organizing principle found in many works is rhythm. Repetition and variety in design elements create patterns that are analogous to rhythms in music, from the predictable drumbeats of a marching band to the swirling rhythms of romantic symphonies to the offbeat intricacies of jazz timing. The same element—such as a line, form, or color—may be repeated visually through space, or groupings may be repeated so that the eye picks out recurring patterns, such as small-large-medium, small-large-medium. Such patterns, which may be easily perceived or complex and subtle, create repeated visual accents with spaces between them, like upbeats and downbeats, or waves and troughs.

Rhythm in a work satisfies the desire for order, for it brings a familiar sense of the pulsing of life. In the Last Supper altarpiece by the medieval artist Ugolino di Nerio (3.14), the rhythm formed by the repetition of the circles of the haloed heads of the disciples is as

regular as heartbeats. This easily perceived regularity is broken by the wider space separating Christ from the others, the grieving position of John the beloved, and the absence of a halo around the head of Judas. These dramatic elements are like crossbeats to the rhythms of the rest of the painting, another being produced by the alternating placement of reds.

Rhythms may flow continuously through time, without the measured pauses seen in Ugolino's Last Supper. In the Thonet rocking chair examined in the last chapter (2.17), the lines flow rhythmically through long curves, never stopping fully except at the delicate ends of the "tendrils." For the most part, the only changes we "hear" in the visual music of the chair are shifts in volume and speed, with slight crescendos through the center of the curves and slowing decrescendos as the lines change direction.

Painter Emily Carr sought to express the underlying unity she experienced in nature, and she felt it as a "unity of movement." Citing van Gogh's paintings (1.41) as an inspiration in her discovery of this rhythmic unity, Carr explained:

3.14 Ugolino di Nerio, Last Supper, c. 1322. Tempera and gold on wood, $13\frac{1}{2} \times 20\frac{1}{4}$ ins (34.3×51.4 cm). Metropolitan Museum of Art, New York. Robert Lehmann Collection, 1975. In Ugolino di Nerio's Last Supper, the break in the rhythm of the haloes makes it clear which disciple is Judas, the betrayer: the figure in the front row closest to Jesus.

3.15 Emily Carr, *British Columbia Landscape*, c. 1934. Oil on wove paper, mounted on cardboard, $35\frac{1}{4} \times 23\frac{1}{4}$ ins (90.2 × 60 cm). National Gallery of Canada. Gift of Douglas M. Duncan Collection.

I felt it in the woods but did not quite realize what I was feeling. Now it seems to me the first thing to seize on in your layout is the direction of your main movement, the sweep of the whole thing as a unit. One must be very careful about the transition of one curve of direction into the next, vary the length of the wave of space but keep it going, a pathway for the eye and the mind to travel through and into the thought. For long I have been trying to get these movements of the parts. Now I see there is only one movement. It sways and ripples. It may be slow or fast but it is only one movement sweeping out into space but always keeping going—rocks, sea, sky, one continuous movement.²

You can easily discern the rhythmic parts in Carr's *British Columbia Landscape* (3.15), but can you see this overall unity of movement to which she refers?

In freely stroked works, each line reflects the rhythm of the breath and movements of the artist. The Levha calligraphy by Sami Efendi (2.2) is created with single brush movements, precisely controlled for a free-flowing effect. The calligrapher cannot lift pen or brush before completing a stroke, for its subtly varying width depends on the movement and angle of the writing implement. Traditional Chinese and Japanese painters were trained to use the whole arm to create brushstrokes.

3.16 Sol LeWitt, *Wall Drawing #1131, "Whirls and Twirls",* 2004. Acrylic paint on wall, approx. 18 \times 115 ft (5.49 \times 35 m). Wadsworth Atheneum Museum of Art, Hartford, Connecticut.

3.18 (opposite) Chest for clothes and jewelry of the Haida people of Queen Charlotte Island, off the northwest coast of North America, 19th century. Wood inlaid with shells and animal tusks. British Museum, London.

They practiced brush movements for years to develop the control and flexibility needed to create free-flowing lines that were also even and continuous. The wrist was used only in drawing very delicate lines.

The rhythm of certain works is like orchestral music, a complex interweaving of voices into a coherent progression in time. Sol LeWitt's Wall Drawing # 1131, Whirls and Twirls (3.16) uses repetition of similar shapes in swirling linear patterns, but of broken colors that get picked up again and again, in different places, like the voices of many instruments in a symphony, with one section after another repeating the same themes. They blend into a continuously flowing rhythmic composition.

Balance

A fourth design principle is **balance**—the distribution of apparent visual weights so that they seem to offset one another. We subconsciously assign visual weight to parts of a work, and we tend to want the parts to be distributed through the work in such a way that they

3.17 Symmetrical horizontal balance.

seem to balance each other. The sense of forms held in balance against the pull of gravity is psychologically pleasing; imbalances may give us an unsettled feeling, a reaction that is not usually the artist's desired effect.

The balancing of visual weights, read horizontally across a piece, is like a seesaw. As diagrammed in Figure 3.17, this kind of balancing of equal forces around a central point or axis is called symmetrical or formal balance. An example of absolutely symmetrical balance is the chest from the Haida culture of Queen Charlotte Island off the northwest North American coast (3.18). If an imaginary vertical axis were drawn right through the center of the piece, the two halves of the central figure and the geometric animal motifs extending to the sides would be exact mirror images balancing each other. If a horizontal line were drawn through the

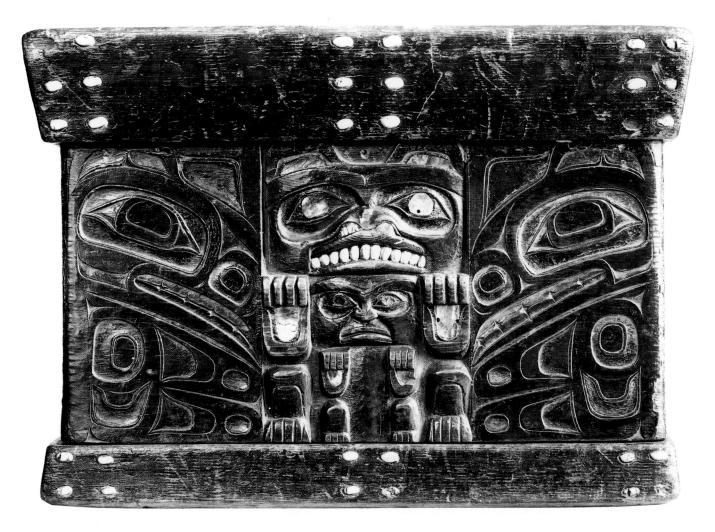

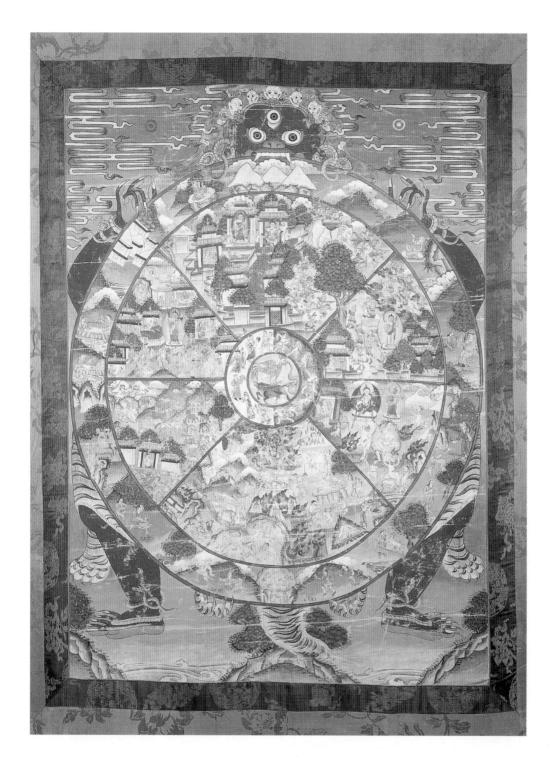

3.19 Tibetan thangka, *The Wheel of Life*, 20th century. Tempera. Trustees of Victoria and Albert Museum, London. *In Tibetan Buddhism, radially balanced thangka paintings are created as aids to mental concentration and inner illumination.*

center of the piece from left to right, the upper and lower halves would also consist of symmetrically balanced, though not identical, visual components.

Symmetrical balance can occur even if images on each side of the vertical axis are not exactly the same. In Rodin's *Gates of Hell* (2.22), the symmetry of the panel frames gives it an underlying architectural structure, with a figure called "The Thinker" brooding in the middle of the vertical axis and "The Three Shades" arranged symmetrically to either side of the axis above him. The other writhing figures are not symmetrically balanced, yet the overall impression is one of symmetry.

Compare this with William Blake's dramatic painting of *The Last Judgment* (3.1). The fact that the right side of the painting is darker than the left—making it seem visually heavier—would unbalance the work. However, it is balanced by the symmetrical circular motion of the figures, as if radiating outward from the point between the two central beings blowing horns, and by the strong vertical axis created by the patterns of the figures rising through the center. The continuing movement of the figures reflects Blake's view that our fortunes are ever-shifting and that those who have sinned are not eternally damned.

3.20 Asymmetrical horizontal balance.

Elements may also be symmetrically arranged around a central point in all directions, in which case the composition may be referred to as **radial balance**. In the Buddhist *Wheel of Life* (3.19), each circle represents a different aspect of existence, with the whole wheel surrounded by the monster of death and impermanence. Note that even his parts are symmetrically arrayed around the center.

When the weights of dissimilar areas counterbalance each other, the result is called **asymmetrical** or informal **balance**. Expressed as a simple diagram (3.20), a large, light-colored area might be balanced by a small, dark-colored area, with the fulcrum off-center. Dark colors generally seem heavier than light ones, busily detailed areas heavier than unfilled ones, bright colors heavier than dull ones, large shapes heavier than small shapes, and objects far from the center heavier than those near the center.

Consider Thomas Gainsborough's Mr. and Mrs. Andrews (3.21). The painting is obviously asymmetrical, for both important figures are on the left side, with nothing but their lands to the right. The balancing point is established by the vertical thrust of the tree, well to the left of center. The pair carry considerable visual weight because they are visually interesting and detailed human figures, because they are looking at us and holding our attention, because they and the tree trunk are the largest and closest objects in the composition, and because their clothes are the brightest colors in the painting. The breadth of the fields to the right is not a wasted area in the composition, for Gainsborough needed a great expanse of less detailed space to balance his strong figures. Note that the fields recede into deep space. To a certain extent, Gainsborough is setting up a balance that extends into—as well as across—the picture plane. And those fields serve a purpose in the content as well as the form of the painting: they demonstrate the wealth of this couple, whose lands seem to stretch as far as the eye can see.

Sometimes artists violate the principle of balance intentionally to create tension in their works. Nancy Graves's *Trace* (3.22) is not visually "safe"; it appears to be extremely fragmented and precariously balanced, about to fall over in the direction in which the three

3.21 Thomas Gainsborough, Mr. and Mrs. Andrews, c. 1749. Oil on canvas, $27\frac{1}{2} \times 47$ ins (69.8 \times 119.4 cm). National Gallery, London.

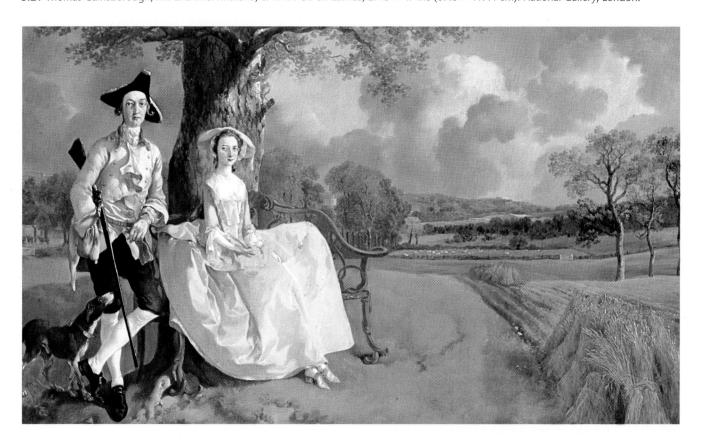

3.22 Nancy Graves, *Trace*, 1979–80. Bronze, steel, patina, and paint, 8ft 11 ins \times 9ft 8 ins \times 4 ft 2 ins (2.71 \times 2.92 \times 1.27 m). Collection of Mr. and Mrs. Graham Gund, Boston, Massachusetts. *Nancy Graves's three-dimensional abstractions in painted bronze seem visually so light in weight that their off-balance compositions appear plausible.*

slender "legs" are bent. Its three-point anchor in a heavy base actually makes the piece quite stable, but visually it seems to be dynamic and fragile. Contemporary aesthetics and materials allow an artist to push balance to limits never seen before.

Compositional Unity

Artists can also hold compositions together by creating strong attachments between elements within the work. They may physically touch each other, like the cut-out shapes forming Matisse's abstract *Snail* collage (2.38). They may be held together by the energy of opposition, like the magnetism of opposing arcs in Tintoretto's *Leda and the Swan* (3.12). Or the artist may have arranged the lines of the work—both actual and implied—in such a way that they lead the viewer's eye from one area to another, visually tying the work together.

A common formula for unifying compositional lines is the implied triangle. Standing on its base, a triangle is a highly stable shape. Christian sacred art has often used the solidity of a double triangle pattern, with a strong primary triangle counterbalanced and filled out by a weaker inverted secondary triangle, as in

Figure **3.23**. The central panel of Perugino's *The Crucifixion with Saints* altarpiece (**3.24**) illustrates a complex series of these compositional triangles. As shown in Figure **3.25**, the major triangle is crowned by the head of Christ and bounded on its lower corners by the pointed feet of the mourners. A secondary inverted triangle is formed by the horizontal of the cross and implied lines joining it from the diagonal stakes pointing upward at the base of the cross.

Another set of triangles is created by the evelines among the figures, as diagrammed in Figure 3.26. Jesus' head is inclined down toward Mary, whose downcast eyes lead us to a diagonal stake, which points us up to the face of John, whose gaze is directed up to Jesus' face. This circuit completes and reinitiates a diamond pattern that is divided into two triangles across the middle by the horizon. We can also read our way round and round each of these triangles. For instance, in the lower one, we read from Mary's gaze down to one stake, up through the other to John's head, and then across along the horizon back to Mary's face. Even the folds in the saints' robes contribute to the triangular patterns. Perugino carefully leads us through the composition, bringing us back again and again to the major figures and thus tying them together both in form and in emotional content. The balance and compositional unity of the work are entirely appropriate for an altarpiece forming the focal point of a symmetrically planned church. But it is not rigid. Notice, for instance, the off-center arrangement of the lake and hills in the background, placing John's head against water and sky and Mary's against rock. This interesting asymmetry is possible because the composition is so well unified by the triangular patterns in the foreground.

In two-dimensional works giving an impression of three-dimensional space, the order may attempt to

3.23 Double triangle composition.

3.24 Pietro Vanucci, called Perugino, *The Crucifixion with Saints*, c. 1485. Oil, transferred from wood to canvas, middle panel $39\% \times 22\%$ ins (101.3 \times 56.5 cm), side panels $37\% \times 12$ ins (95.2 \times 30.5 cm). National Gallery of Art, Washington, D.C. Andrew W. Mellon Collection.

3.25 Double triangle composition in *The Crucifixion with Saints*.

3.26 Implied triangles in *The Crucifixion with Saints*.

3.27 Piero della Francesca, *Flagellation of Christ*, c. 1455–60. Tempera on wood, $32\frac{3}{4} \times 23\frac{1}{2}$ ins (83.2 \times 59.7 cm). Palazzo Ducale. Galleria Nazionale delle Marche, Urbino, Italy.

unify the spatial planes of the composition. Piero della Francesca (c. 1420-92) was concerned with the study of perspective and mathematics as a reflection of the divine order. In his enigmatic Flagellation of Christ (3.27), painted for the lord of a tiny Italian state who had great interest in Classical scholarship, he has used linear perspective not only to unify areas of the composition but also to establish links across time: the period of Jesus, of Classical Rome, and of contemporary Italy. To the far left, in the middle ground, Pontius Pilate sits watching the whipping of Christ. Tied to a heroic Roman statue, Jesus is in the midst of the second group in the middle distance, slightly forward of Pilate. Three more unidentified but visually prominent contemporary figures are standing at the far right, in the extreme foreground, ignoring the beating. If we see them first, we read back along a diagonal from front right to back left to discover the other two groups. Piero has used architectural details to create a second diagonal from front left toward back right in the illusionary deep space of the picture plane. He has set up precisely rendered one-point perspective in which only the left side of the perspective lines are seen receding into the background. The two front-to-back diagonals are thus set in opposition to one another, linked where they cross in the figures to the left of Jesus. The two diagonals—the lines of humans and the architectural perspective line—are further tied together through the overlapping of the pillars by the human figures.

In later works, compositional unity is often achieved by less formulaic means. Renoir's Impressionist painting *The Boating Party* (3.28) uses a series of devices to unify the many individual figures. The first is the subject-matter: these people are relaxing together at a pleasure garden overlooking the Seine. They are unified into small groups because we see them talking to and looking at each other. The friends having lunch together in the foreground are not in conversation with each other—Aline Charigot, who was to become Renoir's wife, is paying more

3.28 Pierre-Auguste Renoir, *The Boating Party*, 1881. Oil on canvas, 4 ft 3 ins \times 5 ft 8 ins (1.29 \times 1.73 m). Phillips Collection, Washington, D.C. Auguste Renoir's apparently free, impressionistic renderings of fresh-air pleasures such as this delightful lunch party are in fact most carefully composed.

attention to her dog—but they are held together by being at the same table. The man standing and bending toward the table at the right brings the groups in the background into relationship with those seated at the table. The canopy over the whole group pulls them together visually, as does the bracketing of the figures by the two boatmen. Placed strategically at the right and left margins of the canvas, they stand out from the others because of their large size and matching athletic clothes. Their gazes cross the canvas, encompassing the whole space.

Three-dimensional works are often unified by compositional lines as well, though they cannot be fully appreciated in a two-dimensional photograph from a single point of view. The sculptors of the Hellenistic marble *Laocoön* group (3.29) wrapped a series of curving lines around the anguished figures of Laocoön and his sons. Most obvious are the lines of the sea serpents winding through the group. They

were said to have sprung out of the sea to attack Laocoön, a Trojan priest, and his sons for defying Apollo or for warning that the Greeks' Trojan horse was a ruse. In addition to the serpents' horrifying way of connecting the figures, the lines of the three straining humans form a continuing series of related curves, as suggested two-dimensionally in Figure 3.30. They are further tied together by the eyelines from the sons to the father.

Emphasis

A further organizing principle in many compositions is that of **emphasis**—the predominance of one area or element in a design. By its size, position, color, shape, texture, or surroundings, one part of a work may be isolated for special attention, giving a focus or dramatic climax to the work.

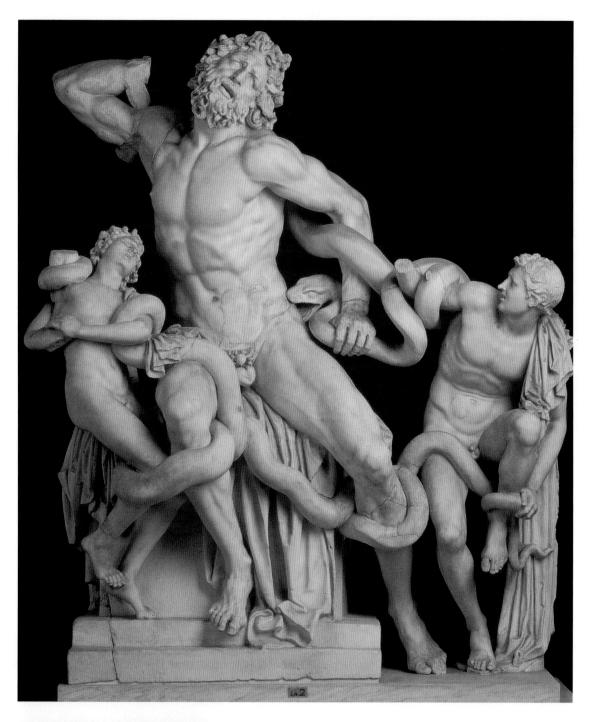

3.29 Hagesandrus, Athenodorus, and Polydorus, *Laocoön*, first century A.D. Marble, height 8 ft (2.44 m). Vatican Museums, Rome.

3.30 Three-dimensional compositional lines in the *Laocoön*.

When awareness is drawn to a single place, it is called the **focal point** of the composition. In Leonardo da Vinci's The Last Supper (3.32), Christ is clearly the central focus of the work. The most obvious device used to emphasize him is his placement at the exact center of the painting. Leonardo has formally lined up the figures along one side of the table, opening the space in front of them so that they all face the audience, as it were, rather than using the arrangement favored by Ugolino di Nerio (3.14). On this stage, Christ's central position is emphasized by the perspective lines, which all come to a point in or behind his head, as shown in Figure 3.31. Or at least, so it now appears. As we shall see in Chapter 5, it is possible that the symmetry of the beams was boldly added by a later restorer, replacing the original beams painted by Leonardo. In either case, the direction toward the center is established by the disciples, who are looking at Christ or pointing to him. Christ's head is also framed within the central window at the back of the room, the largest of three symbolizing the divine Trinity, and by the arch over it, like a halo as a visual metaphor of Christ as the light of the world.

Sacred architecture often develops a single focal point to center worshipers' attention on the forms used to represent divinity. In the small chapel (3.33)

3.31 Perspective composition in The Last Supper.

reconstructed at the Cloisters in New York from twelfth-century sources, the altar is clearly the focal point, with its candles, marble ciborium (canopy), and statue of the Madonna and Child. The altar is clearly the most visually interesting area of this simple chapel, and is further emphasized by the domed arch in the architecture, the windows to either side that highlight the area, the contrasting value of the curtain behind the statue, and the raised platform on which the altar rests. These devices also symbolize the sacredness of the spiritual, elevating it above the mundane.

Not all works of art have a focal point. In a wallpaper or fabric pattern, the same design motif may be

3.32 Leonardo da Vinci, *The Last Supper*, c. 1495–98. Mural painting, 15 ft 1% ins \times 28 ft 10% ins (4.6 \times 8.6 m). Refectory, Convent of Santa Maria delle Grazie, Milan.

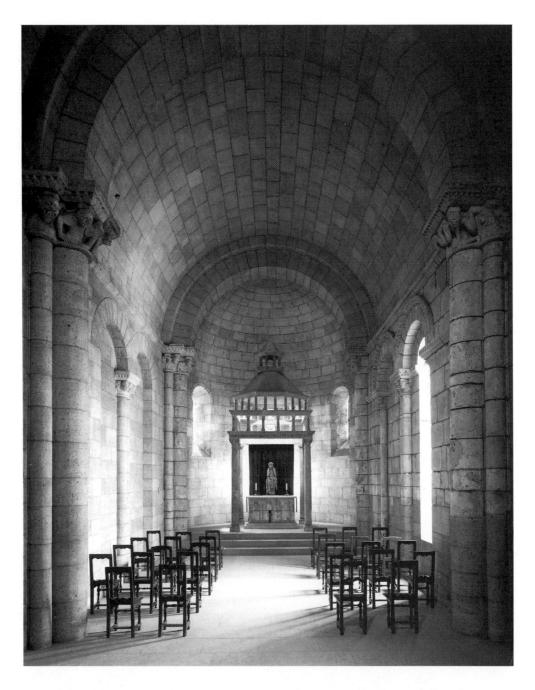

3.33 Chapel, from the church of Notre Dame du Bourg, Longon, Bordeaux, France, after 1126. Marble ciborium from the church of San Stefano, near Finao Romano, Rome, 12th century. Metropolitan Museum of Art, New York. Cloisters collection.

repeated again and again with equal emphasis, scattering the attention in the interest of creating an overall effect. If the repeating unit has a particularly strong visual element, it may appear as accents within the larger pattern. Many pieces of sculpture also lack a single focal point, for the intention may be to lead the viewer to examine the work from all angles, unlike two-dimensional images in which many elements must be unified across a single plane. Sometimes the entire sculpture becomes a focal point, as it were. Imagine how Brancusi's *Bird in Space*

(1.16) would look if it were displayed by itself in a darkened room with a single spotlight gleaming off its polished bronze surface. In most museum settings, works are shown among many others rather than being emphasized by isolation in a dramatic setting. Altarpieces, for example, were originally intended as the focal points of symmetrical churches. Much of their emotional impact is lost when they are hung on the walls of museums, seen under uniform lighting, and flanked by other pieces to which they are visually unrelated.

3.34 Liang Kai, *The Poet Li Bo*, 13th century. Ink on paper, $42\% \times 13$ ins (109 \times 33 cm). National Museum, Tokyo.

Economy

The principle called **economy** refers to the ability of some artists to pare away all extraneous details, presenting only the minimum of information needed by the viewer. Economy is a hallmark of some contemporary design, and also of artists influenced by Zen Buddhism. In his portrait of the poet Li Bo (**3.34**), Liang Kai captured the man's spiritual essence as well

as his voluminous form with a few quick brushstrokes. This was considered inspired art, possible only when the artist was in direct communion with the Absolute. Nevertheless, to develop the technique of the "spontaneous" brushstroke took many years of practice.

Economy is not limited to figurative art that suggests real forms by using a minimum of clues. The principle can also be applied to nonobjective art. In contrast to the decorative approach of those who paint marble

3.35 Vase, Qing-de-zhen ware, China, Qing Dynasty, probably Kangxi period, 1662–1722. Porcelain, sang de boeuf glaze, height 7% ins (20 cm). Metropolitan Museum of Art, New York. Bequest of Mary Clark Thompson, 1924.

sculptures or cast salt cellars in the forms of the gods, it is possible to create objects of great beauty by severely limiting the design elements used. The elegant porcelain vase from Qing dynasty China (3.35) eschews any ornamentation in order to focus attention on the gracefulness of the form and the subtle crackles and color changes in the oxblood glaze. The intensity of the red gets our attention, but, in its simplicity, the vase becomes an object for quiet contemplation.

Isamu Noguchi, whose spare aesthetic is apparent in his unadorned rock sculptures (2.112) and his point-balancing cube (1.31), speaks of the difficulties of reducing art to the minimum:

The absence of anything is very beautiful to me. That is to say, emptiness is very beautiful to me. And to desecrate that emptiness with anything takes nerve. So you might say, well, I'm not a lover of art. But I am, you know. I'm always in a quandary. Too much is not good. Too much of anything is not good. With my attitude, it makes it rather difficult to do anything at all. Nevertheless, I'm rather prolific.³

As in the Bauhaus dictum, "Less is more," it is possible to suggest very complex forms or ideas with very few visual clues. Graphic designers are challenged to do so when they are commissioned to create logos. A successful logo is a highly refined image that bespeaks the nature of an entire group or corporation with an absolute minimum of marks. The logo Peter Good designed for the Hartford Whalers hockey team (3.36) immediately suggests the tail of a sounding whale, completed by a fluid "W" for the Whalers and a figureground reversed "H" for Hartford implied in the unfilled white space. Open to the surrounding space, the "H" has a dynamic flowing quality through the upper portion, with squared-off legs giving strength to the base. If you look very closely at the outer corners of the feet of the "H" you can see **light wells** there—tiny outward swells that counter the eye's tendency to round off the corners. The light wells actually make the lines of the "H" look straighter. The light pouring in through the opening seems to collect in these corners, creating vibrant effects and perhaps even colors in the eyes of some viewers. In what is actually only two simplified filled areas, this economic logo gives us the initials of the town and team, suggests the derivation of the Whalers name, and gives the impression of liveliness, strength, and speed.

3.36 Peter Good, logo for the Hartford Whalers Hockey Club, 1979.

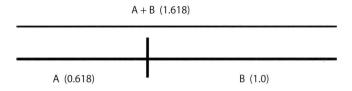

3.37 Golden Mean Proportion.

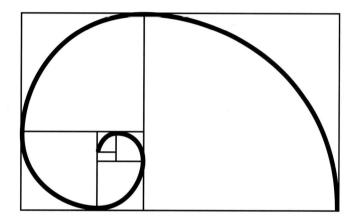

3.38 Golden Rectangle.

Proportion

A further principle in composing artworks is that all parts should be in pleasing proportions to each other. From our experiences in the three-dimensional world, we have a learned sense of "correct" size relationships. In representations of the human figure, we expect the head, feet, arms, and fingers to be a certain size in relationship to the rest of the body. These expectations have been institutionalized in certain schools of art. In the art of China and Japan, for instance, one set of conventions for drawing the human figure was to make the standing body seven times the height of the head, the seated body three times the height of the head, the head itself twice the size of the open palm, and so on. These same schools taught proper proportions for representing on a panel the illusion of the vastness of landscapes, called shanshui, or "mountain-water" pictures in Chinese. According to one convention of proportions, if a mountain were shown ten feet (3.1 m) high, a tree should be one foot (30.5 cm) high, a house a tenth of a foot (3.05 cm) high, and a human the size of a pea.

In addition to these artistic conventions about proportion in figurative art, theories have been put forward suggesting that we have an innate abstract sense of ideal proportion. The Greeks formulated this idea of mathematical perfection as the Golden Mean (also called Golden Proportion, Golden Ratio, or Golden Section). It can be demonstrated by a line divided into two unequal parts, in which one section is 0.618 times as long as the other (3.37). In this case, the ratio of the shorter segment to the longer segment is the same as the ratio of the longer segment to the sum of the two segments, a:b=b:(a+b). These proportions can be turned into the Golden Rectangle, in which the width is 0.618 percent of the length. It can be endlessly subdivided on one side to yield more Golden Rectangles (3.38).

3.39 Diagrammatic section of a nautilus shell.

This ideal proportional relationship can be seen not only in the ground plans, elevations, and doors of Greek buildings but also in the Taj Mahal and in the paintings of many Italian Renaissance artists. It is also found in nature—for instance, in the patterns of leaves, shells, cells, and DNA. This "sacred geometry" is thought by some to be an expression of the basic structure of the cosmos: the pattern of growth from cosmic unity, such that all divisions of the whole relate back to the whole. The seeds in a sunflower head, the florets in a daisy, and the chambers in a nautilus shell (3.39) grow in spiraling increasing patterns in the same mathematical relationship, the so-called Fibonacci series. The ratio of the size of one unit to that of the following unit is 0.618 ... (an infinite, irrational number that approaches 0.618 the farther it is extended mathematically); the size of any unit divided by the size of the preceding one is 1.618

Although the Greeks worked out the Golden Rectangle as a mathematical formula, they also recognized that our visual perception is not flawless and that it is influenced by our mental assumptions. Ictinus and Callicrates, the architects of the Parthenon (3.40), therefore used an astonishing series of "optical refinements" in the proportions of the building to make it appear perfectly regular and rectangular to the human eye. Exact measurement of the Parthenon has revealed many apparently intentional deviations from regularity and rectangularity. Because the Greeks recognized that our visual apparatus perceives vertical lines as sloping and horizontal lines as sagging in the center, they corrected for these human errors in perception. The platform and steps actually curve upward.

So does the entablature (the horizontal element above the columns), though to a lesser degree, presumably because it was farther from the viewer's eye. The columns and entablature also slope inward slightly to prevent their appearing to slope outward. At the corners, the columns are thickened slightly to counteract the optical thinning effect of their being silhouetted against the sky. The diameter of the columns bulges out by two-thirds of an inch (1.7 cm) part-way up to accommodate the human assumption that the columns will be slightly compressed by the weight they appear to bear (a subtle principle called **entasis**), and the illusion of regular spacing among the columns is created by spacing that is actually irregular. The result is what we perceive as the most perfectly proportioned building ever created.

Artists who are able to create satisfying proportions may thus be working with the actual visual "feel" of objects rather than mathematical precision. The lovely chalice by Timothy Brigden (3.41) is divided into three areas that are approximately—but not exactly—the same size: the cup, stem, and base. The base is actually slightly shorter in height than the cup and stem, but with its outward flare it would appear awkward if it were any higher. Brigden has also forsaken exact regularity in the area just below the bottom of the cup, making it straighter than the curves of the rest of the stem. It serves as a transition from the straighter lines of the cup to the undulations of the stem. If it had a more rounded curve, there would be "too many" curves. As it is, the chalice appears just right to the human eye.

There are also proportional relationships that are entirely intuitive, based totally on the individual's

 $\boldsymbol{3.40}$ Ictinus and Callicrates, Parthenon, Athens, 447–438 B.C.

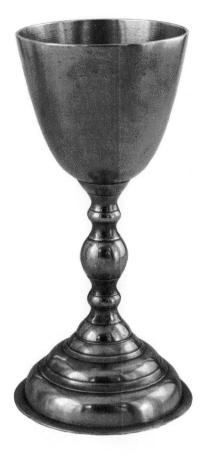

3.41 Timothy Brigden, chalice, late 18th or early 19th century. Pewter, height 8½ ins (22.5 cm). Metropolitan Museum of Art, New York. Gift of Joseph France, 1943.

innate sense of aesthetics. An extreme example is the perfection of the Zen rock garden in Ryoanji (3.42), consisting of fifteen stones arranged in five groups amid sand. The relationships of sand (raked in lines to represent the sea) to rocks (representing mountainous islands, like the islands of Japan), and rock to rock are the result of a meditative attunement to the perfection of the universe, rather than obedience to any human system of perfection.

Relationship to the Environment

A final organizational principle that affects the harmony of a work of art is the relationship of the piece to its environment. When we see art on the pages of a book or on the walls of a museum, we cannot grasp this dimension, for it can be appreciated only within the living setting for the work.

Barnett Newman's *Voice of Fire* (1.24), whose purchase by the National Gallery of Canada raised a furor among those who considered it a waste of public funds, has been exhibited in various settings, but now that it is in a commanding place in the Ottawa museum,

visitors are often stunned by its impact. The eighteenfoot-high (5.9 m) painting has been hung by itself at the end of a tall gallery, dominating the space and the perception of the viewer.

Installation art is often designed with reference to a particular environment and will not work so well anywhere else. In fact, often the architectural or natural features of the environment become an intentional part of the installation. Marina Abramovic has capitalized on the dungeon-like features of the Kunstmuseum des Kantons Thurgau to create an installation (3.44) that makes us feel that we are trapped within it. The only apparent ways out are ladders whose rungs are hostile knives, hot metal, or ice.

The environmental setting was a critical issue in the planning of the Guggenheim Bilbao Museum (3.45). The site chosen by the architect, Frank Gehry, would seem an impossible place to work, for it was a small area hemmed in by a river and two bridges. But Gehry chose it precisely because he wanted to use the river and the bridges as part of the design. The river reflects the gleaming, asymmetrical contours of the museum, and some of the museum is built under the bridge, linking it with the existing history of the city. Visually, however, the museum is an anomaly, presenting a free-form contrast to the more

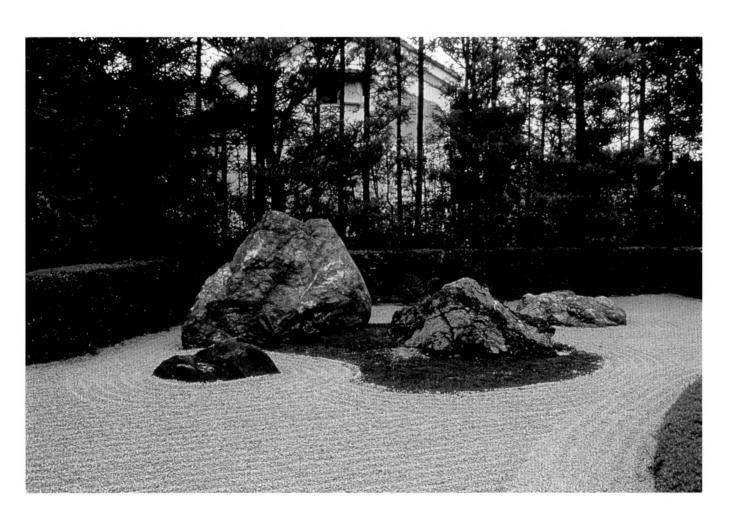

3.42 Rock garden of Ryoanji temple, Kyoto, Muromachi Period (1338–1573). Courtesy Japan National Tourist Organization, London. This famous dry garden was seemingly created not only for meditative contemplation of the relationships among the rocks, with all their attendant symbolism (such as groups of three rocks suggesting the Buddhist triads of heaven, earth, and humans, or Buddha, the Law, and the spiritual community). Its perfection lies also in the relationship between positive and negative spaces, between the rocks and the voids between them. They lead to contemplation of the "perfect mutual solution" in which the mind flows naturally between form and space and realizes the dynamic underlying relationship between them.

ARTISTS ON ART

Wassily Kandinsky on Underlying Harmony

THE RUSSIAN NONOBJECTIVE painter Wassily Kandinsky (1866-1944) began his adult career in the realm of principles, as a budding professor of law. But he gave that up for painting, and as a painter he worked to free himself from attempts to copy the world of outer appearances or abide by traditional ideas of aesthetic harmony (3.43). A mystic, he believed that expressions of a higher inner harmony could be presented through the pure language of colors and forms, with no references to the objective world. Excerpts from his book, Concerning the Spiritual in Art, follow:

"The need for coherence is the essential of harmony—whether founded on conventional discord or concord. The new harmony demands that the inner value of a picture should remain unified whatever the variations or contrasts of outward form or color. The elements of the new art are to be found, therefore, in the inner and not the outer qualities of nature."

"The spectator is too ready to look for a meaning in a picture—i.e., some outward connection between its various parts. Our materialistic age has produced a type of spectator or 'connoisseur,' who is not content to put himself opposite a picture and let it say its own message. Instead of allowing the inner value of the picture to work, he worries himself in looking for 'closeness to nature,' or 'temperament,' or 'handling,' or 'tonality,' or 'perspective,' or what not. His eye does not probe the outer expression to arrive at the inner meaning.

"In a conversation with an interesting person, we endeavor to get at his fundamental ideas and feelings. We do not bother about the words he uses, nor the spelling of those words, nor the breath necessary for speaking them, nor the movements of his tongue and lips, nor the psychological working on our brain, nor the physical sound in our ear, nor the physiological effect on our nerves. We realize that these things, though interesting and important, are not the main things of the moment, but that the meaning and idea is what concerns us. We should have the same feeling when confronted with a work of art. When this becomes general the artist will be able to dispense with natural form and color and speak in purely artistic language."

"New principles do not fall from heaven, but are logically if indirectly connected with past and future. What is important to us is the momentary position of the principle and how best it can be used. It must not be employed forcibly. But if the artist tunes his soul to this note, the sound will ring in his work of itself.

"The 'emancipation' of today must advance on the lines of the inner need. It is hampered at present by external form, and as that is thrown aside, there arises as the aim of composition—construction. The search for constructive form has produced Cubism, in which natural form is often forcibly subjected to geometrical construction ...

"The harmony of the new art demands a more subtle construction than this, something that appeals less to the eye and more to the soul. This 'concealed construction' may arise from an apparently fortuitous selection of forms on the canvas. Their external lack of cohesion is their internal harmony. This haphazard arrangement of forms may be the future of artistic harmony. Their fundamental relationship will finally be able to be expressed in mathematical form, but in terms irregular rather than regular."4

3.43 Wassily Kandinsky, *Panel for Edward R. Campbell, no. 2,* 1914. Oil on canvas, 5 ft $4\frac{1}{6}$ ins \times 4 ft $\frac{3}{6}$ ins (1.63 \times 1.23 m). Museum of Modern Art (MOMA), New York. Nelson A. Rockefeller Fund. (By exchange.)

3.44 Marina Abramovic, *Double Edge*, 1995–96. Installation with wood, metal, ice, and sand.

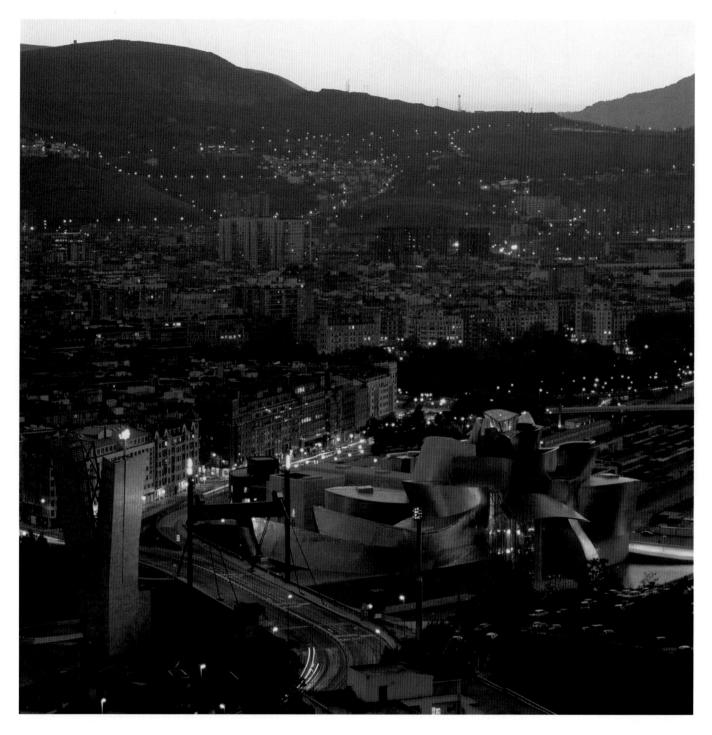

3.45 Frank O. Gehry, Guggenheim Museum, Bilbao.

symmetrical traditional building forms. Seen in the context of the cityscape, do you think this contrast is desirable or undesirable? In what sense? What about the relationship of the museum to the long view of the surrounding hills?

Artists must work often within the limitations and features of the settings imposed by their commissions. Architect Frank Lloyd Wright, asked to build a house near a creek in Pennsylvania, chose to build it on top of the falls (3.46), "not simply to look at the waterfalls but to live with them." Preserving and capitalizing on the beauty of the waterfall, Wright cantilevered the decks of the house right out over it. The horizontal lines of the building mirror the slabs of rock below, echoing their pattern of linear, light-struck mass punctuated by deeply shadowed recesses. His ideal was

3.46 Frank Lloyd Wright, Kaufmann House ("Fallingwater"), 1936–39. Bear Run, Pennsylvania.

what he called "organic architecture"—that which respects and merges with the natural environment. Wright wrote:

When organic architecture is properly carried out no landscape is ever outraged by it but is always developed by it Fallingwater is a great blessing—one of the great blessings to be experienced here on earth. I think nothing yet ever equalled the coordination, sympathetic expression of the great principle of repose where forest and stream and rock and all the elements of structure are combined so quietly that really you listen not to any noise whatsoever although the music of the stream is there. But you listen to Fallingwater the way you listen to the quiet of the country.⁵

Two-dimensional Media and Methods

David Em, *Navajo 1978* (detail of Figure 9.11).

SINCE HUMANS FIRST approached their cave walls to scratch and paint images of the animals they hunted and spirits they sensed, flat surfaces have lured us to record our impressions of life and invent new images. Across the millennia, we have appropriated everything from plaster walls to computer screens for this purpose.

Drawing

4.1 Pablo Picasso, *Three Female Nudes Dancing*, 1923. Pen and ink, $13\% \times 10\%$ ins (35.2 \times 26.3 cm). National Gallery of Canada, Ottawa, Ontario.

■ KEY CONCEPTS

Why and when artists draw

How artists use dry and liquid media to draw

How different media influence drawing

IN THIS DECEPTIVELY simple line drawing (4.1), the master Pablo Picasso has expressed the movement and lightness of dance, despite the apparent weightiness of the women. Part of the greatness of the drawing lies not in what he depicted, but in what he left out. By not defining all parts of the women's anatomies, he has created an impression of motion and space. Threedimensional space is also suggested by the relatively small size of the left foot of the dancer on the right, making that foot seem very far behind her. Picasso invites our participation in order to make sense of the figures, particularly the central dancer, about whom he has given very little information. We can truly perceive the structure and volume of the bodies within the few penned lines without any shading. It takes great skill to create the sense of space and volume with a simple contour drawing.

In this chapter, you will see many examples of great artfulness in the use of drawing techniques and media. Each **medium**—the material with which the artist works, such as watercolor, oil paint, or stone—has unique characteristics that can be seen in certain works, though some artists use their medium so skillfully that they transcend its limitations and can make it do anything they choose. In this chapter we will examine a variety of media that have been used in drawing.

Approaches to Drawing

Drawing is perhaps the most direct of all the arts and has often been considered the foundation for all visual arts. To **draw** is to create the impression of shapes and forms on a surface, chiefly through the use of lines. The impression of three-dimensional volume may be developed by laying down a series of lines that follow the contours of the form (**hatching**), by making clusters of dots (**stippling**), or by pulling soft media across the surface to develop areas of different colors or

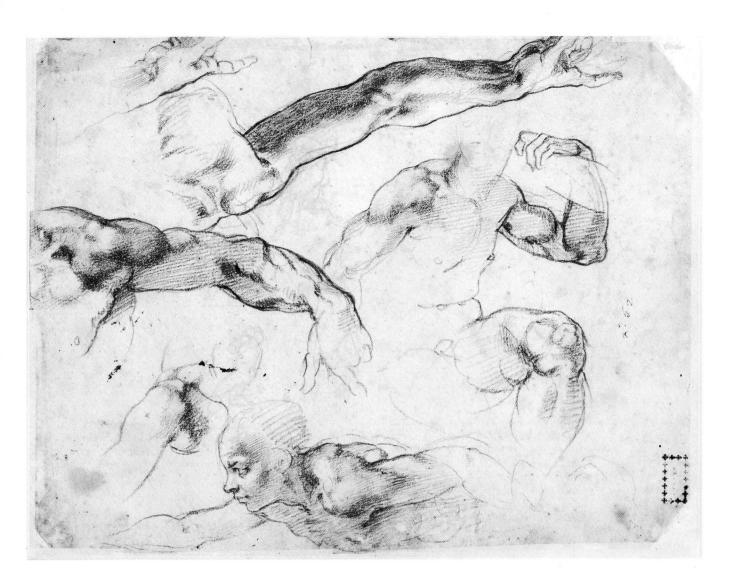

4.2 Michelangelo Buonarroti, preparatory drawings for *The Creation of Adam*, Sistine Chapel ceiling, 1511. Red chalk over black chalk, $8\% \times 11$ ins (21.3 \times 27.9 cm). Teylers Museum, Haarlem, Netherlands.

values. In Michaelangelo's drawings for *The Creation of Adam* (**4.2**), you can see how he has built up the forms of bones and muscles by means of lines drawn with chalk.

The marks the artist lays down in a drawing reflect the movements and skillfulness of the arm and hand. This aspect is somewhat different from the visual quality of the lines themselves. Aubrey Beardsley's Ali Baba (4.3) is composed of elegant flowing lines, but to get this free-flowing effect with pen and ink took tremendous manual control on Beardsley's part. Even the letters are elegantly controlled drawn lines.

Some drawings do, however, have a distinctly **gestural** quality, revealing the artist's hand at work. Rick Bartow draws standing up, for greater physicality. He explains,

That allows for good motion, so there's a gesture in the process. And then erasing in. If I put in a big graphite area it takes a lot to get a line erased back through that. Even when I'm painting, I get my fingers in there to do what I need to do. Mostly what I do is draw and draw and draw. [I learned to start with] gestural beginnings, just make marks and marks, big marks, then refine, refine, refine until you start coming up with something.¹

The intense physicality of Bartow's drawing methods is related to his intense feelings about his subject matter. His *Bear for Lily K* (4.4) was drawn when his infant daughter Lily was born, struggling for life at only three and a half pounds (1.5 kg). From his Native American roots, in this vigorous drawing he seems to have invoked the healing energy of the bear to help her—and she indeed survived.

Drawings are often created as illustrations, such as Beardsley's illustration for the book *The Forty Thieves*.

4.3 Aubrey Beardsley, cover design for *The Forty Thieves*, 1879. Pen and black ink, brush, and black chalk, $9\frac{7}{16} \times 7^{13}\frac{1}{16}$ ins (24 × 19.7 cm). Fogg Art Museum, Harvard University, Cambridge, Massachusetts. Grenville L. Winthrop Bequest. Aubrey Beardsley was a leading exponent of the curvilinear, flowing Art Nouveau style, and often applied it ingeniously to the interpretation of myths in graphic design.

Techniques of book printing are easily adapted to reproduction of drawn lines, and they resemble and complement the lines of letter forms, as in the Ali Baba cover.

Another way in which artists have often used drawing is in studying natural forms in preparation for rendering them in another medium. Artists do not typically paint or sculpt a human figure, for example, by starting at the head and working down, filling in all the details as they go along. Rather, they first analyze the general form, the underlying structure and relationships between parts. They study the figure in terms of volume, values, proportions, lines, and the dynamics of gestures. What they see they may then draw in a preliminary series of sketches—thinking on paper, as it were. Before painting the Sistine Chapel ceiling (16.14–16.19), Michelangelo made numerous drawings to work out the musculature and gestures of the figures. The sketch page shown in Figure 4.2 includes his working out of the famous arm of the Lord that we see infusing Adam with life in the celebrated Creation of Adam (1.1) portion of the ceiling. Michelangelo's

4.4 Rick Bartow, *Bear for Lily K*, 2002. Pastel, tempera, graphite, 54 x 40 ins (137.2 x 101.6 cm). Froclick Gallery, Portland, Oregon.

technique in these drawings is alternately free and "sketchy," and tighter and more refined.

A third way in which drawings may be used is in presentations, as models for future works. Such presentation drawings are now considered collectable works of art in their own right. Christo often sells his drawings of proposed earthworks to help finance his projects, such as *Running Fence* (2.10).

In today's broad aesthetic, all of these kinds of drawings—illustrations, sketches, and presentation drawings—are appreciated and hung as works of art. Many artists also create finished drawings as ends in themselves. The many media now at their disposal are explored in the following sections. Those described are not an exhaustive list; some contemporary artists are drawing with new media such as felt-tip pens. Neither are these categories absolute. Chalks, crayons, charcoal, and pastels are quite similar, and pastel work is often classified as painting rather than drawing because it involves laying down masses of color rather than lines.

Note that most of the illustrations of drawings are of relatively recent works, for the medium on which most drawing is done—paper—has been readily available only since the early 1500s. At that time, increasing urbanization concentrated the population, and the

manufacture of less expensive yarn goods coupled with growing affluence led people to throw away clothes as they were worn, outgrown, or out of style. Rag collectors moved through the cities buying the used fabric and selling it to paper manufacturers, enabling paper to be produced in greater quantities than in the past and bringing its price down. Today the best artist's papers are still made with rag; less expensive papers, made from wood pulp, yellow and deteriorate with time and don't hold up well under repeated working.

Dry Media

GRAPHITE PENCIL

The pencils used by artists are similar to those used as writing tools. They are thin rods of **graphite**—a soft form of carbon, mixed with clay, baked in a kiln and

encased in wood or some other material as a holder. Though now commonplace, the graphite (or "lead") pencil was not widely used in drawing until the end of the eighteenth century, when techniques for varying the hardness of graphite were developed. Values range from silver-gray to black depending on the proportional relationship of clay to graphite. The hardest grades of graphite produce the palest, finest lines; the softer grades produce darker, broader lines and glide more smoothly across the paper. A lighter touch with a soft pencil can also be used to create paler values.

Artists may use many grades of graphite or varying techniques with a few grades to create a range of values in a single drawing. In Corot's *Cività Castellana* (4.5), soft grades of graphite have been used to create very

4.5 Jean-Baptiste-Camille Corot, *Cività Castellana*, 1826. Graphite pencil on beige paper, $12\frac{1}{4} \times 15\frac{3}{8}$ ins (31 \times 39 cm). Louvre, Paris.

black filled-in areas. For lighter gray values, Corot has used parallel lines of hatching. And on the right side of the drawing, he has used the side rather than the point of a pencil to lay down broad areas of graphite, which are then rubbed for an overall gray tone. These value gradations create contrasts that remind us of the continual variations between darks and lights in a deciduous forest. Corot has used a visual shorthand for trees, leaves, stream, and rocks, but gives enough information for us readily to perceive the representational scene.

SILVERPOINT

The advent of the graphite pencil greatly lessened the use of **silverpoint**, which had been popular in the fifteenth and sixteenth centuries. Silverpoint drawings are made with hard, finely pointed rods of silver in a holder. The paper is first coated with some medium,

4.6 Käthe Kollwitz, Self-portrait with a Pencil, 1933. Charcoal, $18^{3/4} \times 24^{7/6}$ ins (48 \times 63 cm). National Gallery of Art, Washington, D.C. Rosenwald Collection.

Charcoal's various possibilities make it an excellent medium for Kollwitz to express the sorrow-molded features of her face as well as the focusing of all the grief of the war years, in which she lost her son, into her creative work.

such as opaque white pigment or rabbitskin glue with bone dust, to prepare a rather abrasive surface that will scrape off and hold minute grains of the metal. The lines made as the silverpoint tool is run across this prepared ground are silver at first but soon oxidize to a darker, duller color with a special light-reflecting quality. Copper, gold, and lead have also been used in the same way. Shadows and textures are usually built up using parallel lines.

CHARCOAL

In contrast to the tight, thin lines produced by silverpoint, **charcoal** is a medium that moves very freely across the paper, depositing broad, soft lines. Charcoal is made of charred wood or vine in sticks of varying width and hardness. The marks it makes are easily smudged. Though this possibility is often exploited by artists in toning an area, charcoal drawings are coated with a fixative when finished to prevent further accidental smudging.

Käthe Kollwitz's uses of charcoal in her *Self-portrait* with a Pencil (4.6) demonstrate the great versatility of the medium. She has given a faint tone to the paper

4.7 Richard Lytle, *Norfolk*, 1976. Charcoal, $22\frac{1}{2} \times 30$ ins (57.1 \times 76.2 cm). Collection of the artist.

with a slight deposit of charcoal. The charcoal has also been used sideways with a light touch to create broad strokes across the chest. Laid down this way, the charcoal dust sits on the surface of the paper, allowing the grainy texture of the paper itself to show through. The side of a soft piece of charcoal has been worked into the paper with great strength along the arm, creating lines of a darker value whose boldness bespeaks the creative energy of the artist at work. The tip of the charcoal has been used to create lines describing the artist's features. And Kollwitz has used the tip of a harder, finer piece of charcoal to complete the upper contour of her head.

Because charcoal is such a soft and free medium, the tendency is to use it in a quick way, as Kollwitz has done. The spontaneity of the act of drawing is revealed in this very natural use of the medium. But it is also possible to use charcoal in a tightly controlled manner. Richard Lytle's charcoal study, *Norfolk* (**4.7**), is a rare example of a very refined charcoal drawing in which the paper is left totally white in places. Whereas many charcoal drawings use only a range of mid-values, Lytle creates very rich blacks whose juxtaposition with true white makes them sing. He comments:

Most people use charcoal since it is a very forgiving medium. You can rub it off, in contrast to the immutability of ink. But I use charcoal with a mentality that was evolved through my work with ink. The imagery in this piece is slow in revealing itself, suggesting a bit of mystery, with the dark areas worked densely to a pure velvet black and the floating white areas developing volumes.²

4.8 (opposite) Leonardo da Vinci, *The Virgin and Child with St. Anne and St. John the Baptist*, 1510. Black chalk heightened with white on paper, 4 ft $7\frac{3}{4}$ ins \times 3 ft 5 ins (1.42 \times 1.04 m). National Gallery, London.

Leonardo da Vinci used chalk very expertly to suggest the threedimensional modeling of the figures and also to soften their edges so that they merge into each other, expressing a loving intimacy.

CHALK

Chalk is a naturally occurring deposit of calcium carbonate and varying minerals, built up from fossil seashells. Powdered, mixed with a binder, and compressed into sticks, it has long been used as a soft drawing medium. Renaissance, Baroque, and Rococo artists used white, red, and black chalks to work up and down the value scale on a tinted surface which served as a midtone. This technique is beautifully illustrated by the cartoon for The Virgin and Child with St. Anne and St. John the Baptist (4.8) by Leonardo da Vinci. A cartoon was a fullsized drawing done as a model for a painting. The lines from the cartoon were transferred to canvas or wall by pressing charcoal dust through holes pricked in the major line of the cartoon. But this cartoon is so striking in its own right that it is displayed by itself in a special dark room of the National Gallery in London, with

lighting designed to keep the paper from deteriorating. To indicate volumes rounding in space, Leonardo used black chalk lines to separate the figures from the tone of the paper and then used dark tones within the figures to indicate areas receding from the viewer in space. Areas that are to be seen as closest are lightened with white chalk. Notice how much flatter the areas that were not yet worked out—such as the upraised hand and the feet—appear without this use of values. Leonardo's very subtle value gradations were called **sfumato**, Italian for the smoky appearance that softens the lines of the contours and gives a mysterious hazy atmosphere to the image. He achieved the same effect in his paintings, such as *The Virgin of the Rocks* (15.26).

The venerable art of chalk drawing has been appropriated in recent years by street artists who have popularized a new genre of public art: sidewalk drawings. Among them is Julian Beever of England, whose sidewalk drawings have captivated passers-by in many countries. Using carefully calculated perspective drawings, he creates the illusion of deep three-dimensional space that descends far below the actual surface of the sidewalk. In the detail shown here from one of his

4.9 Street artist Julian Beever working on his three-dimensional cityscape at the launch of the *Ultimate Spider-Man* comic-strip console game in central London, October 16, 2005.

three-dimensional cityscapes (4.9), Beever appears to be kneeling on the top of a column several feet below the roof of a tall hotel, but in fact, he is at the same level as the sidewalk. His drawings work from only one angle; seem from other angles, the images seem quite distorted. And being made of chalk in places where they are subject to rain and smudging, they are impermanent—fleeting scenes of imaginary worlds below city sidewalks that last only briefly and then survive only in photographs.

PASTEL

Often confused with chalk, which is harder, **pastel** is a chalky stick made of powdered pigment plus filler bound with a small amount of gum or resin. When rubbed onto a rough-textured paper with enough "tooth" to hold the particles, it deposits masses of color. Pastel drawings are very fragile until treated with a fixative; if they are shaken before they are fixed, some of the powder will fall off. But an overabundance of fixative will deaden or spot the drawing, so the only way to

assure the permanence of a pastel is to seal it under glass.

The word "pastel" is commonly associated with pale tones, and pale pastels are well suited for creating light and romantic images. In the hands of Degas, pastels became a brilliant medium, like paints, but with their own special powdery effect. After the Bath (4.10) is one of his many major works in pastel. Because pastels are so soft, most artists smudge and blend them on the paper: Degas handles them as lines of color that reveal the act of drawing. Degas was able to lay one coat of pigment on top of another without their blending, using a special fixative between layers. The formula for the fixative has since been lost, and it is now difficult to build up layers with pastels using contemporary fixatives without dulling the brightness of the colors. In addition to his special fixative, Degas used pastels made with a high ratio of pigment to filler, juxtaposed at maximum strength so they intensify each other's brilliance.

Contemporary artist Tom Matt has chosen a new ground for pastel drawings: a newspaper front page dating from the day he begins each drawing, as in

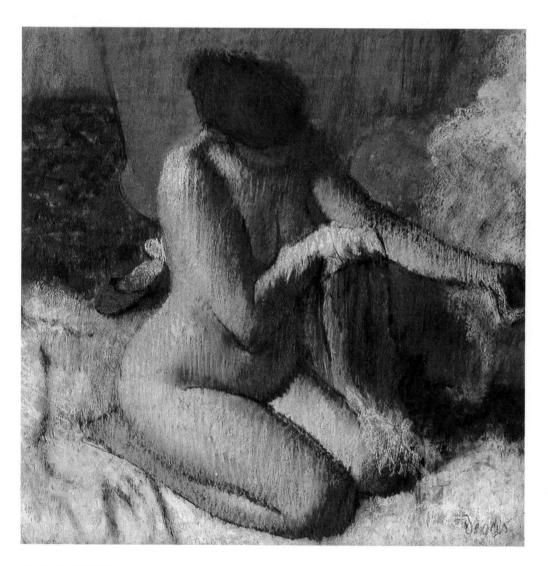

4.10 Edgar Degas, After the Bath, c. 1895-98. Pastel on paper, $27\frac{1}{2} \times 27\frac{1}{2}$ ins (70 \times 70 cm). Musée d'Orsay, Paris. Degas again and again created pastels of women bathing and drying themselves, in intimate compositions seen as if through a keyhole. He explained, "These women of mine are honest, simple folk, unconcerned by any other interests than those involved in their physical condition."3

4.11 Tom Matt, *Cityscapes of New York*, 2003. Pastel on newspaper, $13\% \times 22\%$ ins $(34.3 \times 57.2$ cm). Artist's collection.

Cityscapes of New York (4.11). Together, he feels, the drawing and the newspaper (in this case, the famous typography of *The New York Times*) give a sense of the city environment. Moreover, he explains,

I find newspaper appealing for its texture and mid-tone value. I can work both dark and light tones over the surface, allowing copy to appear directly or emerge through the transparent quality of the pastel. Since the newspaper is not archival, it will fade, which is part of the charm of the natural process of the medium. To bring longevity to this particular art form, I made limited edition prints—giclée prints—of the work on archival paper. This is a digital solution: archival prints preserving images of art drawn on a non-archival, non-acid-free surface.⁴

CRAYON

Several media carry the name "crayon." **Conté crayon**, named after the man who invented it in the eighteenth century, is a fine-textured grease-free stick made of powdered graphite and clay to which red ocher, soot, blackstone, or alumina chalk has been added to give it a red, black, brown, or white color. Its somewhat powdery nature can be seen in *L'Echo* (**4.12**). Seurat drew with conté crayons on a handmade textured paper which broke up the conté crayon marks and thus developed a range of values. Artists find conté crayon a versatile drawing medium because it can be applied softly to create gently shaped areas, or the crayon can be sharpened to a point to create hard, crisp lines or shapes.

Children's crayons are made of pigmented wax. Oil-based crayons come in brighter colors than wax crayons and can be blended on the paper, rather like oil paints. Lithographic crayons are made of grease for use in lithographic printing, but have been adopted for drawing by contemporary artists who like the pleasing way they glide across the paper. Each has its unique qualities, but crayons in general tend to skip quickly

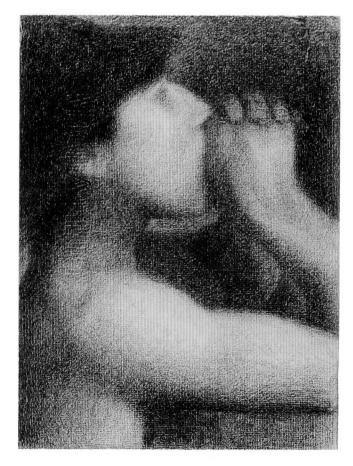

4.12 Georges-Pierre Seurat, *L'Echo*, 1883–84. Conté crayon, $12 \times 9^{1/4}$ ins (30.5 \times 23.5 cm). Yale University Art Gallery, New Haven, Connecticut. Bequest of Edith M. Wetmore.

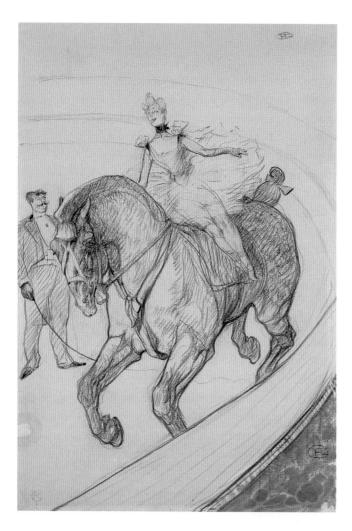

4.13 Henri de Toulouse-Lautrec, *L'Equestrienne*, 1899. Crayon, $19^{1/4} \times 12^{3/6}$ ins (48.9 \times 31.4 cm). Museum of Art, Rhode Island School of Design, Providence, Rhode Island. Gift of Mrs. Murray S. Danforth. Photo Erik Gould.

across paper. This quickness—and the humor it brings out in the artist—is apparent in Toulouse-Lautrec's *Equestrienne* (4.13). To see how differently the mass of the horse is described when the artist is using drawn lines rather than painted masses of color, compare this crayon drawing with Toulouse-Lautrec's oil painting of a similar subject shown in Figure 2.144.

Liquid Media

PEN AND INK

The drawing media discussed so far are all **dry media**. It is also possible to draw lines with a **liquid medium**, usually ink. Today's drawing inks are made of pigment particles, shellac, and water. In China and Japan, and in Europe during the Middle Ages and Renaissance, ink was traditionally made from ground lampblack mixed into a weak glue. Ink is usually applied with pens made of steel, quills, reeds, or bamboo. Depending on the

shape of its point, a pen may produce either lines of uniform width or lines that vary in width according to the direction and pressure of the pen.

Pen and ink drawings are difficult to execute, for the point of the pen may catch on the surface of the paper and splatter ink unpredictably. Today's technical pens can move more easily across the paper, like fine ballpoints, but it is still difficult to create so free-flowing a line as Picasso has used in his *Three Female Nudes Dancing* (4.1). If you follow the lines, you will see areas where the ink came out in spurts rather than a continuous flow, but the lines keep moving with utter assurance and seeming spontaneity, which expresses the abandon of the dancers.

Whereas most ink drawings are dark lines on a white or toned surface, Hyman Bloom creates the texture and form of fish skeletons (4.16) by working in white ink against maroon paper. By varying the amount of white laid down in an area, Bloom creates a range of values that gives an in-and-out spatial quality that borders on both realism and fantasy.

Pen and ink is essentially a line medium; tone or shade is conveyed by the use of special techniques such as stippling (dots), scratching, hatching, or cross-hatching (see Bittleman's *Martyred Flowers*, 2.16). As an alternative, ink can be thinned with water or spirit and brushed on as a wash to suggest the tone. The wash can be applied to penned line which is still wet to soften and dilute it. If it is added to a dry drawing the original pen marks usually remain hard and dark.

In Claude Lorraine's *Campagna Landscape* (4.15), brown ink has been watered down and used to fill in varying brown tones, without overpowering the darker penned lines used to describe the trees and rocks. The tower, however, is described by a darker wash accented by drawn marks, and the distant hills are suggested by a very thin wash alone that almost blends into the light values of the sky.

BRUSH AND INK

The final step into liquid media that can still be classified as a "drawing" is the application of ink with a brush without any penned marks. Developed to a fine art by Oriental schools (see Box), this technique is used in a near-abstract manner by Rembrandt in his sketch of a sleeping girl (4.17). The action of making each wet stroke is clearly evident, including passages where the ink on the brush was spent and the white of the paper began to show through. Above the girl's head an area of the background is suggested with a brushed wash. Note the attention to the placement of the figure on the

THE WORLD SEEN

Chinese Landscape Paintings

THE ARTS OF monochromatic painting with brush and ink, and of calligraphy, upon which it was based, were highly developed centuries ago in China. They flourished most when religion was vibrant, for in China they were spiritually expressive arts. A respected sixth-century treatise on art theory gave first priority to the "spirit resonance" of a work—the artist's ability to transmit invisible life energy through the brush.

Alongside formal concerns, meditation was regarded as a normal and necessary part of life, partly due to the pervasive influence of nativeborn Taoism. Taoism is linked to the perhaps legendary figure of Lao-tzu (c. 600–500 B.C.), whose *Tao te Ching* urges natural compliance with the flow of Tao, the mystical "Way" of the cosmos. Buddhism came to China from India in approximately A.D. 50, picking up elements of Taoism as it became widely popular

throughout China, and then transmitting this Ch'an Buddhism mixture to Japan, where it was called Zen. This stream of Buddhism placed great emphasis on direct spiritual experience of the underlying unity of all things, gained through silent sitting in meditation. The third major philosophy of China, named after Confucius (c. 551–479 B.C.) but hearkening to more ancient traditions, placed great emphasis on the arts, on proper observance of rituals and relationships, and on harmony between Heaven and earth.

Ever since the Han dynasty (202 B.C.—A.D. 220), Chinese rulers were connoisseurs and patrons of the arts. Painting was the most treasured of all the arts, and records were carefully kept of artists and their works. One of the categories of paintings that developed was the "mountain-water" genre, remembered or imagined landscapes

painted indoors to convey a contemplative atmosphere, by artists who themselves practiced meditation.

During the highly influential Sung period (A.D. 960-1280), painters were gathered from various regions to form an imperial Academy supported by the emperors. The Sung artists understood space as being spiritually vibrant, full of chi, or life force. With a few lines and washes, they not only defined the subject-matter but also imparted meaningfulness to the surrounding space. Daringly, they often left large areas unworked, to suggest in open space the purity of the Tao. In his Mountain Village in a Mist (4.14), the Ch'an Buddhist master Yu-Jian has used a minimum of gestures to depict rocky mountain forms appearing and disappearing in the mist, revealing the impermanence of even the most solid worldly landscape amid the unchanging, eternal wholeness of the Tao.

4.14 Yu-Jian (Yu-Chien), *Mountain Village in a Mist*, 13th century. Ink on paper. Idemitsu Museum of Arts, Tokyo.

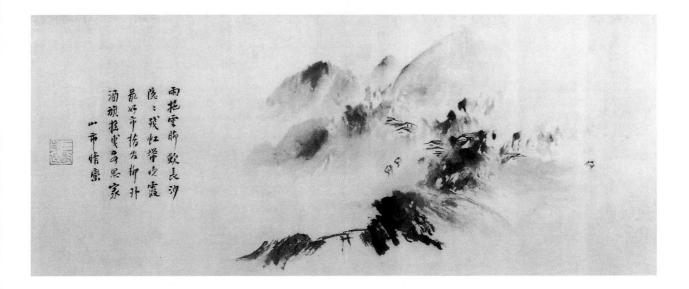

4.15 Claude Gellée, called Claude Lorraine, Campagna Landscape, 1660. Pen and bister with wash, $12\frac{5}{8} \times 8\frac{1}{2}$ ins (32×21.6 cm). British Museum, London. By using a single neutral color, Claude Lorraine has created a mood of bleakness in a landscape dominated by a stunted dead tree and abandoned tower.

4.16 Hyman Bloom, *Fish Skeletons*, c. 1956. White ink on maroon paper, $16\frac{3}{4}\times22\frac{3}{4}$ ins (42.5 \times 57.8 cm). Collection of Mr. and Mrs. Ralph Werman.

ground, a consideration that is particularly important when large areas of the ground are left unfilled and will be perceived as flat shapes in themselves. The wash tends to contradict such an interpretation, softening and pushing the largely unworked area back in space.

There is no limit to the tools artists can use to draw with and surfaces to draw on: anything that will make a mark and anything that can be marked on can be used. As we shall see in Chapter 9, which is devoted to computer graphics, computers now offer a powerful medium capable of producing drawings unlike anything ever done with traditional media and methods.

4.17 Rembrandt van Rijn, *Sleeping Girl*, c. 1660–69. Brush drawing in brown ink and wash, $9\% \times 8$ ins (24.5 \times 20.3 cm). British Museum, London.

Rembrandt's use of brush and ink is very similar to that of the Ch'an and Zen Buddhist masters in China and Japan, laid down with such seeming simplicity that it evokes a sense of the natural relaxation in the girl's posture.

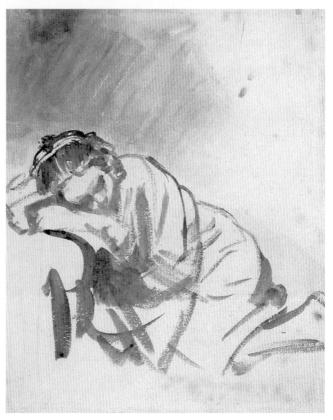

Painting

5.1 Claude Monet, *Water Lilies*, 1907. Oil on canvas, $39\frac{1}{4} \times 28\frac{3}{4}$ ins

(100 \times 73 cm). Musée Marmottan, Paris.

KEY CONCEPTS

What is painting?

Different methods of painting using a variety of paint media

Use of collage to create twodimensional art

Mixing various media in a single work

Cleaning and restoring paintings

DURING THE LAST years of his life, Monet focused his entire attention on painting impressions of the water garden he had created at his home in Giverny, northern France. He even had a special studio constructed there in order to paint on very large canvases. Their beauty is largely due to the way he uses oil paint to create the feeling of a liquid world without any particular focal point, eliminating superficial surface characteristics to concentrate on what seems almost a glimpse into infinity (5.1). One can make out some lily pads, but even these tend to disappear into a diaphanous world of light and color vibrations. He has achieved an interplay of color and space, with reflections of the evening sky and nearby trees and glimpses into the depths of the water intermingling. Monet has at the same time captured the feeling of water so well that his painting itself appears to be wet.

Many paint media and techniques have evolved over time, each with its own effects, but the act of applying sheer color to a surface yields results that are quite different from those of any other medium.

Approaches to Painting

Painting is the process of coating a surface with colored areas by using a hand tool such as a brush or a palette knife. There is no absolute demarcation between drawing and painting. Some drawing techniques, such as pastel, can also be used to create areas of color, and a brush may be used for drawings, such as brush and ink drawings. There is a slight difference in approach, however: drawing is primarily linear markmaking. The media discussed in Chapter 4 are usually considered drawing media, while encaustic, fresco, tempera, oil, watercolor, gouache, and synthetics are considered paint media.

We now tend to associate the word "painting" with a flat, movable surface to which paint has been added, such as a canvas which can be hung on any wall, but paint was probably first applied directly to stationary surfaces such as the walls of caves and buildings. The women of West Africa still maintain a dramatic wall-painting tradition of unknown antiquity. They use their hands to paint liquid clays mixed with plant and mineral colors onto the mud and clay walls of their houses and shrines (5.2). Each rainy season these vibrant clay paintings dissolve and are then reapplied, usually by groups of women using patterns handed down from mother to daughter.

Over the years and around the world, many different technical solutions have been devised to allow the

5.2 Silla Camara painting the wall of her family compound, Soninke village, Djajabinnit, Mauritania. Paste of ground white kaolin, water, and pigments collected from the Senegal River area.

spreading of colored **pigments** (particles of color) across a surface. In general, painting is made possible by suspension of pigments in a liquid **medium** such as water or linseed oil plus a **binder** that makes the pigments adhere to a surface. The surface on which the paint (that is, pigment plus medium) is spread is called the **support**, be it a wall, a piece of wood, or a stretched canvas.

Through time, varying media have been developed to improve properties such as ease in working, drying time, permanence, or brilliance. The forms of painting thus evolved are often referred to as media, in reference to the varying vehicles that distinguish them. Each medium has its own strengths and difficulties. Most are still in current use, though sometimes only by a few artists who are willing to tolerate the technical difficulties for the sake of the special effects possible.

Approaches to painting have changed as well. In general, the older approach was to plan carefully and execute a painting in stages, beginning with drawing studies of the forms to be represented. Once the drawing satisfied the artist, it was transferred to a support and the forms were developed in a series of stages. In this **indirect** method, used for works such as Bronzino's *Portrait of a Young Man* (5.3), perfection in technique was a painstaking matter but was capable of representing subtleties such as the textures of wood and fur and the translucent appearance of skin. Such

5.3 Angelo Bronzino, *Portrait of a Young Man*, c. 1550. Oil on wood panel, $37\% \times 29\%$ ins (95.7 \times 74.9 cm). Metropolitan Museum of Art, New York. H. O. Havemeyer Collection. Bequest of Mrs. H. O. Havemeyer, 1929.

effects involved a process of sketching, **underpainting** to define the major forms and values, and then a series of overpaintings to tint and describe the forms.

Another approach—the **direct** (*alla prima*) method—is to paint imagery directly on the support without staged underlayers. By this means the paint and the painter may reveal their presence. Oil paint, for instance, has a lush, creamy quality. Van Gogh laid down his paint with heavy **impasto** strokes that reflected the spontaneity of his gestures. His paintings (such as *The Starry Night*, 1.41) have appreciably three-dimensional surface textures. Oil paints now available also carry sensually rich colors. In Pierre Bonnard's *Nude in a*

5.4 Pierre Bonnard, *Nude in a Bathtub*, 1941–46. Oil on canvas, 4 ft \times 4 ft 11½ ins (1.22 \times 1.51 m). Carnegie Museum of Art, Pittsburgh, Pennsylvania. The Sarah Mellon Scarfe Family. *Pierre Bonnard was part of a group of artists who called themselves "Nabis" (prophets), for they tried new ways of using color and composition to evoke moods and explore visual patterns.*

Bathtub (**5.4**), the model's body is almost obscured by the way the dabs of paint juxtapose varied colors, breaking up the outlines of the forms. The colors are playful, sensual delights rather than reports of actual local colors; the shapes they "describe" are flattened, abstracted.

Contemporary direct painting does not necessarily call attention to the texture of the paint or the activities of the painter, and may not even be used to describe forms. Whereas canvases are usually treated with a glue solution to hold the paint on their surface and titanium dioxide (gesso) to keep oils from rotting the canvas, certain nonobjective painters since the twentieth century have worked in acrylics (which do not rot canvas) on unsized canvases so that the paint would be absorbed, with no noticeable surface texture and no trace of the artist's hand. Their works (for example, the paintings of Louise Frankenthaler in Figures 2.42 and 5.27) are created with an appreciation for the essential quality of pigment as pure, flat color.

5.6 (opposite) Diego Rivera, *Creation*, 1922–23. Encaustic and gold leaf, Anfiteatro Bolívar, National Preparatory School, Mexico City.

5.5 (below) Young Woman with a Gold Pectoral, Egypto-Romano (Coptic), c. A.D. 100. Encaustic, $16\frac{1}{2} \times 9\frac{1}{2}$ ins (42 \times 24 cm). Louvre, Paris.

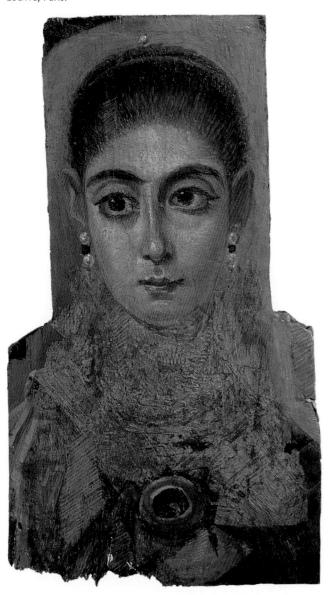

Paint Media

ENCAUSTIC

A very early method of painting that was used by the Greeks, Romans, and early Christians in Egypt, **encaustic** involves the mixing of pigments with wax. The wax must be kept hot as it is applied, to keep it liquid. Knowledge of the technique used to make such luminous works as *Young Woman with a Gold Pectoral*

(5.5) was lost for many centuries, though temptingly described by writers such as Pliny. Leonardo da Vinci, ever the experimenter, may have tried to revive the process in 1503, but his attempts failed. Early in the twentieth century, the Mexican muralist Diego Rivera studied books in Paris describing the techniques of the ancient Greeks, Romans, and Egyptians and experimented with combining hot wax and pigments. He was searching, he said, for "the traditional encaustic with its solidity, purity, depth, and richness of colors."

Rivera mastered the difficult encaustic process sufficiently to use it for the first of his immense murals, *Creation* (5.6), and then switched to fresco for all his other major works.

FRESCO

The **fresco** technique was developed by the ancient Mediterranean civilizations, refined to a supreme art by the Italian Renaissance painters, and used with great vigor by twentieth-century Mexican muralists. The

word "fresco" means "fresh" in Italian, for traditional buon fresco paintings must be created quickly and spontaneously, and allow little room for error. They are wall paintings in which pigments in a water base are painted onto freshly applied plaster. The immediacy of this method is apparent in the lively feeling of the figures in Ambrogio Lorenzetti's *Allegory of Peace* (5.8). As indicated in Figure 5.7, which is a reconstruction of the progress of Lorenzetti's fresco, the wall is first given two or three layers of plaster. Once the last of these is dry,

5.7 Layers in a fresco: 1. Masonry wall; 2. Underlayers of plaster; 3. Cartoon of image; 4. Fresh *intonaco* with pounced cartoon for the day's work; 5. Previously completed portion.

5.8 Ambrogio Lorenzetti, *Allegory of Peace* (detail), 1339. Fresco. Palazzo Pubblico, Siena, Italy.

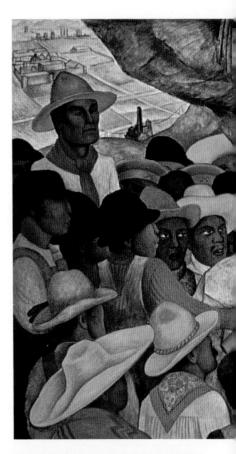

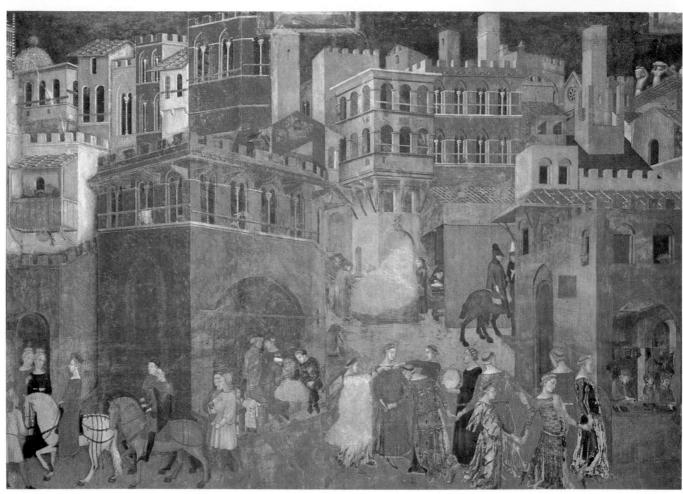

5.9 Diego Rivera, The Agitator, 1926. Fresco, 8 ft \times 18 ft $2^{1}/2$ ins (2.45 \times 5.55 m). Mexico. Diego Rivera was a leading figure in the post-Revolution movement in Mexico to create a new nationalistic public art which was ideological, monumental, and not based on European traditions of painting. Thus Rivera created huge frescos portraying themes such as agitation to combat exploitation of the poor.

the cartoon of the intended image may be traced or freely sketched by the artist onto the wall. Transparent paper is then used to make a copy of this cartoon; tiny holes are made along the lines of the copy with a perforating wheel. When the final layer of plaster, the intonaco, is applied, a fine powder ("pounce") is tapped along the perforations of the tracing to transfer the sketch onto the wet wall. The intonaco is applied over the underlying cartoon in sections small enough to be painted that day while the plaster is still damp, so that the paint is immediately absorbed into the plaster. If changes are made on the surface after the plaster is dry (a secco) they are more fragile. Once it is dry, buon fresco is as permanent as the plaster of the wall. Over the centuries, chunks of the plaster may fall away, as in Allegory of Peace, but fresco is by and large a very durable method of painting, so long as it is indoors. Outdoor frescos are vulnerable to air pollution and to wearing away by wind-blown particles.

Fresco is usually an intense collaborative effort involving a team of plasterers and assistants as well as

the artist. For Diego Rivera's huge murals of Mexican political history (5.9), plasterers covered a wall with two coats of plaster, and then Rivera sketched with red chalk or charcoal directly on this rough "brown" coat. Assistants traced this sketch onto transparent paper and ran a perforating wheel over the copy. Very early in the morning, a third coat of plaster was applied to the part of the wall to be painted first that day, and the sketch was pounced with lampblack powder. Rivera had specified the area, following the lines of the shapes rather than a uniform square, so that all figures could be finished rather than trying to match colors another day.

Once the plaster had dried to the proper humidity, Rivera was awakened, usually about dawn. The plaster would remain sufficiently wet for six to twelve hours, depending on the weather, and his method was to paint the same area twice in one day. The first painting was to establish black modeling of the figures, the second to add colors. Even as he worked, usually sitting on a scaffolding, another team of plasterers was preparing a second section of the wall. Rivera would continue

5.10 The gloved hands of a restorer attempting to piece together the face of Saint Jerome in a fresco attributed to Giotto in the ruins of the vault of the Basilica of Saint Francis, Assisi.

painting until evening, when there was no longer enough natural light to work by. Examining the day's work by the dim light, he often decided it was not quite right, and would instruct his assistants to remove it all. The same lengthy process would begin again the next morning.

Because buon fresco becomes part of the plaster of its wall or ceiling, when in 1997 the precious frescos in the Basilica of Saint Francis in Assisi collapsed with the vaults during an earthquake, those that had been painted in traditional buon fresco methods were reduced to plaster fragments that could be meticulously salvaged and pieced together again. This method has been used in the attempt to restore frescos attributed to Giotto, such as an image of Saint Jerome (5.10). However, fragments of frescos painted a secco, as overlays on dry plaster, crumbled into even smaller bits when handled, so they could only be photographed and reassembled by computer. Both methods are extremely time consuming, but the extensive frescos of the Basilica of Saint Francis have been such objects of adoration that every effort was made to save them.

TEMPERA

Another old and very demanding painting technique involves the mixing in water of pigments with egg yolk or some other glutinous material. The resulting **tempera** paint dries very quickly to a matt finish that will not crack. Unlike later paints, tempera colors will not blend or spread well. In order to create subtle modulations of light and shadow across three-dimensional surfaces, as in Giovanni Bellini's realistic *Christ's Blessing* (5.11), the artist must painstakingly lay down tiny individual brushstrokes side by side, hatching or cross-hatching to cover an area with pigment.

The painting of the final surface follows lengthy preparation procedures. As diagrammed in Figure **5.12**, a simplified detail of Ugolino di Nerio's tempera painting of the *Last Supper* (3.14), the support used—wood or canvas—is first coated with gesso. This is a fine white substance that gives the panel a smooth, brilliant, eggshell finish that accepts paint readily and has enough "tooth" to allow control of the brush. After the gesso dries, the cartoon of the drawing is scratched

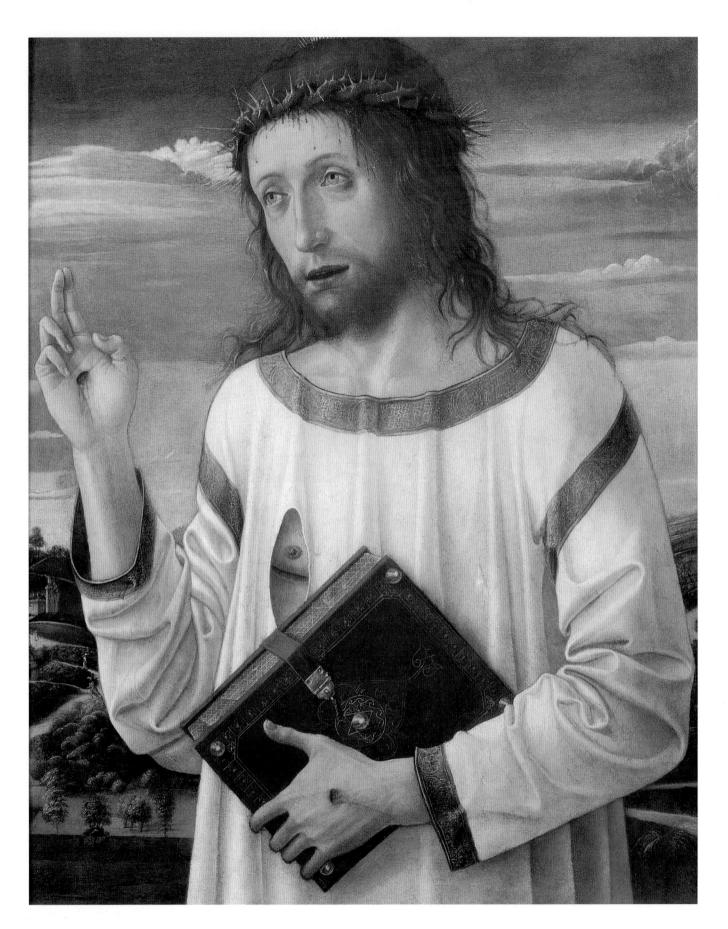

5.11 Giovanni Bellini, *Christ's Blessing*, c. 1460. Tempera on wood, 55×18 ins (58×46 cm). Louvre, Paris.

5.12 Layers in a tempera painting.

- 1. Wood panel
- 2. Gesso and perhaps linen reinforcement
- 3. Underdrawing
- 4. Gold leaf
- 5. Underpainting
- 6. Final tempera layers.

5.13 Cimabue, *Madonna Enthroned with Angels and Prophets* (detail of 2.69), c. 1280–85, showing handling of tempera paint. Tempera on wood, 12 ft 6 ins \times 7 ft 4 ins (3.85 \times 2.23 m). Galleria degli Uffizi, Florence.

Cimabue added gold highlights to his figures and their draperies to symbolize the light falling from heaven.

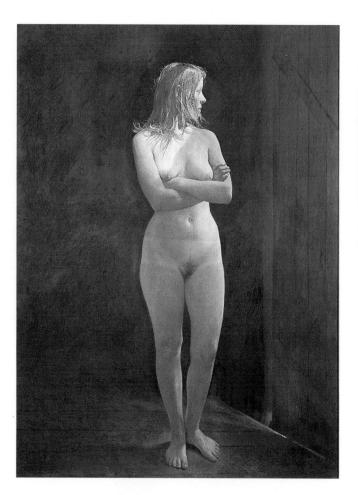

5.14 Andrew Wyeth, *The Virgin*, 1969. Tempera on canvas, 46×36 ins (116.8 \times 91.4 cm). Brandywine River Museum, Chadds Ford, Pennsylvania.

Andrew Wyeth is renowned for his precise attention to details and visual textures, even in the highly demanding medium of tempera.

onto it. These scratched outlines can sometimes be seen beneath the paint in the finished work. If there are to be gold areas in the work (as in **5.13**), they are covered with a light coating of red gilder's clay, **burnished** (rubbed) to a gloss. Extremely thin leaves of gold are applied over the gilder's clay in layers, each of which is also burnished. As the gold leaf wears off, patches of the red gilder's clay underneath may show through.

Then comes underpainting. Most areas are first underpainted with a base tone of their local colors. But to keep flesh tones from appearing too flat, the painting guilds of the Middle Ages worked out a system of underpainting flesh passages with *terre verte* (green earth). In the final layers of the painting, the flesh areas are covered with pink pigment; the bits of green that show through make the complementary reds of the skin seem more vibrant. A faintly greenish cast that persists can often be seen in the finished work.

It is so difficult to create lively, fresh paintings with tempera that most artists eventually switched to

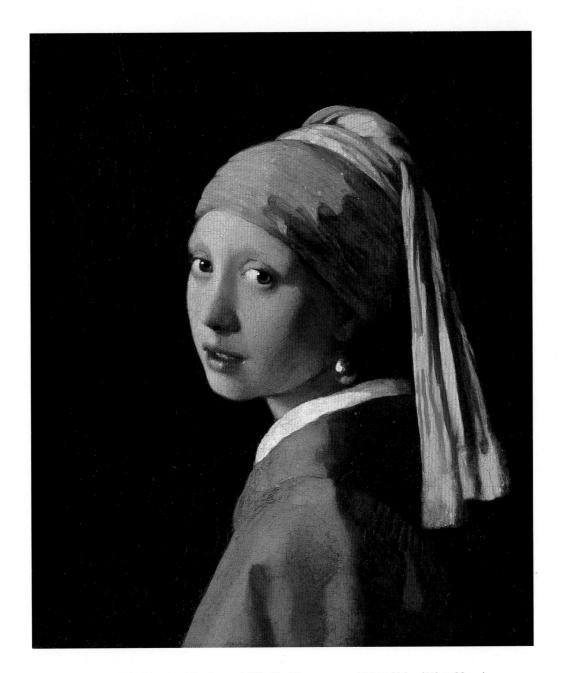

5.15 Jan Vermeer, *Girl with a Pearl Earring*, c. 1665–66. Oil on canvas, 44.5×39 ins $(113 \times 99 \text{ cm})$. Stichting Vrienden van het Mauritshuis (no. 670), The Hague, Netherlands. *Jan Vermeer was one of the seventeenth-century Dutch masters who applied their great skill with oil paints to the realistic but almost reverent depiction of everyday subjects.*

oil paints. But a few contemporary artists still use this old medium quite skillfully, most notably Andrew Wyeth (5.14).

OIL

Tempera is a uniform thin film. By contrast, paint that uses oil as a binder for pigment can be piled up thickly and dries very slowly, allowing the artist to blend colors right on the canvas. The use of oil paints by artists began in the fifteenth century, opening great vistas to painters. Now they could simulate textures, portray

the effects of light and shadow, model three-dimensional forms, add tiny bits of colors as highlights, and work from the darkest to the lightest tones without losing the brilliance of the pigments.

Vermeer's *Girl with a Pearl Earring* (**5.15**) is sparkling and lush in its use of color. The girl's garments are softly modeled, and her face glows with a fresh brilliance that can be seen now that the canvas has been cleaned and restored to what are considered its original colors (but see pages 232–33 for a discussion of the controversies surrounding restorations).

Cleaning and Restoring Paintings

OVER THE CENTURIES, great paintings are vulnerable to damage by aging processes, dampness, and filth. They may be further damaged by the methods used by restorers to attempt to clean and repair their surfaces. And attempts to repaint areas that are damaged are inevitably controversial, for restorers, no matter how skillful, do not have the rare talent and aesthetic judgment of the original masters.

Attempts to clean and restore great paintings are now undertaken with considerable caution. Restorer Pinin Brambilla Barcilon worked on a miniature scale for over twelve years trying to bring Leonardo da Vinci's The Last Supper (3.32) back to life as the master had originally painted it. Such restorations are now matters of high technology, including infrared and ultraviolet photographic analyses of what lies beneath the surface, and microscopic examination of paint chips to determine their layers. Even so, the restorer's task is quite daunting and, in some cases, nearly impossible.

The Last Supper is a restorer's nightmare. It is painted on a wall in the convent of Santa Maria delle Grazie, but it is not a fresco. Leonardo had apparently treated the wall as if it were a wood panel and painted it in tempera on a pitch and mastic ground. Art historians speculate that this approach allowed Leonardo to work at his own pace and make corrections to the painting, whereas fresco cannot be handled in this way. But soon after its completion in 1497, the paint surface began to decay and crumble off the refectory wall, due to dampness from a spring 20 feet

(6 m) below the wall. To try to save the masterpiece, it was repainted twice in the eighteenth century and three more times in the nineteenth century. It is thought that what then remained to be seen was only 20 percent Leonardo's work; the rest was painted by restorers.

How can anyone, even working with the most sophisticated of means, now be sure what the original looked like? The surface of the mural has disintegrated into myriad delicate flakes, each no bigger than a grain of rice. No single pattern can be discerned in the layers of the flakes after the painting has been reworked with different painting approaches and additions of glues, waxes, and lacquers. "There is an incredible variety of materials in the painting, meaning that a cleaning technique that might have worked in one section could be totally ineffective or even harmful a few centimeters away,"2 says Brambilla.

Despite the treacherous difficulties, Brambilla claims that repainters' work is easily distinguished from Leonardo's original painting when each flake is examined under a microscope, cleaned, and then reattached to the wall. It has thus been determined that the roof beams as shown in Figure 3.32 are the work of a repainter; Leonardo's beams are actually in a different place, beneath the ceiling that was apparently added to the painting in the eighteenth century. The restored painting of the figures is also different, more three-dimensional than earlier repaintings. Are we now seeing the true hand of Leonardo

revealed afresh or the hand of the latest restorer at work?

The question of authenticity has brought great controversy into some restoration projects. Most notably, controversy raged throughout the major twentieth-century restoration of the Sistine Chapel ceiling in Rome (16.18). Opponents of the project particularly object to the newly brilliant but rather flat and simple colors, convinced that they are not those originally used by the artist. As we will see in Chapter 16, critics also assert that the new cleaning has removed delicate a secco overpaintings by which Michelangelo had finished the modeling of his figures and added details. Supporters of the restoration claim that Michelangelo worked only in the best buon fresco tradition, with very little a secco overpainting, so that nothing significant has been lost during the restoration, and that the newly cleaned fresco reveals Michelangelo's extraordinary use of color.

Even routine removal of aged varnish to clean the surface of paintings may engender controversy. Artists have traditionally used varnish on their paintings to protect the surface and keep the underlying image clean. The idea was that the varnish would be removed from time to time, again revealing the clean surface, which would then be revarnished. The varnish itself would get dirty and change color as it aged, usually turning yellow. Grays and greens then tend to look brown, and blues turn green. Other materials have accumulated on top of the yellowing varnish. In addition to being darkened by the soot from the

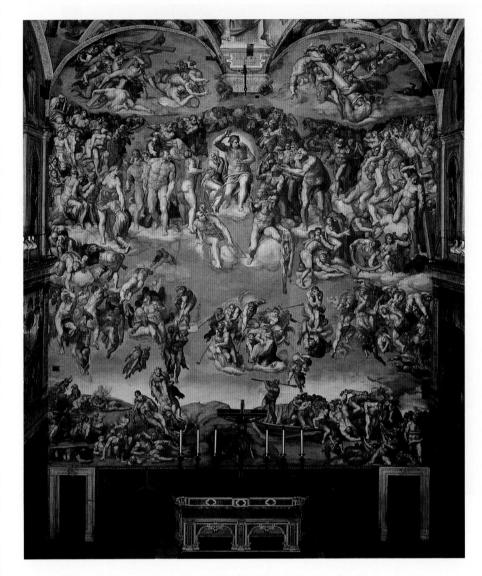

5.16 Michelangelo's *Last Judgment*, end wall of the Sistine Chapel, after latest restoration (completed c. 1994). Vatican City, Rome.

candles of the devout, church paintings in Italy and elsewhere were often rubbed with bacon rind before major holidays. To remove these coatings without harming the glazes of the painting itself is very difficult. Even water brushed lightly over the surface may dissolve glazes as well as varnish.

Leonardo's Mona Lisa is extremely dirty, as you can see in Figure 2.95, but it is otherwise in good condition and is only dusted lightly each year. Cleaning has been eschewed to avoid outraging a public who are accustomed to the painting as it is, with thick yellowed varnishes. A clue to its original colors is revealed when

Mona Lisa's frame is annually removed for dusting: a clear blue color can be seen on the untrimmed and unvarnished edges of Leonardo's painting of the sky. Elsewhere the built-up layers of varnish are reportedly a quarter of an inch (0.63 cm) thick. The Louvre's chief curator of paintings, Pierre Rosenberg, explains that the painting has not been cleaned because it was treated with reverence from the beginning and thus escaped harmful restorations. Now, he says, "We are not afraid of the job-it's a simple procedure—but of reactions nationally and internationally."3 When other oil paintings by

Leonardo have been restored, it has been discovered that he worked with extraordinarily fine strokes, some as minute as 0.0013 of an inch (0.03 mm), and sometimes he blended areas with his fingers for a soft-focus *sfumato* effect.

Public reactions and technical difficulties in rejuvenating a masterwork are not the only problems in restoration. Aesthetics may be lost in the process. Art history Professor James Beck of Columbia University argues that, especially in the case of the restoration of Michelangelo's huge Last Judgment fresco on the end wall of the Sistine Chapel, restorers have worked piece by piece among scaffolds and thus have lost the aesthetic harmony of the whole. Beck explains:

"The fundamental problem was that no viewing distance was possible. Seen at arm's length, the oversized details, segments, and fragments were overwhelming but fundamentally misleading."

After four years of section-bysection work, the scaffolds were
removed and the restoration
unveiled. According to Beck, it was
a "garish and disharmonious"
mistake. No consistent light source
remained, and the figures appear
flat, with loss of the modeling effects
of careful differences in value.
Another loss, claims Beck, is
Michelangelo's shifting use of
outlines sometimes as borders and
sometimes as shadows. Figure 5.16
shows the entire Last Judgment after
its recent restoration.

5.17 Antonio Correggio, *Danaë*, c. 1532. Oil on canvas, $64\frac{1}{2}\times29$ ins (163.5×74 cm). Galleria Borghese, Rome.

It is known that Vermeer used costly ultramarine, made from the semi-precious stone lapis lazuli, as a blue-green pigment. He also created delightful highlights on the girl's lips, earring, and eyes by placing dots of light-reflecting paint on the surface of the painting.

Using oils, artists could work with optic realism, for, as they began to recognize, we do not necessarily see figures distinctly. Unless the air and light are very clear, colored areas may blend together visually. In Tintoretto's *Leda and the Swan* (3.12), which was painted entirely in oils, the attendant's dress merges into the dark tones of the background, as do Leda's left arm and hair, emphasizing her radiant torso as the central focus of the painting.

This radiance or luminosity is another special characteristic of traditional oil paintings. The flesh of Correggio's *Danaë* (**5.17**) actually seems to glow. Even the shadows glow with life. These striking effects were

the result of underpainting and then overpainting with layers of glazes (films of pigments suspended in a transparent medium) to build up color tints and details of form. A very light passage, such as Danaë's body, might be thickly underpainted with white and then glazed with skin tones; a dark passage such as the shadows of the room might be underpainted with brown and then glazed with thin layers of a darker gold-brown.

An unfinished painting by Leonardo da Vinci (5.18) allows us to see how he has blocked out certain areas by underpainting before building up details and enriching the luminosity and complexity of the surface with glazes. The painting appears much flatter than his completed works, such as *The Virgin of the Rocks* (15.26). Underpainting and then overpainting with glazes deepens the shadows of dark areas and also gives more power to lighter and brighter pigments. Layers in complementary hues may also be used to create a more

5.18 Leonardo da Vinci, *The Adoration of the Magi*, begun 1481 (unfinished). Underpainting on panel, 8 ft \times 8 ft 1 in (2.44 \times 2.46 m). Galleria degli Uffizi, Florence.

lifelike color sensation, with a layer of green glaze over red underpainting, for instance.

Oil paint is itself luscious and can become part of the visual focus of a work. Sharon Booma's *Blue Divide* (5.19) reveals the vitality and flexibility of the medium. Color passages are built one atop the other, by scumbling (brushing one opaque layer of paint on top of a dried lower layer in such a way that some of the undercolor still shows through) and heavy impasto strokes that leave such a thick deposit of the medium that the strokes of brush or palette knife are recorded as an actual texture on the surface. When layered wet, oil colors can be blended; if the underneath hue is to be kept the same, it is allowed to dry before the next layer is applied.

Blue Divide is an abstraction that begins with Booma's Nebraska countryside. We see hints of barns, fields of grain, perhaps water or dark sky. But her handling of the oil paint creates an impression that transcends the material world. She says:

My work is representative of the effort to find a balance between the tangible materials that surround us and the ungraspable spiritualism that defines us as individually unique people. Each piece is a new attempt to corral the undefined—the amorphous areas—by the more precise structural boundaries of both the canvas and the painted forms themselves. Additionally, because I am creating a surface that is rich in texture, I am adding a history to the painting. The combined effect is one that attempts to simplify the visual image but is complex in its beauty.⁵

Whereas Booma has painted on board, when canvas is the support, a layer of **sizing**, traditionally derived from animal skins, is typically given to reduce its absorption of the paint. A ground, white or tinted,

5.19 Sharon Booma, Blue Divide, 2000. Oil and mixed media on board, 96×96 ins (243.8 \times 243.8 cm). Courtesy of the artist.

of white chalk, warm glue, and water ("glue gesso") or white pigment in linseed oil is often applied to the surface before painting, giving it a characteristic overall tone. The oil paint is then applied in various methods: the artist may first draw important outlines on the support, or, in the direct or *alla prima* method, paint all the colors and details in a few sessions or a single session. In the indirect method, the artist works in steps, painting one color or object, letting it dry and then adding a glaze.

Highly saturated hues in prepared tubes of paint were a nineteenth-century innovation. Earlier oil paintings were built on a more subdued palette created from natural pigments, ground and mixed with oil by apprentices who devoted years to learning how to formulate paint. Even then, some of the formulas have not held up with time. For instance, in the fourteenth and fifteenth centuries it was a common practice to mix or glaze ultramarine blues with red lake (a pigment made from a dye) in order to paint lush purple

robes for Jesus and Mary. The red lake was unstable, so after some time only the blue hue was left. Similarly, in the late fifteenth century, verdigris (a natural green pigment made from copper or brass) was commonly mixed with resins. The resins have unfortunately turned the paint black as they decomposed, changing what was probably green foliage in Italian landscape paintings into dull areas of dark brown or black.

WATERCOLOR

An extremely fluid and transparent medium—water-color—is created when pigments are bound with a water-soluble binder such as gum, thinned with varying amounts of water, and applied to paper. The white of the paper is usually allowed to shine through the thinned pigment in some areas. Whereas the white usually appears as the background against which images have been worked, Richard Lytle brings the white into the foreground as the color of flower petals

in his *Spring Thaw on Goose Pond* (**5.20**). Note how well watercolor adapts itself to portraying the transparency of water and sky here, with one tone blurring into another.

Although watercolor can be applied with a "dry brush" it is generally a very runny medium, so hard to control that Lytle's tight rendering is exceptional. Watercolor cannot be extensively corrected and reworked like oil paint, so the artist is committed to each stroke, which must be made quickly, before the paper dries. This necessity becomes a virtue in the hands of artists such as Turner, whose *Looking out to Sea: A Whale Aground* (5.21) uses the medium's liquid freedom of gesture and transparent airiness to the fullest. The heaviness of the whale is barely suggested by the shadowed area in this powerful and free abstraction.

A more traditional approach to watercolor is exemplified by Winslow Homer's *The Gulf Stream* (5.22).

5.20 Richard Lytle, Spring Thaw on Goose Pond, 1986. Watercolor, $30 \times 41 \frac{1}{2}$ ins (76.2 \times 105.4 cm). Courtesy of the artist.

5.21 (opposite) Joseph Mallord William Turner, *Looking out to Sea: A Whale Aground*, 1845. Pencil and watercolor on paper, $9\% \times 13\%$ ins (23.8 \times 33.5 cm). Tate Gallery, London.

The paint looks very wet, as if freshly painted, but bleeding into the paper and blending of colors are carefully controlled, with the white of the paper revealed as a significant design element. In this transparent handling of the watercolor, the shark in the foreground blends almost invisibly into the water surrounding the storm-damaged boat.

GOUACHE

In contrast to the transparency of watercolor, **gouache** is an opaque medium. It, too, is water-soluble, but in this case it is mixed with inert pigments such as Chinese

zinc white or chalk for opacity, with gum arabic as the binder. This combination makes painting with gouache feel like spreading not quite melted butter, in contrast to painting with oils, which flow like melted butter. Some artists use opaque gouache passages to strengthen their otherwise transparent watercolors: some paintings referred to as "gouache" are actually watercolors painted over an opaque white ground.

Gouache cannot be piled up like oil paint, for it will crack if heavily built up. But it will stay opaque as it ages, rather than becoming more transparent as water-color tends to do. This means that it can be worked over a colored ground and be counted upon to cover it thoroughly.

In *The Crow Who Wanted to be an Eagle* (**5.23**), Marc Chagall has painted gouache in brilliant hues on brown paper. This unworked ground is allowed to

5.22 (opposite, below) Winslow Homer, *The Gulf Stream*, 1899. Watercolor, 11¾ × 20 ins (28.9 × 50.9 cm). Metropolitan Museum of Art, New York, Catharine Lorillard Wolfe Collection, Wolfe Fund, 1906. *In this transparent handling of the watercolor, the shark in the foreground blends almost invisibly into the water surrounding the storm-damaged boat.*

5.23 Marc Chagall, *The Crow Who Wanted to be an Eagle*, 1926–27. Gouache, 16×20 ins (40.8×51.5 cm). Leon Dierx Museum, Réunion Island (West Indian Ocean).

THE WORLD SEEN

Tibetan Sand Paintings

SEVERAL OF THE WORLD'S cultures have developed an extraordinary form of "painting" in which materials of various hues are laid on a horizontal surface in solid form, without any liquid medium. Among these are the sand paintings of the Navajos, the auspicious rangoli designs on the earth of rural India, yantras constructed by Hindu priests, and sand mandalas created by Tibetan Buddhist monks. The different colors are supplied by ground stones, flowers, herbs, or grains such as rice and brightcolored lentils. Typically these materials are used to create radially symmetrical designs. The creation of the work is a consecrated ritual act; the finished artwork may be considered ephemeral and purposely destroyed.

The creation of elaborate Tibetan sand paintings is itself a meditative practice, for it requires intense concentration and a high level of spiritual development, as well as artistic skill. According to the teachings of the Buddha, one should cultivate a clear mind, an accurate perception of things as they are, and pure behavior. One should not harm others but rather seek to help them and recognize the interdependence of all life. This realization comes through years of meditation practice, which in the Tibetan version of Buddhism includes concentration on various deities.

Creation of the elaborate sand paintings is a sacred and traditionally secret way of evoking the deities. In recent years, this elaborate procedure has occasionally been performed in public settings in order to bring attention to Tibetans' desire for political independence, to initiate witnesses into higher levels of Tibetan Buddhist practice, and to heal life on earth.

The Tibetan sand paintings take the form of mandalas, circular symbolic designs. Meanings of these diagrams can be read on various levels. On an outer level, the iconography symbolizes the divine nature of the world—the cosmos and its forces, and the abodes of the deities. On an inner level, mandalas represent the process by which the mind is transformed and enlightened. On the secret esoteric level, the diagrams represent the spiritual adept's balance of the body's subtle energies and the clear light of the mind.

These mandalas were traditionally made of bright stones, ground to fine sand, but are today often constructed of white marble which has been ground and dyed with bright pigments. Fourteen colors are used: black, white, and light, medium, and dark values of blue, red, yellow, and green.

Creation of the mandala begins with laying out the basic geometric pattern, using a ruler, compass,

strings, and white ink. Monks work as a group surrounding the center, each laying down bits of the intricate pattern by grating a metal rod against a long metal funnel, creating vibrations that cause the colored sand to flow like liquid from the funnel (5.24). Over a number of days, they gradually work outward to the perimeter, just as human life originates in an egg that divides and grows in a process that can be seen as extending to embrace the entire cosmos. The monks' hands and minds must be perfectly aligned with the work in order to create its elaborate symmetries without mistakes and without shaking the fragile sand patterns which have already been deposited.

Creation of a sand mandala is thought to have a transformational effect on the patrons, participants, observers, and surroundings, for the local spirits and deities are thought to be so pleased that they shower the area with light. All its purposes accomplished by the process of creation, the completed mandala is then swept together from the outer perimeter to the center, like the indrawing into the source of life at the time of death. The gathered sands are then placed reverently in a body of water, thus dedicating the positive energies of the mandala to goodness in the universe.

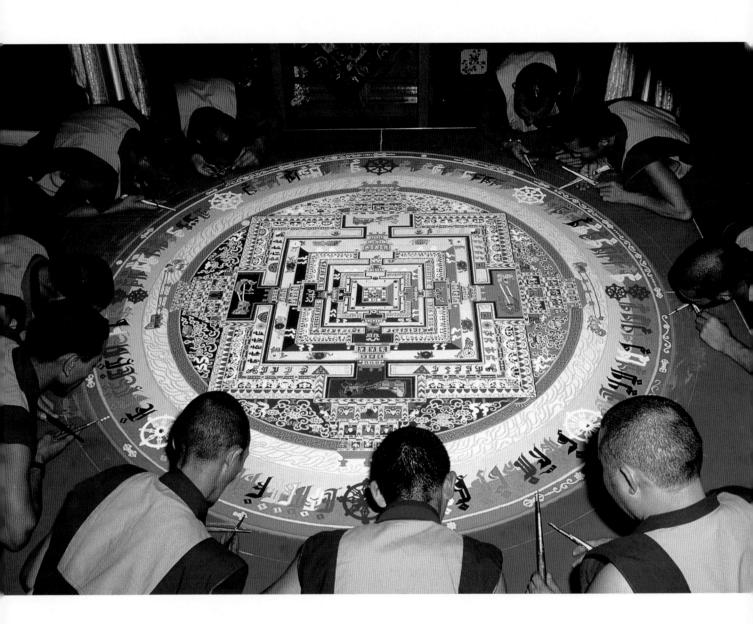

5.24 The Kalachakra (Wheel of Time) Sand Mandala. Grains of colored sand, constructed during a twelve-day ritual by monks from the Dalai Lama's Namgyal Monastery, Dharamsala, India.

5.25 Bill Martin, Abalone Shells, 1982. Gouache, $11\frac{7}{8} \times 15\frac{3}{4}$ ins $(30.2 \times 40 \text{ cm})$. Courtesy of the artist.

show through here and there, but where it has been painted, the brown does not dim the brilliance of the yellow and blues. Chagall has handled the medium in flat folkloric fashion to depict this traditional fable.

Gouache is quite flexible, however, and can also be used to create realistic illusions of depth and form. The artist using gouache can also paint light colors over dark without bleed-through. In Bill Martin's *Abalone Shells* (**5.25**), a tour de force of realistic gouache painting, light highlights sit atop darker areas.

Gouache dries very quickly by water evaporation, in contrast to oils that dry slowly by oxidation. Gouache is usually painted in immediate, spontaneous, direct ways as in the Chagall. Wet can so soon be painted over dry that blending of adjacent colors is difficult. The paint is also flat and non-reflective. Despite these characteristics of the medium, Bill Martin has painstakingly juxtaposed soft-edged areas of similar hues to create striking pearlescent illusions of glossy, light-reflecting surfaces. The opaque gouache gives the shells a convincing solidity: even the paint has the appearance of thickness. This is a special characteristic of gouache. Even though it cannot be built up deeply like oils, it forms a film of paint on a surface, unlike watercolor, which sinks into the paper.

SYNTHETICS

Several decades ago, synthetic media, created chemically rather than derived from natural substances, were introduced as part of the artist's tool kit. The form most used today—called acrylic emulsion, or acrylics —is a water-based medium that can be used straight from the tube with techniques similar to those of oil paints, thinned and blown out as a fine spray through an airbrush, or thinned right down to the consistency of watercolor. Acrylics dry quickly, and for this reason are preferred by some artists to oils. This property not only allows the artist to complete a painting quickly, but also makes it possible to create special effects, such as painting hard-edged shapes by laying a line of masking tape over previously painted, already dried areas. Even without tape, acrylic stops where the brush stops, unlike oil, which spreads slightly into the canvas. A retarder may be added to extend the period during which the acrylic paint is workable.

Very bright, pure colors can be formulated with synthetics; without the pigment, the medium itself would dry clearer than glass. The colors do not yellow with age, as oils tend to do. Acrylics are also permanent and fade-proof; in theory, even if the support rots away, the acrylic paint won't. Its molecular structure is

similar to that of the superglues, so it has tremendous bonding power and can be used on many different grounds. Not all artists have switched from slow-drying oils to acrylics, however, for acrylics have a different feel and optical quality and are less easy to blend on the canvas. They do not have the sheen of oils, and whereas oils flow from the brush like softened butter, acrylics have a slight drag.

Airbrushing with acrylics can be used to create very even gradations in value. As used by some fantasy illustrators and commercial artists, these transitions are flawless rather than more realistically irregular. But by precisely controlling the gradations, Chuck Close is able to create photorealistic human heads of monumental proportions, such as his *Frank* (**5.26**), which is nine feet (2.75 m) tall. Close begins with a photograph, which he blows up and transfers to the canvas by a grid system and then re-creates in minute detail, complete with facial blemishes and slightly fuzzy areas where the close-up photograph was out of focus.

Helen Frankenthaler's *Hint from Bassano* (**5.27**) demonstrates how synthetic paints behave when thinned to the consistency of very fluid watercolors. The paint can get so runny that Frankenthaler often works with her canvases on the floor rather than on an easel. Unlike watercolors, acrylics can be painted in

5.26 Chuck Close, *Frank*, 1968–69. Acrylic on canvas, 7 ft \times 9 ft (2.13 \times 2.75 m). The Minneapolis Institute of Arts, Minneapolis, Minnesota. The John R. van Derlip Fund.

5.27 Helen Frankenthaler, *Hint from Bassano*, 1973. Acrylic on canvas, 7 ft 1 in \times 18 ft 11½ ins (2.16 \times 5.77 m). Collection of Mr. and Mrs. David Mirvish, Toronto, Ontario.

layers, allowing the preservation of the hue of an underlayer rather than the blending that occurs when two watercolor hues are laid on top of each other wet. Frankenthaler's thinned acrylics sink into the unsized canvas and become part of that ground itself, rather than sitting on top of it. She had earlier used a similar technique with oils thinned with turpentine, but the turpentine left a halo where it spread into the canvas. The striking freshness of the results is a quality for which she aims:

A really good picture looks as if it's happened at once. It's an immediate image. For my own work, when a picture looks labored and overworked, and you can read in it—well, she did this and then she did that, and then she did

that—there is something in it that has not got to do with beautiful art to me. And I usually throw those out, though I think very often it takes ten of those over-labored efforts to produce one really beautiful wrist motion that is synchronized with your head and heart, and you have it, and therefore it looks as if it were born in a minute.⁶

COLLAGE

A relatively new art form, introduced in 1912 by Picasso, is **collage**. Though technically classified with paintings, a collage does not necessarily involve the

5.28 Layers in painting: various techniques.

General method commonly used in Europe after the 1600s	Claude Monet	Helen Frankenthaler
Support: canvas or wood	Support: canvas	Support: raw, unsized canvas
Gesso	Pale gray, cream, or beige ground	Acrylic paints thinned to watercolor consistency, sinking into and blending with the canvas
Oil paint, beginning with dark ground	Broad areas of local color using thin, opaque, scumbled oil paint	
Glazes (thin layers of pigment in transparent medium, with lighter colors over the dark ground)	Layers of oil paint, brushed as a web of colors over the partially visible lower layers	
Varnish to protect the painting		

5.29 Kurt Schwitters, *Merz 19*, 1920. Collage on paper, $7\frac{1}{4} \times 7\frac{5}{8}$ ins (18.4 × 14.7 cm). Yale University Art Gallery, New Haven, Connecticut.

application of paint to a surface. Rather, it is built up two-dimensionally, or as a relief, by selecting and gluing to a surface varying flat materials. For the artist, it is exciting to collect materials that are interesting in themselves—such as old documents and drawings—and then combine them into an effective whole. Having ready-made areas of colors, textures, and shapes that can be physically moved around allows a very experimental approach to design. One item compels the artist to lay another next to it. For the viewer, the excitement comes first in responding to the work as a whole and then trying to figure out the original identity of its parts. As in a successful recipe, one does not at first notice the different spices used as ingredients.

Kurt Schwitters, a master of collage, often used bits of paper with writing or printing that read first as abstract design elements and then, as one examines the work more closely, as cryptic clues to meaning. Schwitters was working in the period after World War I in Germany, where inflation was so great that stamps were overmarked from 5 marks to 5 million marks, and money was so worthless that houses were wallpapered with banknotes. But Schwitters has given these discarded fragments of a disordered life a kind of dignity by the way in which he has put them together.

In a successful collage, such as Merz 19 (5.29), the fragments appear to be spontaneously laid down but are actually chosen and juxtaposed very carefully.

5.30 Detail of Alexander the Great from *The Battle of Issus*, 2nd to 1st century B.C. Mosaic, 8 ft 11 ins \times 16 ft $9\frac{1}{2}$ ins (2.72 \times 5.13 m). Museo Archeologico Nazionale, Naples. From a distance, the many small tiles used to create a mosaic blend optically to give the impression of value changes as light falls across three-dimensional figures.

If one more thing were added to this collage, it would be too much; if one thing were subtracted, its visual unity would fall apart.

Collage is sometimes used as a medium that bears the message in itself. The fact that it is made of found bits of this and that is often used to refer to the industrial throw-away society and its victims.

MOSAIC

An ancient and long-lived technique for creating two-dimensional imagery, **mosaic** is composed of small pieces of colored ceramic tile, glass, pebbles, marble, or wood. These are embedded in cement along the surface of a wall, floor, or ceiling of a building. The subtleties possible with this process are illustrated by *The Battle of Issus*, an impressive Roman mosaic that was buried by the eruption of Vesuvius in A.D. 79 and not unearthed until the eighteenth century. The image is a lively depiction of Alexander the Great's defeat of the Persians, with the Persian King Darius in retreat in his chariot. Its vigorous realism seems all the more surprising when we recognize that the colors are composed of small **tesserae**, cubes of natural stone that can readily be distinguished in a detail view (**5.30**) but not

from a distance. The hues are limited to black, white, yellow, and red, but stones of varying values in each hue have been used to suggest spatial modeling and to provide details for the forms.

Mosaics were common in the early civilizations of Sumeria, Greece, and Rome and were used to decorate early Christian and Byzantine churches until the fourteenth century, when the cheaper medium of fresco was introduced. But the technique has not been lost. Mosaic work still plays an important role in Muslim mosques. And visionary architect Lluís Domènech i Montaner used it lavishly and playfully in the decoration of architectural structures such as pillars in his Palau de la Música Catalana in Barcelona (5.31). An exhilarating feast for the senses, the building borrows from the Byzantine, Moorish, and Gothic styles of Catalonia's past. The architect's exuberant use of the mosaics on the pillars almost negates their function. Pillars are usually convincingly solid visual evidence that they are holding up heavy structures. We don't expect them to appear so flowery and airy as these do. Here the tiles are much larger than in the Roman mosaic and no attempt is made to hide their identity as individual pieces.

5.31 Lluís Domènech i Montaner, balcony of the Palace of Catalan Music (Palau de la Música Catalana), Barcelona. Completed 1908.

5.32 Robert Rauschenberg, *Monogram*, 1959. Stuffed ram, automobile tire, collage, and acrylic, $4 \times 6 \times 6$ ft (1.22 \times 1.83 \times 1.83 m). Moderna Museet, Stockholm.

Mixed Media

Art forms no longer fit neatly into the traditional categories. We live in a period of great experimentation with all media, and some artists are introducing media and art forms that have never existed before. Often media are mixed, crossing all previous boundaries. Robert Rauschenberg gleefully mixes media, combining fine art techniques such as painting and printmaking with a great variety of ready-made and partially altered bits of popular culture, in ways

that suggest meaning, even if one cannot be quite sure what it is. His *Monogram* (**5.32**) features a stuffed ram within a tire mounted on a base of Abstract Expressionistic paintings. Rauschenberg says the point is to:

begin with the possibilities of the material and then you let them do what they can do. So that the artist is really almost a bystander while he is working. The hierarchy of materials is completely broken down.⁷

Printmaking

METAL CONCEPTS

What is printmaking?

The techniques of printmaking processes—relief, intaglio, planographic printing, stencil, modern technologies

Why artists choose particular processes to create art

Mixing printmaking and other media

6.1 Hokusai, *Southerly Wind and Fine Weather*, late 1820s. Woodblock print, $10\times14\%$ ins (25.5 \times 37.5 cm). British Museum, London.

THE JAPANESE PAINTER and woodblock print-maker Hokusai is most famous for his landscape prints, including forty-six multicolored prints of Mount Fuji seen from many different perspectives. The view shown here (6.1) uses stylized simplification of natural cloud and tree forms into flat shapes and a limited palette of hues, creating a unique atmosphere that expresses the respect of the Japanese people for their most-loved mountain.

The color woodcut print was highly developed in Japan as a way of illustrating popular picture books. Hokusai created tens of thousands of such prints, each

6.2 Antonio del Pollaiuolo, *Battle of the Ten Nude Men*, c. 1460. Engraving, $15\frac{1}{8} \times 23\frac{1}{4}$ ins (38.4 \times 59 cm). Metropolitan Museum of Art, New York. Purchase 1917, Joseph Pulitzer Bequest.

of which was reproduced in multiples and usually sold very cheaply. These mass-produced *ukiyo-e* woodcut prints were quite popular, but nonetheless the artist was poor most of his life. They were not considered fine art until pages from one of his illustrated books turned up in Paris in 1856 as packing material for a shipment of valued porcelains. Thereafter the artfulness of his majestic prints had a considerable influence on artists such as Gauguin, van Gogh, and Toulouse-Lautrec.

As the images in this chapter illustrate, many great artists have developed expertise in printmaking techniques, extending the aesthetic potential of these unique media. **Prints**—images made by transference of ink from a worked surface onto a piece of paper, usually in multiples—were originally used as illustrations in books and other kinds of printed matter. Books, in turn, were largely dependent on the appearance of inexpensive, readily available paper. Aside from handillustrated, one-of-a-kind treasures, books were illustrated with images printed from durable blocks of wood, metal plates, or stones worked by hand. Even after photomechanical methods of reproduction removed this need for prints, the printmaking arts

6.3 Battle of the Ten Nude Men (detail), c. 1460.

continued to be practiced, for prints became valued as artworks in themselves. Now artists can print a limited edition of an image and sell each one as an original.

6.4 Mary Frank, *Untitled*, 1977. Monotype on two sheets, printed in color, $35\frac{1}{2} \times 23\frac{13}{16}$ ins (90.2 × 60.4 cm). Museum of Modern Art (MOMA), New York. Mrs. E. B. Parkinson Fund.

Approaches to Printmaking

Processes used for the creation of transferable images allow great variety in artistic styles. Some prints are similar to tightly rendered representational drawings. Antonio del Pollaiuolo's influential *Battle of the Ten Nude Men* (6.2) is a highly skilled example of this approach. All of the muscular human forms and foliage in this line engraving are built up through a series of small lines, as shown in the detail view (6.3). The painstaking effort involved in making such a work is not immediately evident because of the great vigor of the image as a whole. Pollaiuolo's skill as an engraver apparently derived from his training as a goldsmith, but his genius in conceiving this dramatic composition of opposing lines far transcends mere manual skill.

Printmaking has usually been defined as a method for creating multiple identical copies of an image by repeatedly inking and printing a worked plate. An alternative introduced in the seventeenth century is monotype, a printmaking process in which the artist paints an image directly onto a sheet of metal or glass with printer's ink or paint and then presses paper onto it to transfer the image. Some ink or paint may be left on the surface, as a ghost of the image which can then be reinked and reprinted. Each time the image may change slightly, so no two monotype prints will be exactly alike. And the fact that the artist is printing and improvising freely, perhaps even wiping off areas with turpentine and adding something else, rather than scratching fixed lines, gives the monotype an entirely different quality from other prints, as is evident in Mary Frank's soft and fresh rendering of an amaryllis in bloom (**6.4**).

Another departure from traditional definitions of printmaking is the possibility of making an image that is transferred without any ink. Covers of some books are **blind embossed**, pressed against an uninked cut plate of metal to create an image that can be seen only when it is turned against the light to bring out the shadows in its indentations.

There are many ways of preparing a plate to be printed. Most can be grouped into four major categories: relief, intaglio, planographic, and stencil. Each is explored below.

Printmaking Processes

RELIEF

In a **relief** technique, a block of wood, metal, linoleum, or even a found object is carved so that lines and areas to be printed are raised above areas that will stay blank. A simplified diagram of the process is shown in Figure **6.5**.

The classic relief process is the **woodcut**. Typically, a drawing of the intended image is created on or transferred to a smooth block of soft wood—though some artists develop the image directly on the block, as they cut it. Everything that is to remain as an inked line or area is left intact; all other wood near the surface is carved away with a knife along the edges of lines. Large areas of wood are gouged away. All cut-away areas will

6.5 Cross-section of a relief block.

be shallower and will not pick up ink when it is applied to the surface with a roller. After the woodblock is inked, a sheet of paper is pressed onto it in such a way that it picks up, in reverse, the inked image.

Traditional European woodcuts used intricate lines of hatching and even cross-hatching to build up tones and textures, rather like ink drawings. Although it is much more difficult and indirect to carve wood away from lines than to draw them, this approach to the medium was handled with superb technical and aesthetic proficiency by Albrecht Dürer. Although Dürer was personally skillful at woodcutting, like many artists of the period he often prepared only the drawing, delegating the actual cutting of the block to some of the finest artisans of the time. Dürer's Saint Christopher (6.6) illustrates the range of tones and flowing lines these collaborators were able to coax out of the stiff, flat wood. Some were used as book illustrations; others were sold as single sheets so cheaply that the middle classes could afford to buy them.

6.6 Albrecht Dürer, *Saint Christopher*, 1511. Woodcut. Metropolitan Museum of Art, New York. Fletcher Fund 1919.

6.7 Antonio Frasconi, Portrait of Woody Guthrie, 1972. Woodcut, $23\frac{1}{2} \times 38\frac{3}{4}$ ins (59.7 \times 98.4 cm). From Antonio Frasconi, Frasconi–Against the Grain (New York, Macmillan Publishing, 1972).

Although the woodiness of the block is well hidden in Dürer's work, some contemporary artists have chosen to reveal the character of the wood. Different kinds of wood have very different grain patterns, which appear as lines in the printed areas. Wood from the beech tree and fruit trees—such as cherry, apple, or pear—is uniformly hard and even-grained. These woods are often used when the artist wants to create fine details that will stand up to hundreds of printings of the block and to avoid obvious grain lines. Certain species of pine, on the other hand, have wood that varies considerably in softness and hardness from one ring to another, producing strong grain lines that the artist may choose to exaggerate in order to create visual textures in the print. The grain may be heightened by scraping a wire brush across it so that it will be sure to print. In Antonio Frasconi's Portrait of Woody Guthrie (6.7), the woody quality is a quiet visual pun that accentuates the rough-cut, homespun character of the folk guitarist. The grain—which can clearly be seen running horizontally through the work—is also used to indicate tones and textures, in a rather serendipitous fashion. Whites with bits of grain printed through them become optically grayer.

Woodcuts can also be executed in colors, as in Joseph Raffael's Matthew's Lily (6.8), in which the image is composed of twenty-eight colors. The traditional way of adding extra colors—developed to a precise art by the Japanese ukiyo-e printmakers—is to cut a series of precisely matched blocks, each having only the area to be printed in a certain color raised as a printing surface. To match the blocks, a master or "key" block with the essential details is first cut and inked, and numerous reference prints are made from it. Areas that are to be printed in different colors are then indicated on these prints. These guides are glued face-down onto new blocks, one for each color, and everything except the intended colored areas is cut away. At the corners, beyond the edges of the print, registration guides are also cut to help in precise placement of the paper used for the final printing of the entire image. After all the blocks are cut, the same piece of paper is printed by each of the blocks, usually working from lighter to darker tones. The ink is somewhat transparent, and where two colors overlap they will blend. Interestingly, although Germany and Japan had little contact with each other until the midnineteenth century, their artists had devised very

6.8 Joseph Raffael, *Matthew's Lily*, 1984. Twenty-eight-color woodcut, edition of 50, 32×37 ins (81.3 \times 94 cm). Courtesy of the artist. Raffael is best known for his large watercolors of fish and waterlilies in water, painted in jewel-like tones that evoke a sense of meditation. Here he has applied the same appreciative aesthetic to the more intractable, indirect medium of the color woodcut.

similar ways of printing color woodcuts from a series of blocks. The chief difference in the result was the more delicate values of the Japanese prints, which were made with water-soluble rather than oil-based inks. As an alternative to the use of separate blocks, some woodcuts were hand-tinted, one-by-one.

When the end-grain rather than a lengthwise slab of wood is cut, the process is called **wood engraving**. The cross-section of a tree trunk is less likely to splinter than a lengthwise plank and can be incised directly with burins and gravers.

As Figure **6.9** indicates, wood engraving tools are solid rather than having grooved cutting lips like woodcutting tools. The engraved lines become areas

6.9 (Left) Wood engraving tools. (Right) Woodcutting tools.

ARTISTS ON ART

Stephen Alcorn on The Art of the Color Linocut

STEPHEN ALCORN IS a contemporary printmaker and painter whose work is often commissioned for applied art uses such as book covers. He explains his approach to the color linocut, as illustrated in *La Sabina Mitologica* (6.10):

"A print is in fact a 'mirror' image of the original drawing on the block. Consequently, the artist works in reverse, not only in the sense of one's orientation of left and right but in terms of the positive and negative elements as well, requiring considerable foresight on the part of the artist.

"Relief-block printing is a medium fraught with imposing constraints, but paradoxically, its constraints have forced me to be more resourceful and inventive as an artist. As poet Richard Wilbur remarked, 'The strength of the genie comes of his being confined in a bottle.' It is an often misunderstood yet fascinating medium, at once age-old and modern. I have embraced its virtues, as well as its inconveniences, enthusiastically.

"It is often assumed that linoleum is soft and easy to cut, but the particular material I use is, in fact, extremely hard and brittle, especially in cold weather. Possessing a smoothness worthy of polished hardwood, the density and hardness of this material permits me to achieve a degree of refinement more often associated with nineteenth-century wood engraving than with the primitivism of children's art. Linoleum does not possess a grain of its own; as a result, a clean jet black may be readily achieved. The challenge lies in trying to bring a barren, nondescript, uncut surface to life by the deliberate creation of texture. In this respect, linoleum is an unforgiving material. The prominent grain in a pine woodcut, for example, may serve to distract the viewer from shortcomings in one's draftsmanship. But there's an inevitable crystalline clarity to every mark you make in a linocut; there is no way of alleviating what is poorly drawn. Finally, what you cut away can't be put back. But it's precisely these qualities that give a good linocut its particular vigor and appeal.

"My initial experiments with color were rendered in just two-color—a pale background and a darker tone for the principal subject. Gradually, the color concepts became more complex. I found myself striving to achieve within the realm of printmaking the kind of sensuous gratification that I derived as a painter from the manipulation of color, glorious gradations of tone, and the use of different types of brushes and palette knives. In time, I found I could achieve analogous effects in my

relief-block prints by manipulating the use of the inks and rollers, and by using the cutting tools in such a way as to create the illusion of tonal gradation. These initial experiments soon led to a series of fresh technical and aesthetic discoveries—discoveries that I have yet to exhaust.

"Producing small editions of twelve to twenty-four, and striving for a delicacy, translucency, and gentle gradation of tone that would seem to be antithetical to the capacities of relief-block printing, I often alternate transparent, glossy, and opaque surfaces, and employ as many as twelve colors. I am apt to further exploit such painterly effects by printing white highlights of such density that they produce a rich impasto effect.

"Linoleum is a bold and healthy medium. It requires vigor, decisiveness, and solidity in drawing. And to experiment to find ways to enrich the initially barren uncut surface, to make it come to life, is very exciting."

6.10 Stephen Alcorn, *La Sabina Mitologica*, 1998. Linoleum relief-block print with rainbow inking, $16 \times 24\%$ ins $(40.6 \times 62.2 \text{ cm})$. Artist's collection.

6.11 Fritz Eichenberg, *Ecclesiastes*, "And in her mouth was an olive leaf," 1945. Wood engraving, 12×6 ins $(30.5 \times 15.2 \text{ cm})$.

that do not print, and are therefore white in the print. Wood engravings are typically conceived as white lines cut directly, rather than black lines from which the wood to either side has been cut away. The difference in these two approaches becomes apparent by contrasting Dürer's classic woodcut style (6.6) with the wood engraving of Fritz Eichenberg (6.11). Noah's beard, hair, and musculature are all described primarily with white lines within areas left black. Of wood engraving, Eichenberg says:

I have made thousands of drawings for many purposes, I have made many etchings and lithographs, but nothing can compare to the excitement when again I hold in my hand a beautiful block of close-grained, polished boxwood. I caress the silky surface before the burin touches it, digs in lightly, and then glides smoothly through the wood. A little curl rises from the groove in the path of the tool. I am in control, I am happy.

Wood engraving is a contemplative medium; it gives one time to think, to meditate, to listen to good music. As the graver cuts into the darkened surface, it creates light, order, beauty, out of a piece of a living thing, a tree perhaps much older than the artist himself. There are no shortcuts as the artist conjures out of a small square of wood a microcosm of life.²

Wood engraving was adopted for printing illustrations in books and newspapers until it was replaced by photographic methods at the end of the nineteenth century. When illustrations were needed quickly for new stories, a team of wood engravers who had been trained to use the same style were given different parts of an image to cut, and then their blocks were bolted together and printed as a unit. The engraved blocks could be clamped into place at the same height as type and the two printed together to make illustrated texts.

In the twentieth century, linoleum blocks were added to the printmaker's options. Linoleum cuts, commonly referred to as linocuts, lack the directional character of woodgrain. Lines can be cut equally smoothly and uniformly in any direction, and uncut areas can print in a strong solid black. When lines are made directly with a gouge, rather than being what is left after the surrounding wood is carved away, the image is often conceived as white lines within a black area, rather than vice versa. Lines tend to be free flowing and bold, reflecting the speed of the direct cuts. Although linoleum is easy to cut, it is also somewhat crumbly and cannot be used for ultra-fine lines. Linocuts have been eschewed by some serious artists because of their association with children's art, but using the medium well is actually quite difficult.

Some prints, such as wood and steel engravings, have historically been used as a means of reproducing works of art originally executed in other media. Picasso plays with this method in his color linocut *Bust of a Woman after Cranach the Younger* (6.12). It is

6.12 Pablo Picasso, Bust of a Woman after Cranach the Younger, 1958. Color linocut, $25\frac{1}{4} \times 21\frac{1}{8}$ ins $(64.1 \times 53.7 \text{ cm})$. Picasso did a series of linocuts based on old master paintings, bringing his own twentiethcentury artistic genius to bear upon the earlier images and compositions.

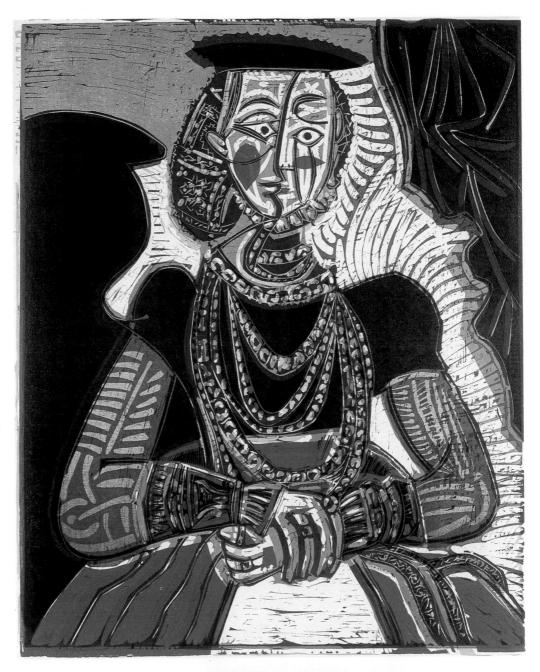

loosely derived from Cranach's sixteenth-century painting, *Portrait of a Woman* (6.13). Note that the linocut image is the mirror opposite of the painting; Picasso apparently worked it with the same orientation as the painting, but when the sheet was pulled off the inked block, the image was reversed. Picasso's linocut version is also obviously much more direct and playful. For the multiple colors of his linocuts he developed the **reduction print** method of continually cutting away areas on a single block, inking the surface a different color at each stage rather than cutting a series of registered blocks.

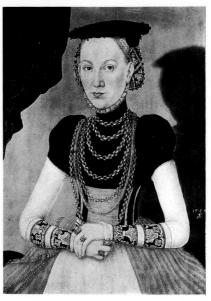

6.13 Lucas Cranach the Younger, Portrait of a Woman, 1564. Oil on wood, $32\frac{5}{8} \times 25\frac{1}{8}$ ins $(83 \times 64$ cm). Kunsthistorisches Museum, Vienna.

6.14 Cross-section of an intaglio plate.

INTAGLIO

The second major category of printmaking methods is **intaglio**, a term derived from the Italian word for engraving. As shown in Figure **6.14**, it is the exact opposite of relief techniques. In intaglio prints, the image is cut into the surface of a plate. Thin ink is applied to the plate with dabbers that force the ink into all the grooves. The plate is then wiped so that no ink remains on the surface, and a sheet of dampened paper is pressed onto the plate so that it picks up the ink that remains in the sunken areas. For special tonal effects or softening of the lines, the plate may first be rubbed lightly with a piece of gauze or muslin, lifting small amounts of ink from the incisions. To avoid

missing any part of the image, a strong roller press—traditionally hand-operated but now mechanized—is used for intaglio prints. There is a slight sculpting of the paper as it is pressed in a damp state into the grooves of the plate.

The earliest intaglio process developed was **line engraving**. In this relatively direct method, the image is drawn on a plate of metal such as copper or copper faced with steel, thus deriving the workability of copper plus the durability of steel for printing multiple copies.

A **burin** is used to cut the lines. This is a bevelled steel rod with a sharpened point and a wooden handle. A similar tool is used for wood engraving, which is a relief process. But because line engraving is an intaglio process, the ink is forced into the v-shaped grooves cut by the burin, and these become the printed lines.

Line engravings, like wood engravings, were traditionally used for illustrations and reproductions of works of art before photography took over this function. The translation of an image from one medium to

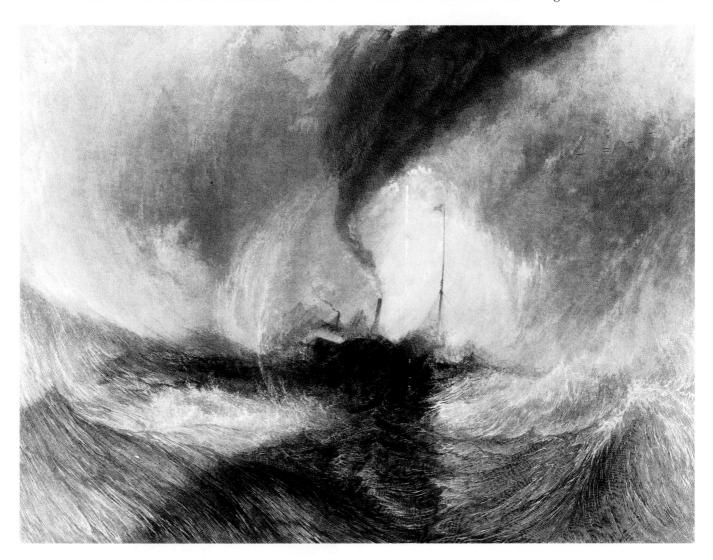

6.15 After Joseph Mallord William Turner, Snow Storm: Steamboat off a Harbor's Mouth, 1842. Steel engraving, 1891. British Museum, London.

6.16 Joseph Mallord William Turner, Snow Storm: Steamboat off a Harbor's Mouth, 1842. Oil on canvas, 36×48 ins (91.5 \times 122 cm). Tate Gallery, London.

6.17 Snow Storm. Steel engraving (detail of 6.15).

another is never precisely accurate. In the steel engraving (**6.15**) of Turner's oil painting *Snow Storm: Steamboat off a Harbor's Mouth* (**6.16**), the engraver has skillfully created a complete range of values from black to white, with many mid-tones, by engraving a tremendous

number of tiny lines that vary in width, length, and proximity to other lines, as shown in the enlarged detail of waves (6.17). But even though the values and shapes are similar in the reproduction and the original, the two versions differ tremendously in attitude.

6.18 Henri Matisse, Young Woman, Goldfish, and Checkered Cloth, 1929. Etching, printed in black, plate: $5 \times 7\%$ ins (12.8 \times 17.9 cm). Museum of Modern Art (MOMA), New York. Stephen C. Clark Fund. Purchased. Matisse's etchings deliberately eschew surface details to explore the inward "forms" of people through the linear quality of drawings.

6.19 Rembrandt van Rijn, *The Three Crosses*, 1653. State II. Drypoint and burin etching, on vellum, $15\frac{1}{8} \times 17\frac{3}{4}$ ins (38.4 \times 45 cm). Metropolitan Museum of Art, New York. Gift of Felix M. Warburg and his family.

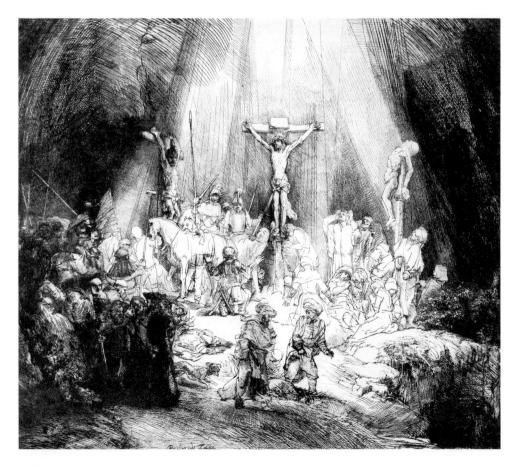

6.20 Rembrandt van Rijn, *The Three Crosses*, 1653. State III. Drypoint and burin etching, $15\frac{1}{8} \times 17\frac{3}{4}$ ins $(38.4 \times 45 \text{ cm})$. British Museum, London.

6.21 Rembrandt van Rijn, The Three Crosses, 1653. State IV. Drypoint and burin etching, $15\frac{1}{16} \times 17\frac{3}{4}$ ins $(38.4 \times 45 \text{ cm}).$ British Museum, London. Throughout all the states one can see the spirituality that suffused Rembrandt's work. He belonged to a pacifist Mennonite sect that based itself only on the authority of the Bible and whose members attempted to live by the teachings in Jesus' Sermon on the Mount. Thus his aesthetic imagination was given free rein rather than being constrained by any ecclesiastical authority.

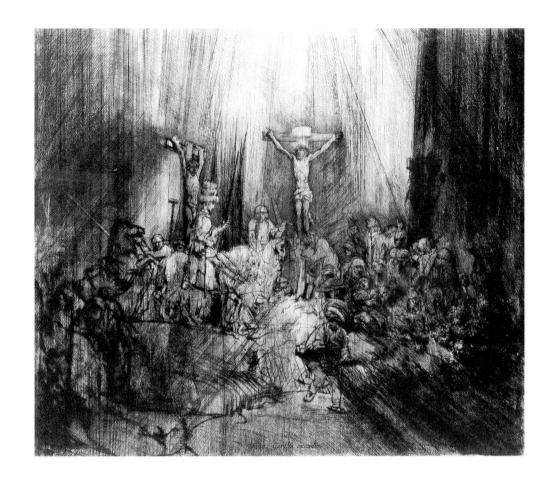

6.22, **6.23** The Three Crosses. States II and IV, detail.

6.24 Mary Cassatt, *The Caress*, 1891. Drypoint, $7^{11}/_{16} \times 5^{3}/_{4}$ ins (20 × 15 cm). Metropolitan Museum of Art, New York. Gift of Arthur Sachs, 1916. Whether working in oil, drypoint, or aquatint, sometimes by her own innovative methods, Mary Cassatt portrayed touching everyday intimacies between mother and child.

The engraving is necessarily conceived in terms of precise lines; the painting is a swirling mass of free-moving brushstrokes, depicting the wild and ever-changing elements as almost obliterating the identity of the steamboat. Another obvious difference, of course, is that the painting is executed in color, whereas line engraving is traditionally a black-and-white medium.

A second major intaglio technique is **etching**. A copper, zinc, or steel plate is coated with a waxy, acid-resistant substance called a **resist**. The design is drawn through this coating with an etching needle, baring the surface of the metal. The plate is then bathed in an acid solution that bites grooves into the metal where the needle has cut through the resist. These grooves are

then inked and printed as in engravings. Because the waxy resist offers little resistance to the etching needle, the lines in an etching can be quite freely drawn, as they are in Matisse's *Young Woman, Goldfish, and Checkered Cloth* (6.18).

Another unique characteristic of etchings is the possibility of varying tones by withdrawing the plate from the acid bath, "stopping out" certain areas with varnish to keep them from being etched any deeper (and therefore printing darker), and then returning the plate to the bath for rebiting of the unstopped areas. If printed individually, each stage is called a **state**. Rembrandt, whose etchings helped to establish the process as a major art form, printed five states of his *Three Crosses*, of

6.25 Prince Rupert, *The Standard Bearer*, 1658. Mezzotint. Metropolitan Museum of Art, New York. Harris Brisbane Fund, 1933.

which three are illustrated in Figures **6.19** to **6.21**. The second state is printed on **vellum**, a fine parchment made of animal skin, rather than paper. The vellum blurs the lines, giving a softer, more paint-like quality to the composition. The fourth state reveals a tremendous amount of reworking. As the states proceed, the work becomes more abstract, with the masses milling below the crosses receding into the shadows (**6.22**, **6.23**) and the focus falling increasingly on Jesus.

In addition to being stopped out and rebitten, etching plates may also be altered directly with a **drypoint** tool—a sharp-pointed device for scratching lines directly into a copper plate. This is a way to work more value and textural variations into the basic design. The long, dark, parallel lines in the later stages of Rembrandt's crucifixion etchings were obviously added after the original plate was cut.

Drypoint cutting can also be used by itself to scratch lines into a blank copper plate. When inked and printed, the plate yields what is called a drypoint print. Mary Cassatt's *The Caress* (6.24) is a lovely example of the directness and sensitivity of this process. The darkness of lines is directly determined by the depth to which they are cut. Drypoints also have a characteristically soft and furry line quality. This softening of the line is created by the burr of metal pushed up by the drypoint tool. The burr tends to hold ink when the plate is wiped. Because the burr does not hold up under repeated prints, editions of drypoints are usually small.

A fourth method of intaglio printing is called **mezzotint**. In this process, the copper plate is first scored with a rocking device, creating a burr across the whole surface. The burr is then smoothed and scraped to varying degrees to create variations in tone and texture.

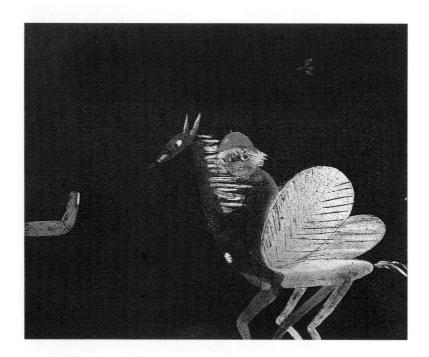

6.26 Anne Sobol-Wejmen, *Boyka Fable*, 1979. Aquatint, $9\frac{1}{4} \times 11\frac{1}{2}$ ins (23.5 × 29.2 cm). Collection Annette Zelanski. *Anne Sobol-Wejmen, a leading Polish printmaker, uses aquatint to dramatize an old Polish fable about the adventures of a young boy carried by a mythical beast.*

The lightest tones will appear in areas that are smoothed the most. Gradations from very dark to white are possible, and the print will have a rich velvet visual texture, as in Prince Rupert's *The Standard Bearer* (6.25).

Another intaglio printing method is called aquatint. Like mezzotints, aquatints are capable of creating toned areas rather than the lines to which line engraving, etching, and drypoint are limited. The aquatint process is like etching tones instead of lines. Transparent areas of ink that resemble a wash drawing are created by allowing acid to penetrate a porous covering of powdered resin. Where the surface of the copper or zinc plate is not protected by the resin particles, the acid etches pits in the metal, producing the grainy tones characteristic of aquatints, as in Anne Sobol-Wejmen's *Boyka Fable* (6.26).

In the traditional aquatint method, the whole surface is first dusted with the resin and then variations in tone are created by repeatedly stopping out areas with varnish to vary the degree to which the acid bites into the plate. Linear details are usually added using line engraving or drypoint. A version of this process that allows more spontaneous, direct work on the plate is called "sugar aquatint." In this method, the composition is painted onto the resin-coated plate with a sugar solution. The plate is then varnished and immersed in

water. The water swells the sugar, which bursts the varnish in the painted areas and exposes the metal there. When the plate is bathed in acid, the previously painted areas will have the grainy aquatint texture, while the varnished areas will remain white.

PLANOGRAPHIC

The major **planographic** or "surface" process of print-making is **lithography**. In lithography, prints are made from a perfectly flat surface rather than one that is raised (as in relief methods) or incised (as in intaglio). Adopted as an art medium in the late eighteenth century, the method is based on the observation that grease and water will not mix. A design is drawn on a slab of fine-grained limestone (or a metal or plastic plate) with a greasy substance, such as a litho crayon made of wax, soap, and lampblack. When oily lithographic ink is spread across the dampened surface of the stone or plate, it is repelled by the wet areas but sticks to the greasy areas.

Lithography can easily reproduce both lines and tones. The dark areas in the prints pulled from a lithographic plate can be very lush, in contrast to darks that must be built up by lines. Artists find it a very free way to work, and one that mirrors the gestures of their drawings exactly. Although many lithographs are

freely drawn, creating dark lines against the white ground of the paper, it is also possible to work in a *manière noire* ("black manner") by brushing a broad area of grease onto the plate and then scratching lines and tones into it. Frank Boyden explains how he used this time-consuming process to develop his exquisite lithograph, *Changes # IV* (**6.27**):

What you see as the black image was brushed out on a stone with autographic ink—a very fine oil- or grease-based emulsion. The lines along the sides are where the brush dragged along. Then I went back into it. The salmon was done with etching needles. The gray of the raven was removed with a very sharp razor blade, like an Exacto knife, to expose the stone just a very little bit. To get those kinds of gradations took about five hours of work, just in that area. Fiddling, just scraping and scraping and scraping. Then the ribbed sorts of things were drawn back over that,

with an etching tool and also a razor blade for just a little bit more contrast. You don't often see this kind of work, because it's a horrible drag. And *manière noire* is very difficult to print, because it's so difficult to hold the values.³

Like many contemporary lithographers, Boyden has his work printed by a fine-printing lithography house. They work together to get a satisfactory print, on which the artist writes BAT, for *bon à tirer* ("good to pull"); all prints pulled are compared to that model in order to be approved for the edition.

Fine lithographs may be printed in limited editions, with each print numbered and signed as an "original" work of art. The stone may then be damaged to prevent printing of any more copies, otherwise a great number of prints can be pulled from a single stone or plate—modern versions of the lithographic process are widely used for commercial printing of everything from cigar labels to books. In **offset lithography**—the

6.27 Frank Boyden, Changes # IV, 1986. Lithograph, $8 \times 9\frac{3}{4}$ ins (20.3 \times 24.7 cm). Courtesy of the artist.

process used to print this book and most others today—illustrations are converted to systems of dots that give the effect of different tones. The dot patterns are created by photographing the image through a screen of crossed lines. You can see the dots if you examine one of the black-and-white illustrations in this book with a strong magnifying glass. Screened illustrations and typeset text are then transferred photochemically to plates for printing. Ink is picked up—"offset"—from the cylindrical plates onto a rubber roller and thence transferred to paper so that the final image is the same way around as that on the plate, rather than reversed, as it is in most art printing processes.

In both original works of art and commercial printing processes, lithography can also be adapted to multiply colored images. In prints that originate as lithographs, such as James Rosenquist's nine-color *Iris Lake* (6.28), a separate plate is made for each color. Each plate is marked so that it can be carefully aligned to match the others during printing. In commercial reproduction of colored images created by other processes, such as those in color in this book, *color*

6.28 (below) James Rosenquist, *Iris Lake*, 1975. Nine-color lithograph, 36×52 ins (91.4 \times 132 cm). Courtesy of the artist. *James Rosenquist's* Iris Lake uses lithography brilliantly to create an enigmatic composition that seems to move from the essence of creation in the natural world to a polemic Pop Art statement about the crude interventions of modern environment-damaging technology.

6.29 Color separations from a 1970 poster by graphic designer Peter Good, employing a photograph by Bill Ratcliffe. Printer: The Hennegan Company. The color separation process. For this demonstration, the four colors are printed separately across the top row. In reality, one color is printed on top of another, as shown in the lower row.

separations are done on a computerized color scanner. It reads a transparency—a flexible transparent photograph of the work—to translate the colors into mixtures of the four colors that will be used to print it on a four-color press: yellow, magenta (red), cyan (blue), and black. Each color is printed from a separate plate; the pages of this book that have color illustrations have received four precisely registered printings. Figure 6.29 illustrates the process and results of four-color printing. In highly specialized printing, additional passes may be used for purposes such as varnish, metallic inks, intensification of reds, or use of mixed inks specified by the designer.

STENCIL

The fourth major printmaking process is *stenciling*—masking out areas that are not to be printed. The form of stenciling now most often used both by fine artists and commercial printers in this increasingly sophisticated medium is the *silkscreen* or *serigraph*. A fine silk or synthetic fiber screen stretched across a wooden frame is masked in places by a cut paper or plastic stencil or by lacquer, glue, or lithographic crayon. High-contrast photographs may also be transferred to special film whose glue-like emulsion is adhered to the screen as a stencil. When ink is brushed across the screen with a squeegee, it passes through

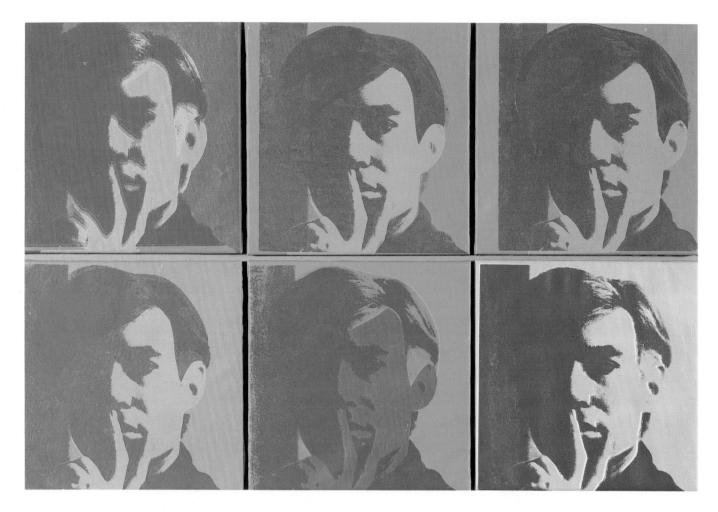

6.30 Andy Warhol, A Set of Six Self-portraits, 1967. Oil and silkscreen on canvas, each $22\frac{1}{2} \times 22\frac{1}{2}$ ins (57.2 \times 57.2 cm). San Francisco Museum of Modern Art. Gift of Michael D. Abrams.

the unmasked areas to be deposited on the paper or other surface to be printed below. A multi-colored image can be created by use of successive screens with different colors and different masked areas. Precise registration (placement of successive screens) is necessary to prevent gaps or overlapping. But in his silkscreened, photo emulsion self-portraits (6.30), Andy Warhol allowed slight misregistrations to reveal the mass-production "non-art" derivation of the medium, as an exercise in Pop Art.

In addition to flat colored shapes, graduated tones can also be created in a silkscreen print by means of a photomechanical screen of dots. Andy Warhol deliberately enlarged the dots in his self-portraits to reveal this mechanical process.

Paints used in silkscreens may be transparent or opaque. Colors can blend into each other through a *split fountain* technique, in which different paints are placed at different ends of the squeegee and blended where they overlap as they are pushed across the screen.

PHOTOCOPY AND FAX ART

Modern technologies have created new possibilities that can also be considered ways of printmaking. **Photocopying** (also called "xeroxing," after an early trade name) is named after photography, though the process is based on a different technology. An original of some sort is exposed to a bright light; the light reflects off the white areas, is totally absorbed by the dark areas, and is reflected to varying degrees by gray and colored areas. "Direct photocopying" digitizes the light image—including analysis of colors—and prints them at high resolution by lasers.

Photocopying technology was not originally created as an art process, but artists have been quick to discover and experiment with its possibilities. Anything that fits into the imaging area can be copied; it can be moved during the copying process, creating blurred results. Color xeroxes can be over-copied, with colors mixing where they lie atop each other. Xeroxed images can be worked on, cut up, assembled, re-xeroxed. Alcalacanales's *La Corrida de Cannes* (6.31) is a

6.31 Alcalacanales, La Corrida de Cannes, 1989. Xerox art, 3 ft 5 ins \times 7 ft (1.04 \times 2.13 m). Courtesy Fernand N. Canales, Colección Museo Internacional de Electrografia, Universidad de Castilla. Many Spanish artists are engaged in exploring aesthetic applications of new scientific technologies, including this use of photocopier technology by Alcalacanales to put a contemporary twist on a traditional family scene.

photocopy collage created from a family photograph, manipulated repeatedly with layers of colors and drawings building up textural and spatial effects.

Anything that can be photocopied can also be faxed—sent electronically by telephone to a facsimile-receiving machine anywhere in the world. David Hockney, who gained fame and fortune as a painter and photographer, became very uncomfortable with the astronomical prices some paintings—including his own—now command, so he switched to xerox and fax art. He explains:

On one hand, there is a movement towards unbelievable prices in art. On the other is a countermovement—fax art is essentially a Xerox copy, isn't it? What's it worth? Nothing. That makes the art world very nervous. They don't know what to do with it. But to me, that's what makes it great: you can send the exhibition

anywhere. You don't really need much of a gallery. You can glue fax art on almost any wall. ... You can give them away, or you can send them to Brazil or to Moscow—anywhere there's a telephone, fax machine, and a bit of paper.⁴

When one of his pieces of fax art was nonetheless sold for US\$17,500, Hockney made his point by placing an offer in the British newspaper *The Sun*, proposing to fax the same work for free to anyone who wanted it. Entitled *House by the Sea*, it consists of a fax glued to an old kitchen blind. It was sent in sixteen pieces to those who answered the ad, along with three pages of instructions and a sketch for assembling the work. Hockney insisted: "Art is for all. I want everyone who wants one to have a fax of this picture. That is what they are there for—for everyone. I don't want them to be exclusive and sold for money. They are free to everyone."

6.32 Gus Mazzocca, Haitian Dance Fantasy "Petwo": Portrait of Ann Mazzocca, 2005. Digital/screen print, 30×40 ins $(76.2 \times 101.6 \text{ cm})$. Artist's collection.

Mixed Print Media

Although we have examined the major printmaking processes separately, in practice they are often mixed with each other. Relief, intaglio, planographic, and stencil plates can be alternately printed on the same surface or combined in photostats. In today's wide-open experimentation, some artists are also combining printmaking with other media.

The addition of computerized techniques to traditional printmaking processes is increasingly common.

To develop *Haitian Dance Fantasy "Petwo"* (**6.32**), Gus Mazzocca took a digital photograph of professional dancer Ann Mazzocca performing traditional Haitian dances. He input the image into a computer, digitally altered it, and printed it on a computer printer. Then he used screen print and monotype print techniques on the surface of the print to further develop the color and texture of the image. The result is truly a hybrid, with the vigor of a hybrid.

Janet Cummings Good coats parts of her own body with gesso, presses herself against paper, and then

6.33 Janet Cummings Good, *Cerulean Sky*, 1990. Mixed media, 12×11 ins $(30.5 \times 27.9 \text{ cm})$. Courtesy of the artist.

works into the texture of the resulting monoprint with oil paint and drawing media (6.33). Sometimes she cuts up the impression and reassembles the parts. She began these body prints after a period of doing very tight drawings of the body. Good reports:

I felt I had taken the realism of the body as far as I could. I wanted to get more personal, more expressive with the subject. I was unsatisfied with representing the surface. The irony is that the way to get beyond my fixation with surface was to deal with it even more directly and immediately, by literally placing my body on the surface of the paper.⁶

Graphic Design

■ KEY CONCEPTS

How graphic designers respond to changing tastes and interests

Graphic design and the consumer

Graphic design as art

The use of typography

The use of illustration

7.1 Paul Rand, poster for the 75th anniversary of the founding of IBM. Courtesy International Business Machines Corporation.

PAUL RAND IS considered one of the world's greatest and most influential graphic designers. He played a major part in the mid-twentieth-century development of the use of graphics to create symbols of corporate identity, such as his famous IBM logo, still used today. He was convinced that for such a symbol to be useful decade after decade, it should consist of simple, universal, and timeless shapes.

For the IBM logo, Rand concentrated on typography, adopting a little-used typeface from the 1930s known as City Medium. Its serifs, or ending strokes, are like broad flat slabs that link the letters visually and give them a solid, orderly appearance. To vary the design for different applications, such as product packaging and annual reports, he broke the letters into stripes that can still clearly be recognized as "IBM." Once the hallmark was widely known, Rand turned it into colorful visual confetti showered across his poster celebrating IBM's 75th anniversary (7.1). This inventiveness is designed to reflect the company's reputation for technological innovations.

Innovation itself is at the heart of graphic design. The term "graphic designer" is a rather new label in the history of art. It is applied primarily to those who design two-dimensional images for commercial purposes, from advertisements, packaging, and corporate images to the pages of books. Their challenge is to catch the eye of an already optically saturated public, conveying information in a memorable way.

The Graphic Designer and Visual Ideas

Graphic designers must have their fingers on the everchanging public pulse. The noted graphic designer Milton Glaser must have sensed that despite the cosmopolitan sophistication of New York City, its inhabitants and also its visitors have a sentimental side. Thus

7.2 Milton Glaser, I♥NY logo (original version), 1976. Currently the I♥NY logo is a registered trademark and service mark of the New York State Department of Economic Development.

7.3 Charles Spencer Anderson, designer/illustrator, Duffy Design Group, packaging for Prince Foods' Classico pasta sauce.

his rendition of the tourism-promoting slogan "I Love New York" with a heart representing "love" and only initials for "New York" in an old-fashioned typeface (7.2) caught on so well that it has spawned more imitations than any other logo in history.

In line with the public mood, many designers are packaging food in ways that make it appear more "natural." To market a new pasta sauce as if it were homemade from an old family recipe using all natural ingredients, Duffy Design Group suggested bottling the sauce in traditional canning jars, with raised measurement marks along the side. The labels they designed (7.3) have the rustic appearance of hand-cut, hand-tinted woodcuts, adding to the homemade image. Through words and imagery, the designers elicit a certain feeling toward the product in the attitude of the consumer.

The graphic designer works with visual ideas. Paul Rand observes that:

ARTISTS ON ART

Peter Good on The Art of Graphic Design

PETER GOOD IS an internationally known graphic designer and illustrator. His graphic design studio, Cummings & Good, works on assignments for corporations, small businesses, and arts organizations. He is best known for his posters. His poster for the Special Olympics (7.4), though carefully conceived, is fresh and childlike in its simplicity. With a few lines and shapes, he creates a dynamic abstraction of a victorious runner joyfully crossing the finish line. Good observes:

"Things are constantly changing. How do you become a graphic designer? I think we need to begin by constantly being open to new ways of seeing things. Everything depends on context; everything is a reaction to what is in the present. The designer works to communicate another person's ideas. The artist is usually someone who has his own ideas.

"If there's anything that can go in two directions [as art and as commercial design], it's posters. They act like paintings—they're on a wall. But there is information on a poster—it has to perform a certain function. After the function is over and people put it on a wall as art, you no longer have the informational requirements."

"There are a few American designers who use ambiguity as Tomaszewski (2.44), the father of Polish posters, does. But the American culture is not receptive to that kind of imagery, that use of metaphor and levels of meaning. It's not as sophisticated. I face this all the time with clients. I say, 'Well, don't you see? Someone will think about it and will become engaged in it, and therefore it will be a stronger

7.4 Peter Good, logo for the Special Olympics, 1995. © Cummings & Good.

communication.' But people tend to think you have to be obvious in all cases. Sometimes the obvious can work, but other times ambiguity enhances the communication. You see that in European and other cultures. Perhaps they have more design education; perhaps it's because multilingual areas rely more on visual language.

"On the other hand, something that works really well may seem

obvious. Even though you never saw it before, it seems understandable, it seems right. It is real genius to take something that's right before our noses and to do something with it that works so well that everyone says, 'Oh, my God!'"

"The worst thing for a young designer is freedom, because the best design, the best art, comes from limitations. There are too many options. There are many different

solutions to design problems, some more successful than others. If you start with the broadest possible range, you can't possibly explore all those possibilities. You have to make certain decisions to narrow the range, so you begin to explore the possibilities within a smaller realm, and then you narrow it further, until you get into a manageable form to deal with. But if you don't know that process of self-limitation—from experience or talent or whateverthis process becomes arbitrary. I see that happening with the possibilities opened up by computer graphics. If you have an area of land to exploresay, an acre of land-you can't possibly explore it in detail. But if you have a square foot, you can get down to molecules, down to very fine things.

"I feel graphic designers work much better if they get involved with things that are not design. If you're doing something for a hospital, go to the hospital and see the people and see what the real problems are. Otherwise you're working blind. Empathy is one of the greatest tools a designer has—to always put yourself in someone else's position."²

Graphic design is essentially about visual relationships ... providing meaning to a mass of unrelated needs, ideas, words, and pictures. It is the designer's job to select and fit this material together ... and make it interesting. The problem is not simple; its very complexity virtually dictates the solution—that is, the discovery of an image universally comprehensible, one that translates abstract ideas into concrete forms.¹

Rand's catalog cover for a Picasso show (7.5) catches the eye with its two bold lines, which still look freshly painted today, and it uses handwritten information in Picasso's style at a time when everyone else was using uniform, machine-set type. Picasso's photograph ever so slightly overlaps the circular line at the chin, setting up a delightful three-dimensional spatial illusion. He appears to be looking out at us from inside the catalog, enticing us to open it. The individual elements seem simple and uncluttered, but putting them together so effectively takes great mastery of design.

Graphic design is usually aimed directly at consumers, though there are often an art director and a marketing team between the designer and the end-user. But its

7.5 Paul Rand, a proposed catalog cover.

commercialism has not kept some graphic design from being treated as fine art. Some is created by recognized artists who have distinguished themselves in other media, such as Toulouse-Lautrec, whose lithographed posters for dance halls and cabarets (7.6) raised the poster to an art form. They were so admired by collectors that they were stolen as fast as they were put up.

The poster, like most graphic design, was initially conceived as an ephemeral piece to be thrown away once its commercial purpose was finished. But posters are often so visually compelling that someone saves—or buys—them and hangs them as would be done with a painting. They have become a relatively inexpensive way to bring art into one's home. Whereas a few decades ago, those who couldn't afford original works of art hung reproductions of them in their homes, many people now display posters by renowned designers. And in Latin America, many populist artists

7.6 Henri de Toulouse-Lautrec, poster, Aristide Bruant dans son cabaret, 1893. Color lithograph, $54\frac{1}{2} \times 39$ ins (138×99 cm). Metropolitan Museum of Art, New York. Harris Brisbane Dick Fund, 1932. Toulouse-Lautrec, himself an habitué of Parisian cafés and cabarets, reveals this world through various media, including his brilliantly designed posters.

7.7 Selection of Czech postage stamps.

have adopted the medium of posters as an inexpensive way of distributing art to the masses.

Another bit of throw-away art that has increasingly captured the public eye and the interest of graphic designers is the humble postage stamp. To make a fascinating and successful work of art on a small scrap of paper is a tour de force. Many countries now commission excellent commemorative art for their stamps as a matter of national pride, and collectors queue up to buy the latest works. Consider the different approaches to this challenge taken up by contemporary designers in the Czech Republic (7.7). What means have they used to catch the eye without confusing it?

Typography

The two major ingredients of graphic design are letters and images. Typography is the art of designing, sizing, and combining letter forms on a printed page. The choices the graphic designer must make are subtle and complex. Hundreds of typefaces that can be used for printing the Roman alphabet have been developed over the years. Most can be grouped into two large categories: serif and sans serif typefaces. A serif is a fine line that finishes the larger "stroke" used to make a letter form. Originally used in the Classical Roman alphabet on which modern letters are based, serifs tend to lead our eye through a word, tying it together visually, as well as giving elegant calligraphic flourishes to the individual letter forms. Most books, including this one, are printed in one of the many serif typefaces. Many modern typefaces eliminate the serifs, however,

A^{a}_{A} A^{a}_{A}

7.8 Baskerville (left) and Gill Sans (right) typefaces.

for a more contemporary look. These sans serif ("without serif") type styles are often chosen when an upbeat, forward-looking message is desired. Figure **7.8** illustrates the general difference between these two categories: Baskerville is a serif typeface originally designed in the eighteenth century by John Baskerville, while Gill Sans is a twentieth-century sans serif typeface often used on modern English signs. Eric Gill based its proportions and shapes on the classic Roman letter forms, but made the rules for their creation so simple that even the least skilled signwriter could follow them perfectly.

When a typeface is designed, each letter is carefully constructed, with attention to the balance between stressed (thicker) and unstressed (thinner) portions. Albrecht Dürer, influential in so many of the visual arts, published in 1525 Underweisung der Messung mit dem Zirckel und Richtscheyt ("A Course in the Art of Measurement with Compass and Ruler"). This book included instructions for applying geometric principles to the construction of letter forms. In the page shown in Figure 7.9 Dürer relates each letter to a square, with a ratio of ten to one between the height and width of the letter strokes. Not only are his letters lovely; the page as a whole is beautifully designed, with pleasing contrast between the scale of the text type and the display type, and enough white space around the printed text to allow it to breathe.

Typesetting has largely been turned over to computerized photocomposition processes rather than handsetting of metal type. But the art of the beautifully designed letter and page is being maintained by aficionados of fine printing. Hermann Zapf designed over fifty typefaces adapted to computer technologies, but with a poetic sense of the aesthetics of typography, as is evident in the alphabet sampler done in his own calligraphic hand (**7.10**), and in these remarks:

Typography is fundamentally two-dimensional architecture. The harmony of single proportions, the grouping of lines of type, the judging of contrast and balance, the symmetry and dynamic

Der mach b). Lafoerflitch laft ben aufrechen ing wil ben oberen bûnnen existig beleptê wie fie ver find allem bem bûnnen istig laft oben innen en ref an ber fant al. Laber aufringegen bem. b. februerf in aufwer wei. Damach 3 eine ben besten engineb auf ben ur d'ben ba februal ber aufrech ben sing win bei servechtur. Le freud auf bei servech. Dalfo bas simfer mit. Av in die bestaugeb bet sing bereen fie blebe wil bas inner eil laft bleben; aber gegen bem. Dafbreerf in ein wenig auf; 20c b) bemach if aufrechen bergen sing met foart bas. Le fefcheben ift. Daran fen widen den fiese ven bem wei gemachen. e. alfo ift bas nachfolget. Laufgenifen.

4. A. m. mach iswererlen were fin fan fierung, a. b. e. b. er flitch jeach bes buflaben femalen unfrechen bergen sing met foart bas. Le fefcheben ift. Daran fen widen den fiese ven bem wei gemachen. e. alfo ift bas nachfolget. Laufgenifen.

4. A. m. mach iswererlen were fin fan fierung, a. b. e. b. er flitch jeach bes buflaben femalen unfrechen in der fier den an in er fier den fan fieren in der fier den fan fier den fieren beren eile betreef de besten der de fieren de betreef de fieren beren eile betreef de besten de fieren fieren de besten de fieren fieren betreef de bestigen de fieren de fieren de besten de fieren de fieren de bestigen de fieren de fieren fieren de bestigen de fieren de fieren fieren de fieren de bestigen de fieren de fieren de fieren de fieren fieren de fieren fieren fieren fieren betreef de fieren de fieren fieren fieren fieren fieren fieren de fieren de fieren de fieren fier

7.9 Albrecht Dürer, page from *Underweisung der Messung*, 1525. Victoria and Albert Museum, London.

tension of axial arrangement—all these are the shaping tools, so employed by the typographer in a given task as to bring the reader a text in its most appealing form. ... The letters' indwelling wealth of form is a fresh, unending astonishment.³

As can be seen in Zapf's sample, each typeface also creates a slightly different value when printed in blocks on a page.

Typefaces are often chosen according to the subtle psychological messages that they convey. Some give a hint of elegance, some a question of older times, some a brisk efficiency, some a sense of humor, and so forth. An ad in the *New Yorker* for Tyco, an international firm making products for water, environment, transportation, and facilities industries (**7.11**), nearly hides most of the names of its products (such as "Filtered

and the common of a common of the common of

7.10 Hermann Zapf, Alphabet with quotations, 1959. Ink. Mr and Mrs Philip Hofer Collection. Houghton Library, Harvard University.

modular jacks") by making them almost too small to read, unless one studies the advertisement closely in full-scale. What stands out then is the image they form—a worried-looking child with what is perhaps a drinking water fountain—and the words printed all in capital letters in a strong sans serif typeface, to convince the viewer that the products are, as they say, truly vital to human life and survival. The ambiguous image is created by modulations in colors of the type, an effect that would have been very costly and time-consuming in the past but is now fairly simple and cheap with the aid of computer technologies.

At Iyoo International we make more than 200,000 products for hundreds of different industries, Tyco's Earth Tech is a global leader in the water, environmental, transportation, and facilities markets. From drinking water to automotive components to emergency room supplies, the things we do aren't simply important. They're vital.

tyco

7.11 Hill, Holliday, Connors, Cosmopulos advertising agency, Boston, Massachusetts, *Tyco - A Vital Part of Your World*. Advertisement for Tyco, *New Yorker*, March 7, 2005.

Illustration

The other major ingredient in graphic design is illustration. Because graphic design is basically a functional art, illustrators must keep the character of what they are illustrating clearly before them. This need is especially true in advertising, where the intent is to portray the client's product as compellingly as possible. At one extreme, visual and textual information about the product dominates the presentation. At the other extreme, valuable ad space is used to lure the potential consumer into wanting to know more about the product, but very little information is given in the ad itself. This is the case with the mysterious two-page advertisement in the upbeat British magazine Wallpaper* (7.12). The photographic image is deliberately blurred, out-of-focus, and almost non-representational. There is an impression of flesh, but in its original blown-up two-page format divided across the middle by the gutter between the pages, one cannot clearly make out any anatomical parts, understand the meaning of the flash of yellow, or discern the almost invisible rope to the lower right, but the overall impression is nonetheless hauntingly erotic.

From the point of view of feminist analysis, gender issues arise: The ad presents stereotypical cultural ideals of thin female bodies and the muscles of a male arm. When seen in full scale, rather than the smaller reproduction shown here, the visual logic of the illustration is not immediately apparent, so we continue looking at it, trying to grasp some clue. In this process, we discover the company's logo, which is printed sideways in small letters on the right, along with the even smaller website address of the company. Hooked, we want to open the website to solve the puzzle—and thus discover that this is a Swedish company selling fashions on-line to a young, smart, computer-oriented clientele. Here the illustration is used to bait the hook rather than to convey any information.

In some applications, illustration must carry the message by itself, with little or no text. Fritz Eichenberg's illustration of the story of Noah's Ark (6.11) speaks for itself when seen by people from Judeo-Christian tradition, because they are so familiar with the story. Nonetheless, Eichenberg, a pacifist who contributed illustrations to the *Catholic Worker* newspaper in hopes that he could thereby help bring

7.12 Two-page advertisement for Filippa K in Wallpaper* magazine, April 2000.

7.13 Illustration from Paikea, written and illustrated by Robyn Kahukiwa. Penguin (New Zealand) Ltd., Auckland, New Zealand, 1993.

attention and compassion to the poor and the weak, has given his own flavor to the illustration. His Noah is a powerful figure who seems to have befriended and united multifarious animals, from walrus to lion.

Children's picture books offer an opportunity for telling a story with few words, largely through the use of illustrations and very simple text suitable for young readers. Robyn Kahukiwa from New Zealand, of Maori lineage, drew on her ancestral legends and artistic traditions to write and illustrate the children's book *Paikea* (7.13). The patterns in the background are taken from traditional woven wall panels; the rhythmic designs forming the sea and the whale also refer to aboriginal designs. Individually strong, the patterns harmonize into a dynamic whole giving a visual impression of the strength of the sea and of the whale.

7.14 William Morris and Edward Burne-Jones, page from *Works of Geoffrey Chaucer*, Kelmscott Press, 1896. Victoria and Albert Museum, London.

William Morris and Edward Burne-Jones were major members of the English Arts and Crafts Movement of the late nineteenth century. In reaction against Victorian industrialization and mass production, these artists stressed the value of handcrafted skills and preferred a return to medieval aesthetics and lifestyles.

Even the environment seems to be pulsing with energy patterns, giving an unspoken spiritual underpinning to the tale.

When graphic design is well planned, there is a certain harmony between the style of illustration and the typography. To illustrate Chaucer's *Canterbury Tales*, William Morris created a special Gothic typeface, surrounded it with intricate borders, inset woodcuts of drawings by Edward Burne-Jones, and embellished the whole with large, illuminated capital letters, as shown in one of the 556 pages of the monumental book (**7.14**). In its brief life from 1891 to 1898, Morris's Kelmscott Press created 18,000 copies of 53 books, all handcrafted. Their quality and lavish decoration revived interest

in fine printing as an art form, at the same time as commercial printing was becoming increasingly mechanized. Morris, who also designed wallpaper, furniture, stained glass, interiors, and industrial products, had a great love for the beautiful object, carefully made of the best materials available. He wrote:

The picture-book is not, perhaps, absolutely necessary to man's life, but it gives us such endless pleasure, and is so intimately connected with the other absolutely necessary art of imaginative literature that it must remain one of the very worthiest things towards the production of which reasonable men should strive.⁴

Today's increasingly high-tech approach to the arts, as well as to other aspects of human life, could be seen as again threatening the survival of more traditional arts, just as Victorian industrialization threatened preservation of the arts in the late 1800s. Many colleges and universities are cutting back on courses in the traditional arts—such as drawing and painting—in favor of computer-based art classes. Will handmade books, handprinted posters, and painstaking typeface design disappear from the graphic design scene? Will any mechanized method arise as a substitute for the designer's inspired ideas? Will economic pressures overcome

human values in commissioned work? Consider the remarks of Milton Glaser (see Figure 7.2), one of the most celebrated contemporary graphic designers:

I like to design something for institutions that did no harm and for personalities that I feel comfortable with. I would say that I'm never not working in my mind, [whether] taking taxicabs or during breakfast. [The best moment of the day occurs] when the new idea emerges from deep in the back of my brain to the front of my brain. It happens any time.⁵

Photography and Filmmaking

■ KEY CONCEPTS

The development of photography—emerging possibilities

Photography and portraiture

Photography as documentary

Extending the range of vision through high-speed technology

Digital imaging

Film defined as an art form

The immediacy of live television

Video and multimedia installations

8.1 Olivia Parker, Four Pears, 1979. Photograph.

TRAINED AS A PAINTER, Olivia Parker composes her images carefully before photographing them and performs many kinds of manipulations at the site of the photography and in subsequent computer alterations of the material. She may even remove objects before the

exposure is completed, to control the extent to which they yield their visual information to the camera.

Parker's photographic image of four pears (8.1) is therefore not a simple still life of ordinary objects. By the mere addition of four brilliant red strings, she has vastly changed the image. And look at her careful use of color. She has selected pears that are beginning to

8.2 William Henry Fox Talbot, *Botanical Specimens*, 1839. Photogenic drawing. Metropolitan Museum of Art, New York. Harris Brisbane Dick Fund, 1936.

rot and placed them against a background that repeats the color of the rotten areas. Where the red strings cross areas of green, they set up an optical vibration of complementary colors. As the strings lead our eye across areas of different hues, the red interacts in different ways with each of those colors.

A good photographer works very consciously with elements and principles of design, not merely recording the outer world but selecting and manipulating that which is photographed, yielding a true work of art. The art of photography led to sequential images once known as "moving pictures" or "movies." The technology of capturing and transmitting images has now evolved to include television, video art, and even photocopying and fax used as art forms.

Photography

Although photography (the Greek word for "writing with light") and filmmaking are now so much a part of our visual world that we take them for granted, they are relatively recent inventions. From the time of the Renaissance, many artists had used the **camera**

obscura to draw forms and linear perspective accurately. A camera obscura is a dark room or box with light entering through a tiny hole, perhaps focused by a lens. An inverted image from the world beyond would be thrown on the opposite wall or side, and its outlines could be traced on paper or canvas. But it was not until the first half of the nineteenth century that several researchers working independently of each other found ways to capture this image permanently.

One of the early developers of what became photography was William Henry Fox Talbot. Longing to be able to capture images from his travels and everyday life that he did not have the skill to draw, this English scientist experimented with various techniques. One yielded what he called a "photogenic drawing," or **photogram**, created by laying objects on paper coated with light-sensitive chemicals and then exposing it to light. The result is a negative, in which the objects appear light and the paper turns dark. Not only scientifically resourceful, Fox Talbot obviously also had an eye for design, as is evident in one of his early photogenic drawings (8.2).

Thomas Wedgwood and Sir Humphry Davy had done initial experiments with the technique, which

they announced in 1802, but unlike Talbot's results, their pictures were only temporary and soon turned completely black. At the same time that Fox Talbot was carrying on his experiments, several French researchers had been developing processes that worked along similar lines. After years of secret experimentation, Joseph-Nicéphore Niépce (an inventor) and Louis-Jacques-Mandé Daguerre (a painter of stage sets) began collaborating to produce the process that Daguerre named daguerreotype in 1837 after Niépce's death. The public was awed by the way in which actual images could be preserved in precisely accurate detail. The process was not yet perfect, of course. One problem was the lengthy time needed for exposures. Daguerre's picture of a Paris boulevard (8.3) makes it appear to be deserted except for

a shoe-shiner and his customer. This strange effect occurred because although there were other people on the streets and sidewalks, they were moving too fast for their images to be recorded. In the excitement over the new invention, improvements appeared quickly, including the means of creating multiple copies of a single image, based on Fox Talbot's work with the negative.

One of the exciting possibilities opened up by the invention of photography was that of having one's portrait captured for posterity. There had long been portrait painters, of course, but a perfect likeness was both rare and expensive. Many of the surviving early photographs are portraits, such as that of writer Edgar Allan Poe (8.4). Taken by an unknown photographer, the image preserves for posterity the look of his hair,

8.3 Louis-Jacques-Mandé Daguerre, A Parisian Boulevard, 1839. Daguerreotype. Bayerisches Nationalmuseum, Munich, Germany.

8.4 Photographer unknown, Edgar Allan Poe, 1849. Daguerrotype. The J. Paul Getty Museum, Los Angeles.

his eyes, and his facial structure, from which we can derive some clues to the personality behind his strange and frightening poems and stories.

Color photography was developed after black and white photography, but when color was desired, it was often added to black and white photographs by hand. Figure **8.5** portrays an Indian landowner photographed before a false backdrop, with details intricately hand-painted.

In addition to being enthusiastically embraced by the public as a new way of capturing images of the world, photography was adopted by many artists as a helpful tool for creating representational works in other media. As we have seen, painters such as Degas and Toulouse-Lautrec developed unusual perspectives and cropping of figures in response to the camera's-eye view of external experience. Then, as now, some artists also used photographs as the initial study from which to develop drawings or paintings. Rather than having

William Morris's wife, Jane, pose through long sittings, Dante Gabriel Rossetti had her photographed as he posed her (**8.6**) and then developed his chalk drawing *Rêverie* (**8.7**) from the photograph. Note that he did not imitate it slavishly; the artist's license he took is obvious when the two images are compared. Even after posing her himself, he changed her posture in the drawing, creating a pleasing circular flow of light across her neck, down her right arm, up her left arm, and back to the Classical styling of her face.

Whenever a new medium appears, artists often try to increase its acceptance by making its products approximate those created with earlier, familiar media. This was true in photography as well. At the turn of the century, the "Pictorialist" movement in photography sought, by elaborate printing techniques, to make photographs look like paintings, emphasizing the hand of the artist at work rather than the sheer duplicating ability of the camera.

8.5 Anonymous, Portrait of a Landowner, India, c. 1900. Painted photograph. ARCOPA (Archival Centre of Photography as an Artform), Bombay, India.

8.6 (below left) Dante Gabriel Rossetti, Jane Morris, 1865. Photograph. Victoria and Albert Museum, London. The unretouched photograph reveals human imperfections— Jane Morris's crumpled clothing, awkward hands, stray hairs that were beautified in the idealized painting.

8.7 (below right) Dante Gabriel Rossetti, Rêverie, 1868. Colored chalk, 33×28 ins (83.8 \times 71.1 cm). Private collection.

8.8 Edward Steichen, Moonrise, Mamaroneck, New York, 1904. Platinum, cyanotype, and ferroprussiate print, $15^{15}\%6 \times 19$ ins (38.9 \times 48.3 cm). Museum of Modern Art (MOMA), New York. Gift of the photographer. 364.1964.

Edward Steichen used layered prints made with different chemicals to create the misty atmosphere of *Moonrise, Mamaroneck* (8.8).

Although such painterly effects were dramatic, Steichen and Alfred Stieglitz, both leaders of the Pictorialist movement, also evolved strong interest in exploring the potentials that were unique to photography. One was the ability to capture a specific moment in time. Stieglitz's *The Terminal* (8.9) is an ephemeral scene of a horse-drawn trolley being turned on a wintry morning. The steamy breath and body heat of the horses, the dusting of snow, and the man walking out of the picture in the background give a sense of immediacy to the image.

Willingness to abandon the search for beauty in favor of the straight documentary photograph made it

possible for sympathetic photographers to share what they had seen of humanity. Documentary photographers—some of them hired by the Farm Security Administration in the United States—wakened public concern for social welfare by recording the plight of the poor, from children working in mines and sweatshops to migrant workers living under wretched conditions. Dorothea Lange's photograph of a migrant mother and her children (8.10) was reproduced in thousands of newspapers and magazines across the country. According to Lange's field notes, this mother, who spoke to the heart of every mother, was "camped on the edge of a pea field where the crop had failed in a freeze. The tires had just been sold from the car to buy food. She was 32 years old with seven children." So effective was this memorable image in waking public sympathy and

8.9 Alfred Stieglitz, *The Terminal*, 1915. Photograph. Gernsheim Collection, Harry Ransom Humanities Research Center, University of Texas at Austin, Texas.

support for government welfare projects that the death of the mother decades later was publicly honored.

Documentary photographs are not necessarily so direct in their impact. Alex Webb has used a palette of pleasing blues and pinks for *Killed by the Army* (8.11) from his *Port-au-Prince* series of 1987, and has purposely underexposed the human figure and kept it in a corner. The viewer is initially drawn in by the colors, textures, shapes—and then comes the secondary realization that the man is dead. One is given no information about who he is or the reason for killing; with no visible weapons, he seems a symbol of the multitudes of innocent, nameless, hidden victims of the Haitian government.

Sociological photo-reporting has not dwelt exclusively on human misery. Even among the poor, photographers have often captured moments of great

integrity, ecstasy, or humor. Henri Cartier-Bresson specialized in images of everyday life around the world that are emotionally familiar to people from all cultures. His genius lies in his ability to catch the "decisive moment" when a naturally shifting scene of unposed people clicks into place as a strong composition. In his *Sunday on the Banks of the Marne* (8.12), everything is placid and staid, from the calm surface of the water to the short, round forms of the well-fed torsos. The only action we sense is the business of eating, a central theme in these people's lives.

Photographs have also been used to preserve views of the earth's natural landscape that are continually threatened by the expansion of population and industry. In the United States, the work of the great landscape photographers, such as Ansel Adams, has played

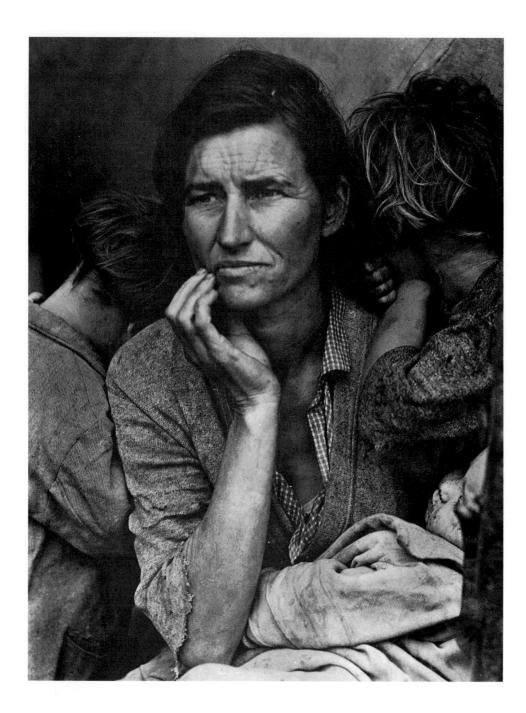

8.10 Dorothea Lange, *Migrant Mother*, Nipomo, California, 1936. Gelatin-silver print, 12½ × 9½ ins (31.75 × 24.9 cm). Museum of Modern Art (MOMA), New York. Purchase. 331.1995.

a major role in wilderness conservation efforts. Adams was a leader in the "f/64 Group," which used a small lens opening (such as f/64) in the interests of exceptional clarity, sharpness of detail, and depth of field (sharpness of detail at all distances from the viewer), as illustrated by Adams's *Clearing Winter Storm, Yosemite National Park* (8.13). Such arresting images resulted from planning at the photographing stage rather than manipulation in the darkroom. Adams's full tonal range, from lush blacks, through many grays, to pure whites, is also a hallmark of his work.

In addition to introducing armchair travelers to human and natural landscapes they have never seen, the eye of the camera has also been used to examine familiar objects in such a way that they become unexpected visual pleasures. Many variables can be juggled for the effect the photographer desires: lighting, type of camera and lens, point of view, exposure time, film, paper, and developing and printing options. Olivia Parker (see Figure 8.1) uses these options to create an unfamiliarly heightened sense of realism in her photographs of "familiar" objects. Parker comments:

Although we think of photography as more "real" than the other visual arts, it allows for transformation of objects in ways I find especially interesting. The substance of an object can be altered by removing it partway through an

8.11 Alex Webb, *Killed by the Army*, from the *Port-au-Prince* series, 1987. Courtesy of the artist.

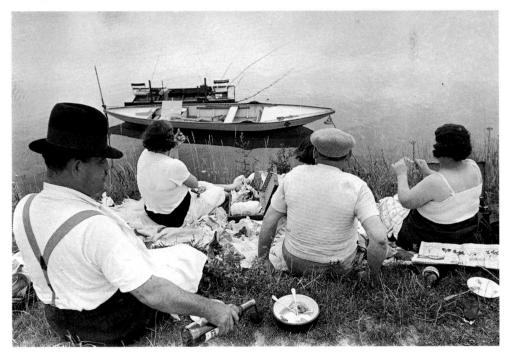

8.12 Henri Cartier-Bresson, Sunday on the Banks of the Marne, 1939. Gelatin-silver print, $9\frac{1}{8} \times 13\frac{3}{4}$ ins (23 \times 34.9 cm).

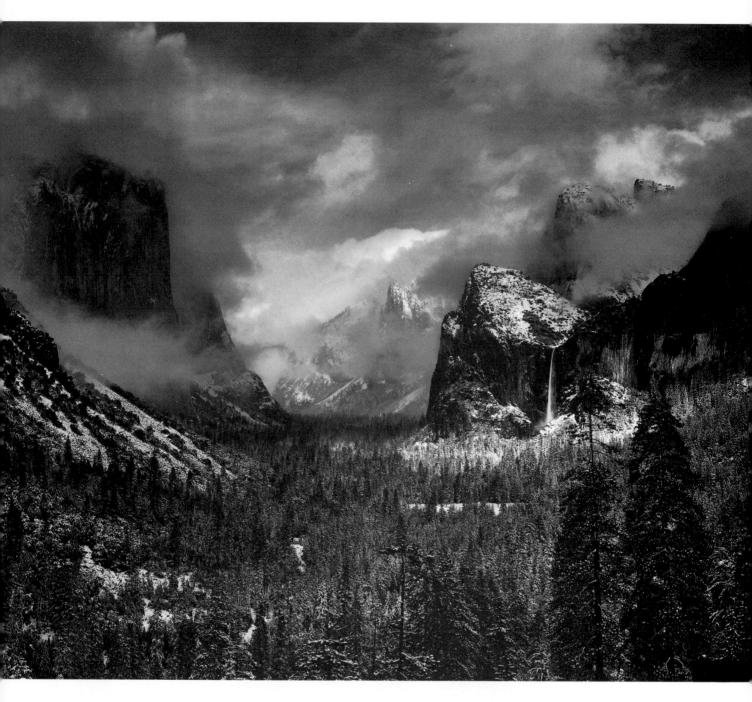

8.13 Ansel Adams, Clearing Winter Storm, Yosemite National Park, 1944. Black and white photograph.

exposure. Light can change form and structure. Objects or figures can exist as shadows yielding only some of their information to a piece. Color can be the color of an object as we think of it, the color of light around an object or a new color caused by filtration, additional projected colored light or the peculiar way a certain film and print material see color.¹

It is one of the wonders of photography that the camera can capture details that the eye does not perceive. Many of us have seen halved artichokes, but as photographed at close range by Edward Weston (**8.14**), this familiar object becomes a world unto itself, a sensual, evocative vision of secret recesses. One of the most influential members of the f/64 Group, Weston used a classic large-format 8×10 inch (20×25 cm) camera and did not enlarge his prints beyond that size, to avoid any distortion of the carefully previsualized image. Such photographs reveal the artist's love for the photographed object and inspire the same feeling in us.

Technological advances in cameras and films are increasing the range of images that can be captured and manipulated. Stephen Dalton, for example, has

8.14 (right) Edward Weston, *Artichoke Halved*, 1930. Photograph.

8.15 (left) Stephen Dalton, *Spores Falling From the Common Horsetail*. Photograph. © Stephen Dalton.

developed high-speed photography as an exquisite art to capture images that usually pass unnoticed by the naked eye. Although our visual perception mechanism is fairly good at judging size, form, distance, and color, it cannot see what is happening when things are moving quickly. Moving objects tend to be seen as blurs; the retina cannot pass information to the brain or the brain interpret the information quickly enough to keep changing imagery in sharp focus. By contrast, the camera needs only to record an image; the brain of the viewer can interpret the arrested movement at leisure.

Technological innovations such as high-speed electronic flash units now allow us to see what we could not see before. Stephen Dalton's photograph in Figure 8.15 reveals the dropping of spores by a common horsetail plant. He has controlled values and composition in such a way that this commonplace occurrence becomes an elegant ballet; rather than appearing frozen in time, the cascading of the spores appears to be happening as we watch. Dalton insists that it is the

ARTISTS ON ART

Edward Weston on Photography as a Way of Seeing

EDWARD WESTON (1886–1958), one of the great figures in American photography, initially created out-offocus, dreamy portraits. But in the 1920s he began a movement he called "straight photography," in which objects were shot in sharp focus, with attention to their details. He particularly loved the "sculptural" forms of vegetables, rocks, trees, the human figure. For him photography was an intense way of seeing, as well as the technical expertise to capture what he saw. The following are excerpts from his daybooks:

"B. sat next to me again. As she sat with legs bent under [8.16], I saw the repeated curve of thigh and calf—the shin bone, knee and thigh lines forming shapes not unlike great sea shells,—the calf curved across the upper leg, the shell's opening

These simplified forms I search for in the nude body are not easy to find, nor record when I do find them. There is that element of chance in the body assuming an important movement: then there is the difficulty in focussing close up with a sixteen-inch lens: and finally the possibility of movement in an exposure of from 20sec. to 2min.,—even the breathing will spoil a line My after exhaustion is partly due to eyestrain and nerve strain. I do not weary so when doing still-life and can take my own sweet time."

"I hold to a definite attitude of approach, but the camera can only record what is before it, so I must await and be able to grasp the right moment when it is presented on my ground glass. To a certain point I can, when doing still-life, feel my conception before I begin work, but in portraiture, figures, clouds,—

trying to record everchanging movement and expression, everything depends upon my clear vision, my intuition at the important instant, which if lost can never be repeated. This is a great limitation and at the same time a fascinating problem in photography.

"Imagine if you had to create in, at the most, a few seconds of time, without the possibility of previsioning, a complete work, supposed to have lasting value. Of course my technique is rapid, and serves me if coordinated at the time with my perception."

"I am the adventurer on a voyage of discovery, ready to receive fresh impressions, eager for fresh horizons, not in the spirit of a militant conqueror to impose myself or my ideas, but to identify myself in, and unify with, whatever I am able to recognize as significantly part of me: the 'me' of universal rhythms. Nature must not be recorded with a viewpoint

colored by psychological headaches or heartaches [I want] an honest, direct, and reverent approach when granted the flash of revealment."

"I have been training my camera on a cantaloup—a sculptural thing.! know I shall make some good negatives for I feel its form deeply. Then last eve green peppers in the market stopped me: they were amazing in every sense of the word,—the three purchased. But a *tragedy* took place. Brett ate two of them!"²

8.16 Edward Weston, *Knees*, 1927. Gelatinsilver print, $6\frac{1}{4} \times 9\frac{3}{16}$ ins (15.9 \times 23.4 cm). San Francisco Museum of Modern Art, California. Albert M. Bender Collection. Albert M. Bender Bequest Fund Purchase.

8.17 Elizabeth Sunday, *Life's Embrace*, 1989. Silver print, 40×30 ins (101.6×76.2 cm). Courtesy of the artist. *Elizabeth Sunday has manipulated her photograph to reveal similarities between the woman's clothing and the trunk of the tree, between the mother's intimate embrace of the child and the tree's enfolding embrace of them both.*

observant eye of the artist that is most important in any form of photography:

Clearly, equipment will not produce pictures on its own—the make and complexity of the camera have little to do with the final results and, more often than not, the simpler the equipment the better The beauty of the natural world can only be revealed to the eye and camera

spending time in the field. Above all, it requires patience, light and an understanding of nature.³

The integrity of real objects, landscapes, and people is only one possible arena for the photograph. There are limitless ways of altering the realism of photography. Elizabeth Sunday uses reflective surfaces to elongate forms (8.17), to convey spiritual truths that are not apparent in conventional photographs. Sunday explains:

8.18 Donna Hamil Talman, *Ancestor Portraits*, 2002. Gelatin silver print, toners, watercolors, 24×20 ins $(60.9 \times 50.8 \text{ cm})$.

Using elongations allows me to go beyond the world of right angles into an inner place of emotions, where we live. We are so used to seeing the world as it appears in the material manifestation—in surfaces. I want to go behind and through that to someplace else.⁴

Sunday's photographs reveal a world in which everything is dynamic; nothing is as solid as it appears on the surface. In this lively, unseen world, whose truth is accepted as fact in modern physics, there are no sharp boundaries between humans and their environment.

Whereas we tend to treat photographs as precious objects, handling them carefully by the edges, some artists have violated this taboo to cut into their pristine surfaces, rearranging the pieces at will. An artist can also work directly on the surface of a photograph, as Donna Hamil Talman has done in her Ancestor Portraits series (8.18), creating evocative one-of-a-kind prints that are not so much records of tangible reality as explorations of psychological, emotional, and spiritual dimensions of life. In this series, she initially photographs the remains of prehistoric creatures in museums with a camera whose plastic lens "creates a softand-sharp distortion that corresponds more to the images we carry in our mind's eye," she explains. The prints are altered with toners and watercolors to "visually capture a quality of living energy," and selectively bleached, in a process that to her is "reminiscent of an archeological dig, in which years are eaten away."

Talman also digs into her own inner connections with our primeval past as she makes archetypal marks on the surface of the prints. She says, "Through the marks layers of time are reflected, as well as layers of space and distance—our distant selves."

DIGITAL PHOTOGRAPHY

A great revolution is now underway in the field of photography: In many applications, digital photography and digital manipulation of photographs are replacing film cameras, transparencies, darkrooms, and prints. Now the dominant method of taking and viewing photographs is with digital cameras, with digitized results viewed on computer screens and perhaps printed on computerized printers. The new digital technologies have led to a great drop in film camera purchases by the general public, but many artists still prefer to work with film.

A digital camera's sensor scans an image to be photographed and stores the information in digitized format as **pixels** (to be discussed in Chapter 9). The look of the image will depend on the quality of the lens, the medium by which it is "captured," the formatting of its "captured" information, and the means of processing the print. Many art photographers are continuing to use the lenses from their traditional professional cameras so that they can maximize qualities such as sharpness or depth of field but are adding digital backs for rapid processing and manipulation of the images captured. Often, a digital camera's sensor will not

capture the full length and width of a 35-mm film frame but, rather, a cropped version.

The **resolution** or sharpness of detail in a digitized image is a function of the density of pixels per area and whether the sensor records only one color in each pixel location or a combination of colors. The issue of visual "noise"—extra bits of color that are most readily seen in areas that should be of solid color—arises when the same pixel is exposed several times by the same light in order to record different colors therein or during long exposures. Some background noise is also created in any case, like the hiss of audio players even when nothing is being played.

The square nature of pixels creates another potential problem in digital image, commonly referred to as "jaggies." These are like stairsteps seen along edges where one color meets another. Higher resolution usually decreases the visibility of jaggies, for they become smaller. An effect known as "anti-aliasing" also softens the effect of jaggies, for a sensor picks up information from two different colors along edges and may combine them, creating a combination of the two that softens the contrast between them but does not produce a distinct outline.

Another major consideration in digital photography is the linked issues of tonal range and dynamic range. Tonal range refers to the number of steps in the value scale a sensor can use to approximate the continuous tones of a subject. Dynamic range refers to the degree of difference between the darkest and lightest values a sensor can register. Because the dynamic range of computer monitors and printers is limited, the data from the sensor may be compressed in order to match the computer's capabilities and still preserve the most noticeable details. This issue becomes an important consideration when digital images are prepared in compressed JPEG (Joint Photographic Experts Group) format, which reduces image file size for the purposes of storage, processing, or transmission. JPEG compresses color information more than detail information, because we perceive details of line and shape more readily than we perceive small color differences. It also sorts the data into fine and coarse details and selectively discards fine details because we see coarse details more readily.

Compared to traditional film photography, digital photography thus has its pluses and minuses. A digitized image may give a somewhat less accurate representation of the visible world. Film cameras have a greater dynamic range and can produce much higher resolution than most digital cameras, although

high-end professional digital cameras and lenses are approaching the resolution of film. Film prints and negatives can also last a long time if properly stored, whereas the lifetime of a digitized image, even if stored on a computer disc, depends on having a computer that can read it. With digital technology evolving so quickly, no one knows what the computers of the future will be. Digital imagery does not fade as film can, but the storage media can become damaged and the image lost, whereas if film negatives or transparencies are stored under proper archival conditions, goodquality prints can be made from them long afterward.

On the plus side, digital photography allows the immediate viewing of images so that composition, lighting, and other factors can be previewed and changed if desired and only selected photos chosen for printing. Film speed can be adjusted as needed, rather than changing rolls of film. The manipulation of features such as color, contrast, and special effects can be handled by the photographer directly in the printing process, although this work can be quite time-consuming. Images can be replicated or copied onto other media without any loss in quality and can be input directly into a computer without scanning. Given these advantages, some—but not all—art photographers are switching to digital photography.

CREATIVE USE OF DIGITAL IMAGING

Computer manipulation of digitized images has opened a vast field of possibilities. Once the image is stored in the computer's memory, anything can be done. Some artists remain close to the original imagery but manipulate its surface qualities. Frank Noelker (8.19) does his initial photography in zoos around the world and then makes hundreds of subtle changes via computer to create the effects he envisions, almost as a painter might work. He explains:

I produce my prints digitally because it gives me so much freedom. Once I have the image in the computer I can manipulate it in an infinite number of ways. In traditional color photography one can control only value and hue. In digital imaging one can accentuate certain areas by manipulating not only the value and hue but the saturation as well.

The eye tends to gravitate toward the areas of an image that are the lightest, most in focus, and most heavily saturated. To be able to select a specific area and gently reduce the chroma and/or value so that it doesn't compete with a more

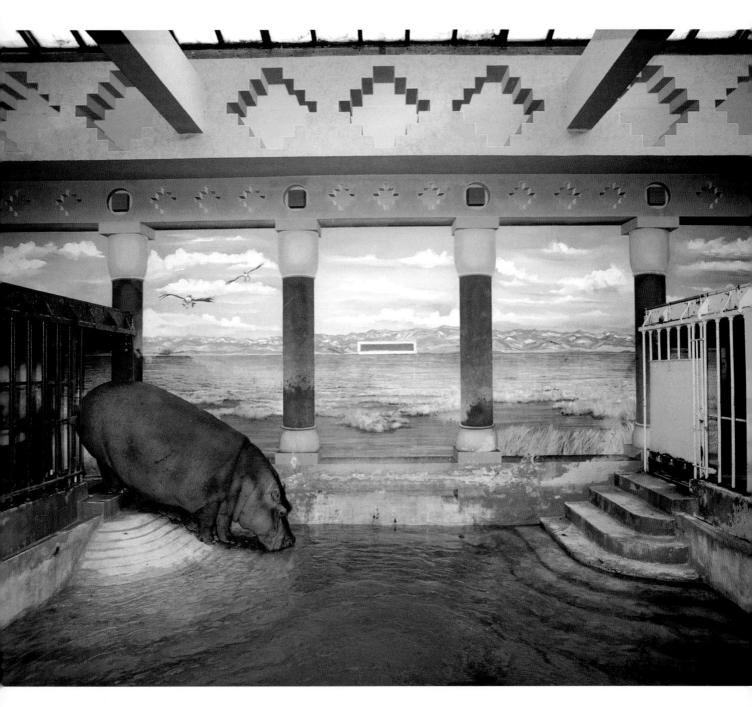

important part of the image is more comparable to the freedom one experiences in painting than to traditional photography.⁶

While digital imaging can be used to build up lushly detailed works, it can also be used to delete details so that the focus falls only upon the subject chosen by the artist, with the camera used as an art medium rather than just a way of recording a likeness. Ruth Zelanski arranged her own wet hairs against shower tiles and photographed them for highest contrast so that the hair became like a dynamic linear drawing against a white ground (8.20). She says she wanted to

bring attention to the commonplace experience of shedding hair:

An unwritten journal, daily experiences are recorded in our hair. Each strand grows for an average of 1500 days, and then silently falls away. Collected in a brush or knotted in the drain, we pay little attention to the record of ourselves that we are throwing away. In the most banal act of sticking hair to the shower tiles, I found beauty that, to me, transcended and transformed the original body waste.⁷

8.20 Ruth Zelanski, Hair, 2003. Digital photograph, inkjet printer, 13 \times 13 ins (33 \times 33 cm).

Not only one but many images stored in computer memory can be overlaid and juxtaposed in infinite ways. Complex collages can be readily manipulated, and the whole image can be printed out at any size onto surfaces such as canvas, wood, fabric, or metal. If the artist so desires, each print can be different, with the basic image stored on the computer disk and altered at will, creating a series of unique original prints. In Dorothy Simpson Krause's Independence Day (8.21), a digitized image of the American flag has been handled spatially in such a way that it appears to be both hanging on a barn behind a young woman in nineteenth-century dress and arrayed like prison bars superimposed across half of her face, as if she is just emerging from old social strictures. All of the elements that were fed into the computer-woman, barn, flag, landscape—have been digitally manipulated for effects that are at the same time surrealistic and representational.

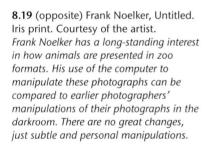

8.21 Dorothy Simpson Krause, *Independence Day,* 1999. Digital transfer, 35×28 ins $(88.9 \times 71.1 \text{ cm})$. Courtesy of the artist.

8.22 Susumu Endo, Space and Space Forest 91A, 1991. Offset lithograph, $23\frac{1}{2} \times 23\frac{1}{2}$ ins (60 \times 60 cm). Courtesy of the artist.

8.23 Eadweard Muybridge, *Headspring, a Flying Pigeon Interfering,* June 26, 1885. Victoria and Albert Museum, London.

Susumu Endo digitizes photographs of everyday objects and natural scenes and then transforms them into magical visions that challenge our understanding of spatial relationships. In *Space and Space Forest 91A* (8.22), a forest photograph changes in hues and values, and is turned into sharp-edged blocks which appear, disappear, and spill beyond their edges. In the center, the imagery becomes so visually dense that it creates an ambiguous series of shadows, as if it were a three-dimensional object. Endo says he seeks to "explore and create new space, to express the coexistence of normal space and the space beyond focus where different planes are fused together."

Film

In traditional photography a work consists of a single shot, but in a motion picture film a single frame is only one of a great number of consecutive shots. Viewed individually, each is like a still photograph, as in the sequences Eadweard Muybridge shot in the nineteenth century to analyze the components of animal and human motion. To photograph the movement of a horse galloping (to answer the question of whether all four feet were ever simultaneously off the ground) or a man turning cartwheels (with interference from a pigeon—8.23), Muybridge set up a line of twelve cameras whose shutters were tripped as the subject rushed

8.24 Robert Wiene, The Cabinet of Doctor Caligari, Germany, 1919. Decla-Bioscop (Erich Pommer).

by. Putting the images side by side in a strip suggested the idea of viewing them through the whirling toy called a zoetrope. This was a topless drum with slits around its sides through which a series of images seemed to merge in the viewer's perception as a continuous movement. The reason for this phenomenon is persistence of vision. Our perceptual apparatus retains images for about a tenth of a second after they have disappeared. In a professionally made film, images are typically presented to us at the rate of twenty-four frames per second.

Late in the nineteenth century, French inventions made it possible to record successive movements on a single strip of film; George Eastman turned this strip into durable celluloid. By the end of the century, means of projecting these images onto a screen for public viewing had been developed. Thus was laid the base for the use of moving pictures as an art medium: cinematography.

Cinematography is broadly defined as the application of photography to moving images. As an art, it involves the technical considerations of photography—such as the control of lighting, color, camera angle, focal length, and composition for desired emotional and atmospheric effects. In addition, it involves relationships between shots and scenes, and between images and sound (which is carried on a separate track alongside the images). These choices are made by a team. In addition to the person behind the camera, the team typically includes a director, a designer, a music director, a sound mixer, and an editor.

The ability to manipulate the elements of cinematography has been used to a certain degree in all films. When these manipulations make little or no attempt at the illusion of realism, films are often termed **Expressionist**. One of the most extreme examples is *The Cabinet of Doctor Caligari* (8.24), which came out of the German Expressionist movement prior to

World War I. Everything in the film was stylized to evoke a mood of dread, the world seen through the eyes of a madman. The sets were painted in stark black and white, with delirious diagonal lines, distorted perspectives, and strange painted shadows. The spatial wrenching was mirrored by jerky, mechanical acting, portraying the nightmarish control of a sleepwalker's mind by the hypnotist Caligari.

The term avant-garde or experimental film has been applied to a great variety of works intended to make a philosophical or artistic statement with little regard for public taste. Some, such as *Un Chien andalou* by Salvador Dalí and Luis Buñuel, have even gone out of their way to shock. Conceived in rebellion against the art of "witty, elegant, and intellectualized Paris," as Dalí wrote in his *Secret Life of Salvador Dalí*, the film begins with a close-up of a woman's eye about to be slit by a razor (8.25). This shot is followed by one of a

cloud crossing the moon, and then a close-up of the slitting of the eye (actually that of a dead animal). It was the Russian director Sergei Eisenstein who had pioneered this technique of **montage**—the splicing together at editing stage of a variety of shots of brief duration to produce a complex visual statement. Although all the scenes in this film are composed of photographs of actual objects, they are as disorderly and yet as surrealistically vivid as images in dreams.

Even in more apparently realistic films, visual effects may be carefully manipulated to control the audience's response. Orson Welles's still-fresh *Citizen Kane* (8.26) is the portrayal of the life of a powerful press magnate. This classic work is a showcase for cameraman Gregg Tolland's brilliant use of deep-focus shots (in which the viewer's eye can travel across subjects in many different spatial planes, all in focus), symbolic camera angles (such as the tilting of the image

8.25 Luis Buñuel and Salvador Dalí, Un Chien andalou (An Andalusian Dog), France, 1928.

8.26 Orson Welles, *Citizen Kane*, USA, 1941. RKO Pictures.

shown here to suggest the distorted nature of the politics in the film), wide-angle shots that make people standing near each other seem widely separated in space, and expressionistic use of dark and light values.

In *Rashomon* (**8.27**), the famous Japanese director Akira Kurosawa's training as a painter is evident in the careful compositions of figures and the elegance with which the camera lingers over lights, shadows, textures, and visual rhythms. As in *Citizen Kane*, the enigmatic narrative proceeds by flashbacks to previous events, as four characters each retell the story of a woman's rape and her husband's murder in a different way, leaving the audience to draw their own conclusions.

Horror and thrill in contemporary movies are greatly exaggerated by computerized special effects. Devices such as scale models, painted backdrops, smoke, cloud tanks, laser beams, light flares, and computer-generated imagery are pieced together to create terrifying illusions of fiery disasters, alien invasions, air battles, explosions, and general devastation. Oddly, the "problem" now is that viewers have become so accustomed to such effects that they no longer find them thrilling. Furthermore, worldwide violence is documented daily. Producer Dean Devlin explains:

8.27 Akira Kurosawa, Rashomon, Japan, 1951. Daiei. Rashomon brought international attention to Japanese films, and particularly the work of Kurosawa, when it won the Grand Prix at the Venice Film Festival in 1951 for its high artistic merits. It is remarkable not only for its multiple perspectives but also for Kurosawa's storytelling skill, his grappling with perennial human problems, and his ability to use film as a "canvas" for his visual art.

8.28 Image from film *Independence Day* shown in *Cinefex*, no. 67, Sept. 1996, p. 72, bottom. Dean Devlin, Producer, Roland Emmerich, Director, and Volker Engel and Doug Smith, Special Effects Supervisors, *Independence Day*, 1996. 20th Century Fox Film Corp.

8.29 *The Matrix Reloaded*, 2003. Larry and Andy Wachowski, Directors; John Gaeta, Special Effects Supervisor; Geof Darrow and Steve Skroce, Concept Artists; Owen Patterson, Production Designer; Grant Hill, Producer; and Yuen Woo-Ping, Martial Arts Choreographer.

At the time *Airport* [an earlier disaster film] came out, it worked because no one had yet captured a plane crash on video. Now, there are cameras everywhere. Riots, earthquakes, fires, tornadoes and floods are on the news every day. It's very hard to create a disaster that people haven't already seen.⁹

Nevertheless, working with some 250 special effects artists, Devlin created the thriller movie *Independence Day*, in which monstrous alien spacecrafts hover over and attack every major city in the world. In the scene shown in Figure **8.28**, New York appears to be in flames because of dozens of smoke and fire special effects overlaid on a miniature backdrop of the Manhattan skyline in forced linear perspective. The Statue of Liberty is a five-foot-tall (1.52-m) model made of foam. The hovering alien spacecraft is also a scale model. Computer imaging was used to create effects such as reflections in the water, tying the separately filmed illusions together into a convincingly realistic scene of mass disaster.

After the horrific events of September 11, 2001, which were shown day after day, hour after hour to television viewers around the world, many people—particularly in the United States—became so traumatized by images suggesting aerial attack on tall buildings that they could no longer tolerate them. Special effects have thus been applied to different subject-matter, such as creating extraordinarily realistic but impossible stunts in the *Matrix* trilogy. For scenes in *The Matrix Reloaded*, such as the physically impossible stunt shown in Figure **8.29**, over 500 digital artists were involved in creating a melee of cloned figures whose

8.30 Robert Flaherty, Nanook of the North, USA, 1921. Revillon Frères. Museum of Modern Art (MOMA), New York, Film Stills Archive.

faces and actions are convincingly like those of the main characters, whose cinematography would have required a real camera to career around at 2,000 miles (3,220 km) per hour, and whose urban surroundings maintain a convincingly realistic dreariness even as the hero flies impossibly through the air.

A contrasting approach to filmmaking is the documentary—a true-to-life depiction of real people, rather than actors, living their own lives, without an imposed story line or fake shots. To create the beautiful 1922 film Nanook of the North (8.30), filmmaker Robert Flaherty lived with the vanishing native people of northern Canada for sixteen months. He shared the hardships of their lives in order to record their everyday activities within a harsh natural environment. The vast arctic whiteness was a constant backdrop for the naturally unfolding narrative.

Even using scripted stories, filmmakers such as the renowned Satyajit Ray of India, who died in 1992, have captured the subtle nuances of ordinary people's struggles, relationships, and emotions. Satyajit Ray's films are authentically rooted in Bengali life, but appeal to universal human sentiments. Some of his characters had no previous experience with acting, and he never put them through rehearsals except for minimal runthroughs on the sets. Rather, he explained the situations and allowed them to make their own interpretations. His cinematographer developed the "bounce lighting" effect, now used by all filmmakers, to simulate diffused natural daylight in preference to the artificial lighting methods then prevalent. Ray explained: "This results in a photographic style which is truthful, unobtrusive and modern." In his later films, he also operated the camera himself in order "to know exactly at all times how a shot is going, not only in terms of acting, but of acting viewed from a chosen set-up which

8.31 Satyajit Ray, still from the Apu Trilogy. BFI: Stills, Posters and Designs.

In this touching scene from The World of Apu (1959), Apu has been united with the antisocial son he has never seen, and a sort of intimacy begins to grow between them. Thus Satyajit Ray uses his cinematic skills to evoke a tender understanding of universal human emotions, set in the specific Bengali culture.

8.32 Ingmar Bergman, still from *The Seventh Seal*, 1956. BFI: Stills, Posters and Designs. *Ingmar Bergman uses symbolic dream-like visual language that requires careful observation and analysis to understand its meaning.*

imposes a particular spatial relationship between the actors."¹⁰ Like the lighting, the camerawork is unobtrusive and matched to the mood he wishes to establish. Among his most-loved films are those of the *Apu Trilogy*, a scene from which is shown in Figure **8.31**.

Finally, there is the film as a poetic image, mysterious and beautiful. This visual poetry is evident in the classic works of the Swedish filmmaker Ingmar Bergman. Using extreme facial close-ups, flashbacks, and dreamlike imagery, he developed such memorable scenes as that of the silhouette of Death leading the peasants along the horizon in *The Seventh Seal* (8.32).

Such art films make demands upon the viewer—demands of understanding, patience, and sympathy—but can also be extremely rewarding as one enters the mood that the filmmaker attempts to evoke. Appreciation of the intensely but mysteriously spiritual works of the Russian filmmaker Andrei Tarkovsky

(1932-86) has continued to grow since his death. Tarkovsky spoke of the difficulty of staying true to the beauty of one's original inspiration when confronted by technical problems and the continual distractions of coordinating the efforts of so many people. He did not rely on editing to fix things; he specialized in extended takes, often incorporating entire twelveminute cans of film in the finished work. He did edit and join segments, but with keen awareness of the effect of editing on the viewer's sense of time in what is essentially a time-based art. He referred to filmmaking as "sculpting in time." Unfortunately, because watching Tarkovsky's extended takes requires patient concentration, they were often heavily cut and previously only minimally shown in the West. But when viewed sympathetically, his haunting and unusual images, such as the scene from Nostalgia (8.33), become deeply impressed upon the mind.

8.33 Andrei Tarkovsky, Nostalgia, Italy, 1982. Opera Film/Sovin Film/RAI.

Television and Video

Television—a staple of our times—includes both live broadcasts and playbacks of videotaped sequences. In live television, **video** (visual) and audio signals are broadcast and read as images and sound on television sets far removed from the transmitter. There is little or no editing. In general, what the camera is recording at the time is what the viewers see. This immediacy can bring the emotional impact of distant events—such as the South Vietnamese policeman executing a Vietcong

officer (**8.35**)—right into people's homes. Such images are more the result of opportunism than of aesthetic technique, but their effect is nonetheless dramatic—and in this case, disturbing.

Television camera lenses translate the amounts of light in a scene to a tube that translates light into electric signals. An electron scanner reads the hundreds of lines of signals so rapidly that the entire image is completely read thirty times a second. These signals, along with audio signals, are transmitted through the air by electromagnetic waves or bounced off communication

Mixing Art and Politics: The Films of Leni Riefenstahl

ART HAS OFTEN been used as propaganda, be it for rulers, religions, or consumer goods. Skillfully developed, visual imagery has tremendous persuasive power. However, when the aims of that persuasion are socially unacceptable, what can one say about the art itself? Is the artist's personal integrity a thing apart, or is the artist morally responsible for the social effects of his or her creations? Such issues have arisen with reference to the contemporary showing of films by Leni Riefenstahl (1902-2003), who will forever be associated with her propaganda for the Nazi regime, despite her later work, such as underwater photography, which has been largely ignored.

In 1997, when Leni Riefenstahl was given a lifetime achievement award in Los Angeles by a society for cinema connoisseurs, there were great protests by many filmmakers and members of the Jewish community. A fellow German filmmaker, Arnold Schwartzman, for instance, said: "As a filmmaker I think she is a genius, but [her filmmaking on behalf of Hitler's Third Reich] was the tool that drummed up the German people for what was to come."

The first retrospective of Riefenstahl's lifetime work was not shown in Germany until she herself was ninety-six years old, in 1998. The Filmmuseum Potsdam curators had chosen to call it "Guilt and Beauty," indicating that its political content could not be divorced from its artistic virtues, but they had to withdraw this title in order to get the artist's consent to display documents and photographs from her personal collection. In general, showings of her films for the Nazi party are still banned in Germany, although illegal video copies are in circulation. The concern is that her cinematography is so powerful that it might stir up fascist sentiments anew. To lessen their impact, Riefenstahl's Nazi propaganda films were displayed only on tiny video monitors for the Potsdam exhibit.

After the fall of Hitler's Third Reich, Riefenstahl insisted that she was simply a naive artist who worked with Hitler for only seven months and was even then concerned with imagery, not with politics. After World War II, she instigated dozens of court cases in an attempt to salvage her reputation but at the same time secure rights to her Nazi-era films. Innocent or not, her cinematography is extraordinarily powerful propaganda for Hitler's cause. Her most famous film, Triumph of the Will (8.34), documents the 1934 Nazi Party congress in Nuremberg, a huge event that was held primarily for the sake of her film. It features masses of Aryan followers and huge banners of swastikas, with Hitler everywhere treated visually as a god, rather than

a mere man. From its outset, the film pulls viewers into the masses of followers looking up to him as he descends from above in an airplane. By manipulations of scale, long shots and close-ups, movement entering from the right, from the left, she draws the viewer into a feeling of the excitement of participating in the grand spectacle. Similarly, her 1938 movie *Olympia*, featuring the Berlin Summer Olympics, gave ordinary Germans a great sense of pride in their country and in their leader who had made its successes possible.

So powerful are these film effects that when Triumph of the Will was first shown in 1950 at Cooper Union in New York, to an audience consisting largely of Jewish students and first-generation European immigrants, people told the first author of this book that they were so drawn into the propaganda that if someone had jumped up and yelled "Sieg Heil!", most of them would have probably joined in. How large a part Riefenstahl's films played in the Nazi propaganda apparatus one cannot say, but surely they must have helped to convince German citizens that the Nazi party was righteous and made people want to join the movement. Can today's audiences therefore look at them detached from their historical context and consider them solely as aesthetic masterpieces?

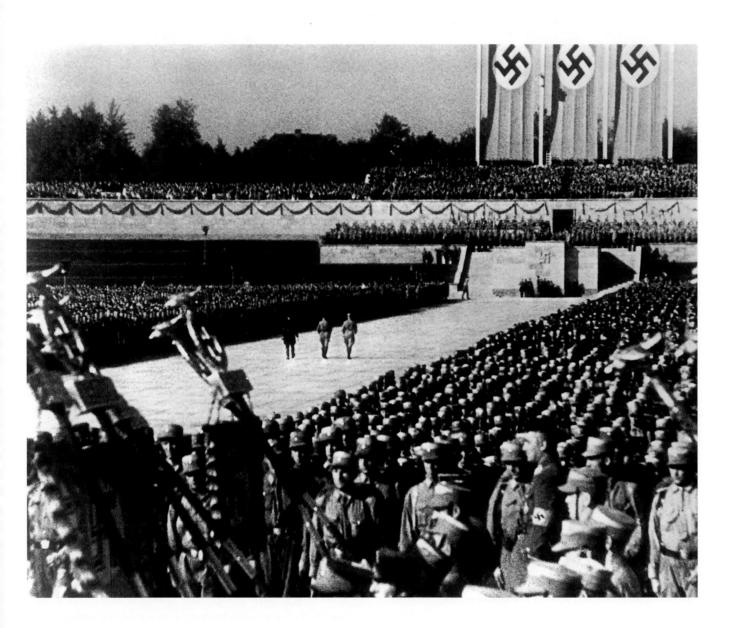

8.34 Leni Riefenstahl, *Triumph of the Will*, 1935. Clip showing Hitler advancing toward the podium of the Nazi Party Congress. Photo: Museum of Modern Art/Film Stills Archive, New York.

8.35 Eddie Adams, Execution of a Vietcong officer by the South Vietnamese National Police Chief in Saigon, 1968. This shocking television image of the execution of a Vietcong officer was one of several that brought home the violence of the war in Vietnam to viewers in the United States and contributed to a division in American society between those for and against United States participation in the war.

satellites and received by antennas, satellite dishes, or cables for transmission to television sets, where the signals are translated into the original pattern of light and sound. The persistence of human vision makes the separately transmitted signals seem to blend into continuous images.

Light and sound signals can also be recorded on magnetic videotapes, which are read by video or audio heads in a videocassette player, or optical disks such as **compact discs** (CDs) or **digital versatile** (or video) **discs** (DVDs), which are encoded as microscopic pits on a polished surface and read by laser beams. Because a permanent recording is made, it can be edited electronically and special effects can be devised. As in digital formats, computer-analyzed images can be broken down into their components, and then visually altered in an ever-expanding variety of ways.

Use of montage and special effects in television has accustomed us to responding to very complex visual manipulations of time and space. When viewers were first exposed to split-screen images in televised baseball games, where close-ups of players on bases were shown at the same time as the pitcher winding up or the batter getting ready, they could not at first understand what they were seeing. Now, especially in music videos, multiple images dissolving into each other are presented very rapidly to a visually sophisticated public, who are so familiar with the techniques that they can grasp the images and follow the sequences at speeds beyond conscious thought.

Since the 1960s, artists have also been experimenting with video as an expressive art form. Video art is collected and shown by museums and presented as installation pieces. A major figure in the development of video art is Bill Viola. In his hands, video art is an intensely colorful, psychologically expressive medium in which multiple images appear, disappear, and reappear, expand and contract, merge, and become transformed. Viola says, "I do not distinguish between the environment as the physical world out there (the 'hard' stuff) and the mental image of that environment (the 'soft' stuff)." ¹² This being his approach, his

8.36 Bill Viola, video still from *Tristan und Isolde*, 2005. Photograph by Kira Perov. Courtesy of Bill Viola Studio.

video art was well matched with the psychological dramas of Wagner's opera *Tristan and Isolde*. When performed in the Walt Disney Concert Hall in Los Angeles, a ship-like building designed by Frank Gehry, the music and singing were accompanied by a world of video imagery that wrapped around the audience, reflecting and enhancing the psychological atmospheres of longing and despair (**8.36**).

This potential intimacy of video art was used by Mona Hatoum to offer an inside tour of her own body via a video of her endoscoped innards (8.37), encased in a circular chamber, and accompanied by the sound of her heartbeat. Entering the chamber, the video installation might be experienced as the ultimate in

narcissism or as a violation of the walls of the self, such that even one's most inward parts are exposed. Paradoxically, she called the installation *Foreign Body*, as though even on most intimate scrutiny, her body is a vehicle with which her consciousness does not identify.

Since the middle of the twentieth century, Nam June Paik has been experimenting with television monitors themselves as art media. In 2000, he transformed the Guggenheim Museum in New York into a grand showcase for his particular version of video art (8.38). On the darkened ground floor, he placed one hundred television monitors face up, each projecting its flickering, fractured electronic imagery upward.

8.37 Mona Hatoum, *Corps étranger* ("Foreign Body"), 1994. Video installation with cylindrical wooden structure, video projector, amplifier, four speakers; height 137½ ins (3.5 m). Musée Nationale d'Art Moderne, Paris.

Around the ramps of the rotunda, six oversized monitors continued the same loops of recycled television material, juxtaposing raw and distorted clips from various cultures and narratives without any linear story. Added to these electronic effects was a projection of green laser beams onto a seven-story waterfall, a swirling laser display on the ceiling of the museum, and laser projections within basic geometric shapes. For good measure, a retrospective of Paik's TV art was displayed around the ramps. Pulsing, disjointed, distracting, the installation evoked the essence of the television medium itself, with viewers immersed in the fragmented light images playing across their own bodies. In Paik's installations, the medium indeed becomes the message—but is that message a new kind of brilliance, shattering older, more sedate ways of looking at life? Ultimately incoherent, bordering on madness? Sheer iconoclastic impishness, without content? Paik himself says that his television art has entered its "sublime" period, "like the great French Gothic cathedrals."13

Be that as it may, video art has broken loose of monitors and may be displayed in a large scale against any

8.38 Nam June Paik in collaboration with Norman Ballard, Paul Garrin, David Hartnett, and Stephen Vitiello, *Modulation in Sync, 2000*, in "The Worlds of Nam June Paik," Solomon R. Guggenheim Museum, New York.

8.39 Image by Ching-Fang Chiang from the DVD "Reconstruction,"— a group project by Lien Fan Shen, Chiang-Fang Chiang, Caroline Quinlan, and Edward Schocker.

surface. Videos are projected onto walls surrounding viewers, filling rooms and pressing in upon their awareness, as in Viola's video accompaniment to Tristan and Isolde, which was projected around the concert hall's irregular contours as the opera progressed. Even otherwise, sound and projections of still images may be added, further encroaching upon the viewer's consciousness as multimedia installations. Computer manipulation creates unlimited possibilities in the video imagery. Lien Fan Shen, Ching-Fang Chiang, Caroline Quinlan, and Edward Schocker have thus created a multimedia digital installation that becomes a virtual environment, evoking in viewers the sensations of confinement in a small space, a now-abandoned state hospital complex in Illinois whose ruins are both peaceful and disturbing, carrying memories of thousands who died within those walls (8.39).

Digital Art

9.1 Jeremy Blake, *Mod Lang*, Installation View at Feigen Contemporary, October 20–November 24, 2001. Sequence from DVD with sound for plasma or projection, 16 minute continuous loop. Courtesy Feigen Contemporary, New York.

KEY CONCEPTS

How artists draw and paint using the computer

Drawing and painting two-dimensional art using the computer

Using the computer as a tool to plan and execute three-dimensional art

Special effects—computer-generated video art

Virtual reality—the viewer as participator

The machine versus art

The opening up of art through the Internet

IN A NEW YORK gallery, three large panels of Jeremy Blake's abstract computer-generated DVD images (9.1) are projected against a wall, creating an extensive animated triptych. Like dynamic color field paintings, they treat the wall as a flat space in which shapes and colors continually mutate into other shapes and colors. The sequence on the left goes through its complete visual narrative in twelve minutes and then starts over; the other two panels take sixteen minutes to complete their loops and begin again. The digital art installation includes a soundtrack resembling the whirring blades of helicopters and the frightening buzz of woodcutting saws. Optically and aurally, the installation would be rather overwhelming, were it not for the fact that the viewing public in New York and other cities around the world is already accustomed to a barrage of visual and

aural stimuli, including commercial uses of computergenerated imagery.

Since the late twentieth century, computer graphics—visual imagery created with the aid of computers—has rapidly moved from high-tech laboratories into artists' studios and thence into galleries and museums. Sophisticated and realistic visual effects are now being widely created, existing only as binary digits in the memories of machines and "cyberspace"—the global network of computer linkages through the Internet. Rapidly evolving innovations in miniaturized memory and high-speed information processing, screens with extremely fine resolution and the capacity to display over sixteen million colors, high-resolution color printers and plotters that can produce a continuous range of values of the same hue, sophisticated graphics software, and the burgeoning world of interactive art on the Internet are opening previously unimaginable possibilities to artists. Some artists are treating the computer as a tool for handling conventional techniques very rapidly and perfectly. Other contemporary artists find that the computer is a new medium in itself, facilitating entirely new approaches to art.

The Computer as a Drawing Medium

The original method of using the computer for drawing purposes was to type out mathematical formulas—programs—in order to communicate with the computer and printer. In this case, art is created solely by

numbers, and it takes a lot of them just to draw a line. Now that computer graphics have progressed tremendously since their earliest days, the artist need not be the one who devises the formulas. Computer professionals have created a number of graphics programs and tools that can be used somewhat more easily by artists.

Some drawing programs allow artists to work rather conventionally, drawing by hand, but using an electronic stylus on a digitizing tablet that transfers their markings to a computer screen. The computer "knows" where to put the marks because the computer screen is divided into an invisible grid of points called **pixels**. The computer assigns mathematical references to points on the image, thus **digitizing** them so that they correspond to the numbered grid of pixels on the screen. Higher resolution screens are those with more pixels. One can also move a "mouse" off-screen in order to give positional commands to a cursor on-screen.

These indirect methods of drawing require that the artist develops some unfamiliar eye-hand coordination skills, for the image appears on the screen as one draws it, rather than directly under the stylus or mouse. Additional "tools" on the computer screen allow the artist to do painterly things such as filling in, blending, or "spraying" colors.

Once the basic information is entered, the artist can manipulate it indefinitely, unlike a drawing done with any other medium. Images can be flipped, rotated,

9.2 Kenneth Knowlton and Leon Harmon, *Computerized Nude*, 1966. AT&T Bell Laboratories, Murray Hill, New Jersey.

stretched, compressed, repeated, added to, or subtracted from; lines can be widened or narrowed, and their surface texture and color altered ad infinitum. Intricate drawings become possible that no one would attempt by hand.

Computer scientists Leon Harmon and Kenneth Knowlton of Bell Laboratories did pioneering experiments in the 1960s with "photomosaics," the process of scanning a photograph into a computer and converting its values into a gray scale. They then recreated the twelve steps in their scale by using marks that were different from any used in traditional drawings (such as hatching and stippling), creating a unique visual texture. They were attempting to determine the minimal amount of information the human eye needs in order to recognize an image as a three-dimensional figure. For this purpose, they scanned a nude photograph of dancer Deborah Hay and printed it 12 feet (3.6 m) long (9.2).

A computer can be programmed to "know" how to create the impression of three-dimensional form on a two-dimensional surface, by using visual clues such as shading, overlapping, linear perspective, and scale change. Such work may require the combined skills of an artist and a computer programmer, or its technological aspect may be carried out by graphics software.

The Computer as a Painting Medium

To use the computer as a medium for creating paintings, pixels are "colored" by electronic instructions, which have become so sophisticated that computer artists can now mimic hand-painted work, if they so choose. In fact, so many artists are now using computer technologies that the touch of the human hand is disappearing from much of today's art.

Various commercial programs are available that allow the artist to draw an image on a digitizing tablet which transfers it to the computer monitor as in computer drawing; areas can then be "painted" on the screen by making choices from a "palette" of over sixteen million colors, in the case of high-end equipment.

Another starting point is to use a colored photograph as a source image which is electronically scanned as a **bitmap** reporting the predominant color of each small area (**9.3**). These areas can be reproduced with realistic color-matching, or the colors can be changed at will, including the option of limiting

9.3 Bitmap scanning. The scanner looks at the image square by square. If there is a lot of dark color in the square, it registers a black dot. If the square is mostly white, it registers nothing. The finer the imaginary grid of squares, the better the resolution and the better quality the bitmapped image. For a color halftone it scans three times, using red, green, and blue filters.

rather than extending the palette. Colors can be "painted" in with brushlike strokes of any size or direction. Edges can be "pushed" to exaggerate the contrast between colored areas, to develop three-dimensionality. The whole background can be "washed" with color, as if toning a canvas, and additional images can be overlaid. Three-dimensional illusions of forms can be created with realistic or skewed "lighting" effects and visually textured surfaces, even if the forms are unlike any ever seen on earth.

With fractal geometry, astonishingly realistic landscapes can be created arithmetically without reference to any known landscape. This mathematical modeling of complex and random patterns in nature was developed in the late 1970s by the mathematician Benoit Mandelbrot. He based his computer models on the concept of "self-similarity"—the observation that large natural forms consist of visually similar smaller forms. Richard Voss's fractal images, Changing the Fractal Dimension (9.4), demonstrate this logic. Using the same program, Voss changed the fractal dimension of this computer-simulated landscape to be more and more attenuated, thus altering the roughness of the smallest details along with the large forms. Fractals have been taken up with great enthusiasm by many artists who are also mathematicians—or mathematicians who also have aesthetic sensibilities.

Computers can now also create a "painting" by manipulating a scanned-in photographic image for painterly effects. They can simulate brushstrokes, produce an image in a particular style such as Impressionist, rotate and warp and stretch the image, without any "hands-on" work by the artist. Further, for traditional painting-like results, artists may choose to print "hard copies" of their computer paintings, using film, plotters, or printers, onto art paper, canvas, or textiles.

However, as the fast-changing world of digital art evolves, artists are taking it into realms that transcend anything previously conceived through traditional painting methods. Images can be projected onto nontraditional "surfaces," such as a fog screen that allows viewers to walk through the image. And once images are scanned into computer memory, they can be overlaid and combined and altered in endless ways. Gwenn Thomas first makes collages by assembling cloth scraps, strips of paper or tape, and bits of old paintings, and then digitizes them via scanning or digital photographs. Then she prints the digitized collages in a larger format on canvas, unifying their diverse surfaces but retaining some impression of the shadows and textures from the original collages, as in her triptych AB:47/Untitled (9.5).

Pamela Zagarenski builds up layers of Russian typography, "painted" lines and washes, rough textures, and simple line art in her 1895 (9.6). Its whimsical

9.4 Richard Voss, *Changing the Fractal Dimension*, 1983. Cibachrome prints, each 10 \times 14 ins (25.4 \times 35.6 cm). Courtesy of the artist.

9.5 Gwenn Thomas, *AB:47/Untitled* (triptych), 2001. Iris print on canvas, each panel 34×28 ins (86.4 \times 71.1 cm). Courtesy of Art Projects International (API), New York.

9.6 Pamela Zagarenski, 1895, 2005. Adobe Photoshop and Adobe Illustrator, digital print, 8 ×10 ins (20.3 × 25.4 cm) or any size. Artist's collection.

ARTISTS ON ART

Janet Cummings Good Compares Computer to Other Media

Janet Cummings Good has worked with various traditional media, such as ink drawing (see Figure 2.63) and printmaking, although she may use them in unique ways (see Figure 6.33). Now she often uses digital technologies as her expressive medium of choice, as in her *Lunar Moth and Morning Glory* (9.7). She speaks as an artist who also loves the feel and effects of traditional media:

"To draw is to experience something in a way that, although certainly related to seeing, is different. For me it is tactile and intimate. When drawing a person, I feel the contours of a cheek, touch an eyelid, a chin. While drawing a cat, the fine point pen is my hand in her fur, as it roams the form and texture of her contours.

"As much as I have preferred to 'draw from life,' there were times when I needed to freeze my subject in time with a camera. (Many

notebooks are filled with sketches of cats who will sleep motionless for hours unless they sense they are being captured by pen and ink.) Why not then be content with the photograph? Because the Nikon's 100mm lens could not record what I saw, and knew, and felt. I could bring a personal sensibility to the moment the camera had captured and allowed me to analyze.

"In attempting to create a kind of realism, I usually drew my subjects as close to lifesize as possible. Later, in an attempt to get beyond the surface realism to an abstraction that could say more about the essence of a subject, I found myself using my own body as a tool. I painted my body with gesso and pressed it to paper and later canvas. Ironically, by confronting the subject in this most direct way, I was able to get beyond the surface to an abstraction both super real (and exactly lifesize), yet

abstract in surprising ways. The difference in the absorption qualities of the paper vs. gesso allowed me to apply color to the image and never lose detail. In fact, the more the surface was worked, the more differentiated the edges became.

"Then the computer entered the scene and enticed me with all its potential. Add the little digital camera, and who could resist the immediacy and versatility of being able to capture, then manipulate and layer images in ways impossible to imagine before this technology. And then there's the scanner, a slow steady camera with a fantastic lens that enables me to see things not seen in real time.

"Yes, digital technology has fed and fueled my obsession with color since I got my hands on that first color monitor and printer ten years ago. The analytical side of my mind loves the limitless possibilities for

9.7 Janet Cummings Good, *Lunar Moth and Morning Glory* from the "Petals and Wings" series, 2005. Epson archival print, printed on an Epson 7600 printer with Ultra Chrome ink on Enhanced Matte paper, 23 × 33½ ins (58.4 × 85 cm). Artist's collection.

adjusting hue, value, and saturation—with a click of a mouse, the choice of a number, the sliding of a bar, the reshaping of a curve.

"The formal opportunities for combining, sizing, layering, repeating, cropping, and editing imagery are equally rich. However, the choices can be overwhelming if intuition does not play its part. The analytical always needs to respond to the intuitive which will react, ponder, contemplate in order to finally arrive at a place of personal sureness.

"One danger in this process is becoming seduced by the beauty and intensity of what is seen on the monitor. The ethereal world of RGB light provides a beautiful deep space that flattens when the digital world is committed to paper. Many love affairs with light imagery have to end in the electronic trash barrel. However, for the work which survives the transformation, all effort is rewarded by the richness and subtlety of color produced by the inkjet printer. I think it miraculous.

"When the 'final' visual is established, I can then choose to produce a series. The electronic original is eventually archived away, remaining available to me as potential raw material—perhaps to rethink, reform, reconfigure.

"Immersed in this twenty-first century technology, I do sometimes wonder if something is lost. There are times when I miss the slow, deliberate flow of ink from the old $4\times.0$) Rapidograph pen onto a sheet of my favorite Arches 22×30 " hot press watercolor paper. Will I ever take up the pen again? Maybe. Can we artists have it all? I'd like to think so."

appearance, complete with what appears to be a paper boat made by a child, belies the technological sophistication of the transparency effects.

Given the infinite possibilities of digital art and the raw materials that it can transpose into new forms, moral and legal issues arise. What state of the process of creating digital art is the work of art?

Can it be freely duplicated by the artist? In traditional print media, a series of prints are pulled from one block and each print is numbered. Then the block must be scored so that it cannot be re-used. If the art consists in programming a computer disk, must the program be erased after an edition is printed or photographed from the electronics of the computer? Should the disk itself be sold? Can the purchaser make changes in it? Does the work exist as art only if it is seen in real time on a computer monitor or video screen? These are new questions evoked by an entirely new set of artistic circumstances.

The Computer in Three-Dimensional Art

In addition to two-dimensional work which is as flat as the computer monitor, computers are also extensively employed to plan and execute three-dimensional sculptures, consumer goods, installations, interior design, and architecture. Computer-aided design programs allow the sculptor to experiment digitally with forms, and "see" and "display" them from all sides, complete with surface and lighting effects. Once the design considerations have been decided, the computer can also specify material and structural details needed to execute the design in real three-dimensional space.

It is only through the computer's ability to perform long strings of calculations very quickly that extremely complicated sculptural forms have become possible in architecture. Although anything is possible in the virtual world of computers, to translate one's fantasies into steel beams and cement requires extensive calculations of gravity-bound requirements such as load-bearing factors. Frank Gehry's Guggenheim Museum in Bilbao (1.51) was created using sophisticated hardware and software initially designed for the construction of spacecraft, ships, and bridges. The result was an innovative structure in which the dimensions of each piece of structural steel are unique. The stones covering its surface were also custom-cut by computer-driven robots.

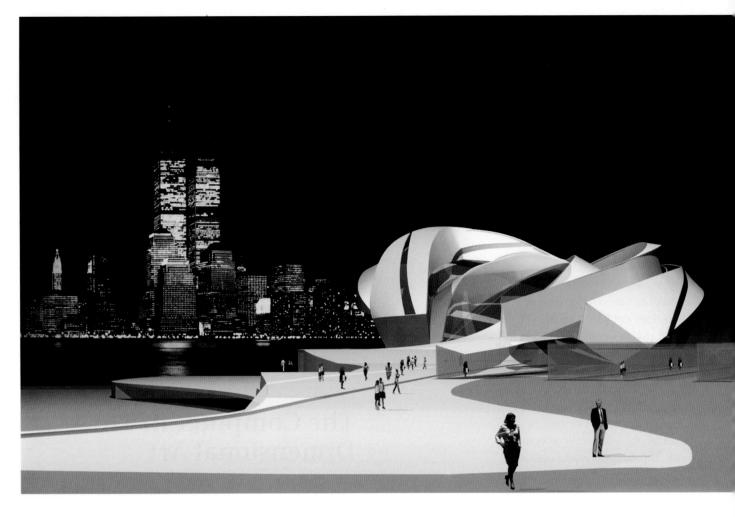

9.8 Eisenman Architects, Staten Island Institute for Arts and Sciences at the St. George Ferry Terminal, 2001. Computer rendering. *Peter Eisenman used computer-aided design to create what he terms a "dislocating architecture" that is "at once presence and absence."* The Institute is now complete, but after September 11, the New York skyline has changed.

Nonetheless, Gehry also used the traditional method of making physical models while developing his basic ideas for the structure. Similarly, Peter Eisenman used a combination of physical and computer models to arrive at the structure for the Staten Island Institute for Arts and Sciences (9.8). Eisenman is at the same time searching for a "new generation" of forms which derive from computer modeling alone, reflecting thinking totally divorced from what was traditionally possible. He reflects, "We haven't yet come to grips with the age of the digital, how it can change the relationships of our bodies to space and time."²

Video Graphics

Lively experimentation is also underway in the field of computer-generated video art. The same processes are used as those described in computer drawing and painting, except that the potential for altering colors, reducing, enlarging, and rotating figures through space, and "photographing" them from differing focal lengths, all at great speed, is played out for the viewer in real time instead of creating a single image.

Science fiction and thriller movies make great use of computer-generated special effects (8.28, 8.29). The first feature-length movie incorporating computer-generated animation was *Tron* (9.9), from Walt Disney Productions. The rapidity of computer calculations enabled the designers not only to design fantasy machines, but also to show them in realistic and continually shifting linear perspective as "light cycles" zoomed through illusionary space.

9.9 Walt Disney Productions, *Tron*, 1982.
Tron was a breakthrough for the special effects industry, with its computer-generated imagery and backlit enhanced live action, and since then film animation for everything from movies to television commercials has never been the same.

Computer graphics technologies have also been used to create animated representations of forms in our natural world that no one has yet seen, but that can be deduced from scientific data. These are primarily created for scientific study, but some are aesthetically exciting as well. Melvin L. Prueitt, of the Los Alamos National Laboratory, where this kind of computer imagery has been generated, speaks of the beauty of the unseen world:

The universe is filled with beauty, most of it unseen and unsensed. What does an intense magnetic field look like as it churns and bubbles near a neutron star? ... The narrow spectrum of our vision, our hearing, designed to detect the coordinated motions of molecules under restricted conditions, our sense of smell allowing us to detect only a few chemical compounds in the gaseous state, and our short-range sense of touch give us only a partial view of all there is ... Although science discovered myriad strange phenomena, we could not see them ... By computer graphics we begin to see what we have suspected for some time: that the foundations of the universe are filled with niches of loveliness.4

As digital video art evolves, designers are also creating dynamic invented forms that tell their own visual stories of change through time and space, from varying "camera angles." They can be programmed for credible if unfamiliar "growth" and movements, through space that need not bear any relationship to spatial realities.

Hybrid forms are also evolving, combining video footage of actual settings with computer-animated figures. Walt Disney Studios has again been one of the pioneers in this effort, creating feature films such as Dinosaur (9.10) by shooting environments around the globe as backgrounds for its computer-animated sequences. For a photo-realistic effect, this means that the animated figures have to look as fully lifelike as the real environments and that the two must be convincingly merged. If a ten-ton animated dinosaur's foot pounds the sand looking for water, that sand has to appear to move realistically under its weight. Shadows and lighting have to be added and minutely adjusted. Some scenes used elements from different parts of the world: sky from one continent, mountains from another, and water from yet another. Thus the last two scenes in the film alone, running only one-and-a-half minutes, took six months of work in the studio, with up to two hundred layers of elements being combined.

9.10 Walt Disney Studios, Aldar bonds with the lemurs, frame from Dinosaur, 2000. Film animation makes use of the persistence of vision, as our brains process a rapidly presented series of drawings as though we were seeing continuous action. In films such as Dinosaur, the effects are now so lifelike that we think we are seeing actual movies of prehistoric creatures.

Virtual Reality

The ultimate computer-generated experience is *virtual* reality systems in which the viewer also becomes participator in the action. This technology allows architects to "walk through" buildings they have planned and examine what they will look like, before they exist in reality. Another art application is an extension of video games. One enters a fantasy world by donning a headset with a pair of miniature monitors and earphones inside or by putting one's head into a tunnel that blocks peripheral vision. Position sensors within the headgear track movements of the user's head, giving a different computerized visual display on the miniature screens depending on which way the user is looking. This gives one the strange illusion of being in a three-dimensional reality, but without one's own body. Disembodied, the user can move through this illusory virtual reality and even "hear" things in the virtual environment.

A "tactile input device" transfers the movements of the participant's hand to the computer by fiber optics and a special tracking system. To make industrial mock-ups, the designer's hand may receive "sensory reaction" feedback to allow manipulation on the screen of "virtual solid objects" by a "virtual hand." Both hand and object actually exist only as numbers but the designer can "feel" an object and alter it on the computer screen in approximation of crafting something by hand. Computer technology is evolving so rapidly that these experiences are becoming more and more lifelike. Animated "tours" of virtual interiors call for highly sophisticated software which can calculate the lighting effects not only of illumination coming from various sources but also the reflections of light off the virtual surfaces.

As virtual reality technology becomes less expensive and more accessible, it is being used not only for the creation of illusory three-dimensional art, but also for virtual access to the art collections of major museums. At the beginning of the twentieth century, universities had plaster casts of master sculptures for students to study. But these were not fully satisfactory, for they were big and easily broken, and soon became dusty. Now students can "enter" a pristine virtual room and examine "sculptures" within it from every angle, or "walk" through the intricacies of ancient rock temples.

A computer graphics team from the Massachusetts Institute of Technology has even taken up the project of creating virtual architectural tours of visionary architecture that was never built, such as Vladimir Tatlin's Monument to the Third International, a spiraling tower designed to allow people to look out across St. Petersburg while ascending through large glass forms in a slowly rotating structure. The virtual tour includes videotaped views of St. Petersburg as one ascends

through the convincingly realistic three-dimensional structure of the unbuilt building. Its virtual surfaces have even been treated to appear eighty years old.

There are also contemporary installations that create immersion experiences without virtual reality paraphernalia, using digital, screen-based, and projection technologies. Viewers may be plunged into an intimate audio-visual environment that surrounds them and transports them to different perceptual and emotional levels—body, mind, and perhaps soul.

The Computer as a Unique Art Medium

As computer graphics engineering advances, the question arises: Is digital art a new art form that does not require artistic sensibilities? Will the ease of creating

complex, rapidly changing, brightly colored images by computer change public tastes in art? Does digital art have any meaning, or is it just a display of technological brilliance?

Computers were not created as art media; they were mathematical tools designed to generate more mathematics. Those who have recently taken them up to create art are now beginning to explore issues of aesthetics and content in computer-generated art.

Much of the money and brilliance behind the digital art explosion initially came from engineering laboratories. Before "user-friendly" software, computers were largely the province of engineers. Artists who tried to use computers to create art faced tremendous struggles to work with the medium. Painter David Em was the artist in residence at NASA's Jet Propulsion Lab (JPL) from 1977 to 1989. He developed ways of commanding computers to create three-dimensional spatial effects and painterly works such as *Navajo* 1978 (9.11). He recalls,

9.11 David Em, Navajo 1978. Cibachrome print from digital image, 16×20 ins (40.6×50.8 cm).

I worked on a Digital Equipment PDP 11/45 minicomputer the size of a horse that ran software written by Jim Blinn. Nothing was documented, and getting information out of the systems programmers about even the simplest things was sometimes like pulling teeth, so learning how to run the JPL system was less than trivial.

The JPL Graphics Lab's physical environment resembled a space station. The rooms were small, cramped, filled with machines, and refrigerated to not much above freezing to keep the computers from overheating. I wore a hooded parka, wool socks that I pulled up over my pants legs, and a pair of thick alpaca gloves with holes cut out for my fingers so I could tap on the keyboard. ...

The tools I use today are literally thousands of times more powerful than the ones I fought tooth and nail simply to get access to in the early days. What had cost a king's ransom then can now be had for pennies. The room-sized behemoths of yore have shrunk to the size of a fingernail, and artists no longer have to deal with lab managers, guards, or cranky programmers to get their work done.

Hallelujah.5

Pioneering computer artist Charles Csuri first labored in the 1960s to create images using stacks of punched cards fed into a giant mainframe. Creating images required the use of mathematical formulas. These early computer technologies were so unwieldy and arcane that few artists attempted to master them. Nowhere was there the traditional tactile connection between the artist and the artwork.

Nevertheless, Charles Csuri persisted, because he had sensed the untapped potential of computer graphics as a unique art medium. Once microprocessors were introduced in the late 1970s, followed by user-friendly software programs that eliminated the need for programming skills, the potential of computer graphics began to be tapped by increasing numbers of artists.

Harold Cohen, for instance, carried out experiments in programming a computer to think for itself, as it were, making decisions and drawing pictures that resemble natural forms. Cohen then hand-colored the ones that he liked.

One of the computer's unique qualities is that it permits major changes to be made very quickly once a program is established—the user can instantly change an image's position, shape, scale, colors, lighting effects, and surface texture, fragment it, duplicate it, destroy it, bring it back in a new virtual incarnation, and at the same time preserve the original unchanged. Another unique quality of computer graphics is that the artist is indirectly creating with light. Csuri explored treating computer-mixed colors as transparent light in his *Wondrous Spring* (9.12). The delicacy and creativity of this image reveal the training and attitude of a visual artist. By contrast, much computer art looks alike, because people have let the machine dictate to them rather than vice versa. Csuri explains:

Just because the computer can do perspective and beautiful shadows and shininess, or make things look like glass, you still need to have an esthetic sensibility; you need a sense of culture and history. Even though we have all this marvelous technology, the problems for the artist are still the same. You can very easily be seduced by some special effect, but that in and of itself doesn't do it. You have to have some way of communicating what you feel as a human being.⁶

Just as early art photographs tried to imitate paintings, a major thrust of digital art has been the attempt to imitate photographs. Digital representation of familiar objects from the real world is becoming stunningly accurate, but is representational art the highest goal of this new medium? Just because computers can alter images with great speed, is there necessarily aesthetic value in doing so? And once computer artists have struggled to create an image, will they have the discipline to examine it critically from an aesthetic point of view and reject it if it does not work well? Will they use a great variety of colors just because they are available, rather than being more selective? As digital video artist John Andrew Berton, Jr., observes:

Objects created for a synthetic cinema piece generally represent a significant amount of creative effort, at least with today's technology. Thus an artist will often include objects in digital works simply because they are available, whether or not they carry meaning. Like all cinema artists, the digital animator must learn to throw away elements, occasionally, for aesthetic reasons, in spite of the work and technique that went into their creation ... The computer makes the viewer believe that an object exists, but the artist must make the viewer believe that the object's existence has meaning.⁷

9.12 Charles Csuri, Wondrous Spring, 1992.

Interactive Art in Cyberspace

The newest frontier in art is the ether of cyberspace. With only a personal computer and a connection to the Internet—the international network of computer communications through telephone lines or electronic signals—a user can upload or download a wealth of digitized art. To **upload** is to enter material from your own computer onto the computer network for access by others; to **download** is to take material from the network and file it on your computer for your own use.

Numerous artists and groups of artists now have their own website (place) on the World Wide Web, the division of the Internet that displays graphics as well as text. Major galleries and museums have digitized their collections for view on computer screens around the world through the Internet or CD-ROMS. With virtal

reality, it is possible to "walk" through a major museum and look at its art treasures from all angles without ever leaving home.

Downloading digitized art onto a computer monitor is a different experience from seeing the original. Using current technologies, the image typically unfolds from the top down, like a scroll being unrolled, so that one first sees the parts rather than the whole. In addition, as in viewing a slide or printed reproduction of a work, one has no real idea of its size. Even if the size is written out, it takes a leap of the imagination to grasp the enormous size of Picasso's Guernica (1.50 and 16.1). To see that 25-foot-long (7.6-m) painting on a small screen is very different from experiencing the powerful impact of the original. One wonders also whether computer-literate generations will become so accustomed to the brightness of computer colors that they will then be disappointed with the lower saturation of the original if they do see it?

Art Websites

Increasingly, the Internet is being used as virtual gallery or museum space for the display of art. Today's computer users who are quite familiar with "surfing" the Net to find things of interest can easily view the works of all famous and many less famous artists, as the digitized array of art grows by leaps and bounds.

Innovative galleries and museums are also innovative in their ways of displaying their collections. DesignMuseo in Helsinki showcases industrial design through a home page that uses a grid like the graph paper of old or bitmap scanning of today to visually suggest the act of designing, plus a few representative examples from their permanent collection and current shows (9.13). Even as the viewer watches, the motorscooter sometimes turns into a mobile phone and also into a mosaic of fleeting imagery that evokes a sense of contemporary people and contemporary art, but that appears and disappears too quickly to be logically grasped.

The Center for Contemporary Art in Kitakyushu, Japan, is a non-profit research and study center subsidized by the city of Kitakyushu to encourage promising young artists from around the world and to sponsor collaborative contemporary art projects. Its home page (9.14) is a dynamic grid reflecting the variety of projects with which it is involved. If you position the cursor over any window in the grid, it enlarges and pulsates. Click on it, and the screen becomes filled with a page of information on that work and a larger version of the picture, plus a place to click for more information about its artist. The home page is thus an easy-to-use entry point to a tremendous amount of information, as well as comprising an intriguing visual collage in itself.

Because of the tremendous potential for attracting viewers through websites, many individual artists have also developed their own websites for display and perhaps sale of their works. Here, well-known and unknown artists are all on the same footing. Internet users are accustomed to moving quickly from one site to another, so the home page has to hold their attention and make them want to explore more of the

website. In this regard, Karen Cassyd-Lent's home page shown in Figure 9.15 is successful in being aesthetically pleasing in itself, conveying the feeling of her vividly colorful abstract paintings, and encouraging the viewer to explore her biography, art, and contact information. However, Cassyd-Lent has found that presenting her art via the Internet involves many difficulties that are quite different from the complexities of creating the art. She says,

"I began the project of creating a website some six years ago when the surge of Internet 'Virtual Art Galleries' came trolling for artists willing to take a chance on posting their wares on their sites. They thought this new venue for selling artwork was going to be the latest and greatest application for this new thing called the Internet. I signed on with two start-ups. The one I was hoping would make it came to my home studio, took photos of my work, had a simple and open contract for me to sign regarding sales, commissions, and responsibilities. Theory and practice ended up being something else. I quickly had to tell her that I was being inundated with phone calls mostly from interior decorators and all wanted to bypass the pricing laid out on the website and deal directly with me at a discount, something I would never do.

"There were all sorts of problems encountered with other sites, mostly due to the lack of programs that allowed for a smooth transfer of data between artists and the host. Every day something was down and artwork sent to them was lost, or the

9.13 The home page of the Design Museum, Finland.

9.14 The home page of the Center for Contemporary Art, Japan.

sites themselves weren't up for days at a time. Those artists who recognized a need to have their own sites to link into these 'Virtual Galleries' were faced with the same problems. There was a limited pool of competent designers, user-friendly software, and quality hardware. The concept was just out of its infancy. The art departments at universities were training the inaugural class of computer artists.

"The website I have now is a result of those years of learning from my errors and finally getting the right help. I figured out how to take advantage of the improvements to computer hardware, software, and the Internet. But my biggest coup

was meeting Rick Melnick, an outstandingly talented, professional digital photographer who happened to have extensive hands-on experience with IBM's PC programs and had every software package anyone doing this work could want. He came to my studio and my home and spent hours shooting everything he saw there. Putting the site together was the easiest so far, even though we communicated almost entirely by e-mail. He understood exactly how I saw my site, and how I wanted it to work. Maybe not everything is perfected, but I'm thrilled with what I've got. It's miles from where I started so I see it as a work in progress."8

the art of

KAREN CASSYD-LENT

SANTA FE. NM

contact

"Karen's work can best be described as brilliant"
- paul zelanski, author of "Color" and "The Art of Seeing"

Thanks to global Internet access, art works and movements that previously took months or years to be known in other countries can now be seen the day they are put on the web or seen on television. Time and distance have been eliminated as factors in the spread of art ideas and public awareness of artists. Information about artists and their lives and artistic intentions can easily be discovered through search engines. From a commercial point of view, the number of "hits" on an artist's or gallery's site can be assumed to be a rough indication of public interest in the work. Galleries may check other galleries' websites to see what is selling, and at what prices.

Even though art can quickly be accessed on the Internet, the experience of seeing it on a computer monitor is not the same as seeing the actual art. Images are usually smaller—sometimes much smaller—than the originals. They may be compressed for quick downloading, so fine details may be compromised. Even threedimensional art is presented on a flat surface and thus can usually be viewed from only one angle. The colors on the computer monitor may not be the true colors of the artwork. Light mixtures on the monitor may be more intense than additive pigment mixtures—a difference that today's monitor-accustomed viewers may actually prefer, but that nonetheless deviates from the original. There is no chance to experience what happens as you move closer to a work; there is no way to see its true surface; there is no way to touch it, to smell it, to be amazed by its scale. Therefore, at best, art websites serve to whet public appetite for exploring artworks in person whenever time and distance are favorable.

9.15 The home page of artist Karen Cassyd-Lent, created 2004.

Once downloaded, someone else's digitized images can be reused and altered at will. Interactive Internet art intentionally uses this technological possibility to make artmaking a community affair. "Open-source" artworks on the Internet provide the code allowing anyone to run the program as a free gift from the artist, and even to make changes in it. Mark Napier, a pioneer in free interactive digital art, has also devised programs that can be run and altered only by those who pay for access to them. Access to his The Waiting Room is limited to fifty collectors who pay \$1,000 each. He has also restricted their choices of colors and shapes so that the work still has a certain visual unity, as seen in three of its modulations shown in Figure 9.16. Napier explains that he has placed these restrictions on the interactive work "to eliminate the noise of 1,000 users a day,"9 which is the minimum number of daily visitors to his free interactive websites.

Interactive possibilities offer new vistas for art students. What happens, for instance, if you add colors to *Guernica*? If you wrap a two-dimensional image around a three-dimensional computer-generated "object"? If you change textures with the click of a mouse?

At the same time, altering digitized artworks raises legal issues. In 1998 Mark Napier offered Shredder, an early interactive website into which anyone could send imagery and encoding from any other website and see it visually torn up. This was a playful exercise, but according to the 1998 Digital Millennium Copyright Act it infringed the provision that it is illegal to tinker with the code of anyone's website other than one's own. Traditionally, all art has been legally copyrighted, but now it is possible to download digitized images from cyberspace networks or CD-ROMS onto slides or printers and thus reproduce them. Artists can download each other's art, change it a bit, and then claim that the new image is their own original work. How can ownership be protected? What does ownership of digitized images mean?

Compared to photography, which was not shown in an art museum until almost one hundred years after its invention, digital art has rather rapidly entered the art mainstream. The very speed of its invention and adoption as a new art form has also brought up legal as well as aesthetic questions which have yet to be clearly defined.

9.16 Mark Napier, *The Waiting Room*, 2002. Interactive video. Courtesy of the artist.

PART

Three-dimensional Media and Methods

Anish Kapoor, *Cloud Gate*, Millennium Park, Chicago, 2004 (detail of fig. 2.94).

IN OUR DAILY lives we are surrounded by works of three-dimensional art. Our clothes, buildings, gardens, cars, and functional objects all bear the designer's stamp, with varying artistic success, as do sculptural works whose main purpose is the aesthetic experience.

Sculpture

MKEY CONCEPTS

Planning the sculpture

Liberating the sculpture from a solid block

Building the sculpture using malleable materials

Making a mold and casting

Creating sculpture from "found" materials

Sculpting from the earth

10.1 Alice Aycock, *Tree of Life Fantasy: Synopsis of the Book of Questions Concerning the World Order and/or the Order of Worlds*, 1990–92. Painted steel, fiberglass, and wood, $20 \times 15 \times 8$ ft (6.1 \times 4.57 \times 244 m). Collection, University of Illinois at Urbana Champaign. Photo courtesy of the artist.

ALICE AYCOCK IS continually pushing the limits of imagination to construct fantastic, intellectually complex metaphorical models of the universe. Her sculpture *Tree of Life Fantasy* (10.1) combines steps that no one could walk on—"They're not quite of this world," she explains¹—with structures from ancient Indian observatories, DNA helixes, amphitheaters by the early twentieth-century architect Walter Gropius (turned vertical so that no one could actually sit there), a roller-coaster to heaven, and medieval and Renaissance pictures of an entrance to Paradise through a swirling hole

in the sky. She has executed these ideas in steel, fiber-glass, and wood in a sculpture rising twenty feet (6.1 m) high, and painted the whole thing white as a symbol of the purity lacking in this world. Her intention was that a live wisteria vine be trained up the back, adding to this melange an overlay of greenery and flowers. Aycock's sculpture is not a three-dimensional report of the physical world, but rather a medium for the multi-storied exploration of ideas gleaned from many eras and cultures, all combined most improbably through artistic license.

Even when sculpture is not so fantastic as Aycock's, moving from two dimensions into three opens infinite possibilities for artistic experimentation.

There are four traditional ways of creating sculptures: carving hard materials, modeling soft materials, casting molten materials that will harden, and assembling materials that can be joined. Other methods that fall somewhat outside these categories include shaping the earth into environmental works and creating sculptures that move through time and space.

Planning Sculptures

Before executing a sculpture by such methods, artists often make a miniature model of the proposed piece, for two-dimensional sketches are of limited use in planning three-dimensional works. A small clay or plaster model is called a **maquette**. The studio of Henry Moore (10.2) was filled with such maquettes. He explained to a visitor:

Everything I do is intended to be big, and while I'm working on the models, for me they are lifesize. When I take one in my hand, I am seeing and feeling it as lifesize. ... When I've got the model in my hand, I can be on all sides of it at once and see it from every point of view—as a sculptor has to do—instead of having to keep walking round it.²

Small-scale models may these days be combined with or replaced by computer-aided models in which one can "see" the three-dimensional aspects of the piece by rotating it or moving around it in virtual space. Computer modeling is essential for Richard Serra's huge sculptures made of torqued steel plates,

10.2 Henry Moore, maquettes, Hoglands studio. Courtesy Henry Moore Foundation, Hertfordshire, England.

The multiplicity of maquettes in Henry Moore's studio illustrates that sculptors may experiment with many more ideas for three-dimensional forms than they actually execute as full-scale sculptures.

10.3 Richard Serra, sculptures in the Fish Gallery at the Guggenheim Museum, Bilbao, 2000 (from front to back) *Torqued Ellipse I*, 1996; *Double Torqued Ellipse III*, 1998–99; *Snake*, 1996; plus five other *Torqued Ellipses* in background. Photo Erika Barahona Ede, FMGB Guggenheim Bilbao Museoa.

A major aspect of the excitement of the installation of Richard Serra's Torqued Ellipses in Frank Gehry's Guggenheim Museum in Bilbao is the relationship of the huge sculptures to the sculptural interior of the Fish Gallery. Computer-aided three-dimensional design could play a role in planning the nuances of such relationships of form to surroundings, but it cannot replace the three-dimensional experience itself.

such as those installed in Frank Gehry's Guggenheim Museum in Bilbao (10.3). Like tilting architectural segments, they loom far above the heads of humans who walk among them and could likely fall over and crush people were they not precisely balanced by engineering considerations. Serra's planning process is an interplay between physical models, computer calculations about how to realize them, and decisions based on the experienced effects of previous sculptures. Serra explains:

The models allowed me to work out the *Torqued Ellipses* in terms of all their basic coordinates, like

major to minor axis, height, balance, openings, whatever. They give a useful indication of layout and shape but obviously no indication of what the temporal experience of the large-scale work will be. The bend, the lean, the overhang of the plates, the equilibrium, where the opening needs to be, that's all worked out *fairly* precisely in models, usually at the scale of one inch to the foot. The engineers translate the models into digital information ... I need to see each sculpture in full scale to understand its effect. That enables me to decide how to continue the series and what to change in the next group of models.³

10.4 Michelangelo Buonarroti, "Atlas" Slave, c. 1513–20. Galleria dell'Accademia, Florence.

Carving

In the **subtractive** process of carving, the sculptor cuts away material from an existing piece of some hard material, such as wood, stone, or ivory. Often the original form of the material is totally altered in the process, but in Michelangelo's unfinished "Atlas" Slave (10.4), we can still see the rectangular block of stone from which he was extricating the form. "Atlas" seems almost to be struggling to free himself from the extra

material. Indeed, Michelangelo, like many sculptors, felt that in carving away excess material he was releasing a form already existing inside the block. One of his poems includes these lines:

The best of artists does not have a concept That the marble itself does not contain within it Within its surface, and only that is reached By the hand obeying the intellect.⁴ Tools from hammer and chisel to chainsaw can be used to "liberate" the form conceived in the block. The artist continually takes clues from the material itself as the form emerges. The form must fit within the bounds of the original block of stone or log of wood. Carvings often therefore have rather compact contours, to minimize the labor involved in removing excess material. A lengthy projection—such as an outstretched arm—requires a tremendous amount of labor in cutting away open space above and below it. Projections also present structural problems in materials with low tensile strength, such as stone. Tensile strength is the ability of the material to resist forces tending to tear it apart—such as gravity, which pulls

10.5 Unkei, Nio, 1203. Wood, height 26 ft 6 ins (8 m). Todaiji, Nara.

at thin unsupported pieces. Often a support is integrated into the design, perhaps disguised as clothing or a tree-stump.

Wood is a highly personal medium, warm and organic to the touch, rhythmic in its unfolding growth patterns, and requiring respect for the natural direction of its grain. If wood is protected from weathering and insects, it can be very long-lived. Beautifully carved wood reliefs over 4,000 years old survive from ancient Egypt. The huge guardian deity statues (10.5) by the master sculptor Unkei at the entrance to the Todaiji Temple in Nara, Japan, have survived since 1203. The guardian's extraordinarily dynamic, vigorous contours and streaming clothes do not betray the slow and painstaking work needed to carve such forms out of hardwood.

In the subtractive process of carving, taking away too much is disastrous. Sculptors must visually imagine the outermost contours, and leaving those, cut toward the more recessed contours. To keep track of where they are in the block, wood sculptors may draw the outline of the intended piece on it and first remove any excess material that clearly lies outside of the outline, perhaps with a handsaw or even a chain-saw. A medium-sized gouge struck by a mallet may then be used to start working in toward the final form. After this roughing out process approximates the desired final form, smaller gouges may be used to create fine details. For the finest of these, the gouge may be hand-driven rather than struck with a mallet. The sculptor continually reads and works the piece in the round, often referring to sketches of the desired appearance from many sides. Finer details are often sketched on the wood itself as the form emerges.

A number of tools are used to give the piece a smooth finish, including a scraper with a beveled cutting edge that is drawn across the surface, revealing the grain, and compressing the fibers to make the surface glossy. If desired, the gloss is enhanced with a wax polish. Contemporary woodcarvers often laminate, or bond, many thin layers of wood together before carving them as a block, revealing striations of color on the surface.

Although stone offers much more resistance to the sculptor's chisel than does wood, its permanence, colors, and textures have long been prized for creating subtractive sculptures. Sometimes the original surface texture of the stone is retained. The twentieth-century *Head of a Woman* by Modigliani (10.8) is carved directly into a limestone block, celebrating its stony texture with a deliberately "primitive" technique. Some traditional marble sculptures have been carved mechanically, often

ARTISTS ON ART

Michelangelo Buonarroti on Marble-Quarrying

MICHELANGELO BUONARROTI (1475-1564) was a true "Renaissance man"-sculptor, painter, architect, and poet. As a sculptor, he is best known for some of his earliest work, especially the colossal David (10.6) and the tender Pietà (15.27), both of which were executed when he was in his twenties. Whereas David was carved from a huge block of marble that had been unsuccessfully begun by another sculptor, Michelangelo took personal responsibility for supervising the quarrying of other blocks of marble he was to use, as well as having them transported. In some cases he hired scarpellini (stonemasons) to do the initial rough carving of the forms. The following excerpts from his letters suggest some of the difficulties he faced in these processes:

March, 1518: "As the marbles [in the mountains of Seravezza] have turned out to be excellent for me and as those that are suitable for the work at St. Peter's are easy to quarry and nearer the coast than the others, that is, at a place called Corvara; and from this place no expense for a road is involved, except over the small stretch of marsh land near the coast. But for a choice of the marble for figures, which I need myself, the existing road will have to be widened for about two miles from Corvara to Seravezza and for about a mile of it or less an entirely new road will have to be made, that is, it must be cut into the mountains with pickaxes to where the said marbles have to be loaded."

April 2, 1518: "Commend me to His Magnificence and beg him to commend me to his agents in Pisa,

so that they may do me the favor of finding barges to transport the marbles from Carrara. I went to Genoa and got four barges sent to the quayside to load them. The Carrarese bribed the masters of the said barges and are bent on balking me, so that I achieved nothing."

April 18, 1518: "These scarpellini whom I brought from Florence know nothing on earth about quarrying or about marble. They have already cost me more than a hundred and thirty ducats and haven't yet quarried me a chip of marble that's any use In trying to tame these mountains and to introduce the industry into these parts, I've undertaken to raise the dead."

December, 1523: "When I was in Rome with [Pope Julius], and when he had given me a commission for his Tomb, into which a thousand ducats' worth of marbles were to go, he had the money paid to me and sent me to Carrara to get them. I remained there eight months to have the marbles blocked out and I transported nearly all of them to the Piazza of St. Peter, but some of them remained at Ripa. Then, after I had completed the payment for the freight of the said marbles, I had no money left from what I had received for the said work, but I furnished the house I had in the Piazza of St. Peter with beds and household goods out of my own money, in anticipation of the Tomb, and I brought assistants from Florence, some of whom are still living, to work on it, and I paid them in advance out of my own money. At this point Pope Julius changed his mind and no longer wanted to go on with it."5

10.6 Michelangelo Buonarroti, *David*, 1501–4. Marble, height approx. 18 ft (5.5 m). Galleria dell'Accademia, Florence.

THE WORLD SEEN

Benin Ivory Carvings

CULTURES WITH ACCESS to animals with large tusks have often used this material—ivory—as a sculptural medium. Ivory from the tusks of elephants, hippopotamuses, walruses, or narwhals is a hard, long-lasting medium with a creamy white surface that can be polished to a soft sheen which is pleasing both to see and to touch. In the West African rain forest, elephant hunters were among the most respected members of the forest kingdom of Benin, where an advanced civilization of Yoruba people grew up from the thirteenth century.

In approximately A.D. 1440, Ewuare the Great became oba (king) of the area, capturing perhaps two hundred towns, ordering the building of good roads and a wall around the capital city of Benin, and developing government structures and royal ceremonies that exalted his power. At the same time that he was making Benin the most advanced kingdom of West Africa, he supported development of the visual arts. A series of powerful kings who succeeded him continued these measures. Specialists in brass casting, wood carving, and ivory carving were given working areas within the king's court and organized into guilds. Much of their output was intended for the oba's personal use. Like rulers of other African kingdoms, he was to be treated as a god. His subjects had to approach him on their knees and could not even look at him unless he permitted. Certain adornments were reserved for the oba alone.

During the 1400s, European traders began arriving in West Africa in search of a route to India. When instead they discovered the riches of

the African kingdoms, they turned their attention there and began trading goods such as beads, cloth, cowrie shells, coral, brass, and eventually weapons for African spices, gold, and ivory. When colonization of the Americas by European countries began, the Portuguese tried to obtain both the precious ivory and large numbers of human beings to be shipped to the Americas as slaves. It was during this period that the fine ivory mask shown in Figure 10.7 was carved for the oba, probably King Esigie. It is thought to represent his mother Idia, who helped end the

civil war at the beginning of his rule. It is pierced through the forehead so that the oba could wear it on his belt during royal memorial ceremonies. In addition to the intricate carving of the interwoven neck ornament and the realism of the powerful portraiture, this small piece is extraordinary in its treatment of the hair: all the braided strands become the heads and beards of Portuguese traders. Such a visual metamorphosis is indicative of both individual genius and also a long and sophisticated design tradition. The mask shown is one of four in existence.

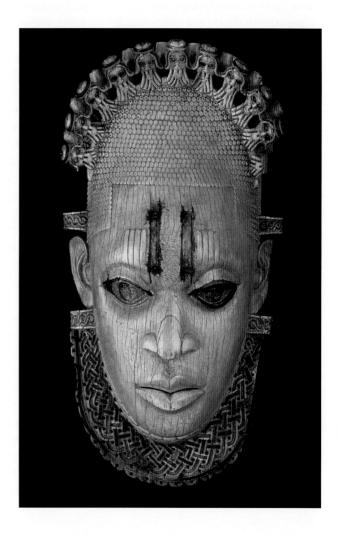

10.7 Mask from Benin, c. 1520. Ivory, height 9¾ ins (25 cm). British Museum, London.

by hired artisans, by transferring measurements from a maquette to a block of stone, but such a process is not responsive to the uniqueness of the individual block. The sculptor may live with a block of stone for a long time, allowing it to "speak" its own nature before approaching it with a preconceived image.

Stone may be carved and polished to resemble nonstone textures, such as the youthfully smooth, tautmuscled skin of Michelangelo's *David* (10.6). The nearly 18-foot-high (5.5 m) statue is famous not only for the beauty of its surface but also for its ability to suggest a highly lifelike, dynamic energy within the form. The **contrapposto** attitude (head and shoulders twisted one way, hips and legs another) of the biblical shepherd suggests that what is frozen in stone is only a brief moment in time, in which David prepares his slingshot for the giant Goliath.

Marble from the quarries at Carrara, Italy, is highly prized for its exceptionally fine, durable, translucent white nature. Granite is hard and more difficult to carve; sandstones and limestones, widely used in northern European architectural sculptures, are more granular. Jade is so hard and brittle that artists may grind it with a power diamond-tipped bur rather than cut it with hammered chisels, claws, points, and files. Whatever the material, stonecarving is a slow and patient art. All kinds of stone—from the roughest limestone to the finest jade—can be polished to a high sheen, enhancing the stone's color and erasing the tool marks. After the lengthy process of carving the form, polishing the surface entails another series of steps with flat chisel, file, carborundum stone, wet sandpaper, or an abrasive sanding screen, and rubbing with a polishing agent that seals the surface and makes it glisten. As these steps are taken, previously hidden colors and deeper tones will often appear, but so also may weaknesses in the design, requiring some reshaping of the piece.

Modeling

At the other extreme from carving hard stone is **modeling**—the hand-shaping of soft, malleable materials. Some are so soft, in fact, that they cannot support their own weight and must be built over an **armature**, a simple skeleton of harder material, such as wood or wire. Plaster is typically built up over an armature by strips of fabric that have been dipped in wet plaster of Paris. The final layer is plaster alone, spread with the hands or tools such as knife or spatula. Details—such as the

10.8 Amedeo Modigliani, *Head of a Woman*, c. 1901. Limestone, height 25³/₄ ins (65.4 cm). National Gallery of Art, Washington, D.C. Chester Dale Collection.

10.9 Jean-Antoine Houdon, *Bust of a Young Girl*, c. 1779–80. Plaster, height 19½ ins (49.5 cm). Metropolitan Museum of Art, New York. Bequest of Bertha H. Busell, 1941.

modeling of the hair on Houdon's *Bust of a Young Girl* (10.9)—are then worked with a blade.

The use of clay—a fine-grained natural deposit—as a modeling medium was common in many ancient civilizations. Worked moist, it can be used to create quite fine details and then be fired to a hard, permanent state. It has more structural integrity than wet plaster, so it will hold slight projections such as the arms and hands of the army of lifesized terra cotta figures built for the powerful first emperor of unified China in the third century B.C. to symbolically guard him after death (10.10). In clay modeling, the major form may be coaxed into shape by the fingers. Details may be added as lines incised into the form or extra bits of clay attached to the piece with slip (a mixture of clay and water).

Archaeologists have determined that the extraordinary "army" of over 7,000 soldiers, horses, and chariots unearthed in China's Shaanxi Province was made from molds, with heads and hands pasted onto the bodies. Unique facial features and hair buns were developed over the rough molded heads by smearing clay on the surface and then skillfully modeling it by hand—pinching, pasting, and carving the features that make each figure different and realistic.

Aside from the Chinese Emperor's tour de force in Shaanxi Province, freestanding clay pieces have usually been relatively small. However, large kilns now allow huge constructions of clay to be fired. Even so, monumental clay sculptures are often constructed and fired in several pieces and then assembled, as can be seen in the joints of Arnold Zimmerman's great ceramic arch (10.11).

Wax is very easily shaped and reshaped when warm. It was used by the ancient Greeks for toy dolls and small religious statues and by the Romans to make

10.10 Columns of infantry soldiers, terra cotta army of Qin Shihuang, 221–210 B.C., Shaanxi province, China. Terra cotta, life-sized.

10.11 Arnold Zimmerman, arch for a private residence, Arizona. Arnold Zimmerman's arch is a huge sampler of sculptural clay forms, serving almost as a tribute to its owner, the grande dame of ceramics instruction, Susan Peterson.

death masks. But wax is vulnerable to melting when the weather is hot. It is therefore more often used to capture the fresh immediacy of hand-shaping and then the figure is cast in some more permanent material. An example is the bronze cast of Degas's wax model of a galloping horse (10.12). The dabs of wax Degas pressed on to build up the form are clearly preserved in the cast. Some collectors prize such evidence of the artist at work.

Casting

In **casting**, easily shaped materials are used to create a negative mold into which a molten material such as bronze or plastic is poured and then allowed to harden. When the mold is removed, anything that was concave in the mold is convex in the cast form, and vice versa.

If the mold is salvageable, multiple copies can be made of the same form.

This process, for which the Bronze Age was named, was refined by the ancient Greeks. They developed the lost-wax process illustrated in Figure 10.14, which is still in use at contemporary foundries. A positive model (a) is used to make a negative mold (b), which is then coated with wax in the thickness desired for the bronze (c). The wax shell is filled with a core of some material such as plaster or clay. The mold is removed and metal rods are driven through the wax into the clay to hold the layers in place (d). Wax vents that allow the metal to be poured in and the gases to escape are fitted around the piece. This assembly is then coated with plaster called the investment—and perhaps buried in a box of sand (e). As molten bronze is poured into the cavity filled with wax, the wax melts and flows out. Once the bronze has hardened, the temporary inner filling and

10.12 Edgar Degas, Horse Galloping on Right Foot, c. 1881. Bronze cast of wax model, height 11⁷/₈ ins (30 cm). Metropolitan Museum of Art, New York. Bequest of Mrs. H. O. Havemayer, 1929. Degas has used easily modeled wax to capture the quickness of a galloping horse's movement that is otherwise too fast to perceive.

ARTISTS ON ART

Benvenuto Cellini on A Near-disastrous Casting

THE FLORENTINE RENAISSANCE artist Benvenuto Cellini (1500–71) was one of the world's greatest goldsmiths and also a bronze sculptor whose *Perseus with the Head of Medusa* (10.13) is considered an amazing tour de force. His casting techniques were difficult and unique to himself, and the fact that the *Perseus* came out intact seemed guite miraculous:

"To increase my anxieties, the workshop took fire, and we were afraid lest the roof should fall upon our heads; while, from the garden, such a storm of wind and rain kept blowing in, that it perceptibly cooled the furnace.

"I could at last bear up no longer, and a sudden fever, of the utmost possible intensity, attacked me. [In despair he announced to his helpers that he thought he was dying, left them with instructions for finishing the project, and went to bed, racked with fever.]

"While I was thus terribly afflicted, I beheld the figure of a man enter my chamber, twisted in his body. He raised a lamentable, doleful voice: 'O Benvenuto! your statue is spoiled, and there is no hope whatever of saving it.' Jumping from my bed, I kept crying out in lamentation, 'Before I die I will leave such witness to the world of what I can do as shall make a score of mortals marvel.'"

[Cellini returned to the workshop, where he discovered work stopped

because the metal had caked. He ordered hotter-burning oak.] "When the logs took fire, oh! how the cake began to stir beneath that awful heat. I sent men upon the roof to stop the conflagration, which had gathered force from the increased combustion in the furnace; also I caused boards, carpets, and other hangings to be set up against the garden, in order to protect us from the violence of the rain.

"I then ordered half a pig of pewter to be brought and flung it into the middle of the cake inside the furnace. The curdled mass rapidly began to liquefy.

"All of a sudden an explosion took place attended by a tremendous flash of flame. I discovered that the cap of the furnace had blown up, and the bronze was bubbling over from its source beneath. But I noticed that it did not flow as rapidly as usual, the reason being probably that the fierce heat of the fire we kindled had consumed its base alloy. Accordingly I sent for all my pewter platters, porringers, and dishes, to the number of some two hundred pieces, and had a portion of them cast, one by one, into the channels, the rest into the furnace. This expedient succeeded, and everyone could now perceive that my bronze was in most perfect liquefaction, and my mold was filling. Seeing my work finished, I fell upon my knees, and with all my heart gave thanks to God."6

10.13 Cellini, *Perseus with the Head of Medusa*, 1550s. Florence, Loggia dei Lanzi. Ht 10ft 6 ins (3.2 m).

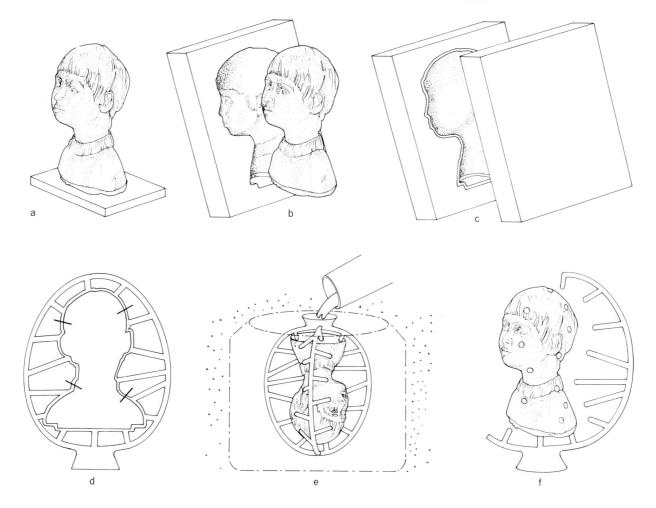

10.14 The lost-wax casting process.

the investment are removed (f), and what remains is a perfect hollow replica in bronze of the original pattern. Solid casting of large pieces does not work well, and hollowness economizes on bronze and weight. Even cast hollow, bronze is quite strong enough to support the open, extended forms of arms and legs.

Despite their complexity, casting processes are capable of reproducing very fine details. In the fifteenth- to eighteenth-century kingdom of Benin in western Africa, intricate bronze castings such as the *Altar of the Hand* (10.15), which celebrated the divine king (the figure whose large head symbolizes his intelligence and power), were made by highly skilled members of a respected professional guild under the direction of the king.

While the *Altar of the Hand* is quite stylized, casts are also capable of reproducing very naturalistic detail, such as the anatomical and psychological accuracy of

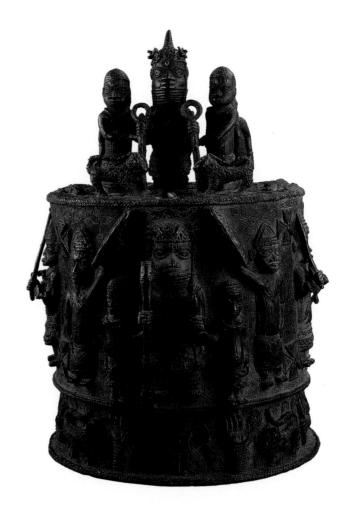

10.15 Anonymous, Altar of the Hand, Benin, Nigeria, 1550–1680. Bronze, height $17\frac{1}{2}$ ins (44.4 cm). British Museum, London.

10.16 Apollonius, *Seated Boxer*, c. 50 B.C. Bronze, height 4 ft 2 ins (1.27 m). Museo Nazionale Romano, Rome.

the Greco-Roman *Seated Boxer* (**10.16**). His musculature is superbly defined, and yet this is not an heroic, idealized portraiture. In the boxer's hunched, tired posture, broken nose, scarred body, and sidelong glance we can infer exhaustion, defeat, battered pride, or introspection about the emptiness of victory.

Assembling

Another approach to sculpture is to fashion or collect pieces of varying materials and then somehow attach them to each other to form an aesthetically unified whole. Some works are assembled from **found objects**.

10.17 Thornton Dial, Freedom Marchers, 1987. Wire, steel, tape, wire screen, packing foam, concrete, enamel, and Splash Zone Compound, $25\% \times 37\% \times 25\%$ ins $(64.8 \times 94.6 \times 64.8 \text{ cm})$. Collection of the Tinwood Alliance.

Self-taught Alabama artist Thornton Dial puts together things he finds such as Styrofoam heads, pieces of decorative ironwork, paint can lids, pots, bits of rope and wire, old clothes, and plastic dolls to make touching political statements, such as *Freedom Marchers* (10.17). He explains,

People throw a lot of things away. You pick it up and make art out of it. I'm always thinking: It's beautiful; put it together and paint it. Where another person don't look at it, I look at it in a different way.⁷

Deborah Butterfield's *Palma* (10.18) is assembled from pieces of found steel, openly welded together to form a structure that is physically strong but that has the paradoxical appearance of delicacy. The impression is of the tenderness of a new colt or the tenuous exploration of space by a finely bred, fineboned, exquisitely sensitive animal. Butterfield's work consists solely of horses made from found materials, sometimes cast in bronze for permanence. She constructs only six to ten of them a year, but they sell for up to US\$240,000 apiece and the demand for them always exceeds the supply, indicating the degree to

which sculpture made of discards may be highly valued.

When a sculpture is obviously constructed of bits of found objects it may be referred to by the French term, assemblage. In addition to unifying an assembled work visually, the artist must deal with the mechanical problems of physically joining the pieces so that they will not fall apart. Metal may be welded or bolted; a wooden piece may be held together with glue, nails, and screws. Ursula von Rydingsvard assembles her sculptural works from 4 by 4 inch (10.16 by 10.16 cm) beams of cedar that she first scars and cuts with a circular saw before stacking and gluing them together into organic-appearing forms, such as *Bowl with Folds* (10.19). Her process thus combines both assembling and carving away parts of the material, suggesting natural processes of geological layering and erosion. She

unifies the jagged mass visually by rubbing it with graphite powder, giving it a sober gray tone that reminds her of her childhood years spent in a German refugee camp and also of her close-to-the-soil roots in a Polish farming family.

When an assembled piece seems to lack aesthetic unity, the effect may be intentional. A certain disunity—according to Classical principles of design—is an intentional choice of freedom to allow new things to happen in sculpture. This trend is often evident in contemporary assembled works and installation pieces. Judy Pfaff, creator of the installation *3D* (10.20), explains:

I want the latitude of shifting thoughts in regard to materials, colors, and references. I can't be bound by how they "should" relate to one

10.18 Deborah Butterfield, *Palma*, 1990. Found steel, $77 \times 119 \times 26$ ins (195.6 \times 302.3 \times 66 cm). Courtesy of the artist and Zolla/Lieberman Gallery, Chicago. Photo by Rob Outlaw.

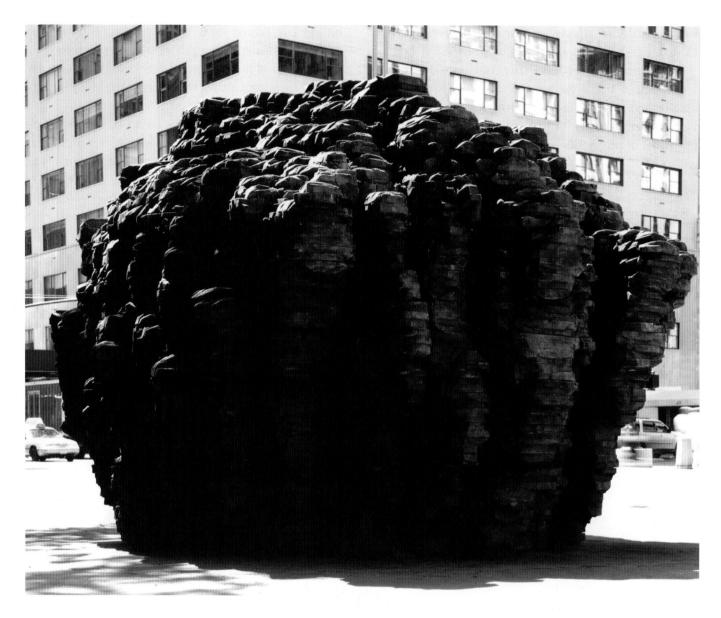

10.19 Ursula von Rydingsvard, *Bowl with Folds*, 1998–99. Cedar and graphite, $12\times16\times16$ ft (365.8 \times 487.7 \times 487.7 cm). Photo by Gerry L. Thompson.

another. By going after a certain speed traditionally reserved for painters, I'm reaching for a crossing over of ideas and a weaving of thinking and making ...

What's happening now in sculpture seems really wide open and generous ... taking all sorts of permission and running with it, full out.⁸

Earthworks

Rather than sculpting materials taken from the earth, some artists have used the earth's surface itself as their medium. This is an ancient form of art, found in certain cultures around the world, in which the earth is

sculpted into serpentine mounds, spirals, and mazes. Most spectacular are the lines on the desert floor of the Nasca Valley in Peru, sculpted by scraping aside the surface to reveal lighter materials beneath, forming huge drawings such as one of a hummingbird (10.22). Perhaps using only strings for measurement, its creators kept its outline surprisingly regular over a vast space—450 feet (137 m) in length. Its superhuman scale has led many observers to speculate that it was meant to be seen from the air, or was even designed by visitors from outer space. However, even though the figure cannot be viewed as a whole from the surface of the desert, it can be seen from the foothills of the Andes. If it is not spaceship art, then what is it? A pilgrimage route? An astronomical calendar? Stylized

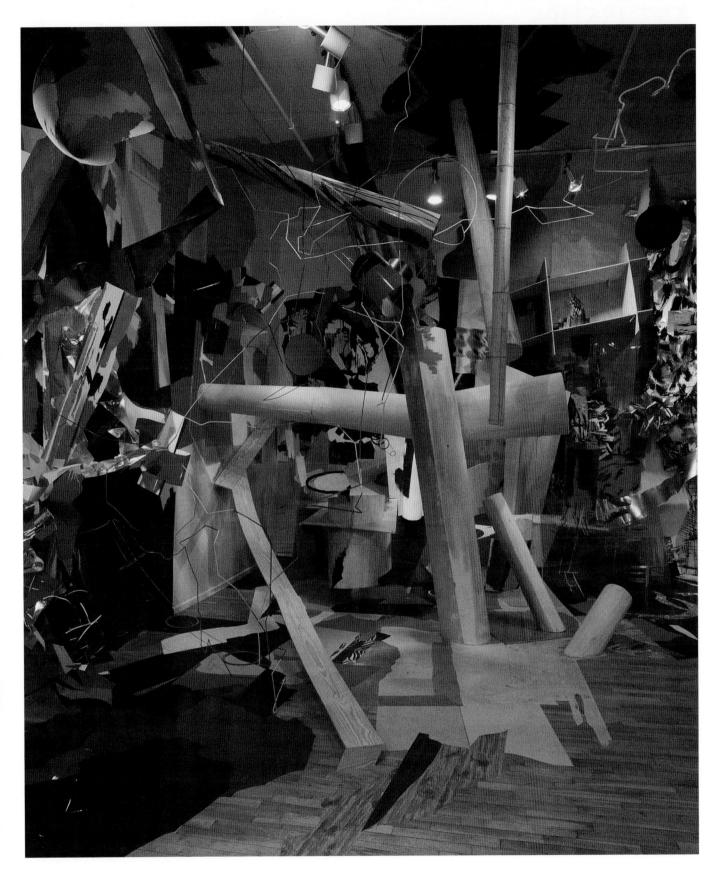

10.20 Judy Pfaff, 3D, 1983. Installation piece made of mixed media, occupying a room 22×35 ft (6.7 \times 10.7 m). Photo by D. James Lee. Courtesy of the artist. Judy Pfaff's room-sized installation seems an expression of a "wired" world gone haywire.

Preserving Ephemeral Materials

CONTEMPORARY ARTISTS WHO work in perishable materials are posing problems for art conservators that they never faced before. If a sculpture or installation piece incorporates chocolates, body fluids, ice, or fragile spider webs, is it to be shown one time only and then abandoned? If it is designed to be consumed, and thus disappears, can the "same" work of art be shown in another location, but refashioned from the same kind of materials, in the same way as the original? If perishable components break down, are they to be shown later in a state of decay? In such matters, conservators and curators hesitate to make decisions unless they know what the artist's intentions were.

In some cases, the artists have already died, leaving only minimal clues about the fate of their ephemeral works. Felix Gonzalez-Torres created installation pieces from wrapped candies that have remained a puzzlement to curators since his death in 1996. His only instructions for the piece entitled *Untitled (Revenge)* were these: "Light blue candies, individually wrapped in cellophane, endless supply; dimensions vary with installation; ideal weight 325 lbs."

Apparently he therefore meant that the work was to be shown in various places and that how to display it was entirely up to local decision-makers. This decision-making thus becomes part of the life of the installation. The work has been shown meticulously laid out as a rectangular carpet, but it could also be shown as a pile of candies, or candies randomly scattered on any surface. Gonzales-Torres did not specify whether it was to be displayed inside or outside, although

one might imagine that animals and insects might carry off some of the candies. "Endless supply" seems to mean that new candies can be purchased to re-create the piece, for museums hesitate to store materials that might attract bugs. As the Guggenheim Museum's associate curator of media arts explains, "The bugs like to take a nibble out of the Kandinsky along with the candy." However, the particular brand Gonzalez-Torres originally used—in which the clear cellophane wrappers had yellow writing-is no longer available. The Los Angeles Museum of Contemporary Art thus arranged a showing of the piece in which blue candies were mixed with yellow candies, to approximate the visual effect of the original. The museum had "borrowed" a piece that did not in fact exist. What was on loan to them was the right to re-create it.

When Zoë Leonard began working on Strange Fruit (for David) (10.21), she did not originally mean it to be a work of art. She was mourning the death of her friend in a unique way: stitching together the empty peels of 302 bananas, grapefruits, oranges, and lemons with thread, wire, buttons, and zippers. Later, she says, she realized that this was a sculpture and tried to preserve it. A German conservator suggested shock-freezing the peels and treating them with a chemical solution. Contemplating this remedy, Leonard recognized that she did not want to preserve the peels artificially. She explains:

"Eventually I reached a decision that the piece needed to be perishable and that in fact the heart and soul of the piece is about its being temporary and fragile. So I made a conscious decision not to preserve it. The kernel of the piece is that it does decay."

Ultimately her art dealer and the museum conservator involved accepted her decision, and stored the pieces as they were in acid-free envelopes. When they became infested with insects, they were chemically treated to prevent the infestation from spreading to other artworks. Damage continues, and some of the fruit has been stepped on during the installations, but Leonard says:

"This is part of the process of decay, so I felt that as long as you can pour it out of the envelopes onto the floor, I would like to keep installing it. I would love for it to be a permanent installation and just decay over time until finally it would be little piles of dust on the floor, with buttons and zippers."

Anticipating the issues involved in preserving and displaying ephemeral works, a team of conservators and curators from the Guggenheim Museum in New York and the Daniel Langlois Foundation for Art, Science, and Technology in Montreal have begun a project called the Variable Media Initiative. Its goal is to ask artists whether and how they want their ephemeral works to be preserved, whether the original materials can be replaced if they decay, what kind of space they should be displayed in, whether it can share the space with other works of art, and how lighting and sound—if any—should be handled. Thus they hope to be able to deal with these pieces in ways that the artists would approve, even after their death.

10.21 Zoë Leonard, *Strange Fruit (for David)*, 1992–97. Peels of bananas, grapefruits, lemons, and oranges, thread, wires, zippers, buttons, dimensions vary with installation. Philadelphia Museum of Art, Pennsylvania.

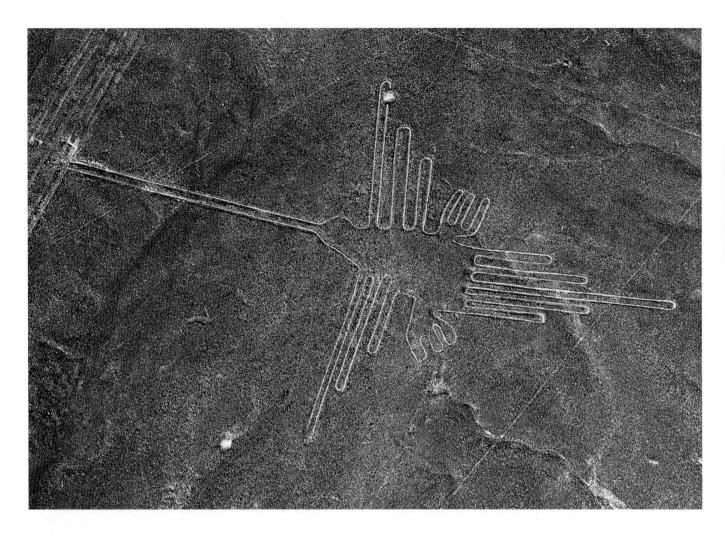

10.22 Aerial view of hummingbird, Nasca Plain, Nasca, southwestern Peru, c. A.D. 200–600. Wingspan 200 ft (60.9 m), total length 450 ft (137.1 m). Weathering and the scraping aside of stones revealed lighter clay and calcite beneath.

paths to waterholes? We do not understand; we can only admire.

Contemporary earthworks have something of the same aura of mystery about them. Robert Smithson's *Spiral Jetty* (**10.23**) is an immense spiral of 6,000 tons (more than 6 million kg) of basalt and limestone laid into the primordial red water of Great Salt Lake. He said it was a concrete expression of the "gyrating space" he experienced at the site.

The tools of contemporary earthwork artists have become those of the earth-mover, from shovels to bull-dozers and dynamite, perhaps with the addition of structurally reinforcing materials, such as the concrete framing Michael Heizer used to strengthen the earth mound of his *City Complex One* (2.32).

Despite the huge amounts of rock and earth that are displaced and rearranged to create earthworks, their existence is often strangely ephemeral. *Spiral Jetty* could be seen for two years after its construction but was then inundated for decades by the rising water of

the lake. During a drought, it re-emerged in a transformed state, covered with salt. Earthworks conceived as huge gashes in the earth's surface have filled in again as a result of erosion. Some earthworks now exist as art only in photographs taken when they were new. But permanency is not necessarily a goal of earth artists. Although their medium is the landscape, their subject-matter is often mental concepts. Some of their writings and conversations are more cerebral than earth-centered. Heizer said he didn't come to the Nevada mesa because of the landscape:

I didn't come here for context. I came here for materials—for gravel and for sand and for water, which you need to make concrete, and because the land was cheap. The desert is a flat and totally theatrical space. There is no landscape. ¹⁰

Robert Smithson encouraged nature to participate in *Spiral Jetty*: He expected the inundation and

re-emergence of the earthwork would be continually choreographed by natural circumstances. And he knew that brine shrimp would gather around the construction, giving it a lovely magenta color. But his approach to earthwork was not naturalistic. He explained:

10.23 Robert Smithson, *Spiral Jetty*, 1970. Great Salt Lake, Utah, 1500×15 ft (457×4.6 m).

I'm not just presenting materials, there's a kind of transformation that takes place. So that it's not a return to nature; it's like a subsuming of physical properties, and then gathering them into some kind of coherence, and this coherence can be quite a wilderness that is quite fascinating at the same time. Just like the actual wilderness, but in this case it becomes abstract, and it becomes a kind of entity that points to a lot of different possibilities.¹¹

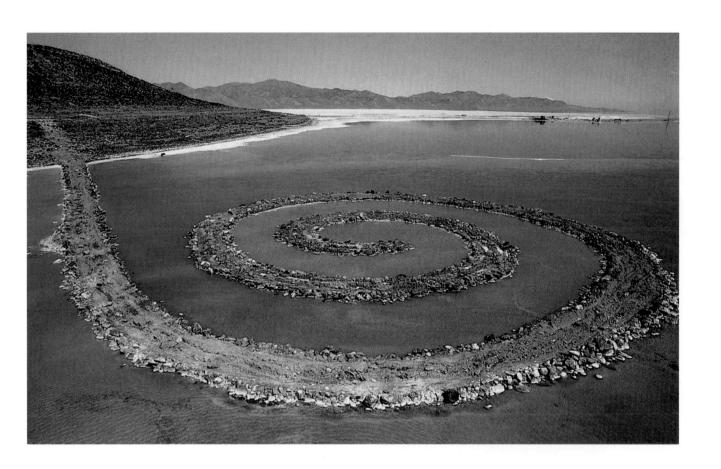

Crafts

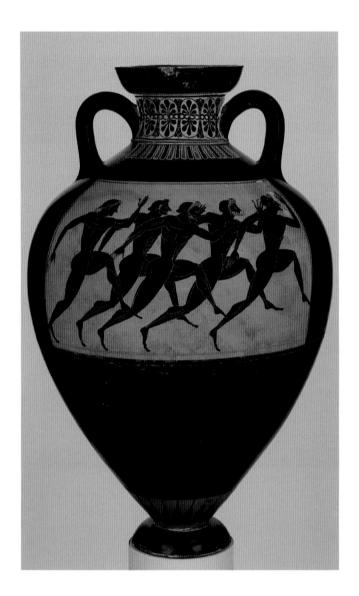

11.1 Attributed to the Euphiletos painter, black-figured prize amphora, Athens, c. 530 B.C. Height 24½ ins (62.2 cm). Metropolitan Museum of Art, New York, Rogers Fund, 1914.

KEY CONCEPTS

Techniques of using clay to form ceramics

Shaping different types of metal

Using and enhancing the natural qualities of wood

Factory produced and handcrafted glass

Flat and 3D art created from fibers

SEVERAL MILLENNIA AGO, ceramic arts were so advanced in Greece that potters were producing pieces as fine as this elegant amphora from Athens (11.1). It was of the type used to hold the prize of sacred olive oil presented to the winners of the Panathenaic Games. The Greek ceramists were quite accomplished in their use of the potter's wheel, and were able to create a form with perfectly symmetrical, beautifully proportioned, swelling and contracting contours. At the same time surface decoration of this "black-figure" work reached a pinnacle, with the foot runners elegantly painted in black and white lines onto a red clay base. The surface was coated with "terra sigillata," a mixture of water and clay naturally ground to a very fine texture over thousands of years. When fired, it turned orange-red with a lovely sheen.

Appreciation of such fine handmade objects is now undergoing a renaissance. This trend may be a reaction to our highly industrialized surroundings, a reassertion of the value of what is made by human hands. Many craftspeople make no attempt to hide their tracks, for the sense of the individual at work may be more highly prized than machinelike perfection and sameness. Even though some craft objects are created in multiples on a semi-production basis, they may still reflect the human touch.

In general, crafts also tend to celebrate the materials from which they are made. The wood, clay, or fiber has been chosen and worked lovingly. This appreciation for natural colors and textures is contagious. To fill one's home with handcrafted functional items is to turn everyday activities—such as eating and storing food—into sensual experiences of beauty. We feel that these objects have been made slowly, with care, and they can evoke the same unhurried appreciation in us.

The major craft media are clay, metal, wood, glass, and fibers. All have been in use since antiquity, and many of the traditional methods are still employed. At the same time, many craft artists are experimenting with new techniques, materials, and approaches, sometimes to the point of using craft techniques to create nonfunctional works of art.

Clay

The ancient craft of making objects from clay is called **ceramics**. In traditional cultures such as rural India, most villages have at least one working ceramist creating functional pieces for everyday use.

Clays are found across the globe, but only those clays that are easily shaped and capable of being

11.3 Lucy Lewis coiling a seed pot.
Lucy Lewis of Acoma Pueblo revived the old tradition of painting fine black lines in geometric patterns onto thinwalled white clay. A finished piece is shown in Figure 1.17.

hardened by heat without cracking or warping are suitable for ceramics. Sometimes several different kinds of clay are mixed to form a clay body that has a combination of desirable properties. The most common clay bodies are **earthenware** (porous clays such as terra cotta), **stoneware** (clays that become impermeable when fired at high temperatures), and **porcelain** (a very smooth-textured clay, translucent when fired, and with an extremely smooth, glossy surface).

Clay can be worked by freeform hand modeling, as in **pinching** a small pot out of a lump of clay (11.2). Three traditional methods of building up clay into larger walled vessels have been in use for thousands of years. **Slab building**, used for straight-sided pieces, involves rolling out flat sheets of clay for sides and bottom. The joints are sealed with a rope of clay or with slip, a slurry of clay and water.

In **coil building** (11.3), the potter rolls out ropes of clay and curls them in spiraling layers on top of a base, welding the bottom layer to the base and joining the coils to each other. Scraping and patting of the outside may be used to obliterate the in-and-out coiled structure. To build up a tall pot, the lower area must be allowed to dry and harden somewhat so that it will support the upper layers. For a narrow-necked piece, the upper layers are gradually diminished and then perhaps pulled out again. The potter must work all around the piece if it is to be uniformly rounded, so it may be placed on a hand-turned base. This method is widely used by Native Americans.

11.2 Maria Martínez pinching a pot. Maria Martínez of San Ildefonso Pueblo, almost one hundred years old in this photo, restored her people's ancient ceramic traditions and became famous for her black-on-black ware, smothered with the manure of wild mountain horses during firing.

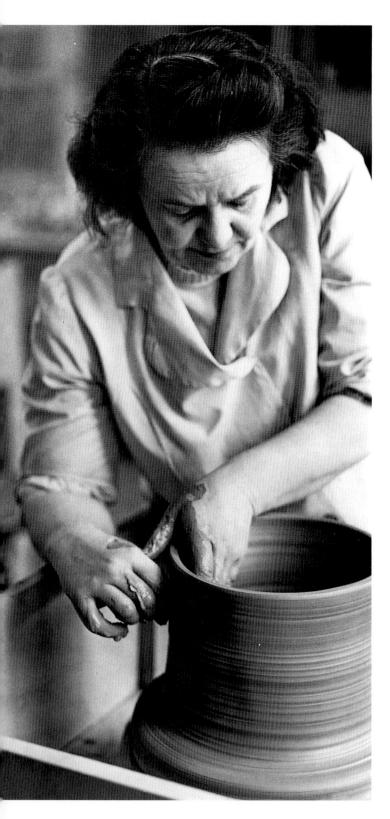

11.4 Maija Grotell throwing a pot on a stand-up wheel. Courtesy of Department of Special Collections, Syracuse University Library, Syracuse, New York.

The third major method is **wheel-throwing** (11.4). The potter's wheel, found in the ruins of ancient Greece, China, and other early civilizations, is a flat disk attached by a shaft to a large flywheel. This lower

wheel is kicked by the potter or driven by a motor to make the upper wheel turn. The continuous turning of the wheel allows the potter to pull the pot upward, symmetrically. After wedging (repeatedly slamming the clay onto a hard surface, cutting and folding it, and throwing it again, to remove air pockets and create an even consistency), the clay is centered on the wheel with the hands while the wheel is being rapidly turned. Working with both moistened hands, the potter then shapes the inside and outside of the pot at the same time by finger pressure applied in just the right places as the wheel is rotating. For a symmetrical form with walls of even thickness, the potter's hands must be disciplined to apply perfectly even pressure.

After any of these building techniques—slab, coil, or wheel-throwing—the pot is typically **glazed** (painted with a material that turns glassy when heated) and **fired** (baked in a kiln or open fire) for permanence and water resistance.

Colored glazes may be used to create designs on the surface in addition to waterproofing it. By contrast, some contemporary potters have eschewed elaborate ornamentation to bring out the beauty of the natural clays and earth-toned glazes. Karen Karnes's pots (11.5) are noted for their simple strength of form and the subtle glazes that emphasize rather than hide the grainy texture of the stoneware. Toshiko Takaezu says of glazing her large, closed ceramic forms, such as *Pacific* (11.8),

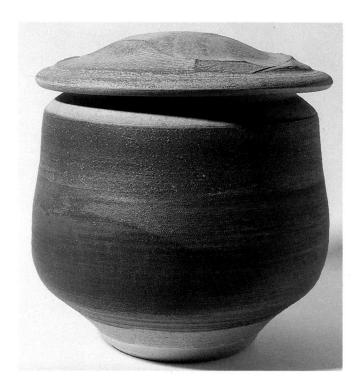

11.5 (right) Karen Karnes, stoneware pot with lid, 1982.

THE WORLD SEEN

Chinese Porcelains

OF ALL THE world's great ceramic traditions, the one with which the medium is most notably linked is that of China. Thus fine ceramic wares themselves are often referred to as "china." This reference derives particularly from the development of true porcelains in China. Porcelain is considered the most precious of ceramic ware. for it is pure white or even translucent when thin enough, glasslike and thus non-absorbent, and very strong except in the thinnest wares. Creating these desired characteristics, however, requires a very particular clay mixture, well-developed glazes, and high and sustained firing temperatures.

Developing ceramic techniques to this degree took millennia of experimentation and practice. In China, ceramic wares were being made from Neolithic times. By 2000 B.C. ceramists were using the potter's wheel, allowing the production of graceful, thin-walled forms. By the Shang dynasty (c. 1523–1028 B.C.), they had discovered kaolin, a very fine white clay that when fired at extremely high temperatures becomes quite hard and, if the walls are sufficiently thin, translucent. They also began using glasslike glazes, which made the surface impervious. These two innovations paved the way for the development of true porcelains, but still the process required great skill and perfection because the purest of clays are also difficult to shape and fire without cracking, and glaze and clay had to be well matched in order to bond properly.

From the first millennium B.C. onward, ceramic research and production was sponsored in China by the ruling dynasties, for their personal use and delight. Up to the

eighteenth century, huge quantities of luxury wares were thus created at special government factories and shipped to the imperial cities.

Under this sponsorship, wares of porcelain-like fineness ultimately evolved, although researchers do not agree on when true porcelains—as opposed to somewhat absorbent stoneware—were first created. During the T'ang dynasty (A.D. 618–907), China was in a very powerful expanding phase and all the arts were flourishing. Archaeological excavations have revealed fine ceramics from this period with influences from the highly developed potteries of Persia and Greece. There are also exquisite pale green "celadon" wares which some regard as the first true porcelains. By the Ming dynasty (1368-1644), China had turned inward in a period of nationalism, glorifying and building upon its older traditions. A pure white porcelain was created at the imperial factory in Ching-te-chen, and underglazes in exquisite hues of jewel-like

intensity were developed: oxblood red (see 3.35), cobalt blues, and lush greens. They were painted onto the unfired porcelain and then covered with transparent glazes which when fired allowed the hues to shine through in full intensity contrasted with a pure white ground.

The flask shown in Figure 11.6 reveals the confidence with which Ming ceramists shaped and decorated their ware. The dragon-in-the-sea motif employs a dynamic interplay of positive and negative shapes. These mythical beasts had long been associated with the vibrant life-energy in the cosmos and sudden enlightenment, and as Chinese empires developed, the dragon motif was used as a symbol of the power of the emperor.

Europeans discovered these precious porcelains during the Ming dynasty and tried without success to replicate the secret process of their manufacture until early in the eighteenth century.

11.6 Porcelain flask with decoration in blue underglaze, Ming dynasty, A.D. 1425–35. Palace Museum, Beijing.

ARTISTS ON ART

Paula Winokur on Working in Clay

PAULA WINOKUR (b. 1935) has been working in clay for over thirty-five years. In the middle of the twentieth century, like most other ceramists of the time, she was creating functional pottery. She has continually evolved along with this rapidly evolving medium, and has for some time been using clay to express ideas sculpturally. Many of her recent works are conceived as mantels, arches (11.7), or geological formations. Winokur explains:

"The material used to be associated with pots and figurines. People didn't think of it as a fine arts material. That's what I grew up with: you made pots, and you made them for use. Now there has been tremendous interest in the material and all of its potentials as a sculptural medium that can be used to describe all sorts of things—political statements, aesthetic statements, one's internal musings. The things that have happened in the clay world have allowed people the flexibility and opportunity to do whatever they want with it.

"Now in my work I'm trying to explore my ideas and use the clay as a vehicle for those ideas. The mantels say something about precipices; as a society, as a species, we are always on the edge, ready to fall off. When I visited Mesa Verde in southwestern Colorado, the peculiar window openings and niches in the canyon walls and the precarious cliff ledges were of great interest to me. The spirit of the Anasazi, the ancient ones, surrounds the place. I was fascinated by the shapes and forms, some left for hundreds of years, some eroded by time and some arranged by the caretakers. Somehow this is information that I continue to use. I believe that for the most part my work is about memory ... of places which exist and yet do not exist.

"Production pottery was physically demanding; many potters have backaches. Doing unique pieces is also very physical. We make our own clay body. We buy bags of a particular clay, a particular feldspar, silica, and grog, and mix all these things together. That's time-consuming and labor-intensive.

"For these big pieces, I wedge maybe 200 pounds [91 kg] of clay at once and then lay out the slabs, let them stiffen, and put them together. Once I understood that you don't have to make something of clay as a single piece, that you could use many parts and put them together, then scale became no problem for me. The big archways are four or

five sections on each side, constructed and fired separately, and then put together with grout over an internal structure of pipe that holds it all together.

"I chose to work in clay many years ago and in 1970 began to work only in porcelain. Porcelain is a material usually thought of as delicate, fragile and transparent. Considered the primary clay from which all other clays are derived, it comes from the earth as pure white, strong and durable. It attracted me because of these qualities rather than its transparency. I have chosen to work with this clay because it has allowed me to explore issues in the landscape without necessarily making literal interpretations; it can be minimal and sometimes surreal in its starkness.

"Despite years of experience, sometimes I still lose things in firing, or sometimes I don't like the way something looks. Clay does have that element of risk, and you wonder why you keep doing this. But I've been committed to this particular material a long time. A lot of people look at someone throwing and say, 'Oh, I can do that,' and then they sit down at the wheel and realize that to be a really good thrower takes years of practice."²

11.7 Paula Winokur, *Entry I: Sakkara*, 1986. Porcelain, $102\times53\times10$ ins (259 \times 135 \times 25 cm). Courtesy of the artist.

11.8 Toshiko Takaezu, *Pacific*, 2002. Glazed stoneware, 50 ins (127 cm) high. Collection of Friends of the Neuberger Museum of Art, Purchase College, State University of New York, gift of the artist in honour of Lucinda H. Gedeon, Director, Neuberger Museum of Art 1991–2004.

Clay is a three-dimensional sculpture and a painting at the same time. To make it into a painting you have to experiment with a lot of glazes and see if they fit. And you don't splash the glaze on. It takes time to get to what you want. You really want something intangible, that you can't pinpoint. I like the idea of going around the piece and glazing—it's almost like dancing.

Another contemporary direction is the use of ceramic techniques for artistic expression rather than the creation of functional pieces. Clay is prized as a very

plastic medium for nonfunctional sculpture, although clay processes are not easily mastered. Many variables come into play at every stage, requiring great skill and knowledge if the piece is not to be ruined during the firing stages. Fired clay can withstand decay over thousands of years, but clay is sometimes built up without firing to create purposely temporary conceptual pieces.

Metal

Like clays, many metals are quite amenable to being shaped. Those used for handcrafted objects have included copper, brass, nickel, pewter, iron, and the precious metals gold, silver, and platinum. They vary in malleability (the capacity for being shaped by physical pressure, such as hammering), ductility (the ability to be drawn out into wire), and hardness. Gold is the most ductile and malleable metal and is of course prized for its untarnishing color and luster. It is often drawn into wires and shaped into jewelry. The Mughal turban jewel in Figure 11.9 is crafted of gold and further ornamented with enamel, a glass-like, jeweltoned coating that can be fused to metal by heating.

At the opposite extreme, iron and steel (an alloy of iron and other materials) are the hardest of the common metals and among the least malleable. But they are somewhat ductile and when heated are malleable enough to be forged (hammered over an anvil), stretched, and twisted into forms such as Joseph Brandom's kitchen utensils and rack (11.10). These combine the sought-after feeling of old-fashioned blacksmithing technology with a light, clean, contemporary design. Note that some of the hammering marks are retained for the desired handcrafted appearance. If a metalsmith chooses to erase all hammer marks, bulges, and wrinkles from a piece, it can be planished smooth with a flattening hammer. As metal is worked, it may also need to be continually annealed, or heated to make it more malleable, because many metals harden when they are hammered.

Iron that is worked in a heated state with hand tools is called **wrought iron**, in contrast to cast iron, in which molten iron is poured into molds. Szabó's extraordinarily crafted wrought-iron clock (11.11)—a product of the early twentieth-century rebirth of art metalwork in France—achieves the delicate filigree usually seen only in jewelry fashioned from fine wires. Such decorative details may be created by drawing out, hammering over varied forming stakes, punching, splitting, bending, incising, or **repoussé** (hammering

11.9 Mughal turban jewel, possibly from Jaipur, c. 1750. Enameled gold, $6\frac{3}{4} \times 1\frac{7}{6}$ ins (17.3 \times 5 cm). Victoria and Albert Museum, London, IM 47–1922. Courtesy of the Trustees of the V&A.

11.10 Joseph L. Brandom, utensils and rack, 1982. Stainless steel, rack length 39 ins (99 cm).

11.11 Szabó, clock, c. 1924. Wrought iron.

THE WORLD SEEN

Precious Metalwork from Tsarist Russia

RUSSIA AND ITS neighboring countries, which once formed the Soviet Union, are home to some of the world's richest deposits of precious metals, such as gold and silver, and of precious stones, including diamonds. In Tsarist times, this tremendous wealth was tapped for the use of the aristocracy and also the Russian Orthodox Church, a most powerful and enduring institution, which was primarily derived from the Byzantine Christian tradition, imported to Russia at the end of the tenth century. Within the precincts of Russian Orthodox church structures, one entered a world of tremendous splendor, with processions of priests displaying huge, gold-bound Bibles and swinging elaborately crafted censers of silver and gold, and bishops wearing golden miters studded with precious stones. All this glittering material gave an impression of the supernatural power of the Church, as the earthly manifestation of the power of God.

Although by the seventeenth century traditional values were being eroded, still the people were at heart profoundly spiritual, and much of the art of Russia was created for religious uses. Central in this artistic output was the work of gold- and silversmiths. A special atelier of these fine metalsmiths and jewelers from the four corners of the vast Russian territory and from foreign countries as well had been set up in the Kremlin in Moscow, the fortified center of the Church and of the state. Their beautiful work was designed to decorate the royal palace and to enhance official and religious ceremonies. Great quantities of their

stunningly opulent creations are collected in the Armory Palace of the Kremlin. Since the fourteenth century this palace had held the treasury of the princes and of the state, and at the beginning of the twentieth century works from the Kremlin cathedrals and monasteries were added to the collection.

In the sixteenth and seventeenth centuries, the jewelers of the Kremlin atelier reached a rare degree of perfection in the use of precious stones and metals. Engraving and repoussé techniques created an overall richness of ornamental detail as well as pictures representing religious themes. In niello work, molten metal was used to fill engraved lines. In filigree work, fine gold or silver wire was shaped into delicate open forms. Inlaid or applied enamel of glasslike sheen was used for colorful figurative work and ornamental designs as in the gold and enamel plate made for Tsar Alexei Mikhailovich shown in Figure 11.12.

In religious art, the poverty of the saints is juxtaposed with the wealth of the Church and state. Biblical figures are represented as barefoot and in simple or even ragged clothing, but they are surrounded by sumptuous designs of gold, silver, and precious stones, some of them enormous. Crosses representing the stark wooden instrument of torture upon which Jesus was crucified are studded with massive emeralds, diamonds, rubies, and chunks of amber, perhaps suggesting the heavenly rewards for the faithful as well as demonstrating the power of the Church and the aristocracy.

With this wealth of ornamental materials and techniques at their disposal, the Kremlin artisans nonetheless often created works of surpassing beauty, with all elements contributing to a harmonious unity rather than competing for attention. Another group of exceptional metalcrafters was supported in St. Petersburg.

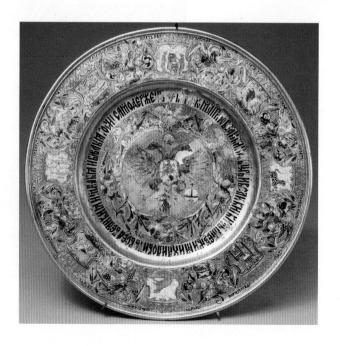

11.12 Plate owned by Tsar Alexei Mikhailovich Romanov (1629–76), c.1675.
Gold and enamel, diameter 8¾ ins (22.2 cm).
Armory Museum, Kremlin, Moscow, Russia.

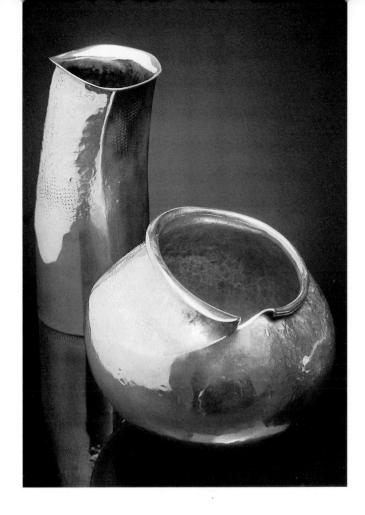

11.13 Douglas Steakley, raised vessels. Copper, (left) height 8 ins (20 cm), (right) height 5 ins (13 cm).

punches against a sheet of metal from the back to create a low-relief pattern). Individually worked pieces of iron can be riveted, screwed, bolted, brazed, or torchwelded together, but purists prefer the traditional hammered weld, with pieces heated to the point at which they will fuse.

Metal can even be coaxed into hollow vessel forms by **raising** (hammering a flat sheet over a stake to raise the sides and work them inward). Douglas Steakley's raised copper vessels (**11.13**) have been purposely textured with marks of punch and hammer to accentuate their handcrafted appearance and add subtle textural interest to their asymmetrically curving surfaces.

Wood

Because trees grow in most parts of the world, and because wood is sturdy and fairly easily shaped by saw, chisel, lathe, file, and sanding devices, it has been pressed into service by artisans of most cultures. Its warmth to the touch, smoothness when sanded and polished, rich natural colors, and lively growth patterns

give it a highly sensual appeal. It has been used to fashion everything from picture frames and furniture to kitchen utensils, toys, and musical instruments. Many handcrafted wooden objects are now valued as collectors' items, from jewelry boxes with ebony inlays to folk-art pieces made of soft woods such as pine and spruce. These soft woods are not necessarily the easiest to work, for they may splinter. Medium-hard woods include birch, butternut, cherry, pear, and apple; the durable, fine-grained hardwoods include walnut, oak, maple, hickory, teak, ebony, and rosewood. These can be worked into extremely ornate and long-lasting forms, and thus have been prized by the wealthy for fine furniture that can be passed down for generations.

Some contemporary crafters of wood take a much simpler approach to the medium, allowing it to express the more natural linear qualities of trunk and branch, such as Drew Hubatsek's *Manzano Trono* chair (11.14), in which the apple wood even retains its rough outer bark.

Whereas those who use milled lumber—such as uniform boards—typically look for clear wood, with no

11.14 Drew Hubatsek, *Manzano Trono*, 2003. Unpeeled apple wood with an antique tapestry upholstered cushion and shellac-oil finish. Artist's collection.

ARTISTS ON ART

George Nakashima on A Feeling for Wood

GEORGE NAKASHIMA (1904–90) was a designer and craftsman of the highest order. Trained as an architect, he began designing handcrafted wood furniture in the 1930s and developed a deep appreciation for the nature of wood from a Japanese woodworker in an internment camp during World War II. When his family was released from the camp, they moved to New Hope, Pennsylvania, where Nakashima established a furniture-making business. His work has many distinctive characteristics, including revealed joinery, architectural bases, and slabs of solid wood (rather than veneers) in which the natural edges are valued. His largest piece is the Altar for Peace (11.15), installed in the Cathedral of St. John the Divine in New York City as a shrine where people from around the world can pray and meditate. The following excerpts from his writings reveal his attitudes toward his material:

"It is not always ... easy to find the best expression of a piece of wood, and sometimes I will keep an extraordinary piece for decades before deciding what to do with it. This process of selection and usage is the creative act ... of the woodworker. It is this point of personal involvement with personal decision that might be called the essence of the craft. There is always an individuality that distin-

guishes craftsman-made furniture from mass-produced pieces. There is life there, and it is at odds with the lifelessness of high technology and mass production."

"In commercial lumber, knots and other imperfections are scorned. Only unblemished lumber will command upper-bracket prices Lesser grades of wood have more extensive figuring and many knots and other defects. They are less expensive and, in fact, logs of 'poor' quality may sometimes be had free of charge. To me, however, it is not the economy but the quality of this wood, the 'uniqueness' imparted by the imperfections, that makes these pieces appealing. Some of my most interesting work has come from logs that seemed hopeless to others. They have inspired a creative act and a close relationship with nature.

"I search for the pieces with huge knots or with gaping cavities. I am drawn to the root section, which has been underground and has an exceptional quality, offset by one potential problem: roots often swallow up stones by growing around them. The root of a great tree such as a giant redwood is almost a natural treasure lying underground. It must be dug from the earth carefully, often by hand with machinery doing only the heaviest part of the work. Some roots can remain in the ground for a century and still be usable."

"Searching out the unusual specimens is an adventure. Deciding how to cut them is a challenge. The thickness and direction of the cut will determine the product that comes from them. I often meditate on a piece for many years before making a final decision. Sometimes a dialogue with a client will inspire the cut of a piece."

"Sadly, many of the world's great trees end up as nothing but a common object, cut into paper-thin veneers or parcels of thin wood for novelty boxes or something similar. Part of my destiny has been to intercept this process and give some trees a fitting and noble purpose, helping them to live again in my work."

"As materials and resources become more and more limited around the world, products of beauty and utility will almost have to become more efficient as man confronts the dwindling reserves of nature Back in our woods, in New Hope, I continue to make casual objects, objects as simple as a tea bowl. I pursue the path of low technology, away from the murderous syndrome of 'progress.' The fight for beauty has occupied my lifetime, and I have sought to create beauty in a world where little of it seems to exist. My efforts are small points of light within a large light that is still possible and can grow to a great illumination."3

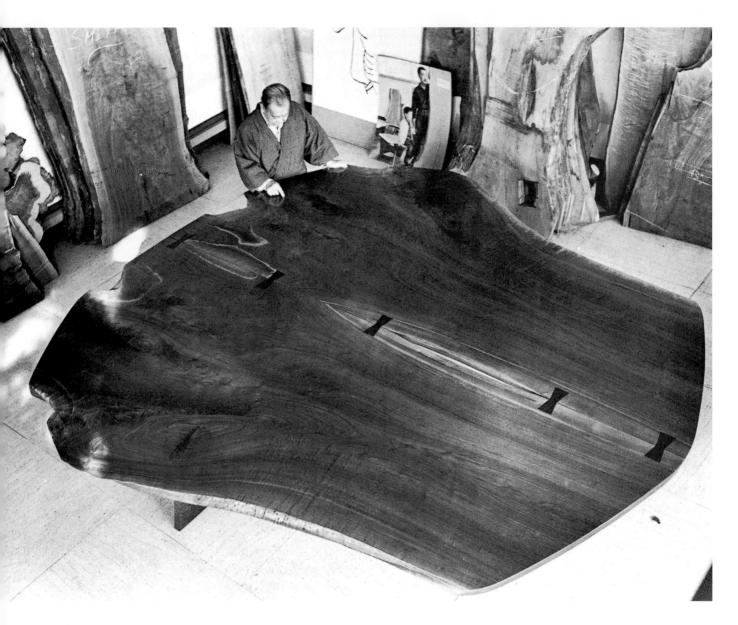

11.15 George Nakashima, *Altar for Peace*, made for the Cathedral of St. John the Divine, photographed in his New Hope, Pennsylvania, studio, 1986.

11.16 Mark Lindquist, *Toutes Uncommon Bowl*, 1980. Spalted yellow birch burl, length 32 ins (81.2 cm). Collection of Duncan and Mary McGowan.

cracks or knots where branches grew out of the main trunk, some woodworkers purposely seek out and emphasize "defects" in wood for their design interest. **Burls**—woody hemispherical knobs that grow on the trunks of certain trees—have curling linear patterns that are often used to advantage in **veneers** (thin overlays of fine woods placed over other woods) and in handcrafted bowls. The art of Mark Lindquist's wood bowl (**11.16**) is less a matter of imposing a design on it than of careful selection of the burl and respectful minimal working to bring out the natural beauty of its sinuous curves.

Glass

For all its fragile, transparent beauty, glass is made by the surprisingly simple process of melting sand with lime and soda. The technique has been in use for at least 3,500 years for creating luxury versions of functional objects.

One of the most common ways of making glass vessels is to scoop up a glob of molten glass with a long metal blowpipe and blow it into a bubble while shaping its form with hand tools. The liquidity of the glass before it hardens is captured in Harvey Littleton's freely blown and draped glass vase (11.17). Littleton was a pioneer in the twentieth-century "studio glass" movement, in which fine artists have learned the craft

of glassblowing, expanding the medium far beyond traditional concepts of what can be done in glass.

Before the twentieth century, glass production had been done by skilled glassblowers using techniques thousands of years old. But industrial techniques were developed that gradually ended the demand for glass-blowers. Even in those art glass studios that remained, the process was broken down into a series of steps handled by different specialists.

By the 1920s and 1930s there were only a few traditional glass craftsmen left. Given the rigors of the profession, it is not difficult to imagine why it was largely abandoned. Maurice Marinot, one of the last great artists in France, described what it was to work with such a hot medium:

To be a glassmaker is to blow the substance to transparency into the blind furnace and to

11.17 Harvey Littleton, vase, 1963. Hand-blown clear glass, $9\frac{3}{4} \times 7\frac{1}{2} \times 4\frac{7}{8}$ ins (24.8 \times 19 \times 12.4 cm). Museum of Modern Art (MOMA), New York. Greta Daniel Design Fund.

reblow it with tools of his art—his lips: to work in the heat, sweating with fever, the eyes full of tears, the hands seared and burnt.⁴

Nevertheless, glass was an enchanting medium with great aesthetic potentials—brilliance, light reflection and refraction, bubbles, iridescence, gem-like colors, extreme malleability when hot. Picking up from Marinot, Harvey Littleton (who had been a ceramist) and a few other artists and technicians held workshops in 1962 to create glass techniques that could be used by individual artists rather than factories, and a new type of glass that was cheap, durable, and easy to melt. The participants were so excited by their discoveries of what could be done with glass that they kept the furnace busy from 5:30 in the morning until midnight.

From this new start, studio glass has become a very dynamic feature of the contemporary art scene. Dale Chihuly is a major figure in today's rapidly evolving art glass field. Many of his pieces take off from traditional ways of forming glass as containers but exuberantly transcend functionality. His *No. 2 Sea Form Series* (11.18) is a dynamic sculptural play of flowing, organic forms, lines, and colors, heightened by the translucent qualities of the glass.

Chihuly's sea forms are so distinctive that he has launched lawsuits against two other glassblowers, including a former collaborator, for making glass sculptures that are too similar to his. Chihuly in fact has not directly blown glass himself for decades, due to a surfing accident that hurt his shoulder. Rather, he provides sketches for a crew of almost one hundred artisans working under his supervision. The lawsuits have thus exposed counterissues of mass production versus hand-crafted work by the artist whose name it carries, as well as of ownership of artistic ideas.

Glass can also be cast. The lost-wax ("cire perdue") process produces one-of-a-kind pieces. René Lalique, one of the great names in glass design, began his studies of the possibilities of glass with the lost-wax casting process. Pieces such as his glass vase shown in Figure 11.19 are prized by collectors not only for their subtle design and the beauty of the glass but also because they retain the human touch: the thumbprints of the modeler, which can be seen in the flowers. Lalique soon abandoned these unique, handcrafted pieces and turned to mass production of beautifully designed glass tableware, vases, bottles, boxes, jewelry, lamps, and panels for luxury cars, trains, and ocean liners.

In addition to blown and cast vessels, glass is also blown or poured into sheets to make two- or three-

11.18 Dale Chihuly, *No. 2 Sea Form Series*, 1984. Width 3 ft 8 ins (1.12 m). Courtesy of Foster/White Gallery, Seattle, Washington.

The energetic Dale Chihuly co-founded the influential Pilchuk Glass School north of Seattle in 1971 and continues to push the boundaries of what can be done with blown glass, including large-scale installations and cooperative projects around the world.

dimensional works that both admit and transform light, as in lampshades or cathedral windows. Antique glass, prized for its metal oxide brilliance and its "imperfections" such as bubbles and warps, is blown by a glassblower as a cylinder, cut lengthwise, and heated until it lies flat. For stained glass, chemical colorants are heated with the base glass in a kiln until they fuse. Opalescent glass, developed by Louis Tiffany and John La Farge, incorporates soda ash for opacity; the glassmaker swirls bright color oxides through the molten glass as it is poured out into a sheet. To create designs of different colors, pieces of stained glass are cut and then joined by means of soldered lead channeling, copper foil, glue, or heat fusing. Tiffany's virtuosity with glass is especially evident in his windows (11.20). They are mosaics of his custom-made glass, thousands of pieces cut and pieced

11.19 René Lalique, glass vase, c. 1905–10. Cast glass, height 6 ins (15.2 cm). Private collection, Miami, Florida.

11.20 Louis Comfort Tiffany, *Irish Bells and Sentinels*, left panel of triptych window, St. James Country Club outside Perryopolis, Pennsylvania. Width 6 ft 8 ins (2.03 m).

together with dark lead strips—which also serve a design function as outlines defining the shapes. But unlike medieval stained-glass windows, the colors within the shapes are not solid; rather, they are mottled, swirled, juxtaposed, and layered to create lush and dynamic interplays of colors. Tiffany did not rely on painting on the glass, for to do so would inhibit the brilliance of the light effects.

Fibers

Another ancient craft that is presently undergoing a great resurgence of interest is fiber art. This broad category includes everything made of threadlike materials, usually woven or tied into larger wholes. Many of these works are conceived with the functional purpose of maintaining warmth, such as the tapestries created in many ancient cultures. In Gothic Europe, tapestries were designed to take the chill off the cold masonry walls of castles and cathedrals during medieval Europe's mini-Ice Age. In these heavy, handwoven textiles, pictures were woven directly into the fabric. A cartoon of the desired image was drawn on the warp, the lengthwise threads strung on the loom. As the crosswise weft threads of varied colors were woven loosely over and under the warp and then pressed downward, complicated pictures emerged, as in the lovely Unicorn Tapestries, of which the last is shown in The Unicorn in Captivity (11.21). In the courtly medieval world, these time-consuming works were far more expensive than paintings.

Baskets woven of pliable materials are a form of fiber art used by many traditional cultures. Traditional basketmaker Susye Billy of the native Pomo people in California points out that appropriate natural plant materials—such as sage grass root, bulrush root, and redbud shoots—are no longer readily available:

They can't be bought anywhere and it's very hard today to find the places where the materials grow and to be able to gather them. The way that rivers have been dammed up, the way that the waters

11.21 (opposite) The Unicorn in Captivity, from the Unicorn Tapestries, c. 1500. Silk and wool, silver and silver-gilt threads, 12 ft 1 in \times 8 ft 3 ins (3.68 \times 2.51 m). Metropolitan Museum of Art, New York. Cloisters Collection, gift of John D. Rockefeller, Jr., 1937. Seven tapestries were made in the Unicorn series, woven from the finest wool and silk with silver- and gold-covered threads. The series depicts scenes from a hunt for the magical unicorn, who is here shown found and tamed in happy confinement, as the beloved.

11.22 Monden Kogyoku, *Flower of a Wave*, 1977. Bamboo, diameter 21 ins, height 17 ins (53 cm \times 43 cm). Tai Gallery, Textile Arts Inc.

run different now, wipe out the roots and things that used to grow along the sides of the rivers. And a lot of the willows have been cut down along the roads, where they've put in roads that used to be just dirt roads You have to be very determined to be a basket weaver today.⁵

But fortunately, some basketmaking materials and craftspeople still exist in many parts of the world. Monden Kogyoku of Japan (b. 1916) has been making woven bamboo baskets, such as *Flower of a Wave* (11.22), since he was a teenager, with such a masterful touch that he was long ago given the artistic name "Kogyoku," meaning "bamboo grove treasure."

In addition to carrying on the traditional fiber arts, contemporary artists are also experimenting with nonfunctional "paintings" and sculptures of fibers ranging from cloth and yarns to wire gauze, hog gut, and vines. Basketry and crocheting have been adapted by fiber artist Norma Minkowitz to create haunting, semitransparent, vessel-like forms that are not designed to hold anything but nonetheless refer to confinement, to containment, as in her *Collected* (11.23). She explains,

The reason for my technique is that it becomes a really fragile but yet structured form which allows me to show an interior space. It's seeing within something, and the inside becomes ambiguous—Is it a shelter? Is it a trap? Is it someplace to be safe or someplace to be stifled or controlled?

It's very repetitious and time-consuming to create your own material, your own fiber, your own canvas. But through the medium of crochet the process becomes part of the content, and structure and surface are achieved at the same time. I am also motivated and excited by the intimate relationship that I have with the object I am creating, which is generally small and easy to hold on my lap. I sit in a quiet corner, alone with my thoughts and my work.⁶

11.23 Norma Minkowitz, *Collected*, 2005. Fiber, resin, wire, and paint, $79 \times 50 \times 11$ ins (200.7 \times 127 \times 27.9 cm). Artist's collection.

11.24 Dorothy Gill Barnes, *North Beach Rocks*, 1995. Mulberry bark, rocks, wrapped, $9\frac{1}{2} \times 5 \times 5$ ins (24.1 \times 12.7 \times 12.7 cm). The "rocks" are red and yellow bricks washed and rounded by the Lake Erie surf. Collection of Daphne Farago. Photo by Doug Martin.

Traditional basketry techniques and fascination with the nature of tree bark led to Dorothy Gill Barnes's *North Beach Rocks* (11.24). Fresh mulberry bark that she wrapped around stones tightened to enclose them and also took on their shape as it dried. Like Barnes, many contemporary fiber artists are women creating non-traditional, nonfunctional container forms suggestive of inner feminine mysteries—enfolding, enclosing, protecting what lies deep within their embrace.

Quilting was traditionally a way of sewing fabric scraps into colorful, durable blankets that are also

THE WORLD SEEN

Persian Carpets

ONE OF THE most prized of fiber arts in many cultures has been the weaving of rugs. In ancient Persia, rugs of intricate beauty were used by nomadic peoples to cover the sand within their tents and to wrap their possessions when traveling. This tribal art seems to have begun with the nomads of Central Asia in prehistoric times, and figures clearly in the paintings and literary references of medieval Islam.

The earliest period that is clearly documented by surviving carpets is that of the Safavid rule in Persia (Iran) from 1502 to 1736. At that time, what had been a cottage industry became a national one, with the court setting up factories for the master carpet weavers in various cities. These craftsmen created carpets of extraordinary beauty, including knotted pile carpets of densities up to four hundred or more knots per square inch (sixty knots per sq. cm). Some were gigantic. The sixteenth-century carpet from Tabriz shown in Figure 11.25, for instance, is more than 26 feet (7.9 m) long. Like other fine Persian carpets, it is superb not only in its perfectly executed symmetrical designs but also in harmonizing many different patterns, from the central circle, to the surrounding medallion linked with mosque lamps, to the field of yellow on red floral patterns, to the blue band, to the wide border of intricate arabesques, to the final yellow-dominant border. Colors are skillfully manipulated to bring unity to these varying patterns. This continual shift in patterns which themselves seem to multiply endlessly can perhaps be seen as

a reflection of the infinity and perfection of the Creator.

As in other Islamic arts, patterns of Persian rugs are often based on stylized, symmetrical floral and vegetal designs, elaborated into interwoven arabesques. In them one sees the language of life, continually growing, multiplying, flowing. Due to the particular sheen of the fibers of some regions such as Kashmir—where silky wools and actual silk are used—the visual impression of such carpets shifts and shimmers as one's point of view changes, making the design even more dynamic. Such

perfection is the outgrowth of close collaboration among highly skilled dyers, designers, and weavers.

In Islamic cultures, the handwork of artisans has long been highly respected. A rug such as the one shown here reflects a tremendous amount of time and effort. Patrons of such work have often been rulers making gifts of these carpets to mosques, or using them to decorate their own courts. Skills are often passed down over generations within families of traditional artisans. Even if in everyday use, these carpets can last a hundred years.

11.25 Carpet from Tabriz, Iran, Safavid period, 16th century. Wool pile on cotton and silk, 26 ft 6 ins \times 13 ft 7 ins (8.07 \times 4.14 m). Metropolitan Museum of Art, New York. Gift of Samuel H. Kress Foundation, 1946.

11.26 Loretta Pettway, *Medallion*, c. 1960. Synthetic knit and cotton sacking material, 87×70 ins $(34.25 \times 27.5 \text{ cm})$.

reminders of one's family history. The tradition evolved within poor African-American families making do with what was at hand, often in the process creating art of surprising vigor. Generations of women of Gee's Bend, a town of 700 people in rural Alabama, have produced a large number of quilts that have been hailed as great works of contemporary art. Using scraps of old work clothes, cotton sacks, fabric samples, handkerchiefs, and even pieces of synthetic suits, the women have improvised on basic patterns handed down from one generation to the next, creating their own bold variations without concern for any formal considerations such as perfect symmetry. Loretta Pettway's energetic Medallion quilt (11.26) is based on a geometric idea but quite freely cut and stitched, with such innovations as open spaces among the colored

shapes that reveal the black material beneath. The artist explains,

Some people would give me old clothes, and some of them my kids couldn't wear, and I would tear them up and make quilts. I didn't think I was too good at cutting out. If I could have got with friends to get me on the right track, maybe. But I just didn't have friends, so I had to piece things the way I could see to do. I ain't never made a real pattern. I just made what my grandmamma had made back in those days.⁷

Handmade fiber works often involve lengthy, painstaking hand labor. Itchiku Kubota has revived and adapted an ancient, time-consuming Japanese

11.27 Itchiku Kubota, *Ohn* (Mount Fuji), *Tender*, Cool *Dawn*. Kimono.

method of preparing silk fabric for kimonos. The silk is gathered into myriad tiny lumps with thread and then painted and dyed selectively, with some of the lumps covered by vinyl thread to resist the dyes. The artist must remember all details of the intended design, for it cannot be seen during the process. Silk cannot absorb much dye at one time, so the fabric is repeatedly dipped in dye baths and then rinsed again and again. After dyeing, it is dried while stretched on short bamboo sticks to prevent shrinking. Tiny scissors are used

in pulling and cutting away the threads wrapped around the lumps; without precision, the silk itself may be cut. The exquisite results can be seen in the subtle color blending of the landscape kimono in Figure 11.27.

Although many of the fiber arts have evolved from handwork done on someone's lap, some contemporary fiber pieces are of tremendous size and weight. Fiber installations may be so large that scaffolding must be used to erect them.

Product and Clothing Design

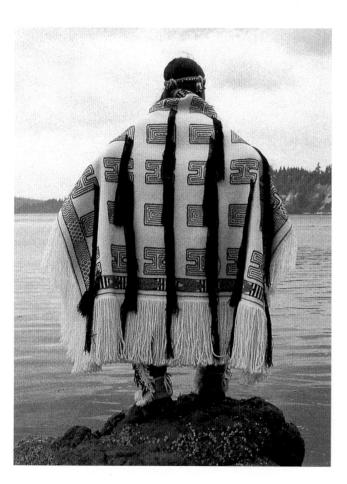

12.1 Cheryl Samuel, Kotlean robe, 1986. Handwoven wool.

KEY CONCEPTS

An aesthetic approach to designing everyday objects

Designing for comfort and ease

Sculpting in fibers—clothing

Making statements about the wearer in fabric

Clothing as an art form

BOTH TRADITIONAL AND modern approaches are thriving in today's product and clothing designs. Interested in the old ways of her own cultural roots among natives of the northwest coast of North America, Cheryl Samuel embarked on a worldwide search for remnants of that culture's fiber arts. She visited museums from St. Petersburg to Toronto to study the eleven remaining old-style Kotlean robes woven over 200 years ago by craftspeople of that area. From what she learned, she produced a twelfth such robe (12.1).

Samuel discovered that the people had used their basketweaving techniques to twine the yarn, working each row from left to right and knotting the weft strands into a fringe on both sides. After each of the concentric geometric patterns was completed, the black weft threads were left hanging as tassels. When a dancer wearing one of these robes moves, the whole garment sways with the body, and the motion of the dance is accentuated by the swinging of the tassels. Because of Samuel's enthusiastic interest, many people in the northwestern Canadian coastal communities have begun to create the traditional weavings once more.

Both handcrafted clothing and mass-produced clothes may be designed according to aesthetic as well as functional considerations. As we will see in this chapter, the same is true of industrial design of everyday goods for contemporary life.

Industrial Design

The furnishings of our homes and offices reflect stylistic trends but also the demands of functionality. When first introduced, machines such as telephones and computers were designed solely as electronic parts within a casing. The parts were initially bulky, and the casing was simply a protective cover. Now, with electronic miniaturization and the application of aesthetics to product design, many products have been carefully sculptured for visual appeal and ease of use. In addition to form, colors, textures, and surface finishes are carefully chosen.

A pioneering effort to bring an aesthetic approach to mass-produced functional goods was launched in Germany in 1919 by leading European architects and painters. The school they developed was known as the

Bauhaus ("house of building"). Courses were offered in materials, the study of form, graphic design, crafts, furniture design, and architecture. Because of the particular aesthetics of the artists involved, the Bauhaus became famous for a clean, open, unornamented rationality in its architecture and its product designs. The Bauhaus designers expressed a strong desire to bring art to the workers, but in fact most workers rejected their houses and furniture as being unwelcoming in their austerity. Nonetheless, the Bauhaus aesthetic was appreciated by many intellectuals and artists. It developed into the highly influential International Style in architecture, and some of the furniture designs remain classics, such as Mies van der Rohe's chair shown here (12.2). Its framework of polished bent tubular steel for legs and armrests was highly innovative at the time but has now entered the contemporary design vocabulary.

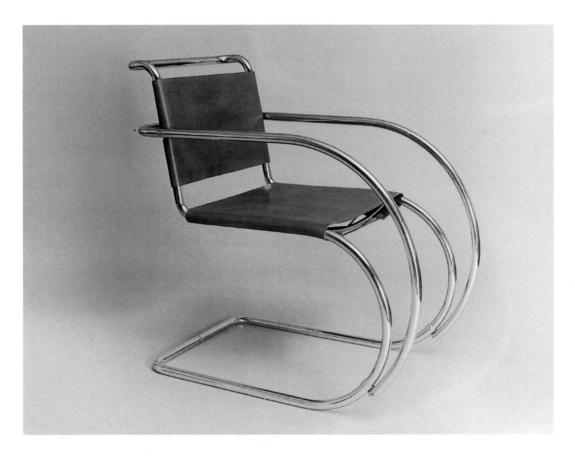

12.2 Ludwig Mies van der Rohe, "MR" armchair, 1927. Chrome-plated steel tubing and leather, $31 \times 20\% \times 32\%$ ins ($79 \times 52 \times 82$ cm). Manufactured by Esteler-Regale GmbH, Germany. The Museum of Modern Art (MOMA), New York. Gift of Edgar Kaufmann, Jr. 20.1949.

12.4 Eva Eisler, *Cimetric Tray 580 with Serving Utensils*, 2002. Stainless steel, $2 \times 23 \% \times 7 \%$ ins (5.1 \times 59.7 \times 19.1 cm). Manufactured and photographed by Mono, Germany.

Design houses are flourishing in many countries, some of which provide governmental support for their designers as national resources. For example, Vignelli Associates has offices in New York, Paris, and Milan and provides many firms with designs for graphics, consumer products, furniture, and interiors. Owners Lella and Massimo Vignelli, in conjunction with David Law—a designer of two-dimensional graphics, packaging, exhibits, furniture, products, interiors, and environmental works—designed the handsome dinnerware shown in Figure 12.3. They gave great attention to the subtly pebbled "organic" texture of the dishes, the dramatic contrast between the black

12.3 (opposite) Lella and Massimo Vignelli and David Law, dinner set, 1984. Stoneware, large plate, diameter $10\frac{3}{4}$ ins (27.3 cm). Manufactured by Sasaki Crystal, Japan.

expanses and the wide, white beveled edges, and the sensuously rounded profile of the teapot. It is functional as well as pleasing to the eye, with an easy-to-grasp open handle, good balance in the hand, and a practical spout for pouring hot liquid.

High-end firms manufacturing consumer products are often known for their particular style. The Mono firm in Germany has a philosophy of designing cutlery and other pieces for tabletop use that are of such sophistication and elegance that they will not become out of date. To meet their requirement of "a sculptural, minimal form, softened by elegant curvy lines that could potentially be used in a pristine, minimal interior space," designer Eva Eisler experimented with sheets of cardboard, scoring and folding them in order to create scale models of serving utensils and trays that were ultimately mass produced of stainless steel shaped by hydraulic presses (12.4).

12.5 Clive Wilkinson Architects, TBWA\Chiat\Day offices (reception desk), Los Angeles, USA, 1998.

Ergonomics is the new science of designing for efficient and comfortable interaction between a product and the human body. It attempts to cut down on awkwardness and fatigue in common home and workplace tasks. The office reception desk shown in Figure 12.5 is designed for maximum comfort and efficiency. The receptionist's revolving chair is on wheels, so the receptionist can easily move throughout a circular space without getting up from the chair. The elevated shelf above the desk is for the convenience of customers, but is open below to avoid cutting off the receptionist's view of approaching people. This attention to functionality also creates a clean and pleasing visual impact.

Although many contemporary products are the result of technological innovations in materials and

industrial processes, paradoxically some aspects of high technology make it possible to mass produce the look of the old and handcrafted. For example, the development of miniature, low voltage, halogen lights has allowed designers to eliminate the fuss of wires and fittings in a lamp and to use relatively flammable materials near the light source. Hiroshi Morishima's table lamp (12.6) has a gentle, handcrafted look, with the light glowing through the soft, random texture of handmade Japanese paper.

12.6 (opposite) Hiroshi Morishima, *Wagami Andon*, 1985. Lamp encircled in a cone of Japanese handmade paper, $29\frac{1}{2} \times 21\frac{1}{2}$ ins (75 \times 55 cm). Manufactured by Time Space Art Inc., Japan.

12.7 Voisard after Desrais, *A Lady of Fashion*, c. 1770. Colored engraving.

12.8 (opposite) After Hans Holbein the Younger, *Henry VIII*, 1537. Oil on canvas, 7 ft 8 ins \times 4 ft 5 ins (2.34 \times 1.35 m). Walker Art Gallery, Liverpool, England.

Clothing Design

Those who design clothes sculpt in fibers, with the human body as a supporting armature. In addition to their aesthetic qualities, our clothes carry symbolic connotations that transcend the sheer function of protecting our bodies from the weather. Naked, we are all much the same. Clothed, we make symbolic statements about our wealth, status, lifestyle, sex role, personality, and taste.

The art of dressing often connotes class rank. Traditionally, the working classes have usually dressed for convenience, with simple sturdy fabrics and designs allowing free movement. Farther up the social scale, wealth and leisure may be demonstrated by a

more ornamental than functional approach to design. In addition to demonstrating that the wearer was not involved in manual work, fashions for women have at times turned them into visual display cases. As indicated in the engraving by Voisard (12.7), high-born French women of the 1770s were almost immobilized by immense side paniers, tight-waisted corsets, frilly sleeves, and towering hats and hairstyles that took hours to put together and needed to be moved very carefully, if at all. Even to be carried in a sedan chair, women so dressed had to kneel on the floor to make room for the height of their headdresses. The hairstyles took so long to construct that they were maintained for a month or two, with the aid of lard and whiting. Sleeping with them was as hazardous as it was

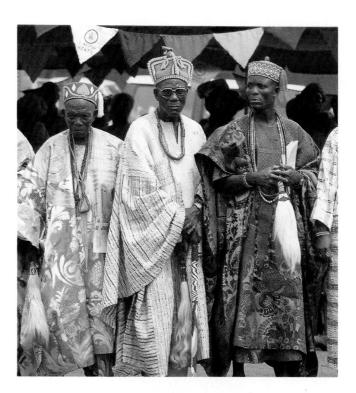

12.9 Traditional dress from Nigeria, Africa.

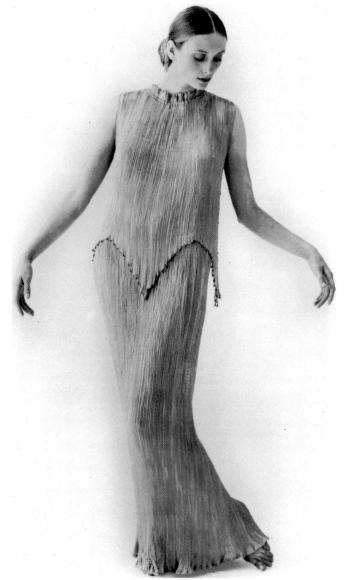

12.10 Mario Fortuny, Delphos dress, c. 1912. Silk.

uncomfortable, for mice liked to nibble on them; the solution, a mouse-resistant nightcap, added to the great weight of the contraption.

As well as being calculated to impress others with one's wealth and position, fashions have been used to accentuate one's gender image. Males may dress in ways that flaunt and exaggerate their masculine traits, such as the immense padded shoulders, decorated codpiece, and barely covered legs of Henry VIII's costume (12.8). Not only do the artificially broad shoulders emphasize his masculinity; they also bespeak the great political power of the monarch.

Flamboyance in male attire has been rare in Western societies during the twentieth century, with

the conservative business suit widely accepted as a uniform. But some cultures drape men with gorgeous fabrics, such as those shown in Figure **12.9**, still the choice of clothing for some of African descent.

As we become more liberated from traditional social role expectations, we are freer to dress as individuals. In the twentieth century, women's emancipation from stricter Victorian standards opened the way for greater freedom in their clothing. The *Delphos* dress of pleated silk by Fortuny (12.10) allowed the natural curves of the body to show, without exaggeration or coyness. Its graceful lines—still in demand—were inspired by the draped garments of Classical Greece. The pleats travel well and are in fact best maintained by twisting the dress into a knot.

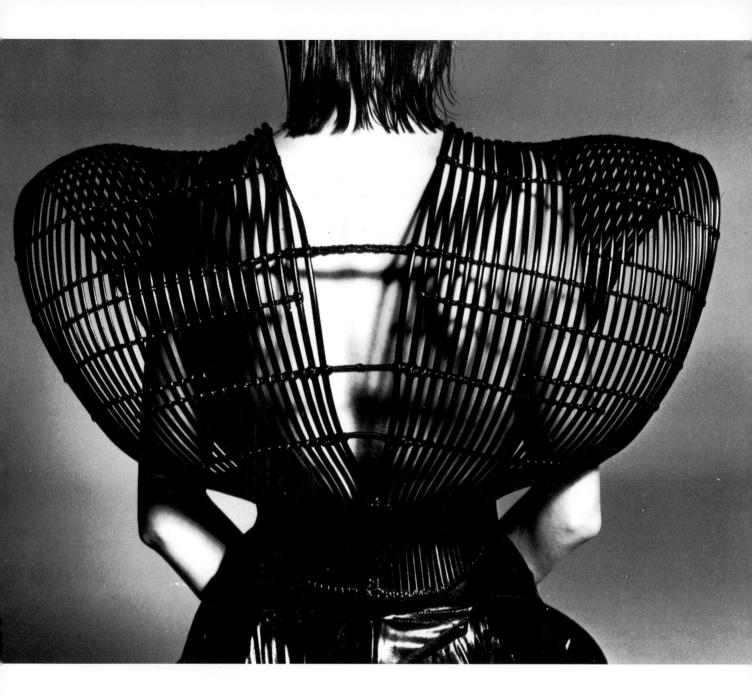

12.11 Issey Miyake, Body Sculpture in Rattan, 1982.

As in the other arts, the world of contemporary high fashion is a melange of different styles. Its variety is personified by the exuberantly unconventional output of Japanese designer Issey Miyake. His garments range from marvelously loose and flowing pieces that allow and encourage free movement of the body to the open basketwork "coat" (12.11). Its cane framework resembles samurai armor, revealing and contrasting with the sensuality of the body. Even Miyake's fabrics are his own invention. To support his broad credo—"Anything can be clothing"—he takes his inspiration for fabrics from everyday images—"leaves, trees, bark,

sky, air. Anything. A noodle." Miyake drapes the fabrics over himself to see what they will do. He says:

Fabric is like the grain in wood. You can't go against it. I close my eyes and let the fabric tell me what to do.¹

Ever pushing at the boundaries established for fashion by social convention and lack of imagination, Miyake observes that the Japanese word for clothing—fuku—also means happiness: "People ask me what I do ... I say I make happiness." The wearer of such a garment

THE WORLD SEEN

Saris of India

ONE OF THE world's most beautiful clothing styles for women consists simply of a single untailored length of cloth, artfully wrapped around the body. This is the sari, which has probably been worn for millennia by women of the Indian subcontinent. Saris are still so popular that more than six million handweavers are producing them on handlooms, in addition to powerlooms in textile mills. The cloth is unstitched because Hindus have traditionally believed that cloth that is cut and pierced by needles is impure.

The single length of cloth may be from 13 to 30 feet (4-9 m) long, with the largest ones generally being worn by the wealthiest women. Most working women wear shorter saris to allow freer movement; the saris of middle-class and wealthy women are quite full and are expected to cover the ankles modestly and brush the floor. There are many ways of draping a sari, according to regional and caste traditions. In general, most of the material is wrapped around the waist, where it is neatly folded into pleats. These may be tucked into a waiststring, a long petticoat, or the first wrap of the material, which is tightly secured around the waist. A loose trouser-like effect is created in some regions by then passing a length of the material between the legs and re-securing it at the waist. The remaining material is then passed around the back and draped over one shoulder and perhaps the woman's head as well to make a veil. Often a short half-blouse is worn beneath, leaving the midriff semiexposed.

To drape and then move in a sari takes considerable practice, and thus they are not worn by young girls. Sari-clad peasant women in many regions are able to perform hard labor nonetheless, and even modern urban women often still choose to wear saris because of their beauty as well as their association with cultural tradition.

The beauty of the sari results not only from the graceful draping but also from the highly structured design and sophisticated patterns of the cloth. There are three main areas: the borders along the sides, the middle field, and the endpiece that is left at the end of the draping process. Usually the border is designed to contrast but at the same time harmonize with the field in color and pattern. The endpiece is related to both but is the most highly elaborated part of the cloth. The most elaborately ornamented saris, woven and perhaps embroidered with the costliest materials-such as silk and gold thread—are worn at weddings and other special occasions and may take up to a year to make.

Embroidered textiles have been famous in the Indian subcontinent for more than two thousand years. Techniques and designs of embroidery have gained from waves of invasions from the northwest as well as from trade with other regions. One of the strongest "recent" influences on textile and embroidery patterns has come from the Muslim aristocracy which invaded and then ruled much of India from the tenth to early nineteenth century. Muslim artisans were highly skilled, and the Mughal

royalty set up special workshops for all the crafts within their living compounds. Use of precious goldwrapped thread for hand embroidery became quite popular among the wealthy and this zardozi work is still commonly used today for wedding saris, such as the one shown in Figure 12.12. The sheen of the metallic threads, the intricate patterns, and the grace of the draped fabric as a sari-clad woman moves tend to transform her appearance into one of great beauty, even though the whole design springs from a single length of untailored cloth.

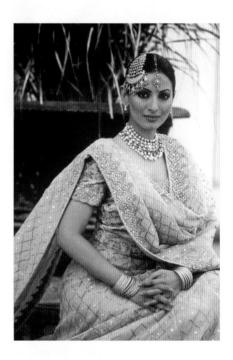

12.12 Tarun Tahiliani, traditional *zardozi* sari combined with jewelwork, 2000. Ensemble, New Delhi.

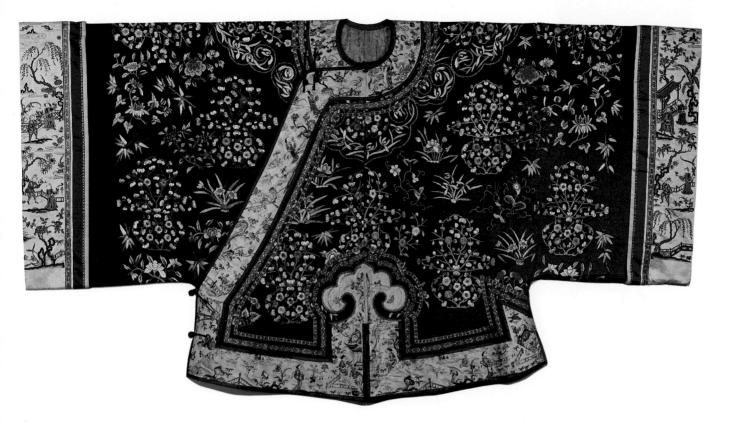

12.13 Woman's coat, north or northwest China, c. 1850–1900. Wool broadcloth, satin borders, embroidered in polychrome silks and gilt threads, length 29½ ins (75 cm). Metropolitan Museum of Art, New York. Gift of Dorothy A. Gordon and Virginia A. White, in memory of Madge Ashley, 1973.

must have something of the same blithe spirit, a sense of independence and self-confidence. Designed for lithe and sensual movement, the clothes only "work" on a person who moves freely within them.

Some garments—such as those by Issey Miyake—are considered wearable art by collectors. High-quality Chinese and Japanese kimonos are hung as paintings, even though they are also very comfortably functional with their deep-cut arms and loose fit. Indeed, kimono designers old and new have treated this traditional

garment as a broad surface for two-dimensional art, such as the intricate embroidered patterns of silk and gold threads worked across the Chinese woman's coat (12.13).

In some cultures elaborate handmade garments are among a family's treasures passed down from one generation to the next and worn on special ceremonial occasions. There are also some contemporary attempts to maintain or revive the old labor-intensive costumemaking arts as symbols of a cultural heritage.

Architecture

KEY CONCEPTS

Architecture and function

Designing buildings according to the environment

Innovations in building techniques

New material and new kinds of architecture

Prepackaging—economy and architecture

The backlash against function—expression and individuality

13.1 Machu Picchu, Peru, c. 1500. Stone gateway.

STONE, BEING WIDELY available, has been used as a building material since prehistoric times. One of the greatest examples of stone architecture has been found in an area that is almost inaccessible from anywhere: a precipitous ridge 12,000 feet (3,658 m) above sea level in the high Andes of Peru. In this unlikely setting, what may have been a major sacred site and/or defensive position was painstakingly built of huge, perfectly cut stones by Inca stonemasons working only with stone hammers and small bronze crowbars early in the sixteenth century.

These masons carved 10- to 15-ton rocks so skillfully that they fit into place stone to stone, without mortar (13.1). Despite earthquakes in the area, they still fit together so tightly that a knife cannot be slipped into the joints. The huge rocks are polygonal, cut on angles and then precisely placed to form inclined walls that are broadest at the base. They are topped by stone pegs and slabs with drilled holes to which thatched roofs were apparently lashed.

These extraordinary structures at Machu Picchu are only one example of the great variety of ways that human effort and creativity have been applied to architectural forms.

Architecture is similar to the other visual arts in aesthetic terms. Visually, buildings are developed from the

same elements and principles of design as are other art forms. For example, architects work with form, texture, line, space, and color, using principles such as repetition, variety, and emphasis to unify the results visually. They are in effect designing large, three-dimensional works of art which have both external and internal contours. The insides and outsides of architecture each have their own aesthetic impact, as can be seen in the inner and outer views of an unusual round stone barn built by the Shaker spiritual community during the nineteenth century (13.2 and 13.3). Seen from outside, the stone exterior settles firmly into the land; seen from inside, the radiating wooden structures designed for cows and hay have a surprising beauty and uplifting effect. Good three-dimensional functional works often demonstrate that what is elegantly logical and purposeful can also be visually beautiful.

Architects' Unique Concerns

Despite its aesthetic links to other visual arts, architecture is a much less direct medium of artistic expression. Professor Richard Swibold, architect and professor of art and architecture, observes:

The architect's is not a one-on-one relationship between conception, design, detailing, and construction, the way a painter's or sculptor's is. Once the architect has the idea—assuming all the other relationships with the client and community agencies and codes are acceptable—then the work is turned over to a contractor to build it. So the architect is cut off, unlike the painter or

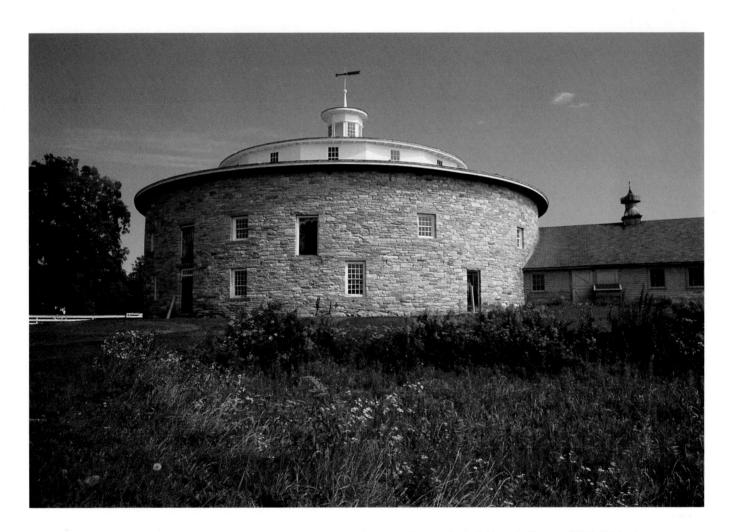

13.2 Round Stone Dairy Barn, Hancock Shaker Village, Pittsfield, Massachusetts, 1826. Height 21 ft (6.4 m), diameter 270 ft (82.3 m).

13.3 Interior of the Round Stone Dairy Barn, Pittsfield, Massachusetts. The Shaker approach to design was so aesthetically pleasing that even a dairy barn feels like a cathedral.

the sculptor, from that final artistic act of doing it himself. The work is performed usually by people he is never even going to meet. He might go to the construction site once a week to supervise and to look at problems and to evaluate quality work, but for the most part, all these craftsmen—sometimes hundreds or thousands on a really big project—are people he'll never have any personal contact with. So his artistic expression is the result of being able to communicate through drawings and details and written specifications and selecting materials. The completed work is almost always a compromise. It's not the pure result of a painter with his idea, his brilliance, completing it with the final brushstroke.

The architect is an artist, but also a social servant. The designer of a house must think of the comfort and happiness of its inhabitants; the designer of university buildings must consider the teaching and learning environment from the point of view of teachers and students. Buildings must not fall down; roofs must not leak. Architects must undergo lengthy, specialized training; their creations must satisfy zoning regulations, building codes, planning committees. Projects must be commissioned and paid for by a client, satisfying the programmatic needs and tastes of the client; they must attempt to accommodate diverse and often contradicting social values. They are executed by contractors and developers, who in today's industrial

societies are usually governed by short-range financial considerations.

Architecture must also concern itself with unique functional and structural considerations. These are explored in the pages that follow.

Function

For comfort in living, we humans have always sought some kind of shelter from the elements. Not only have we clothed our bodies; we have also tried to create miniature environments that are warmer or cooler than our natural setting and that will provide shelter from the elements for ourselves and our possessions.

In the countryside along the Ganges River in India, the local canes and grasses are cleverly woven and bound together into comfortable dwellings that can be erected in two or three days (13.4). Although they may last only four or five years, they keep the rain out, keep inhabitants cooler in summer and warmer in winter, cost nothing, are minimally disruptive to the natural site, and are easily replaced when they fall apart or are swept away by floods. They are even lovely to look at, with their rhythmic repetition of woven lines.

In most cultures, however, there has been a desire to create larger, more permanent structures. Those designed for group assemblies—places of worship, houses of government, and commercial institutions—have required more elaborate technologies in order to

13.4 Kanna hut, Shiv Sadan, Uttar Pradesh, India. Despite their use of simple local materials, kanna huts are constructed by skilled workers who weave the roof as two hinged units that must then be hoisted into place by a large and spirited team of helpers.

THE WORLD SEEN

The Hidden Temples of Angkor

CIVILIZATIONS HAVE RISEN and fallen over the millennia, and along with their demise, some of their architectural triumphs have been buried by time, or lost to decay in the case of wooden buildings. To the great excitement of contemporary historians, the immense temple complex of one of these "lost" civilizations, the city of Angkor in central Cambodia, has been rediscovered by the outside world, and its ruins are presently being restored by specialists from many countries.

The largest monument site in Asia, Angkor covers an area of over 154 square miles (400 km²). It was once the capital of the Khmer empire, whose kings ruled an area stretching from southern Vietnam to Yunan, China, in the east and the Bay of Bengal in the west. The over one hundred remaining stone temples were built between A.D. 879 and 1191, at the height of Khmer civilization. Other structures in the city, from palaces and public buildings to houses, were made of wood and have thus disappeared. Even the stone temples were long hidden in dense jungles among huge tropical trees after the city was conquered by Thais and abandoned in 1432. Over the centuries, as the history of Angkor was forgotten and its grand

temples taken over by the jungle, legends developed about a mysterious city of the gods. These were considered only myths until Henri Mouhot, a French explorer, discovered the huge complex in 1860.

The largest temple in the Angkor complex is Angkor Wat. It was built during the reign of Suryavaram II (1112-52) to honor the Hindu god Vishnu and then, after his death, to serve as the tomb of the king himself. Many of the temples seem to have been built for this dual purpose, for the people had been encouraged to regard the Khmer kings as embodiments of the gods. Over the centuries, the Angkor Wat temple has remained in good shape because it has often been occupied by Buddhist monks. Even though the monks were massacred in 1975 in the midst of decades of brutal civil strife, the temple escaped structural harm. Another remarkable massive temple complex called The Bayon features huge, carved, smiling stone heads on all four sides of forty-five towers, surrounding the viewer with the omnipresence of the benevolent Buddhist deity, Avalokitesvara, to whom the builder King Jayavarman VII (r. 1181-1220) likened himself.

All of the stone surfaces in Angkor are covered with beautiful low-relief

carvings and statuary, mostly representing scenes from the great Hindu epics. One of these is the longest continuous low-relief in the world. The ancient Khmers had great expertise in woodcarving, which they then transferred to the medium of stone.

The tall roofs of some of the temple complexes are built in a pyramid fashion known as corbeling. In this technique, vaults are made by piling long, flat stones one on top of the other, each inset from the one below, until they join at the top. No mortar is used; the structures are held together by the sheer weight of the stones. Many of them have collapsed nonetheless. International efforts to restore this architectural treasure have in some cases involved cement, but the purists among the restorers are insisting instead on maintaining the distinctive Khmer culture by using stones from irreparable areas to replace those that have fallen. The vigorous jungle growth is still toppling structures, as tree roots and standing water are causing foundations to shift. Nonetheless, the exquisitely beautiful Ta Prohm (13.5) complex has been allowed to remain surrounded by jungle as it has been for centuries, retaining the mysterious aura of a hidden palace of the gods.

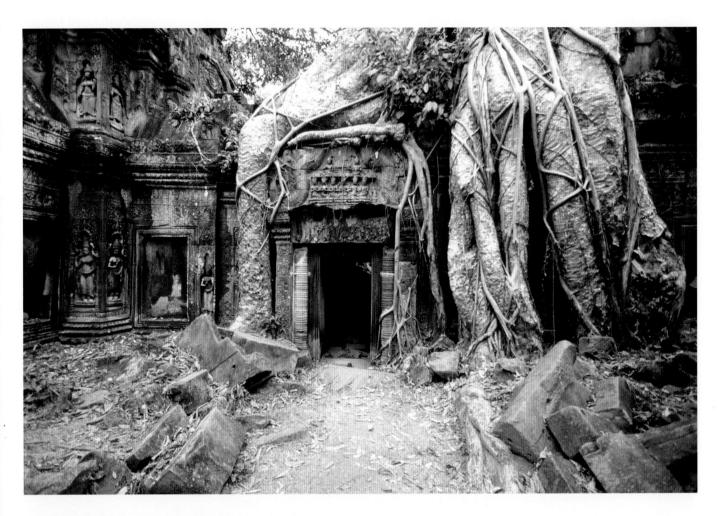

13.5 Temple of Ta Prohm, 12th century. Angkor, Cambodia. Photograph courtesy of www.sacredsites.com.

stretch roofs over larger interior spaces and protect structures from wind, snow loads, earthquakes, and the like, while at the same time creating impressive or spiritually awesome covered public spaces.

Where precipitation is infrequent, such as desert climates, buildings are often flat-roofed. In relatively warm but rainy climates, shallow domes or slightly pitched roofs are sufficient to shed rain. These were used in designing the Pantheon, an enormous second-century temple to the gods in Rome (13.6 and 2.46). The great circular **rotunda** is roofed by a hemispherical dome; the **portico** (column-supported porch) is cov-

13.6 Pantheon, Rome, c. A.D. 118-28.

13.7 (opposite) Barma and Posnik, St. Basil's Cathedral, Moscow, 1555–61.

ered by a slightly pitched roof from an earlier temple. When this kind of architecture was attempted farther north in Russia, it collapsed under the weight of snow. A snow-shedding solution devised in the twelfth century was the "onion" dome (actually intended to look like a candle flame), which was used in fantastic varieties in St. Basil's Cathedral in Moscow (13.7).

Where environments are hot, people have often designed structures that are dark and cool inside, such as the thick-walled structures of Suq al-Ainau in Yemen (13.8) made of packed-mud bricks. In such cases, dark

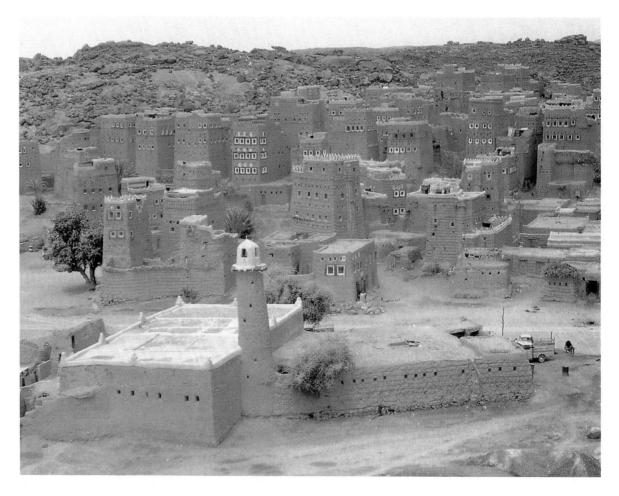

13.8 Suq al-Ainau, Barat region of the Yemen Arab Republic.

interiors are preferable to the heat. In temperate climates, structures may be more open to the outside air and light, as in the Wayfarers' Chapel by Frank Lloyd Wright (Jr.) in Palos Verdes, California (13.9). His illustrious father, the architect Frank Lloyd Wright, was highly enthusiastic about such uses of plate glass. In 1955, he wrote:

By means of glass, open reaches of the ground may enter into the building and the building interior may reach out and associate with these vistas of the ground. Perhaps more important than all beside, it is by way of glass that sunlit space as a reality becomes the most useful servant of the human spirit. Free living in air and sunlight aids cleanliness of form and idea.²

In cold climates, heating the interior for comfort creates new design considerations. Because heat rises rather than spreading out horizontally, buildings need to be more vertical, and their skins must keep cold out and heat in. With increasing concern about our impact on the environment, architects in cool climates are searching for better ways to capture the natural heat of the sun and prevent heat from leaking out of buildings. Ton Alberts's energy-efficient bank complex in Amsterdam (13.10) incorporates special design features such as solar energy panels on its ten towers, cutting energy use to only 25 percent of that normally used by buildings of the same size. The complex also features "flowforms," sculptures that channel and purify rainwater to water the plants in the building.

Architecture modulates people's movements as well as their climate, organizing their activities three-dimensionally. Ton Alberts's bank complex is designed with a curving interior walkway; in Moshe Safdie's Vancouver Library Square (see Figs. 1.32, 2.24), pedestrians' movements are channeled through ramps, staircases, catwalks, and through the open gallery between the central library block and the outer structure.

Sound as well as movement is modulated by build-

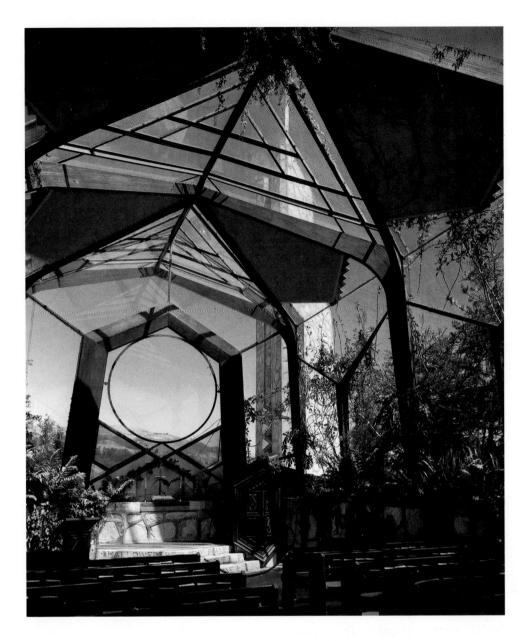

13.9 Frank Lloyd Wright (Jr.), Wayfarers' Chapel, Palos Verdes, California, 1951.

ing structures. **Acoustics**—the science of sound—becomes a major consideration in large open spaces. Sounds bounce off hard surfaces and reverberate within an enclosed space. To prevent this effect, soft materials may be used to help absorb sounds. In concert halls, acoustics are a major consideration in the design process. The Kirishima International Concert Hall in southern Japan (13.11) is shaped like a leaf, with an intimate relationship between the stage and the audience. Within this form, sound seems to expand. Triangular panels on the ceiling are designed to "smooth" the sound quality.

Architecture's functionality is not only physical but also psychological. Sacred structures, for example, create a devotional atmosphere based on the community's concept of the sacred. Christian cathedrals built in Europe during the Gothic period, such as the one at Chartres (13.12), attempted to elevate worshipers above the difficulties of mundane existence. Their height was designed to lift one's awareness to the heavens, considered the abode of a distant, awe-inspiring God. Much of the community's resources were channeled into these great building projects, creating structures that tower far above the surrounding houses.

For thousands of years, Hindu Indian architects and artisans have been guided by laws of architecture referred to as Vastushastra. They are said to have been divinely given by Vishkarma, architect of the cosmos, and recorded by ancient sages. If these laws are applied in building, they will reportedly promote truth, beauty,

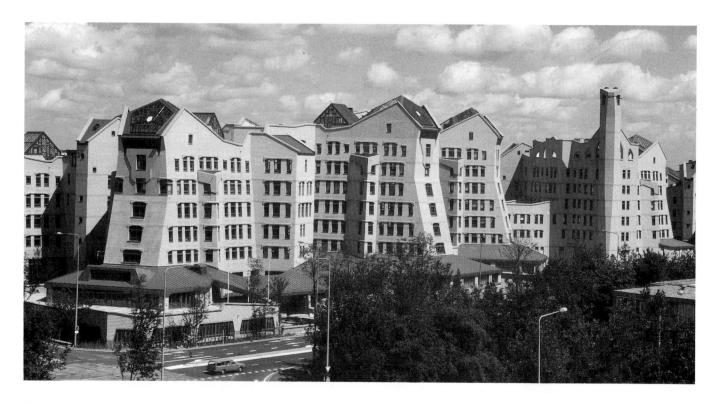

 ${\bf 13.10}.~{\rm A.}$ (Ton) Alberts and Van Huut Architects, ten-building bank complex, Amsterdam, Holland.

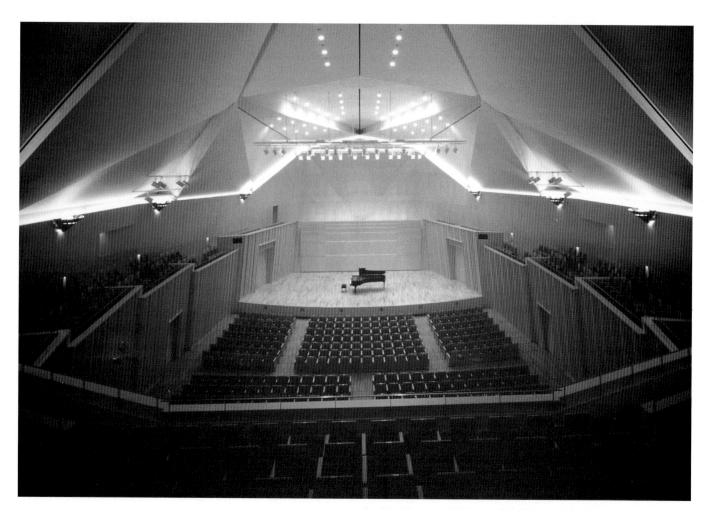

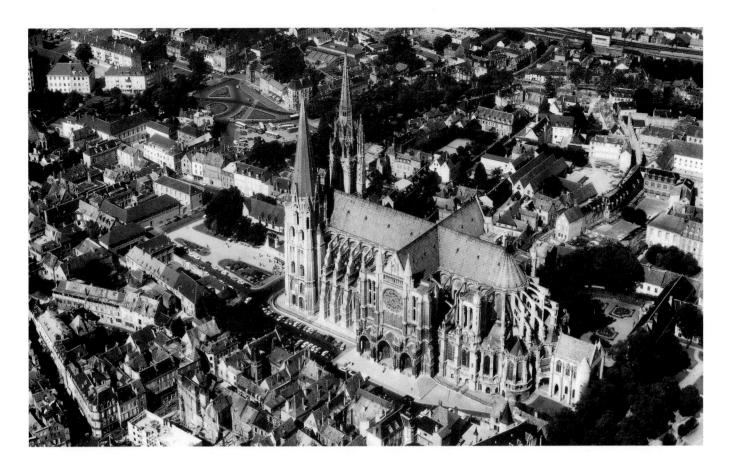

13.12 Chartres Cathedral, Chartres, France, constructed 1142–1220. The immense Chartres Cathedral is a great center of devotion to the Virgin Mary, for it enshrines what is thought to be the garment she was wearing when she gave birth to the infant Jesus.

harmony, peace, prosperity, and the health of the inhabitants. In Vastushastra, every detail—including geography of the land, placement of doors and drains, and the best time for building—is governed by cosmic relationships to planetary bodies, via compass directions (13.13). Some of India's great temples were built according to these guidelines. Plagued by mental and social problems prevalent in the world, some modern Indians are again attempting to build their homes according to Vastushastra as a way of restoring inner peace.

;	Southwest	South	Southeast	
	Wardrobe, tools	Bedrooms	Kitchen	
ines. Plagued by mental and in the world, some modern oting to build their homes as a way of restoring inner	Dining room	Courtyard	Bathroom	East
ement of doors and drains, ng—is governed by cosmic podies, via compass direc- 's great temples were built	Granary and cow shed	Treasury	Worship room	

Northwest

13.11 (opposite) Fumihiko Maki, architect, interior of Kirishima International Concert Hall, Aira, Kagoshima prefecture, Japan, 1994. *The leaf-shaped design has proved to be acoustically outstanding. It also unifies the stage with the rest of the auditorium, creating a bond between performers and their audience.*

13.13 Ideal relationships of rooms within a house based on compass directions, according to Vastushastra.

North

Northeast

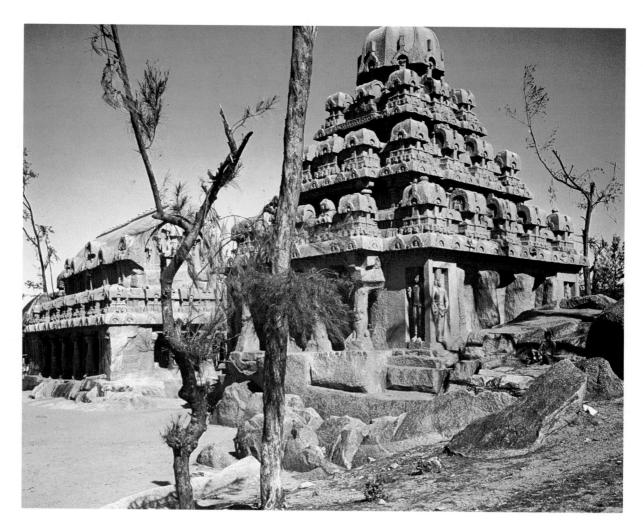

13.14 The Dharmaraja Rath and other rock-cut temples, Mahabalipuram, India, A.D. 625–74. *Near Madras, two huge natural mounds of granite and gneiss were carved into nine great shrines in the shape of temple chariots such as the one on the right in this photograph, plus three stone temples, four relief-carved panels, and fourteen cave temples. In a culture with stonecarving skill, devotion, and imagination, these mounds of living stone were fully utilized during the seventh century as a medium for sacred architecture.*

Structure

Architectural innovations have usually involved new materials or new ways of putting them together. Stone has been used since ancient times because of its great compressive strength—the ability to support pressure without breaking. In India, temples have been carved out of "living" rock as caves or as freestanding structures (13.14). The process is like subtractive sculpture—the boulder or mountain is treated as a giant block, and everything not needed is cut away. Metaphysically, their creation is thought to be a divinely inspired act that parallels the process by which material substance is created from ether. The resulting stonework is visually quite lively, expressing its infusion with the divine.

Stone and other materials with a certain compressive strength, such as bricks, have more often been

used for what is termed **bearing wall construction**. One stone or flat block is stacked atop another in such a way that the wall thus formed will not topple; a roof may be placed over the walls by laying logs across the top. Earth that has adequate clay content to hold it together has often been shaped into blocks and then built up in this way. Using this technology, the Yemen packed-mud houses (13.8) could rise many stories high.

Note that their walls slope inward, with each brick offset slightly from the one below it. This technique, which creates a strong, broader base and prevents tall walls from falling outward, was used to make the massive brick-walled **ziggurats** of ancient Mesopotamia (13.15). These were solid pyramidal structures with a series of receding terraces, the highest of which bore a temple. The thick walls of fired bricks were filled with the remains of smaller, older ziggurats and millions

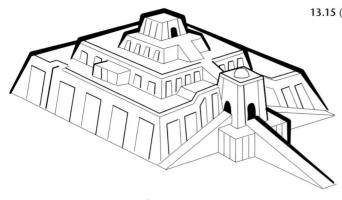

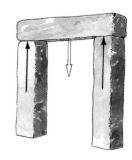

13.17 (below) Erechtheum, Athens, 421-405 B.C.

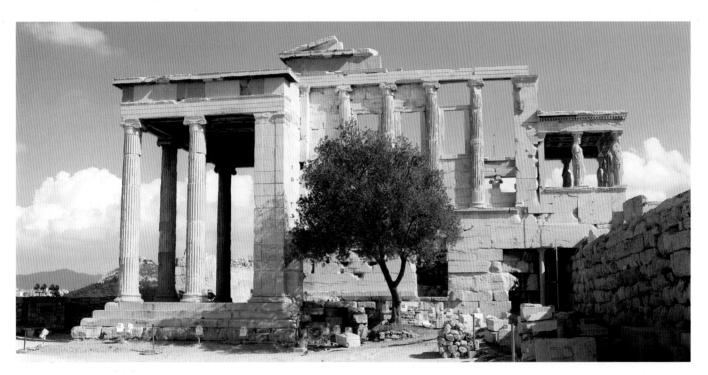

of sunbaked bricks. These massive structures were designed to lift the temple as high as possible up to the heavens, the realm of the god who would hopefully come down to live in the temple and help the people below. One such tower in what is now Iraq built by King Nebuchadnezzar over 2,500 years ago apparently rose 231 feet (70.4 m) into the sky.

Where wood is more plentiful than clayey soil, people have often flattened and notched the sides of logs and built them up as log cabins. Often some kind of mortar is used between the pieces of a bearing wall construction building to hold the pieces together and fill the cracks.

One of the limitations of bearing wall construction is that walls must be very solid, creating imposing separations between living spaces. A more open form of construction is allowed with **post and lintel** construction (13.16), which uses strong columns (posts) to support beams (lintels) across which the roofing materials are laid. The horizontal lintel helps

to stabilize the posts as well, and the space beneath can serve as an opening, whether door, window, or room. Stone buildings made by this system may be held together by gravity; wooden post and lintel arrangements require some means of notching or bolting the horizontal and vertical parts together.

The Classical Greek architects became so confident in their development of post and lintel construction that they could use graceful refinements solely for the sake of visual proportion, such as posts that tapered toward the top. Sometimes they even used columns carved as goddesses bearing the lintels on their heads, as in the Erechtheum in Athens (13.17). The structures originally designed for wooden temples (partly to keep water from seeping into pillars and foundation) were translated into stone as elaborate sequences of parts known as the "Greek orders" (13.18). These started with a solid masonry foundation that spreads out the weight of the structure and keeps the building from settling. Upon this sat the

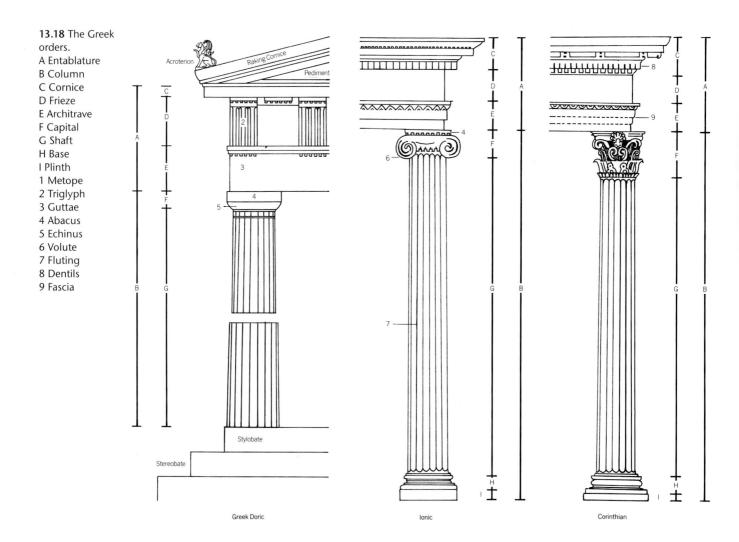

stylobate, or base. Atop this were columns, carved vertically with lines to conduct rainwater downward, and topped by a capital on which the lintel rested. Next came the entablature (the elaborated lintel), and atop that, the pediment, the slightly pitched triangular roof support at the end of the temple. The simplest style in the Greek orders was the Doric. It is thought that it was derived from the flat clay patty and tile that were used atop wooden columns to protect them from rain. More elaborate versions were the scrolled Ionic and the Corinthian, which had capitals carved to look like acanthus leaves pressed outward by the weight of the lintel.

A major development that appeared in Roman architecture was the **arch** (13.19). Crafted of stone by master stonemasons, arches were made of **voussoirs**. These are wedged-shaped stones cut to taper toward the inside of the curve. They are propped up with scaffolding until the **keystone** at the top is set in place. The counterpressure they then exert on each other supports the arch, and weight is transferred downward onto the posts. The Romans used the arch to construct

an elaborate system of aqueducts, much of which still stands (13.20). They also developed ways of combining arches to span broad interior spaces. These three-dimensional arches were widely used in Roman, Byzantine, Romanesque, and Gothic architecture (styles that are explored historically in Chapter 15). They transcended the low tensile strength of stone, which makes it difficult to span a broad area with a single stone beam without its breaking of its own weight; in post and lintel construction the beam must be supported at frequent intervals by posts.

The desire to open greater areas as public spaces without obstructive columns led to elaborations of arch technology. Tunnel-like barrel vaults were made of rows of round arches; groin vaults were made of intersecting barrel vaults. The lofty fourth-century Basilica of Maxentius was constructed with barrel vaults along the sides and groin vaults in the higher central hall (13.21). Pointed arches were those that intersected in a sharp angle. Gothic cathedral architects perfected systems of ribbed vaulting that carried most of the weight of an arch, allowing lighter

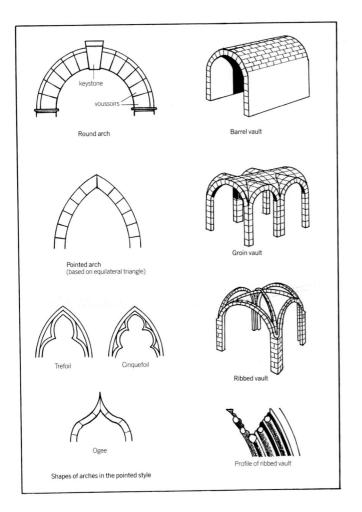

13.19 Arch and vault construction.

13.20 The Pont du Gard, Nîmes, France. Mid-first century A.D.

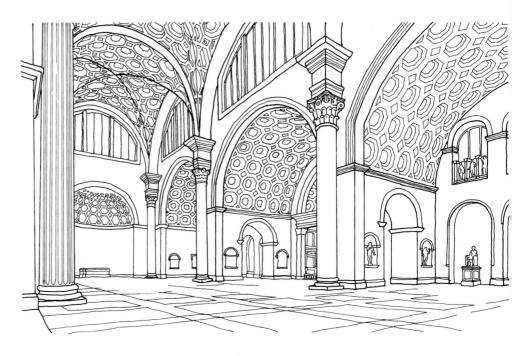

13.21 Reconstruction drawing of the Basilica of Maxentius, Rome. A.D. 307-312.

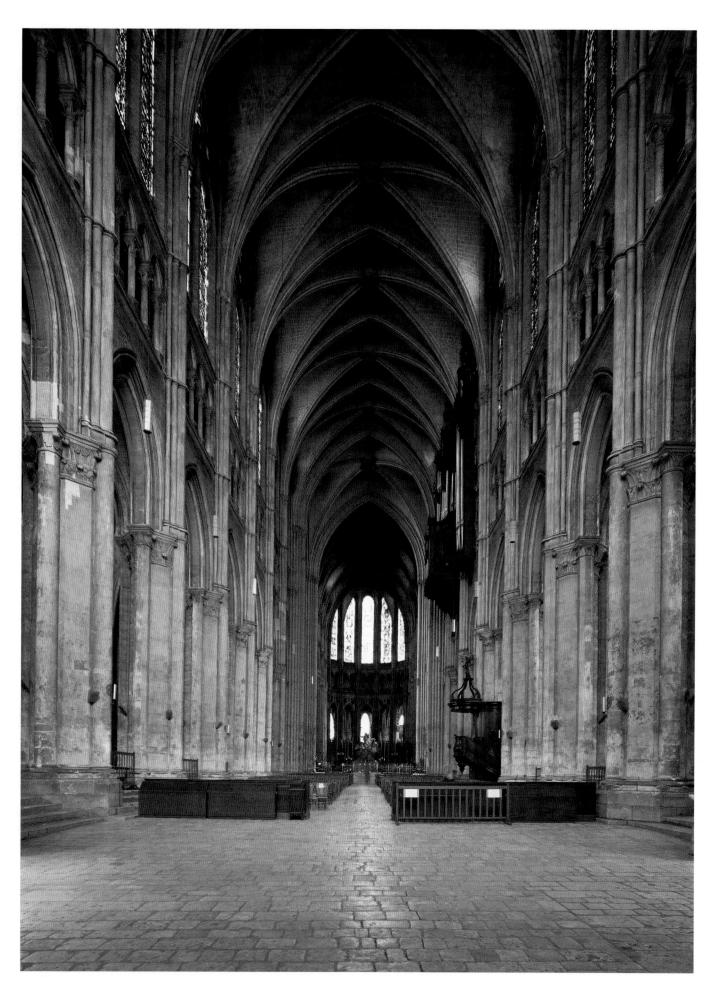

13.23 Flying buttresses.

materials to be used for the areas between. Seen from within, these cathedrals were symphonies of soaring arched lines and spaces, rhythmically repeated above and to either side of a long central hall, or **nave** (13.22).

Because arched vaults transferred pressure not just downward but also outward, the vertical structure had to be either very thick or else firmly braced to keep the sides from being pushed apart. To avoid overly massive walls, a Gothic solution was to engineer systems that gradually transferred lateral pressure to flying buttresses (13.23) external to the interior space.

When an arch is rotated through 360 degrees, the result is a dome. The immense and impressive dome of the Pantheon (2.46 and 13.6) was for its time a marvel of engineering and building skills, with coffers (sunken panels) used to diminish the weight of the massive concrete roof, and a great oculus—"the eye of heaven"—for natural illumination. Even today, we do not fully understand the structural principles that have allowed the second-century temple to remain intact to the present. But it is known that the concrete mixture the Romans invented hardened into a highly coherent rigid structure, that the width of the drum (the vertical walls) is equal to the height of the dome above, as indicated in Figure 13.24 (so we can suspect some kind of intricate mathematical balance), and that an impressive series of arches is embedded in the concrete walls of the drum to help support the dome and counteract any possible outward-spreading pressure of the dome. In Byzantine architecture, the lateral thrust of the dome was frequently transferred to a lower-ceilinged surrounding aisle, as seen in this cross-section of a Byzantine church (13.25).

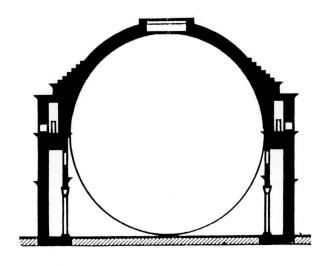

13.24 Section of the Pantheon, Rome.

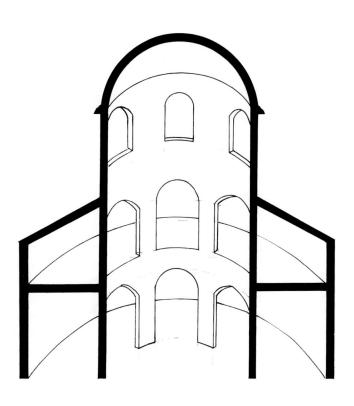

13.25 Cross-section of Byzantine church.

THE WORLD SEEN

Moorish Arches and Domes

IN MASONRY CONSTRUCTION, a basic problem faced by builders is how to create openings in the walls for doors and windows while ensuring that the roof is properly supported. The simplest solution—post and lintel—has evolved in many cultures. Over time, more elaborate means have been devised, including a great array of arches and domes. Of these, some of the most elaborate and fanciful were built in Moorish Spain.

Muslim North Africans of mixed Berber and Arab descent, the Moors also crossed over to what are now southern Spain and Portugal in the eighth century. There they ruled until the eleventh century, when Christian princes began to reconquer the area. The last holdouts of this advanced culture were Cordoba and Seville, reconquered in the thirteenth century, and Granada, in which a small Islamic state continued to flourish until 1492. In the meantime, the Moors had created some splendid architectural triumphs which had a continuing influence on Spanish architecture. Their most distinctive features are their elaborate pointed and horseshoe arches, as in the Great Mosque of Cordoba, where arches are built upon arches, and mugarnas, in which honeycombs of stucco-clad structures project into the open spaces that they support. Although they were initially conceived as interlocking structural supports for vaults, eventually they became more ornamental. These structures are mathematically brilliant, geometry manifested as architectural form, for indeed architecture was considered a part of the science of geometry as it developed in eighth-century Islam. Moorish architecture in general is also

thought to have taken inspiration from the Mediterranean architecture of the Roman Empire, yielding lovely hybrid forms that appeal to the mind and the spirit, as well as the senses.

The most beautiful expression of Moorish architecture is often said to be the Alhambra in Granada. This is a fortified series of pleasure palaces built by the Moorish kings from approximately 1230 to 1354 on a high point in the hills. Its staunch outer walls of glistening red masonry, from which the complex derived its name, enclose 35 acres (14.2 ha) of gardens, colonnaded courtyards, fountains, cool pavilions, and heated baths, with intricate ornamentation in marble, alabaster, carved and painted plaster, stained glass, and glazed tiles. The walled gardens, fed by ingenious irrigation channels, seem to have been an embodiment of the Muslim ideal of paradise, where the good are promised an eternal Garden of Delights.

In the Alhambra, the Hall of the Abencerrajes, shown in Figure 13.26, is part of the Palace of the Lions, a private retreat built by a fourteenth-century ruler. Its central courtyard,

whose geometry is based on the Golden Mean (see page 195), features a marble fountain with twelve lions, a garden probably once planted with fragrant bushes, flowers, and small fruit trees, and pavilions supported on 124 thin and graceful columns of marble, leading to two-story halls used for dining and cultural performances. The Hall of the Abencerrajes was probably a music room, for which its acoustics are excellent. Its star-shaped dome contains a beautiful example of mugarnas, in which clusters of supporting squinches are treated as lacy stalactites, covered with such fine stucco (wet-carved plaster) reliefs that they appear more ethereal than substantial. There is a horrifying bit of history here, for the room is thought to be the place where the ruler's children from a previous marriage were murdered when he took a new wife. The architecture lends itself to thoughts of a heaven beyond this world, and one might speculate that this site was chosen in the hope that these innocent children might be thenceforth transported there.

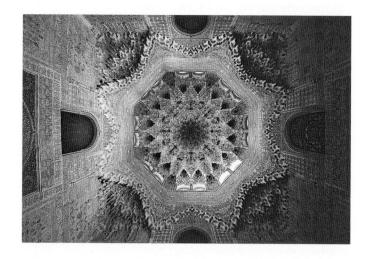

13.26 Muqarnas dome, Hall of the Abencerrajes, Palace of the Lions, Alhambra, Granada.

13.27 Truss.

Another approach is frame construction. In woodframed buildings, pieces of wood are attached at right angles to each other and braced at the top with triangular trusses (such as the one shown in 13.27). Initially, heavy weight-bearing timbers were used for posts and space-spanning floor and ceiling beams in such structures. But the development of massproduced nails and sturdy but relatively lightweight milled boards in 2×4 -inch (10-cm) widths allowed the invention, in the early nineteenth century, of balloon-frame construction (13.28). In such a frame, the thin vertical, horizontal, and diagonal roofing boards are closely spaced and nailed together. Stresses are borne by the multi-part frame as a whole rather than by individual posts and beams. The "skin" placed over the frame, such as windows and clapboards, plays no structural role. This system is still predominant in the building of individual houses in areas such as the United States, where wood is fairly plentiful.

In the nineteenth century, industrialization revolutionized architecture. It was found that iron had great tensile strength, with relatively little weight, and could be wrought or cast into columns, beams, trusses, and arches which could be quickly joined into huge skeletons with nothing but glass between the bones. This

13.28 Balloon-frame construction.

13.29 Steel-frame skyscraper.

technology permitted new uses for architecture, and there followed a spate of building great arcades for new kinds of public gatherings, such as trade expositions. The most celebrated of these early iron-skeleton buildings was Joseph Paxton's Crystal Palace (2.57). Built in London for the Great Exhibition of 1851, it was the world's largest building, covering an area of 770,000 square feet (71,535 sq m). All of its parts were prefabricated, in standardized repeating units. The entire thing was put up by 2,000 workers in three months, and then dismantled after the six-month exhibition. The bits were re-used to build a similar, even larger structure (which accidentally burned down in 1936). The "palace" was cleverly engineered not only for speed of construction but also for such functional considerations as shedding of water. The structural columns and beams doubled as a rainwater-conducting system; the structure was entirely watertight.

The metal skeleton method was developed into steel-frame skyscrapers (13.29). As in Singapore (13.30), the urban landscape of many cities was transformed during the twentieth century into clusters of these structures. With real estate extremely expensive in urban areas, the only economically feasible direction for expansion was upward. Vertical expansion became possible only through the development of steel and steel-reinforced concrete frameworks capable of supporting tremendous loads, and of elevators to lift people through the numerous floors. With these frameworks, walls became non-load-bearing curtains and could be made entirely of glass. Interiors also became broad-spanned open spaces within which partitioning could be arranged and moved about according to changing interior needs, rather than needing to support the upper structure.

The steel and concrete framework was mated with an austere approach to design which evolved in the 1920s in the Bauhaus—the so-called **International Modern Style**. Buildings were constructed along

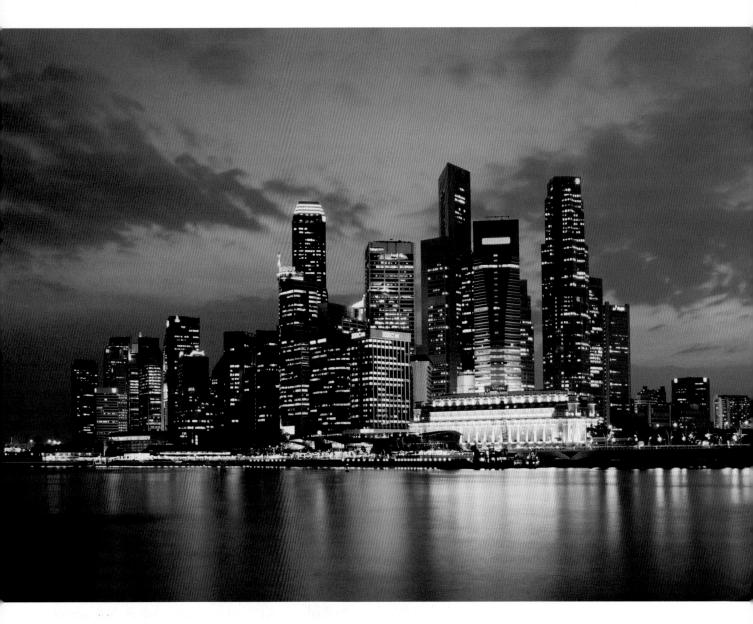

13.30 The Singapore skyline at sunset.

purely functional lines, with largely glass exterior walls, flat roofs, a lack of ornamentation except for horizontal bands defining floors, and symmetrical modular grids. The visual effect of these structures is that of space-filled volume rather than the solid mass associated with earlier architectural forms.

The style was hailed as fresh and honest architecture for the machine age. It was even thought the new approach to design would liberate humanity itself. The Swiss architect Le Corbusier wrote about the emancipating potential of a new tobacco factory:

The sheer façades of the building, bright glass and gray metal, rise up ... against the sky....

Everything is open to the outside. And this is of enormous significance to all those who are working, on all eight floors *inside*. The Van Nelle tobacco factory in Rotterdam, a creation of the modern age, has removed all the former connotations of despair from the word 'proletarian.'

Taking a different approach, a unique use of metal to frame a structure with non-bearing walls was developed by the pioneering genius of R. Buckminster Fuller. His brilliant investigations into natural structures led him to develop buildings on entirely different principles from any seen before. He explained:

13.31 Geodesic dome.

I often hear it said that architects build buildings out of materials. I point out to architectural students that they do not do that at all. ... What they do is to organize the assemblage of visible modular structures out of subvisible modular structures. Nature itself, at the chemical level, does the prime structuring. If the patterning attempted by the architect is not inherently associative within the local regenerative dynamics of chemical structure, his buildings will collapse.⁴

Derived from natural structures, Fuller's **geodesic dome** is a very lightweight but sturdy metal framework in which the bracing strength of triangles is organized into a dome that needs no other support (13.31). Any flat sheet material such as wood, metal, plastic, or glass can be cut into triangles and attached to the frame as a weatherproof skin. Though minimal, capable of being quickly erected, and enclosing the greatest volume with the least surface, geodesic domes have proved to be the strongest structures ever developed. No properly built geodesic dome has been damaged by either hurricanes or earthquakes, which pose considerable threats to many other types of structures.

Reinforced concrete—concrete that is internally strengthened with metal rods or mesh—has been widely used in modern architecture. In a post-and-lintel arrangement, reinforced concrete beams can be cantilevered (13.32)—projected beyond supporting

13.32 Cantilever of steel-reinforced concrete.

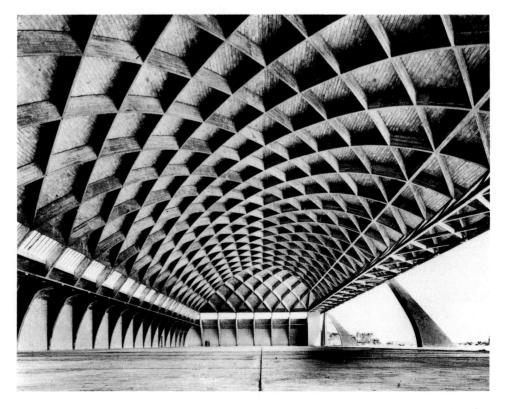

13.33 Pierre Luigi Nervi, aircraft hangar at Orbello, Italy, 1939–40.

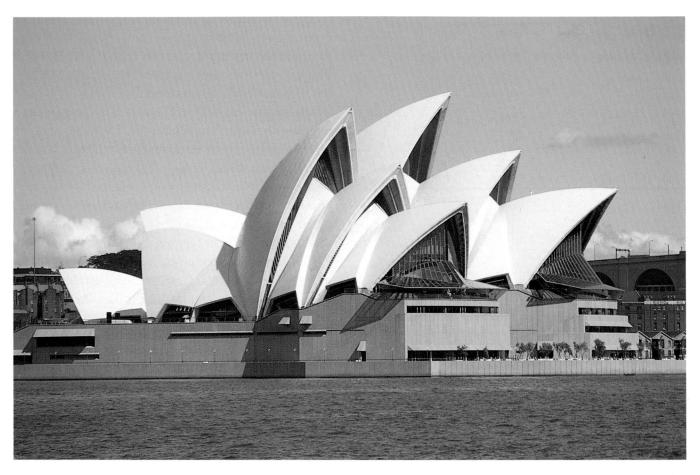

13.34 Jorn Utzon, Sydney Opera House, Australia, 1956–73.

13.35 (above) Drawing of suspended structure.

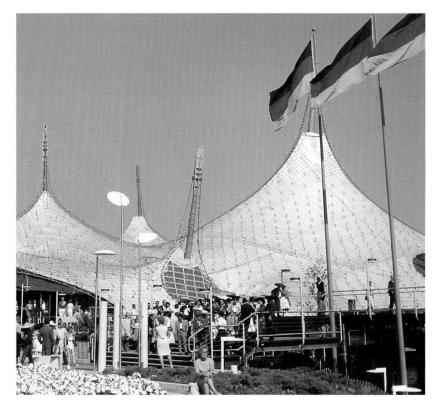

13.36 Frei Otto, German Pavilion, Expo '67, Montreal, 1967.

posts—if anchored into those posts. Frank Lloyd Wright's Fallingwater (3.46) cantilevers large terraces out over the falls. In addition to flat slabs, reinforced concrete can also be used to create articulated freeform structures unlike any that have been seen before. Italian post-war architectural engineer Pierre Luigi Nervi demonstrated that precast, reinforced concrete sections could be used in ways that were beautiful as well as functional. He applied this aesthetic sensitivity even to aircraft hangars (13.33). The famous Sydney Opera House (13.34), designed by Danish architect Jorn Utzon, features roof forms resembling ships' sails which cover a complex of separate concert halls and restaurants beneath.

Whereas such structures have to support tremendous compressive (downward-pressing) loads without buckling, the German architect Frei Otto envisioned extremely light structures (13.35) where the primary stress would be tensile (pulling). Cables are strung under tension among a few anchored masts to support lightweight curving fabric membranes, as in the German Pavilion in Montreal for Expo '67 (13.36). Such structures can be easily altered or moved, as needs change; they lack the monumentality and permanence long assumed necessary in public buildings.

There have also been attempts to use modern factory production-line technologies to pre-package structures and thus cut down on their cost. A common approach is modular construction. Using standard dimensions with electrical and plumbing connections sandwiched into the walls, buildings can be quickly assembled on site from factory-made components. In an extreme example of this technology, Kisho Kurokawa created the Nakagin Capsule Building in Tokyo (13.37) from a series of stackable prefabricated rooms, each a complete dwelling. Each capsule is only 8×12 feet (2.43 \times 3.65 m), but includes a bathroom, double bed, desk with typewriter, chair, tape deck, clock radio, storage space, kitchen, and a heating, ventilation, and air conditioning unit. The capsules form a "community" connected to a central water, oxygen, and power supply.

Now that many building technologies are available to support architects' visions, there has been a backlash against strictly functional industrial construction and against the repetitive use of look-alike glass boxes. In what is called **post-modern** architecture, buildings tend to be more expressive and individual, and, some say, less elitist. There is no one look that defines them all. Some are sensual and decorative, some refer back to historical styles, some are lively and playful.

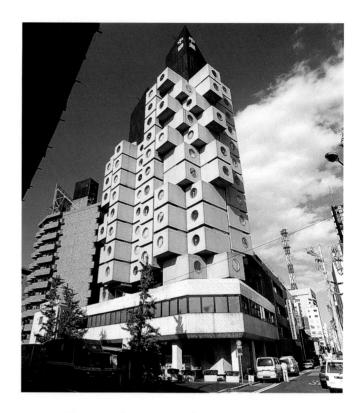

13.37 Kisho Kurokawa, Nakagin Capsule Building, Tokyo, 1972.

The Australian architectural firm McBride Charles Ryan has designed a home for an extended family that looks like a solid spherical interlocking puzzle, partially buried and partially opened. Narveno Court (13.38) carries out the firm's stated philosophy of "challenging the physical perceptions of surface and depth by juxtaposing what is hidden and what is revealed," and of "generating new architectural form through cutting, fragmenting and eroding 'pure architecture." ¹⁵

A revolutionary break with the past is evolving in which architecture has been totally liberated from the rectangle. In some cases, referred to as **Deconstructionist** architecture, there are explosive arrangements of colliding asymmetrical forms. As this anarchical style arose at the end of the twentieth century, those who did not like it saw it as a symptom of social chaos. Daniel Libeskind's design for an addition to the otherwise more classical Victoria and Albert Museum in London—a fractured series of irregular flat-sided structures which are daringly stacked atop each other in a free-standing spiral (13.39)—drew fierce criticism when the plan was revealed. The former editor of *The Times* of London referred to it as "a disaster for the Victoria and Albert Museum in particular and for

civilization in general. What is deconstructionism? It is the tearing down of the old [Enlightenment] culture of scholarship, truth, beauty, reason and order." But the museum officials had a different interpretation. They felt that the unconventional design would draw people from all over the world and challenge them to look at contemporary art forms with a more open mind; they also presumed that it would spark healthy aesthetic debates. They wrote enthusiastically that the addition would provide

a radical design ... a spectacular sculptural presence in the urban landscape. The walls of the Spiral overlap and interlock in a strong, robust manner that gives the structure its stability. The internal floors which span between these walls

are flat and column-free, and lend the interior spaces a serene, uncluttered quality. ... The inside of the Spiral will provide dramatic and unusual spaces which will challenge preconceptions about the designed environment.⁷

The language used to describe the Libeskind design is typical of that used in appreciation of the new directions in architecture: "radical," "robust," "unusual," "challenging." Revolutionary free-form designs are in demand around the world, given the popularity of Frank Gehry's Guggenheim Museum in Bilbao (1.51).

13.38 McBride Charles Ryan architecture firm, Narveno Court, Hawthorn, Melbourne, 2005. Radius of dome 44 ft 3 ins (13.5m).

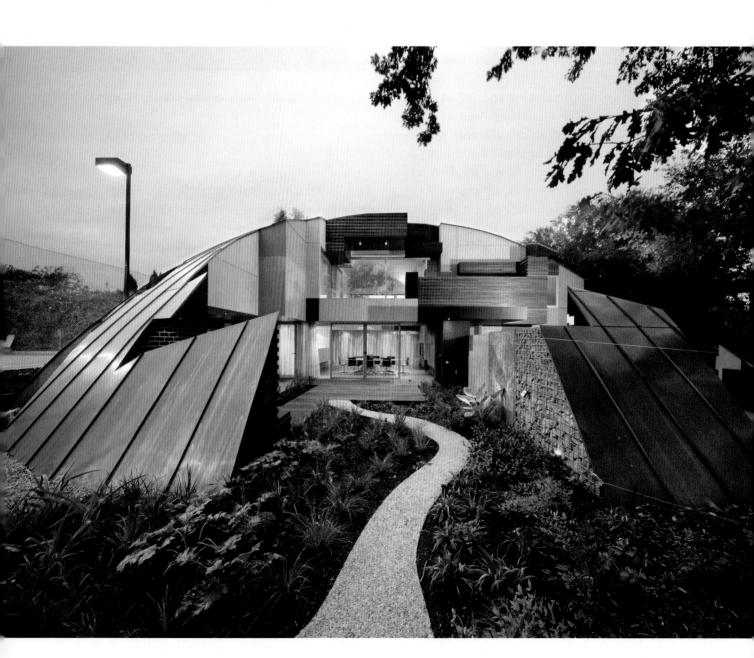

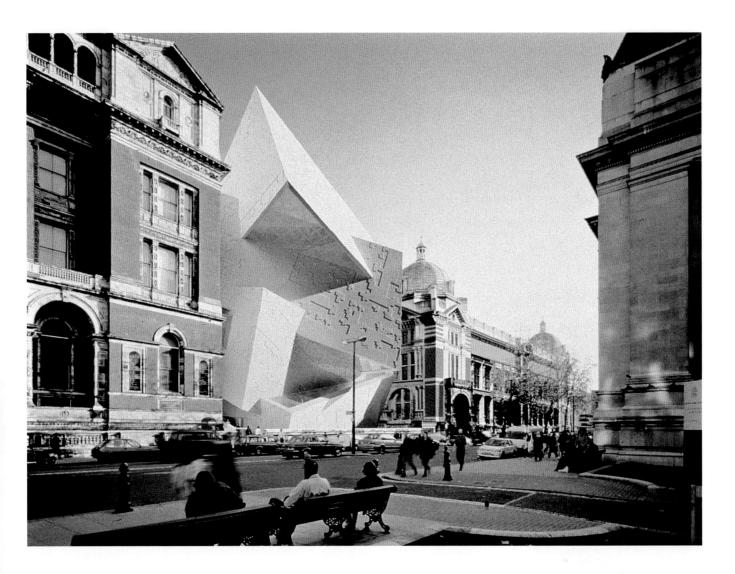

13.39 Gregg Baker and Jay Colton, photo-illustration for *Time Magazine* of computer model of Daniel Libeskind's design for an addition to the Victoria and Albert Museum, London, now unlikely to be built.

Deconstruction, an intentionally disruptive and philosophical movement, is a stunning departure from the tradition of architecture as unified, coherent assembly of materials to provide shelter.

With computer-aided design, almost any structure that the architect can conceive can theoretically be engineered, and many cities are eagerly seeking their own distinctive works of revolutionary architecture.

One of the most prominent features of contemporary life, at least for those with discretionary income, is shopping. High-end retailers now face competition from catalog and Internet shopping channels; in many parts of the world, consumerist passions can be indulged easily from one's own home. Thus designers are being called on to offer new ways in which consumers can be attracted into shopping spaces. One of the most prominent strategies is to combine shopping with entertainment and excitement. In contemporary shopping malls, the interior weather is modulated for perennial comfort; greenery and water features bring

the outside inside; and restaurants, playspaces, and even hotels are combined with stores so that people can happily spend hours and even days in a shopping mood. Entertainment places for children increase the possibility that they will prevail upon their parents to take them to the mall. The mega-malls become like mini-cities in their own right.

The Bluewater Shopping Complex in Kent, England, has 320 stores and a dizzying variety of extra attractions designed to lure consumers (13.40). Within a former cement quarry strategically located near the Dartford tunnel, architect Eric Kuhne has created an immense complex dedicated to what he calls "worshipping a way of life." Within and surrounding its sleek metal and glass forms there are 50 acres (20 ha) of gardens including a rain forest and a sensory garden, 23 acres (9.3 ha) of lakes, three miles (4.8 km) of

13.40 Eric Kuhne, Bluewater Shopping Complex, Kent, 1997.

mountain bike trails, sculptures, a freeform climbing tower, a nursery for children, forty restaurants, and endless interesting details, such as a limestone map of the River Thames running along one of the malls comprising the complex. With a populace that has learned

to tolerate and even expect intense sensory stimulation, it is highly likely that this recreational approach will be a continuing influence in the architecture of the twenty-first century, not only for consumerist paradises but also for other public spaces.

Designed Settings

14.1 Jesus' Place at Gobind Sadan, Gadaipur, New Delhi, India. Photo Mary Pat Fisher.

KEY CONCEPTS

Organizing interiors

Shaping the outdoor environment

Planning livable and aesthetically pleasing cities

Creating artificial settings for the performing arts

Costume and illusion

The artist as performer

HOW CAN A particular atmosphere be developed visually in a space? In 1984, Jesus appeared in vision to His Holiness Baba Virsa Singh at Gobind Sadan, a farmbased devotional community outside Delhi, standing in a most unlovely place: the thorny, manure-strewn wasteland behind the dairy. Baba Virsa Singh had a large rock placed on the spot and told volunteers to go there daily to light oil lamps in Jesus' honor. People lovingly cleared the area and surrounded it with stones, marking it off as a holy place. Masons were brought in to build a raised stone platform with a lifesized statue of Jesus (14.1). Boulders were carried down from the hillside by a crane, and a large and lovely garden was developed around the platform, complete with a fountain made from an old watering tank.

People of all religions began visiting the garden to bow before Jesus, imbibe the spiritual atmosphere of "Jesus' Place," rest under the trees, and play on the grass. Sikhs, Hindus, Muslims, and Christians now gather there nightly to light candles and pray together, feeling uplifted and blessed by the special ambience they experience in that setting.

Similarly, from our homes, public plazas, and business places to our theatrical and sacred spaces, we humans have long tried to create particular atmospheres to enhance our endeavors and our emotional states.

This chapter will examine aesthetic and functional aspects of interior and environmental design, and conclude with a look at overtly staged settings for the performing arts.

Interior Design

Once a building is erected, there is the issue of selecting and organizing its contents—furniture, fabrics, art objects, functional objects, and personal possessions. In some cases, functionality of furnishings is the prime consideration. The old Reading Room (now restored) of the British Museum, London (14.2), is a businesslike

14.3 (opposite) Greg Natale Interior Design, one-bedroom Gonano apartment with Broadhurst "Steps" print on wallpaper and bedding, Broadhurst print framed upside down, bed by Cappellini, lights by Luceplan.

arrangement of lighted reading tables fanning out like spokes from the central hub—shelves of reference volumes and an information desk. Chairs are upright, with no arms. All space is dedicated to task-solving equipment, with aisles left for convenient traffic flow. This is obviously not a place designed for comfort or conversation, but it efficiently carries out the function of providing reading spaces for a great number of people, with the elegance of a truly functional design.

In our homes we tend to try to surround ourselves with things we consider beautiful or interesting. The exotic life of Australia's Florence Broadhurst (1899–1977) is reflected in her luxurious patterns, which have been adapted for both wallpaper and bedding in the designer apartment shown in Figure 14.3. Greg Natale Interior Design Studio framed her original print and

14.2 The Reading Room, British Museum, London, 1826-47.

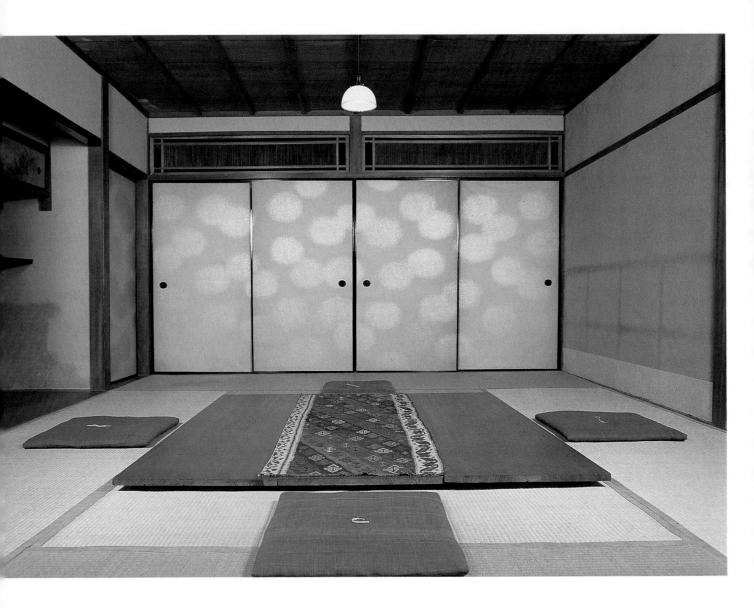

14.4 Zashiki or main parlor of a merchant's house, Kyoto, Japan.

turned it upside-down as a strong counterpoint to hang on the wall. The result is an intensely stimulating environment.

At the other extreme are interior spaces designed for peaceful existence, as in traditional Japanese homes. The main parlor in a Kyoto merchant's home (14.4), lovingly restored along traditional lines by the son, is almost entirely bare of furnishings. The simple cushions and table are low to the floor, covered with a *tatami* (mat), and all other possessions are stored out of sight. The only exception is a single painting within a *tokonoma* alcove to the left. This spare aesthetic turns a relatively small space into a quietly spacious sanctuary, a haven from the busyness and crowds of the streets. In the absence of visual noise, inhabitants can develop a heightened awareness of, and appreciation for, the exquisite experiences of the moment. Instead of being

submerged in a symphony, in this space one listens keenly to single notes—the scent of a flower, the texture of a cup, the sound of a voice. Kojiro Yoshida, the son, named his family's treasured home Mumeisha: "the hall for casting light on the unnamable things of the present."

Interior design necessarily involves a relationship with the architecture of the place. Architect James Stewart Polshek's Rose Center for Earth and Space in New York is a "floating" aluminum sphere within a ten-story glass case, and within that sphere, all interiors have a streamlined futuristic styling which continues the spherical motif with curving walkways through educational models of the cosmos, from atoms to planets, suns, and galaxies (14.5).

Frank Lloyd Wright often designed the interior furnishings as well as the architectural structure of

14.5 James Stewart Polshek, architect, The Space Carrier at the Rose Center for Earth and Space, New York, 2000. Photo American Museum of Natural History.

The huge central sphere in the Rose Center is designed to give an impression of the vastness and tremendous age of the universe, while illustrating its presumed 13-billion-year history.

houses. Typically, he attempted to relate the inside and the outside as a single whole, characterized by use of natural materials. His "Solar Hemicycle" house built in Wisconsin (14.6) curves to embrace the sun, drawing it into a cavelike interior in which wood and stone are featured as organic surfaces which match the stone and wood used on the outside. A circular pool at the far end of the patio lies half inside, half outside the glass wall of the house. The simple wooden furniture was also designed by Wright specifically for the house. He insisted:

Furnishings should be consistent in design and construction, and used with style as an extension in the sense of the building which they "furnish." Wherever possible all should be natural. The sure reward for maintaining these simple features of architectural integrity is great serenity.¹

Environmental Design

Beyond our homes and public buildings, we humans have also longed to shape our immediate outdoor environment. Traces of gardens have been found in the ruins of the earliest civilizations. In arid countries, water and lush plantings have been especially prized. On the Indian plains, for example, few wildflowers can survive the fierce sun, but cultivated gardens were mentioned in early Buddhist and Hindu texts. During the great Mughal period of the sixteenth and seventeenth centuries, the emperors had magnificent formal gardens built around their mountain retreats in Kashmir. One of the most beautiful, Nishat Bagh (14.7), was built by Asaf Khan, Prime Minister to the emperor Jahangir and brother of his wife. When the emperor saw its lovely green terraces, the sparkling play of water over its stone water ladders, and its views of the lakes and mountains beyond, he strongly

14.6 Frank Lloyd Wright, Herbert Jacobs, "Solar Hemicycle" house, Middleton, Wisconsin, 1944. Living room. Photograph Ezra Stoller, Esto. 1950.

recommended that Asaf Khan give it to him. Asaf Khan demurred, and the emperor in anger cut off the irrigation supply, without which the garden was deprived of much of its soul-soothing beauty. The water was eventually restored, and the garden again became a serenely refreshing oasis.

Every natural environment has its own underlying structure and harmony, both aesthetic and functional. Development has often obliterated these natural environments and resulted in unplanned, disharmonious concentrations of buildings. As urban centers become intolerable, the wealthy abandon them to live on their fringes, somewhat closer to nature. Then, as suburban developments proliferate, the inner cities often decay, both architecturally and socially. However, the urban concentration of living spaces is a reasonable strategy

for distribution of human beings across the earth. Cities allow preservation of tracts of undeveloped land and also energy-efficient systems of transportation. Urban planning is thus being revived to help create cities in which people like to live.

Cities that are most appealing have livable patterns and aesthetically pleasing relationships among buildings, open spaces, promenades, roads, shops, sacred places, gardens, bodies of water, and so forth. Subtle

14.7 Nishat Bagh, India, seventeenth century. View from the pavilion along the main axis of the garden.

Those with means to do so have long retreated to the higher elevations for relief from the heat of Indian summers. Nishat Bagh is one of the most celebrated of the formal gardens developed for this purpose in mountainous Kashmir.

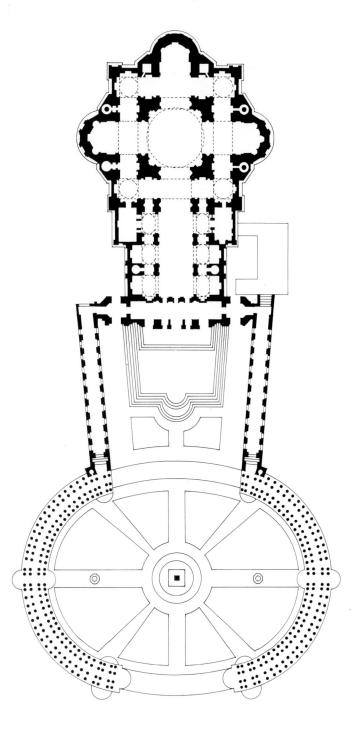

14.8 Gian Lorenzo Bernini, plan of the Piazza of St. Peter's, Rome, begun 1656.

human preferences are at work, such as the desire to be able to discover the entrance to a building, to see water, to find shade in a hot climate or sun in a cold climate, or to congregate with other people.

Urban planning is not a new science. Rather, it seems to have been practiced quite effectively in some times and places to create vibrant environments for the multiplicities of human activities. From ancient times, one feature of well-planned cities has been the

provision for public gathering spaces. Within cities crowded with busy people on the move, plazas and public squares offer a different pace.

In seventeenth-century Rome, a need was felt for a great open public space to accommodate crowds approaching St. Peter's, the monumental central structure of the Roman Catholic Church. The desired piazza (14.8) was designed by Gian Lorenzo Bernini, who in addition to being a great painter and sculptor (1.34) was also an architect. He planned a huge oval area open at one end and embraced by enormous Tuscan columns lined up to form two giant colonnades, like the arms of the Church welcoming the people. The project was so expensive that it almost bankrupted the Vatican.

Municipalities have also made provisions for their occupants to benefit from natural settings without having to leave the city, by creating city parks. Some are extensive green belts whose trees take in carbon dioxide and give off oxygen, serving as "lungs" for the

14.9 Hideo Sasaki, Greenacre Park, New York, 1979.

14.10 Richard Haas, Trompe-l'oeil mural on Brotherhood Building, Kroger Company, Cincinnati, 1983. Photographed in 1995.

city; some are tiny areas with plantings and benches. In the heart of mid-town Manhattan, the Greenacre Foundation used the space between two buildings for a "vest-pocket" park featuring an artificial waterfall, tables and chairs, and trees to provide shade (14.9). To step off the street into the ambience of this place is a psychological and aesthetic respite from the high-pressure atmosphere of commercial New York. The sound of the waterfall drowns out street noises and its cooling spray adds to the soothing quality of the park.

Another unusual approach to enhancing the interest or beauty of cityscapes has been taken by artist Richard Haas. He has created *trompe l'oeil* murals on buildings such as the Brotherhood Building in Cincinnati (14.10). Using methods of creating the visual illusion of deep space, he has turned the flat face of an existing building into what appears to be a grand Roman temple inset within the building, with an oculus and dome like the Pantheon, Corinthian columns, elaborate staircases, and the like. The only

actual deviations from the flat façade are the cornices at the top; the rest of the grand three-dimensional architecture is entirely illusionary. Neither is an area recessed at the top, nor does the staircase project forward at the bottom. Haas comments that his use of *trompe l'oeil* "was never merely an end in itself, but a means to grab the viewer's attention. It was my hope that, once thus engaged, the viewer might seek other layers of meaning and be able to read the larger story told by the artwork." If we look closer at Haas's façade, we see that there is what appears to be a huge torch enshrined in the "temple," with its smoke rising up and apparently out into the sky through the false oculus. We are then left to wonder what it means, in the context of a building named for Brotherhood.

In trying to deduce some general aesthetic principles common to all those cities around the world that are invigorating or pleasant rather than disagreeable, Lawrence Halprin came to the conclusion that good city planning—or happenstance—respects both the

THE WORLD SEEN

Japanese Stone Gardens

SINCE ANCIENT TIMES in the Shinto religious tradition, the Japanese people had revered unusual rocks as the dwelling places of the *kami* or spirits. This spiritual sensitivity to the natural environment became allied to the art of gardening under the influence of Chinese culture and the adoption of Buddhism, which was brought to Japan from China through Korea in the sixth century A.D.

During the Heian Period (794–1185), the Japanese capital was moved to Kyoto, where the aristocracy enjoyed a long period of peace and leisure. As their attention turned to the arts and philosophy, the design of gardens as exemplars of paradise and aids in contemplation flourished, with Buddhist monks engaged as the garden designers. At the end of this period, the principles of garden design were set forth by a court noble in a manual entitled the *Sakuteiki*, or "way of gardening."

Amidst detailed prescriptions for constructing ponds and paths, and the symbolic meanings of certain rock groupings, the four basic principles were that a) a garden should be created in the likeness of nature (such as the patterns of natural mountains and water); b) the garden's design should be sympathetic to the "request" of the landscape; c) asymmetrical balances should be set up; and d) the atmosphere of the surroundings should be taken into account.

During the ensuing Kamakura Period (twelfth to fourteenth century), the Samurai warrior class embraced the Zen version of Buddhism, with its austerity and simplicity, and sponsored the designing of gardens specifically for contemplative purposes. By the Muromachi Period (1335-1573), Zen monks were designing small temple gardens of such abstract refinement that some contained no plants at all. Instead, they featured stones, gravel, and water—or perhaps even the suggestion of water by means of striated stones and gravel raked into patterns representing the movement of water among the rocks.

Often these dry stone gardens were created only to be viewed from a particular point, rather than to be walked through. The dry-landscape garden shown in Figure 14.11 was designed to be seen from the quarters of the temple's abbot. Within a space only ten feet (3 m) deep, the garden creates a highly naturalistic illusion of water cascading from mountain heights, slowing and widening across a riverbed flowing from left to right, and thence disappearing toward the sea. As is typical of these dry-landscape gardens, the stones were probably chosen and transported from a great distance for their craggy, ancient appearance. Relationships between the rocks, and from one rock group to another, and from the rocky "streambed" to the surrounding trees, are worked out so perfectly that one has a very realistic feeling of the concentrated energy of the stone masses and the dynamic movement of the water. So subtle is the effect that one barely notices that there is no actual water in the landscape.

As the mind is steadied and focused on these primordial forms and forces, it naturally turns from worldly thinking toward a peaceful state in which realization of eternal reality arises spontaneously. As the Zen monk D. T. Suzuki explains, "The object of Zen discipline consists in acquiring a new viewpoint for looking into the essence of things."

14.11 Detail of dry-landscape garden, abbot's quarters, Daisen-in, Daitoku-ji, Kyoto, Japan, built from 1513.

14.12 Lawrence Halprin, environmental specifications for Sea Ranch, 1963. Notebook sketch.

old and the new and provides a creative, vibrant environment for the multiplicities of human activities:

The provocative city results from many different kinds of interrelated activities where people have an opportunity to participate in elegant, carefully designed art and spontaneous, non-designed elements juxtaposed into what might be called a folk idiom, a series of unplanned relationships ... those chance occurrences and happenings which are so vital to be aware of—the strange and beautiful which no fixed, preconceived order can produce. A city is a complex series of events.⁴

On a broader scale, many people now feel a need to protect the beauty and environmental functions of the

natural environment. Lawrence Halprin's sketch for Sea Ranch (14.12), a planned community on the Californian coast, set up a series of restrictions that kept houses and roads hidden from view. In landscape design, he specified use of native materials, forbidding attempts to create artificial grassy lawns, in the interests of preserving water and the original character of the dramatic setting. These are moral judgments about how our control of the environment affects the quality of our lives, as well as the ecological characteristics of the land.

In both urban and rural environments, there are now efforts to mitigate the aesthetic and environmental damage done by human habitation. Many artists are involved in projects such as sewage treatment and landscaping of garbage landfills, to make them both ecologically and visually successful.

14.13 Patricia Johanson, *Pteris Multifida*, Fair Park Lagoon, Dallas, Texas. Photo courtesy of the artist.

To create such a major shift from a stagnant lagoon to a biologically alive and sculptural landscape required considerable vision, creativity, and determination.

Patricia Johanson "biologically restored" a formerly stagnant lagoon in Dallas (14.13) by reintroducing indigenous species of plants, turtles, and fish, and creating bridges and walkways with large plantlike sculptures. Not only do children like her Fair Park; birds are also returning to it. She asserts:

The reason we [artists] have to participate is that we can do something that's very visual, very poetic; we have the power to sway people to our point of view.⁵

Aesthetics in the Performing Arts

While environmental designers use plants, water, earth, stone, paving materials, and screening devices to create pleasant settings for our daily lives, designers connected with the performing arts create artificial settings for make-believe. In the ancient Greek theater, actors initially performed from a flat space at the foot of a hill, with the audience seated on the hillside. There was no scenery. This simple way of separating the imaginary space of the performance from the real space of the audience was later formalized with tiered seating rising up a hillside in a semicircle around a wooden platform (14.14). Actors entered and exited from a small building called a skene, from which we get the words "scene" and proscenium (in front of the skene).

14.14 Reconstruction drawing of the Hellenistic theater at Ephesus, Turkey, c. 280 $_{\rm B.C.}$, rebuilt c. 150 $_{\rm B.C.}$

To enhance the illusionary setting for theatrical performances, the area designated as a stage became more elaborate, with fabricated scenery designed to give the illusion of deep space. The chief way of creating this spatial illusion was the use of **forced perspective**, an exaggeration of the speed at which parallel lines converge toward a vanishing point. Shortly after perspective drawings were adopted by Renaissance artists, the device was transferred to the stage. At the Teatro Olimpico in Vicenza, designed by Andrea Palladio,

completed by his pupil Vincenzo Scamozzi in 1585, and still standing, three elaborate arches opened onto illusionary city streets with their floors raked upward and rows of models of wooden houses built in forced perspective. All of this elaborate scenery, shown in a frontal view in Figure 14.15 and in the plan in Figure 14.16, was intended to give the illusion of streets intersecting in a public square. Actors were confined to the space in front of the scenery; if they were to move up the streets, the falseness of their scale would become apparent.

14.15 Andrea Palladio and Vincenzo Scamozzi, interior of the Teatro Olimpico, Vicenza, Italy, 1580–85.

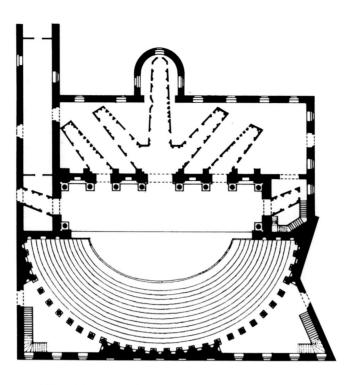

14.16 Plan of the Teatro Olimpico, Vicenza.

Shortly after Scamozzi finished the Teatro Olimpico, he invented the form most familiar to us today, in which the entire stage is framed by a single **proscenium arch**. This arch is used to hide all the mechanics of the stage setting, such as the tops of painted sets, light banks, and pulleys that allow actors to "fly." Within the recessed space of the stage, slides may be cast onto rear projection screens to accompany the play, opera, or dance, and these may be timed by computer to coincide with changes in the lighting as the mood and events of the performance shift.

Another major illusionary device used in performing arts is costuming. Even when there is no stage, when performers and audience share the same space, performers may assume roles by wearing masks and costumes that hide their everyday identity. The Papuan costume shown in Figure 14.17 transforms ordinary people into spirits attending boys' initiation ceremonies.

Similarly, in some traditional African cultures, layers of cloth and wooden masks are used to transform the wearer into a representation of a deceased ancestor, god, or goddess. The spirits are thought to be close to the living, but invisible, and to have an active interest in intervening in earthly affairs. Their presence-made-visible is a powerful influence on the behaviors of the living. In the Yoruba language, the

word *iron*, which means "theatrical performance," also means "vision." It signifies levels of reality that humans cannot usually see but which they can envision with the mind's eye, inspired by stories and masquerades. When the masqueraders dance, the layers upon layers of cloth whirl about like patterns of energy, dissolving the impression of solidity and physical boundaries.

In some performing arts, the bodies of performers are deliberately turned into design elements—elongated lines, opposing or harmonizing forms—like parts of a painting or sculpture that changes through time. This is true in classical ballet; in this scene from *La Bayadère* (14.18), the *corps* forms a low circle around the central characters, like a splash radiating outward from the action in the middle. Dramatic high-contrast lighting is used to make the dancers appear as points of light within a dark and otherwise empty space.

The body is used as symbolic mask and gesture by Japanese *kabuki* actors. They wear highly stylized make-up over a white base, transforming their own faces into visages suggesting their roles. They offer their bodies as armatures for costumes weighing up to 50 pounds (23 kg), requiring frequent adjustments by stage attendants who wear black and are therefore not considered visible. These highly trained actors, whose

14.17 Costume of a *kaivakuku* (taboo adviser) from Waima, Papua New Guinea, c. 1900. Bark cloth.

14.18 Scene from La Bayadère, Royal Ballet Company, London, 1978. Choreographed by Marius Petipa. Produced by Rudolf Nureyev.

14.19 Ennosuke Ichikawa III of the Shochiku Kabuki Company, 1981.

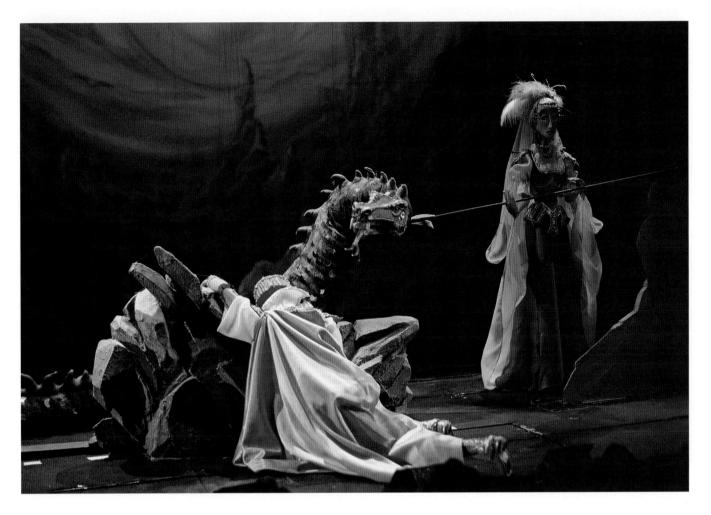

14.20 Frank Ballard, puppets for *The Magic Flute*. Courtesy of the artist.

In this image from Frank Ballard's puppet show of The Magic Flute, the prince, dragon, and magic lady can all be regarded as unique works of art that are visually engaging in themselves, but were even more so when they moved and seemed to speak.

apprenticeships begin at the age of six or seven, assume stylized gestures, freezing momentarily like statues in melodramatic poses (14.19) that carry clear meaning for those familiar with *kabuki* conventions. Men play all parts; women were banned in 1629 as part of an attempt by the rulers to restrict the popularity of this art form.

In puppetry, all is illusion. Figures can be as fantastic as the puppeteer's imagination allows, and designed to hide the hands or bodies that move them. Master puppeteer Frank Ballard, designer of the puppets for *The Magic Flute* (14.20), explains:

It may surprise some folks to hear puppets referred to as "works of art," but why not? The creation of a puppet is no different than the creation of any other form of art. It is fraught with as much frustration or rewarded with as much satisfaction. Its conception requires inspiration, imagination, design, sculpture, painting, and endless hours of dedicated labor. The product is hand-crafted, and utilizes materials as varied as the mind can conceive.

Most importantly, like other art forms, puppets communicate. They stir our emotions. They speak to us not only as characters in the story for which they were created, but also as extensions of our human souls. A puppet may be conceived with human attributes, but it can far surpass us. It can fly, it can change shape and size, it can succeed in doing what we find possible only in our dreams. Perhaps that is why the appeal of puppetry is universal.⁶

In the past few decades, performance art and also installation pieces have come to the fore in the

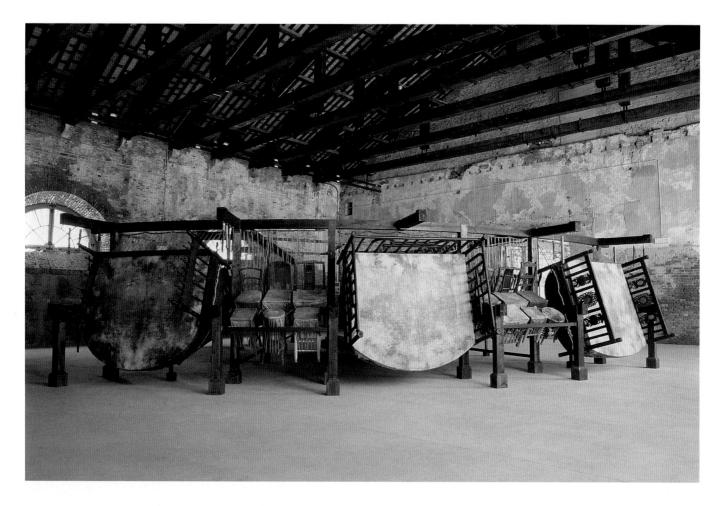

14.21 Chen Zhen, *Jue Chang (50 Strokes to Each)*, 1998. Wood, iron, chairs, beds, leather, ropes, nails, objects, $8\times32\times33$ ft ($2.4\times9.75\times10$ m). Collection Annie Wong Art Foundation, Hong Kong.

contemporary art world. Sometimes it is the artist who is the performer; in Chen Zhen's interactive work *Jue Chang (50 Strokes to Each)* (14.21), viewers are not merely passive spectators but actually become part of the piece. The artist collected old chairs, stools, and beds from many countries and turned each one into a drum by stretching a hide across its frame and hanging them from a wooden structure. Sticks hung along with them invite viewers to test how they sound when beat as drums, and they do so with great gusto, turning the gallery into a space filled with reverberating sounds. The piece was not created merely with playful intent; in the years before his death from a long struggle with a rare blood disease, the eminent Chinese artist expressed his concern for "the eternal

misunderstanding between East and West." The title of this installation is somewhat political, taken from a Chinese adage that when there is a dispute, it can be ended by physically striking the opposing parties. There is also a spiritual reference to Buddhist meditations in which the aspirant is whacked on the collarbone to shock him or her out of normal consciousness. When the piece was installed as the introduction to a group of works by Chen Zhen about Western and Chinese traditional approaches to medicine, it even developed connotations of healing, through cathartic beating of the drums. When audiences are invited to become part of a work of art, their unique responses can sometimes add unexpected dimensions to its meanings and effects.

Art in Time

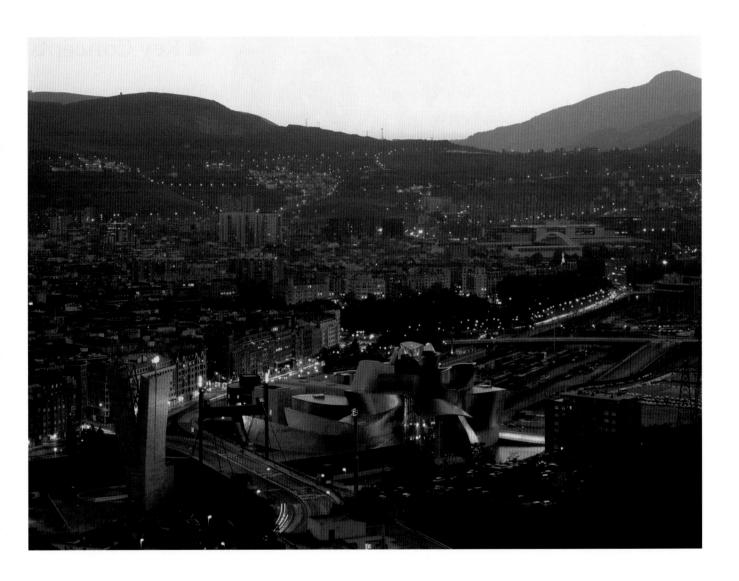

Frank O. Gehry, Guggenheim Museum, Bilbao (detail of Figure 3.45).

CHANGE IS THE one sure constant in art. Over time, art movements typically go as far as they can in one direction and then some artists veer off to explore other approaches. Each work of art also has its own history, with its final appearance the result of many choices made as it evolved from an abstract idea into physical form.

Historical Styles in Western Art

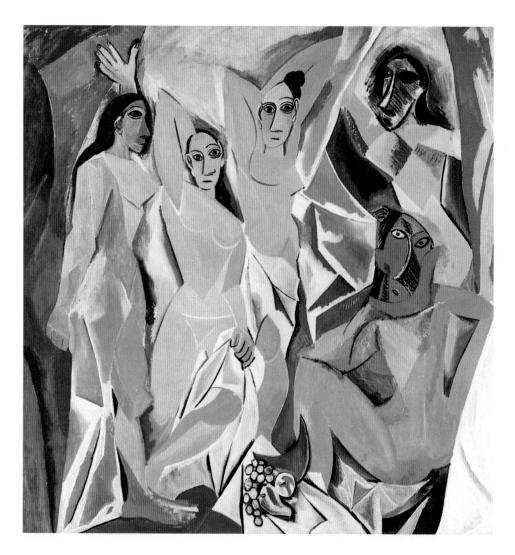

■ Key Concepts

The art of ancient cultures

Medieval art

Renaissance art

Baroque art

Eighteenth- and early nineteenth-century art

Later nineteenthcentury art

Twentieth-century art

Into the twenty-first century

15.1 Pablo Picasso, *Les Demoiselles d'Avignon*, Paris, begun May, reworked July 1907. Oil on canvas, 8 ft \times 7 ft 8 ins (2.44 \times 2.34 m). Museum of Modern Art (MOMA), New York. Acquired through the Lillie P. Bliss Bequest. 333.1939.

AFTER MILLENNIA OF artistic attempts to depict the beauty of women's forms, when Picasso painted a group of prostitutes in *Les Demoiselles d'Avignon* early in the twentieth century (15.1), people considered the painting so ugly and shocking that they tried to attack it physically when it was first shown in the United States. Ever exploring new styles and responding to other art movements, Picasso was fascinated with African sculpture; the head of the woman at the upper right resembles a stylized African tribal mask. The

spatial treatment of the forms is somewhat reminiscent of Cézanne, who had divided three-dimensional forms into a series of flat shapes (see Figure 1.44). Picasso went even farther, fragmenting his subjects into disjointed geometric planes that simultaneously revealed more than one side at once, as though the artist were walking around a three-dimensional form and reporting the view from many angles. The ancient Egyptians had developed stylistic conventions for doing somewhat the same thing (see Figure 15.6). However, Picasso's approach—here employed to somewhat erotic effect—evolved into an angular, nearly abstract, highly intellectualized twentieth-century movement known as Cubism. It is one of the many stylistic approaches to art that have evolved throughout human history, each building on the past but leading in new directions.

In this chapter we will trace major art movements that have developed within Western cultures.

Art Movements

Works of art may express something of the person who created them. They may also reflect the views and artistic conventions of the society at the time. Approaches to art have often carried enough similarities among varying artists who were working at the same time, in the same place, for us to be able to categorize them as stylistic movements. These movements lasted a long time at first, since societies were isolated from each other and information passed very slowly from one to the next. Then, as commerce between areas became more common, innovations in one area were more rapidly reflected elsewhere.

Today styles come and go with such speed that the twentieth century alone was characterized by a great number of artistic movements. Contemporary societies are also far less uniform, supporting a plurality of lifestyles and life views. When the major patrons for art were the state and Church, and when the academies dictated whose work was approved and shown, their views dominated what was done. Many stylistic movements now coexist, and many artists are doing unique work that does not fit into any group designation.

In this chapter we will trace the chain of the major art styles from earliest times to the present. Although we have examined art from all cultures throughout this book, in this chapter we will limit our focus to the evolution of European and North American art for the sake of clarity. The art of each culture has similarly evolved through many styles, partly through internal innovations and partly through contact with other cultures. Western art has often been influenced by that of non-Western societies—Rembrandt, for instance, was a collector of Near Eastern art, and Picasso was strongly affected by African sculpture. As communications shrink our globe, techniques and approaches to art are increasingly cross-pollinating. Many of the works in Western art discussed earlier are drawn into this discussion and are placed in context on the timelines on the following pages:

page 434	35,000 B.CA.D. 500 Prehistoric to		
	Roman		
page 450	500–1500 Early Christian to Gothic		
page 466	1425–1640 Early Renaissance to		
	outhern Baroque		
page 469	1500–1800 Northern Renaissance to		
	Rococo		
page 477	1750-1950 Neoclassicism to		
	Surrealism		
page 502	1945–2000+ Into the Twenty-First		
	Century		

The accompanying maps show the key artistic centers and the location of important buildings in the periods covered. The timeline (pages 436–37) covers movements from prehistory to the present and is illustrated with key works of art from this chapter.

Although our society tends to equate the passage of time with progress, some art historians feel that the art of certain periods in our past has never been surpassed. Note, too, that many of the historical groupings of artists are rather artificial constructs that were developed after the fact; others were actual groups of artists working together with a shared vision. Some of these are still called by the derogatory terms given to them by their detractors.

The Beginnings of Western Art

PREHISTORIC

Few traces remain of the lives of our earliest ancestors. But piece by piece, archaeologists are reconstructing possible histories of prehistoric humans. Controversy rages over the dating of the first signs indicating that

35,000 B.CA.D. 500 Prehistoric to Roman		Works of art	Events
35,000 в.с.	c. 30,000–3000 Stones Ages (Paleolithic, Mesolithic, Neolithic) c. 4000 Sumerian civilization emerges in Mesopotamia	c. 32,000–30,000 cave paintings in Ardèche, France c. 30,000–25,000 Woman of Willendorf, Lower Austria (15.2) c. 15,000–10,000 "Hall of Bulls," Lascaux, France (15.3)	c. 20,000 toolmaking c. 9000 domestication of animals c. 4000 cuneiform script developed in Mesopotamia
	c. 3000–1000 Aegean civilizations: Crete, Cyclades	c. 2685 Harp of Ur, Iraq (15.5) 2500 Cycladic figure, Amorgos (15.4)	c. 3000 hieroglyphic writing, Egypt c. 3000–2000 use of bronze
	c. 2780–1085 Kingdoms of Ancient Egypt	2700 Panel of Hesira, Saqqara, Egypt (15.9) c. 2500–2470 Pyramids of Giza, Egypt (15.8) c. 1450 Senmut with Princess Nefrua, Thebes,	tools/weapons, Sumer c. 2000 Book of the Dead, first papyrus book c. 1725 horse-drawn wheeled vehicles, Egypt c. 1200 beginning of Jewish religion
	c. 1760–612 Assyrian Empire, Mesopotamia	Egypt (2.27) c. 720 <i>Lamassu</i> , Khorsabad (15.7)	
1000 в.с.	c. 800–650 Geometric period, Greece c. 700–480, Archaic period, Greece	8th cent. Dipylon vase, Athens, Greece (<i>15.10</i>) c. 540–515 Kouros statue, Anavyssos, Greece (<i>15.11</i>)	c. 900 ideographic writing, China c. 800 Homer's <i>The Iliad</i> c. 700 first Olympic Games
		c. 530 Amphora, Athens, Greece (11.1)	550–480 Gautama Buddha, founder of Buddhism
	c. 500–400 Classical period, Greece	c. 450–400 Spear Bearer, Greece (Roman copy 2.28) 448–405 Acropolis and Parthenon, Athens (15.12, 3.40)	509–31 Roman Republic
	c. 500–150 Hellenistic period, Greece	c. 190 Victory of Samothrace, Aegean island (15.13) c. 150 Venus de Milo, Aegean island (2.80)	c. 336–323 conquests of Alexander the Great
0	31 B.C.—A.D. 500 Roman Empire	c. 20 B.C. Augustus of Primaporta, Rome (15.14) 1st century A.D. Laocöon, Rhodes, found in Rome (3.29) A.D. 118–129 Pantheon, Rome (2.46, 13.6) A.D. 220–230 Sarcophagus, Rome (2.21) A.D. 312–315 Arch of Constantine, Rome (1.21)	c. A.D. 30 crucifixion of Jesus Christ A.D. 79 Pompeii and Herculaneum destroyed A.D. 98–117 Roman Empire at greatest extent c. A.D. 400 Byzantine Empire begins

humanoids were capable of symbolic thinking. A lumpish human-like stone figurine found 49 feet (15 m) underground in Morocco is said to be up to 400,000 years old; whether it was sculpted by hand or by natural weathering is uncertain. Abstract crisscrossing marks cut into the surface of a piece of ocher found in a South African cave have been dated to over 70,000 years. Such finds may push the date of the earliest known human art far earlier than the previous dating of pieces found in Europe.

Cro-Magnons, the first ancestors who seem to have looked similar to modern humans, date from approximately 50,000 years ago. Their remains have been found in many sites in northern Africa, southern Asia, and Europe. Apparently they developed ways of living not only in temperate climates but also in the cold of the last Ice Age in Europe. Several families lived together in tents and other temporary human-made shelters, in a nomadic life of hunting and gathering, using tools made from stone, bones, and antlers.

The archaeological evidence suggests that their lives may have included spiritual rituals associated

with hunting, birth, and death, for they seem to have produced specialized articles such as statuettes made for these purposes, rather than simply everyday utilitarian objects. Although we can only guess at the meanings of the artifacts for the people who made them, by 35,000 or 30,000 B.C. our ancestors were creating what we now consider works of art, including paintings and sculptures. Of the latter, the most famous is the tiny female figure found at Willendorf in Austria (15.2). She is only $4\frac{1}{2}$ inches (11.5 cm) tall, small enough to fit comfortably in one's hand. Archaeologists think she, like other similar figures from the same period, was probably a fertility image, judging from the exaggeration of her reproductive areas to the exclusion of facial features, or an image of the Creator as Mother. Somebody carved her of limestone and painted her red, just as the people painted their bodies with red ocher.

In addition to other small, stylized stone carvings of humans and animals, early peoples incised and painted remarkably realistic animals on the roofs and walls of caves. The most famous of the cave paintings were

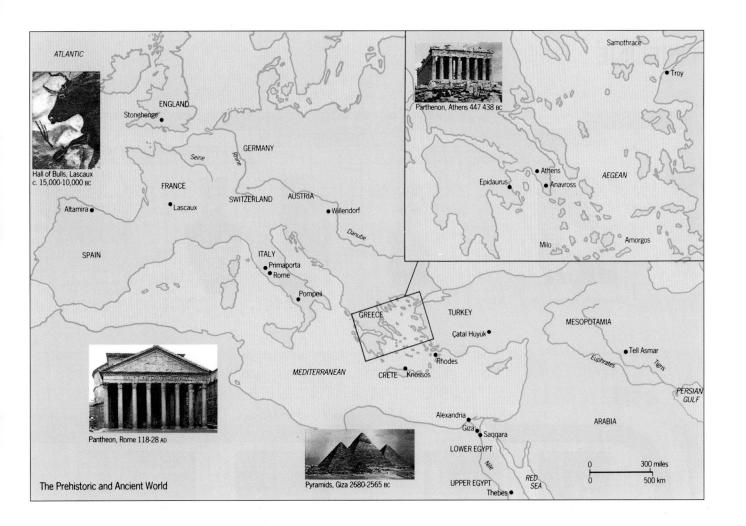

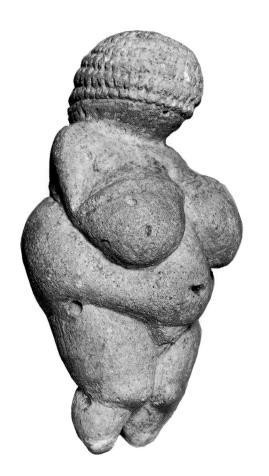

15.2 Woman of Willendorf, Lower Austria, c. 30,000–25,000 B.C. Limestone, height 4½ ins (11.5 cm). Natural History Museum, Vienna. Very ancient female figurines may be symbolic images of the Supreme as a female Creator and Sustainer Goddess.

TIMELINE

Differential timescales have been used, resulting in the relative compression of earlier periods. This apparent bias in favor of recency should be noted, although it is difficult to avoid: for if this Timeline represented all periods on the timescale used for the twentieth century, it would measure 315 feet (96 meters) in length.

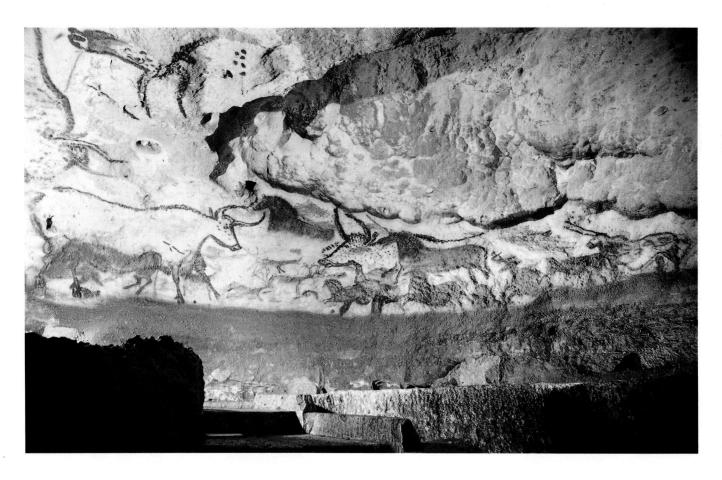

15.3 Main hall ("Hall of Bulls"), Lascaux, France, c. 15,000-10,000 B.C.

found in Lascaux, France (15.3), by children exploring an extensive cave beneath an uprooted tree. Some of these cave paintings are so vividly wrought that archaeologists at first thought they were fakes, but now their authenticity has been verified, and the ones at Lascaux have been dated to about 15,000 B.C. There are hundreds of paintings covering a series of chambers, with large figures of bulls, deer, horses, bison, and ibexes. They were apparently created by many artists over many years, using fur, feathers, moss, sticks, or fingers to outline the creatures with pigments from natural minerals. These outlines were then colored in with powders perhaps blown through tubes of bone. Holes in the walls suggest that the artists sometimes created temporary scaffoldings of wood to allow them to work high on the walls and ceilings of the caves. These caves were tortuous underground water channels up to 4,000 feet (1,300 m) long, and the painted areas were far removed from the cave mouths where the people took shelter. They would have been very dark, illuminated only by small stone lamps.

In 1994, cave explorers in the Ardèche Valley in France crawled through a hole and discovered a great

gallery of more than 300 such cave paintings, some of which seem to be over 30,000 years old—the oldest known paintings in the world. Despite their age, they employ sophisticated artistic techniques to represent perspective and movement. They include rare paintings of owls, hyenas, and panthers and engravings of the silhouettes of birds and large mammals that are now extinct, such as woolly rhinos and mammoths. As in other cave artworks, the artists sometimes took advantage of natural bulges in the rock to create low-relief, three-dimensional imagery of their subjects.

The question arises: Why did these people from technologically simple cultures go to such trouble to carve such detailed figurines from hard stone and to create such accurate paintings in the remote and dark reaches of caves? One theory was that they were created for magical purposes, to ensure success in the hunt. According to this theory, their surprising representational accuracy would have been a valuable aid in invoking the spirit of the animal in advance and ritually killing it. Those animals depicted as pregnant might have been magically encouraged to be fruitful. Or perhaps the paintings and figures served other

spiritual purposes which were very important to these people. Another line of thinking is that the cave paintings had some relationship to time reckoning, with plants and pregnant animals representing particular seasons.

From an art historical point of view, the mother figures and cave paintings are so far the earliest confirmed uses of visual signs to represent form and meaning. They seem to have been executed by various artists at different times. Their representational accuracy may perhaps have resulted from aesthetic skills passed down and improved upon from one generation to the next over a very long period, as well as from the individual artists' keenly perceptive observation of natural forms.

AEGEAN

From small roving bands of hunters and gatherers of wild foods, some of our remote ancestors began to settle in peasant villages supported by agriculture. In time, large, organized settlements developed as food surplus allowed some people to devote themselves to specializations other than basic survival skills—special occupations such as pottery-making, defense, and civil leadership. Cities and divisions of labor are basic indicators of what historians consider "civilization."

One of the earliest known Western civilizations was a seafaring culture centered in the Aegean Sea around Crete and islands to its north, known as the Cyclades. It was in the Cyclades that the art objects most often found in the ruins of these civilizations seem to have originated. Like the figure shown in 15.4, they were small, stylized female figurines with folded arms, carved out of marble with hard obsidian blades and rubbed to a smooth surface. Remaining bits of paint suggest that they once had painted eyes and jewelry. The fact that they will not stand upright suggests that they were conceived as lying down; usually they have been found in tombs, perhaps as partners for the dead or as homage to the Goddess. This translation of living, fully round forms into abstracted, nearly flat geometric shapes did not begin to reappear in Western art until the late nineteenth century.

MESOPOTAMIAN

The other earliest settled civilizations in the West were in Mesopotamia, on the plains between the Tigris and Euphrates rivers in what is now Iraq. Though fertile, the land was wracked by storms, floods, and political violence, for invasions and competition between many cultures seem to have gone on for thousands of years.

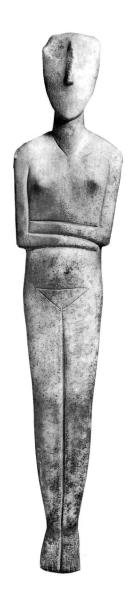

15.4 Cycladic figure from Amorgos, c. 2500–1100 B.C. Marble, height 30 ins (76.2 cm). Ashmolean Museum, Oxford.

The first and most influential of these cultures was that of the Sumerians, who founded advanced walled cities in southern Mesopotamia from 3500 to 2400 B.C. Their great cultural contributions included the invention of writing, by means of a stylus used to make marks in soft clay tablets which were then baked for permanency. They also developed massive ziggurat structures, as shown in Figure 13.15. One of the Sumerian cities, Babylon, was apparently quite magnificent, with avenues, canals, hanging gardens, and fine buildings. But because they were constructed of impermanent mud bricks, little remains of their former splendor.

Much of the Sumerians' art was devoted to ritual religious themes, such as presentations of gifts to the local deities. Some of the low-relief stone carvings and impressions made in clay or wax by cylindrical seals are often lively and realistic. The statues placed around

Looting of Art Treasures

ONE OF THE tragic outcomes of the bombing of Iraq in April 2003 by the United States and Britain was the sudden disappearance of priceless ancient treasures in the Iraqi National Museum in Baghdad as well as untold thousands of artifacts from archaeological sites in Iraq where Mesopotamian civilization had once flourished. Neither the museum nor the archaeological sites had been bombed; they were ransacked by art thieves under the cover of war.

One of the greatest losses first reported was the beautiful Harp of Ur shown in Figure 15.5, which had been found in excavations in ancient Ur sponsored by the British Museum and the University of Pennsylvania in the 1920s and 1930s. The Iraqi Museum, founded in 1923, contained all the most significant archaeological finds from then onward, plus their photographs and records. The collection included metalwork, sculpture, ceramics, glass, ivory, textiles, jewelry, and parts of ancient buildings, as well as inscriptions about the history of the area which lay between the Tigris and Euphrates valleys, considered the cradle of Western civilization. There had been over 170,000 objects in the great collection and tens of thousands of ancient manuscripts, so numerous that most had not yet been studied.

Mourning the emptying of many of the galleries, Dr. Moayad Damerji, Professor of Archaeology at Baghdad University and former Director General of the Iraqi Department of Antiquities, said, "The Iraqi National Museum is the only museum in the

world which shows all the steps in the history of mankind. These witnesses to our own development have gone, they are gone."¹

Art historians and curators around the world shared the great sense of loss and were critical of the failure of American and British troops to protect the artifacts. Critics pointed out that in 1943, during World War II, a branch of the American military was formed of art historians and scholars to find and protect the art of important sites in Europe from damage in war and looting afterward. This effort went on until 1951 and was successful even amidst the chaos of war.

After the great loss in Iraq, there was a global alert to try to prevent illegal sale of what is known to be missing. Seizures at checkpoints, airports, and international borders resulted in the retrieval of hundreds of items: hundreds more were returned within Iraq during an amnesty program. Still more had been placed in a secret location by the museum staff before the bombing. The Harp of Ur was found in a temporary storage area, damaged, but reportedly not beyond repair. Nonetheless, many thousands of pieces are still missing.

At the same time, the government of Greece was trying to pressure the British Museum to redress what it considers the theft of one of its great art treasures: the so-called Elgin Marbles. Over half of the marble statues on the frieze of the Parthenon (Figure 3.40) had been removed from 1803 to 1812 on the order of

Lord Elgin, British ambassador to the Ottoman Empire, and sold to the British government for an estimated \$159,600. The Turkish government, which was then in charge of the region, had given Lord Elgin permission to do so, apparently on the grounds that the statues were thus being protected from damage in wartime. Turkish forces had reportedly been storing ammunition in the ruins of the Parthenon, and their enemies had shelled the famous structure. The British government placed the Elgin Marbles in the British Museum, where they remain to this day, despite continued entreaties by Greece that they be returned to their home country. The British Museum also contains a fine collection of bronzes removed from Benin in colonial days.

Thus in the international trade in art treasures two major issues arise: What is the responsibility of an attacking country to protect the art of the country it is attacking? And when victors carry off the spoils of war, under whatever explanation, and put them in their own museums, can the country from which they were removed later demand them back? In 2003 famous museums with international collections, including the Louvre in Paris, the Metropolitan Museum of Art in New York, the Hermitage in St. Petersburg, and the Berlin Museum, declared that artifacts of universal importance should be kept wherever they are on display to the world, rather than repatriated to their home countries.

15.5 Bull detail from the soundbox of a harp, from the tomb of Queen Puabi, Ur (modern Muqaiyir, Iraq), c. 2685 B.C. Wood with shell inlay, $12\frac{1}{4} \times 4\frac{1}{2}$ ins (31.1 \times 11 cm). Photo from University Museum, University of Pennsylvania, Philadelphia.

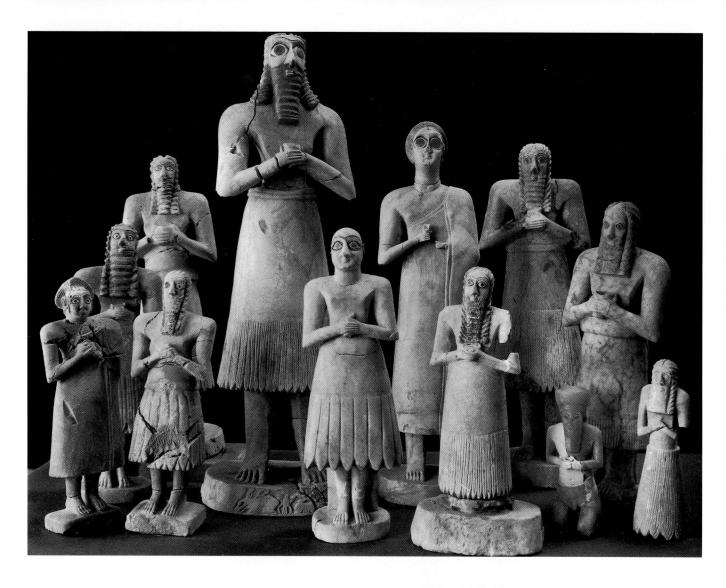

15.6 Statuettes from the Abu Temple, Tell Asmar, c. 2700-2600 B.C. Marble, height of tallest figure 30 ins (76.2 cm). Iraq Museum, Baghdad.

Sumerian cities were each protected by a local god or goddess, whose earthly representative was the local ruler. The height of these statuettes might indicate a spiritual-political hierarchy; the tallest figure is thought to be that of Abu, the god of agriculture.

the inner walls in a temple devoted to Abu, god of vegetation (15.6), are more simply conceived as dignified, stylized cylindrical forms in a static attitude of worship. The lovely harp soundbox shown in Figure 15.5 illustrates the development of stylistic conventions in the representation of figures, but they nonetheless have an animated appearance.

From the mid-ninth century B.C. to 612 B.C., the Mesopotamian area was dominated by the Assyrian Empire, by dint of its military superiority. Its art reflected the focus on military power and the might of its kings, who were thought to be directly in communication with the gods. The Assyrian kings built themselves huge palace complexes, within which

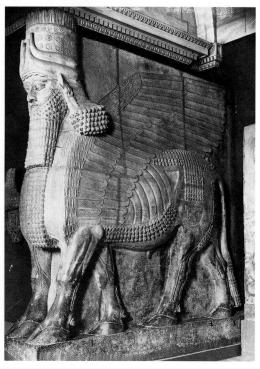

15.7 *Lamassu* from Khorsabad, c. 720 B.C. Limestone, height c. 13 ft 10 in (4.21 m). Louvre, Paris.

long narrative low-reliefs showing episodes in their military adventures were finely carved on stone slabs, including naturalistic depictions of the animals they captured as booty. Other unusual features of these palaces included huge winged bulls with bearded human heads, called lamassu, guarding their entrances. These guardian figures, such as the ones at the fortified palace complex of King Sargon II near what is now Khorsabad (15.7), were often carved partially in deep relief and partially in the round. That is, from the front the lamassu appears to be a full-round statue with sturdy legs firmly planted. From the side, the body and legs are carved in relief and appear to be walking forward. To achieve this double effect, a unique artistic convention was adopted by Assyrian sculptors: they gave the creature a fifth leg, which is noticeable only when the work is seen not from front or side, but at an angle. Note also the great attention to detail, including the veins of the feathers in the mighty wings and the blood vessels swelling outward on the legs.

EGYPTIAN

In isolation from the Mesopotamian civilization, an elaborate culture was developing in Egypt that spanned about 3,000 years. Growing up along the Nile River, these settlements enjoyed a mild climate and

the agricultural benefits of the regular flooding of the river. Here there were neither warring city-states nor invaders as in Mesopotamia. The relative serenity and permanence of the civilization was manifested in its religion and arts. There was great interest in eternity itself, and at first the arts of Egypt focused almost exclusively on the hereafter, particularly on ensuring eternal life for deceased rulers. Great pyramids, such as those at Giza (15.8), were erected to house the mummies, statues, and belongings of kings (pharaohs). The pyramid form was intended as an image of the rays of the sun, a stairway on which the king could ascend to heaven. He was, it seems, worshiped as a god in himself. Thus massive efforts must have been undertaken to assure his eternal life. The tomb of Cheops in Giza covers a ground area of 13 acres (5.26 ha) and is 450 feet (137 m) high. Its limestone blocks-and we still do not know for certain how they were raised to this great height-form an almost solid mass of stone, with only a small burial chamber and narrow passageways inside.

Egyptian paintings and sculptures, such as the block form of the Chancellor Senmut with Princess Nefrua as a child shown in Figure 2.27, often combined considerable artistic skill with rigid stylistic conventions. Sculptures were quite obviously rectangular; paintings and exquisite low reliefs of the human form

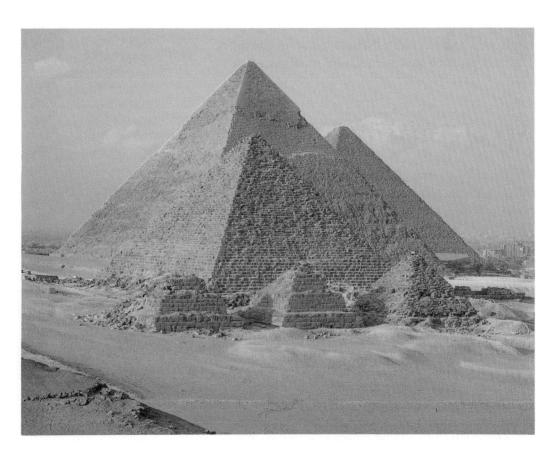

15.8 The Pyramids of Mycerinus (c. 2470 B.C.), Chefren (c. 2500 B.C.), and Cheops (c. 2530 B.C.), Giza, Egypt.

15.9 Portrait panel of Hesira, from Saqqara, c. 2700 B.C. Wood, height 4 ft 7½ ins (1.41 m). Egyptian Museum, Cairo.

(15.9) usually showed the head in profile, the torso in frontal position, and the legs in profile, leading to some anatomically impossible positioning. Such conventions seem to have been ways of ensuring that a statue would be a suitable dwelling place for the spirit, or that a painting gave as much information as possible on a flat surface.

Art of Ancient Cultures

On the northern shores and islands of the Mediterranean, advanced cultures were developing, including the Classical Greek civilization. During the fifth century B.C., powerful city-states came under the leadership of Athens, with a particularly spectacular cultural blossoming under the democratic rule of Pericles. After his death in 429 B.C., wars with Sparta and Macedonia and then the expansion of the Roman Empire ended Athenian political power, but the artistic influence of Greece was readily adopted and perpetuated by the Romans.

15.10 The Dipylon Vase, Attic Geometric amphora, eighth century B.C. Height 4 ft 11 ins (1.5 m). National Archaeological Museum, Athens.

GREEK

Prior to the Golden Age of Athens, Greek arts were already becoming highly refined. During the **Geometric period**, potters created two-handled amphoras and other vessels of symmetrical beauty, worked with elaborate geometric patterns. The lovely Dipylon Vase (**15.10**), thrown in sections on a potter's wheel, is almost 5 feet (1.5 m) high. In addition to the Greek fret pattern later used on buildings, the amphora—used to mark a grave—is decorated with a frieze of mourning human figures reduced to a visual shorthand.

The **Archaic period** in Greece (approximately 700 to 480 B.C.) was influenced, through trade with Egypt, by Egyptian sculptural traditions. Statues representing humans are rather rigidly and frontally positioned. In the Greek enthusiasm for Olympic Games played in the nude, physical fitness and personal discipline were held up as noble ideals. Thus the sculptures reveal both a serious enquiry into the natural structure of the naked human body and an idealization of its contours. The Kouros ("young male") statues (**15.11**) are fully freed from the block of marble from which they were carved, in contrast to the block-like Egyptian statues.

15.11 (left) Kouros, c. 540-515 B.C. Marble, height approx. 6 ft 4 ins (1.92 m). National Archaeological Museum, Athens.

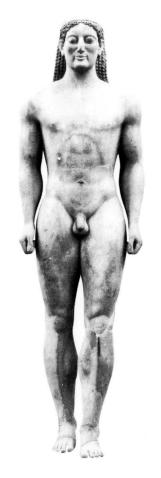

The Golden Age of Athens—the heart of the Classical period—lasted for only part of the fifth century B.C., but its emphasis on rationality, idealized beauty of form, with avoidance of extraneous ornamentation, has never been equaled. It was during this period that Pericles signaled his victory by rebuilding the Acropolis high above the city, with the Parthenon (15.12 and 3.40) as its focal point. Grand public buildings such as theaters, concert halls, and temples were of sophisticated stone construction with columns and entablatures designed according to one of two basic stylistic orders: Doric or Ionic (see 13.18). In sculpture, artists abandoned the contrived Egyptian poses for more naturalistic ones, as in the Spear Bearer (2.28). This sculpture turns the body in a dynamic, spiral twist known as contrapposto in which the head and shoulders face a different way from the hips and legs. Despite the realistic appearance of the Spear Bearer, it has been based on a Classical tradition of ideal numerical proportions.

15.12 The Acropolis and Parthenon, Athens, 448–405 B.C. View from the west.

15.13 Victory of Samothrace, c. 190 B.C. Marble, height 8 ft (2.44 m). Louvre, Paris.

Even with her head missing, this statue seems charged with life and energy, and her long outstretched wings, which remain aloft without support, are a remarkable achievement by her Hellenistic marble sculptor.

After the elegant restraint of the Classical period, the **Hellenistic period** was marked by greater emotionalism. During this period, dating from the death of Alexander the Great in 323 B.C. and spanning about 300 years, the power of the Greek city-states declined but Greek culture continued to spread and was adopted by the newly dominant Romans. One of the greatest Greek works of this period was the life-filled, wind-blown *Victory of Samothrace* (**15.13**), a marble sculpture erected by the people of the little island of Samothrace to celebrate a victory at sea. The emotional drama of her form also characterizes the Hellenistic mosaic of *The Battle of Issus* (5.30). The more natural, informal style of the Hellenistic period can also be sensed in the

warm body of the *Venus de Milo* (2.80), and its predilection for "human interest" is reflected in the late Hellenistic bronze of the *Seated Boxer* (10.16).

ROMAN

Whereas the Greeks developed a culture of ideas, the Romans built a military empire that eventually controlled southern and western Europe and much of North Africa and the Near East. As peoples of varied cultural background, those living within the Roman Empire did not have a single artistic style, nor did the Romans themselves develop significantly new styles in art. In general, they copied the much-admired Greek art, to the point of using copies of Greek statues with sockets in their necks so that heads of Romans could be attached. If you compare the statue of Augustus (15.14), the first Roman emperor, with the Greek Spear Bearer (2.28), on which it is thought to be based, you will see clear similarities, despite the addition of a breastplate and drape. Note that the Spear Bearer itself is a Roman copy of an original Greek statue.

Many Roman sculptures were celebrations of the secular might of the emperors. Augustus' cuirass is covered with symbols of victory. As part of their empire building, the Romans erected many public buildings, larger than those of Greece, on a scale facilitated by the introduction of concrete and space-spanning arches, vaults, and domes, as in the great Pantheon (Figures 2.46, 13.6). It was the Romans who introduced nonfunctional architectural monuments, such as the Arch of Constantine (1.21). Funerary art of the times included busts made from death masks and sarcophagi for honored corpses once the practice of cremation was abandoned. An example is the one featuring high reliefs of Dionysus and the Seasons (2.21).

EARLY CHRISTIAN AND BYZANTINE

In the first centuries after Christ's death, Christians were persecuted as threats to the state, so they kept what little sacred art they created secret and symbolic. Most of it consisted of burial pieces for those of the faith buried in the catacombs beneath Rome.

When the Emperor Constantine embraced Christianity in 313 as the official religion of the Roman Empire and made Constantinople its second capital, Christian art began to flower. This was particularly so in the eastern half of the Empire as barbarian

15.14 (opposite) Augustus of Primaporta, c. 20 B.C. Marble, height 6 ft 8 ins (2.03 m). Vatican Museums, Rome.

sixth—seventh century A.D.
Encaustic on wood.
Santa Francesca Romana,
Rome.
Byzantine icons were made by
the saintly under conditions of
intense spiritual discipline, and
thus were thought to be
charged with divine blessings by
which many people were

15.15 Madonna (detail),

groups inundated the Western Empire in the fifth century. In the eastern **Byzantine** culture, which lasted 1,000 years, all art was religious and created anonymously by the devout. **Icons**, inspired paintings of Christ, the Virgin Mary, and the saints, were revered for their mystical wonder-working powers. The elongation of figures was stylistically distinctive (**15.15**). Elaborate mosaics (**15.16**), rendered in a stylized, spiritually expressive manner, covered the ceilings and walls of churches with Christian stories. The vast domed church of Hagia Sophia, built in Constantinople by the Emperor Justinian as the greatest of all Christian churches, was so large for its structure that it had to be rebuilt and buttressed after the dome collapsed.

Medieval Art

EARLY MEDIEVAL

Under pressure from Germanic invasions, the Roman Empire was destroyed and western Europe fell into a period of cultural, social, and economic chaos which is often referred to as the Dark Ages. Learning, spirituality, and art were kept alive in the monasteries and convents. A stunningly beautiful new development under these circumstances was the appearance of elaborate illuminated manuscripts. These unique, handmade copies of sacred texts, such as the Gospels, became especially ornamental in Ireland and the northern islands of Britain, where Christian fervor was allied with ancient traditions of interlaced and spiraling

15.16 Abraham's Hospitality and the Sacrifice of Isaac, c. A.D. 547. Wall mosaic. San Vitale, Ravenna, Italy.

A.D. 500-1500 Early Christian to Gothic		Works of art	Events
500	c. 400–1453 Byzantine Empire	6th–7th cent. Madonna, Rome, Italy (15.15) c. 547 Sacrifice of Isaac, Ravenna, Italy (15.16)	c. 500 Fall of Rome c. 570–632 Mohammad, founder of Islam c. 622–900 Islamic Empire 652 Qu'rān written down c. 700 porcelain invented in China
750 750–900 Feudalism in Europe c. 1050–1200 Romanesque pe		9th century Book of Kells, Ireland (15.17)	c. 750 Beowulf epic written c. 800 Charlemagne crowned Emperor of Western (Holy) Roman Empire
	c. 1050–1200 Romanesque period	c. 1077–1124 Cathedral of Santiago de Compostela, Spain (15.18)	c. 962–1056 Ottoman Empire 1096–1204 Crusades c. 1100 rise of universities in Spain, France, England
	c. 1200–1400 Gothic period	1142–1220 Chartres Cathedral, France (13.12, 13.22, 15.19) c. 1280–85 Cimabue, <i>Madonna Enthroned</i> with Angels, Florence (2.69) 1305–6 Giotto, <i>The Lamentation</i> , Padua (15.20)	c. 1200–50 Marco Polo travels to China and India c. 1250 Arabic numerals introduced to Muslim cultures from India
	750–1492 Moorish culture in Spain	1339 Lorenzetti, <i>Allegory of Peace</i> , Siena (5.8) 1309–54 Alhambra, Granada, Spain (13.26)	
1350	c. 1400–1500 Late Gothic	1423 Da Fabriano, <i>The Adoration of the Magi</i> , Florence (2.1) 1434 Van Eyck, <i>The Marriage of Arnolfini</i> , Flanders (15.23)	c. 1350 Black Death in Europe 1446–50 Gutenberg prints using movable type 1492 Granada falls. Columbus voyages to America

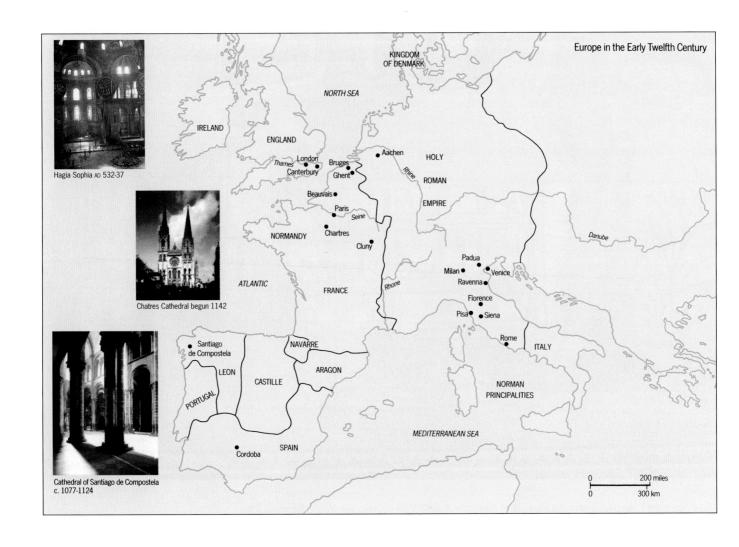

15.17 Incarnation initial from the *Book of Kells* (fol. 34), early ninth century A.D. Vellum, 13×10 ins $(33 \times 25$ cm).

Trinity College Library, Dublin.

This glorious page from the Book of Kells is entirely devoted to the Chi-Rho monogram that begins St. Matthew's story of the birth of Christ.

spiritual motifs. In the hands of the monks of the Iona community off the coast of Scotland, capital letters became extraordinarily ornate. In the *Book of Kells*, which they created, there are over 2,000 illuminated capitals used at the beginning of Gospel passages, such as the one shown here (15.17).

ROMANESQUE

In the middle of the eleventh century, Europe entered a new period of intense creative activity influenced by Byzantine and Islamic cultures via the Crusades, but centered on the Latin Church. As secular kings consolidated their power, so did the papacy, with the Church increasingly dominating all aspects of life in Western Europe. The rise of a mercantile class, urbanization,

and expansion of trading networks began to replace isolated feudal villages, facilitating the spread of ideas and culture. Life was still uncertain, and the Roman culture that had once dominated the area was still widely considered the height of the arts. Nevertheless, a new, distinctive aesthetic began to emerge. It was later called Romanesque because of its supposed borrowings from Classical Rome, but it had its own form, expressed primarily through architecture. The demand for churches was answered with a sacred architecture characterized by rounded arches, thick walls and columns, and relief carvings in stone (3.33). Desire for personal repentance inculcated by the Church led many people to undertake long pilgrimages to certain churches, most notably the Romanesque Cathedral of Santiago de Compostela in Spain (15.18). These heavy structures admit only indirect lighting in most areas, lending Romanesque interiors a massive, blocky, almost fortress-like atmosphere.

GOTHIC

In the middle of the twelfth century, European art and architecture began to undergo an even more profound change. As burgeoning cities shifted the concentration of power from feudal rural areas, spirits seemed to lift, and with them soared the ethereal vertical heights of the new Gothic cathedrals. This way of building had a clear beginning in the directions given by Abbot Suger for the first great Gothic church: that space be used to symbolize the mystery of God, that God is mystically revealed in light, and that perfect harmony between parts is the basis of beauty. The pointed arch, ribbed vault, and flying buttress allowed architects to replace the heavy appearance of Romanesque structures with more slender and vertical architectural details, such as those at Chartres Cathedral (13.12). The new technology also allowed much larger windows, and these were often filled with intricate stained-glass designs and pictures of gemlike brilliance. They were created from cut pieces of colored glass, some of which were also painted for fine details, joined with lead strips, and reinforced with a framework of iron bands. The great rose window in Chartres Cathedral (15.19) is over 42 feet (13 m) in diameter; it offers an illuminated view of the Virgin Mary surrounded by angels, archangels,

15.18 Interior of the Cathedral of Santiago de Compostela, Spain, c. 1077–1124.

15.19 Rose window, north transept, Chartres Cathedral, Chartres, France, c. 1221. Stained glass, diameter 42 ft 8 ins (13 m).

doves representing the Gospels and the Holy Spirit, and then outer circles of Old Testament figures.

In painting, artists began using the two-dimensional surface as a frame within which to create the illusion of three-dimensional depth. Although it was difficult to do so in the demanding medium of fresco, Giotto's *The Lamentation* (15.20) illustrates a revolutionary approach to the modeling of forms and the new effort to give figures an appearance of being alive and

mobile, rather than frozen in static postures. These figures are also imbued with individualized human emotions, from the fierce grief of Mary to the pitiful sorrow of Mary Magdalene, to the philosophical acceptance of the two disciples to the right. Giotto was a great Florentine artist whom many consider the originator of the movement that led to the Renaissance.

Sculpture of the Gothic period, as in the Romanesque, consisted primarily of carvings incorporated into the sacred architecture, but the Gothic sculptures were more three-dimensionally separate from their supports.

15.20 Giotto, *The Lamentation*, 1305–6. Fresco, 7 ft 7 ins \times 6 ft $7\frac{1}{2}$ ins (2.31 \times 2.02 m). Arena Chapel, Padua, Italy.

LATE GOTHIC

Although Gothic art appeared in countries throughout Europe, it waxed and waned at different times at different places. In northwestern Europe, an increasingly expressive and naturalistic successor to the Gothic style lived on until about 1500. Painting was developed to new heights by artists of the Flemish school using the new medium of oil rather than tempera. The van Eyck brothers were early masters of the medium and used it to create the illusion of threedimensional figures in deep space, with fine details and the luminous appearance possible only with skillful use of oils. Jan van Eyck's The Marriage of Giovanni Arnolfini and Giovanna Cenami (15.23) is studded with traditional symbols from the Gothic period—such as the dog indicating faithfulness in marriage, the single candle in the chandelier symbolizing Christ's sacred

presence in the marriage ceremony, and the couple's shoes on the floor, reminders of God's commandment to Moses to take off his shoes when he was on holy ground. Yet the textures of metal, furs, fabrics, and wood are rendered with a realism never before achieved in any medium.

Renaissance Art

During the fourteenth to seventeenth centuries, major new cultural formations gradually took over from medieval ones. This set of values became known as the **Renaissance** ("Rebirth"), because its proponents felt that they were restoring the spirit of Classical Greek and Roman culture. In contrast to the other-worldly and community-centered ideas promoted by the medieval Church, Renaissance thinkers were markedly secular, humanistic, and individualistic. In many regions, power was consolidated by kings controlling

national states. These were supported by taxes assessed on urban merchants, the initial beneficiaries of a growing money economy. These newly rich merchants, in turn, were to become patrons of the arts.

The prestige of the papacy was diminished by its corruption and abuses of power. Desires for reform led to the vigorous Protestant Reformation movement in the sixteenth century, and then to the similarly vigorous Catholic Counter-Reformation.

EARLY RENAISSANCE IN ITALY

The Renaissance spirit was particularly vibrant in Italy. Classical Greek and Roman sculptures and architecture were carefully studied for their principles of harmony and symmetry. To these were added a new understanding of perspective based on rediscovery of Euclidian geometry from Classical Greece. The careful use of linear perspective contributes to the sense of spaciousness in Fra Angelico's *Annunciation* (15.21), one of many frescos he painted for a

Dominican convent in Florence. A gentle and conservative monk, Fra Angelico retained many Gothic traits—such as bright pigmentation and the use of the flowery garden as a symbol of Mary's virginity—while incorporating some of the new devices such as perspective rendering and more realistic depiction of anatomy and fabric draping.

The work of the Florentine painter Sandro Botticelli, such as *The Birth of Venus* (15.24), likewise shows certain ties with Gothic traditions, such as a more two- than three-dimensional approach to figure drawing. But Botticelli's lyrical evocation of the idealized beauty of the human body and of harmonious configurations of forms is clearly innovative, with Classical origins apparent in its style as well as its mythological subject-matter.

The Early Renaissance also marked a rebirth of logic, though still in the service of the Church. In contrast to the devotional quality of Gothic arts, the Renaissance artist and art historian Lorenzo Ghiberti

15.21 Fra Angelico, Annunciation, c. 1440–45. Fresco, San Marco, Florence, Italy.

The Camera Obscura: A Trade Secret?

DID SOME OF the great masters of painting trace their images using a camera obscura? As we noted in Chapter 8, the precursor of the modern camera is the use of a darkened room into which light is admitted through a lens in a small hole. The image of the illuminated area is thrown upside down as if by magic onto a surface in the darkened room. This technique was known as long ago as the fifth century B.C. in China. Aristotle also experimented with it in the fourth century B.C., and Leonardo da Vinci described it in his notebooks in 1490. In 1558 Giovanni Battista della Porta wrote in his twenty-volume work Natural Magick instructions for adding a convex lens to improve the quality of the image thrown against a canvas or panel in the darkened area where its outlines could be traced. Later, portable camera obscuras were developed, with interior mirrors and drawing tables on which the artist could trace the image (15.22). For the artist, this technique allows forms and linear perspective to be drawn literally as they would be seen from a single viewpoint. Mirrors were also used to reverse the projected images to their original positions.

Some art historians are now looking for clues of artists' use of such devices. One of the artists whose paintings are being analyzed from this point of view is the great Dutch master, Jan Vermeer, who lived from 1632 to 1675 during the flowering of art and science in the Netherlands, including the science of optics. Vermeer produced only about thirty known paintings, including the famous *Art of Painting* (2.34). The room shown in it closely resembles

the room in other Vermeer paintings, with lighting coming from a window on the left, the same roof beams, and similar floor tiles, suggesting that the room was fitted with a camera obscura on the side in the foreground. The map hung on the opposite wall was a real map in Vermeer's possession, reproduced in such faithful detail that some kind of tracery is suspected. By the eighteenth and nineteenth centuries, camera obscuras were definitely used to make accurate copies of prints and pictures. Another clue is the cameralike perspective, a literal snapshot of a piece of the world in which objects are cropped off incomplete at the edge of the picture plane and those close to the point of view loom very large and perhaps even out of focus. When one of Vermeer's paintings was x-rayed, it did not have any preliminary sketches on the canvas beneath the paint, but rather, the complete image drawn in black and white without any trial sketches. Vermeer did not have any students, did not keep any records, and did not encourage anyone to visit his studio, facts that can be interpreted

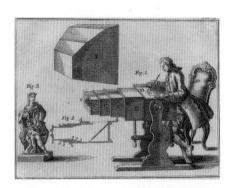

15.22 Georg Brander, *Table Camera Obscura*, 1769. Engraving. Gernsheim Collection, Harry Ransom Humanities Research Center, University of Texas at Austin.

as protecting his secret use of a camera obscura.

In recent times, the British artist David Hockney has published his investigations into the secret use of the camera obscura, claiming that for up to 400 years, many of Western art's great masters probably used the device to produce almost photographically realistic details in their paintings. He includes in this group Caravaggio (2.92 and 15.32), Hans Holbein (12.8), Leonardo da Vinci, Diego Velázquez (15.33), Jean-Auguste-Dominique Ingres (2.36 and 2.79), Angelo Bronzino (5.3), and Jan van Eyck. From an artist's point of view, Hockney observed that a camera obscura compresses the complicated forms of a threedimensional scene into twodimensional shapes that can easily be traced and also increases the contrast between light and dark, leading to the chiaroscuro effect seen in many of these paintings. In Jan van Eyck's The Marriage of Giovanni Arnolfini and Giovanna Cenami (15.23), the complicated foreshortening in the chandelier and the phenomenal detail in the bride's garments are among the clues that Hockney thinks point to the use of the camera obscura.

So what are we to conclude? Even if these artists did use a camera obscura, does that diminish their stature? Hockney argues that the camera obscura does not replace artistic skill in drawing and painting. And experimenting with it, he found that it is actually quite difficult to use for drawing, and speculates that the artists probably combined their observations from life with tracing of shapes.

15.23 Jan van Eyck, *The Marriage of Giovanni Arnolfini and Giovanna Cenami*, 1434. Oil on oak panel, $32\frac{1}{4}\times23\frac{1}{2}$ ins (81.8 \times 59.7 cm). National Gallery, London.

15.24 Sandro Botticelli, *The Birth of Venus*, c. 1482. Tempera on canvas, 5 ft 8 ins ×9 ft 1 in (1.75 × 2.78 m). Galleria degli Uffizi, Florence.

held that artists should be trained in grammar, geometry, philosophy, medicine, astronomy, perspective, history, anatomy, design theory, and arithmetic. In his splendid gold-covered *Gates of Paradise* (15.25), paneled with ten scenes from the Old Testament, he used linear perspective as well as low relief to create the illusion of very deep space.

HIGH RENAISSANCE IN ITALY

During the brief period in Italy now known as the **High Renaissance**, roughly 1490 to 1520, a number of artists centered in Rome created some of the best-loved works of Western art. This great outpouring was freed from the stylized conventions of earlier sacred art, and informed by but not held to Classical traditions.

Leonardo da Vinci applied his inventive genius to many fields, including art, and was thus the epitome of the "Renaissance man." His searching mind led him to engineering, mathematics, music, poetry, architecture, and natural science, as well as painting and sculpture. He continually studied animals, plants, human anatomy, the movement of water, and the play of light

and shadow for a fuller understanding of the natural world. In art, his beautifully observed figure drawings are still consulted by artists as guides to the depiction of human anatomy. He used chiaroscuro effects not only to round his forms in space but also to enhance the emotional qualities of his paintings and guide the viewer's eye. In his compelling *The Virgin of the Rocks* (15.26), light glimmers on the flesh of the sacred figures and beckons in the mysterious distance.

It was Leonardo who also developed **sfumato** modulations in oil painting to soften contours and create hazy atmospheric effects. Ever experimenting, he completed few works. His famous *The Last Supper* (3.32) was done in tempera with a ground of pitch and mastic that he had invented—and which soon began to break down, requiring a series of restorations, as described on page 232.

The work of Michelangelo was passionately individualistic, glorifying the divine in the individual. After hundreds of years, people are still deeply moved by Michelangelo's *Pietà* (15.27), sculpted when he was only twenty-four years old. He regarded the human

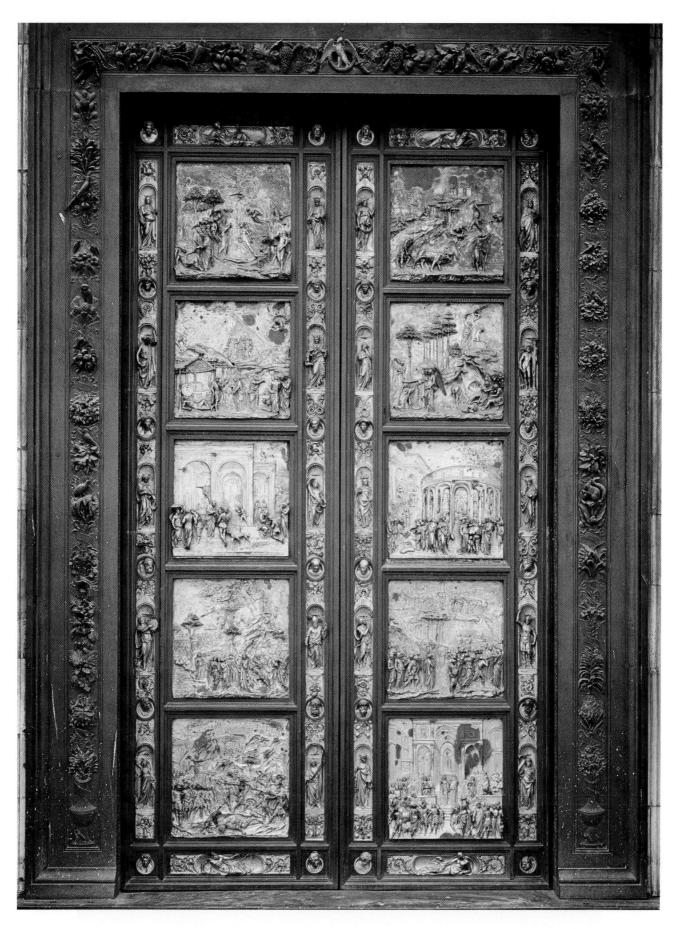

15.25 Lorenzo Ghiberti, Gates of Paradise, 1424–52. Gilt bronze, height 17 ft (5.2 m). Baptistery, Florence, Italy. Ghiberti's Gates of Paradise reflect his goal to "imitate nature as much as possible ... with buildings drawn to the same proportions as they would appear to the eye and so true that, if you stand far off, they appear to be in relief."2

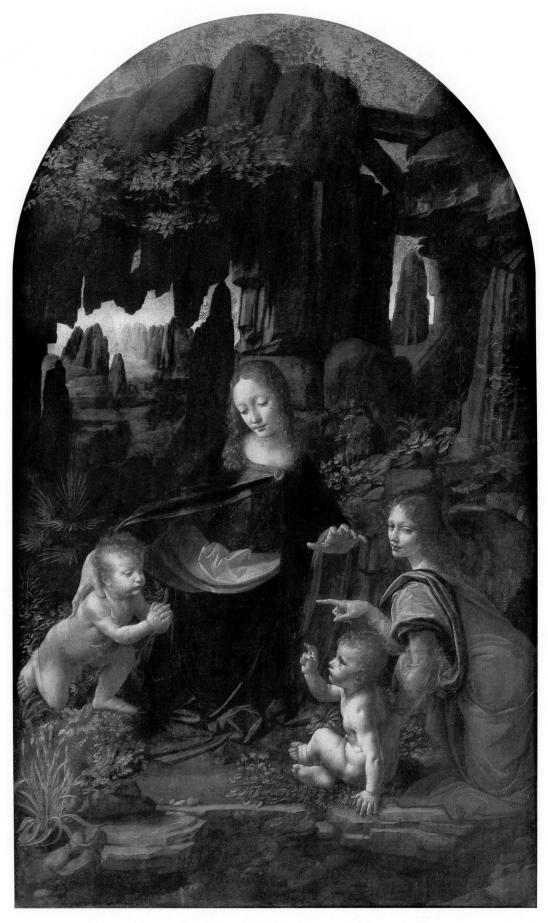

15.26 Leonardo da Vinci, *The Virgin of the Rocks*, c. 1485. Oil on panel, 6 ft 2% ins \times 3 ft 11% ins (1.89 \times 1.2 m). Louvre, Paris.

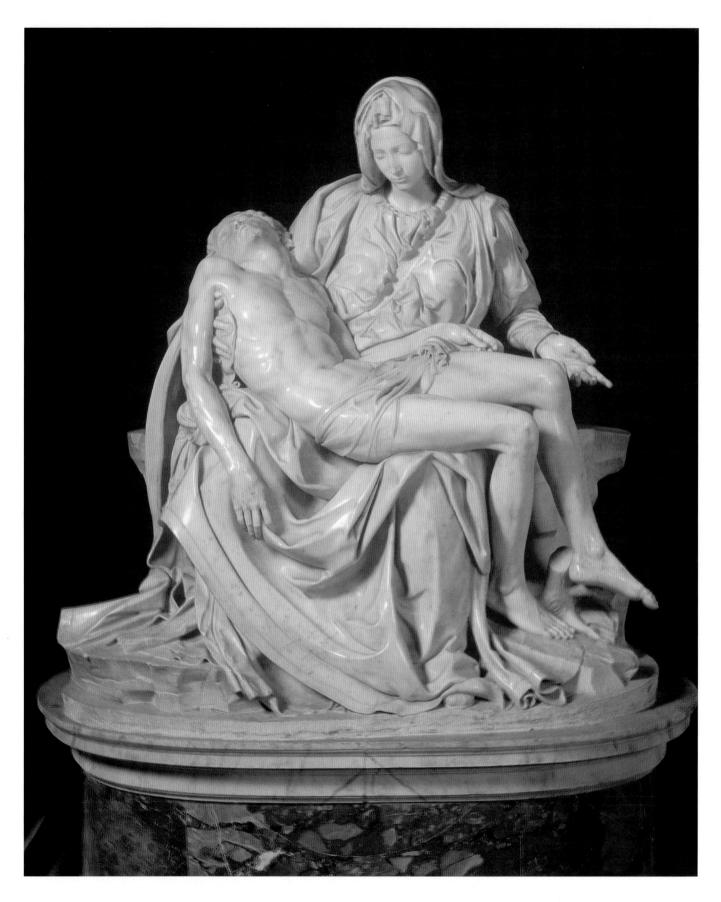

15.27 Michelangelo Buonarroti, *Pietà*, 1499. Carrara marble, height 5 ft 9 ins (1.75 m). St. Peter's, Rome. *Michelangelo was critical of all human authority but strove to reveal the beauty inherent in the natural world. His* Pietà is an extremely touching spiritual composition that emphasizes the great compassion of the divine Mother, and also a marvel of naturalistic surface textures belying the reality of the cold stone.

15.28 Raphael, *The School of Athens*, 1509–11. Fresco, 26×18 ft (7.9 \times 5.5 m). Stanza della Segnatura, Vatican Palace, Rome.

body as the prison of the soul, noble on the surface and divinely yearning within, and experienced sculpting as liberating a living form from inert stone. In addition to his anatomically and emotionally powerful sculptures, he also painted the vast Sistine Chapel ceiling (16.14) in an agonizingly awkward upward-looking position. Perhaps the extreme example of the Renaissance ideal of human freedom, Michelangelo refused to be enslaved by tradition or other people's standards, recognizing only his own divinely inspired genius and his longing for beauty as his guides.

The artist whose work most clearly characterizes the High Renaissance was Raphael. In contrast to Michelangelo's passion and Leonardo's inventiveness, Raphael's work emphasizes Classical harmony, reason, and idealism. His *The School of Athens* fresco (15.28) stands as a symbol of the humanistic High Renaissance appreciation of learning. The central figures are Plato and Aristotle, flanked by other ancient philosophers,

mathematicians, scientists, and their students, including Pythagoras writing at the lower left and Euclid demonstrating a theorem at the lower right. This serenely balanced composition covers a 26-foot (8-m) span at the Vatican Palace in Rome. Raphael further developed the triangular composition associated with Leonardo, and it was thereafter used extensively in depictions of the Madonna and the Holy Family.

NORTHERN RENAISSANCE

Beyond the Alps, the explosion of creativity in Italy at first had little effect on artists still following Late Gothic traditions until 1520, when distinctively northern and Protestant versions of the new trends appeared briefly and vigorously in Germany. At one extreme was the dramatic intensity of Matthias Grünewald's work, such as *The Isenheim Altarpiece*, with its agonizing outer *Crucifixion* panel, and exuberant inner *Resurrection* panel (15.29).

15.29 Matthias Grünewald, The Resurrection, from The Isenheim Altarpiece, c. 1510–15. Oil on panel, 8 ft 10 ins \times 4 ft 8 ins (2.7 \times 1.4 m). Musée Unterlinden, Colmar, France.

Grünewald's buoyantly resurrected Christ poses an extreme contrast to the central panel of the altarpiece, which dramatizes the suffering of the Crucifixion.

Protecting Famous Artworks

WHEN TOURISTS FROM around the world visit the Louvre in Paris, seeing Leonardo's Mona Lisa at first hand is the most essential experience the majority of them are seeking (2.95 and 15.30). But nowadays the object of their pilgrimage can be viewed only in a temperature- and humiditycontrolled box through a protective bulletproof shield of 1.52-inch (3.8-cm) thick nonreflective glass. They are held at a distance by a wood railing, which also helps to control the crowds as some six million visitors try to visit the painting every year. They are warned not to photograph the painting, much less try to get closer to it. Within its hermetically sealed box, the painting is quite dirty, for the museum curators dare not remove its yellowed varnish lest there be a public outcry. A twenty-four-hour alarm system is always on alert to prevent damage or theft.

With all these protective measures, what is left of the intimate encounter between the viewer and the famous artworks? The *Mona Lisa* has become a sacred icon of sorts. Museum officials have taken extreme measures to protect the painting precisely because it is so famous.

The bulletproof shield is to protect the painting from physical attack. In 1956, a Bolivian tourist threw a rock at it, damaging the left elbow. The ban on photographs is to prevent flashes of bright light, which could turn the varnish even yellower and change the pigments. The climatecontrol case keeps the painting at 68°F (20°C), with 50-55 percent humidity maintained by boxes of silica gel below, to help preserve the poplar wood panel on which Leonardo painted his famous image. Behind the panel, a series of slats has been added to check its expansion and contraction. Already there is a fine crack descending from the top into the forehead. Monitoring the health of the painting is a precise science, carried out with a sense of sacred duty.

Paintings are designed to be seen only from the front, so they can be mounted behind glass shields if necessary. To protect sculptures from human damage requires measures that distance the public even farther. Famous statues are often cordoned off. After Michelangelo's touching Pietà (15.27) was attacked in 1972 by someone who was out of his senses, a bulletproof glass shield was also placed around it. Without such a shield, the foot of Michelangelo's great statue of David (10.6) was attacked in 1991 by a mentally ill person wielding a hammer. He explained that a woman in a painting by Veronese told him to strike the David. In a moment of sheer madness, the painstakingly and perfectly sculpted end of a toe was reduced to a pile of marble chips and dust. Museum officials are also trying

to find ways to protect the *David* from corrosive dirt particles without surrounding it with glass; one solution may be a curtain of air jets.

The other side of the arguments about protection and seclusion from the public is that masterworks are irreplaceable and can perhaps never be restored to their original condition once they are damaged. Masters such as Michelangelo and Leonardo are rare in human history. But to truly protect their works for posterity would require fully sealing them off from the public in climate-controlled. tamper-proof archives. Herein lie the difficulties. What balance should be struck between the desire of people to see famous works of art and the desire to preserve them as long as possible? Who has the right to see them?

In 1998, the Hermitage in St. Petersburg again put Rembrandt's Danaë on display, but this time behind a barrier, after twelve years of painstaking efforts to restore some of its original beauty, damaged almost beyond salvation by an attacker who threw acid on the painting and slashed it with a knife. And in 1995. the Reina Sofia Museum of Modern Art in Madrid chose to remove the protective glass shield with which it had covered Picasso's Guernica (1.50). Now the great work can be fully seen again, but it is again vulnerable to the unpredictable passions of the viewing public.

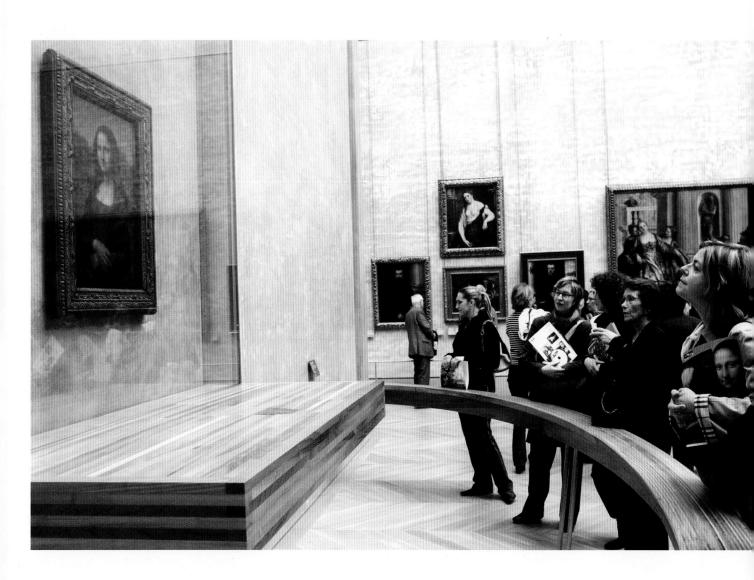

15.30 Visitors view Leonardo Da Vinci's *Mona Lisa* in the Salle des Etats, the Louvre, Paris, 2005.

A.D. 1425-	-1640 Early Renaissance to Southern Baroque	Works of art	Events
1425	Renaissance begins in Italy	 1424–52 Ghiberti, Gates of Paradise, Florence (15.25) c. 1440–45 Fra Angelico, Annunciation, Florence (15.21) c. 1460 Del Pollaiuolo, Battle of the Ten Nude Men, Florence (6.2) c. 1482 Botticelli, The Birth of Venus, Florence (15.24) 	1416–25 Brunelleschi reinvents linear perspective 1431 Joan of Arc burned at the stake 1434–94 de Medici dynasty in Florence c. 1450 printing press invented 1453 Turks enter Constantinople; end of Byzantine Empire
1485	c. 1490–1520 High Renaissance	c. 1485 Da Vinci, <i>The Virgin of the Rocks</i> , Milan (15.26) c. 1495–98 Da Vinci, <i>The Last Supper</i> , Milan (3.32) 1499 Michelangelo, <i>Pietà</i> , Rome (15.27) 1501–4 Michelangelo, <i>David</i> , Florence (10.6) 1509–11 Raphael, <i>The School of Athens</i> , Rome (15.28) 1508–12 Michelangelo, <i>Sistine Chapel ceiling</i> , Rome (16.14)	
	c. 1500–1600 Northern Renaissance	1508 Dürer, Head of an Apostle (2.15) 1510–15 Grünewald, Isenheim Altarpiece (15.29)	Opening of European trade routes 1512–1683 Ottoman Empire 1520–22 Magellan sails round the world
	c. 1525 Mannerism begins	1532 Correggio, <i>Danaë</i> , Rome (<i>5.17</i>) 1554 Cellini, <i>Perseus with the Head of Medusa</i> , Florence (<i>10.13</i>) 1592–94 Tintoretto, <i>The Last Supper</i> , Venice (<i>15.31</i>)	1543 Copernicus refutes geocentric view of universe
1595	Baroque period	1596 Caravaggio, <i>The Calling of St. Matthew</i> , Rome (<i>15.32</i>) 1656 Velázquez, <i>The Maids of Honor</i> , Spain (<i>15.33</i>) 1656 Bernini, Piazza of St. Peter's, Rome (<i>14.8</i>)	1607–19 Kepler establishes planetary systems 1620 Puritans land in New England

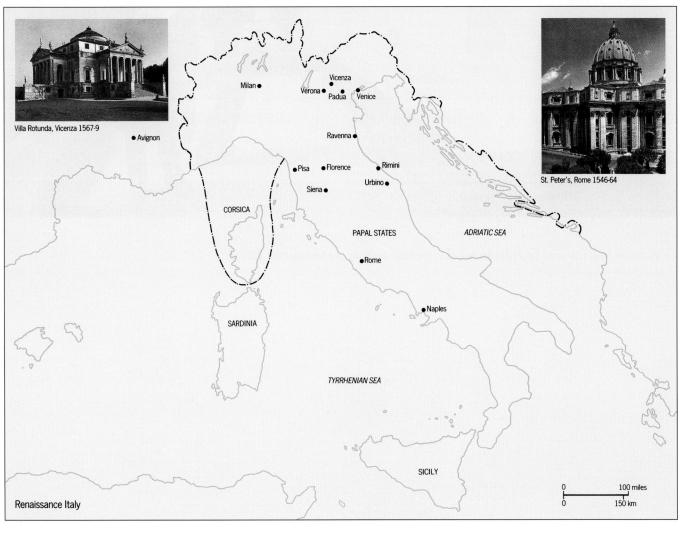

15.31 Jacopo Tintoretto, *The Last Supper*, 1592–94. Oil on canvas, 12×18 ft (3.65 \times 5.5 m). San Giorgio Maggiore, Venice, Italy. Seventeenth-century critics looking back at the work of Tintoretto and others of his period called it "Mannerist" because of its dramatic style, which the critics perceived as over-contrived.

Created for the hospital of a monastery in Isenheim, the altarpiece was normally closed, revealing only the crucifixion on the outer panel, apparently to help patients deal with their own sufferings by seeing the greater sufferings of Jesus on behalf of humanity. On Sundays, the altarpiece was opened, revealing the annunciation, nativity, and resurrection, all of them full of sacred mysteries and celebration, culminating in the risen Christ's brilliant resurrection from the life of the flesh to the life of the spirit. Such a visionary work was made possible by the attacks of the northern Christian humanists on what they regarded as the corrupt authority of the Catholic Church.

While Grünewald was little known at the time, Albrecht Dürer (2.15, 6.6) was a significant artistic influence in northern Europe because his skillful woodcuts and engravings were widely distributed, and because he wrote extensively. He traveled twice to Italy, where he was so impressed by the disciplined, rational approach of the Renaissance artists that he intentionally modeled himself as a humanistic scholar. He wrote

volumes to convince his compatriots of the value of Renaissance approaches to art, including the use of one-point linear perspective and simple, balanced composition.

MANNERISM

In opposition to the humane balance and order of High Renaissance works such as *The School of Athens*, many Italian artists from 1525 to 1600 developed a more self-consciously sophisticated approach called **Mannerism** by their detractors. Bronzino's work (5.3) is one example of the cool, sometimes almost sinister quality of elegance that some artists sought; Correggio (5.17) explored the refinements that technical perfection could lend to sensuality. A comparison of Tintoretto's version of *The Last Supper* (15.31) with that of Leonardo (3.32) reveals the great aesthetic distance between the Renaissance ideals of harmony and logic and the inventive theatricality of Tintoretto's Mannerism, which is considered an outgrowth of the Counter-Reformation. As in his *Leda and the Swan*

15.32 (left) Merisi da Caravaggio, The Calling of St. Matthew, 1596. Oil on canvas, 11 ft 1 in \times 11 ft 5 ins $(3.37 \times 3.47 \text{ m})$. S. Luigi dei Francesi, Rome. Although Caravaggio has broken with earlier tradition by dressing Matthew and Jesus in naturalistic contemporary clothing, he has used the device of a great shaft of light over Jesus' head to symbolize the Light of God that he brought.

(3.12), bodies turn in agitated gestures to tell a story of the infusion of the divine spirit into the bread and wine as if the narrative were being expertly enacted on a stage. In sculpture, Mannerism is most obviously exemplified by the sensuous work of Benvenuto Cellini (10.13).

Baroque Art

The Protestant Reformation was reflected in the work of rather few artists, for reformers such as Martin Luther and John Calvin raised strong objections to lavish expenditures of the Church on religious art. Considering it a potential form of idolatry, Protestant extremists even destroyed existing artwork in churches. Only in the Netherlands was a strong Protestant ethic linked to intense artistic activity, sponsored not by the Church but by the wealthy merchants, who treated art as a commodity to be bought and sold. By contrast, in

areas where the Counter-Reformation was dominant, the Church resumed its commissioning of sacred art as a vehicle for teaching and inspiring the masses with religious subjects, leading to the vigorous **Baroque** movement in which painting, sculpture, interior design, and architecture all merged in the creation of churches and palaces intended to elicit an emotional response in the viewer and create a sense of awe and reverence.

SOUTHERN BAROQUE

Throughout Europe, the seventeenth century was a period in which the new middle classes joined the Church and nobility as patrons of the arts. Art became more realistic and emotional, speaking directly to viewers in sensuous, exuberant forms. In Catholic Italy, the tempestuous Caravaggio opened this Baroque period with his earthy focus on real people, an entirely new concept for religious paintings. In his *The Calling of St. Matthew* (15.32), he dresses Matthew and his companions in contemporary clothes and has them

1500-1800	Northern Renaissance to Rococo	Works of art	Events
1500	c. 1500–1600 Northern Renaissance	1508 Dürer, Head of an Apostle, Nuremberg, Germany (2.15) c. 1510 Bosch, The Carrying of the Cross, Ghent, Netherlands (2.64) c. 1510–15 Grünewald, The Resurrection, Germany (15.29) 1511 Dürer, Saint Christopher, Nuremberg, Germany (6.6) 1565 Bruegel, Hunters in the Snow, Antwerp, Netherlands (2.54)	1517 Reformation begins 1521 Luther translates Bible into German, pub. 1534 1545–64 Catholic Counter-Reformation 1523–1643 Protestant iconoclastic destruction in Netherlands Spread of Humanism, availability of books increases
1600	Northern Baroque	c. 1626 Rubens, <i>The Assumption of the Virgin</i> , Antwerp, Netherlands (15.34) c. 1635 Rubens, <i>Landscape with Rainbow</i> , Antwerp, Netherlands (1.8) 1660 Claude Lorraine, <i>Campagna Landscape</i> , France (4.15) c. 1660 Rembrandt, <i>Self-Portrait</i> , Amsterdam, Netherlands (1.3) 1660–69 Rembrandt, <i>Sleeping Girl</i> , Amsterdam, Netherlands (4.17) c. 1665–70 Vermeer, <i>The Art of Painting</i> , Amsterdam, Netherlands (2.34) 1669–85 Palace of Versailles, France (1.30) 1675–1710 Wren, St. Paul's Cathedral, London (15.35)	1611 first authorized version of the Bible 1663 reorganization of the French Academy 1672 Bellori writes <i>Lives of Modern Artists</i>
1700	Rococo style	1743–72 Neumann, Vierzehnheiligen Church, Germany (<i>15.36</i>)	c. 1710–95 rise of Prussia 1789 French Revolution 1792 Paine, <i>The Rights of Man</i>

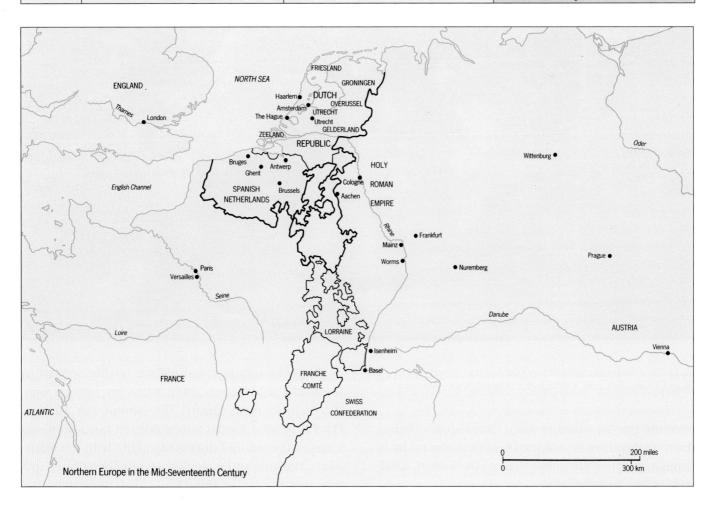

15.33 Diego Velázquez, *Las Meninas (The Maids of Honor)*, 1656. Oil on canvas, 10 ft 5 ins \times 9 ft (3.18 \times 2.76 m). Prado, Madrid.

counting the day's takings when Christ appears before them, recognizing his spiritual beauty in the midst of familiar everyday life rather than in the formal, idealized settings familiar before. The same unposed, naturalistic quality appears in the works of Velázquez, even when his subjects were the Spanish royal family. His famous *Las Meninas* (15.33) is not a formal family portrait but a domestic scene of the young Princess Margarita with her attendants; the king and queen are seemingly reflected in a mirror at the end of the room. Is Velázquez, who has

15.34 Peter Paul Rubens, *The Assumption of the Virgin*, c. 1626. Oil on panel, $49\% \times 37\%$ ins (125.4 \times 94.2 cm). National Gallery of Art, Washington, D.C. Samuel H. Kress Collection.

painted himself before the canvas, looking at them? Does the mirror reflect part of the canvas instead? The artist's fascination with the effects of light is evident not only in these compositional ambiguities but also in the subtle variations of light and shadow throughout the work.

In sculpture, Bernini created ornate new forms for everything from fountains to building façades. His *The Ecstasy of St. Teresa* (1.34) reflects the actively emotional quality of the Baroque period, in contrast to the cool intellectualism of Mannerism. Swirling and diagonal lines create complex circular paths through the piece, which differs from the serenity of Classical draping, and Bernini dares to give St. Teresa a facial expression of supreme ecstasy whose sexual quality is hardly ambiguous. Bernini's approach was soon copied by artists throughout Europe.

NORTHERN BAROQUE

In northern Europe one of the greatest exponents of the Baroque style was Peter Paul Rubens of Antwerp. His *The Assumption of the Virgin* (15.34) represents plump, rounded figures in an appreciative, joyful way, with flowing movement and warm colors. This was spirituality in the flesh. His typically large, swirling paintings are quite recognizable in style, even though Rubens employed a workshop of assistants to do much of the work on his 3,000 signed paintings, a common practice at the time.

In the Netherlands, where a Protestant culture drew its strength from a sober and prosperous middle class which rejected the influence of Rome, Rembrandt emerged as one of the greatest artists of all time. Influenced by the work of Rubens—as well as that of many other artists, including those of non-European cultures—he made use of Baroque devices for leading the eye through undulating three-dimensional space. Highly spiritual, he brought the psychological impact of religious themes directly through to the viewer with subtlety and deep human understanding. His self-portraits (such as 1.3) and treatments of religious subjects, such as *The Three Crosses* (6.19–6.23), are the work of one who feels life profoundly, as well as of a master of the visual arts.

In architecture, the Baroque period was characterized by grand effects and exuberant, swelling forms. This tendency was combined with a certain Classical restraint by Christopher Wren in his rebuilding of St. Paul's Cathedral (15.35) in London. He planned the structure from the bottom up, while it was under construction, and the clearly Baroque dome and towers are wedded to more Classical lower levels inspired by the Italian Renaissance architect Palladio.

ROCOCO

In the late Baroque—or Rococo—period in central Europe (the first half of the eighteenth century), formal restraint was abandoned. In France, painters such as Antoine Watteau and Jean Honoré Fragonard (2.143) honored the whims of the aristocracy (led by Louis XV, who called for a more lighthearted art) with dreamy scenes of carefree and beautiful people in a natural paradise. These visions were rendered with delicate, swirling lines and pastel colors in a style considered so frilly by the French revolutionaries who overthrew the aristocracy that they dubbed it "Rococo," a frivolous concoction of shells. Today the Rococo style is considered to have rather more substance—an intentional freeing of art from academic rules of composition in favor of exuberant, dancing lines and gentle coloring.

Architecture also became unabashedly ornate and fantastic. The most extraordinary of the German Rococo churches is Balthasar Neumann's pilgrimage church of Vierzehnheiligen (15.36). Everything seems to be in constant motion. There are few straight lines; curling motifs developed in France swirl endlessly, and the ceiling is treated to create a floating illusion of boundless space. The gaiety expressed here is a far cry from the heavy, still atmosphere of Romanesque churches or the soaring, vertical thrusts of the Gothic cathedrals—yet all are conducive to certain kinds of spiritual experiences and appropriate for their times.

Eighteenth- and Early Nineteenth-Century Art

In the late seventeenth and eighteenth centuries, movement toward scientific and philosophical rationalism known as the Enlightenment brought new influences to bear on artistic developments. The mathematical arguments of Isaac Newton that the universe runs like a clock according to natural laws gradually led some rationalist thinkers to reject the Judeo-Christian-Islamic belief in a Creator God. The powerful French king Louis XIV, who ruled from 1643 to 1715, was the greatest patron of the arts of the time, exceeding the Church, and with his extensive purchases of Italian painting and sculpture and establishment of royal academies of the arts, he encouraged absolutist conformity to elegant Classical styles (see his Palace of Versailles, Figure 1.30).

15.35 Christopher Wren, St. Paul's Cathedral, London, 1675–1710.

Whereas Classical restraints were particularly strong in French art, a somewhat contrasting **Romantic** movement also developed in the eighteenth century, emphasizing individualistic approaches, subjective emotional and mystical experience, love of nature, folklore, exoticism, and alienation from the urban squalor, mass production, and despoiling of the environment brought by early industrialization. The American Revolution and French Revolution occurred during this period, fueled by powerful yearnings for individual liberty.

NEOCLASSICISM

In the swings of action and reaction that increasingly characterized art movements, the late eighteenth century brought another return to the aesthetics of ancient Greece and Rome. As a reaction to Baroque and particularly Rococo styles, and as an expression

of the Enlightenment, artists such as Jean-Antoine Houdon sought a quiet, informal dignity (10.9). Archaeologists' discoveries of Classical cities such as Pompeii gave architects models to follow in their return to noble, restrained buildings. Winckelmann's highly influential *Thoughts on the Imitation of Greek Works of Art* (1755) held that "The only way to become great ... is by imitation of the ancients ... [Art] should aim at noble simplicity and calm grandeur."³

Neoclassical painters tried to re-create the style of Classical sculptures, since little was known of ancient painting. Using his art to encourage reformist patriotism and stoicism during the French Revolution, Jacques-Louis David re-created a story of heroic self-sacrifice from Republican Rome in his *The Oath of the Horatii* (15.37). Its severity and clarity are clear departures from the works of the recent past.

15.37 Jacques-Louis David, The Oath of the Horatii, 1784–85. Oil on canvas, approx 14×11 ft $(4.3 \times 3.7 \text{ m})$. Louvre, Paris.

ROMANTICISM

Throughout the history of Western art certain artists have focused more on emotion and imagination than on the logic and harmony of Classicism. This perennial tendency surfaced in the Romantic movement in the early decades of the nineteenth century. In contrast to the austere Neoclassical attempts to be impersonal, Romantic artists openly expressed their own feelings. In their landscape paintings, newly elevated to a position as significant as figure paintings, they portrayed the natural world as an extension of their own sensibilities, which ranged from the peacefulness of John Constable's rural scenes to the turbulence of J. M. W. Turner's seascapes (5.21). Turner discovered the emotional impact of pure color and pushed it to the point where it almost became the subject-matter.

Théodore Géricault's *The Raft of the Medusa* (15.38) illustrates the emphasis on sensation and passion in content and dynamism in composition that characterized the French version of Romanticism. The huge painting, which implies criticism of the social status quo, depicts the thirteen-day ordeal of the few passengers who survived the sinking of a government ship. They were left adrift on a crude raft by the captain and crew who took the good lifeboats. Emotions of despair, suffering, and hope are built into a strong doubletriangle composition charged with energy.

The mystical prints and paintings of William Blake (3.1) carried something of the passionate emotional content of the Romantic movement, although Blake had his own unique visionary agenda. In architecture, Romanticism was expressed through nostalgia for Gothic structures, eclecticism, and exoticism.

15.38 Théodore Géricault, The Raft of the Medusa, 1818–19. Oil on canvas, 16×23 ft (4.9×7 m). Louvre, Paris.

Later Nineteenth-Century Art

Major social changes accompanied the onset of industrialization in Europe and the United States. New technologies drew workers from the countryside into burgeoning cities, detaching them from the agricultural rhythms of the seasons as well as from traditional ways of life. Previous social and spiritual values were eroded as human-made technologies held out the lure of rapid material progress. Art amidst these social sea-changes was increasingly varied.

REALISM

At odds with the idealized content of both Neoclassicism and Romanticism, another approach to art began to appear as a recognizable movement in France from about 1850 to 1875. It was the work and theories of Gustave Courbet that led this rebellion against the "grand manner." In paintings such as *The Stone Breakers* (15.39), Courbet sought to present real people without artifice rather than idealized or heroic scenes drawn from the artist's imagination. It was his choice of subject-matter—everyday contemporary life—as much as his attempt to portray it truthfully that represented a sharp break with the past. Courbet eschewed historical, mythological, or abstract subjects ("Show me an angel and I'll paint one"), insisting on painting only what he could see, exactly as he saw it, without artistic conventions. In his "Open Letter to a Group of Prospective Students" (1861), Courbet gave a clear definition of Realism:

Painting is essentially a *concrete* art, and can consist only of the representation of things both *real* and *existing* ... Imagination in art consists in finding the most complete expression for an

1750–1950	Neoclassicism to Surrealism	Works of art	Events
1750	Neoclassicism, France	c. 1779–80 Houdon, Bust of a Young Girl, France (10.9) 1784 David, The Oath of the Horatii, France (15.37)	1775–83 American Revolution 1789 French Revolution
1800	Romanticism, France and England	1808 Blake, The Last Judgment, England (3.1) 1818–19 Géricault, The Raft of the Medusa, France (15.38) 1842 Ingres, Two Nudes, France (2.36) 1845 Turner, Looking out to Sea, England (5.21)	1804–14 Napoleonic Empire 1814 first steam engine 1815–50 industrialization of Britain 1837 invention of telegraph 1839 invention of photography (Daguerre) 1848 revolutionary uprisings in Europe
1850	Realism c. 1875–1900 Impressionism 1880–1900 Post-Impressionism	1849 Courbet, The Stone Breakers, France (15.39) 1863 Manet, Le Déjeuner sur l'herbe, France (15.40) c. 1878 Degas, Dancer with a Bouquet, France (2.61) 1881 Renoir, The Boating Party, France (3.28) 1884–86 Seurat, La Grande Jatte, France (15.44) 1892 Monet, Rouen Cathedral, France (15.41) 1889 Van Gogh, The Starry Night, France (1.41) 1892 Gauguin, The Spirit of the Dead Watching, Tahiti (15.42) 1895–98 Cézanne, Still-Life with Apples,	1859 Darwin, <i>Origin of Species</i> 1861–65 American Civil War 1876 Bell patents telephone 1894 Edison invents motion picture
1900	c. 1900–20 Expressionism Fauvism begins 1905 c. 1907–14 Cubism Futurism begins 1910 c. 1916–22 Dada Surrealism begins 1924	France (15.43) 1880–1917 Rodin, The Gates of Hell, France (1.49) 1911 Matisse, The Red Studio, France (2.117) 1911 Braque, The Portuguese, France (15.47) 1913 Boccioni, Unique Forms of Continuity in Space, Italy (15.48) 1917 Duchamp, The Fountain, France (15.50) 1931 Dalí, The Persistence of Memory, Spain (15.51) 1937 Picasso, Guernica, Spain (1.50) 1939–40 Nervi, aircraft hangar, Orbello, Italy (13.33)	1903 Wright Brothers' first flight Rise of women's suffrage movement 1914–18 World War I 1928 first sound movie produced 1939–45 World War II

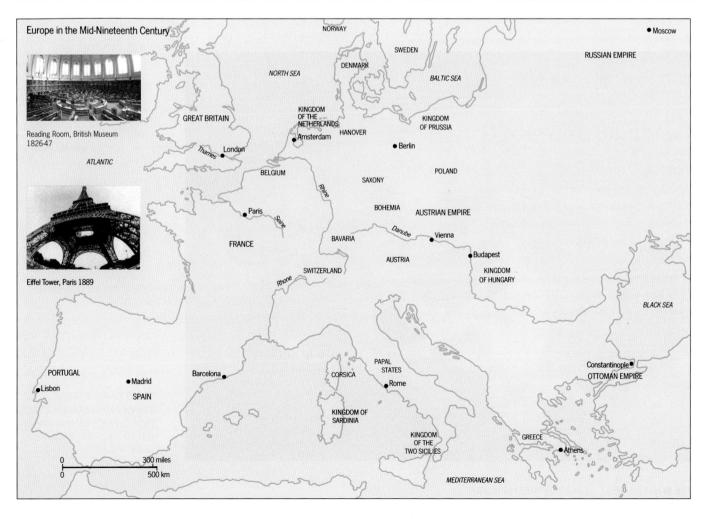

15.39 Gustave Courbet, *The Stone Breakers*, 1849. Oil on canvas, 5 ft 3 ins \times 8 ft 6 ins (1.6 \times 2.6 m). Formerly Gemäldegalerie, Dresden (destroyed 1945).

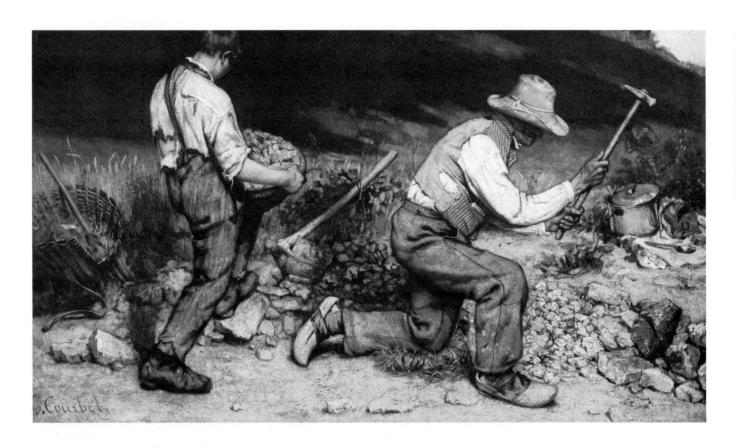

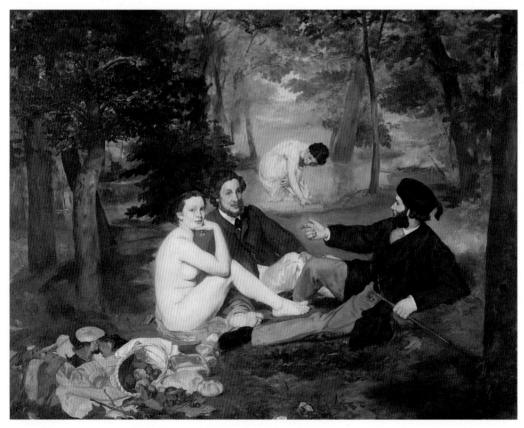

15.40 Edouard Manet, Le Déjeuner sur l'herbe (The Picnic), 1863. Oil on canvas, 6 ft 10 ins \times 8 ft 8 ins (2.08 \times 2.65 m). Louvre, Paris.

existing thing, but never in imagining or creating this object itself ... Beauty as given by nature is superior to all the conventions of the artist.⁴

IMPRESSIONISM

Realism was not considered good art by the academic juries who controlled most of the purchasing of art in France. They also rejected the work of Edouard Manet, whose *Le Déjeuner sur l'herbe* (15.40) shocked even those who visited the counter-exhibition held in 1863 by many angry artists whose work had been refused by the official Salon. Manet used a Classical composition borrowed, in heavy disguise, from Raphael, but in such a manner as to obscure its meaning. In a complex way, he was denying the use of paintings to teach or arouse emotions; paintings, he asserted, can exist for the sheer beauty of colors, light, patterns, and the brush-strokes on the surface of the canvas.

Manet's **Naturalism** was closely followed by a group of artists who were dubbed **Impressionists**. Some of them rejected not only story-telling and meaning but even realistic depiction of objects, seeking instead to capture the ephemeral impressions of light reflecting off surfaces under different atmospheric conditions. If anything, their dabs of unblended colors broke down images into montages of light, as in Monet's *Rouen Cathedral* **(15.41)**. Whereas Realists often worked from photographs of everyday scenes, these Impressionists painted outside in order to observe and record the effects of natural lighting.

Others who are often grouped with the Impressionists—such as Degas (2.61, 4.10)—tried to capture the fleeting action or transient moments rather than focusing solely on the changing effect of light. Renoir (3.28) is also grouped with the Impressionists, but the style of his later works—luminous but blended use of color to describe lush, three-dimensional forms—varied considerably from the increasingly abstract brushstrokes of Monet. Renoir wrote:

I had wrung impressionism dry, and I finally came to the conclusion that I knew neither how to paint nor how to draw Light plays too great a part outdoors; you have no time to work out the composition; you can't see what you are doing If the painter works directly from nature, he ultimately looks for nothing but momentary effects; he does not try to compose, and soon he gets monotonous.⁵

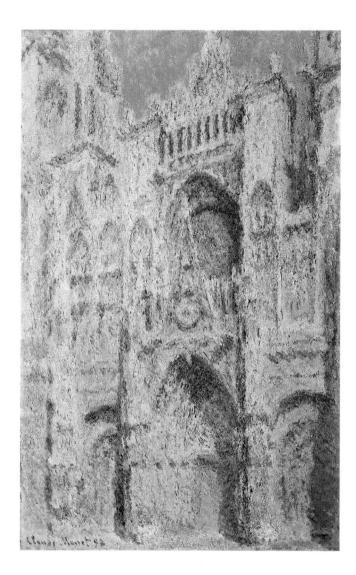

15.41 Claude Monet, *Rouen Cathedral*, 1892. Oil on canvas, $39\frac{1}{4} \times 25\frac{7}{8}$ ins (99.3 × 65.7 cm). Metropolitan Museum of Art, New York. Theodore M. Davis Collection, 1915. Monet painted certain scenes again and again under different lighting conditions, trying to capture what the eye was actually perceiving rather than any preconceived notions of objects and local colors. He thus produced twenty paintings of Rouen Cathedral, each differing in its hues and effects of light and shadow.

POST-IMPRESSIONISM

In some art historians' ways of categorizing styles, the late works of Degas and Renoir are included in a group of paintings known as **Post-Impressionist**. In a narrower definition of this style, however, the major Post-Impressionists were Cézanne, Seurat, van Gogh, and Gauguin. What unites them is their movement beyond what they conceived as the limitations of Impressionism and their highly personal explorations of the art of painting. Van Gogh (1.41) distorted lines and forms to express essence; Gauguin (15.42) intentionally rejected a "civilized" style. In Cézanne, by

ARTISTS ON ART

Paul Gauguin on Cross-Cultural Borrowings

CONTACTS BETWEEN CULTURES often bring new influences into art. In the middle of the nineteenth century, European artists began to discover the advanced arts of China and Japan and to take lessons from them. At the turn of the century, Picasso discovered African sculpture in a French museum as a great "revelation," and he became an avid collector of such works, as well as being influenced by them. Paul Gauguin (1848-1903), the French Post-Impressionist painter, has documented his fascination with Oceanic cultures, which deeply affected the style and the content of his work.

Gauguin had what he called "a terrible itching for the unknown."6 Leaving the security of his job as a stockbroker, he traveled widely, living as an impoverished artist. His journals and letters are full of disdain for European culture and idealistic impressions of the materially simpler Oceanic cultures in which he eventually tried to realize his dreams-to "escape to the woods of a South Sea Island and live there in ecstasy and peace."7 But even in Tahiti and the Marquesas, he did not find inner peace, and he openly acknowledged that, while his paintings seemed to be about Oceanic subjects, they were his own inventions. "My artistic center is in my head; I am not a painter who works from nature," he wrote in 1892. "With me, everything happens in my wild imagination."8 The ideas behind his The Spirit of the Dead Watching (15.42) are those of a European wondering about something he does not fully understand. The painting thus evokes in the viewer as well a sense of mystery:

"A young native girl lies on her belly, showing a portion of her frightened face. She lies on a bed covered with a blue *pareo* and a light chrome-yellow sheet. As it stands, it is a slightly indecent study of a nude, and yet I wish to make a chaste picture of it, and imbue it with the native feeling, character, and tradition.

"The pareo being closely linked with the life of a Tahitian, I use it as a bedspread. The sheet, of bark-cloth, must be yellow, because, in this color, it arouses something unexpected for the spectator, and because it suggests lamplight. I need a background of terror, purple is clearly indicated.

"I see only fear. What kind of fear? The *tupapau* (Spirit of the Dead) is clearly indicated. For the natives it is a constant dread. Once I have found my *tupapau* I attach myself completely to it, and make it the motif of my picture. The nude takes second place.

"What can a spirit be, for a Maori? She knows neither theater or novels, and when she thinks of someone dead, she thinks necessarily of someone she has seen. My spirit can only be an ordinary little woman.

"The title has two meanings, either she thinks of the spirit; or, the spirit thinks of her. The Soul of a living person linked to the spirit of the dead. Night and Day."

As well as being intrigued by the Oceanic people and landscapes, Gauguin had great admiration for their design traditions. His own increasing use of large areas of relatively flat colors and abstracted shapes is probably influenced by the

traditional approaches to design in the cultures he adopted. He wrote:

"We do not seem to suspect in Europe that there exists, both among the Maoris of New Zealand and the Marquesans, a very advanced decorative art. In the Marquesan especially there is an unparalleled sense of decoration. Give him a subject even of the most ungainly geometrical forms and he will succeed in keeping the whole harmonious and in leaving no displeasing or incongruous empty spaces.

"Today, even for gold, you can no longer find any of those beautiful objects in bone, rock, iron-wood which they used to make. The police have stolen it all and sold it to amateur collectors; yet the Administration has never for an instant dreamed of establishing a museum in Tahiti, as it could so easily do, for all this Oceanic art.

"None of these people who consider themselves learned has ever for an instant suspected the value of the Marquesan artists. Dowdy from head to foot, with their superannuated finery, vulgar hips, tumble-down corsets, imitation jewelry, elbows that threaten you or look like sausages, they are enough to spoil any holiday in this country. But they are white—and their stomachs stick out!

"The Marquesan art has disappeared, thanks to the missionaries. The missionaries have considered that sculpture and decoration were fetishism and offensive to the God of the Christians.

"That is the whole story, and the unhappy people have yielded."¹⁰

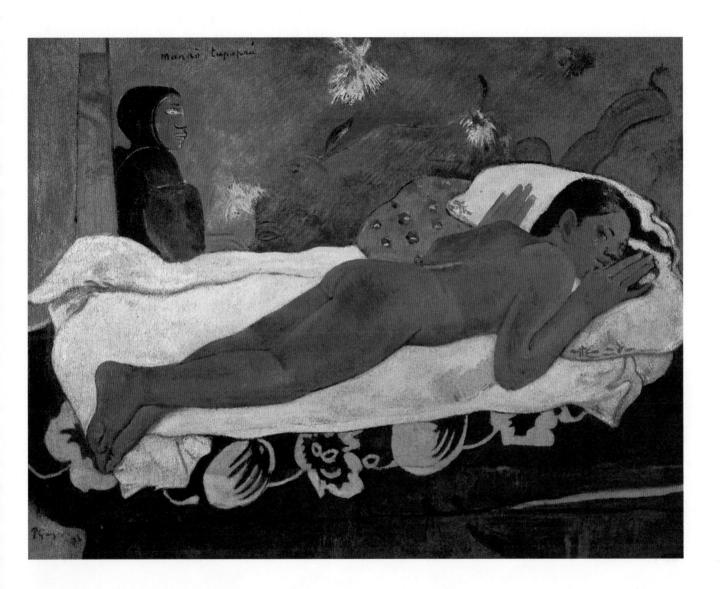

15.42 Paul Gauguin, *The Spirit of the Dead Watching*, 1892. Oil on canvas, $38\frac{3}{4} \times 36\frac{1}{4}$ ins (98.4 \times 92 cm). Albright-Knox Art Gallery, Buffalo. A. Conger Goodyear Collection.

contrast, there was a return to careful composition in an intense search for artistic perfection. But Cézanne did not return to the past; rather, he was perhaps the pioneering figure in modern painting. Rejecting both the messiness of Impressionism and the conventions of linear perspective used since the Renaissance to give the illusion of form and space, Cézanne tried to reinvent two-dimensional art from scratch. He built up spatial layers, geometric forms, and rhythms with colors, lines, and shapes alone, with careful attention to orderly relationships between forms across the picture plane. Even in his clearly representational works, such as Still-Life with Apples (15.43), he concentrated on meeting aesthetic goals such as balance, intensity of color, and the feeling of depth, even if doing so meant distorting the outlines of objects.

Seurat's approach to painting was highly analytical in approach. His Pointilliste technique of juxtaposing dots of unblended colors (to be blended optically)—as in his ground-breaking painting A Sunday Afternoon on La Grande Jatte (15.44)—is superficially similar to the unblended brushstrokes used by the Impressionists. But the tiny vibrant dots of pigment are meticulously applied to the canvas and are calculated to define shapes rather than allow them to disintegrate under the effects of light. Under Seurat's systematic analysis, forms become precise, almost flat geometric shapes, carefully organized in space. Seurat's clearly delineated shapes and painstakingly applied dots of pigment contribute to a timeless sense of order that is in sharp contrast to the immediacy and spontaneity found in Monet's paintings.

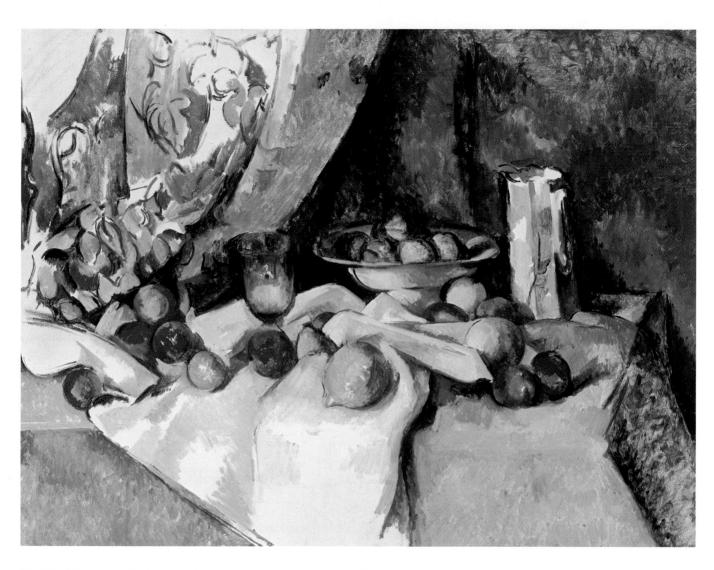

15.43 Paul Cézanne, Still-Life with Apples, 1895–98. Oil on canvas, $27 \times 36\frac{1}{2}$ ins (68.6 \times 92.7 cm). Museum of Modern Art (MOMA), New York. Lillie P. Bliss Collection. 22.1934.

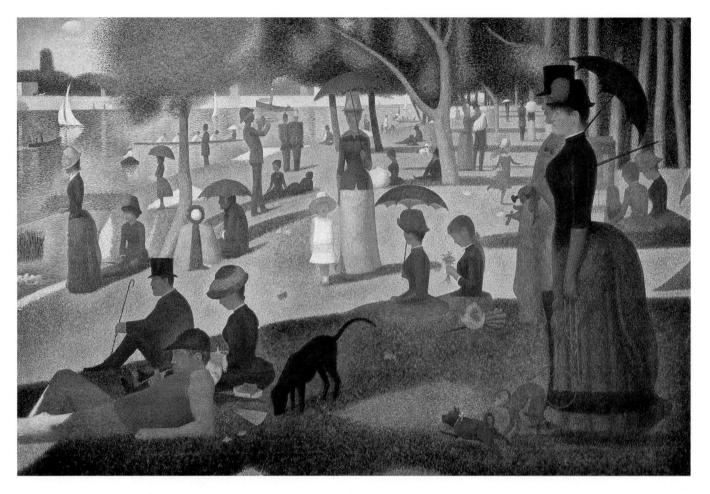

15.44 Georges Seurat, A Sunday Afternoon on La Grande Jatte, 1884–86. Oil on canvas, 6 ft 9 ins \times 10 ft $\frac{3}{2}$ in (2.07 \times 3.08 m). Art Institute of Chicago, Chicago, Illinois. Helen Birch Bartlett Memorial Collection, 1926, 224.

Twentieth-Century Art

Early in the twentieth century, the "modern" age dawned, with new discoveries in physics and a rapid rise in technology—cars, radios, color photography, skyscrapers, highly mechanized factory production, air and even space travel. Time seemed to be speeding up, and with it, some artists perceived themselves as the *avant garde* of political and social progress, abandoning centuries of academic conservatism.

At the same time, the terrible brutalities of World War I, the difficulties of the widespread Great Depression, particularly in the United States, and the skepticism of science drew many sensitive people toward pessimism about life in general. After World War II, the breakdown not only of the extended family but also of nuclear families, and the Cold War fears of nuclear holocaust brought doubts that humanity had a future. In the face of these realities, many artists

withdrew from social and historical associations and began to make art that was neither beautiful nor object-oriented, nor did it attempt to please the masses. They disdained the popular culture. Art existed in an ivory tower, "art for art's sake alone." From this point of view, humans seem to be capable of great savagery and to be strongly influenced by the unconscious, as explored by Freudian psychology. The universe itself may be chaotic or paradoxical rather than clearly ordered by a divine hand or by natural laws which can be neatly discerned and harnessed by human logic and scientific research. In the search for truth, plumbing of one's own inner depths may be more to the point than looking for meaning in nature, society, or religious subjects. Indeed, individual creativity and originality is prized more than adherence to accepted canons of aesthetic quality.

The art of the twentieth century thus cannot be neatly pigeonholed, for during the "modern" age and

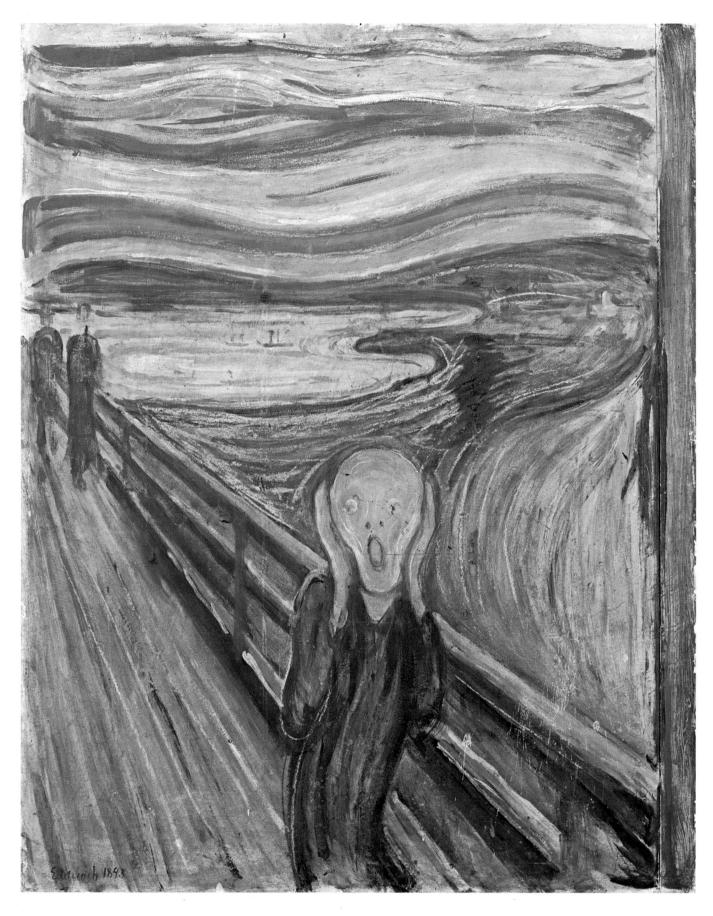

15.45 Edvard Munch, *The Scream*, 1893. Oil, pastel, and casein on cardboard, 36×29 ins (91.4 \times 73.6 cm). National Gallery, Oslo.

15.46 Henri Matisse, *Femme au Chapeau* (Woman with the Hat), 1905. Oil on canvas, $31\% \times 23$ ins (80.7 \times 58.4 cm). San Francisco Museum of Modern Art, Bequest of Elise S. Haas.

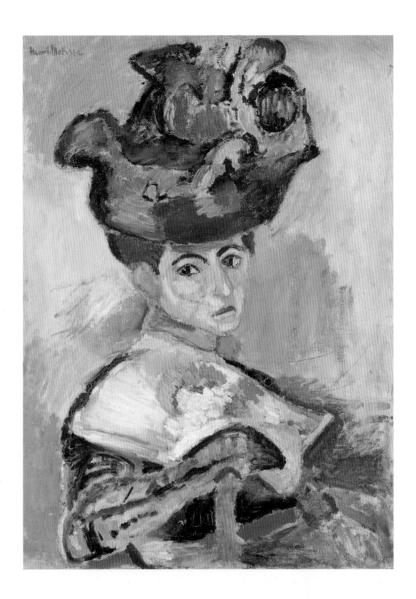

then the **post-modern** period of reaction against "modernism" which began during the 1970s, many different art movements coexisted.

EXPRESSIONISM

Art used as a vehicle for the portrayal of inner psychological states has been called Expressionism. This tendency was already evident in the late works of van Gogh (1.41), for whom trees and sky writhed in sympathetic resonance with his intense inner torments. The Norwegian Edvard Munch abandoned any attempt at objective reporting of external realities in his *The Scream* (15.45). The terror he feels inside becomes visible as wave upon wave of undulating colored bands, filling the environment. Prior to World War I, German artists in groups called *Die Brücke* ("The Bridge") and *Der Blaue Reiter* ("The Blue Rider") became Expressionists, usually portraying states such as anxiety or anger rather than the hopeful sweetness and materialistic complacency they perceived in French

Impressionism. German Expressionism encompassed many of the arts, including filmmaking, with works such as *The Cabinet of Doctor Caligari* (8.24).

FAUVISM

Meanwhile, in France a group of artists led by Matisse held an exhibition in 1905 of works so revolutionary that the artists were called *les Fauves* ("the wild beasts"). They had abandoned any attempt at descriptive, naturalistic use of color and, in some cases, form. Instead they used these elements of design as ends in themselves or expressions of the essence of things, freed from strict associations with the observable world. Henri Matisse's *Woman with the Hat* (15.46) illustrates the use of semirealistic forms with free choice of colors. In his *The Red Studio* (2.117), forms are translated into flat shapes and painted with seemingly childlike abandon. Matisse had serious and orderly intentions, however. He rejected the "jerky surface" of Impressionist paintings, complaining:

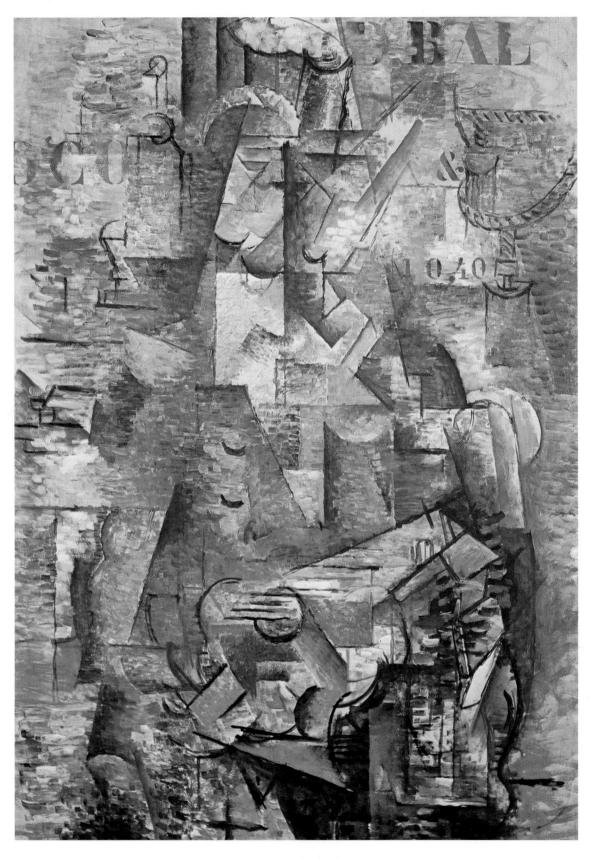

15.47 Georges Braque, *The Portuguese*, 1911. Oil on canvas, $45\% \times 31\%$ ins (116 \times 81 cm). Kunstmuseum, Basel. In the "Analytical Cubism" of Braque and Picasso, subject-matter is almost lost, as it is broken into flat, intersecting shapes without any single lighting source and without reference to deep space.

The splitting up of color brought the splitting up of form and contour ... Everything is reduced to a mere sensation of the retina, but one which destroys all tranquility of surface and contour. Objects are differentiated only by the luminosity that is given them. ¹¹

By contrast, Matisse sought to create the sensations of space and form by using color purely and simply rather than in dabbed spots. Moreover, he felt that color, like other elements of design, should serve the expressive purposes of the artist. Matisse's seminal experiments in modern art continued, but the **Fauve** group disbanded after three years.

CUBISM

The next significant steps in modern art were taken by Pablo Picasso and Georges Braque. Some of Picasso's early paintings, such as The Old Guitarist (2.116), were delicately representational. But in 1907 he abruptly switched directions. Heavily influenced by the geometric forms of Cézanne and the stylization of African sculpture, Picasso suddenly launched a new style with the large and shocking painting Les Demoiselles d'Avignon (15.1). Disassembling and reassembling the women's bodies as a series of disjointed planes, Picasso opened the way for an angular, analytical movement known as Cubism, experimenting with multiple points of view in which figures are seen from many sides at once. In this he worked closely with Georges Braque, in whose work the subject sometimes becomes almost totally lost from view, as in *The Portuguese* (15.47).

Of this highly intellectual approach to art, Braque wrote, "The senses deform, the mind forms. Work to perfect the mind. There is no certitude but in what the mind conceives." And Picasso asserted, "Nature and art, being two different things, cannot be the same thing. Through art we express our conception of what nature is not." ¹³

FUTURISM

In Italy, the sweeping changes of an industrializing civilization were answered by a call for revolution in the arts. In 1910 a group of artists set forth a passionate statement they called the *Manifesto of the Futurist Painters*. It contained these conclusions:

Destroy the cult of the past, the obsession with the ancients, pedantry and academic formalism ...

Elevate all attempts at originality, however daring, however violent ...

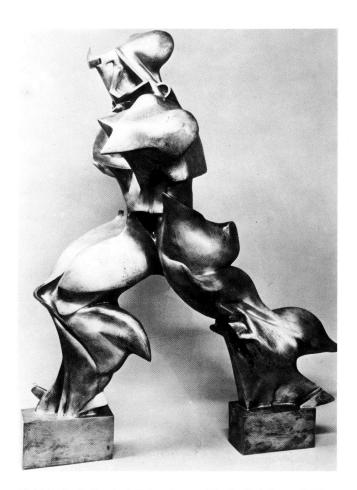

15.48 Umberto Boccioni, *Unique Forms of Continuity in Space*, 1913. Bronze (cast 1931), $43\% \times 34\% \times 15\%$ ins (111.2 \times 88.5 \times 40 cm). Museum of Modern Art (MOMA), New York. Acquired through the Lillie P. Bliss Bequest. 695.1949.

Regard art critics as useless and dangerous ... Rebel against the tyranny of words "harmony" and "good taste" ...

Support and glory in our day-to-day world, a world which is going to be continually and splendidly transformed by victorious Science.¹⁴

The principal aesthetic attempt of the **Futurists** was to capture in art the vigor, speed, and militant pride they felt characterized modern life. In paintings, this meant portraying successive movements over time, as Duchamp had done in the "dynamic cubism" of *Nude Descending a Staircase* (2.141). In sculpture, Umberto Boccioni tried to express not form but action in works such as *Unique Forms of Continuity in Space* (15.48).

ABSTRACT AND NONOBJECTIVE ART

In the same year that Boccioni's *Unique Forms* was completed, the Russian-born painter Wassily Kandinsky created another of the abstract paintings he had been working on for several years: *Improvisation No. 30*

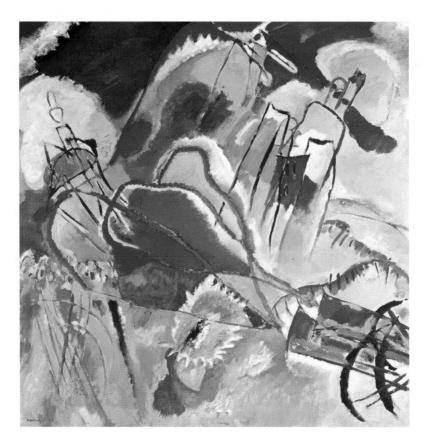

15.49 Wassily Kandinsky, *Improvisation No. 30 (Cannons)*, 1913. Oil on canvas, 3 ft $7\frac{1}{4} \times 3$ ft $7\frac{1}{4}$ ins (1.10 \times 1.10 m). Art Institute of Chicago, Chicago, Illinois. Arthur Jerome Eddy Memorial Collection, 1931, no. 511.

(15.49). In the intellectual ferment that followed the freeing of art from meaning, naturalistic representation, and academic aesthetic standards, Kandinsky's piece reflected the penultimate stages of movement away from art that tries to represent forms from the outer world. In Kandinsky's painting, bare references to the phenomenal world are retained only to keep art from descending to mere pattern-making; he uses colors and barely recognizable forms (here, cannons and tall buildings) to lead the viewer into a world of non-material spiritual realities.

Piet Mondrian used the process of **abstraction** to strip natural forms to their aesthetic essence, as in his abstract paintings of trees (1.10–1.12). But he—as well as generations of later twentieth-century artists—soon abandoned all references to natural forms, creating purely **nonobjective** art. Works such as *Composition in Blue, Yellow, and White* (1.13) and *Fox-Trot A* (2.12) were so different from traditional paintings that Mondrian offered many written explanations of the theories behind nonobjective art. No longer were paintings self-evident; one needed an intellectual understanding of the artist's intention. Mondrian held that because paintings are created on a flat surface, they should

honor that flatness rather than trying to give it the illusion of three-dimensionality. Furthermore, line and color are the essence of art, and to be seen most clearly they should be separated from forms to which each person brings personal associations. To display line and color nonobjectively, Mondrian chose the "universal" or "neutral" form of the rectangle.

DADA

In contrast with the sublime rationality of Mondrian's theories and paintings, a group of rebellious artists and authors in Zurich launched in 1916 an anti-rational, anti-aesthetic movement called **Dada**, babytalk which they claimed meant nothing. The members of this highly influential movement had decided that humans were so unjust to each other that they did not deserve art, so they set out to destroy it. The ironically humorous, intentionally uncensored output of the group included offbeat art forms with titles such as "rubbish constructions," "rayographs," "exquisite corpses," and "ready-made objects."

Marcel Duchamp's *The Fountain* (15.50) is one of the more infamous examples of Dadaist "art." It consists solely of a men's urinal, purchased from the Mott

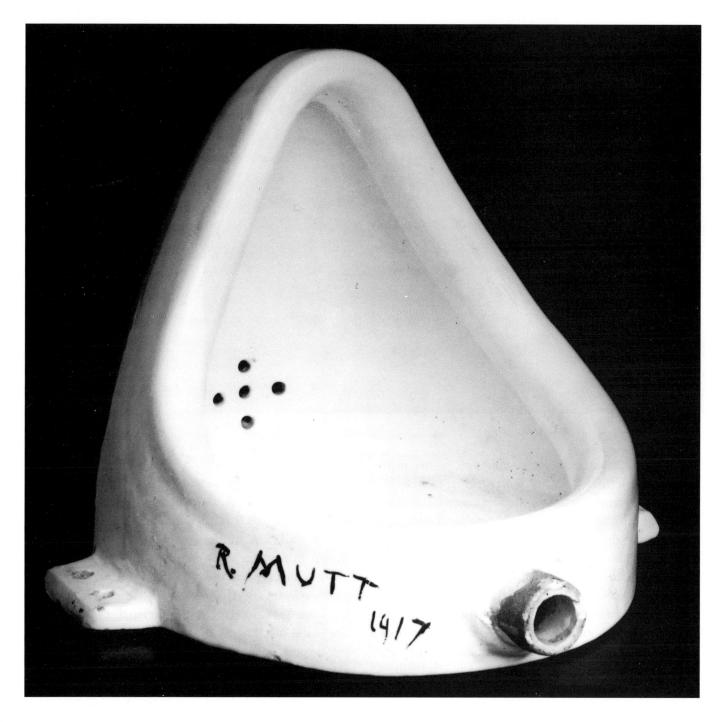

15.50 Marcel Duchamp, The Fountain, 1917. Ready-made, porcelain urinal on its back, inscribed on upper edge. Sidney Janis Gallery.

Works Company and presented lying on its back, otherwise unaltered except for the crude signature Duchamp painted on the front, "R. Mutt, 1917." This "work" defies not only logical analysis but also the traditional minimal expectation that art is something physically created by the artist. The anarchistic Duchamp claimed that it is simply the act of choice that defines the artist. In a tongue-in-cheek defense of the art of "R. Mutt," which was banned from an exhibition, an anonymous article apparently written by Duchamp insisted:

Now Mr Mutt's fountain is not immoral, that is absurd, no more than a bathtub is immoral. It is a fixture that you see every day in plumbers' show windows.

Whether Mr Mutt with his own hands made the fountain or not has no importance. He CHOSE it. He took an ordinary article of life, placed it so that its useful significance disappeared under the new title and point of view—created a new thought for that object.¹⁵

15.51 Salvador Dalí, *The Persistence of Memory*, 1931. Oil on canvas, $9\frac{1}{2} \times 13$ ins (24.1 \times 33 cm). Museum of Modern Art (MOMA), New York. Given anonymously. 162.1934.

SURREALISM

Many of the Dadaist artists became part of the next major twentieth-century movement: Surrealism, in which the source of images is the subconscious. Rather than abandoning forms, surrealists render them with the illogic of dreams. Based on the theories of Freud, this approach spanned the period between World Wars I and II, for the most part, though surrealistic elements had appeared throughout the history of art and still do. One of the most famous Surrealist artists is Salvador Dalí, whose 1928 movie Un Chien andalou (8.25) was like a bad dream in itself. Expressed in a static painting rather than a time sequence, Surrealism often relies on unusual perspectives and symbols to express the apparently realistic but logically impossible contents of dreams. In Dalí's The Persistence of Memory (15.51), there is a haunting sense of loneliness and of time become meaningless. Melting watches, lightstruck cliffs, and unrecognizable forms are meticulously described, as if in a vivid hallucination.

TRADITIONAL REALISM

While all these modernist movements were cropping up, many artists continued to work in a variety of traditionally realistic, representational styles. The United States particularly had an historical fondness for realistic art, and even after industrialization brought the country into the forefront of international commerce many artists retained a distinctive appreciation for naturalistic representation of life in their homeland. The emerging artform of photography was dominated in the United States by those who wanted to remain true to their subjects, as well as their medium, such as Alfred Stieglitz (8.9), Dorothea Lange (8.10), and Ansel Adams (8.13). A number of painters who had been drawn to abstract movements in Europe returned to more realistic work, such as the perennially popular Andrew Wyeth. With meticulous tempera technique, he focuses on quietly meaningful rural scenes, such as the world of a small Maine island community as seen by a young woman with polio in Christina's World (15.52). The dreamlike content, asymmetrical composition, and unusual point of view bespeak a modern approach to design, coupled with relatively representational imagery.

ABSTRACT EXPRESSIONISM

A parallel development at the opposite pole from traditional realism established New York as the leading center of modern art in the West. After World War II, the term **Abstract Expressionist** was applied to those of the New York school who rejected traditional European painting styles and instead emphasized the spontaneously expressive gesture and all-over composition, with all areas of the canvas equally important. One of the major figures in this movement was Jackson Pollock. He engaged in what was known as **Action Painting**, throwing or dripping paint with

whole-body motions onto a long sheet of canvas on the floor (15.53). Pollock did not feel that his movements were random; rather, his experience was that they were directed by the psychic forces within himself. To him, his paintings were a direct and fresh expression of the inner life that impels all artists. The frenetic, interlacing lines that he laid down have a restless energy, which leads the viewer around and through, again and again, to no conclusion—perhaps an apt metaphor for the pace and meaninglessness of contemporary urban life. The subjective, "painterly" approach of expressing oneself through freely applied paint was also used by other mid-century New York artists, including Willem de Kooning and to a certain extent Mark Rothko (1.40), and is still present in the brushwork of Karen Cassyd-Lent (9.15), among others.

POST-PAINTERLY ABSTRACTION

As the New York school evolved, many artists developed more controlled nonobjective styles that had in common the attempt to remove the evidence of their presence, allowing their work to stand by itself as a

15.52 Andrew Wyeth, *Christina's World*, 1948. Tempera on gessoed panel, $32\frac{1}{4} \times 47\frac{3}{4}$ ins (81.9 \times 121.3 cm). Museum of Modern Art (MOMA), New York. Purchase. 16.1949.

stimulus to which the viewer can react. Barnett Newman explains these efforts in spiritual terms:

The present painter is concerned not with his own feelings or with the mystery of his own personality but with the penetration into the world mystery. To that extent his art is concerned with the sublime. It is a religious art which through symbols will catch the basic truth of life The artist tries to wrest truth from the void.¹⁶

To engage the viewer in a direct experience of truth without using imagery, the Post-Painterly Abstractionists tended to focus on color and color relationships. The Abstract Imagists (or Chromatic Abstractionists) typically used open, relatively flat but fluid imagery created impersonally by pouring dyes onto unsized canvas, as in the work of Helen

15.53 Jackson Pollock painting. Photo by Hans Namuth.

15.54 Barnett Newman, Vir Heroicus Sublimis, 1950–51. Oil on canvas, 7 ft 11% ins \times 17 ft 9% ins (2.42 \times 5.14 m). Museum of Modern Art (MOMA), New York. Gift of Mr. and Mrs. Ben Heller, 1958.

Frankenthaler (5.27). **Hard-edge** painters created flat, unvarying areas of pigment with immaculately sharp boundaries, sometimes with even nonobjective imagery reduced to a bare minimum. As Barnett Newman suggests by naming the hard-edged painting shown here (**15.54**) *Vir Heroicus Sublimis* ("Heroic, Elevated Man"), such works may have a sublime, Classical effect of ordered perfection and grandeur. But if you stare at his painting for a while, those fine stripes—which Newman called "zips" of light—may begin to create extra optical effects that transcend the flatness of the colossal red field.

In fact, hard-edged paintings are called **Op Art** when they deliberately use the peculiarities of human vision to make people see things that have not actually been physically placed on the canvas. The artist steps back, allowing the experience of the work to take form in the perceptions of the viewer. Josef Albers, highly influential as a teacher as well as an artist, evoked optical color phenomena in his *Homage to the Square* series (2.119). Some Op Art even triggers perceptual effects that create illusions of color, space, and movement in black and white compositions, such as Bridget Riley's *Crest* (15.55).

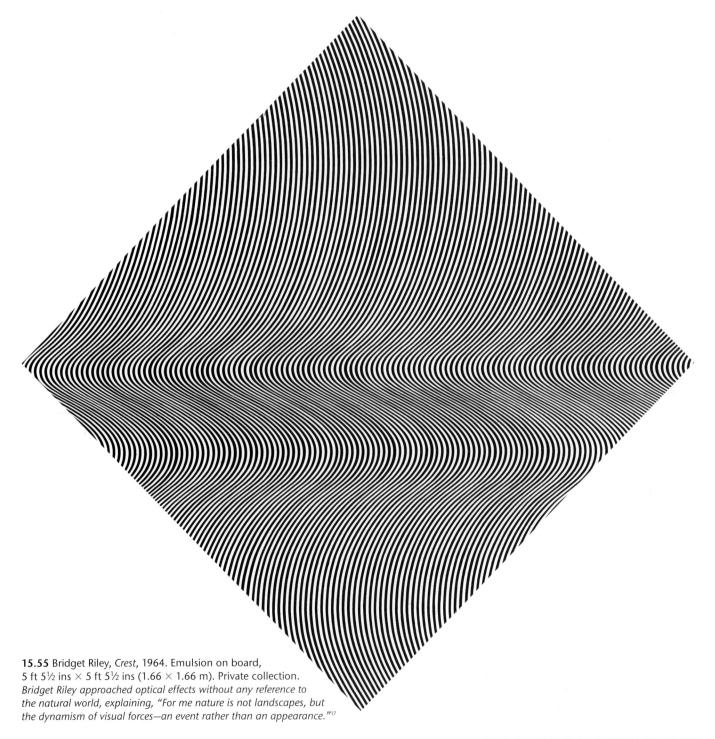

POP ART

Another mid-century direction in modern art emerged in London and has encompassed some artists in the United States. This trend, called **Pop Art**, uses objects and images from popular, commercial culture-from cartoons to beer cans—rather than the rarefied imagery of the fine arts. Some of the work is hostile toward contemporary throw-away culture; some presents it as having a rather zany aesthetic validity. As we have seen, Claes Oldenburg's monuments to the banal (such as his Stake Hitch, 2.66) are humorously conceived. Some of Andy Warhol's famous pop creations, such as the well known painting of 200 Campbell's soup cans or his later self-portraits (6.30), reflect the repetitive visual patterns of the modern marketplace a reminder of the aesthetic realities of modern life that one can interpret as one pleases. Roy Lichtenstein, one of the major early figures of the movement, exaggerated cheap printing techniques by rendering pop culture images with blown-up dot screens. He has carried this approach into the present with works such as Mural with Blue Brushstroke (15.56). It is his desire, he says, for his art to appear impersonal.

15.57 Agnes Martin, *Untitled X*, 1982. Acrylic and pencil on canvas, 72 ins (183 cm) sq. Courtesy Pace Gallery, New York.

MINIMALISM

During the 1960s and 1970s, an influential new trend developed in sculpture and painting, in which form was extremely simplified and expressive content, if any, undefined. **Minimal** art avoided representation and narrative in order to represent merely itself. In three-dimensional work, impersonal industrial materials and techniques were employed, with artists often leaving the execution of the works to industrial fabricators. Sculptures focused on geometry, the reduction of form to its mathematical basis, such as cubes, spheres, or triangles, with nothing to distract the eye or appeal to the senses, such as Noguchi's *Red Cube* (1.31).

One of the pioneers of this movement was Ad Reinhardt, whose totally nonobjective paintings in a single flat color expressed the extreme reductionism of Minimalism. He asserted:

- A fine artist has no use for uses, no meaning for meaning, no need for any need ...
- A fine artist by definition does not use or need any ideas or images,

15.56 (left) Roy Lichtenstein, study for *Mural with Blue Brushstroke*, 1985. Cut-and-pasted paper, pen and ink, pencil, $34\frac{1}{4} \times 17\frac{1}{2}$ ins $(87 \times 44.5 \text{ cm})$. © Estate of Roy Lichtenstein.

does not use or need any help, cannot use or help anyone or anything. Only a bad artist thinks he has a good idea. A good artist does not need anything.¹⁸

This spare aesthetic is apparent in Agnes Martin's paintings. For decades, they have consisted largely of thin parallel lines, as in *Untitled X* (**15.57**). She uses only this simple line, which one critic has called "a signature without an ego," laid down with a ruler, and subtle washes of paint. Paradoxically, when the artist gives so little visual information, the viewer is given an open field in which meaningfulness can be sensed. Minimalism requires maximum imaginative response on the part of the viewer. People tend to respond spiritually to Martin's paintings as if they were seeing fields of luminous space. Martin speculates:

I think that our minds respond to things beyond this world. Take beauty: It's a very mysterious thing, isn't it? I think it's a response in our minds to perfection. My paintings are certainly non-objective. They're just horizontal lines. There's not any hint of nature. And still everybody responds, I think.²⁰

TECHNOLOGICAL ART

Whereas Minimalist sculptors adopted industrial methods to their aesthetic purposes, other twentieth-century artists made machines themselves their expressive media. This approach included projections of light onto translucent screens and the kinetic sculpture of Jean Tinguely (2.138). More recently, technological art has taken forms such as laser and multimedia installations, digital art, fax and photocopy art, and virtual reality works

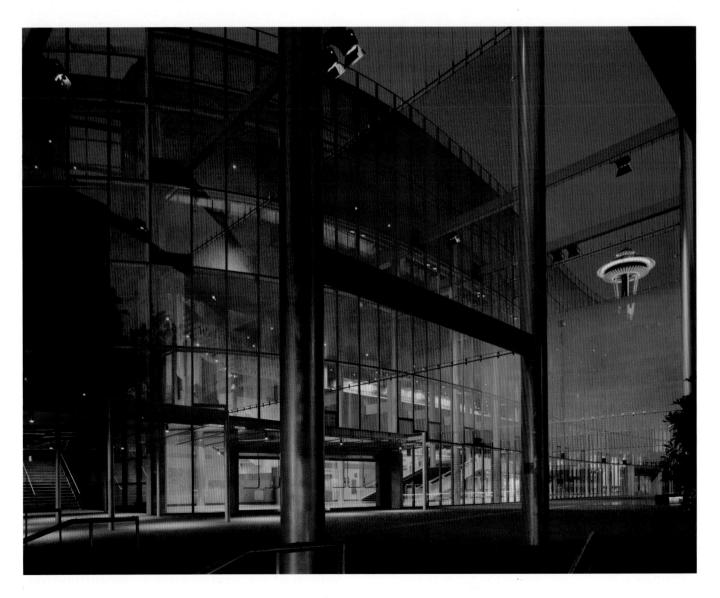

15.58 Leni Schwendinger, *Dreaming in Color*, 2003. Illumination and computer controls, $45 \times 30–50 \times 150$ ft ($13.7 \times 9.1–15.2 \times 45.7$ m). Installation in Kreielsheimer Promenade on the Seattle Center campus, Washington, USA.

15.59 Joseph Kosuth, Zeno at the Edge of the Known World, 1993. Venice Biennale, the Hungarian Pavilion, Venice. Photo courtesy of the artist.

(see Chapters 8 and 9). In Leni Schwendinger's *Dreaming in Color* (**15.58**), a changing array of color atmospheres is created by projections of colored lights onto 45-foot (13.7-m) high scrims. In such pieces, it is a machine that directly creates the art, with the artist one step removed —building, programming, or operating the machine. In virtual reality installations, it is even the observer who seems to create the art by activating devices that produce image, sound, and tactile sensation.

At one time, art and religion were closely linked in the West. Now art and science are forming new alliances, and some very exciting contemporary art is coming out of the high-technology research laboratories, created by people whose skills and sensitivities encompass both science and art. Developments in information technology may in the future be used to create art forms that have never before existed and are even now inconceivable.

CONCEPTUAL ART

During the twentieth century, the definition of art was continually expanded. Art became defined as whatever an artist declares to be art. No longer confined to such traditional media as painting, sculpture, and architecture, art in the hands of some modern artists became almost totally detached from traditional assumptions that artwork implies an object of some sort. Conceptual art, which began to appear in the early 1960s in Europe and America and continues to a certain extent today, rejects the art object as a "degradation" of the artistic project. It deals with ideas and immediate experience rather than with permanent form. Conceptual artists present their underlying idea in some abstract, philosophical way. They tend to focus on art as a visual language, a code with open possibilities, rather than reducing these possibilities to a particular form. If the art has any form, it is regarded as

documentation of the idea rather than its concrete manifestation.

This highly philosophical movement was initially called "anti-art," for it tends to negate the entire history of art and raises fundamental questions about the definition of art. Joseph Kosuth, a pioneering Conceptual artist whose Zeno at the Edge of the Known World (15.59) uses printed words as an obscure visual code, explains:

We don't work with forms and color and other devices. Materials and those other things are simply the vehicles through which one produces meaning. [The important thing] is the thinking. Anybody can buy paint and canvas. ... I don't want the people who see my work to be passive consumers. Work like mine demands completion by the viewers.21

EARTHWORKS

In earthworks, such as Robert Smithson's Spiral Jetty (10.23) and Michael Heizer's City Complex One (2.32), the natural environment itself is drawn into and reshaped as a huge three-dimensional piece. In the artist's hands, the very surface of the earth becomes a sculptural medium, sometimes in locations so remote that few people can experience the work directly.

Robert Smithson explains,

My work is impure. It is clogged with matter. I'm for a weighty, ponderous art. There is no escape from matter. There is no escape from the physical nor is there any escape from the mind. The two are on a constant collision course. You could say that my work is an artistic disaster. It is a quiet catastrophe of mind and matter.²²

James Turrell's experiments with our experience of space from the earth have led him to such ambitious projects as reshaping an extinct volcano as a place for viewing the heavens. Huge quantities of earth have already been "rearranged" for the Roden Crater project in Arizona (15.60) Turrell's grand plan, which has become his lifetime project, involves tunnels, stairways, viewing spaces, and visitors' stations from which to perceive visual phenomena such as celestial vaulting.

15.60 James Turrell, Roden Crater, 1982, aerial view. Photo by James Turrell and Dick Wiser. Courtesy Skystone Foundation and Barbara Gladstone.

15.61 Marina Abramovic, The House with the Ocean View, November 15–26, 2002. Installation at Sean Kelly Gallery, New York.

PERFORMANCE ART

During the 1970s, some artists began creating **performance art** featuring themselves as actor or director of a live event of some sort. A 1999 example of this ongoing movement involved Ming Wei Lee cooking an Asian dinner for a new guest each night. Their conversation while they ate it together, sitting in a New York gallery on a wooden platform, encircled by a ring of dried black beans and resting their feet on mounds of dry white rice, was "profoundly artistic," according to Lee.²³ No audience was present at the time. Documentation of the performance consisted of tapes of these conversations.

Performance art is often deliberately provocative or political, with the motive of challenging existing cultural assumptions and changing the public's awareness. Sometimes the artist's own body becomes the subject of performances involving acts of self-exposure and self-mutilation.

Performance artist Marina Abramovic thus created three ascetic "rooms" in which she lived in silent ritualistic fashion for twelve days in full view of spectators. She took no food, and was constantly on display throughout the days and into the nights, whether using the toilet, showering, gazing at the audience, sitting, standing, turning over the stark furniture, sighing, crying, or quietly laughing to herself. The audience space was fitted with a telescope to make her

even more visible as the effects of fasting became more and more stressful to her body. Abramovic's open-sided rooms for her performance *The House with the Ocean View* (15.61) were connected with the gallery floor by ladders, but their rungs were made of butcher knives. The measured passage of time was marked by the ticking of a metronome. The entire performance was like a public exercise in Buddhist Vipassana meditation, in which the central effort is to keep one's mind fully focused on the present moment. For the most part, the audience of up to 500 spectators per day was also drawn into this meditative atmosphere and maintained respectful silence along with the artist.

INSTALLATIONS

Some artists from the 1970s onward have created three-dimensional works that totally occupy a space, such as a room of a museum or gallery or an outdoor area. Those that are designed for a particular place are called **site-specific**. Often they are installed only temporarily for an exhibition, and this ephemeral quality may be part of the content of the work. Serge Spitzer's *Reality Models—Re/Cycle (Don't Hold Your Breath)* (15.62) was

15.62 (opposite) Serge Spitzer, *Reality Models—Re/Cycle (Don't Hold Your Breath)*, 1999, installed in the Arsenale, Venice Biennale. Installation with approximately 8,000 drinking glasses. Courtesy of the artist.

15.63 William Bailey, Monte Migiana Still-Life, 1976.
Oil on linen,
4 ft 6¼ ins × 5 ft ¾ ins
(137.8 × 152.6 cm).
Acc. No: 1980.2. Courtesy of the the Pennsylvania Academy of Fine Arts, Phildadelphia.

installed in the Arsenale, a 400-year-old shipbuilding facility in Venice, as part of the Venice Biennale, a major international showcase for new art projects. Spitzer's installation used the beams and rafters as well as the floor of the building as surfaces upon which he placed thousands of drinking glasses, so closely spaced and so fragile that one wonders how they were ever placed thus. With shifts of the aging structure and birds flying in to roost, glasses were continually falling and shattering. Six months after its installation, when the Biennale closed, the shards were collected for recycling in nearby factories as Venetian glass. Similarly, as Ann Hamilton's installation mantle (1.47) remained on display for three months, the flowers inevitably wilted and died as the radios continued playing garbled voices and static and a woman kept stitching, stitching, leading the observer to ponder the impermanence of life within the monotony, seeming meaninglessness, and confusion of everyday events.

NEW REALISM

Alongside the various nonobjective movements in twentieth-century art, a number of artists returned to more realistic treatment of actual objects. Their subjects have not necessarily been traditional ones, however. Many have explored the visual facts of industrialized life—the neon-lit shops, fast-food places, city streets, automobiles, depressed or overweight people. This investigation has become super-realistic or photorealistic in the hands of artists such as Chuck Close (5.26) and Richard Estes (2.96). Some are finding beauty in close investigations of features of the environment such as Bill Martin's Abalone Shells (5.25). William Bailey (15.63) has turned from abstraction to figurative subjects in his painting, but with sensitivities developed from modern art, rather than traditional representative paintings. Using objects painted from memory and references to the actual objects, but without setting up a still-life, he works with aesthetic issues such as the meanings of groupings, intervals, tensions between the flatness of the picture plane and the illusion of space, and inferences of diagonals projecting into space. Bailey says, "I wanted a painting that was silent and unfolded slowly, that offered a contemplative situation."24

THE CRAFT OBJECT

In the current redefining of the boundaries of art, one interesting direction is the merger of the fine and applied arts. Industrial design, for example, is benefiting from a sculptural approach, and handcrafts are

15.64 Ryoichi Yoshida, Doll (detail), 1990.

being collected and shown as works of art. Exhibitions of applied design are of great popular interest, and new museums are arising that deal in applied disciplines alone. At the same time, a number of artists trained in traditional crafts are carrying their knowledge and skills into the creation of art for art's sake.

Dollmaking, for example, has been purloined from its traditional use in children's toymaking, and handmade dolls such as those by master dollmaker Ryoichi Yoshida (15.64) are now treated as valuable collectors' items. At costs of up to \$20,000 each, handmade dolls are treated as unique pieces of sculpture rather than as playthings. Yoshida has taken great pains with details such as lifelike painting of the doll's eyes. Contemporary dollmakers go to great lengths to create

not only the doll's body but also its clothing and accessories in delightful miniature scale.

The crossover between functional and fine arts has resulted in entirely new approaches to two- and three-dimensional design. Norma Minkowitz (11.23) crochets three-dimensional forms, resin-coats them to a hard state, and colors their surfaces, thus creating seethrough sculptures that are unlike any that can be developed using traditional sculptural media.

Many pieces bridge crafts and fine arts because although they may be built with craft techniques, they are nonfunctional, meant only to be experienced. Art quilts are often deliberately made too small to fit on any bed; they demand to be hung on a wall and responded to like a painting. As art critic Edward Lucie-Smith observes:

1945-2000+	Into the Twenty-First Century	Works of art	Events
1945	1912–55 Abstract and Nonobjectivism Abstract Expressionism	1950s Jackson Pollock painting, New York (15.53) 1950–51 Newman, Vir Heroicus Sublimis, U.S.A. (15.54) 1956 Rothko, Green on Blue, New York (1.40) 1956–73 Utzon, Sydney Opera House, Australia (13.34)	1944 computer technology developed 1945 atomic bomb dropped on Hiroshima, Japan 1946 xerography invented 1950–53 Korean War
1960	Minimal Art Op Art Pop Art	1968 Noguchi, Red Cube, New York (1.31) 1964 Riley, Crest, England (15.55) 1967 Newman, Voice of Fire, New York (1.24) 1967 Warhol, A Set of Six Self-Portraits, New York (6.30) 1968–69 Close, Frank, U.S.A. (5.26)	1961 Berlin Wall built, East/West Germany 1961–73 Vietnam War 1969 first manned moon landing
1970–2000+	Earthworks	1970 Smithson, Spiral Jetty, Utah (10.23) 1976 Christo, Running Fence, California (2.10)	1970 Greer <i>The Female Eunuch</i> 1978 first test-tube baby born in England
	New Realism		1976 first test-tube baby born in England
	Neoexpressionism	1976 Estes, Double Self-Portrait, U.S.A. (2.96) 1977–84 Hodgkin, Interior with Figures, England (15.65)	1978 personal computers become available
	Technological Art	1983–84 Kiefer, Athanor, Germany (2.55) 1982 Disney Productions, Tron, U.S.A. (9.9) 1992 Csuri, Wondrous Spring, U.S.A. (9.12)	1982 first artificial heart implanted 1986 Chernobyl accident in Soviet Union
	Crafts as Art	2003 The Matrix Reloaded, U.S.A. (8.29) 1989 Minkowitz, Collected, U.S.A. (11.23)	1989 fall of communist governments in
	Conceptual Art		eastern Europe 1990 First Gulf War
	Installation and Performance Art	1993 Kosuth, Zeno at the Edge of the Known World, Venice (15.59) 1998 Hamilton, mantle, Florida (1.47) 2002 Abramovic, The House with the Ocean View, New York (15.61)	1990 Reunification of Germany 1991 Ethnic war shatters Yugoslavia 1996 Hubble telescope opens our universe 1996 Internet connects the world
	Post-modernism	1997 Gehry, Guggenheim Bilbao, Spain (1.51) 2003 + Libeskind, New World Trade Center, U.S.A. (1.25)	2001 September 11th

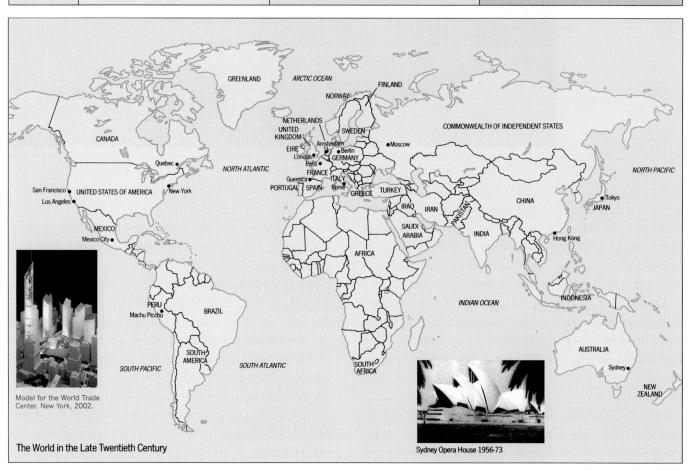

Craft objects increasingly tend to be used in precisely the same way as paintings and sculptures in domestic and other interiors—as space modulators and as activators of particular environments, lending their own emotional coloring. We respect and value them as totems and touchstones as we do fine art.²⁵

NEOEXPRESSIONISM

In the continuing replay of earlier movements, with new twists, a major redirection in painting is called **Neoexpressionism**. Its adherents around the world are using painting to express their own emotions, as the Abstract Expressionists did, but now with figurative imagery that is distorted by those emotions. Images

15.65 Howard Hodgkin, *Interior with Figures*, 1977–84. Oil on wood, 4 ft 6 ins \times 5 ft (1.37 \times 1.53 m). Saatchi Collection, London.

are often derived from the mass media, and the emotional content is typically violent or anguished, charged with energy, as in Anselm Kiefer's *Athanor* (2.55). Howard Hodgkin's *Interior with Figures* (15.65) is a relatively quiet example, but even here the feelings expressed seem charged with sexual energy. Hodgkin tries to recapture the emotion of an experience through evocative objects, colors, and spatial effects. He says, "I want to include more because the more feeling and emotion you include in the painting, the more it will come out the other side to communicate with the viewer."²⁶

POST-MODERNISM

As we have seen, the term "modernist" has been applied to a great variety of twentieth-century movements, giving it considerable imprecision. Nonetheless, it is now common to speak of **post-modernism** as well. This similarly imprecise term was first applied to architecture of the late 1970s that broke out of the austere confines of the International Modern Style glass and steel skyscrapers and eclectically combined stylistic elements from various periods. Modernist movements are still continuing, waxing and waning in popularity, but alongside them, various reactionary styles that can be rather vaguely referred to as "Post-modern" are also vigorously present on the contemporary art scene.

If post-modernism can be defined as a particular style, it is usually used with reference to art that employs an abundance of images from contemporary popular culture as well as eclectic references to past artistic traditions. It may present them as a new synthesis of past and present. Mariko Mori creates unusual hybrid artworks referring to the complex overlaying of the old, new, and futuristic in contemporary Japan. High-technology "Future Pop" and the conflicting roles expected of women are drawn into her pastiche called *Pratibimba I* (15.66).

In contrast to such new syntheses, the post-modern aesthetic may be expressed in fragmented, disjointed fashion, reflecting the fragmentation, commercialism, and meaninglessness that some feel characterize contemporary life. Judy Pfaff's 3D (10.20), for instance, contains many visual references to the chaotic mechanical, electrically wired, despoiled urban environment, as though everything around us has gone haywire.

This trend toward entropy raises new questions about the role of the artist in society. If traditionally the artist tried to discern and communicate meaning-fulness and unity, today many artists are opting instead to communicate the dearth of meaningfulness and unity in society as a whole. **Deconstructionist** architecture, which has appeared in the most materialistic "advanced" cultures—such as Daniel Libeskind's "tumbling blocks" design for an addition to the Victoria and Albert Museum (13.39)—portrays a world that is chaotic and out of balance, as if exploding.

WIDENING OF THE MAINSTREAM

The last decades of the twentieth century witnessed a growth in social activism among artists, bringing forth the voice and art of those who had been ignored in the white Western male dominance of the art world.

Since women have long been devalued in most cultures, so has their art. In the past, relatively few women received art education or recognition as fine artists and their craft works have not been valued as art. One major art history textbook commonly used in the United States contained not a single woman artist in its first edition.

This situation is changing. Art historians are now trying to unearth evidence of art by women from the past, and contemporary women artists are receiving more attention from the world of collectors, galleries, museums, and art critics.

As women's art gains recognition, some women are developing art explicitly about their personal experiences as women. Socially freed to discover their own identity, distinct from cultural roles prescribed for them, many are searching and creating art depicting previously taboo aspects of female life, such as menstrual blood and the vagina, and affirming and celebrating their sexuality. Thus Jan Good has made prints of her own body (6.33), and Shilpa Gupta of Mumbai transcended her orthodox Hindu background, where menstruating women are considered ritually unclean, to prepare an installation made of cloths dyed with the menstrual blood of friends and relatives (15.67).

Another huge section of the world's population has long been ignored by the Western art establishment: the art of non-European people of color. Asian art was "discovered" hundreds of years ago by the dominant European and then the North American

15.67 Shilpa Gupta, *Untitled*, 2001. Installation, menstrual bloodstained cloth.

ARTISTS ON ART

Deborah Muirhead on Art as Ancestral Exploration

DEBORAH MUIRHEAD WAS born in Bessemer, Alabama, in 1949 into an African-American family. She grew up in Chicago, where she spent every Saturday strolling through the Art Institute looking at the paintings and sculpture. She particularly recalls standing before a Georgia O'Keeffe painting of clouds which "made me feel like I was soaring, floating in a sea of blue mist alone and quite safe." Muirhead is now a respected East Coast artist and art professor whose dark abstract paintings (15.68) evoke similar sensations of "something felt and experienced."27 Their abstract subject-matter arises from her compelling interest in researching her roots. She has done extensive genealogical research in census records, county courthouses, and also in novels, poems, and texts on slave history, folklore, folk culture, and life in the agrarian South. She wonders:

"Who were these people in the eighteenth century? What did they believe in, and how much of their belief system survived? The cultural continuities from Africa began to merge with both Native American and Anglo beliefs to form a distinctly new culture.

"As I began researching all of that my paintings got darker and darker. The genealogical research provided a correspondence to the paintings, a mystery, a kind of searching in the dark. I was so immersed in the research that I literally dreamed about these people. They were with me all the time, almost guiding me. The dark paintings challenge the notion of darkness as void; for me,

the dark paintings were full of richness and life. They were about history with all its tragic consequences for people. But they also were about life, and continuity.

"I've been inspired by specific folklore legends, although I try not to illustrate. There is also a continuing legacy of the important effect of water in the lives of West Africans and then of African Americans. Water is traditionally one of the resting places of the ancestral world. The spirits reside in rivers, ponds, and streams. Africans of many tribal groups with this belief system came here and put down roots in this country, continuing belief in water's special spiritual significance. I was interested in the way that belief system combined with new religion which influenced many African Americans: Christianity, particularly Southern Baptist influence, in which there is total water immersion in baptism. The notion that you are a sinner, that you die in the water during total immersion, your sins are washed away, and you are reborn a new person free of your sins combined powerfully with the beliefs of second- or third-generation African Americans in the spirit world in the water.

"One of the things I've tried to do in this series of paintings is to create a surface that could resemble a watery surface, with undefinable objects, forms, or implements. They seem to arise mysteriously from all of this stuff that I'm thinking about and reading about and totally immersed in. I think in part they are farm implements and objects that might be devices of torture or fragments

that might have some archaeological significance if you knew its context but now are just fragments with no known context.

"Just after I visited the plantation where my people were slaves, the paintings became incredibly dark and opaque. There was almost no point in them in which you could find a light source. In the last year or two there have been more openings in the paintings. I want people to be moved by them-to find their haunting power. Some are moved by an overwhelming sense of tragedy, but you can move through that to something more significant, something about survival. I think because the dark surface also resembles land or soil, it feeds a sense that life is always there, always coming back, always able to provide something.

I have all this ancestral research stuff swimming around in my head but the hard thing is to do a painting that is also about painting—that is about color, value, and chroma, and works formally, but not too formally, because if they do, then you've assembled the puzzle too neatly. I try to use as many colors as possible, and keep them really dark, working with the structure of low value and low intensity of color. People who spend a little bit longer time with them are amazed at what they begin to see. They are so elusive, like shadows on a landscape.

One of my former grad students said, 'I can smell these. These are like dirt.' It's the smell I love, in the spring after it rains So they're about a lot of things, and hopefully they're about paint, too."²⁸

15.68 Deborah Muirhead, *Water World Voices from the Deep*, 1991. Oil on canvas, 5 ft \times 4 ft (1.52 \times 1.22 m). Courtesy of the artist.

15.69 Museo de Arte Contemporaneo de Monterrey, with Juan Soriano's *The Dove*, 1991. Courtesy Marco.

white cultures, but historical art by Africans and Native Americans was described as "primitive," and contemporary artists in Africa and Latin America were largely overlooked.

This situation is changing rapidly. In North America's multicultural society the art world is beginning to appreciate the contributions of non-European cultures, and there are now major museums and galleries devoted solely to the art of these previously neglected cultures, including their contemporary artists. Others place multicultural art on a par with that of famous "white" artists, such as Mexico's Museo de Arte Contemporaneo in Monterrey (15.69). Despite economic difficulties, Latin American countries are developing partnerships between business, government, and the art world to train and show the work of their own artists and to research and preserve artifacts from their cultural heritage. This heritage includes the

religious beliefs that were nearly lost by oppressed cultures but had previously been central to their lives.

Resurgence of indigenous religious ways is now being explored in works such as the installations of Renée Stout, who is of African, Irish, and Cherokee background. She creates ritualistic pieces based in African-American vodun culture, in which objects are venerated for their mystical power and personal meaning, and their conscious installation is a way of reverence and healing. Use of art to invoke and communicate with the Unseen has long disappeared from the mainstream Western tradition, but it is present in some other cultures and perhaps also motivated the ancient cave paintings. Such work is not a direct link with the past but rather a modern re-interpretation. Stout's Trinity (15.70) combines the Christian threepaneled triptych format with the Kongo nkisi form: a wooden case with short legs for the personal power objects of a vodun practitioner. Both are employed in

15.71 (opposite) Romare Bearden, *Family Dinner*, 1968. Collage on board, 30×40 ins (76.2 \times 101.4 cm). ACA Galleries, New York.

15.70 Renée Stout, *Trinity*, 1990. Wood and mixed media. Open, 45 \times 22 ins (114.3 \times 55.9 cm). Closed, 45 \times 11 ins (114.3 \times 27.9 cm). Courtesy of LewAllen Contemporary, Santa Fe, New Mexico.

the expression of her feminine identity: she has given her own portrait in the center and those of her mother and sister on the side wings, in clear contrast to the Christian Trinity of Father, Son, and Holy Spirit.

There is a particular poignancy to the work of those whose cultural heritage and sense of self, as well as economic and social freedom, have been historically repressed. Sometimes the humanity of the oppressed is revealed in anger; sometimes it is as quietly moving as the montage paintings of Romare Bearden (15.71). Bearden said:

I work out of a response and need to redefine the image of man in the terms of the Negro experience I know best. I cannot divorce myself from the inequities that are around me.²⁹

Art as Investment

WHEN JAPANESE BUSINESSMAN Ryoei Saito bought van Gogh's *Portrait of Dr. Gachet* for \$82.5 million in 1990, he called the price "very reasonable." Prices of artworks up for auction had reached extraordinary heights at that time, driven by international wealth and an increasing trend on the art scene. Instead of being purchased by people who primarily love and live with art, works by artists who are in

vogue are more than ever before being bought as investments, for later auction at a higher price.

In 2004 a new world record was set at Sotheby's auction house in New York for an auctioned painting—\$104 million for *Boy with a Pipe*, an early painting by Picasso that had been purchased in 1950 by private collectors for \$30,000 (15.72). Then in 2006, that record was broken by the sale of a Gustav Klimt painting,

Adele Bloch-Bauer I (15.73) for a reported \$135 million. The Klimt sale is of particular historical as well as artistic interest because it capped a long effort by the family of Adele Bloch-Bauer to recover the painting, which had been stolen from them by the Nazis in 1938, along with four other paintings by Klimt. They had ended up in an Austrian museum, but a law passed in Austria in 1998 required its museums to return art that Nazis had seized. The aged niece of Adele Bloch-Bauer, Maria Altmann, was there when the paintings were taken away from her family. She fought the case for seven years, and now that the family has won, they have sold the painting to a small New York museum so that it can be viewed by the public. Their lawyer explained, "One of the things we always wanted to do was for this to tell the story of what happened to Maria and her family and Jews in the Holocaust. Now by having this painting on the wall, it will allow this story to be told and retold."31

Art has become a sought-after commodity because the prices that people are willing to pay for art have rapidly escalated. Not surprisingly, this situation raises many new issues, both for artists and for those who buy art.

For buyers of art offered for resale at auctions, there are the risks of buying on speculation—being sure that one is buying an original rather

15.72 Picasso, *Boy with a Pipe*, 1905. Oil on canvas $39\% \times 32$ ins (100×81 cm). Collection of Mr and Mrs John Hay Whitney, New York, USA.

Picasso painted this image of a young Parisian boy when he was only 24 years old, during his "Rose period."

15.73 Gustav Klimt, *Adele Bloch-Bauer I*, 1907. Oil and gold on canvas, $54\% \times 54\%$ ins (138 \times 138 cm).

This gold-flecked portrait by Gustav Klimt (1862–1918) will now hang in the Neue Galerie, a New York museum owned by cosmetics magnate Ronald S. Lauder devoted to German and Austrian art.

than a copy, assessing its quality, preserving its condition, insuring it, and then at a later date arranging to sell it for much more than was paid for it. In 1990, prices had become so inflated that the market for artworks crashed. However, the art market is heating up again, with especially high prices being paid for Impressionist paintings. As the supply of Impressionist art dwindles, people are paying huge sums for mediocre or little-known works by famous artists. In 1996, Christie's in New York sold a van Gogh painting of empty tables at a restaurant, with a few people in the background, for \$10.3 million. The auction house explained that this might be the last van Gogh interior ever to come up for auction.

In sales of both pre-owned art through auctions and new art

through galleries, prices are determined by a star system. It is ruled by what one artist characterizes as:

"a headless entity consisting of auctions, rumors, the media, newspapers, art magazines, interviews and so on. If you're out, you're out—you simply don't count. There is no opposition, no different opinion. [In this system] a painting which consists of a few square inches of paper can cost more than a building. The building is much larger and, when it rains, people can go inside. But nobody asks what this is all about." 32

For living artists, the lure of big money may lead people to concentrate on making art that sells rather than art that comes from the urge to create. And should they receive a percentage of profits that buyers make on reselling their work? Are they only economic pawns in a high-risk game?

Where do museums stand in this game? With prices so high, small museums cannot compete with the larger ones. There are only a limited number of true masterpieces, but museums may nevertheless try to have something from every period and many famous artists in their collections. Some observers therefore think that museums have become repositories of second-rate art. Furthermore, some pieces in museum collections are antiquities taken out of other countries without permission. And some works may not have been executed by the famous artists whose names they bear. In the workshop system, which is not uncommon even today, the master artist creates the visual idea but employs helpers and apprentices for jobs such as-in the case of paintings—preparing the supports, grounds, and paints, painting the underlayers, painting certain details such as clouds and horses, and perhaps executing the whole painting under the master's supervision. Rubens had a large studio since his work was so popular, and even when he traveled abroad, the production of paintings continued in his absence. In the output of Rembrandt's workshop, we do not now know which pieces were created solely by the hand of the master or what the "Rembrandt" signature meant at the time. The Rembrandt Research Project suggests that of the 711 existing works that were thought in 1920 to be created by Rembrandt, perhaps fewer than 300 were actually done by Rembrandt himself.

Art that remains from the past is art that someone liked enough to keep. After one hundred years, two hundred years, another millennium, will twentieth-century art be in or out? Will Western art command the highest prices or will the great art traditions of other cultures come to the fore?

15.74 Bessie Harvey, Tribal Spirits, 1988. Mixed media, $45 \times 26 \times 20$ ins (114.3 \times 66 \times 50.8 cm). Dallas Museum of Art, Dallas, Texas. Metropolitan Life Foundation Purchase Grant. The exploitation of poor outsider artists continues. Some are trying to get at least a fraction of their works' resale price, but without much success. Bessie Harvey counters, "What they've taken from me they can have, but they can't have me. I'd rather be at peace with a biscuit and butter than to live in hell with steak and gravy."³³

As these "discoveries" are breathing new life into the art world, another lively trend is the embracing of **outsider art** by galleries, museums, and collectors. In contrast to **folk art**, in which relatively untrained artisans are working within a cultural tradition, like the quilters of Gee's Bend in Alabama (Figures 3.2 and 11.26), outsider artists are those sheer individualists who are self-taught and are working totally outside of both community traditions and establishment ideas about what constitutes good art.

This nonconformist work is highly personal, spontaneously expressive, and often spiritual. The artist may begin by creating art as a private act, not for the eyes of others, and certainly not for sale. Bessie Harvey was a cleaning woman in a hospital, quietly following her inner spiritual calling to make sculptures of found wood for patients to help them heal, before people began noticing, loving, and collecting her work (15.74). Her inspirations come from vision and the spirits she senses in the wood:

15.75 (opposite) Raymond Isidore, detail of La Maison Pique Assiette, Chartres, France, 1934–64.

I talk to God for advice, not my neighbors. I talk to trees, weeds, and animals. I see things in dreams and when I close my eyes before sleep. I thought everyone was like that. When I meditate and close my eyes, faces and people begin to pass by—like watching a movie. Then one face stays. So I get up and try to draw it out or capture it in a piece of wood. All nature is crying out to tell us things.³⁴

Raymond Isidore (1900–64) lived near Chartres Cathedral, unhappily working as a cemetery sweeper after brief jobs of other sorts, from tram driving to foundry work. He had no artistic training whatever, but felt that he was receiving inner spiritual guidance which compelled him to build "a place where my spirit feels at home." Collecting mounds of broken china and glass, he ultimately spent thirty years using these shards to cover every surface of his home with visionary mosaics, using only a trowel, a soupspoon, a fork, and a pocket-knife to create a series of courtyards and interiors embellished with floral designs, thrones, cathedrals, tombs, angels, crosses, and the Virgin Mary (15.75). His family thought his perennial efforts were ridiculous, but now some 30,000 visitors a year come to view his creation.

The first "insider" to laud such work was the Swiss painter Jean Dubuffet. In the mid-twentieth century he collected a whole museum full of such pieces, which he termed *art brut* ("raw art"). In it lay true life, he felt; cultural conditioning had asphyxiated all other art:

Simplifying, unifying, making uniform, the cultural machine, based on the elimination of flaws and scrap, on the principle of sifting in order to retain only the purest essence from its raw material, finally manages to sterilize all germination. For it is precisely from flaws and scrap that thought derives sustenance and renewal. A fixative of thought, the cultural machine has got lead in its wings.³⁶

Dealers who have "discovered" outsider art are now swamping the outsider artists, snapping up cartloads of work, typically at prices that are only a fraction of their resale value in galleries. While Aboriginal artist Johnny Warangkula Tjupurrula was living destitute in a dry creek bed in 1997, his painting was sold for A\$206,000 at an art auction; he had received only A\$150 for it in 1972. The exploitation of these sincere, eccentric artists is a serious scandal in the art world.

Understanding Art on All Levels

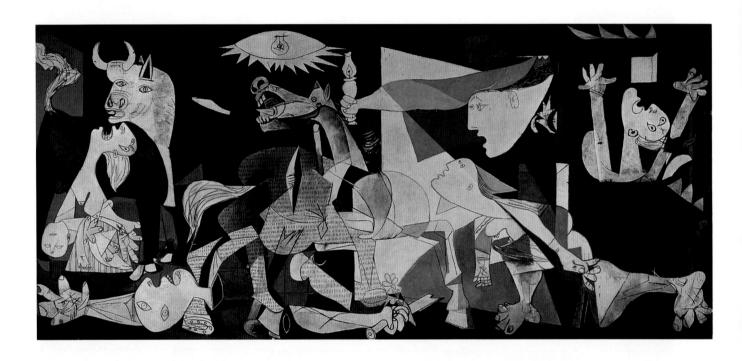

■ KEY CONCEPTS

The making of great works of art

Context

Preliminary work

Composition

Meaning

Critical reception

16.1 Pablo Picasso, *Guernica*, 1937. Oil on canvas, 11 ft $5\frac{1}{2}$ ins \times 25 ft $5\frac{1}{4}$ ins (3.49 \times 7.75 m). Reina Sofia Museum of Modern Art, Madrid.

THUS FAR WE have looked at works of art from one perspective at a time—seeing, feeling, awareness of technical skill or design qualities, historical knowledge, or understanding of the content. When we have the opportunity to see actual works of art, however, our appreciation is richest if we can bring all these levels into play more or less simultaneously. In this chapter we will look at four monumental works of art:

- a painting (Pablo Picasso's Guernica)
- a piece of sculpture (Auguste Rodin's *Gates of Hell*)
- a ceiling fresco (Michelangelo's Sistine Chapel ceiling)
- a new public building (Frank Gehry's Guggenheim Museum in Bilbao).

We have followed these key works throughout this book, but now we will look at each of them in greater depth. In the course of time, Picasso's *Guernica*, Rodin's *Gates of Hell*, and the Sistine Chapel ceiling painted by Michelangelo have been judged as great works of art. Frank Gehry's Guggenheim, Bilbao is as yet new. The process of assessing its ultimate value began only at the end of the twentieth century. By considering its pros and cons on the basis of the understanding of art that you have developed in this book, you become part of this process.

Picasso's Guernica

Pablo Picasso's *Guernica* (16.1) is thought to be the most looked-at painting of the twentieth century. It was commissioned by the Spanish Government in Exile during the Spanish Civil War, to be displayed in the 1937 Paris International Exhibition. At Picasso's request, it was then placed in the Museum of Modern Art in New York for safekeeping until "public liberties" were reestablished in his homeland, Spain. In 1981, after Franco's fascist regime had ended, the painting was moved to the Reina Sofia Museum of Modern Art in Madrid. For fourteen years it was kept behind security glass, lest it be attacked. But now the glass has been removed so that it

16.2 The city of Guernica after bombing by Nationalist forces, 1937.

can again be clearly seen. It stands as a monument not only to the genius of the most prolific and influential artist of the twentieth century but also to human questioning of the sufferings caused by war.

The incident Picasso chose as his subject occurred less than a week before he began work on the painting. It was the bombing of Guernica, capital and symbolic heart of the Basque provinces. To break Basque resistance, Hitler's forces, who were supporting Franco's war against the Loyalist government, carried out one of the world's first experiments in saturation bombing of a civilian population. They dropped over 3,000 incendiary bombs over a period of three hours and machinegunned the people as they tried to flee. The world was aghast, and Picasso had his subject. But the way in which he presented it is symbolic of all wars, all repression. It is not at all a literal representation of the actual bombing of the city or its aftermath (16.2). The figures are highly allegorical, abstracted in Cubist style; and the use of blacks, whites, and grays rather than more colorful hues erases any racial or nationalistic associations. The horror of Guernica becomes the horror of all war, an epic presentation that struck home in an age that thought itself too sophisticated for sentimentality.

Despite its evocation of the chaos of surprise attack, *Guernica* is held together by its triangular compositional devices. The major triangle runs from the open

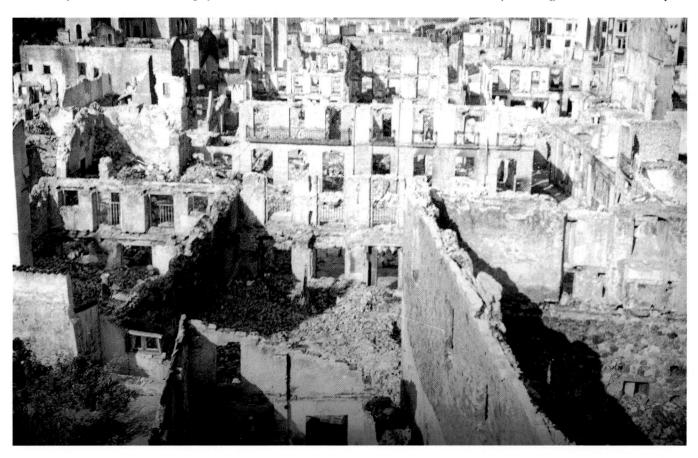

palm of the dead warrior at the lower left, up to the lamp held by the woman at upper center, down to the outstretched foot of the kneeling woman on the right. A secondary triangle on the left contains the head of the bull, facing away from the disaster, and the upturned head of the wailing woman with the dead baby hanging limp in her arms. There is also a bird on a table, with the same upward-turned imploring head as that of the mother. To the right, the outer triangle encompasses the agony of the burning woman—whose pose mirrors that of the woman with the dead baby—and the powerful questioning form of the woman thrusting a light into the scene.

Within the central triangle, there is a jumble of fragmented parts. The body of the dead warrior stretches across the base of the triangle, visually

16.3 Pablo Picasso, first compositional study for *Guernica*, 1937. Pencil on blue paper, $8\frac{1}{4} \times 10\frac{5}{8}$ ins (21 \times 26.9 cm). Reina Sofia Museum of Modern Art, Madrid.

sharing the right leg with the kneeling woman. In the center is the horse with the gaping wound, whom Picasso in a rare moment of explanation identified as the spirit of the people.

The strong diagonals send the eye zipping around through the painting, searching for understandable forms and clues. We note that most of the people are women and children; this is not an heroic battle scene but the aftermath of an assault on civilians. Above all the figures is a sun or ceiling lamp or an eye—or perhaps all of these—watching, and shedding some light on the scene.

What do these images mean? Picasso generally refused to explain his symbols, insisting that viewers respond through personal, subconscious associations and emotions rather than impersonal logic:

This bull is a bull, this horse is a horse It is necessary that the public, the spectators, see in the horse, the bull, symbols that they interpret

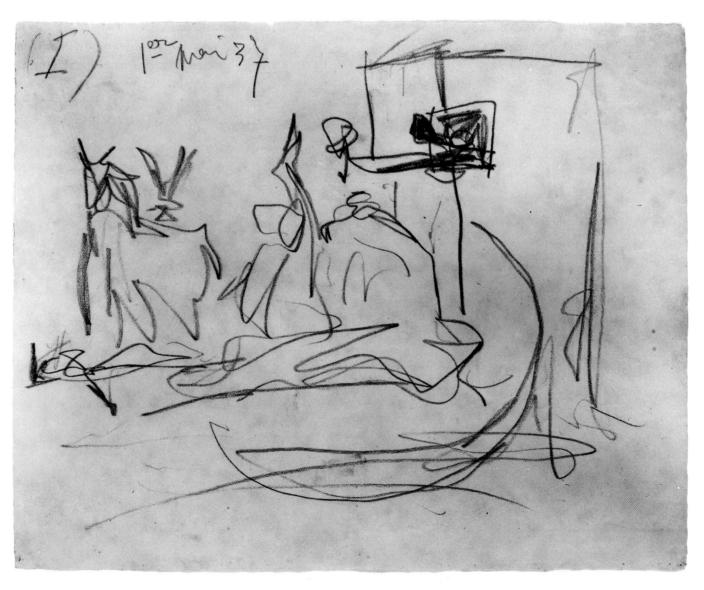

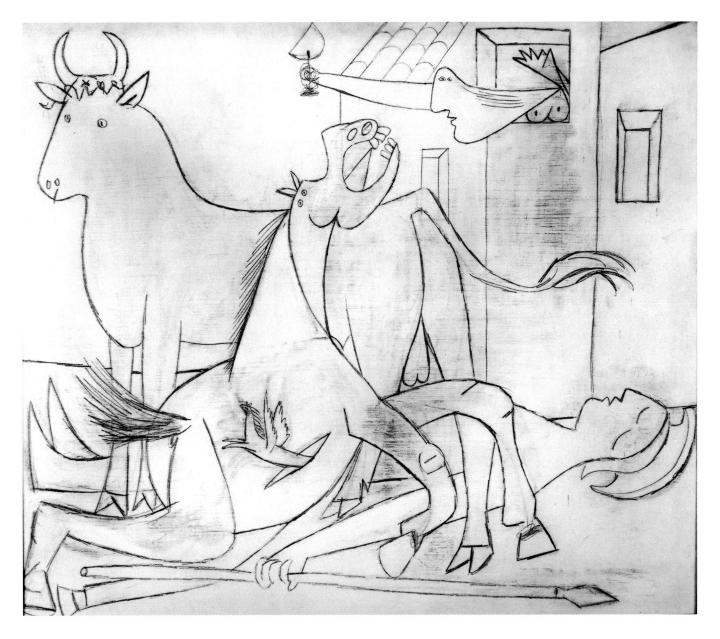

16.4 Pablo Picasso, compositional study for *Guernica*, May 1, 1937. Pencil on gessoed wood, $25\frac{1}{2}\times21\frac{1}{8}$ ins (64.7 \times 53.6 cm). Reina Sofia Museum of Modern Art, Madrid.

as they understand them. These are animals. These are massacred animals. That is all, for me; let the public see what it wants to see.¹

The painting rivets our attention and involves us by making us ask questions. It does not answer them. Is the bull, for example, a symbol of unthinking brutality, the detached and stupid presence of repression, pushing down all the human forces that are trying to rise? Is he the representative of humanity, affected by but yet isolated from what happens to each person? Is he the eternal power of Spain, reassuringly solid even in the midst of devastation? Or does he represent sheer force, power that is in itself neither good nor evil? The

possibilities—and there are others—have intrigued viewers of the painting for decades, and whole books have been written about the subject.

Picasso himself approached *Guernica* with an open, extremely flexible mind, continually changing its form. Quite aware of the historic significance of his attempts, he dated the scores of sketches in which he worked out the images and composed the powerful whole of the finished painting, leaving tracks for us to follow. From the very first compositional study (16.3), Picasso knew much of the basic structure. In this simplified visual note to himself, we can readily make out the woman with the lamp, the bull, and the horizontal shape of the dead soldier.

By the end of the first day, after five preliminary sketches, Picasso had worked out the compositional study shown in Figure **16.4**. The woman with the lamp already has her distinctive cometlike shape. The fallen

soldier is wearing a classical centurion's helmet; the spirit of the horse escapes through the wound in its side. At this point, the figures are fairly representational and drawn with curving lines, in contrast to their fragmented, straight-edged appearance in the final version, and there is a sense of three-dimensional space receding to the rear.

Picasso then introduced some new elements. A major group he added is the mother and the dead baby (16.5). Throwing her head back into a reverse scream makes her plight all the more hideous. The baby's eyes seem partially aware here; its blood oozes through the mother's fingers. By the final painting, the baby's eyes

16.5 Pablo Picasso, study for *Guernica, Mother with Dead Child on Ladder,* May 9, 1937. Pencil on white paper, $9\frac{1}{2} \times 17\frac{7}{6}$ ins (24.1 × 45.4 cm). Reina Sofia Museum of Modern Art, Madrid.

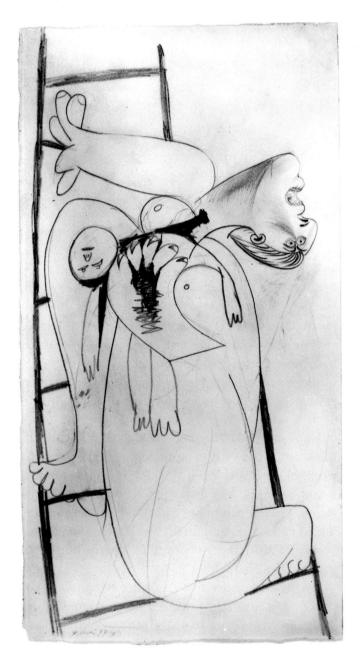

are mere empty half-moons and the blood is gone, making it the most peaceful figure in the general agony of the scene. Before Picasso worked out the fully extended reverse scream posture, he had experimented with bringing the mother and baby into the painting on bended knee at the right (16.6). At this point, Picasso also began to introduce the triangular shapes that play such an important role in the final composition. Three human corpses now lie on the ground, clenched fists rise heavenward, and the horse writhes into a new position.

In addition to the innovations in the sketches, Picasso continued to reassemble, add, and eliminate figures directly on the mural itself. Seven states preceding the final mural were photographed, giving us further insight into the evolution of the artist's thoughts. In the second state of the painting (16.7), the woman with the lamp is thrust into greater prominence than before: She is larger and brought forward by the flattening out of the crowded space of the picture. The flaming woman with upraised arms has appeared to fill the space at the far right. Triangles are everywhere elaborated. Perhaps the most striking-later abandoned—aspect of this state is the hopeful, defiant fist of the dead soldier, raised with a patch of Spanish turf against a luminous sun. This dramatic gesture is reduced to a subtle sign of hope that must be discovered in the final version: the small flower in the soldier's hand. And the sun dwarfs the light brought to the situation by the woman with the lamp, who seems to have been needed from the first as a call to the world to witness what has happened.

In the final mural, all those who are suffering are imploring upwards or looking to the left, while the eyes of the centurion have swiveled around to face us, staring blankly even in death. The other eyes that face us are those of the bull—and what do we read in them? Although the bull turns away from the violence, he is clearly involved with it on some level. And so are we. No one can see this huge mural, full of larger-than-life suffering figures, without being deeply affected by it. Most people walk toward it until it fills their peripheral vision and then stop, held back by the jagged points and the pain that is more felt than seen.

Even at a distance it is impossible to grasp the whole composition at once or to resolve the meaning of the whole. Its ambiguities, even on the most basic level (for instance, is this scene inside or outside?), keep us exploring and feeling our way through the work. It is quite likely that this painting will still be studied hundreds of years from now. Showing only the effects and

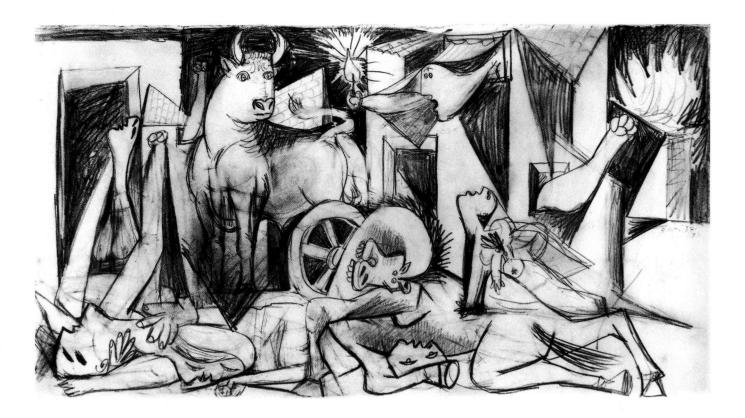

16.6 Pablo Picasso, compositional study for *Guernica*, May 9, 1937. Pencil on white paper, $9\frac{1}{2} \times 17\frac{7}{8}$ ins (24.1 \times 45.4 cm). Reina Sofia Museum of Modern Art, Madrid.

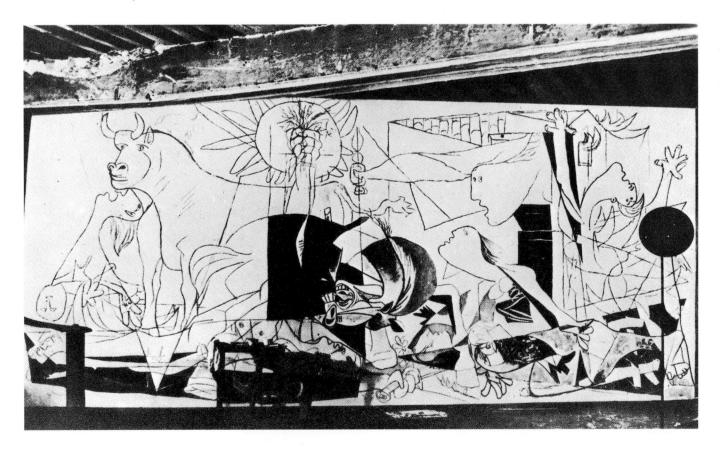

16.7 Pablo Picasso, State II of *Guernica*, 1937. Reina Sofia Museum of Modern Art, Madrid.

not "the enemy," it stands as an incredibly powerful illumination of the suffering that we humans are capable of inflicting. In this compassionate awareness lies some hope for change.

Rodin's Gates of Hell

What may have been the greatest sculpture of the nineteenth century was never displayed until well into the twentieth. This work—*The Gates of Hell* by Auguste Rodin, who reinvigorated the art of sculpture at a time when most significant work was being done in painting—occupied the artist intermittently from 1880 to 1900 but was not cast in bronze until 1926, nine years after his death. It had been commissioned

for the proposed Museum of Decorative Arts in Paris, which was never built. Rodin welcomed the opportunity to prove his stature as a skilled and imaginative sculptor after charges that his earlier lifesized sculptures were so realistic that they must have been cast from live models. His proposal for the great door was a sculptural image of The Inferno from Dante's Divine Comedy, whose allegorical account of the soul's return to God had deeply moved Rodin. He peopled his portal with nearly 200 fluidly expressive bodies, all smaller than life. Some are modeled in such low relief that they disappear into the swirling inferno; some reach out in full three-dimensionality toward the viewer. All bear witness to the profundity of Rodin's vision and his ability to use the human body to express the full drama of existence.

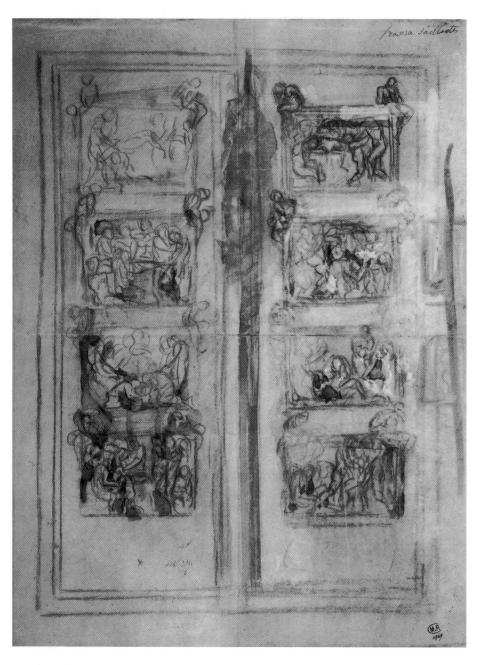

16.8 Auguste Rodin, sketch for *The Gates of Hell*, 1880. Pencil, ink wash, and white gouache. Musée Rodin, Paris.

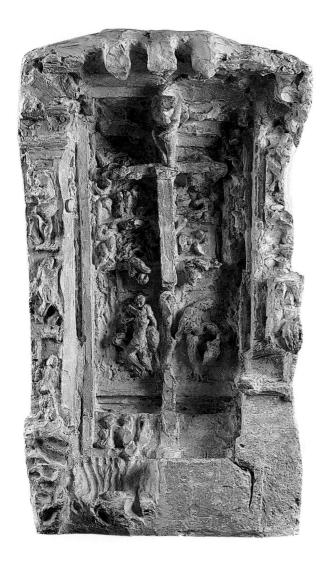

16.9 Auguste Rodin, terra cotta study for *The Gates of Hell*, Musée Rodin, Paris.

Historical precedents for *The Gates of Hell* included Ghiberti's Renaissance *Gates of Paradise* (15.25), which Rodin had seen in Florence. Rodin started out with a similar concept. His first architectural sketches, such as the one shown in Figure 16.8, divide the massive width of such a door into eight symmetrical panels. Yet even here, the organic forms they contain are starting to spill over their boundaries, until, in its final form, the straight lines of the architectural framework are mated to, and in places obscured by, the multitude of sensual figures.

Rodin soon abandoned any attempt at a literal, compartmentalized depiction of the levels of Hell described by Dante. An early terra cotta study for *The Gates of Hell* (**16.9**) suggests its final form: a quasiarchitectural framework with a cross at its center, topped by the seated figure later known as *The Thinker*. Rodin eventually executed *The Thinker* as an isolated sculpture; indeed, many of his sculptures first appeared in

his preparations for *The Gates of Hell*. He worked with the malleability of clay, using live models moving freely as inspiration for gestures expressing their own inner lives. The figures and groupings thus developed were attached to a large wooden frame, on which clay was built up in relief. Plaster casts were then made of areas of the work, with the intention of using them as the basis for bronze lost-wax casts. Only one of the casts that were ultimately made was done by the fine lost-wax process. Rodin actually dreamed of having the side jambs carved in marble, with the central panels cast in bronze.

Even the plaster casts themselves (1.49) reveal the extraordinary dynamism of Rodin's sculpture. Figures move far out and way back in space, creating areas of light and shadow that undulate continually through the piece. Extremely busy passages alternate with quieter ones, weaving another dimension into the visual rhythm of the piece. At the very top are the figures called *The Three Shades*. Like *The Thinker*, they were also cast and shown as a sculpture in themselves. They are actually the same figure cast three times and shown from three different angles. Their gestures keep directing the viewer's glance down into the turmoil below.

After absorbing an impression of the whole 18-foot (5.5-m) structure, viewers are inevitably drawn in to try to decipher individual forms blended into the writhing turmoil. Among the inhabitants of Hell—which Rodin conceived as a state of mind rather than a place in the hereafter—is Count Ugolino (16.10). He and his sons were historical figures who had been locked in a tower to starve. There is an ambiguous suggestion in Dante's account that Ugolino ate his sons' corpses in his hunger. The horror of their torment is expressed physically, with the aristocratic count reduced to the crawling stance of a beast. They are placed on the left panel at the viewer's eye level, making their agony inescapable.

Below the Ugolino group are the historical figures of Francesca da Rimini and her lover, Paolo, brother of the man she had married for family political reasons. Her husband, who was deformed and ugly, killed the pair when he found them out. Rodin treats their forbidden love sympathetically, if tragically. In Rodin's Hell, it is humanity that torments itself with its frustrated longings and inability to find peace.

The only still figure in the work is that of *The Thinker*. Many observers consider him a self-portrait of the artist. We can imagine that Rodin is describing his own experience of the creative process when he describes his *Thinker* as:

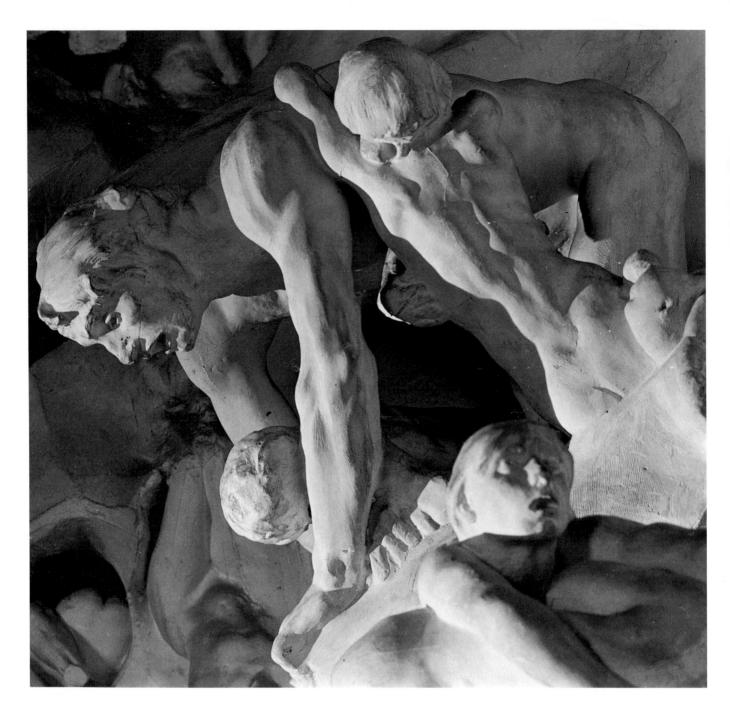

16.10 Plaster cast of The Gates of Hell. Detail of the lower section of the left door panel, with the Ugolino group and Paolo and Francesca.

a naked man, seated upon a rock, his feet drawn under him, his fist against his teeth; he dreams. The fertile thought slowly elaborates itself within his brain. He is no longer dreamer, he is creator.²

All about *The Thinker* bodies are struggling and climbing, only to fall—even the angels (**16.11**). Within the maelstrom, some try to help and console each other; others are physically touching but isolated in their individual pain. As observers, we stand equal to the fallen, looking upward to the barrier one would have to cross to

reach the level of *The Thinker*, who separates himself enough from the endless motion of human strivings to see the whole picture, wondering why.

To complete this epic depiction of the human condition, Rodin had intended that his sculptures of Adam and Eve be placed on either side of *The Gates of Hell*, as suggested in one of his early sketches (**16.12**). This sketch also reveals his vision of the doors as a portal at the top of a flight of stairs, framed by an arch. If this were so, if *The Gates of Hell* had actually been installed architecturally as doors, imagine what it

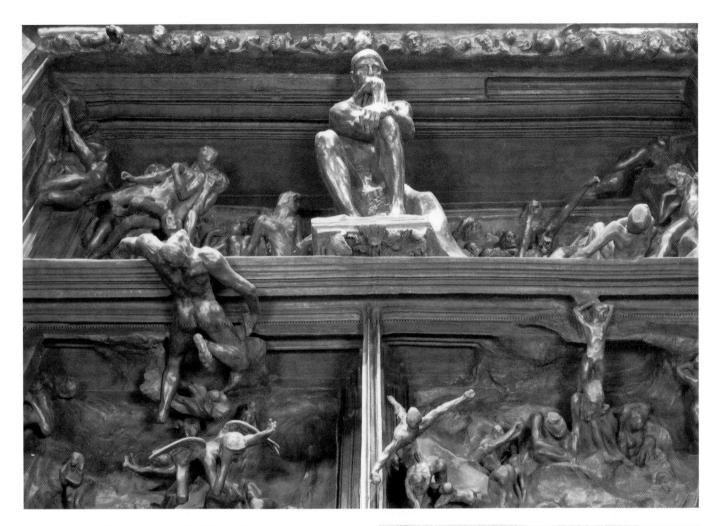

16.11 Auguste Rodin, *The Gates of Hell* (detail). *The Thinker*, with portions of the door panels and tympanum. Bronze. Stanford University Museum of Art. Gift of B. Gerald Cantor Collections.

would feel like to walk up to and then through them, as if entering the world they describe. When *The Gates of Hell* are set up with the lifesized sculptures of Adam and Eve (see Figure 2.22), a strongly triangular composition results from the obvious reading from Adam to the Three Shades to Eve, justifying the large scale of the Shades. And to enter Hell by passing reminders of the idea of original sin—one explanation for human suffering—extends the logic of the whole.

Keenly aware of the pain of human existence, Rodin himself died of cold in an unheated villa, as intrigues and manipulations swirled around his bequest of his art to France.

Despite the difficulties of his own situation and the frequent rejections of his work by more conventional minds, Rodin was passionately fond of art—and of what it reveals to us of life.

Great works of art, which are the highest proof of human intelligence and sincerity, say all that can be said on man and on the world, and, besides, they teach that there is something more that cannot be known We [artists] are misunderstood. Lines and colors are only to us as the symbols of hidden realities. Our eyes plunge beneath the surface to the meaning of things, and when afterwards we reproduce the form, we endow it with the spiritual meaning which it covers. An artist worthy of the name should express all the truth of nature, not only the exterior truth, but also, and above all, the inner truth.³

Michelangelo's Sistine Chapel Ceiling

The next piece of art that we will explore in depth in this chapter is earlier than the first two, but it is by no means less "evolved." The complexity of its conception and execution is staggering.

At the age of thirty-three, Michelangelo was commissioned by Pope Julius II to paint a fresco to decorate the ceiling of the Sistine Chapel in the Vatican, which

was used for devotions and ceremonial purposes by the pope and those surrounding him, such as cardinals and archbishops. At the time, 1508, the ceiling was already painted to look like the blue heavens, studded with stars (16.13), with scenes from the lives of Jesus and Moses painted below the high windows and painted statues of the popes between the windows. Several years later, Raphael was commissioned to design tapestries which were hung in the place of the fictitious painted drapes near the floor. Michelangelo was reluctant to accept the ceiling commission, for he was embroiled in sculpting a tomb in which the same pope was to be buried eventually (a project that plagued him for the rest of his life, in continual wranglings with the authorities over funds and design). Furthermore, he considered himself a sculptor rather than a painter, and the difficulties he would face in painting the immense ceiling for the exaltation of its august visitors were staggering.

Michelangelo faced a vast curving surface 118 feet (38.5 m) long, broken by triangular arches over each window. He also had to create images that could be seen and make sense to people standing 70 feet (21 m) below on the floor. Fresco is a very demanding medium

16.13 G. Tagnettis, reconstruction of the fifteenth-century Sistine Chapel before Michelangelo's frescos. Vatican Museums, Vatican City.

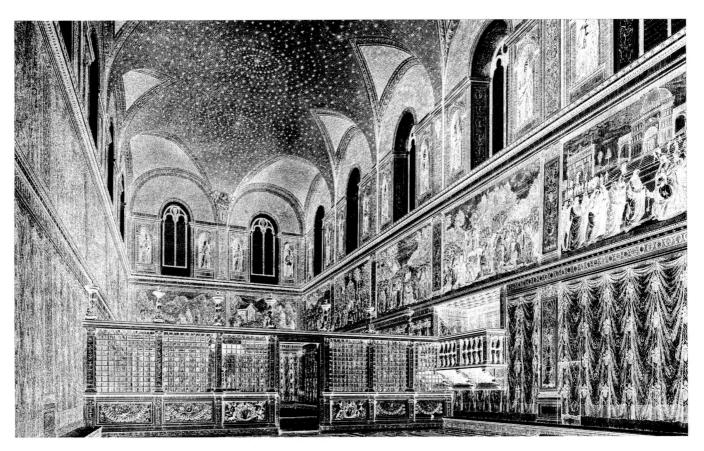

even on a vertical surface, and to work on the ceiling, Michelangelo had to perch on a scaffolding, apparently with his head continually thrown back and paint falling onto his face and beard. It was his first major attempt at fresco.

What he created under these extraordinarily difficult conditions is one of the world's greatest works of art. He painted it in two portions, during the winter of 1508 to 1509—when work stopped for lack of further funds, seemingly absorbed by the military operations of the Vatican—and then again from 1511 to 1512. He tried using assistants but soon gave up and worked mostly alone in the Chapel, in pain and exhaustion, but apparently also driven by some kind of inner inspiration. We know from his letters that he dedicated himself as an artist to the service of religion and beauty, and that the two were not different in his mind. One of his sonnets explains:

Beauty was given at my birth to serve As my vocation's faithful exemplar ... To sense the Beauty which in secret moves And raises each sound intellect to Heaven!

And in conversations recorded by a visiting Portuguese miniature painter, Michelangelo reportedly said in reference to Italian painting:

With discreet persons nothing so calls forth and fosters devotion as the difficulty of a perfection which is bound up in union with God. For good painting is nothing but a copy of the perfections of God and a recollection of His painting; it is a music and a melody which only intellect can understand, and that with great difficulty. And that is why painting of this kind is so rare that no man may attain it.⁵

Michelangelo's own surviving letters give us no clues as to what he was attempting aesthetically and theologically in the vast work. The pope had originally suggested that he paint the Twelve Apostles, with false painted architectural decorations about them, but Michelangelo argued that the Apostles wouldn't make good subjects because they were "too poor." He won, and the pope gave him a free hand. What evolved probably exceeded anybody's wildest expectations.

The sculptor-as-fresco-painter conceived the ceiling as an illusionary continuation of the architectural details of the building, within which over 300 figures tell the Christian story of the human situation. The

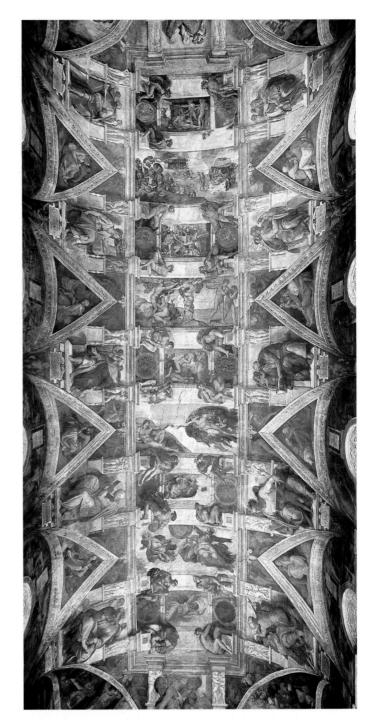

16.14 Michelangelo Buonarroti, Sistine Chapel ceiling (before restoration), Vatican Palace, Rome, 1508–12.

panels in the crown of the vault contain the events recounted in Genesis, beginning over the altar with God's separating of the darkness and the light, proceeding through the stories of Adam and Eve, and ending with Noah, the flood, and Noah's drunkenness (16.14). The drama expresses God's creative power and humankind's unworthiness and need for divine salvation. Surrounding these panels are the *ignudi*, enigmatic nude male figures in a great array of poses. Michelangelo treated the curving sides of the vault as

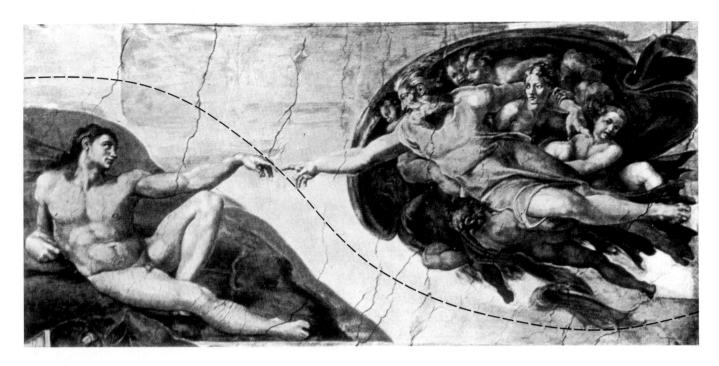

16.15 Michelangelo Buonarroti, Sistine Chapel ceiling, 1508–12, detail of the *Creation of Adam* with an overlay showing the "S" composition.

thrones for those who prophesied the coming of Christ (the Prophets and Sibyls), with the real architectural triangles between them housing the ancestors of Christ. Between these concave triangles he painted illusionary "columns" of figures and stone ribs that seem to support the upward curve of the ceiling.

The scale of the figures changes continually, with God smaller than the Prophets and Sibyls along the sides, and with scale changes from one panel to the next through the center. Even our point of view switches from looking at God overhead to looking at God as if we were alongside, in witnessing the *Creation* and *Fall of Adam and Eve*. But rather than being disunified, these variations have the effect of a great symphonic work with many voices and recurring themes.

The major story carried through the center devotes three panels to God's creation of the world, three to the creation and fall of Adam and Eve, and three to the story of Noah, with the flood, Noah's sacrifice to God, and Noah's drunkenness. The first three portray the omnipotence of God, depicted as a gray-haired man who hovers and zooms above the spectator in the first three panels, bringing the sun and the moon into being with a gesture of his hand.

The next panel is the most famous portion of the whole ceiling: the *Creation of Adam* (16.15). It is said to have been the first thing Michelangelo painted when he returned to it in 1511. The use of unfilled space

draws our attention in contrast with all the busy details surrounding it, and the use of outstretched fingers that almost touch, but not quite, conveys an electrical sense of the infusion of the legendary first man with life. The actual Biblical reference has God breathing life into Adam, but artistic license serves Michelangelo well here, for we can almost "see" the implied line as the spark of life jumps the gap between God and Adam. Compositionally, the panel is designed as a long horizontal "S," a device known as "the line of beauty" and used repeatedly by Michelangelo and other Renaissance artists in posing single figures and composing scenes.

The male prophets of the Old Testament alternate along the sides with female Sibyls, who were prophetesses from the pre-Christian traditions of Classical Greek and Roman culture. The Renaissance brought a resurgence of interest in these Classical civilizations and attempts to embrace them within the fold of Christianity. To this end, oracles ascribed to the Sibyls prophesied the coming of Christ, and Michelangelo places them on equal footing with the Old Testament Prophets in this regard. Although they are supposed to be females, in Michelangelo's hands they become androgynous figures with the heavy musculature more characteristic of men. The Libyan Sibyl (16.16) is particularly famous as an idealized combination of the beauty of both sexes. Her exaggerated spiraling contrapposto pose and arched feet, like many of the great variations of poses in the ceiling, are thought to be precursors to the theatrics of Mannerist painting. On the other hand, some see Michelangelo as reaching

16.16 Michelangelo Buonarroti, Sistine Chapel ceiling, 1508–12, detail of *The Libyan Sibyl*.

backward in time to Classical interest in depictions of the nude male body, accentuated by poses involving strain, thrust, and counterthrust.

The Prophet Jonah (16.17) seems flung backward from his perch above the altar, perhaps in awe of God, who hovers just above on the ceiling. Michelangelo's genius with foreshortening is particularly evident here, for we perceive the figure as leaning away in space even though architecturally this area curves forward. Notice, for instance, how Michelangelo has shortened Jonah's trunk and right thigh to help us "see" them as extending back from us in space. Notice also Michelangelo's strong use of complementary colors, with the green of the drape heightening the lively red glow of the skin.

Michelangelo's colors are currently the source of great controversy. For centuries the Sistine Chapel ceiling was so dulled by candle smoke and darkened varnish that people tended to assume that Michelangelo used muted, unsaturated colors. Many liked the ceiling that way. But there were clues that these were not the original colors. For instance, one observer who saw the ceiling when it was new wrote about its unprecedented luminosity. Despite international protests, a team of restorers began trying in 1980 to repair minute paint flaking and to remove the layers of old varnish without damaging the original fresco. Twelve years of painstaking work revealed surprisingly bright and glowing colors beneath, as shown in the restored version (16.18). The contrast is striking, as can be seen in comparing

16.17 Michelangelo Buonarroti, Sistine Chapel ceiling, 1508–12, detail of *The Prophet Jonah*.

before-and-after-cleaning photos of one of the lunettes over the windows (16.19).

The drastic cleaning may have removed too much, however. Comparison of the lunette in Figure 16.19 before and after cleaning reveals that the new effect is much flatter than before cleaning. The woman's cloak, for instance, is rather flat across the back, whereas before cleaning it had deep shadows, lending it more three-dimensionality and more distance from the background, and giving the work a certain rhythm and balance in its subtle use of values. The major argument still being passionately debated is whether or not Michelangelo had worked a secco, adding darker values for spatial modeling after the plaster was dry. The proponents of restoration claim that Michelangelo worked almost exclusively in the pure Florentine buon fresco tradition, applying paint directly to a fresh layer of wet plaster, the intonaco. They say that he rarely made corrections a secco, on dried plaster, a much less durable technique. They also speculate that he painted huge areas each day. Each of the lunettes, for example, was painted in only three days, with each day's work said to have covered about 54 square feet (5 sq. m). There is no evidence that he used a cartoon in these areas, but

rather he seems to have been painting directly and freely. According to the restorers, he limited his palette to those colors that worked well in *buon fresco*, laying them side by side and often allowing the ground to show through for added brilliance. Figure 16.18 reveals that Michelangelo also boldly juxtaposed complementary colors—especially red-oranges and blue-greens—to give a stunningly vibrant effect to the figures.

Those who think that Michelangelo made *a secco* amendments to the fresco have the anguished feeling that the great fresco has been inalterably ruined by the restoration, for it took away all layers down to the *intonaco*. They question whether such a drastic cleaning was justified, and they also raise questions about commercial aspects of the restoration. It was funded by the Nippon Television Network Corporation, which tightly controlled the rights of photographing and reproducing pictures of the work in progress and the cleaned paintings and then made them available only at high prices.

The Sistine Chapel's commercial exploitation—or accessibility, depending on one's point of view—was further expanded in 1996 by the introduction of its frescos on interactive CD-ROM. A user can select any of

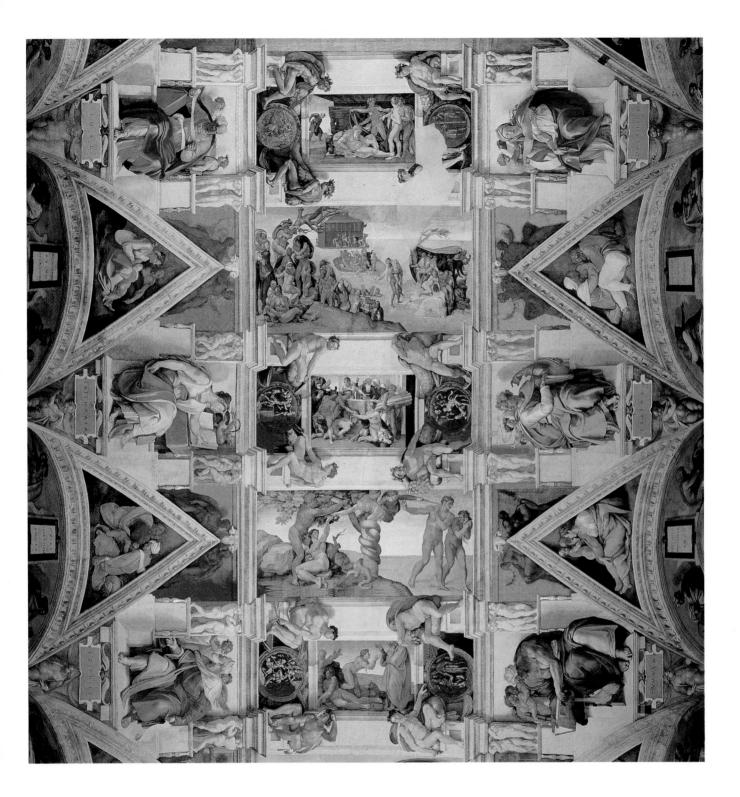

16.18 Michelangelo Buonarroti, Sistine Chapel ceiling (after restoration), 1508–12. Detail of the ceiling showing the *Intoxication of Noah* to the *Creation of Eve*. © Nippon Television Network Corporation, Tokyo, 1991.

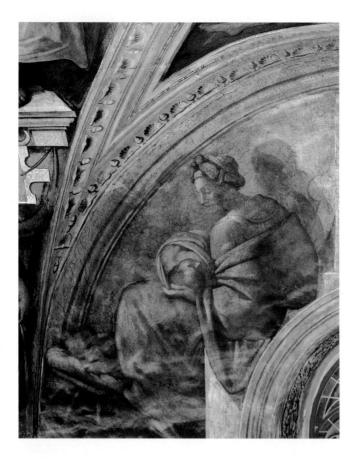

the parts of the Chapel ceiling, zoom in to see its details magnified, or request information including Biblical quotations and art critics' writings about the work. The paintings can even be extracted for use on one's business calendar, with angels surrounding happy events and devils marking difficult appointments. One cannot imagine how Michelangelo would respond to all of this, but the Vatican explains that it is offering CDROMS of its art treasures in order to better share them with the world. Cardinal José Castillo Lara told a news conference:

We are moved to do this because the Vatican belongs to everyone but not everyone can enjoy it. Throughout its history, the Vatican has become the depository and custodian of priceless art works. We now bring these treasures into people's homes.⁶

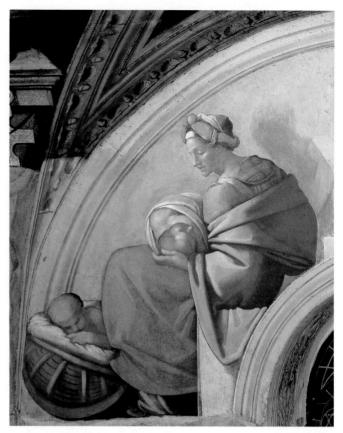

Frank Gehry's Guggenheim Museum in Bilbao

The final piece we will consider in depth is the ground-breaking Guggenheim Museum in Bilbao, Spain, designed by architect Frank O. Gehry (Figures 1.51 and 3.45). Bilbao had been a prominent industrial city and the center of Basque culture, but during the 1980s and 1990s its main industries, steelmaking and shipbuilding, both declined. Many companies had to close, bringing widespread unemployment and urban decay. The Nervion River running through the city was also badly polluted from years of industrial waste dumping. In addition, there were intermittent problems of violence because of the Basque separatist movement.

In 1987, the Basque Public Authority developed a revitalization plan for the city, centered around a unique feature: Make it the home of a great modern art museum that would draw international attention. They approached the Solomon R. Guggenheim Foundation, which is dedicated to collecting and displaying contemporary art. Its New York Guggenheim Museum (2.88) had been built according to an

innovative design by the great architect Frank Lloyd Wright, and the Foundation was looking for other cities in which to establish branches. To design a new branch in Bilbao, the Foundation selected another highly innovative architect, Frank O. Gehry of Los Angeles. Gehry was already famous for his ability to transform industrial areas into sculptural spaces.

Gehry chose a site right on the Nervion River, thus bringing attention to the city's shipbuilding history and, rather improbably, sandwiched his building between two existing bridges. One of them, the busy Puente de la Salve, now runs right over part of the museum.

The initial planning stages are reflected in Gehry's many drawings. In Figure **16.20**, an early sketch, we can see the bridge to the left, with a portion of the building passing under it and erupting into an

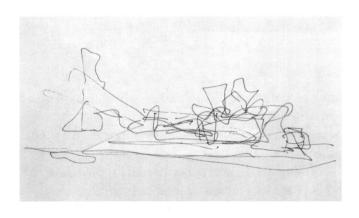

16.20 Early drawing by Frank Gehry. Guggenheim Museum, Bilbao.

eccentric tower on the other side. Already it is apparent that Gehry's thinking involves clusters of irregular forms surrounding a central core. There is very little rectangularity in his planning; this museum was going to become an explosive icon of dynamic Deconstructionist architecture.

For help in designing such an irregular structure, Gehry's assistants then began to work out the contours by means of CATIA (Computer-Assisted Three-Dimensional Interactive Application) renderings. What Gehry drew by hand and developed with paper and cardboard models was digitized by scanning the three-dimensional models into the CATIA software. Figure 16.21 shows a CATIA rendering of one of the models from the outside. Figure 16.22 shows the designers working out the elaborate internal structure. The virtual models did not replace traditional modeling; Figure 16.23 shows an intricate physical model made over a period of over one year late in the design stage.

Using CATIA software, Gehry's team was also able to work out the precise shapes of the many glass, titanium, and stone pieces with which the museum is clad. Few of the pieces are rectangular. Such intricate calculations could not have been done without the help of computers. At that time, the Guggenheim Bilbao was one of the biggest projects ever undertaken with the help of three-dimensional modeling software. Computer-driven robots were also used for manufacture of the irregular, curving panels.

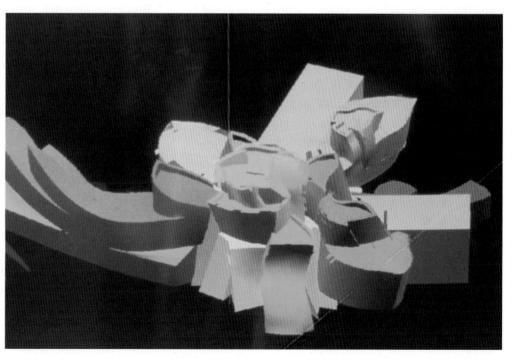

16.21 CATIA rendering of the model exterior. Guggenheim Museum, Bilbao.

16.22 CATIA rendering of the internal structure. Guggenheim Museum, Bilbao.

The choice of titanium for cladding most of the museum was an unusual one, for titanium had rarely been used for the exterior of a building. In fact, the thin titanium sheets covering the Guggenheim Bilbao ripple slightly in the wind and do not lie flat. Rather than being a disadvantage, however, these qualities add to the dynamic, living nature of the museum. Their gleaming surfaces, which continually seem to change in color as each one variously reflects the surrounding urban environment, sun and clouds, and are in turn reflected in water pools near the river, are part of the distinctive visual appeal of the museum.

The Guggenheim Bilbao is an exceptionally sculptural building, but it has been carefully designed for functionality as well. It is a space for displaying art, with a variety of galleries surrounding a tall atrium through whose glass panels light pours into the center of the museum. The upper galleries are connected by catwalks hanging from the roof, by elevators with glass sides, and by stairways at impossible angles. The largest of the galleries resembles a fish; it houses temporary exhibits and Richard Serra's *Snake* shown in the background of Figure 10.3. This permanent installation exists in harmonious relationship to the vast space, for it is a large piece of architecturally conceived sculpture, just as the building is sculptural architecture. Smaller,

more rectangular galleries make it possible for smaller works to hold their own in the midst of the extraordinary architecture, which tends to compete with the art collection for attention.

Extremely Deconstructionist in its approach to volumes, the Guggenheim Bilbao was greeted by great praise from both public and art critics. Some two million people visited it in the first year of its operation. Since it is not derived from any previous architectural pattern, reviewers have been very creative in their attempts to describe its impact. Soon after the museum's opening, one art critic wrote,

Rising in a whorl of sculptural masses, the gleaming metal-clad colossus beguiles like few buildings in recent memory. ... The topsy-turvy tumble of titanium takes an anachronistic leap into the coming century, as if extra-terrestrials had set up an embassy on the banks of the Nervion River. ... It is like nothing we have seen before.⁷

Another critic appreciatively described the unique museum as being composed of "a group of freeflowing volumes that seem to have met in a train crash."

The Guggenheim Bilbao has also been extremely successful in the goal of reviving the dying industrial

16.23 Design model in basswood and paper, built from fall 1992 to December 1993. Bridgeman Art Library.

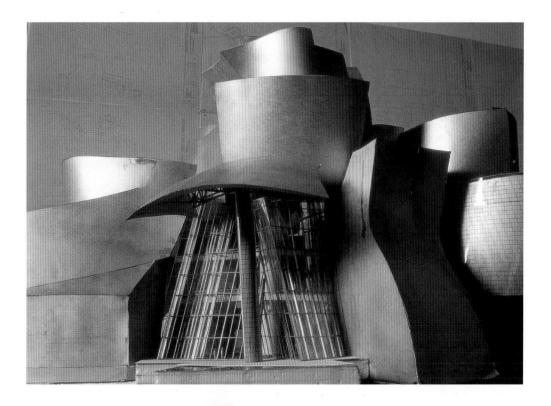

city. Many art events have been staged there, such as laser light shows played across its contours, and the Guggenheim Foundation has displayed in it the work of many world-famous modern artists, including Pablo Picasso, Marc Chagall, Andy Warhol, Robert Rauschenberg, Nam June Paik, Magdalena Abakanowicz, and Claes Oldenburg, as well as contemporary artists from the local region. The millions of visitors have made tourism a major source of income and employment for Bilbao. A new airport has been developed for the city, plus a new subway, a new water treatment system, and a riverfront redevelopment project with parks, shopping areas, offices, and apartments.

Within the overall redevelopment program, the Guggenheim Bilbao is so strong that it still holds place of honor as the gateway to the city and a living piece of modern sculpture whose gleaming, visually swaying contours are reflected in the river, rise above the traffic of the roads amidst older pieces of architecture from Bilbao's earlier heydays, and merge with the natural setting of the hills beyond (16.24). It is a great tribute to the power of art to excite and enrich human life.

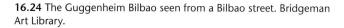

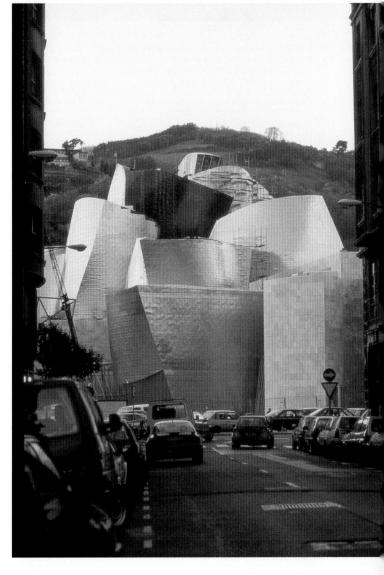

Notes

CHAPTER ONE

Thomas Hoving, Art for Dummies, International Data Group Books Worldwide, 1999, p. 9.

Federico Zeri, quoted in "Interview," by Isabelle Dillman de Jarnac, Air France Magazine, May 1999, p. 120.

Piet Mondrian, The New Art—The New Life: The Collected Writings of Piet Mondrian, ed. and trans. Harry Holtzman and Martin S. James, Boston, 1986, p. 121.

Piet Mondrian, as quoted in Michael Seuphor, Piet Mondrian: Life and Work, New

- York, 1956, p. 118. Georgia O'Keeffe, "Some Memories of Drawing," Atlantis Editions, New York, 1974. Quoted in *Georgia O'Keeffe*, Viking Press, New York, 1976, p. 1. Copyright © 2004 The Georgia O'Keeffe Foundation/ Artists Rights Society (ARS), New York
- Ouoted in Jack Coward and Juan Hamilton, Georgia O'Keeffe: Art and Letters, letters selected by Sarah Freenough, National Gallery of Art, Washington, D.C., 1987, pp. 200, 266, 242–43. Copyright © 2004 The Georgia O'Keeffe Foundation/Artists Rights Society (ARS), New York. Quoted in Herbert Read, A Concise History of

Quoted in Herbert Read, A Concise History of Modern Sculpture, Oxford University Press, New York, 1964, p. 14.
Conversation with Erik Satie, quoted in Carola Giedion-Weleker, Brancusi, Editions du Griffon, Neuchâtel, Switzerland, 1959, p. 1.
Quoted by C. G. Guilbert, "Propos de Brancusi," Prisme des Arts, no. 12, 1957, p. 7, trans by Mary Pat Fisher

- trans. by Mary Pat Fisher.
- Miller vs. California, US Supreme Court ruling 1973.
- As quoted in Robin Cembalest, "The Obscenity Trial," *ARTnews*, December 1990, p. 138. 11

Ibid., p. 137.

- Gustavo Lopez, in Peter Hudson, "The Show that had all Buenos Aires Talking," ARTnews, April 2005, p. 62.
- Gaye, Carteggio Inedito, vol. ii, p. 500, as quoted in Anthony Blunt, Artistic Theory in Italy 1450-1600, The Clarendon Press, Oxford, 1940, p. 119.

Quoted in "Decadent, Un-German, Morally Offensive," *ARTnews*, May 1991, p. 123.

- Felix Holtmann, quoted in "Canada Museum Imports Trouble," *Artworld*, June 1990, p. 208.
- 1990, p. 208.
 Shirley Thomson, quoted in April Lindren, "MP Questions Art Purchase," *Calgary Herald*, July 16, 1993, p. C4.
 Brydon Smith, quoted in "National Gallery Buys Abstract Red-Stripe Painting for \$1.8m," *Montreal Gazette*, March 8, 1990, p. F3.
 Quoted in *National Geographic Magazine*, May 1985, p. 557

May 1985, p. 557.

- "Vancouver Library Square Competition," *Canadian Architect*, July 1992, vol. 37, no. 7, 20
- Ganapathi Stapati, as quoted by Mark Tully, No Full Stops in India, Viking Penguin, New Delhi and London, 1992, p. 60.
- Written in 1918 and quoted by Eleanor S. Greenhill, Dictionary of Art, Laurel/Dell, New York, 1974, p. 283.
- From Klee's Jena lecture, 1924, quoted in Will Grohmann, Paul Klee, Harry N. Abrams, New York, p. 367.

- Soo-ja Kim, "Cloth and Life," in Art Vivant,
- Contemporary Korean Artist. Quoted in S. Rodman, *Conversations with Artists*, first published by Devin-Adair, New York, 1957, reprinted by Capricorn Books, New York, 1961.

George Chaplin, personal communication 26 to co-author, November 2005.

Le Charivari on Renoir's Mother and Children, 1874, now in the Frick Collection, New York. Quoted in Portfolio Art, New Annual #2, 1960.

L'Art on Cézanne's The Suicide House, 1873, now in the Louvre, Paris. Quoted in Portfolio Art, New Annual #2, 1960.

William Bouguereau, as quoted in Eric M. Zafran, "French Salon Painting from Southern Collections," High Museum of Art, Atlanta, 1983, p. 55 Lorie Mertes, Joan Simon and Tami Katz-

Freiman, as quoted in "Scents and Sensibility," *ARTnews*, December 1998, pp. 132–33.

Daryl Chin, "Some Remarks on Racism in the American Arts," M/E/A/N/I/N/G, #3, May 1988, pp. 22, 25.

Imna Arroyo, personal communication to co-author, 30 October, 2005.

CHAPTER TWO

- Quoted in Lucy R. Lippard, *Eva Hesse*, New York University Press, New York, 1976, p. 24. Barnett Newman, "The Sublime is Now," *The Tiger's Eye*, no. 6 (December 1948), pp. 51-53.

- pp. 51–53. Quoted in Jonathan Fineberg, "Theater of the Real: Thoughts on Christo," *Art in America*, December 1979, p. 96. *Barbara Hepworth: A Pictorial Autobiography*, 1978 edition published by Moonraker Press, Bradford-on-Avon, Wiltshire, p. 27. Henry Moore, "The Sculptor Speaks," article in *The Listener*, vol. XVIII, no. 449, August 18, 1937, pp. 338–40. Quoted in *Henry Moore on Sculpture*, ed. Philip James, Viking Press, New York, 1967, p. 62. [Reprinted by kind permission of the Henry [Reprinted by kind permission of the Henry Moore Foundation.

Henry Moore in H. Felix Man, Eight European Artists, Heinemann, London, 1954. Quoted in James, op. cit., p. 118. [Reprinted by kind permission of the Henry Moore Foundation.]

- Henry Moore in Donald Hall, "An Interview with Henry Moore," article in Horizon, A Magazine of the Arts, November 1960, vol. iii, no. 2, American Horizon, New York, 1960. Interview quoted without omissions in James, op. cit., p. 119. [Reprinted by kind permission of the Henry Moore Foundation.]
- Henri Matisse, Ecrits et propos sur l'art, ed. Dominique Fourcade, Paris, 1972. pp. 43–45, 60. Translation by Roger Lipsey in An Art of Our Own: The Spiritual in
- in An Art of Our Own: The Spiritual in Twentieth Century Art, Shambhala, Boston and Shaftesbury, 1989, p. 250. Arshile Gorky (Vosdanik Adoian), interviewed by Malcolm Johnson, "Café Life in New York," New York Sun, August 22, 1941, as quoted in Arshile Gorky: Drawings to Paintings, The University of Texas at Austin, Austin, Texas, p. 67.

Excerpted from Arshile Gorky, "Toward a Philosophy of Art," translated extracts from his letters in Armenian by Karlen Mooradian, reproduced in Arshile Gorky: Drawings to Paintings, Archer M. Huntington Art Gallery, The University of Texas at Austin, Austin, Texas, 1975, pp. 31–36. Helen Frankenthaler, as interviewed by

Emile de Antonio, in *Painters Painting: The New York Art Scene 1940–70*, 1972, 116-minute video, Montauk, New York: Mystic Fire Video.

- Letter to Emile Bernard, Aix-en-Provence, July 25, 1904, quoted in Robert Goldwater and Marco Treves, eds., Artists on Art, Pantheon Books, New York, third edition, 1958, p. 364.
- Quoted in Barbara Rose, Claes Oldenburg, The Museum of Modern Art/New York Graphic Society, New York, 1970.
- Katherine Alling, personal communication, April 2000.
- Mark Rothko, quoted in Bonnie Clearwater, "How Rothko Looked at Rothko," Art News, November 1985, p. 102.
- Quoted in Martin Kemp and Margaret Walker, eds., Leonardo on Painting, Yale University Press, New Haven and London, 1989, pp. 15, 97, 98, 162. [Reprinted by kind
- permission of the publisher.] Olafur Eliasson, "Your Colour Memory," Arcadia University Art Gallery, www.arcadia.edu/gallery.
- James Turrell, as interviewed by Esa Laaksonen, 1996, 'Art Minimal and Conceptual Only', originally published in ARK (The Finnish Architectural Review). home.sprynet.com/~mindweb/page44.htm
- Wassily Kandinsky, *Concerning the Spiritual* in *Art*, trans. M. T. H. Sadler, Dover Publications edition, New York, 1977, p. 25.
- Publications edition, New York, 1977, p. 25. Quoted in Isamu Noguchi, *The Isamu* Noguchi *Garden Museum*, Harry N. Abrams, New York, 1987, p. 98. Quoted in Robert Goldwater and Marco Treves, eds., op. cit., pp. 409–10. Johann Wolfgang von Goethe, *Theory of Colors*, trans. Charles Lock Eastlake, The MIT Press, Cambridge Mass. 1970, p. 317.
- MIT Press, Cambridge, Mass., 1970, p. 317. Josef Albers, *Interaction of Color*, revised
- edition, Yale University Press, New Haven, Connecticut and London, 1975, pp. 1, 3, 5, 12, 34, 41, 42. By kind permission of the Artists Rights Society. Copyright © 2004 The Josef and Anni Albers Foundation/ Artists Rights Society (ARS), New York
- Frank Stella, quoted in Bruce Glaser (interviewer) and Lucy R. Lippard (editor), "Questions to Stella and Judd," ARTnews, September 1966, p. 59.
- Alexander Calder, in Jean Lipman, Calder's Universe, Whitney Museum of American Art and Viking, New York, 1976, p. 172.
- Ron Lambert, personal communication to the co-author, October 25, 2005.
- Quoted in Paul Gsell, Art by Auguste Rodin, trans. by Romilly Fedden, Small, Maynard and Company, Boston, 1912, pp. 66-78.
- Umberto Boccioni, Carlo Carrà, Luigi Russolo, Giacomo Balla, Gino Severini, "Futurist Painting: Technical Manifesto 1910," in Umbro Apollonio, ed., The Documents of 20th Century Art: Futurist Manifestos, Viking Press, New York, 1973 (English language translation copyright

1973 by Thames & Hudson Ltd., London), pp. 27-28.

http://www.myjnyc.org/visit_gardenof stones.htm, accessed May 22, 2006.

CHAPTER THREE

"Magadelena Abakanowicz: Confession,"

Sculpture, October 2005, p. 37. Emily Carr, quoted by Christopher Varley in Emily Carr: Oil on Paper Sketches, Edmonton, Alberta, Edmonton Art Gallery, 1979.

Quoted in "The Courage to Desecrate Emptiness," *ARTnews*, March 1986, p. 108. Quoted in Wassily Kandinsky, *Concerning*

the Spiritual in Art, trans. M. T. H. Sadler, Dover Publications, New York, 1977 (from The Art of Spiritual Harmony, Constable and Company Ltd., London, 1914).

Quoted in Frank Lloyd Wright, An Organic Architecture: The Architecture of Democracy, Lund Humphries, London, 1939, and in Edgar Kaufmann, Jr., ed., An American Architecture, Horizon Press, New York, 1955, as quoted in Frank Lloyd Wright: In the Realm of Ideas, ed. Bruce Brooks Pfeiffer and Gerald Norland, Southern Illinois University Press, Carbondale, Illinois, 1988, pp. 32, 43.

CHAPTER FOUR

- Rick Bartow, interviewed by Larry Abbott, www.britesites.com/native_artist_interviews/ rbartow.htm
- Personal communication, October 1986.
- Edgar Degas to George Moore, as quoted in Hugh Honour and John Fleming, The Visual Arts: A History, second edition, Prentice-Hall, Inc., Englewood Cliffs, New Jersey, 1982, p. 551.

Tom Matt, personal communication to co-author, October 11, 2005.

CHAPTER FIVE

- Diego Rivera, in Juan O'Gorman, Diego Rivera: Fifty Years of His Work, "Report on a Dissertation by Diego Rivera Concerning the Techniques of Encaustic and Fresco Painting," Department of Plastic Arts, National Institute of Fine Arts, Mexico City, undated, p. 269.
- Pinin Brambilla Barcilon, quoted in Ken Shulman, "Like Seeing Leonardo for the First Time," *ARTnews*, November 1991, p. 53.
- Pierre Rosenberg, quoted in Ginger Danto, "What Becomes a Legend Most," ARTnews, Summer 1989, p. 153.
- James Beck with Michael Daly, Art Restoration: The Culture, the Business, and the Scandal, W. W. Norton and Company, New York, 1996, p. 194.
- Sharon Booma, Artist's statement for exhibition "Sharon Booma: New Works," at Anderson/O'Brien Fine Art Gallery, Omaha, Nebraska, May 5-19, 2000.
- Helen Frankenthaler, as quoted by Barbara Rose, Frankenthaler, Harry N. Abrams, New York, 1970, p. 85.
- Robert Rauschenberg, as interviewed by Emile de Antonio, in Painters Painting: The New York Art Scene 1940-70, Mystic Fire Video, Montauk, New York, 1972.

CHAPTER SIX

- Stephen Alcorn, personal communications to the co-author, October 25, 2005, and June 20, 1996.
- Fritz Eichenberg, "Eulogy to the Woodblock," in The Wood and the Graver: The Work of Fritz Eichenberg, Clarkson N. Potter, Inc., New York, 1945, p. 178.
- Frank Boyden, interviewed June 20, 1989.
- David Hockney, quoted in David Sheff, "David Hockney: But is it art?", *Publish*, December 1991, p. 128.

- 5 David Hockney, "UK Artist Snubs Art World with Fax Offer," *Asian Age*, October 20, 1999, p. 8.
- Interview with Janet Cummings Good, January 1992.

CHAPTER SEVEN

- Paul Rand, Paul Rand: A Designer's Art, Yale University Press, New Haven, Connecticut and London, 1985, pp. xiii, 7.
- Interview with Peter Good, November 1991
- Quoted in Hermann Zapf, Manuale Typographicum, M.I.T. Press, Cambridge Massachusetts and London, 1954 and 1970, . 101.
- William Morris, The Ideal Book, Essays and Lectures on The Arts of the Book, William S. Peterson, ed., University of California Press, Berkeley and Los Angeles, 1982, p. 73.
- Milton Glaser, interviewed by designboom.com, May 18, 2004, www.designboom.com/eng/interview/ glaser.html, accessed May 29, 2006.

CHAPTER EIGHT

- 1 Quoted in Susan Weiley, "New Light on Color," ARTnews, October 1985, p. 88.
- Excerpted from Nancy Newhall, ed., The Daybooks of Edward Weston, vol. 2, Horizon Press, New York, in collaboration with the George Eastman House, Rochester, 1966, pp. 10, 18, 37, 206.
- Stephen Dalton, At the Water's Edge: The Secret Life of a Lake and Stream, Century Hutchinson Ltd., London, 1989, p. 158.
- Interview with Elizabeth Sunday, April 20, 1992
- Donna Hamil Talman,
- www.er3.com/donna/ancestor.htm
- Frank Noelker, personal communication, February 2000.
- Ruth Zelanski, communication to co-author, January 2006.
- Susumu Endo, as quoted by Richard Thornton, "Space Transformations," Print magazine, January/February 1991, p. 91.
- Dean Devlin, quoted in Tim Prokop "Fireworks," *Cinefex*, no. 87, September 1996, p. 60.
- Satyajit Ray, as quoted in Maanvi Media article at http://members.tripod.com/satyajit_ray.
- Arnold Schwartzman, quoted in Karen Lowe, "Jeers, Cheers as Leni Riefenstahl is Honoured," *Asian Age*, September 2, 1997, p. 5.
- Bill Viola, in Art at the Turn of the
- Millennium, p. 518. Nam June Paik, quoted in Ann Landi, "Screen Idyll," ARTnews, January 2000, p. 146.

CHAPTER NINE

- Janet Cummings Good, personal communication to co-author, January 20,
- Peter Eisenman, quoted in Madison Gray, "Doing the Digital Twist," ARTnews, June 1998, p. 93.
- Peter Eisenman, The House of Cards, Oxford University Press, New York, 1988,
- Melvin L. Prueitt, Los Alamos National Laboratory, "Scientific Applications of Computer Graphics," The Visual Computer, 1986, vol. 2, p. 189.
- http://www.davidem.com/em_cg_art/ em_cg_pages/em_cg_art_writing.htm, accessed June 9, 2006.
- Charles Csuri, quoted in Paul Trachtman, 'Charles Csuri is an 'Old Master' in a New Medium," Smithsonian, pp. 57-58.

- 7 John Andrew Berton, Jr., "Film Theory for the Digital World: Connecting the Masters to the New Digital Cinema," Journal of the International Society for the Arts, Sciences, and Technology, Leonardo Supplemental Siggraph Issue 1990, pp. 6, 9.
- Karen Cassyd-Lent, personal communication to co-author, March 2006.
- Mark Napier, quoted by Carly Berwick in "Net Gains," ARTnews, December 2002, p. 89.

CHAPTER TEN

- 1 Alice Aycock, "Alice Aycock, Reflections on Her Work, an Interview with Jonathan Fineberg," quoted in J. Fineberg, Art Since 1940 (second edn), Laurence King Publishing, London, 2000, p, 405
- Henry Moore, as quoted by Tom Hopkinson, "How a Sculptor Works," *Books* and Art, London, November 1957, reprinted in Henry Moore on Sculpture, Philip James, ed., Viking Press, New York, 1967, p. 123.
- Richard Serra, quoted in David Sylvester, "Serra in Bilbao," Modern Painters, p. 26.
- Michelangelo Buonarroti, *Rime*, a cura di Enzo Noe Girardi Bari: Laterza, 1960, no. 151: 1-4, p. 82. © Instituto Geografico de Agostini, Novara, Italy. As translated by Eugenio Garin in The Complete Work of Michelangelo, Reynal and Company/ William Morrow and Company, New York,
- undated, p. 525.
 Excerpted from *The Letters of Michelangelo*, trans. E. H. Ramsden, vol. 1, Stanford University Press, Stanford, California, 1963, pp. 108, 110, 112, 148. [Reprinted by kind
- pp. 108, 110, 112, 140. [Reprinted by Kin permission of the publisher.] Excerpted from Charles Hope, ed., and Alessandro Nova, The Autobiography of Benvenuto Cellini, from the translation by John Addington Symonds, St. Martin's Press, New York, pp. 179-81.
- Thornton Dial, in Edward M. Gomez, "You pick it up and make art out of it," ARTnews, October 2005, p. 154.
- Judy Pfaff, quoted in "Sculptors' Interviews," Art in America, November 1985, p. 131.
- Zoë Leonard, in "Sticks and Stones and Lemon Cough Drops," by Silvia Hochfield, ARTnews, September 2002, p. 120. [By kind permission of Zoë Leonard.]
- Michael Heizer, as quoted by Bertram Gabriel, "Works of Earth," Horizon, January/February 1982, p. 48.
- Robert Smithson, conversation with Dennis Wheeler, quoted in Eugenie Tsai, Robert Smithson Unearthed, Columbia University Press, New York, 1991, p. 105.

CHAPTER ELEVEN

- Toshiko Takaezu, in Althea Meade-Hajduk, "A Talk with Toshiko Takaezu," American Craft, February/ March 2005, pp. 48-49.
- Interview with Paula Winokur, April 21, 1992, and Artist's Statement, May 2003.
- George Nakashima, essay in Derek Ostergard, George Nakashima: Full Circle, Weidenfeld and Nicolson, a Division of Wheatland Corporation, New York, 1989, pp. 104-5, 90-91, 109.
- Maurice Marinot, as quoted in Robert A. Cohen, "Origins of the Studio Glass Movement," Glass Studio, no. 32, p. 37.
- Susye Billy, as quoted by Ralph T. Coe, *Lost and Found Traditions*, University of Washington Press, Seattle, 1986, p. 232.
- Norma Minkowitz, personal communication, October 23, 1989.
- Loretta Pettway in John Beardsley, William Arnett, Paul Arnett, and Jane Livingston, The Quilts of Gee's Bend, Tinwood Books, in association with The Museum of Fine Arts, Houston, Texas, Atlanta, 2002.

CHAPTER TWELVE

Quoted in Jack Cocks, "The Man Who's Changing Clothes," Time, October 21, 1985, pp. 77-78.

CHAPTER THIRTEEN

Richard Swibold, personal communication, January 4, 1990.

Quoted in Edgar Kaufmann, ed., Frank Lloyd Wright: An American Architecture, Horizon

Press, New York, 1955, p. 106. Le Corbusier, Plans, 12 February 1932, p. 40, as quoted in William J. R. Curtis, Modern Architecture Since 1900, Prentice-Hall, Inc., Englewood Cliffs, New Jersey, 1987, p. 177

Excerpted from R. Buckminster Fuller, "Conceptuality of Fundamental Structures," in Gyorgy Kepes, Structure in Art and in Science, George Braziller, New York, 1965, p. 68.

www.mcbridecharlesryan.com.au, accessed June 16, 2006.

William Rees-Mogg, quoted in Alan Riding, "London Museum Plan Sparks Uproar," New York Times Service in International Herald Tribune, July 4, 1996, pp. 1, 8.

"A Revolutionary New Architectural Form," publicity piece from the Victoria and Albert Museum.

CHAPTER FOURTEEN

- Ouoted in Bruce Brooks Pfeiffer and Gerald Nordland, eds., Frank Lloyd Wright: In the Realm of Ideas, Southern Illinois University Press, Carbondale and Edwardsville, 1988, p. 24.
- Richard Haas, *The City is My Canvas*, New York: Prestel, 2001, p. 9.
 D. T. Suzuki, "Satori, or Acquiring a New Viewpoint," in *An Introduction to Zen* Buddhism, D. T. Suzuki, Eastern Buddhist Society, Kyoto, 1934, as quoted in Nancy Wilson Ross, ed., *The World of Zen*, Random House, New York. 1960, p. 41. Lawrence Halprin, *Cities*, Reinhold Publishing Corporation, New York, 1963,

Patricia Johanson, quoted in Robin Cembalest, "The Ecological Art Explosion," *ARTnews*, Summer 1991, p. 99.

Frank W. Ballard, "Hidden Treasures: Rediscovering Twenty-Nine Years of Puppetry Arts," in catalog for *Hidden* Treasures: A Glimpse of Puppet Masterworks from the University of Connecticut, William Benton Museum of Art, June 5-August 7, 1994, p. 2.

CHAPTER FIFTEEN

- Quoted in Rosalind Russell, "Statues smashed, Vase of Uruk and Harp of Ur stolen," Reuters, Asian Age, April 16, 2003, p. 6.
- From the Commentaries of Lorenzo Ghiberti, quoted in Robert Goldwater and Marco Treves, eds., Artists on Art, Pantheon Books, New York, third edition, 1958, pp. 28-30.

- 3 Johann Joachim Winckelmann, Thoughts on the Imitation of Greek Works of Art, Dresden, 1755, English translation 1765, quoted in Hugh Honour and John Fleming, The Visual Arts: A History, Prentice-Hall, Inc., Englewood Cliffs, New Jersey, second
- edition, 1986, p. 496.
 "Open Letter to a Group of Prospective Students," Paris, 1861, quoted in Goldwater
- and Treves, eds., op. cit., p. 296. Conversation with Ambroise Vollard, quoted in Goldwater and Treves, op. cit., p. 322.
- Quoted in Robert Goldwater, Paul Gauguin, Abrams, New York, 1983, p. 13.
- Ibid.
- 8 Ibid., p. 118.
- 9 Ibid., p. 114.
- 10 Excerpted from Paul Gauguin's Intimate Journals, trans. Van Wyck Brooks, Crown Publishers, New York, 1936, pp. 92-97
- Quoted in Faber Birren, History of Color in Painting, Reinhold Publishing, New York, 1965, p. 332.
- "Reflections on Painting," Paris, 1917, quoted in Goldwater and Treves, op. cit.,
- An interview with Pablo Picasso, quoted in Goldwater and Treves, op. cit., p. 417
- Umberto Boccioni, Carlo Carrà, Luigi Russolo, Giacomo Balla, Gino Severini, "Futurist Painting: Technical Manifesto 1910," in Umbro Apollonio, ed., *The Documents of 20th Century Art: Futurist* Manifestos, op. cit., p. 26. Anonymous article in *The Blind Man*,
- published in May 1917 by Marcel Duchamp, Beatrice Wood, and H. P. Roche, quoted in *Marcel Duchamp*, eds. Anne D'Harnoncourt and Kynaston McShine, The Museum of Modern Art, New York, and Philadephia Museum of Art, 1973, p. 283.

Barnett Newman, as quoted in Thomas B. Hess, *Barnett Newman*, exhibition catalog, The Museum of Modern Art, New York, 1971, p. 38. Bridget Riley, in Ian Chilvers, *A Dictionary*

of Twentieth-Century Art, Oxford Paperback Reference, Oxford University Press,

Oxford/New York, 1999. Ad Reinhardt, "Art as Art," *The Selected Writings of Ad Reinhardt*, undated, reprinted

on http://home.sprynet.com/~mindweb 19 Holland Carter, Art in America, April 1989, p. 257.

Agnes Martin, in Joan Simon, "Perfection Is 20 in the Mind: An Interview with Agnes Martin," *Art in America*, May 1996, p. 85.

Joseph Kosuth, quoted by Barbara A. MacAdam, "A Conceptualist's Self-Conceptions," *ARTnews*, December 1995, pp. 126-27

Robert Smithson, from "Fragments of an interview with P.A. (Patsy) Norvell," 1969, in Robert Smithson: The Collected Writings, p. 194. "Art of Eating: Sure, It's Dinner. But Is It

Art?", Asian Age, August 1, 1999, p. 1.

Personal communication, May 19, 1987.

Quoted in Edward Lucie-Smith, "Craft Today: Historical Roots and Contemporary Perspectives," introductory essay for American Craft Today: Poetry of the Physical, American Craft Museum, New York, 1986, p. 37.

- 26 Quoted in Judith Higgins, "In a Hot Country," ARTnews, Summer 1985, p. 65.
- Deborah Muirhead, personal communication, March 1996.
- 28 Interview with Deborah Muirhead, April 9, 1992.
- Romare Bearden, as quoted by John A. Williams, in M. Bunch Washington, *The* Art of Romare Bearden: The Prevalence of Ritual, Harry N. Abrams, New York, 1972, pp. 9, 11.

Ryoei Saito, quoted in Charles Danziger, 'Where the Buyers Are," Art in America, July

- "High partial Painting_S.shtml, accessed June 21, 2006.
- Sandro Chia, quoted in "Making Art, Making Money," Art in America, July 1990, p. 138.
- Bessie Harvey, as interviewed by Eleanor E. Gaver, "Inside the Outsiders," Art and Antiques, Summer 1990, p. 85.
- Bessie Harvey, in interview July 1988, Alcoa, Tennessee, in "Spirit in the Wood/Spirit in the Paint," curated by Sal Scalora, Artspace exhibit, New Haven, Connecticut, 1989.
- Raymond Isidore, in Linda Goddard, "La Maison Picassiette," in Raw Vision, #30, Spring 2000.
- Jean Dubuffet, quoted in Roger Cardinal, Outsider Art, Praeger, New York, 1972, p. 26.

CHAPTER SIXTEEN

- 1 Quoted in Frank D. Russell, Picasso's Guernica, Allanheld and Schram, Montclair, New Jersey, 1980, p. 56.
- From a letter written by Auguste Rodin to Marcel Adam, published in Gil Blas, July 7,
- Auguste Rodin, *Art*, Small, Maynard and Company, Boston, 1912, pp. 181, 178, translated from the French of Paul Gsell by Mrs. Romilly Fedden.
- Michelangelo Buonarroti, sonnet "On Beauty," quoted in Robert Goldwater and Marco Treves, eds., *Artists on Art*, op. cit.,
- pp. 59–60. Michelangelo Buonarroti, "Conversations with Vittoria Colonna as recorded by Francisco de Hollanda," quoted in Goldwater and Treves, eds., op. cit., pp. 68-69.
- Cardinal José Castillo Lara, quoted by Philip Pullella, "Click, and thou shalt see angels on the Vatican's CD-ROM" (Reuter News Service), Asian Age, January 18, 1996,
- Ĵason Edward Kaufman, "Gehry's Guggenheim Bilbao: New Colossus," The Washington Post, October 26, 1997, p. G2, on http://www.jasonkaufman.com/ articles/gehrys/_guggenheim_bilbao.htm, accessed June 18, 2006.
- Arthur Lazere, May 30, 2001, http://www.culturevulture.net/ ArtandArch/Bilbao.htm, accessed June 18,

Glossary/Pronunciation Guide

Most words are accompanied by a guide to pronunciation. Syllables are separated by a space and those that are stressed are underlined. Letters are pronounced in the usual manner for English unless they are clarified in the following list.

a	flat	
aa	father	
aw	saw	
ay	pay	
ai	th <i>e</i> re	
ee	see	
e	let	
i	pity	
ī	h <i>i</i> gh	
O	not	
00	food	
oy	boy	
Ō	no	
OW	now	
yoo	you	
u	but	
er, ir, or, ur	fern, fir, for, fur	
ă, ĕ, ĭ, ŏ, ŭ	about, roses, (to)	
suspect: (unaccented vowels		

j	<i>j</i> et	
kh	guttural aspiration	
(ch in Welsh and German)		
nσ	$sin\sigma$	

represented by "shwa" in some

*ch*urch

ng	sing
sh	<i>sh</i> ine
wh	where
y	yes
zh	beige

phonetic alphabets)

ch

A

Abstract Referring to the essence rather than the surface of an object, often by stripping away all nonessential characteristics.

Abstract Expressionism The post-World War II movement centered in New York in which paint was freely applied to a large canvas, expressing the energy and feelings of the artist *nonobjectively*, usually with no emphasized *focal point*.

Acoustics The science of planning the properties of sound in architecture.

Acrylic (ă <u>kril</u> ik) A water-based synthetic *medium* for painting, also called *acrylic emulsion*.

Action Painting A style of painting, most notably practiced by Jackson Pollock, in which paint is dribbled and splashed onto the *support* with broad gestural movements.

Actual Texture The true physical feeling of a form's surface.

Additive color mixing The combination of *refracted colors*.

Additive sculpture That which is created by a process of building up or combining materials.

Adze A woodcarving tool with both chiseling blade and axlike handle.

Aerial view A downward perspective on an image.

Aesthetic (es <u>thet</u> ic) Pertaining to a sense of the beautiful.

Aesthetic distance The spatial relationship between the viewer and a work of art.

Aesthetics Theories of what is beautiful.

Airbrush A tool used for blowing a fine spray of paint onto a surface, to allow smooth graduations of *values* and *hues*.

Alla prima (al ă / pree mă) See *direct painting*

Analogous colors Those lying near each other on the *color wheel*.

Anneal (ă <u>neel</u>) To heat metal to make it more malleable, to counteract the hardening typical as metal is worked.

Antique glass Sheets of glass that have been handblown as cylinders, cut, and heated to flatten them, often characterized by bubbles and warps.

Applied arts Disciplines in which functional objects are created.

Apse In church architecture, the semicircular end of the building.

Aquatint An *intaglio* printmaking technique, producing grainy tones rather than lines, that uses acid to penetrate areas of a metal plate that are covered by porous powdered resin.

Arch A curving or pointed structural device supporting an opening, doorway, or bridge.

Archaic period In Greek arts, the 700 to 480 B.C. age during which interest in depicting the natural human body flourished.

Armature (<u>aar</u> mă ch ŭr) An inner skeleton that supports a sculpture made of some malleable material.

Art brut (aart / broot) "Raw art," Jean Dubuffet's term for outsider art.

Artisan A person who is skilled at a certain *craft*.

A secco Referring to paint applied to the surface of a fresco after the plaster has dried, in contrast to *buon fresco*.

Assemblage (ă sem blij) A combination of varying materials to create a three-dimensional work of art.

Asymmetrical balance The distribution of dissimilar visual weights in such a way that those on either side seem to offset each other, also called *informal balance*, in contrast to *symmetrical* or formal *balance*.

Atmospheric color The effects of lighting and environmental reflections on local colors.

Atmospheric perspective The illusion—and illusionary device—that forms seen at great distance are lower on *value* contrast and less sharply defined than objects close to the viewer.

Axis An imaginary straight line passing centrally and/or longitudinally through a figure, form, or composition.

B

Balance The distribution of apparent visual weights through a composition. See *asymmetrical balance*.

Balloon frame construction Framing for a building in which relatively small pieces of wood are nailed together rather than heavy timbers connected by joinery.

Baroque (bă <u>rōk</u>) Seventeenth-century artistic styles in Europe, characterized by swirling composition, sensuality, emotionality, and exuberant sculptural and architectural ornamentation.

Barrel vault A ceiling in the form of an unbroken tunnel.

Bas relief (bas / ri leef) See Low relief.

Bearing wall construction A support system in which the weight of ceiling and roof is borne by the entirety of the walls.

Binder The material used in paint and some drawing *media* to bind the particles of *pigment* together and enable them to stick to the *support*.

Bitmap A matrix of pixels (dots in the computer's memory) of which an image may be composed in computer graphics.

Blind embossing Pressing an uninked, cut plate of metal against paper to create a sculptured, uninked image.

Broken colors In contrast to areas of a single *hue*, use of fragments of different hues next to each other in a painting to approximate the dynamism of color perception.

Buon fresco (booawn / fres kō) "True fresco" in which paint is spread on wet plaster and becomes part of the wall surface itself as it dries.

Burin (<u>byoor</u> in) A beveled steel rod used for cutting lines in *line engravings* or *wood engravings*.

Burl A woody circular knob on the trunk of certain trees, prized for its whorled lines in woodworking.

Burnish To rub to a shiny finish.

Buttress An external supporting structure built against a wall to counteract the thrust of an arch or vault. See *flying buttress*.

Byzantine Referring to art of the Byzantine period in the eastern half of the Roman Empire, from A.D. 330 to the mid-fifteenth century. This art was primarily religious and characterized by *stylized* elongated human forms and rich ornamentation.

C

 $\begin{tabular}{ll} \textbf{Calligraphy} (\texttt{k} & $\underline{\textbf{li}}$ gr~~å fee) & The art of fine writing. \\ \end{tabular}$

Camera obscura (kam er ă / ŏ b skyoor ă) A dark chamber in which the image of an object enters through a lens or small opening and is focused on a facing wall.

Cantilever (kantĭ leev ĕr) A projection from a building or sculpture that is supported, anchored, or balanced at only one end.

Capital The head of a column that bears the weight of the structure above.

Cartoon A full-sized drawing for a twodimensional work, such as a *fresco*, which is transferred to the *support* at the preparatory stage.

Casting The creation of a threedimensional form by pouring into prepared molds a molten or liquid material that will later harden.

Ceramics The art of making objects of clay and *firing* them in a *kiln*.

Chalk Naturally deposited calcium carbonate, ground to a powder and reconstituted with a *binder* for use as a drawing *medium*.

Charcoal Charred vine or wood used in sticks as a soft drawing *medium*.

Chiaroscuro (kee <u>aar</u> ă <u>skoor</u> ō) The depiction in two-dimensional art of the effects of light and shadow, highly developed in *Renaissance* paintings as a means of rendering the solidity of bodies.

Chroma (krō mă) See saturation.

Cinematography The artistic and technical skills involved in creating motion pictures.

Cire perdue (seer / pair doo) See *lost-wax*.

Classical The art and culture of ancient Greece and Rome.

Classical period Greek art from c. 500 to 323 B.C., characterized by serene balance, harmony, idealized beauty, and lack of extraneous detail.

Classicism Movements, periods, and impulses in Western art that prized qualities of harmony and formal restraint and claimed direct inspiration from *Classical* models. Traditionally contrasted with *Romanticism*.

Closed form In sculpture, an unbroken volume with no projections or *voids*.

Coffer (<u>kaw</u> fer) A recessed panel, often repeated as a pattern, in a ceiling or vault.

Coil building A method of building a form of clay by rolling it into long ropes which are coiled in a spiraling pattern to raise the sides of the piece.

Cold color (or "cool color") A hue traditionally thought to suggest low temperature and peacefulness, chiefly blues and greens.

Collage (kŏ <u>laazh</u> *or* kō <u>laaj</u>) A twodimensional technique in which materials are glued to a flat surface.

Color wheel Relationships among *hues* expressed in a circular two-dimensional model.

Compact disc (CD) A flat circular device on which visual and/or audio information is stored *digitally*, to be decoded by a laser beam.

Complementary hues Colors lying opposite each other on a *color wheel*.

Compositional line A line that leads the eye through a work, unifying figures or parts of figures.

Compressive strength In architecture, the amount of downward pressure a structural material can withstand without breaking.

Computer graphics Various techniques of creating two-dimensional artworks by computer.

Conceptual art Art that deals with ideas and experience rather than permanent form.

Conté crayon (kon tay / kray on) A fine-textured, non-greasy stick of powdered graphite and clay with red ocher, soot, or blackstone added for color, used as a drawing tool.

Content The subject-matter of a work of art and the emotions, ideas, symbols, stories, or spiritual connotations it suggests. Traditionally contrasted with *form*.

DRY MEDIA LIQUID MEDIA

GRAPHITE

CONTÉ

BRUSH AND INK

PEN AND INK

Context The surrounding circumstances.

Contour The outer edge of a three-dimensional form or the two-dimensional representation of this edge.

Contrapposto (con tra $p\bar{o}s$ t \bar{o}) In figurative works, counterpoised *asymmetrical balance* between parts of the body, with most of the weight on one leg and an S-curve in the torso, first used by *Classical* Greek sculptors.

Contrast Abrupt change, as when opposites are juxtaposed.

Control To determine how an area will be seen or experienced.

Cool colors Those from the blue and green side of the *color wheel* thought to convey a feeling of coldness.

Corinthian ($k\bar{o}$ rin thee an) In Classical Greek architecture, the lightest and most ornate order, with the appearance of outward-curling acanthus leaves on the capital.

Crafts Disciplines in which functional objects are made by hand.

Crop To delete unwanted peripheral parts of a design.

Cross-hatching Crossed parallel lines used to create the illusion of form on a two-dimensional surface, by suggesting shadows and rounding in space.

Cubism (kyoob iz ĭm) An art movement of the early twentieth century, dominated by Picasso and Braque and distinguished by its experiments with analyzing forms into planes seen from many sides at once and by the liberation of art from representational depictions.

Cyberspace (<u>sī</u> ber spays) The "world" of communication through international computer networks.

D

Dada (daa daa) An anti-rational, antiaesthetic art movement begun in 1916.

Daguerreotype (då ger ō tip) An early photographic process invented by Louis Daguerre.

Deconstructionist Referring to contemporary architecture which deliberately gives the impression of chaos and instability rather than order and stability.

Decorative line A line that embellishes a surface.

Defensive grid Our ability to screen out unnecessary stimuli.

Descriptive line A line that tells the physical nature of an object.

Digital versatile disc (DVD) A device for miniature storage of audio and/or visual information in *digitized* format, to be decoded by a laser beam.

Digitize In computer graphics, to convert an image into computer language so that it can be projected or manipulated by computer.

Diptych (dip tik) A work consisting of two panels side by side, traditionally hinged to be opened and closed.

Directional Telling the eye which way to look.

Direct painting Application of paint directly to a *support* without *underlayers*, in contrast with *indirect painting*. Also called *alla prima*.

Divisionism See Pointillism.

Dome A hemispherical vault over a room or building.

Doric (<u>daw</u> rik) In *Classical* Greek architecture, the simplest order, with a heavy, fluted column, a dish-shaped capital, and no base.

Download To take information from the Internet or an external storage device and save it on a computer.

Draw To make lines and marks.

Dry media A means of drawing such as graphite pencil, charcoal, pastel, *conté crayon*, or computer printer ribbon, in which the base that carries the *pigments* is not fluid. As shown in the drawing, each of these media creates a different line quality.

Drypoint An *intaglio* printmaking technique, often used in combination with *etching*, in which lines are scratched

directly into the metal plate with a sharp-pointed tool.

Ductility (duk <u>til</u> ĭ tee) The capacity for being drawn out into wires or hammered into sheets, a varying property of metals. Gold and copper are noted for their especially high ductility.

Dynamic form A mass that appears to be in motion.

Dynamic range The degree of difference between the darkest and lightest values that the sensor of a digital camera can register.

E

Earthenware *Ceramics* made from porous, coarse-textured clays such as terra cotta.

Earthwork A large-scale sculpture in which the surface of the earth is the *medium*.

Economy The use of as few means as possible to achieve a desired visual result.

Edge A boundary where two areas treated differently meet.

Elements of design The basic components of the visual arts: line, shape or form, space, texture, lighting, color, and perhaps time.

Emphasis Predominance of one area or element in a composition.

Enamel A colored glassy coating heatfused to metal.

Encaustic (en <u>kaws</u> tik) A painting technique in which *pigment* is mixed with a *binder* of hot wax.

Engraving An *intaglio* printmaking technique in which lines are cut on a metal or wood printing surface with a sharp tool.

Enlightenment Eighteenth-century European philosophical movement promoting individual reason rather than tradition.

Entablature The horizontal member atop a column, supporting what lies above.

Entasis (en tă sis) A slightly convex curve given to the shaft of a column to correct the illusion of concavity produced by a perfectly straight shaft.

Environmental design The art of manipulating outdoor areas for practical and aesthetic purposes, from landscaping to relationships among buildings in urban settings.

Ergonomics (ur gō <u>naam</u> iks) The study of the mechanics and proportions of the human body, with the aim of designing products with which the body can interact efficiently and comfortably.

Etching An *intaglio* printmaking technique in which lines are produced by scratching away a protective covering of wax on a copper plate, which is then bathed in acid that bites channels where the metal has been exposed.

Expressionism An art movement particularly strong in Germany before World War I, in which the artist reports inner feelings rather than outer realities.

Expressive Giving form to emotions.

Exterior contour The outside form of a three-dimensional piece.

Eye level line In *linear perspective* drawings, the horizon line.

Eyeline The implied line along which the eyes of a human figure in a work of art seem to be looking.

F

Façade (fă <u>saad</u>) The front or principal elevation of a building.

Fantasy Imagery existing only in the imagination.

Fauvism (<u>fŏ</u> viz ĭm) An art movement of the first decade of the twentieth century, using color boldly to express the inner qualities rather than superficial appearance of things.

Fax Technology by which a facsimile of text or line art is transferred electronically from one location to another via telephone connections.

Figurative Referring to artworks based on images of identifiable objects.

Figure-ground relationship In twodimensional art, seeing images as having been applied over a background.

Figure-ground reversal A twodimensional work in which it is difficult to discern which is figure and which is ground, because they are visually interchangeable.

Fine arts The nonfunctional art disciplines, such as painting and sculpture.

Fire To heat *ceramics* to make them durable.

Flying buttress A *buttress* in the form of strut or segmented arch that transfers thrust to an outer support.

Focal plane shutter A common type of camera in which there is a double curtain of shutters close to the film; when a flash is used, the film must be exposed at a relatively slow speed because the double shutters take some time to open and close.

Focal point The area of a composition to which the viewer's eye is most compellingly drawn.

Folk art Works created by aesthetically untrained artists working somewhat within a community tradition.

Forced perspective The exaggerated illusion of deep space, often employed in setmaking for theatrical performances.

Foreground In two-dimensional work, the area of a composition that appears closest to the viewer.

Foreshortening Contraction of the length and adjustment of the contours of a figure perpendicular to the viewer. This is done to counteract the perceptual distortion of proportions of objects receding from the viewer into the distance.

Forge To hammer heated metal over an anvil to shape it.

Form 1. The mass or volume of a threedimensional work or the illusion of volume in a two-dimensional work. 2. The physical aspects of a work, as opposed to its emotional and intellectual *content*.

Formal balance See symmetrical balance.

Formalism Art criticism concentrating on outer form rather than inner content.

Found object An object that is presented as a work of art or a part of one, but which was not originally intended as art; also called *objet trouvé*.

Fractal geometry Mathematical modeling of natural forms, often used in computer graphics.

Frame construction A building system in which spaced horizontal and vertical members are interlocked to form a solid skeleton to which an outer skin is added.

Fresco (<u>fres</u> kō) A wall painting technique in which *pigment* in a water base is applied directly to fresh, still-damp plaster, into which it is absorbed.

Frontal Referring to sculpture designed to be seen only from the front.

Full round Referring to sculpture that exists in fully three-dimensional space and is to be seen from all sides.

Full tonal range A term used chiefly in black and white photography to signify representation of all values in a single picture, from black through mid-grays to white.

Futurism A movement initiated in Italy in 1909 to sweep aside all artistic conventions and capture the qualities of modern industrialized life.

G

Geodesic (jee ō <u>des</u> ik) **dome** A structural framework of small interlocking polygons forming a *dome*.

Geometric Having mathematically regular contours, such as a circle, square, or rectangle.

Geometric period A stylistic phase of ancient Greek art between c. 800 and 700 B.C. characterized by abstraction of forms to geometric elements.

Gesso (jes ō) A fluid white coating of plaster, *chalk* and *size* used to prepare a painting surface so that it will accept paint readily and allow controlled brushstrokes.

Gestural A style of painting or drawing in which the artist's arm and hand movements are apparent in the finished piece.

Glaze 1. A thinned, transparent layer of oil paint. 2. A mineral solution, applied to a *ceramic* piece, that vitrifies to a glossy and water-resistant coating when *fired*.

Golden Mean In ancient Greek *aesthetic* theory, an ideal proportional relationship between parts, whereby the smaller is to the greater as the greater is to the whole. This ratio cannot be worked out mathematically, but is approximately 5:8, or 1:1.618.

Golden Rectangle A rectangle the lengths of whose sides correspond to *golden section* proportions. Much used as a compositional and format-establishing device in *Renaissance* painting.

Gothic A style of European art from the mid-twelfth to mid-fifteenth century, especially noted for its soaring vertical cathedrals, three-dimensional sculptures, and the sense of depth and emotion in two-dimensional paintings.

Gouache (gwaash) An opaque watersoluble painting *medium* bound with gum arabic, the lighter tones being mixed with Chinese white watercolor.

Graphic design The arts involved in creating two-dimensional images for commercial purposes. Graphic designers often work with type as well as illustrations; the printed surface may range from paper to fabrics.

Graphite A soft carbon used in drawing pencils.

Groin vault In architecture, two intersecting, identical *barrel vaults*.

Ground 1. See *figure-ground relationship*. 2. The surface on which a two-dimensional work is developed.

H

Hard-edged A term used chiefly in referring to twentieth-century paintings in which clean, sharp edges are formed where areas of different colors meet.

Hatching Fine, short parallel lines used in two-dimensional arts to create the effect of shadow on three-dimensional forms. See also *cross-hatching*.

Hellenistic period Greek art from 323 to 100 B.C. or later, characterized by greater dynamism, emotional drama, and naturalism than that of the *Classical period*.

High contrast The polarization of the normal ranges of *values* towards the extremes of light and dark.

Highlight A spot of highest (lightest) *value* in a work—usually white.

High relief Sculpture in which figures emerge three-dimensionally from a flat surface to half or more than half of their natural depth.

High Renaissance The years between roughly 1490 and 1520 in Italy, productive of some of the world's greatest art, informed by but not bound to *Classical* traditions.

High-tech revival A late twentieth-century return to machine-like architectural structures.

Horizon line The perceived line where earth and sky seem to meet, an aspect of *linear perspective*.

Hue The property of a color that enables us to locate its position in the *spectrum* or on the *color wheel* and thus label it as "red" or "blue," etc. This is determined by its wavelength.

I

Icon A two-dimensional depiction of a sacred figure or figures, thought to work miracles, particularly characteristic of *Byzantine* sacred art.

Iconography (ī kŏ naa gră fee) Visual conventions and symbols used to portray ideas in a work of art.

Idealized Referring to art in which *representational* images conform more closely to ideal *aesthetic* standards than to real life.

Impasto (im <u>pas</u> tō) Thickly applied paint, mainly oil or acrylic.

Implied A line, shape, or form that is suggested to the eye but not actually present.

Impressionism An art movement originating in late nineteenth-century France, in which the artist attempts to capture what the eye actually sees before the brain interprets the image. This may be a surface broken by fragmented lights or an ephemeral moment in time.

Indirect painting Using a series of layers to produce a desired final effect, in contrast with *direct painting*.

Industrial design The art of creating functional products that also have *aesthetic* appeal.

Installation piece A three-dimensional designed environment set up (often temporarily) as a work of art.

Instrumentalism Art criticism focusing on how well an artwork fulfills a particular purpose.

Intaglio (in \underline{tal} $y\bar{o}$) A category of printmaking processes in which the desired image is cut into the surface of a plate, which is inked and then wiped, leaving ink only in the cut channels. Dampened paper is forced against the plate, picking up the ink.

Intensity See saturation.

Interior contour The form of the inside of a three-dimensional piece.

Interior design The art of decorating the insides of human environments.

International Modern Style An architectural style, originating in Europe after World War I, characterized by rectangular forms, white walls, large windows, flat roofs, and the absence of ornament.

Interpretive color Color chosen to represent an emotional atmosphere or idea rather than the visual reality of an object.

Interpretive values Lights and darks used to convey an atmosphere or idea rather than a literal description of the actual *values* of a real scene.

Intonaco (in ton ă kō) In *fresco* technique, the final layer of plaster, to which paint is applied during the course of the day.

Investment A heat-resistant outer mold packed around a *lost-wax casting*.

Ionic (ī <u>aan</u> ik) In *Classical* Greek architecture, an order characterized by fluted columns topped by scroll-like spirals.

K

Keystone The central wedge-shaped piece of masonry in an arch, added last to lock the structure in place.

Kiln A special oven or furnace for *firing ceramics*.

Kinetic ($kin \underline{e} tik$) **sculpture** A three-dimensional work that moves.

L

Laminate (lam i nayt) To unite flat layers of the same or different materials, such as bonded plates of wood, paper, or plastics.

Late Gothic Work produced in Europe toward the end of the *Gothic* period, characterized by increasing *naturalism* and expressiveness and by the fine details and luminosity of oil paintings.

Lead crystal High-quality, exceptionally clear and colorless glass in which a large percentage of the formula is lead oxide.

Light well 1. A shaft that allows daylight to enter the interior of a building. 2. The optical illusion of a visual pool of light created by contrast with surrounding darker areas.

Limited palette Highly selective use of only a few colors.

Line engraving A *print* made by cutting lines into a plate of metal, forcing ink into them, and printing the cut lines.

Linear perspective The illusion of deep space in a two-dimensional work through convergence of lines perpendicular to the *picture plane* toward a *vanishing point* in the distance.

Linocut (lī nō kut) A *print* made by gouging away areas of a linoleum block that are not to be inked and printed.

Liquid medium A fluid base used to carry pigments for painting or drawing, such as ink, oil, or acrylic emulsion.

Lithography (li thaa gră fee) A printmaking technique in which a flat stone or metal or plastic plate is drawn on with a greasy substance that retains ink when the wettened plate is inked for printing.

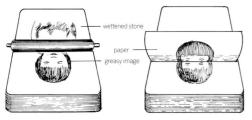

Local color The color usually associated with an object, as seen from nearby under normal daylight without shadows or reflections.

Local value The degree of light or darkness seen on an actual surface.

Logo A graphic or typographic image that identifies a business or group.

Lost-wax A *casting* process in which wax is used to coat the insides of molds and then melted away when the molds are assembled, leaving an empty space into which molten metal is poured; also called *cire perdue*.

Low relief Sculpture in which figures exist on almost the same *plane* as the background.

M

Malleability (mal ee ă bil <u>i</u> tee) The capacity for being shaped by physical pressure, as in hand modeling or hammering.

Mandala A circular symbolic spiritual pattern.

Mannerism An artistic style in Italy from approximately 1525 to 1600 in which artists developed a more subjective, emotional, theatrical approach than in the preceding *High Renaissance* period.

Maquette (ma <u>ket</u>) A small model used for planning and guiding the creation of a sculpture.

Mass The solid content of a three-dimensional form.

Medium (plural *media*) 1. The material or means of expression with which the artist works. 2. The liquid solvent, such as water or linseed oil, in which *pigment* is suspended to make paint fluid and workable.

Mezzotint (mez ō tint) An *intaglio* printmaking technique in which an overall burr is raised on the surface of the metal plate and then smoothed in places, creating various tones and textures.

Miniature A work of art done on a much smaller scale than the object being represented.

Minimalism Use of highly simplified form devoid of representation or expressive content.

Mixed media Combined use of several different techniques—such as drawing, painting, and printmaking—in a single work of art.

Mobile See kinetic art.

Modeling 1. In two-dimensional art, the depiction of three-dimensional form, usually through indications of light and shadow. 2. In sculpture, creating a form by manipulating a soft *medium*, such as clay.

Modular construction A building system developed from preconstructed and perhaps preassembled parts.

Monochromatic (maan ŏ krō ma tik) Having a color scheme based on *values* of a single *hue*, perhaps with accents of another color or neutral colors.

Monotype A printmaking process in which an image is painted directly onto a sheet of metal or glass and then transferred onto paper. The process can be repeated with some repainting of the plate, but this is basically a means of creating relatively few prints of an image.

Montage (mon taazh) 1. A composite two-dimensional image produced by assembling and pasting down cut or torn sections of photographs or drawings.

2. In cinematography, the composition of a sequence of short shots of related meaning.

Mosaic (mō <u>zay</u> ik) Two-dimensional art created by attaching small pieces (*tesserae*) of ceramic tile, glass, pebbles, marble, or wood to a surface.

Motif (mō <u>teef</u>) A recurring pattern in a work of art.

Multimedia Installation involving audio as well as visual components.

Mural (<u>myoor</u> ăl) A painting, usually large, done on a wall.

N

Naive art That which is created by artists with no formal training.

Narrative Referring to art with a storytelling quality.

Naturalism A style of art that seeks to represent accurately and faithfully the actual appearance of things.

Nave (nayv) In church architecture, the central hall.

Negative space Unfilled areas in the design.

Neo-Classicism The late eighteenthand early nineteenth-century return to *Classical aesthetics* in Europe.

Neoexpressionism A contemporary art movement in which painting is used to express the artist's feelings, projected as distorted images from the exterior world.

Nonobjective Referring to art that does not represent any known object.

Nonrepresentational See *nonobjective*.

Northern Renaissance Referring to German art from c. 1500, when the individualistic and rational aspects of the Italian *Renaissance* were adopted and adapted to north European styles.

0

Offset lithography A commercial printmaking process in which the inking of illustrations and text is offset from the plate onto a rubber-covered cylinder that transfers them to paper so that the printed image reads the same way as the original, rather than being reversed.

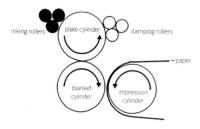

One-point perspective In *linear perspective*, the representation of parallel lines converging to a single point on the horizon, to create the illusion of deep space.

Opalescent (ō păl es ĕnt) glass Opaque glass used for art objects, with color oxides swirled through it as it is poured in a molten state into sheets.

Op Art Paintings that produce visual phenomena in the perception of the viewer that do not actually exist on the canvas.

Open form In sculpture, a volume broken by projections and/or *voids*.

Open palette Use of an unlimited range of colors in juxtaposition.

Optical color mixtures Those in which colors are mixed in the viewer's perception rather than in physically mixed *pigments*.

Outsider art Unique works created by untrained people who do not fit into any aesthetic tradition.

Overlapping Hiding of part of one figure by another, a device used to suggest depth in space.

Overpainting The final layers in an *indirect* painting, such as *glazes* or *scumbling*.

P

Pastel A chalky stick of powdered *pigment*, calcium carbonate filler, and *binder*, used as a drawing *medium*.

Pattern An all-over design created by repetition of figures.

Pediment In *Classical* architecture, the triangular area at the front of a building; also a similarly-shaped area used decoratively over a window, door, or *portico*.

Performance art Art in which the medium of expression is the artist's own body and its coverings.

Perspective See *aerial perspective*; *linear perspective*.

Photocopy A photographic reproduction of graphic material, in which a negative image is quickly taken and electronically transferred to paper as a positive.

Photogram One of the precursors of modern photography, an image made by laying objects on light-sensitive paper and exposing it to sunlight, leaving the masked areas white while the rest of the paper turns dark.

Photorealism Art that is as *representational* as a photograph, but created by other media; also called *super-realism*.

Picture plane The flat surface of a twodimensional work, often conceived as a transparent window into threedimensional space. See *linear perspective*.

Pigment Powdered colored material used to give *hues* to paints and inks.

Pinching A simple means of using the hands to shape a ceramic vessel from a lump of clay.

Pixel (piks \Breve{e} l) In computer graphics, one of many tiny points on the computer screen determined by intersections of x and y axis.

Placement In two-dimensional art, the positioning of images on the *picture plane*, often used with reference to the illusion of three-dimensionality.

Plane A flat surface.

Planish To hammer metal smooth.

Planographic (<u>play</u> naa <u>gra</u> fik) Referring to a printmaking technique in which images are transferred from a flat surface, as in *lithography*.

Pointed arch An arch formed by the intersection of two curves of greater radius than that of the opening; an innovation introduced in *Gothic* architecture.

Pointillism (pwan tǐ lizǐm) A technique of painting using dots of *primary* and *secondary hues* in close juxtaposition to make them mix in the viewer's perception. Also called *divisionism*.

Point of view The place from which a two-dimensional scene is reported.

Pop Art A movement beginning in the mid-twentieth century that uses objects and images from the commercial culture.

Porcelain *Ceramics* made from the finest clays, which produce an extremely smooth, glossy surface when fired.

Portico (<u>por</u> ti kō) A covered colonnade at the end of a building in *Classical* architecture.

Positive space Filled areas in a design, or those intended to be seen as figures.

Post and lintel An architectural construction system in which upright members support horizontal members, or lintels.

Post-Impressionism Transcendence of the perceived limitations of *Impressionism* by mid-nineteenth- and early twentieth-century artists such as Cézanne, Seurat, Gauguin, and van Gogh.

Post-modernism An architectural movement of the 1970s and 80s, countering the glass boxes of the *International Style* with more historically eclectic forms.

Post-Painterly Abstraction Various mid-twentieth-century styles of creating *nonobjective* paintings that evoke certain responses in viewers, with the hand of the artist less obvious than in *Abstract Expressionism*.

Primary colors The set of three basic *hues* from which all other hues can be mixed; in *refracted* colors, red, green, and blue; in *reflected* colors, red, yellow, and blue.

Primary contours The outer edges of a *form*.

Principles of design The organizing factors in the visual arts, including repetition, variety, *contrast, rhythm, balance*, compositional *unity, emphasis, economy, proportion*, and relationship to the environment.

Print An image made by transferring ink from a worked surface onto a surface, usually paper, and usually in multiples.

Proportion Size relationships of parts to each other and to the whole.

Proscenium (prō <u>see</u> nee ĭm) 1. The part of a stage for theatrical production that projects in front of the curtain. 2. In ancient Greek theater, the whole of the stage.

Proscenium arch The arch that frames the stage, hiding its mechanics.

Putti (singular putto) (poot tee: poot tō) Chubby nude male babies often depicted in Italian art from the fifteenth century onward.

Q

Quilting Making blankets or other covers of two layers of fabric stitched together with padding in between, in which both the pieces of fabric and the pattern of stitching offer vehicles for aesthetic creativity.

R

Radial balance Symmetric arrangement of design elements around the center of a circle.

Raise In metalworking, to hammer a flat sheet over a stake to bring up the sides of a vessel and work them inward.

Read To see and assign meaning to aspects of a design.

Realism The attempt in art to capture the appearance of life as it is, as opposed to *stylized* or *Romanticized* portrayals. In mid-nineteenth-century France, the artistic movement of this name concentrated on subjects from everyday, and often working-class, life.

Reduction print A color relief print in which portions of a single block are cut away in stages, with each stage overprinted in another color, rather than creating a series of registered blocks for the various colors.

Reflected hues *Hues* seen when light is reflected from a *pigmented* surface.

Refracted colors Hues seen in light.

Reinforced concrete Concrete into which metal mesh or rods have been embedded so that the two interact to strengthen the structure.

Reliefs 1. A sculptured work in which an image is developed outward or inward from a two-dimensional surface. 2. A printmaking category in which areas that are not to be inked are carved away, leaving the image raised on the block.

Renaissance (ren ĭ saans) A movement beginning in fifteenth-century Italy to recapture the harmony, symmetry, and rationality of *Classical* works, with an elaboration of *linear perspective*.

Repoussé (rě <u>poo</u> say) The working of a sheet of metal from the back to create designs in relief on the front.

Representational Referring to artworks that aim to present likenesses of known objects.

Resist The waxy, acid-resistant substance used to coat the metal plate used for *etching*, into which the lines of the image are drawn.

Resolution Degree of sharpness in a *digitized* image.

Rhythm The visual equivalent of notes and pauses in music, created by repetition, variety, and spacing in a design.

Ribbed vault In architecture, a masonry ceiling in which arched diagonal ribs form a framework that is filled with lighter stone.

Rococo (rŏ \underline{ko} kō) The late *Baroque* period, particularly in France, southern Germany, and Austria, characterized by extremely ornate, curvilinear forms in architectural decoration and delicacy and looseness in painting.

Romanesque (rō mă <u>nesk)</u> A style of European art from about the eleventh century to the beginning of the *Gothic* period, most notable for its architecture of rounded arches, thick walls and columns, and stone relief carvings.

Romanticism The tendency to emphasize emotion and imagination rather than logic, occurring at many times in the history of Western art, including the first half of the nineteenth century. Traditionally contrasted with *Classicism*.

Rotunda A circular building or room, especially one with a dome.

Round arch An arch formed by a semicircle; an innovation introduced by Roman architecture and much used in *Romanesque* architecture.

S

Sans serif (sanz / ser if) Referring to a *typeface* that has no fine lines finishing the major strokes.

Saturation The relative brightness or dullness of a color, also called *chroma* or *intensity*.

Scale Relative size.

Scale change Difference in size of objects, used in paintings to suggest three-dimensional depth in space, with the nearest ones being largest.

Screen print See silkscreen.

Scumbling In oil painting, the technique of brushing one layer of paint on top of another in a way that reveals some of the undercolor.

Secondary contours *Forms* developed across the surface of a larger form.

Secondary hues *Hues* produced by combining two *primary* hues.

Serif (<u>ser</u> if) In *typography*, the fine lines used to finish the heavier main strokes of letters; also used of a *typeface* that has this feature

Serigraph (ser ĭ graf) See silkscreen.

Sfumato (sfoo <u>maa</u> tō) Softly graded tones in an oil painting, giving a hazy atmospheric effect, highly developed in the work of Leonardo da Vinci.

Shading The darkening of an area in a two-dimensional work to suggest curving of a three-dimensional form away from a light source.

Shape A flat, defined area.

Silkscreen A printmaking process in which ink is pressed through a fine screen in areas that are not masked by a stencil or other material; also called *serigraph*.

Silverpoint A drawing *medium* in which a finely pointed rod of silver encased in a holder is used to make marks on a slightly abrasive surface; the minute deposit of metal darkens by oxidation.

Simulated texture The illusion that an image would feel a certain way if touched, in contrast to the reality of its actual texture.

Site specific An installation designed for a particular location.

Size or **Sizing** A coating of glue or resin to make a surface such as canvas less porous so that paint will not sink into it.

Skene (skeen) In early Greek theaters, the building at the back of the performance area from which actors entered and exited, also used as a changing room and as a backdrop for the action.

Slab building The process of building a form of clay by attaching flat shapes to each other.

Slip A mixture of clay and water.

Soft-edged In two-dimensional work, blending of *hues* where they meet, so that no hard line forms a boundary between them.

Space The area occupied, activated, or suggested by a work of art.

Spectrum See visible spectrum.

Squinch A structure spanning the corner of a tower to help support a superstructure such as a dome.

Stained glass Art glass colored with chemical colorants heated in a kiln with the glass base.

State One of the stages of an *etching*, if printed separately.

Static form A mass that appears inert.

Still-life A two-dimensional representation of a group of inanimate objects such as fruit, flowers, and vessels.

Stippling Use of dots in a drawing or engraving to develop areas of a particular *value*, usually to suggest three-dimensional form.

Stoneware *Ceramics* made from clays that become very hard when *fired* at high temperatures.

Stylized Referring to distortion of *representational* images in accordance with certain artistic conventions or to emphasize certain design qualities.

Stylobate (stī lŏ bayt) In *Classical* Greek architecture, the flat base on which a series of columns rests.

Subtractive color mixing The combination of *reflected* colors.

Subtractive sculpture That which is created by the process of carving away material to reveal the desired *form*.

Super-realism See photorealism.

Support The solid material base on which a two-dimensional work of art is executed, such as canvas or panel in the case of a painting.

Surrealism Art based on dreamlike images from the subconscious, appearing as a recognized movement beginning in the 1920s.

Symmetrical balance Distribution of equal forces around a central point or *axis*, also called *formal balance*.

Synergistic color mixing A system of *optical color mixing* in which new *hues* are created in the spaces between colored figures.

Synthetic media Liquid media in which industrially created chemicals, such as acrylic emulsion, are used to carry the pigments.

T

Tapestry A heavy, handwoven textile with pictures woven into the surface of the fabric, usually used as a wall hanging.

Tempera A painting *medium* in which *pigments* are mixed in water with a glutinous material such as egg yolk, usually yielding a fast-drying, matt finish that cannot be blended.

Tensile strength A measure of the ability of a material to be stretched without breaking.

Tertiary hues *Hues* that are a mixture of a *primary* and a *secondary hue* lying next to each other on the *color wheel*.

Tesserae (singular tessera) (tes ĕr ee: tes ĕr ă) The small cubes of colored glass, ceramic, or stone used in mosaics.

Texture The surface quality of a form or the illusion that it would feel a certain way if touched.

Three-dimensional Having length, height, and width.

Three-point perspective Two-dimensional spatial illusions of forms receding toward three *vanishing points*.

Throwing See wheel-throwing.

Tokonoma (tō kō \underline{no} mǎ) In a traditional Japanese home, an alcove devoted to contemplation of a single scroll painting, perhaps accompanied by a flower arrangement.

Tonal range The degree to which a work (particularly a photograph) approaches the full range of *values* from black through grays to white.

Transition The abrupt or gradual change from one portion of a design to another.

Triad color scheme The use of three *hues* lying at equal distances from each other on the *color wheel*.

Trompe l'oeil (tromp / lōyee) Work that "deceives the eye" into believing it sees something other than the reality of a surface, such as architectural forms on what is actually a flat wall or ceiling.

Truss In architecture, a framework of wood or metal beams, usually based on triangles, used to support a roof or bridge.

Two-dimensional Existing on a flat surface with only length and height but no depth in space.

Two-point perspective In linear perspective drawings, the representation of a three-dimensional form viewed from an angle, so that the lines formed by its horizontal edges will appear to diminish to two different *vanishing points* on the horizon.

Typeface One of many styles of letter design, in which the entire alphabet is rendered with certain repeating characteristics.

Typography The art of designing, sizing, and combining letterforms on a printed page.

U

Underpainting The initial layers of paint in *indirect painting*.

Unity Visual coherence in a work of art; also used sometimes to refer to repetition of similar motifs in a design, in contrast to *variety*.

Unsized Referring to canvas that has not been treated with a glaze or filler, leaving it porous to paint.

Upload To place *digitized* material from a computer onto the Internet or an external storage device.

V

Value Degree of dark or light.

Value scale A graded representation of differences in *value*.

Vanishing point The seen or implied spot in the distance where all lines perpendicular to the *picture plane* would appear to meet if extended. In real life, a vanishing point can only be seen where one can look across a great distance; in art, if lilies appear to converge rapidly to a vanishing point there will be an impression of great depth.

Variety Change rather than sameness in design elements.

Vellum (<u>vel</u> <u>um</u>) A fine parchment prepared from the skin of a calf, kid, or lamb.

Veneer (vě <u>neer</u>) A thin surface layer, such as a fine wood placed over other woods.

Video A process of creating moving pictures by laying down images and sound as tracks on magnetic tape.

Video raster graphics Computergenerated and -manipulated *video* images.

Virtual reality Computer graphics in which the operator interacts with a scene as if existing within it.

Visible spectrum The color frequencies that humans can see; the distribution of colors produced when white light is dispersed, e.g. by a prism. There is a continuous change in wavelength from red, the longest wavelength, to violet, the shortest.

Visual weight The apparent heaviness of an area of design.

Void In sculpture, a hole through a work.

Volume The solid content of a form.

Voussoirs (voo <u>swaar</u>) The wedge-shaped stones in an arch.

W

Walk-through Referring to large sculptures that the viewer can move through as well as around.

Warm colors Colors from the red and yellow side of the *color wheel*, associated with heat.

Watercolor A transparent watersoluble painting *medium* consisting of *pigments* bound with gum.

Website A personal domain of the Internet managed by a person or organization.

Wheel-throwing A method of creating forms of clay by centering a mass of clay on a circular slab and then pulling the sides up from it with the hands as this wheel is turned.

Woodcut A *print* made by carving away areas of a wood block and inking the remaining *relief* surfaces.

Wood engraving A *print* made by cutting the end-grain of a piece of wood, capable of rendering finer lines than the lengthwise grain used for *woodcuts*.

Wrought iron Iron that is shaped in a heated state with hand tools.

Z

Ziggurat A stepped pyramid with a temple on top.

Artists' Pronunciation Guide

Aalto, Alvar (aal tō)

Abakanowicz, Magdalena (maag daa <u>lay</u> nă / aa baa kaa

<u>nō</u> vich)

Albers, Josef (<u>yō</u> sef / <u>aal</u> berz)

Anuszkiewicz, Richard (aa nus ke vich)

Bernini, Gianlorenzo (jaan lō <u>ren</u> zō / bair <u>nee</u> nee)

Boccioni, Umberto (oom <u>bair</u> tō / bō <u>kee</u> ō nee)

Bonnard, Pierre (peeair / bon aar)

Botticelli, Sandro (<u>san</u> drō / bōt ee <u>chel</u> ee)

Bouguereau, William (bu <u>grō</u>)

Brancusi, Constantin (<u>kaan</u> stan teen / braan <u>koo</u> see)

Braque, Georges (zhorzh / braak)

Bronzino, Agnolo (ang <u>nō</u> lō / <u>bron</u> zee nō)

Bruegel, Pieter (pee tair / broo gĭl)

Buonarroti, Michelangelo (mee kěl \underline{an} jě lō / booawn ă $\underline{r\bar{o}t}$ ee)

Caravaggio, Michelangelo (mee kĕl \underline{an} jĕ lō / kaa raa \underline{vaa} geeō)

Cartier-Bresson, Henri (aan ree / kar teeay / bres on)

Cellini, Benvenuto (ben ve noo tō / che lee nee)

Cézanne, Paul (pōl / say zan)

Chagall, Marc (sha gal)

Christo (krees tō)

Cimabue (chee mă boo ay)

Claude Lorraine (klōd / lor en)

Corot, Jean-Baptiste Camille (zhaan / bap teest / ka mee / kō rō)

Corregio, Antonio (an tō nee ō / kō re geeō)

Courbet, Gustave (goos taav / koor bay)

Cranach, Lucas (craw nok)

Csuri, Charles (tshoo ree)

Daguerre, Louis Jacques Mande (loo ee / zhaak / man <u>day</u> /

daa gayr)

Dalí, Salvador (sal vaa dor / daa lee)

David, Jacques-Louis (zhaak / loo ee / dă <u>veed</u>)

Degas, Edgar (ed gaar / day gaa)

Derain, André (aan <u>dray</u> / de <u>ran</u>)

Dubuffet, Jean (zhaan / doo boo fay)

Duchamp, Marcel (mar sel / doo shaan)

Dürer, Albrecht (<u>aal</u> brekht / <u>door</u> ĕr)

Eames, Charles and Ray (ayms)

Escher, M. C. (esh ĕr)

Eyck, Jan van (yaan / van / īk)

Fathy, Hassan (<u>has</u> ăn / fat <u>hee</u>)

Fortuny, Mario (maar ee ō / for too nee)

Fragonard, Jean-Honoré (zhaan / aw nō ray / fraw gō naar)

Frankenthaler, Helen (<u>fraank</u> ĕn taal ĕr)

Gaudí, Antonio (aan tō neeō / gow dee)

Gauguin, Paul (pōl / gō gan)

Gehry, Frank (gee ri)

Gentile da Fabriano (gen <u>tee</u> lĕ / da / fab <u>ree</u> aan ō)

Géricault, Theodore (tay ō dōr / je ree cō)

Ghiberti, Lorenzo (lō <u>ren</u> zō / gee <u>bair</u> tee)

Giacometti, Alberto (aal <u>bai</u>r tō / jeeaa cō <u>met</u> ee)

Giotto (jeeō tō)

Glaser, Milton (mil ton / glay ser)

Gogh, Vincent van (vin sent / van / gō)

Gorky, Arshile (ar sheel / gor kee)

Goya, Francisco (fraan sis cō / goy aa)

Greco, El (el / gre kō)

Grotell, Maija (mī yă / gro tel)

Grünewald, Matthias (maa tee ăs / groon ĕ vaalt)

Heizer, Michael (hītz ĕr)

Hokusai (hō kĕ sī)

Holbein, Hans (haans / hol bin)

Ingres, Jean Auguste Dominique (zhaan / ō goost /

dōm en eek / ăn grĕ)

Isozaki, Arata (i sō ză kee / ă ră tă)

Kahlo, Frieda (free dă / kaa lō)

Kandinsky, Wassily (vaa see lee / kan din skee)

Kiefer, Anselm (an selm / keef ĕr)

Klee, Paul (klay)

Kollwitz, Käthe (kay tě / kōl vits)

Kooning, Willem de (wil ĕm / dĕ / koo ning)

Lachaise, Gaston (gas ton / la shes)

Lalique, René (re <u>nay</u> / la <u>leek</u>)

Le Corbusier (lĕ / cōr boo zeeay)

Leonardo da Vinci (lay ō <u>naar</u> dō / daa / <u>vin</u> chee)

LeWitt, Sol (lĕ wit)

Lichtenstein, Roy (likh ten shtīn)

Lin, Maya Ying (mī yă / ying / lin)

Lorenzetti, Ambrogio (am <u>brō</u> jeeō / lor en <u>zet</u> ee)

Lubalin, Herb (loo ba lĭn)

Manet, Edouard (ayd <u>waar</u> / ma <u>nay</u>)

Mantegna, Andrea (aan <u>dray</u> ă / maan <u>tayn</u> yaa)

Martinez, Maria (ma <u>ree</u> ă / mar <u>tee</u> nez)

Masur (ma zoor)

Matisse, Henri (aan ree / ma tees)

Mies van de Rohe, Ludwig (<u>loot</u> fik / mees / van / dair / <u>rō</u> ĕ)

Miró, Joan (hō <u>awn</u> / mee rō) Miyake, Issey (mee yă kay)

Modigliani, Amadeo (a me <u>dayō</u> / <u>mō</u> dee glee <u>an</u> nee)

Mondrian, Piet (peet / mon dree aan)

Monet, Claude (klōd / mon <u>ay</u>)

Morisot, Berthe (bairt / mo ree sō)

Mu-ch'i (moo chee)

Munch, Edvard (ed vart / moonkh) Munsell, Albert (al bert / mun sl)

Nakashima, George (nă kă shee mă)

Nervi, Pier Luigi (peeair / loo ee jee / nair vee)

Nevelson, Louise (ne věl sn)

Newman, Barnett (bar <u>net</u> / <u>noo</u> man) Noguchi, Isamu (i să moo / nō goo chee)

O'Keeffe, Georgia (j<u>ōr</u> jeea / ō <u>keef</u>)

Oldenburg, Claes (klaas / <u>ōl</u> den burg)

Orozco, José $(\underline{h}\underline{\bar{o}} say / \bar{o}r \underline{\bar{o}s} k\bar{o})$

Otto, Frei (frī/ aa tō) Paik, Nam June (payk)

Palladio, Andrea (an <u>dray</u> ă / pa <u>la</u> deeō)

Panini, Giovanni Paolo (jeeō <u>van</u> ee / <u>paō</u> lō / pa <u>nee</u> nee)

Perugino (Pietro Vanucci) (<u>pay</u> trō / va <u>noo</u> kee / pe <u>roo</u> jee nō)

Picasso, Pablo (pab lō / pi ka sō)

Pollaiuolo, Antonio del (an <u>tō</u> neeō / <u>pō</u> la eeō lō)

Pollock, Jackson (paal uk)

Raphael (<u>raf</u> fī el)

Rauschenberg, Robert (<u>row</u> shen bairg)

Ray, Satyajit (<u>sat</u> ya jeet / ray)

Redon, Odilon (ō di lo / rĕ do)

Rembrandt Van Rijn (rem <u>brant</u>)

Renoir, Auguste (ō goost / ren waar)

Riefenstahl, Leni (<u>len</u> ee / <u>reef</u> ĕn shtal)

Rigaud, Hyacinthe (ee aa <u>sant</u> / ree <u>gō</u>)

Rivera, Diego $\quad (\text{dee} \ \underline{aa} \ \underline{go} \ / \ \text{ree} \ \underline{\text{ver}} \ \breve{\mathtt{a}})$

Rodin, Auguste (<u>ō goost</u> / rō dan)

Rosetti, Dante Gabriel (<u>daan</u> tay / <u>gab</u> ree el / rō <u>se</u> tee)

Rothko, Mark (roth kō)

Rousseau, Henri (aan ree / roo sō)

Rubens, Peter Paul (roo benz)

Saarinen, Eero (saa ree nen)

Safdie, Moshe (saf dee)

Scamozzi, Vincenzo (vee $\underline{\mathrm{chen}}$ sō / ska $\underline{\mathrm{m}}$ ō see)

Schwitters, Kurt (schvit airs)

Seurat, Georges (zhorzh / syoo raa)

Stankiewicz, Richard (stan kee ay vich)

Steichen, Edward (shtī khĕn)

Stieglitz, Alfred (shteeg litz)

Thonet, Gebrüder (ton et)

Tiffany, Louis Comfort (<u>ti</u> fă nee)

Tinguely, Jean (zhaan / ta glee)

Tintoretto, Jacopo (ja $\underline{k\bar{o}}$ pō / tin tō \underline{re} tō)

Tomazewski, Henryk (tō ma shev skee)

Toulouse-Lautrec, Henri (aan ree / too looz / lō trek)

Ugolino di Nerio (oo gō <u>lee</u> nō / dee / ner ō)

Van der Rohe, Mies (mees / van der rō ŭ)

Varo, Remedios (re me dee ōs / vaa rō)

Vasarely, Victor (vaa saa <u>ray</u> lee)

Velázquez, Diego (<u>deeay</u> gō / vay <u>las</u> kes)

Vermeer, Jan (yaan / vair meer)

Voisard (vwaa zar)

Warhol, Andy (an dee / wor haal)

Weyden, Roger van der (way dĕ)

Wyeth, Andrew (wayth)

Zapf, Hermann (her maan / zapf)

Zelanski, Paul (ze <u>lan</u> skee)

Credits

Laurence King Publishing and Pearson Prentice Hall wish to thank the institutions and individuals who have kindly provided photographic materials for use in this book. In all cases, every effort has been made to contact the copyright holders, but should there be any errors or omissions the publishers would be pleased to insert the appropriate acknowledgment in any subsequent edition of this book.

Laurence King Publishing have paid DACS' visual creators for the use of their artistic works.

- 1.1 Vatican Museums and Galleries, Vatican City, Italy/Bridgeman Art Library, London, Musées des Antiquities Nationales, St Germain-en-Laye
- 1.3 Andrew W. Mellon Collection © 1998 Board of Trustees, National Gallery of Art, Washington D.C. 1.4 © Estate of Duane Hanson/VAGA, New York/DACS,
- London 2006
- 1.7 © The Fitzwilliam Museum, Cambridge, UK
- 1.14 Estate of Georgia O'Keefe. Licensed by © DACS 2006
- 1.15 Pace Primitive Art, New York
- 1.16 © 2006 Digital Image, Museum of Modern Art, New York/Scala, Florence/© ADAGP, Paris and DACS, London 2006
- 1.18 © 2000, Lucia Eames/Eames Office (www.eamesoffice.com)
- 1.20 Takeschi Nishikawa
- 1.21 © Vincenzo Pirozzi, Rome
- 1.22 Victoria Miro Gallery
- .23 Archivi Alinari/Art Resource, New York
- 1.24 National Gallery of Canada/© ARS, NY and DACS, London 2005
- 1.25 Courtesy Daniel Libeskind. Photo Jok Pottle
- 1.26 Chris Mellor/Telegraph Colour Library
- 1.27© Vera Mukhina. Licensed by DACS 2006 1.29 National Park Service, Washington D.C.
- 1.30 © Photo RMN/Gerard Blot
- 1.31 Isamu Noguchi, New York
- 1.32 © Timothy Hursley 1.33 Library of Congress, Washington D.C. Licensed by DACS 2006

- 1.34 © Araldo De Luca, Rome 1.35 V & A Picture Library 1.36 Photograph: South Australia Museum
- 1.37 © 2006 Digital Image, Museum of Modern Art, New York/Scala, Florence/© DACS 2006
- 1.38 © 2006 Digital Image, Museum of Modern Art, New York/Scala, Florence
- 1.39 Courtesy of the artist
- 1.40 © 1998 Ќate Rothko Prizel & Christopher Rothko/DACS 2006
- © 2006. Digial Image, The Museum of Modern Art, New York/Scala, Florence
- 1.42 Courtesy of the Artist
- 1.43 © 2006. Digital Image, The Museum of Modern Art, New York/Scala, Florence/© ARS, NY and DACS, London 2006
- 1.45 Sterling and Francine Clark Art Institute, Williamstown, Massachusetts
- 1.46 Photo Thibault Jeanson, courtesy Miami Art Museum
- 1.47 Courtesy of the artist
- 1.48 Vatican Museums and Art Galleries
- 1.49 Photo courtesy of Musee Rodin
- 1.50 Museo Nacional Centro de Arte Reina Sofía, Madrid/Giraudon, Paris/Bridgeman Art Library, London/© Succession Picasso/DACS 2006
- Photo: Erika Barahona Ede/© FMGB Guggenheim Bilbao Museoa
- 2.2 Private Collection, London
- 2.3 Courtesy of the artist
- 2.4 Riksantikvaren, Directorate for Cultural Heritage,
- 2.5, 2.6 Institute of Religion and Human Development, Houston, Texas/© ARS, NY and DACS, London
- 2.7 The Art Institute of Chicago/© The Estate of Eva Hesse

- 2.8 By permission of the British Library
- 2.9 Hirshhorn Museum & Sculpture Garden, Smithsonian Institution/© ADAGP, Paris and DACS, London 2006
- 2.11 V & A Picture Library
- 2.12 Yale University Art Gallery, New Haven, Connecticut. Gift of the Société Anonyme 2.13 The Mansell Collection, London
- 2.14 © 2006. Digital Image. The Museum of Modern Art, New York/Scala, Florence
- © 2006 Digital Image, Museum of Modern Art, New York/Scala, Florence
- 2.19 V & A Picture Library
- 2.24 © Timothy Hursley 2.25 Photo by Ricardo Barras, courtesy of Grounds for Sculpture
- 2.26 The Mansell Collection, London
- 2.37 Van Gogh Museum, Amsterdam/The Bridgeman Art Library, London
- 2.28 © Fotografica Foglia, Naples
- 2.31 Reproduced by permission of the Henry Moore Foundation
- 2.32 © Michael Heizer, courtesy Xavier Fourcade Inc, New York
- 2.35 V & A Picture Library
- 2.38 © Succession H. Matisse/DACS 2006 2.39 Courtesy of Francine Seders Gallery, Seattle, WA
- 2.40 © ADAGP, Paris and DACS, London 2006
- 2.41 © British Museum, London
- $2.42 \ @$ 2006 Digital Image, Museum of Modern Art, New York/Scala, Florence
- 2.44 Stedelijk Museum/© DACS 2006
- 2.45 © 2006 Digital Image, Museum of Modern Art, New York/Scala, Florence/© ARS, NY and DACS, London 2006
- 2.47 National Gallery of Canada, Ottawa/© The Joseph & Robert Cornell Memorial Foundation/ DACS
- London/VAGA, New York 2006 2.48 Milwaukee Art Museum/Jack MacDonough
- 2.49 Japan National Tourist Organization, London
- 2.52 Daitokuj, Kyoto, Japan
- 2.53 © Romare Bearden Foundation/DACS, London/VAGA, New York 2006
- 2.62 Courtesy of Nancy Hoffmann Gallery, New York
- 2.63 Courtesy of the artist
- 2.67 V & A Picture Library 2.69 © Studio Fotografica Quattrone, Florence
- 2.70 V & A Picture Library
- 2.71 M.C. Escher's "Relativity" © 1998 Cordon Art-Baarn-Holland. All rights reserved
- 2.72 Reproduced by permission of the Henry Moore Foundation
- 2.73 © The British Museum, London
- 2.74 Cameron Books
- 2.75 Werner Forman Archive, London
- 2.78 Reprinted by kind permission of David R Goding
- 2.79 Metropolitan Museum of Art, New York/ Bridgeman Art Library, London
- 2.80 © Photo Josse, Paris
- 2.81 Harris Works of Art, New York
- 2.84 © 2006 Digital Image, Museum of Modern Art, New York/Scala, Florence
- 2.85 Courtesy of the artist
- 2.86 Reprinted with permission of Joanna T. Steichen 2.86 Courtesy of Milton Glaser
- 2.88 Metropolitan Museum of Art, New York (63.210.11) 2.90, 2.91 © DACS, London/VAGA, New York 2006
- 2.92 © 1990, Photo Scala, Florence/Fondo Edifico di Culto Min.dell'Interno
- 2.93 Norman McGrath, New York
- 2.94 Courtesy of the artist, Barbara Gladstone Gallery, Lisson Gallery and the Millennium Park, Chicago
- 2.96 © 2006 Digital Image, Museum of Modern Art, New York/Scala, Florence/© DACS, London/VAGA, New York
- 2.97 Sakamoto Photo Research Laboratory, New York 2.98 Sonia Halliday/© AGAGP, Paris and DACS, London
- 2.99 Photograph Florian Holzherr © 2003 Scottsdale Cultural Council/Scottsdale Public Art Program

- 2.100 Arcadia University Art Gallery/Photo Aaron Igler
- 2.108 © 2006 Digital Image, Museum of Modern Art,
- New York/Scala, Florence/© DACS, London 2006 2.110 Photo Scala, Florence
- 2.111 Courtesy of the artist
- 2.112 Shigeo Anzai, courtesy of The Isamu Noguchi Foundation, Florence
- 2.114 Metropolitan Museum of Art, New York
- 2.115 The Art Insitute of Chicago
- 2.113 The Art Institute of Chicago/© Succession Picasso/DACS 2006
- 2.117 © 2006 Digital Image, Museum of Modern Art, New York/Scala, Florence/© Succession H. Matisse/DACS 2006
- 2.118 Courtesy of the artist/photo by Eduardo Calderon
- 2.119 © 2006 Digital Image, Museum of Modern Art, New York/Scala, Florence/© ADAGP, Paris and DACS, London 2006
- 2.121 Courtesy of the artist/photo by Eduardo Calderon
- 2.125 Metropolitan Museum of Art, New York (26.100.6) 2.126 AKG London/Tretyakov Gallery, New York
- 2.127 Fotografia credita y autorizada por El Patrimonio Nacional, Spain 2.129 © Richard Anuszkiewicz/DACS, London/VAGA,
- New York 2006 2.131 © 2006 Digital Image, Museum of Modern Art, New York/Scala, Florence
- 2.132 © 1962 Ives Sillman, New Haven, Collection Arthur Hoener/Photo Beverley Dickinson/© The Josef and Anni Albers Foundation/VG Bild-Kunst,
- Bonn and DACS, London 2006
- 2.133 The Art Institute of Chicago
- 2.135© ADAGP, Paris and DACS, London 2006 2.136 Metropolitan Museum of Art,New York (53.140.4)/© Succession Picasso/DACS 2006
- 2.137 © 2006 Digital Image, Museum of Modern Art, New York/Scala, Florence/© ARS, NY and DACS, London 2006
- 2.138 Museum of Fine Arts, Houston, Texas/© ADAGP, Paris and DACS, London 2006
- 2.139 Courtesy of the artist 2.141 Philadelphia Museum of Art/Bridgeman Art Library, London/© Succession Marcel Duchamp/ADAGP, Paris and DACS, London 2006
- 3.1 The National Trust, London
- 3.2 Collection Tinwood Alliance 3.3 © Magdelena Abakowicz/© ADAGP, Paris and DACS,
- London 2006 3.4, 3.5 © 2006 Digital Image, Museum of Modern Art, New York/Scala, Florence/ Licensed by DACS 2006
- 3.6 © Succession Picasso/DACS, London 2006
- 3.7 International Olympic Committee
- 3.8 © Inigo Bujedo A. Guirre, London
- 3.11 Winifred Zakowski, Helsinki 3.12, 3.13 © 1990 Scala, Florence. Courtesy of Ministero
- Bene e Att.Culturali 3.14 Metropolitan Museum of Art, New York (1975.1.7)
- 3.16 Wadsworth Atheneum Museum of Art, Hartford, Connecticut/© ARS, NY and DACS, London 2006
- 3.18 © British Museum, London 3.19 V & A Picture Library 3.22 Nancy Graves Foundation/DACS, London/VAGA,
- New York 2006 3.23 Andrew W. Mellon Collection, Image © 2003 Board of Trustees, National Gallery of Art,
- Washington D.C. © 1990. Photo Scala, Florence. Courtesy of the
- Ministero Benni e Att.Culturali 3.29 © Araldo De Luca, Rome
- 3.32 © Quattrone, Florence
- 3.40 Craig & Marie Mauzy, Athens mauzy@otenet.gr
- 3.42 Japan National Tourist Organization, London 3.43 © 2006 Digital Image, Museum of Modern Art,
- New York/Scala, Florence/© ADAGP, Paris and DACS, London 2006 3.44 Kunstmuseum des Kantons Thurgau/© DACS,
- London 2006 3.45 Photo: Erika Barahona Ede © FMGB Guggenheim Bilbao Museoa
- 3.46 © ARS, NY and DACS, London 2006

4.1 National Gallery of Canada, Ottawa, Ontario/© Succession Picasso/DACS, London 2006

4.4 Froelick Gallery, Portland, Oregon 4.6 National Gallery of Art, Washington DC/ Licensed by DACS 2006

4.7 Joseph Szaszfai

4.7 Joseph Szasztai 4.9 Steve Parsons/PA/Empics 4.10 Rosenwald Collection, 1998, Board of Trustees, National Gallery of Art, Washington D.C

4.11 Courtesy of the artist 4.15, 4.17 © British Museum, London

5.1 AKG London

5.2 Margaret Courtney-Clarke

5.3 Metropolitan Museum of Art, New York (29.100.16) 5.4 Carnegie Museum of Art, Pittsburgh/© ADAGP,

Paris and DACS, London 2006

5.5 Louvre, Paris/Peter Willi/The Bridgeman Art Library, London

5.6 Bob Shalkwiik/AMI

5.9 © 1990.Photo Scala,Florence

5.10 Photo Alberto Pizzoli/Sygma/Corbis

5.11 © Photo Josse, Paris 5.13 © Studio Fotografico Quattrone, Florence 5.15 Photo: © Mauritshuis, The Hague, inv. no. 670

5.16 Photo Vatican Museums

5.17 © 1993. Photo Scala, Florence. Courtesy of Ministero Beni e Att. Culturali 5.22 Metropolitan Museum of Art, New York (06.1234)

5.23 Conseil General de la Réunion/Photo Jacques Kutyen/© ADAGP, Paris and DACS, London 2006 5.24 Photograph John Bigelow Taylor, New York

5.26 The Minneapolis Institute of Arts

5.27 David Mirisch Gallery, Toronto

5.29 Yale University Art Gallery/Licensed by DACS 2006 5.31 F. Catala Roca, Barcelona

5.32 © Robert Rauschenberg Moderna Museet, Stockholm/© DACS, London/VAGA, New York 2006

6.1 The Bridgeman Art Library, London

6.7 © Antonio Frasconi/© DACS, London/VAGA, New York 2006

6.8 Experimental Workshop

6.11 © Fritz Eichenberg Trust//VAGA, New York/DACS, London 2006

6.12 © Succession Picasso/DACS 2006 6.16 © Tate London, 2004 6.18 © 2006 Digital Image, Museum of Modern Art, New York/Scala, Florence/© Succession H. Matisse/DACS 2006

6.27 Photo Jim Piper, Oregon 6.28 © James Rosenquist/© DACS, London/ VAGA, New York 2006

6.30 © Licensed by the The Andy Warhol Foundation for the Visual Arts, Inc/ARS, New York and DACS, London 2006

6.32 Courtesy of the artist

6.33 Courtesy of the artist

7.1 Courtesy of International Business Machines Corporation

7.2 New York State Department of Economic Development

7.5 Metropolitan Museum of Art, New York (32.88.17) 7.7 Courtesy of Mary Pat Fisher

7.11 Tyco/ Hill, Holliday, Connors, Cosmopulos, Boston, Mass.

7.12 Client: Filippa K, Photo Christian Coinbergh, Art Director Patrick Seklstedt/TBWA, Stockholm

8.6 V & A Picture Library

8.7 Christie's Images 8.8 © 2006 Digital Image. The Museum of Modern Art, New York/Scala, Florence

8.9 © ARS, NY and DACS, London 2006

 $8.10\ @$ 2006 Digital Image. The Museum of Modern Art, New York/Scala, Florence

8.11, 8.12 Magnum Photos, London

8.13 Trustees of the Ansel Adams Publishing Rights Trust. All rights reserved 8.14 © 1981 Arizona Board of Regents, Center for

Creative Photography

8.16 © Stephen Dalton/NHPA

8.20 Courtesy of the artist 8.24, 8.26, 8.27, 8.32 British Film Institute

8.25 British Film Institute/© Kingdom of Spain, Gala-Salvador Dali Foundation, DACS, London 2006 8.28 Courtesy of DSA, London 8.29 Capital Pictures, London

8.33 Associated Press

8.35 Photo Philippe Migeat 8.36 Courtesy of the Bill Viola Studio. Photo: Kira Perov. The video of *Tristan und Isolde* was produced by Bill Viola Studio in collaboration with the National Opera, Paris, the Los Angeles Philharmonic Association, the Lincoln Center for the Performing Arts, the James Cohan Gallery, New York and Haunch of Venison, London.

8.37 Photo David Heald © The Solomon R. Guggenheim

Foundation, New York 9.1 Courtesy Feigen Contemporary, New York

9.2 Courtesy of the artist

9.5 Courtesy of Art Projects International (API), New York

9.6 Courtesy of the artist 9.7 Courtesy of the artist

9.9, 9.10 © Disney Enterprises, Inc.

9.11 Courtesy of David Em 9.13 Courtesy of the artist 9.14 Courtesy of Karen Lent

10.2 Reproduced by permission of the Henry Moore Foundation

10.3 Provenance Museo Guggenheim Bilbao, Photo Erika Barahona Ede/© ARS, NY and DACS, London 2006

10.4 The Mansell Collection, London 10.5 Japan National Tourist Organization, London

10.6 Chester Dale Collection © 1998 Board of Trustees, National Gallery of Art, Washington

10.7 © British Museum, London 10.9 Daniel Schwartz

10.11 From The Craft and Art of Clay by Susan Peterson, by permission of the author 10.13 Alinari/Loggia dei Lanzi, Florence 10.15 © British Museum, London

10.17 Collection of the Tinwood Alliance

10.19 Public Art Fund/Photo Gerry L. Thompson

10.19 Public Art Fund/Photo Gerry L. Hompson 10.20 Courtesy of the artist 10.21 South American Pictures, Woodbridge, Suffolk 10.22 Prestel Verlag, Munich/© Estate of Robert Smithson/ DACS, London/VAGA, New York 2006 10.23 The Philadelphia Museum of Art, 11.1 Metropolitan Museum of Art, New York (14.130.12) 11.2, 11.3 From The Craft and Art of Clay by Susan

Peterson, by permission of the author 11.4 Photo courtesy of the Department of Special Collections, Syracuse University Library, Syracuse, New York

11.8 Courtesy of the artist/Photo Georg Erml 11.9 V & A Picture Library

11.10 © 1982 David Arky

11.12 The Bridgeman Art Library, London

11.13 Lee Hocker

11.14 Drew Hubatsek

11.15 New York Times Pictures

11.16 © 2006 Digital Image, The Museum of Modern Art, New York/Scala, Florence 11.17 Photo Dick Busher 11.19 Private Collection, Miami, Florida/© ADAGP, Paris

and DACS, London 2006

11.20 Courtesy Alistair Duncan 11.22 Courtesy of TAI Gallery, Santa Fe, New Mexico 11.23 Courtesy of the artist. Photo by Bobby Hansson

11.24 Courtesy of the Daphne Farago Collection. Photo courtesy of the artist. Photo by Doug Martin 11.25 Metropolitan Museum of Art, New York (46.128)

11.26 Copyright Tinwood Media 2006

11.27 From the exhibition: Homage to Nature: Landscape Kimonos of Itchiku Kubota, "Ohn (Mount Fuji), Tender, Cool Dawn" courtesy of Itchiku Kubota. Print by Victoria Hyde

12.2 © 2006 Digital Image. The Museum of Modern Art, New York/Scala, Florence 12.4 Courtesy of Mono

12.5 Benny Chan/Fotoworks

12.6 Courtesy Young Aspirations, Young Artists, New York

12.7 Getty Images, London

12.9 The Hutchinson Library, London

12.13 Courtesy of Ensemble, New Delhi

13.1 Robert Harding Picture Library 13.2, 13.4 Mary Pat Fisher

13.5 Courtesy www.sacredsites.com. Photo Martin Gray

13.6 © Vincenzo Pirozzi, Rome

13.7 Spectrum 13.8 F. Veranda

13.9 Julius Shulman, Los Angeles/© ARS, NY and DACS, London 2006

13.11 Courtesy of International Affairs Division, Kagoshima Prefectural Government, Japan

13.12 Aerofilms Ltd, Borehamwood

13.14 Giraudon, Paris 13.19 Robert Harding Picture Library

13.21 © Paul M. R. Maeyaert

13.25 Topham

13.29 © Joseph Savant 13.30 Alamy/Paul Thompson Images

13.32 Synd Int.

13.33 Susan Griggs Agency 13.36, 13.37Architects Association, London 13.38 McBride Charles Ryan 13.40 Courtesy of Stephen Doherty, Victoria and Albert Museum

13.40 Peter Durant/arcblue

14.3 Greg Natale Interior Design (www.gregnatale.com)

14 4 Tochio Mori

14.5 Photo by D. Finnin, no. K18943 (Courtesy Department of Library Services, American

Museum of Natural History) 14.6 Photo by Ezra Stoller/Esto 1950

14.7 John Olbourne, Swanbourne, Western Australia

14.9 Sasaki Associates, Inc., New York 15.10 Richard Haas

14.11 Terry Schoonhoven, Los Angeles 14.17 Royal Anthropological Institute of Great Britain and Ireland

14.18 Zoë Dominic Photograhy 14.21 Galleria Continua, Italy

15.1 © 2006 Digital Image, The Museum of Modern Art, New York/Scala, Florence/© Succession Picasso/DACS 2006 15.2 Hans Hinz, Allschwil, Switzerland

15.5 University of Pennsylvania Museum (neg T35-110c)

15.6 Oriental Institute, University of Chicago

15.10 Hirmer Foto Archiv, Munich 15.14 Photo Vatican Museums

15.18 Arxiu, MAS, Barcelona

15.19 Sonia Halliday 15.20, 15.25, 15.28 Scala, Florence

15.21 Archivi Alinari, Florence

15.27 © Araldo de Luca, Rome 15.29, 15.36, 15.37 The Bridgeman Art Library, London

15.28 © Alain Choisnet/Image Bank

15.30 Empics

15.31 © Cameraphoto, Venezia

15.32 The Mansell Collection, London 15.33 Oronzo, Madrid

15.34 © 1998 Board of Trustees, National Gallery of Art, Washington

15.35, 15.36 A. F. Kersting, London 15.40 © Photo Josse, Paris 15.43 © 2006 Digital Image, The Museum of Modern Art, New York/Scala, Florence

15.44 The Art Institute of Chicago 15.45 © Munch Museum/Munch-Ellingsen Group,

BONO, Oslo/© ADAGP, Paris and DACS, London

15.46 San Franciso Museum of Modern Art/© Succession H Matisse/DACS 2006 15.47 Kunstmuseum Basel/© ADAGP, Paris and DACS,

London 2006

15.48 © 2006 Digital Image, The Museum of Modern Art, New York/Scala, Florence 15.49 The Art Institute of Chicago/© ADAGP, Paris and

DACS, London 2006 15.50 © Succession Marcel Duchamp/ADAGP, Paris and DACS, London 2006

15.51 © 2006 Digital, The Museum of Modern Art, New York/Scala, Florence/© Salvador Dalí, Gala-Salvador Dalí Foundation, DACS, London 2006 15.51 © 2003 Digital Image, The Museum of Modern

Art, New York/Scala, Florence 15.52 © 2006 Digital Image, The Museum of Modern Art, New York/Scala, Florence/© ARS, NY and DACS, London 2006

15.54 Juda Rowan Gallery, London

15.56 © The Estate of Roy Litchenstein/Licensed by DACS 2006 15.57 Private Collection, photo courtesy Pace-

Wilderstein

15.57 Arch-Photo/Leni Schwendinger 15.59 Photo courtesy of Joseph Kosuth Studio, New York/© ARS, New York and DACS 2006

15.60 © James Turrell/Barbara Gladstone Gallery, New York

15.61 Courtesy of the artist/Licensed by DACS 2006

15.62 © Serge Spitzer/Photo Paul Ott 15.63Pennsylvania Academy of Arts

15.64 Photo courtesy of Ryoichi Yoshida: with kind help of Chieko Ogawa, Editor, Doll Forum, Japan 15.67 Courtesy of Shilpa Gupta 15.71 © Romare Bearden Foundation/VAGA, New

York/DACS, London 2004 15.71 Christie's Images, London 15.72 The Bridgeman Art Library, London

15.73 Empics 16.1 Museo Nacional Centro de Arte Reina Sofía, Madrid/Giraudon, Paris/The Bridgeman Art Library, London/© Succession Picasso/DACS 2006

16.2 Associated Press 16.3, 16.4, 16.5, 16.6, 16.7 © Succession Picasso/DACS 2006

16.10 Louis-Frederic, courtesy Albert Eisen

16.13, 16.14, 16.16, 16.17 Photo Vatican Museums 16.18, 16.19 Nippon Television Network Corporation, Tokyo 1991

16.20, 16.21, 16.22, 16.23 © FMGB Guggenheim Bilbao Museoa

Index

Abakanowicz, Magdalena: Agora 172, 175, 3.3 Abalone Shells (B. Martin) 242, 500, 5.25 Aboriginal art 41, 97–8, 512, 1.36, 2.50 Above Eternal Peace (Levitan) 137, 2.110 Abraham's Hospitality and the Sacrifice of Isaac (mosaic) 448, **15.16**Abramovic, Marina: *Double Edge* 198, **3.44**; *The House with the Ocean View* 498, **15.61**abstract art/abstraction 18–21, 487–8 Abstract Expressionism 490-1 Abstract Imagists 491–3 Abstraction Blue (O'Keeffe) 137, 2.108 Abu Temple, Tell Asmar: statuettes 442, 15.6 AB:47/Untitled (Thomas) 316, 9.5 Acoma ware 25-6, 89, 1.17 acoustics 395 Acropolis, Athens 445, 15.12; Erechtheum 399, 13.17; Parthenon 196, 445, 3.40, 15.12 acrylics/acrylic paintings 223, 242–4, 1.24, 2.62, 2.129, 5.26, 5.27, 15.57 Action Painting (drip paintings) 174, 490-1, Adams, Ansel 289-90, 490; Clearing Winter Storm, Yosemite National Park 290, 8.13 Adams, Eddie: Execution of a Vietcong Officer ... 307, 8.35 Adele Bloch-Bauer I (Klimt) 510, 15.73 Adoration of the Magi, The (Gentile) 58–9, 2.1 Adoration of the Magi, The (Leonardo) 234, 5.18 advertising 38–9, 277–8, 279, 7.11, 7.12 see also poster art Aegean civilizations 439, **15.4** aerial views 105-6 African art 508; masks and masqueraders 113–14, 178, 336, 426, 2.73, 3.10, 10.7; sculpture 342, 10.15; wall-painting 221, 5.2; Yoruba diviner's bag 24, 1.15 African-American art 53, 372, 506, 508–9, 1.46, 11.26, 15.68 After the Bath (Degas) 214, 4.10 Agitator, The (Rivera) 227–8, 5.9 Agora (Abakanowicz) 172, 175, 3.3 Agra, India: Taj Mahal 34, 48, 196, **1.26** airbrushing 242, 243 aircraft hangars, Orbello, Italy (Nervi) 409, 13.33 Albers, Josef 157; Homage to the Square series 145, 157, 493, 2.119, 2.132 Alberts, A. (Ton): bank complex, Amsterdam 394, 13.10 Alcalacanales: La Corrida de Cannes 268-9, 6.31 Alcorn, John: The Scarlet Letter 59-60, 2.3 Alcorn, Stephen 255; La Sabina Mitologica 255, 6.10 Alhambra, Granada 404, 13.26 alla prima method 223 Allegory of Peace (Lorenzetti) 225-7, 5.7, 5.8 Alling, Katherine: Feathers # 22 120-1, 2.85 Alphabet with quotations (Zapf) 277, 7.10 Altar for Peace (Nakashima) 362, 11.15 Altar of the Hand (Benin bronze) 342, 10.15 altars/altarpieces 192; Bernini 40, 472, 1.34; Cimabue 110, 2.69, 5.13; Grünewald 462-7, 15.29; Nakashima 362, 11.15; Perugino 186, 3.24-3.26 amphorae: Dipylon Vase 444, **15.10**; Euphiletos painter (attrib.) 352, **11.1** Amsterdam: bank complex (Alberts and Van Hutt) 394, 13.10 Ancestor Portraits (Talman) 296, 8.18 Ancestors of the Passage: A Healing Journey through the Middle Passage (Arroyo) 53, 1.46 Anderson, Charles Spencer: packaging 273, 7.3 Angel de la Guarda (Kuna people) 137, 2.109

Angelico, Fra: Annunciation 455, 15.21 Angkor, temples of 390, 13.5 annealing 358 Annunciation (Angelico) 455, **15.21** 'anti-aliasing' 297 Anuszkiewicz, Richard: Splendor of Red 152-4, 2.129 Apollonius: *Seated Boxer* 343, **10.16** *Apples* (Kelly) 67–9, **2.14** applied arts, the 25 Apu Trilogy (Ray) 306, 8.31 aquatints 264, 6.26; sugar 264 aqueducts, Roman 400, 13.20 arch construction 400, 13.19; ceramic (A. Zimmerman) 338, 10.11; Moorish 404 Archaic period, Greece 444 architecture 386-9; Assyrian 442-3; Baroque 472; Byzantine 246, 360, 400, 403; and computers 319-20, 411, 531; and contrast 178; Deconstructionist 409-10, 505; Egyptian pyramids 443; and the environment 198–204, 394; focal points 191; and function 389–97; Gothic 246, 400–3, 452–3; Greek 196, 399–400, 445; Indian 34, 48, 196, 395-7; International Modern Style 375, 405-6; Japanese 131, 395, 409; modular construction 409; Moorish 246, 404; Postmodern 409, 505; and power and propaganda 37–8; Rococo 472; Roman 27, 57, 93–5, 392, 400, 403, 446; Romanesque 400, 452; Russian 392; Shaker 387; shopping malls 411–12; structural materials and techniques 398–412; Sumerian 439; and variety 175; and virtual reality 322–3 see also cathedrals Ardèche Valley, France: cave paintings 438 Arena Chapel, Padua: Giotto frescoes 453, 15.20 Aristide Bruant dans son cabaret (Toulouse-Lautrec) 276, **7.6** Aristotle 456, 462 armatures 337 Arnolfini Marriage see Eyck, Jan van Arroyo, Imna 53; Ancestors of the Passage: A Healing Journey through the Middle Passage 53, 1.46 'art,' definition of 13 art brut 512 Art Nouveau: glass 82, 2.33 Art of Painting, The (Vermeer) 83, 456, 2.34 art websites 325, 326–7 Artichoke Halved (Weston) 292, 8.14 artworks: changes over time 169; as investment 27-9, 510-11; looting 440; protection 464; reproductions 16 see also restoration Asaf Khan: Nishat Bagh 417-18, 14.7 assemblage 345-6, 10.19 Assisi, Italy: Basilica of St. Francis: restoration of frescoes 228, 5.10 Assumption of the Virgin, The (Rubens) 472, Assyrian art and architecture 442-3, 15.7 asymmetrical (informal) balance 185, 3.20 Athanor (Kiefer) 103, 503, 2.55 Athenodorus see Hagesandrus Athens 444, 445 see also Acropolis 'Atlas' Slave (Michelangelo) 333, 10.4 atmospheric color 141 atmospheric perspective 103–4 Augustus of Primaporta 446, **15.14** Australian Aboriginal art 41, 97-8, 512, 1.36, 2.50 avant garde 483; film 302

Aycock, Alice: Tree of Life Fantasy 330, 10.1

Azarian, Mary: T is for Toad 116, 2.78

Babylon 439 Bailey, William 500; *Monte Migiana Still-Life* 500, **15.63** balance 183-6; asymmetrical (informal) 185, 3.20; radial 185; symmetrical (formal) 183-4, Balega mask 178, 3.10 Ballard, Frank 429, 8.38; puppets for The Magic Flute 429, 14.20 Ballard, Norman 8.38 ballet 426, 14.18 balloon-frame construction 405, 13.28 Bulzac (Rodin) 166, 2.142 Banner of Las Navas de Tolosa 152, 2.127 Barcelona: Church of the Holy Family (Sagrada Familia) (Gaudì) 175, 3.8; Palau de la Música Catalana (Domènech i Montaner) 246, 5.31 Barcilon, Pinin Brambilla 232 bark paintings, Aboriginal 97-8, 2.50 Barma and Posnik: St. Basil's, Moscow 392, 13.7 Barnes, Dorothy Gill: North Beach Rocks 370, 11.24 Baroque art and architecture 40, 213, 468-72 barrel vaults 400 Barsukov, Vladimir: *Joy* 138, **2.111** Bartow, Rick 207; *Bear for Lily K* 207, **4.4** bas relief 73 Baskerville, John: typeface 277, 7.8 baskets/basket-making 369, 11.22 Batelela mask 113–14, 2.73 Battle of Issus, The (det.) (mosaic) 246, 5.30 Battle of the Ten Nude Men (Pollaiuolo) 6.2, 6.3 Bauhaus 375, 405 Bayadère, La (Petipa) 426, **14.18** Bear for Lily K (Bartow) 207, 4.4 Bear Run, Pennsylvania: Kaufmann House (Wright) 203-4, 409, 3.46 Bearden, Romare 509; Family Dinner 509, 15.71; She-Ba 100, 2.53 Beardsley, Aubrey: *Forty Thieves* cover design 207–8, **4.3** bearing wall construction 398 beauty 48 Beck, Professor James 233 Beever, Julian 213-14, 4.9 Beggarstaff Brothers: Harper's Magazine poster 65-6, 2.11 Bellini, Giovanni: Christ's Blessing 228, 5.11 Benin: bronzes 342, 440, 10.15; ivories 336, 10.7 Bergman, Ingmar: The Seventh Seal 306, 8.32 Bernini, Gian Lorenzo: The Ecstasy of St. Teresa 40, 472, **1.34**; St. Peter's piazza 420, **14.8** Berton, John Andrew, Jr. 324 Bikini (Thiebaud) 15, 34, 1.4 Bilbao, Spain: Guggenheim Museum (Gehry) 57, 198–203, 319–20, 410, 530–3, **1.51**, **3.45**, 16.20-16.24 Billy, Susye: baskets 369 binders (paint) 221 Bird in Space (Brancusi) 25, 1.16 Birth of Venus, The (Botticelli) 455, 15.24 bitmap scanning 315, 9.3 Bittleman, Arnold: *Martyred Flowers* 69, 216, 2.16 Blake, Jeremy: *Mod Lang* 313–14, **9.1** Blake, William 475; *The Last Judgment* 170–1, 184, 3.1 Blaue Reiter, Der ('The Blue Rider') 485 Blinn, Jim 324 Bloom, Hyman: Fish Skeletons 216, 4.16 blown glass 145, 364-5, 2.118, 11.17, 11.18 Blue Divide (Booma) 235, 5.19 'Blue Rider, The' 485 Bluewater Shopping Complex, Kent (Kuhne) 411-12, **13.40**

Board Call (Albers) 145, 2.119 Boating Party, The (Renoir) 188-9, 3.28 Boccioni, Umberto: Unique Forms of Continuity in Space 487, 15.48 Body Sculpture in Rattan (Miyake) 383, 12.11 'bon à tirer' (BAT) 265 Bonnard, Pierre: Nude in a Bathtub 223, 5.4 Book of Kells 452, 15.17 books: blind embossed covers 252; illustrations 207-8, 250, 252, 256, 258, 266-7, 279-81, 4.3, 7.13, 7.14 Booma, Sharon: Blue Divide 235, 5.19 Bosch, Hieronymus: The Carrying of the Cross 106, 2.64 Botanical Specimens (Talbot) 284, 8.2 Botticelli, Sandro: The Birth of Venus 455, Bouguereau, William 48-9; Nymphs and Satyr 48, 67, 1.45 bounce lighting 305 Bowl with Folds (von Rydingsvard) 345, 10.19 Boy with a Pipe (Picasso) 510, 15.72 Boyden, Frank: Changes # IV 265, 6.27 Boyka Fable (Sobol-Wejmen) 264, 6.26 Brancusi, Constantin: Bird in Space 25, 1.16 Brandom, Joseph: utensils and rack 358, 11.10 Braque, Georges 487; *The Portuguese* 487, **15.47** brass 138–9, 358 Brassempouy, Woman from (ivory) 13, **1.2** 'Bridge, The' 485 Brigden, Timothy: chalice 196, **3.41**British Columbia Landscape (Carr) 182, **3.15**British Museum, London 440; Reading Room 414, 14.2 Broadhurst, Florence 414–16, 14.3 broken color 158 Broken Obelisk (Newman) 60, 2.5, 2.6 bronzes 79, 340; Benin 342, 440, **10.15**; Boccioni 487, **15.48**; Brancusi 25, **1.16**; Cellini 341, 10.13; Danish 79, 2.29; Degas 340, 10.12; Giacometti 64, 2.9; Graves 185–6, 3.22; Greek and Hellenistic 67, 74, 343, 2.13, 10.16; Hindu 40-1, 1.35; Lachaise 120, 2.84; lost-wax casting 340-2, 10.14; Moore 80, 2.31 see also Rodin, Auguste Bronzino, Angelo 456, 467; Portrait of a Young Man 221, 5.3 Brotherhood Building, Cincinnati: trompe l'oeil mural (Haas) 421, 14.10 Brücke, Die ('The Bridge') 485 Bruegel, Pieter, the Elder: Hunters in the Snow 100, 2.54 brush and ink drawings 216-19, 4.17 'Buddha' calligraphy (Nguyen) 70, 2.18 Buddhism 417; sand mandalas 240, **5.24**; Wheel of Life 185, **3.19** see also Zen Buddhism Buddhist Temple in the Hills after Rain (attrib. Li Cheng) 109–10, 2.68 Buñuel, Luis: (with Dalì) Un Chien andalou 302, 490, 8.25 buon fresco technique 225-7 burins 258 burls 364 Burne-Jones, Edward (with Morris): Works of Geoffrey Chaucer 281, 7.14 burnishing 230 Burrowing Skink Dreaming at Parikirlangu (Jampijimpa) 41, 1.36 Bust of a Woman after Cranach the Younger (Picasso) 256–7, **6.12** *Bust of a Young Girl* (Houdon) 338, **10.9** Butterfield, Deborah: *Palma* 344–5, **10.18** buttresses, flying 403, 452, **13.23** Byodoin Temple, Uji, Japan 131, 2.97 Byzantine culture: architecture 246, 360, 400, 403, 13.25; icons 448, 15.15; mosaics 448,

Cabinet of Doctor Caligari, The (Wiene) 301-2, 485, 8.24 Calatrava Valls, Milwaukee Art Museum 95, 2.48 Calder, Alexander 161; Cow 93, 2.45; Lobster Trap and Fish Tail 161, 2.137 calligraphy: Buddhist 70, **2.18**; Chinese 217; Islamic 59, 62, 182, 2.2, **2.8**; Zapf 277, **7.10** Calling of St. Matthew, The (Caravaggio) 468-70, Calvin, John 468 Camara, Silla **5.2** camera obscura 284, 456, **15.22** Campagna Landscape (Claude Lorraine) 216, Canterbury Tales (Chaucer), Kelmscott ed. 281, 7 14 cantilevers 407-9, 13.32 canvases 221, 223 capitals (architecture) 400 captured moments 168-9 Caravaggio, Michelangelo Merisi da 456, 468; The Calling of St. Matthew 468–70, **15.32**; The Conversion of St. Paul 125, **2.92** Caress, The (Cassatt) 263, 6.24 carpets, Persian 371, 11.25 Carr, Emily 181-2; British Columbia Landscape 182, 3.15 Carrying of the Cross, The (Bosch) 106, 2.64 Cartier-Bresson, Henri 289; Sunday on the Banks of the Marne 289, 8.12 cartoons (drawings) 213, 227, 4.8 carving processes 333-7 Cassandre, A. M.: poster 70-3, 2.19 Cassatt, Mary: The Caress 263, 6.24 Cassyd-Lent, Karen 326-7, 491, 9.15 Castillo Lara, Cardinal José 530 casting processes: bronze 340-3; glass 365; iron 358 see also lost-wax casting cathedrals 26; Chartres, France 395, 452-3, 13.12, 13.22, 15.19; Rouen, France 479, 15.41; St. Basil's, Moscow 392, 13.7; St. Paul's, London 472, 15.35; Santiago de Compostela, Spain 452, 15.18 'Caution! Religion' exhibition 30–1 cave paintings 434–9, **15.3** Cellini, Benvenuto 341, 468; *Perseus with the Head of Medusa* 341, **10.13** censorship 27–9, 30–1 CDs (compact discs) 310 Center for Contemporary Art, Kitakyushu, Japan 326, **9.14** ceramics see pottery and ceramics Cerulean Sky (J. Good) 270-1, 6.33 Cézanne, Paul 101, 479-82; Mont Sainte-Victoire seen from Les Lauves 48, 1.44; Still Life with Apples 482, **15.43** Chagall, Marc: *The Crow Who Wanted to be an* Eagle 239-42, **5.23** chairs: Eames 26, 1.18; Hubatsek 361, 11.14; Mies van der Rohe 375, 12.2; Thonet 70, 181, chalice (Brigden) 196, 3.41 chalk drawings 207, 213-14, 4.2, 4.8, 4.9 Ch'an Buddhism see Zen Buddhism Changes # IV (Boyden) 265, 6.27 Changing the Fractal Dimension (Voss) 316, 9.4 Chaplin, George: Da Kara 47, 1.42 charcoal drawings 210-11, 4.6, 4.7 Charigot, Aline 188-9 Chartres, France: Cathedral 395, 452-3, 13.12, 13.22, 15.19; La Maison Pique Assiette 512, 15.75 Chiang, Ching-Fang: image from 'Reconstruction' 312, 8.39 chiaroscuro 124-5, 128, 458 Chien andalou, Un (Buñuel and Dalì) 302, 490, 8.25 Chihuly, Dale 365; No. 2 Sea Form Series 365, 11.18 Chin, Daryl 53 China: paintings and drawings 98–100, 109–10, 119, 182–3, 195, 216, 217, 2.52, 2.68, 2.82, 4.14; porcelain 26–7, 194, 355, 1.19, 3.35, 11.6; sculpture 139, 338, 2.113, 10.10; woman's coat 385, 12.13 Christian art: early 446–8; medieval 448–52 see also altars/altarpieces; cathedrals Christina's World (Wyeth) 490, 15.52 Christo and Jeanne-Claude 208; Running Fence 65, 208, 2.10 Christ's Blessing (Bellini) 228, 5.11 'chroma' 137 Chromatic Abstractionists 491-3 Cimabue: Madonna Enthroned with Angels and Prophets 110, 2.69, 5.13 Cimetric Tray 580 with Serving Utensils (Eisler) 377, 12.4

Cincinnati: Brotherhood Building: trompe l'oeil mural (Haas) 421, 14.10 cinematography 301 see also film(s) Citizen Kane (Welles) 302–3, **8.26** City Complex One (Heizer) 79–82, 350, 497, **2.32** City Medium typeface 273, 7.1 Cityscapes of New York (Matt) 215, 4.11 Cività Castellana (Corot) 209-10, 4.5 Classical period (Greece) 444 Claude Lorraine: Campagna Landscape 216, 4.15 clay 353–8; coil building 353, 11.3; modeling 338; Paula Winokur on 356; pinching 353, 11.2; sculptures 338, 10.11; slab building 353; wedging 354; wheel-throwing 354, 11.4 cleaning paintings 232–3 Clearing Winter Storm, Yosemite National Park (A. Adams) 290, **8.13** clock (Szabó) 358, 11.11 Close, Chuck 500; Frank 243, 5.26; Self-Portrait 155, 2,131 closed forms (sculpture) 78-9 clothes 26, 380-5; Chinese coat 385, 12.13; Delphos dress (Fortuny) 382, **12.10**; kimonos 372-3, 385, **11.27**; Kotlean robes 374, **12.1**; Liberian gown 89, 2.41; Miyake 383–5, 12.11; Nigerian dress 382, 12.9; Papuan costume 426, 14.17; saris 384, 12.12 Cloud Gates (Kapoor) 127, 2.94 coffers 403 Cohen, Harold 324 coil building (clay) 353, **11.3** collages 100, 244–6, **2.53**, **5.29**; digital 299, 316, Collected (Minkowitz) 369-70, 11.23 color scanners 267 color separations 266-7, 6.29 color tree (Munsell) 138, 2.107 color wheels 134, 135, 2.103, 2.105 color(s) 134–8; advancing 148; Albers on 157; analogous 150; applied 139; atmospheric 141; broken 158; combinations 148-52, 2.123; complementary 135, 139, 152; contrasting 178; cool 145–8; emotional effects 142–5; hue 134–5; interactions 152–8, **2.130**; interpretive 142; limited palettes 2.130; interpretive 142; limited palettes 158–9; local 141; natural 138–9; open palettes 158–9; perception of 154–5; pigments 135, 221; primary 134–5, 2.104-2.106; receding 148; reflected 135, 2.106; refracted 134–5, 2.104; saturation 137, 2.107, 2.109; secondary 135, 2.104–2.106; tertiary 135, 2.105; triad 152, 2.128; and value 137, 2.107; warm 145–8 losseum. Rome 57 Colosseum, Rome 57 Combat of the Giaour and Hassan, The (Delacroix) 158, 2.133 compact discs (CDs) 310 complementary hues 135, 139, 152 Composition in Blue, Yellow, and White (Mondrian) 21, 488, 1.13 compressive strength 398 Computerized Nude (Knowlton and Harmon) 315, computers/computer-generated art: architecture and 319-20, 411, 531; copyright 319, 328; digital art 313-28, 495; digital imaging 297-300; as drawing medium 219, 314-15; film special effects 303-5; interactive art 325-8; legal/moral issues 319, 328; as painting medium 315-19; sculpture and 319, 331–2; typefaces 277; as unique art medium 323–4; video art 312; video graphics 320–1 see also virtual reality Conceptual art 496-7 Concourse of the Birds, The (Habib Allah) 122, 2.89 concrete 403; reinforced 407-9; Roman 403 Concrete Architectural Associates: Supperclub Roma, Rome 150, 2.124 Confucius 217 Constable, John 475 Constantine, Emperor 448 Conté crayon drawings 215, 4.12 content of art 33–48 context 34 contours/contour lines 67-9, 77 contrapposto 337, 445

contrast 178-9; and value 154-5, 2.130 design 48, 59 see also environmental design; graphic design; industrial design DesignMuseo, Helinsky 326, 9.13 Conversion of St. Paul, The (Caravaggio) 125, 2.92 copperwork 138, 358, 361, 11.13 Coptic encaustic painting 224–5, 5.5 copyright: and cyberspace 328; and digital Devlin, Dean 303–4 Dharmaraja Rath, India 398, **13.14** Dharmaraja Rath, India 398, 13.14 Dial, Thornton: Freedom Marchers 344, 10.17 digital art 313–28, 495 digital imaging 297–300 digital photography 296–7 digital versatile discs (DVDs) 310 Dinosaur (Disney) 321, 9.10 Dipylon Vase 444, 15.10 direct painting 223 artworks 319 Cordoba, Spain: Great Mosque 404 Corinthian order 400, **13.18** Cornaro, Cardinal 40 Cornell, Joseph: The Hotel Eden 95, 2.47 Corot, Jean-Baptiste-Camille: Cività Castellana 209-10, 4.5 direct painting 223 direct painting 223
direct photocopying 268
directional lines 70–3
Disney (Walt) Productions: *Dinosaur* 321, **9.10**; *Tron* 320, **9.9** corporate art 27 Corps étranger (Hatoum) 311, 8.37 Correggio, Antonio 467; Danaë 234, 5.17 Corrida de Cannes, La (Alcalacanales) 268-9, documentary film 305-6 documentary photography 288–9 dollmaking/dolls 501, **15.64** Counter-Reformation 54, 467, 468 Courbet, Gustave 476-9; The Stone Breakers 476, dome construction 403, 13.24, 13.25; geodesic Cow (Calder) 93, **2.45** crafts 26, 52, 352–73, 500–3 407, 13.31; Moorish 404, 13.26 Domènech i Montaner, Lluis: Palau de la Música Cranach, Lucas, the Younger: Portrait of a Catalana, Barcelona 246, 5.31 Woman 257, 6.13 Doric order 400, 13.18 Doryphorus see Spear Bearer Double Edge (Abramovic) 198, **3.44** crayon drawings 215-16, **4.12**, **4.13** Creation of Adam (Michelangelo) 12, 40, 207, 208, 1.1, 4.2 Double Self-Portrait (Estes) 127-31, 2.96 Creation (Rivera) 225, 5.6 Dove, The (Soriano) 15.69 creative impulse 13–14 Crest (Riley) 493, **15.55** critics and criticism 48–54 drawing(s) 206-9; brush and ink 216-19, **4.17**; chalk 207, 213-14, 4.2, 4.8, 4.9; charcoal 210–11, 4.6, 4.7; computers 219, 314–15; crayon 215–16, 4.12, 4.13; paper 208–9; pastel 208, 214–15, 4.4, 4.10, 4.11; pen and ink 207, 216, 4.1, 4.3, 4.16; pencil 209–10, 4.5; sidewalk 213–14, 4.9; silverpoint 210 Cro-Magnons 434 cross-hatching 69, 216, 252 Crow Who Wanted to be an Eagle, The (Chagall) 239-42, 5.23 Crucifixion with Saints, The (Perugino) 186, 3.24–3.26 crystal 77, 2.26 Dream, The (Rousseau) 44, 1.38 Dreaming in Color (Schwendinger) 496, 15.58 drip paintings (Action Painting) 174, 490–1, 15.53 Crystal Palace (Paxton) 103, 405, 2.57 drypoint 263, **6.19–6.24** Dubuffet, Jean 512 Csuri, Charles 324; Wondrous Spring 324, 9.12 Cubism 433, 487 Duchamp, Marcel 487; *The Fountain* 488–9, **15.50**; *Nude Descending a Staircase # 2* 164–8, Cuff, R. P. (engraving): The Crystal Palace 103, 487, 2.141 Cummings and Good (design studio) 274 see ductility (of metals) 358 Good, Janet; Good, Peter Duffy Design Group: packaging 273, 7.3 Dürer, Albrecht 252, 467; Head of an Apostle 69, 2.15; Saint Christopher 252, 6.6; Underweisung cyberspace 314, 325-8 Cycladic figures 439, 15.4 Da Kara (Chaplin) 47, 1.42 der Messung 277, 7.9 DVDs (digital versatile discs) 310 Dada 488-9 Daguerre, Louis-Jacques-Mandé daguerreotypes dynamic forms 82 285; A Parisian Boulevard 285, 8.3 dynamic range (digital photography) 297 Dalì, Salvador: The Persistence of Memory 490, 15.51; (with Buñuel) Un Chien andalou 302, Eames, Charles and Ray: chair and ottoman 26, 1.18 Dallas, Texas: Fair Park Lagoon (Johanson) 424, earthenware 353 earthworks 64-5, 346-51, 497; Christo and Dalton, Stephen 292–5; Spores Falling from the Common Horsetail 293, 8.15 Jeanne-Claude 65, 2.10; Heizer 79-82, 350, 497, 2.32; Nasca hummingbird 346-50, Damerji, Dr. Moayad 440 10.22; Smithson 350-1, 497, 10.23; Turrell Danaë (Correggio) 234, 5.17 Danaë (Rembrandt) 464 Eastman, George 301 Ecclesiastes (Eichenberg) 256, 279-80, 6.11 Dancer with a Bouquet (Degas) 104, 2.61 Echo, L' (Seurat) 215, 4.12 Dark Ages 448 economy of design 193-4 David, Gerard: The Resurrection 141, 2.114 David, Jacques-Louis: The Oath of the Horatii 473, Ecstasy of St. Teresa, The (Bernini) 40, 472, 1.34 Eddy, Don: Imminent Desire/Distant Longing II 15.37 Davy, Sir Humphry 284–5 de Kooning, Willem 491 Deconstructionist architecture 409–10, 505, 13.39 104-5, 2.62 edges 60 Efendi, Sami: Levha 59, 182, 2.2 Egypt: ancient art and sculpture 78, 443–4, 2.27, 15.9; encaustic painting 224, 5.5; pyramids 13.39
decorative lines 67
Deductive Object (Kim) 44–5, 1.39
Degas, Edgar 168, 479; After the Bath 214, 4.10;
Dancer with a Bouquet 104, 2.61; Horse
Galloping on Right Foot 340, 10.12
Déjeuner sur l'herbe, Le (Manet) 479, 15.40
Delacroix, Eugene 155–8; The Combat of the
Giaour and Hassan 158, 2.133
Delhi: Jesus' Place, Gobind Sadan 413–14, 14.1 443, 15.8 Eichenberg, Fritz 256; *Ecclesiastes* 256, 279–80, 6.11 1895 (Zagarensky) 316–19, 9.6 Eisenman, Peter: Staten Island Institute for Arts and Sciences 320, 9.8 Eisenstein, Sergei 302 Eisler, Eva: Cimetric Tray 580 with Serving Utensils 377, **12.4** Elgin Marbles 440 Delhi: Jesus' Place, Gobind Sadan 413-14, 14.1 Delphos dress (Fortuny) 382, 12.10 Eliasson, Olafur 132; Your Colour Memory 132, Demoiselles d'Avignon, Les (Picasso) 432-3, 487, 2.100 Denmark: bronze 79, 2.29; rune stone 114-15, Em, David 323-4; Navajo 1978 323, 9.11 embroidery 137, 152, 385, 2.109, 2.128, 12.13;

zardozi work 384, 12.12

descriptive lines 67-9

Emmerich, Roland: Independence Day 304, 8.28 emphasis 189-92 enamel 358, 11.9 encaustic paintings 224-5, 5.5 Endo, Susumu: Space and Space Forest 91A 300, engravings: colored 380–2, **12.7**; line 103, 258–62, **2.57**; steel 258–62, **6.15**, **6.17**; wood 254–6, **6.9**, **6.11** 'enhancement' 48 Enlightenment, the 472, 473 entablatures 196, 400 entasis 196 Entry I: Sakkara (Winokur) 356, 11.7 environment: and architecture 198-204, 394; and art 198 environmental design 26, 417-24 ephemeral materials, preserving 348 Ephesus: theater 424, **14.14** Equestrienne (At the Circus Fernando) (Toulouse-Lautrec): (crayon) 216, 4.13; (oils) 168-9, 2.144 Equivocal (Albers) 157, 2.132 Erechtheum, Athens 399, 13.17 ergonomics 378 Escher, M. C.: Relativity 112, 2.71 Essence Mulberry (Frankenthaler) 175–8, **3.9** Estes, Richard 500; Double Self-Portrait 127–31, etchings 262–3, **6.18**; drypoint 263, **6.19–6.24** Euphiletos painter (attrib.): amphora 352, **11.1** Ewuare the Great, oba of Benin 336 Execution of a Vietcong officer ... (E. Adams) 307, Expressionism 301-2, 485 expressivist criticism 49 Eyck, Jan van: The Marriage of Giovanni Arnolfini ... 454, 456, 15.23 eye-level lines 103 evelines 67 f/64 Group 290, 292 fabric design 414–16, **14.3** 'Fallingwater' (Kaufmann House) (Wright) 203-4, **3.46**Family Dinner (Bearden) 509, **15.71**Farm Security Administration, USA 288 Fauvism 485-7 fax art 269, 495 Feathers # 22 (Alling) 120–1, **2.85** featherwork, Hawaiian 115, **2.76** Femme au Chapeau (Matisse) 485, 15.46 Ferrari, Leon 30 fiber art 369–73; baskets 369, **11.22**; carpets 371, **11.25**; installations 44–5, **1.39**; kimonos 372–3, 385, **11.27**; quilting 171–2, 370–2, 3.2, **11.26**; sculpture 369–70, **11.23**, **11.24**; tapestries 369, 11.21 see also clothes Fibonacci series 196 figurative art 17 figure-ground relationship 97 figure-ground reversal 98 filigree work 360 film(s) 300-1; avant-garde/experimental 300-6, 302; computer-animated 321; documentary 305-6; Expressionist 301-2, 485; montage 302; Nazi propaganda 308; Surrealist 302, 490; visual/special effects 302-5, 320 fine arts 24-5, 26-7 firing (pots) 354 Fish Skeletons (Bloom) 216, 4.16 Flagellation of Christ (Piero della Francesca) 188, Flaherty, Robert: Nanook of the North 305, 8.30 Floor Show (J. Good) 105-6, 2.63 Florence, Italy: Baptistery doors (Ghiberti) 455-8, 15.25 455-8, 15.25
Flower Day (Rivera) 18, 1.9
Flower of a Wave (Monden Kogyoku) 369, 11.22
Flower-form Vase (Tiffany) 82, 2.33
Flowering Apple Tree (Mondrian) 21, 1.12
'flowforms' 394
flying buttresses 403, 452, 13.23
focal points 191
folk art 49, 512
forced perspective 425 forced perspective 425 'Foreign Body' (Hatoum) 311, **8.37** forging (metals) 358

Golden Mean 195, 3.37 form 73; and space 80; two-dimensional illusion Hay, Deborah 315 of 83-5 Golden Rectangle 194, 196, 3.38 Head of a Woman (Modigliani) 334, 10.8 gold/goldwork 360, 11.12 formalist criticism 49 Head of an Apostle (Dürer) 69, 2.15 Goldsworthy, Andy: Garden of Stones 169, 2.145; Fortuny, Mario: Delphos dress 382, 12.10 Headspring, a Flying Pigeon Interfering Forty Thieves cover design (Beardsley) 207-8, 4.3 (Muybridge) 300-1, 8.23 Two River Stones Worked around with Curved found objects 95, 343-4 Fountain, The (Duchamp) 488-9, **15.50** Heizer, Michael: *City Complex One* 79–82, 350, 497, **2.32** Sticks 114, 2.75 Gonzalez-Torres, Felix: Untitled (Revenge) 348 Four Pears (Parker) 283–4, 8.1 four-color printing 267, 6.29 Hellenistic period: mosaics 246, 446; sculpture Good, Janet Cummings 318-19, 505; Cerulean Sky 270-1, 6.33; Floor Show 105-6, 2.63; 67, 74, 118, 189, 446, 2.13, 2.80, 3.29, 15.13; Fox-Trot A (Mondrian) 66-7, 488, 2.12 Lunar Moth and Morning Glory 318, 9.7 theater 424, 14.14 fractals 316 Good, Peter 274-5; Hartford Whalers Hockey Helsinki: Taivallahti church (T. and Fragonard, Jean-Honoré 472; The Swing 168, Club logo 194, 3.36; Special Olympics T. Suomalainen) 178, 3.11 2.143 logo/poster 274, 7.4 Henry VIII (after Holbein) 382, 12.8 frame construction 405 Gorky, Arshile 88-9; Making the Calendar 89, Hepworth, Barbara 77-8; Pendour 79, 2.30 Franco, General Francisco 56 2.40 Hersey, William see Moore, Charles W. Frank, Mary: Untitled 251, 6.4 Gothic style 26, 369; architecture 246, 400-3, Hesse, Eva: Hang-up 60, 2.7 Frank (Close) 243, 5.26 452-3; painting 453, 454, 455, 462-7; Hicks, David: sitting room 146, 2.121 Frankenthaler, Helen 223, 243-4, 491-3; Essence sculpture 453; typeface 281 high contrast works 122 Mulberry 175-8, 3.9; Hint from Bassano 243-4, gouache paintings 239-42, 2.39, 5.23, 5.25 high relief 73 5.27; Mauve District 89-92, 2.42 gouges 334 High Renaissance 179, 458-62 Frasconi, Antonio: Portrait of Woody Guthrie 253, Granada, Spain: Alhambra 404, 13.26 highlights 120 granite 337 Hill, Holliday, Connors, Cosmopulos advertising agency: ad for Tycho 277–8, 7.11 Hinduism: art 40–1, 83–5, 417, 1.35, 2.35; laws of architecture 395–7, 13.13; yantras 240 Hint from Bassano (Frankenthaler) 243–4, 5.27 graphic design 26, 38–9, 194, 273–82, 274–5 graphite 209–10 Freedom Marchers (Dial) 344, 10.17 frescoes 225-8, 455, 462, 5.7-5.9, 15.20, 15.21, 15.28 see also Sistine Chapel Grausman, Philip: Leucantha 77, 2.25 Graves, Nancy: Trace 185-6, 3.22 Freud, Sigmund 483, 490 Gray Tree, The (Mondrian) 18, 1.11 Grear (Malcolm) Designers: Guggenheim frontal works 74 Hiroshima Series #7: Boy with Kite (Lawrence) 86, full round sculpture 74 92, 2.39 Fuller, R. Buckminster 406-7; geodesic dome Museum poster 122, 2.88 Hitler, Adolf 39, 308 Hockney, David 269, 456; A House by the Sea 269 407, 13.31 greatness in art 54–7 greatness in art 54–7
Greco, El: View of Toledo 150, 2.125
Greece, ancient 338; amphorae 352, 444, 11.1, 15.10; architecture 196, 399–400, 445, 13.17, 13.18; city-states 444, 446; Golden Mean/Rectangle 195, 196, 3.37, 3.38; lost-wax casting 340–2, 10.14; orders 399–400, 13.18; sculpture 338, 444, 15.11; theater 424–5, 14, 14 see also Hellenistic period function, architecture and 389-97 Hodgkin, Howard: Interior with Figures 503, furniture 25, 26 see also chairs 15.65 Hogarth, William: frontispiece to *Kirby's Perspective* 111–12, **2.70** Futurism 168, 487 Gainsborough, Thomas: Mr. and Mrs. Andrews Hohlwein, Ludwig: poster 39, 1.33 185, 3,21 Hokusai: Southerly Wind and Fine Weather 249, Garden of Stones (Goldsworthy) 169, 2.145 gardens 74; city parks 420-1, 14.9; Indian 424-5, 14.14 see also Hellenistic period Holbein, Hans, the Younger 456; (after) Henry 417-18, 14.7; Japanese 97, 198, 422, 2.49, Green on Blue (Rothko) 45, 1.40 VIII 382, 12.8; Jane Small 108-9, 2.67 3.42, 14.11 Greenacre Park, New York (Sasaki) 421, 14.9 Holt, Nancy: Sun Tunnels 124, 2.90, 2.91 groin vaults 400 Garrin, Paul 8.38 Holy Virgin Mary, The (Ofili) 30, 1.22 Gates of Hell, The (Rodin) 24, 56, 74, 184, 520-4, Gropius, Walter 330 Homage to the Square series (Albers) 145, 157, 493, 1.49, 2.22, 16.8-16.12 Grotell, Maija 11.4 2.119, 2.132 Gates of Paradise (Ghiberti) 455-8, 15.25 grounds 97 Homer, Winslow: The Gulf Stream 237-9, 5.22 Gaudi, Antoni: Church of the Holy Family Grünewald, Matthias: The Isenheim Altarpiece horizon lines 101 (Sagrada Familia) 175, 3.8 Gauguin, Paul 250, 479, 480; The Spirit of the 462-7, 15.29 Horse and Sun Chariot (Danish bronze) 79, 2.29 Gsell, Paul 166 Horse Galloping on Right Foot (Degas) 340, 10.12 Dead Watching 480, 15.42 Guanyin (Chinese statue) 139, 2.113 Hotel Eden, The (Cornell) 95, 2.47 Guernica (Picasso) 56-7, 86, 174, 464, 515-20, 1.50, 3.6, 16.1-16.7 Gehry, Frank 311; Guggenheim Museum, Bilbao Houdon, Jean-Antoine 473; Bust of a Young Girl 57, 198–203, 319–20, 410, 530–3, 1.51, 3.45, 16.20-16.24 Guggenheim Museum, Bilbao (Gehry) 57, House by the Sea, A (Hockney) 269 gender: art criticism and 52-3; feminist issues 198-203, 319-20, 410, 530-3, 1.51, 3.45, House with the Ocean View, The (Abramovic) 498, 279 see also women's art 16.20-16.24 15.61 Hoving, Thomas 13 Howell, Jim and Sandy: Washington home 146, Gentile da Fabriano: The Adoration of the Magi Guggenheim Museum, New York 348; poster 58-9, 2.1 (Grear) 122, 2.88 geodesic domes 407, 13.31 Gulf Stream, The (Homer) 237-9, 5.22 2.120 Geometric period (Greece) 444 Gupta, Shilpa: Untitled 505, 15.67 Hubatsek, Drew: Manzano Trono 361, 11.14 geometric shapes 89 Guthrie, Woody: portrait by Frasconi 253, 6.7 hue 134-5 Géricault, Théodore: The Raft of the Medusa 475, hummingbird, Nasca 346-50, 10.22 15.38 Haas, Richard: trompe l'oeil mural, Brotherhood Hunters in the Snow (Bruegel the Elder) 100, 2.54 gesso 223, 228; glue gesso 236 Building, Cincinnati 421, **14.10** Habib Allah: *The Concourse of the Birds* 122, **2.89** gestural qualities 70, 207 'I Love New York' logo (Glaser) 273, **7.2** IBM logo/poster (Rand) 273, **7.1** Ghiberti, Lorenzo: Gates of Paradise, Florence Hacilar aceramic la (Stella) 158, 2.135 Baptistery 455–8, **15.25** Giacometti, Alberto: *Walking Man* 64, **2.9** Hagesandrus, Athenodorus, and Polydorus: *Laocoön* 189, **3.29** Ichikawa, Ennosuke, III 14.19 icons, Byzantine 448, 15.15 Gill, Eric: Gill Sans typeface 277, 7.8 Hagia Sophia, Istanbul 448 Ictinus and Callicrates: Parthenon, Athens 196, 445, 3.40, 15.12 Giotto: frescoes in the Basilica of St. Francis, Haida culture, Queen Charlotte Island: chest Assisi (attrib.) 228, 5.10; The Lamentation 183, 3.18 idealization 17–18 453, 15.20 Haitian Dance Fantasy 'Petwo' (Mazzocca) 270, illusion: of movement 164-8; of space 83-5, Girl with a Pearl Earring (Vermeer) 231–4, 5.15 Giza, Egypt: pyramids 443, 15.8 Glaser, Milton 282; 'I Love New York' logo 273, 7.2; Monet Museum poster 121–2, 2.87 97–108, 111–12; of texture 116–19; *trompe l'oeil* 118–19, 421, **2.81**, **14.10** illustration, books 207–8, 250, 252, 256, 258, 266–56, 279–81, **4.3**, **7.13**, **7.14** 6.32 Halprin, Lawrence 421-3; Sea Ranch (sketch) 423, 14.12 Hamilton, Ann: *mantle* 50–4, 500, **1.47** Hancock Shaker Village, Pittsfield 387, **13.2**, glass/glassware 364–9; antique 365; blown 145, 364–5, 2.118, 11.17, 11.18; cast 365, 11.19; Imminent Desire/Distant Longing II (Eddy) 104-5, 13.3 2.62 crystal 77, **2.26**; opalescent 82, 365–9, **2.33**; plate 394; stained 131–2, 452–3, **2.98**, **15.19**; impasto 223 Hang-up (Hesse) 60, 2.7 Hanson, Duane: Museum Guard 15, 1.4 implied lines 65-7 studio 364-5 hard-edge painters/paintings 92, 493 implied triangles 186 glazes: painting 234-5; pottery/porcelain 354, Harmon, Leon 315; (with Knowlton) Impressionism 48, 141, 479, 511 355 Computerized Nude 315, 9.2 Improvisation No. 30 (Kandinsky) 487-8, 15.49 glue gesso 236 harmony, Kandinsky on 200 Independence Day (Emmerich) 304, 8.28 Gobind Sadan, Gadaipur, New Delhi: Jesus' Independence Day (Krause) 299, **8.21** India: architecture 395–7, **13.13** (see also Taj Harper's Magazine poster (Beggarstaff Brothers) Place 413-14, 14.1 65-6, 2.11 Mahal); film-making 305-6, 8.31; gardens Goethe, Johann von 155 Hartnett, David 8.38 Gogh, Vincent van 45, 48, 223, 250, 479, 485, Harvey, Bessie 512; Tribal Spirits 512, 15.74 417-18, 14.7; Jesus' Place, Gobind Sadan, 511; Portrait of Dr. Gachet 48, 510; The Starry hatching 69, 85, 206, 216, 252 Delhi 413-14, 14.1; kanna huts 389, 13.4;

Hatoum, Mona: Corps étranger 311, 8.37

Hawaiian featherwork 115, 2.76

miniatures 83-4, 2.35; rock-cut temples 398,

13.14; saris 384, 12.12

gold leaf, applying 230

Night 45, 223, 1.41; The Yellow House 85, 2.37

indirect painting 221-3 industrial design 26, 375-8, 500 Ingres, Jean-Auguste-Dominique 456; Portrait of the Princesse de Broglie 116-18, 2.79; Two Nudes 85, 2.36 ink drawings: brush and ink 216–19, **4.17**; pen and ink 207, 216, **4.1**, **4.3**, **4.16** inner experience 41-7 installation pieces (theater) 429-30 installations 198, 498; cast iron 172, 3.3; computer-generated DVDs 313-14, 9.1; ephemeral materials/qualities 348, 498–500, 10.21, 15.62; fiber 44–5, 1.39; light/reflected light 97, 127, 132–3, 2.94, 2.101; mixed media 50-4, 345, 1.47, 10.20; multimedia 312, 495, 8.39; and sites 198, 3.44; video 311–12, **8.37**, **8.38**; virtual reality 496 instrumentalist criticism 49 intaglio printmaking 258–64, **6.14** Intagio printmaking 258-64, 6.14 interior design 26, 414-17, 14.2, 14.3, 14.5, 14.6, 14.8; Japanese 27, 416, 1.20, 14.4 Interior with Figures (Hodgkin) 503, 15.65 International Modern Style 375, 405-6 intonaco 227 investment (casting process) 340 investment, art as 27–9, 510–11 lonic order 400, **13.18** Iraq 439, 440 *see also* Mesopotamian civilizations Ireland 448 Iris Lake (Rosenquist) 266, 6.28
Irish Bells and Sentinels (Tiffany) 365-9, 11.20 iron 358; frame construction 405; wrought 358-61, 11.11 Isenheim Altarpiece, The (Grünewald) 462–7, 15.29 Isidore, Raymond: La Maison Pique Assiette, Chartres 512, 15.75 Islamic art: calligraphy 59, 62, 182, 2.2, 2.8; carpets 371, 11.25 see also Moorish architecture Istanbul: Hagia Sophia 448 ivories: Benin 336, 10.7; prehistoric 13, 1.2 jade carving 337 jaggies' 297 Jahan, Shah 34, 48 Jahangir, Mughal Emperor 417-18 Jampijimpa, Darby: Burrowing Skink Dreaming at Parikirlangu 41, 1.36 Jane Morris (Rossetti) 286, 8.6 Japan: architecture 131, 395, 409, **2.97**, **13.11**, **13.37**; film 303, **8.27**; gardens 97, 198, 422, 2.49, 3.42, 14.11; interiors 27, 416, 1.20, 14.4; *kabuki* theater 426–9, 14.19; kimonos 14.4; *kabuki* theater 426–9, 14.19; kimonos 372–3, 385, 11.27; lamp 378, 12.6; painting and drawing 106–8, 182–3, 195, 216, 2.65; printmaking 249–50, 253–4, 6.1; woodcarving 334, 10.5
Jelling, Denmark: Rune Stone 114–15, 2.74
Jesus' Place, Gobind Sadan, India 413–14, 14.1 jewelry: Mughal 358, 11.9; Russian 360
Johanson, Patricia: Fair Park Lagoon, Dallas 424, 14.13 14.13 Joy (Barsukov) 138, 2.111 JPEG format 297

Jue Chang (50 Strokes to Each) (Zhen) 430, 14.21 Julius II, Pope 54 Justinian, Emperor 448 kabuki theater 426-9, 14.19

kabuki theater 426–9, 14.19
Kagoshima, Japan: Kirishima Concert Hall
(Maki) 395, 13.11
Kahukiwa, Robyn: Paikea 280–1, 7.13
kaivakuku costume, Papua New Guinea 426, 14.17
Kalachakra sand mandala 240, 5.24
Kandinsky, Wassily 31, 134, 200; Concerning the Spiritual in Art; Improvisation No. 30 487–8, 15.49; Panel for Edward R. Campbell 200, 3.43
kanna huts, India 389, 13.4
Kapoor, Anish: Cloud Gates 127, 2.94
Karnes, Karen: stoneware pots 354, 11.5
Katsura Palace, Kyoto, Japan: garden 97, 2.49
Katz-Freiman, Tami 50–4
Kaufmann House ('Fallingwater'), Bear Run, Pennsylvania (Wright) 203–4, 409, 3.46
Kells, Book of 452, 15.17

Kelly, Ellsworth: Apples 67-9, 2.14; Spectrum II 148, 2.122 Kelmscott Press 281, 7.14 Kent, England: Bluewater Shopping Complex (Kuhne) 411–12, **13.40** keystones 400 Khmer empire 390, 13.5 Kiefer, Anselm: Athanor 103, 503, 2.55 Killed by the Army (Webb) 289, 8.11 Kim, Soo-ja: *Deductive Object* 44–5, **1.39** kimonos 372–3, 385, **11.27** kinetic sculpture 161-2, 495, 2.137, 2.138 Kinoshita, Susumu: A Man Staring 16, 1.5, 1.6 Kirishima Concert Hall, Kagoshima, Japan (Maki) 395, 13.11 Klee, Paul: Twittering Machine 41-4, 1.37 Klimt, Gustav: Adele Bloch-Bauer I 510, 15.73 Knees (Weston) 294, 8.16 Knight Rise (Turrell) 133, 2.101 Knowlton, Kenneth 315; (with Harmon) Computerized Nude 315, 9.2 Kollwitz, Käthe: Self-portrait with a Pencil 210-11, 4.6 Kosuth, Joseph: *Zeno at the Edge of the Known World* 497, **15.59** Kotlean robe (Samuel) 374, **12.1** Kouros statues 444, **15.11** Krause, Dorothy Simpson: *Independence Day* 299, 8,21 Krishna (Hindu miniature) 83–4, 2.35 Kubota, Itchiku: kimonos 372–3, 11.27 Kuhne, Eric: Bluewater Shopping Complex, Kent 411-12, 13.40 Kukailimoku (Hawaiian feather god) 115, **2.76** Kuna people: *Angel de la Guarda* 137, **2.109** Kurokawa, Kisho: Nakagin Capsule Building, Tokyo 409, 13.37 Kurosawa, Akira: Rashomon 303, 8.27 Kyoto: Daisen-in garden 422, 14.11; Katsura Palace garden 97, 2.49; Ryoanji temple garden 198, 3.42; *zashiki* 416, 14.4

La Farge, John 365 Lachaise, Gaston: Standing Woman 120, 2.84 Lady of Fashion, A (Voisard) 380-2, 12.7 Lalique, René 365; glass vase 365, 11.19 lamassu 443, 15.7 Lambert, Ron: Sublimate (Cloud Cover) 162-3, 2.139 Lamentation, The (Giotto) 453, 15.20 laminates 334 landscape design 74 see also gardens landscape painting: Chinese 109–10, 217, 2.68, 4.14; Japanese 249, 6.1; Romantic 475 landscape photography 289–90 Landscape with Rainbow (Rubens) 17–18, 1.8 Lange, Dorothea: Migrant Mother 288-9, 490, Laocoön (Hagesandrus et al.) 189, 3.29 Lao-tzu: *Tao te Ching* 217 Lascaux, France: cave paintings 438, **15.3** laser art 495 Last Judgment, The (Blake) 170-1, 184, 3.1 Last Judgment, The (Michelangelo) 31, 233, 1.23, 5.16 Last Supper, The (Leonardo) 191, 232, 458, 3.31, 3.32 Last Supper, The (Tintoretto) 467–8, 15.31 Last Supper (Ugolino) 181, 191, 228, 3.14, 5.12 Law, David: (with L. and M. Vignelli) stoneware dinner set 377, 12.3

131-2, 2.98 Leda and the Swan (Tintoretto) 178-9, 186, 234, 467-8, 3.12, 3.13 Lee, Ming Wei 498 Leonard, Zoë: Strange Fruit (for David) 348, 10.21 Leonardo da Vinci 128, 224, 456, 458; The Adoration of the Magi 234, 5.18; The Last Supper 191, 232, 458, 3.31, 3.32; Mona Lisa 128, 233, 464, 2.95, 15.30; The Virgin and Child with St. Anne and St. John the Baptist 213, 4.8; The Virgin of the Rocks 213, 458,

Lawrence, Jacob: Hiroshima Series # 7: Boy with

Le Corbusier (Charles-Édouard Jeanneret) 406;

Notre-Dame-du-Haut, Ronchamp, France

Leucantha (Grausman) 77, 2.25

Kite 86, 92, 2.39

Levha (Efendi) 59, 182, 2.2 Levine, Marilyn: Two-toned Golf Bag 119, 2.81 Levitan, Isaac: Above Eternal Peace 137, 2.110 Lewis, Lucy 11.3; water jar 25–6, 89, 1.17 LeWitt, Sol: Wall Drawing # 1131, 'Whirls and Twirls' 183, 3.16 *Li Bo* (Liang Kai) 193, **3.34** Li Cheng (attrib.): Buddhist Temple in the Hills after Rain 109–10, 2.68 Liang Kai: The Poet Li Bo 193, 3.34 Liberian gown 89, 2.41 Liberskind, Daniel: Victoria and Albert Museum extension (design) 409–10, 505, 13.39; World Trade Center (design) 33, 1.25 Lichtenstein, Roy 494; Mural with Blue Brushstroke 494, 15.56 Life's Embrace (Sunday) 295-6, 8.17 light wells 194 light/lighting 122-7; artificial 125-7; as a medium 97, 131-3; reflected 127-31; and sculpture 124; and value 119-20 Lightning Spirit, The (attrib. Nangulay) 97-8, 2.50 Lily-White with Black (O'Keeffe) 22, 1.14 limestone 337 Lin, Maya: Vietnam Veterans' Memorial 35-7, Lindquist, Mark: Toutes Uncommon Bowl 364, 11.16 line engravings 103, 258-62, 2.57, 6.15, 6.17 linear perspective 100–3, 188, 455 line(s) 59–65; contour 67–9, 77; decorative 67; descriptive 67–9; contour 6/–9, //; decorative 67; descriptive 67–9; expressive qualities 70; eyelevel 103; implied 65–7 linocuts 255, 256–7, 6.10, 6.12 lithography 264–5, 6.27; color 266–7, 6.28, 6.29; offset 265–6 Littleton, Harvey 364, 365; glass vase 364, 11.17 Lobster Trap and Fish Tail (Calder) 161, 2.137 local color 141 logic 455-8 logos 26, 194; Hartford Whalers (P. Good) 194, **3.36**; T Love New York' (Glaser) 273, 7.2; IBM (Rand) 273, 7.1; Special Olympics (P. Good) 274, 7.4; XIX Olympiad (Wyman) 174, 3.7 London: British Museum Reading Room 414, 14.2; Crystal Palace (Paxton) 103, 405, 2.57; St. Paul's Cathedral (Wren) 472, 15.35; Victoria and Albert Museum extension (Libeskind) 409-10, 505, 13.39 Looking out to Sea: A Whale Aground (Turner) 237, 5.21 looting of art treasures 440 Lorenzetti, Ambrogio: Allegory of Peace 225-7, 5.7, 5.8 lost-wax casting: bronze 340-2, 10.14; glass 365 Louis XIV, of France 472 Louis XV, of France 472 low relief 73 Lucie-Smith, Edward 501–3 Lunar Moth and Morning Glory (J. Good) 318, 9.7 Luther, Martin 468 Lytle, Richard: Norfolk 211, 4.7; Spring Thaw on Goose Pond 237, 5.20 Machine Tractor Driver and Collective Farm Girl (Mukhina) 34–5, **1.27** Machu Picchu, Peru 386, 13.1 McBride Charles Ryan: Narveno Court,

Hawthorn, Melbourne 409, 13.38 McNutt, David: 'Master Harold' ... and the Boys 98, 2.51 Madonna (Byzantine icon) 448, 15.15 Madonna Enthroned with Angels and Prophets (Cimabue) 110, 2.69, 5.13 Magic Flute, The (F. Ballard) 429, 14.20 Mahabalipuram, India: rock-cut temples 398, 13.14 Maids of Honor, The (Velázquez) 470-2, 15.33 Maison Pique Assiette, Chartres 512, 15.75 Maki, Fumihiko: Kirishima Concert Hall 395, 13.11 Making the Calendar (Gorky) 89, 2.40 malleability (of metals) 358 Malyavin, Philipp: The Whirlwind 152, 2.126 Man Staring, A (Kinoshita) 16, 1.5, 1.6 mandalas, sand 240, 5.24 Mandelbrot, Benoit 316

Mandingo, Liberia: gown 89, 2.41 Mona Lisa (Leonardo) 128, 233, 464, 2.95, Natale (Greg) Interior Design: Gonano Manet, Edouard: Le Déjeuner sur l'herbe 479, 15.30 apartment 414-16, 14.3 15.40 Nataraja 40-1, 1.35 Monden Kogyoku 369; Flower of a Wave 369, Native American art/crafts 26, 73, 89, 142, 353, 369, 374, **2.20**, **11.2**, **11.3** manière noire 265 11.22 Mondrian, Piet 59, 488; Composition in Blue, Yellow, and White 21, 488, 1.13; Flowering Mannerism 179, 467-8 mantle (Hamilton) 50-4, 500, 1.47 Naturalism 479 Apple Tree 21, 1.12; Fox-Trot A 66–7, 488, 2.12; The Gray Tree 18, 1.11; Tree II 18, 1.10

Monet, Claude 48, 221, 244; Rouen Cathedral 479, 15.41; Stacks of Wheat (End of Summer) 141, 2.115; Water Lilies 221, 5.1 manuscripts, illuminated 448–52, 15.17 nautilus shells 196, 3.39 Manzano Trono (Hubatsek) 361, 11.14 Navajo 1978 (Em) 323, 9.11 Maori art 280-1, 480 Navajo sand paintings 240 naves 403, 13.22 Mapplethorpe, Robert 30 maps 435, 450, 466, 469, 477, 502 maquettes 331, 10.2 Marabar (E. Zimmerman) 74–6, 2.23 Nazis: confiscation of artworks 31; Riefenstahl monochromatic color combinations 150 films 308, 8.34 Monogram (Rauschenberg) 248, 5.32 negative space 60 marble 335, 337 monotype prints 251, 6.4 Neoclassicism 473 Marinot, Maurice 364; flask 77, 2.26 Mont Sainte-Victoire seen from Les Lauves Neoexpressionism 503 Marquesan art 480 (Cézanne) 48, 1.44 Nervi, Pierre Luigi: aircraft hangars 409, 13.33 Marriage of Giovanni Arnolfini ..., The (van Eyck) montage 302 Neumann, Balthasar: Vierzehnheiligen church, Monte Migiana Still-Life (Bailey) 500, 15.63 454, 456, 15.23 nr. Staffelstein, Germany 472, 15.36 Martin, Agnes 495; Untitled X 495, 15.57 Monterrey, Mexico: Museo de Arte New Orleans: Piazza d'Italia (C. Moore and W. Martin, Bill: Abalone Shells 242, 500, 5.25 Contemporaneo 508, 15.69 Hersey) 125-7, 2.93 Martinez, Maria 11.2 Montreal: German Pavilion (Otto) 409, 13.36 New Realism 500 Martyred Flowers (Bittleman) 69, 216, **2.16** masks, African 426; Balega 178, **3.10**; Batelela Monument to Balzac (Rodin) 166, 2.142 New York: Altar for Peace (Nakashima), Monument to the Third International (Tatlin) Cathedral of St. John the Divine 362, 11.15; 113-14, 2.73; Benin 336, 10.7 322 - 3chapel from church of Notre Dame du Bourg mass 69 Moon House post (Tlingit) 73, 2.20 191, 3.33; Greenacre Park (Sasaki) 421, 14.9; 'Master Harold' ... and the Boys (McNutt) 98, 2.51 Matisse, Henri 142–5, 485–7; The Red Studio 142, Moonrise, Mamaroneck, New York (Steichen) 288, 'I Love New York' logo (Glaser) 273, 7.2; Museum of Jewish Heritage: Garden of Stones 485, 2.117; The Snail 85, 86, 89, 186, 2.38; Moore, Charles W. (with William Hersey) (Goldsworthy) 169, 2.145; Rose Center for Earth and Space (Polshek) 416, 14.5 Woman with the Hat 485, 15.46; Young Piazza d'Italia, New Orleans 125-7, 2.93 Woman, Goldfish, and Checkered Cloth 262, Moore, Henry 80; maquettes 331, 10.2; Reclining New Yorker (magazine) 277-8, 7.11 Figure 113, 2.72; Sheep Piece 80, 2.31 Newman, Barnett 491; Broken Obelisk 60, 2.5, 6.18 Matrix trilogy (A. and L. Wachowski) 304-5, Moorish architecture 246, 404, 13.26 2.6; Vir Heroicus Sublimis 493, 15.54; Voice of Mori, Mariko: Pratibimba I 505, 15.66 Fire 29-33, 48, 198, 1.24 Newton, Sir Isaac 472; color wheel 134, 2.103 Matt, Tom 214-15; Cityscapes of New York 215, Morishima, Hiroshi: table lamp 378, 12.6 Nguyen, Cuc: 'Buddha' calligraphy 70, **2.18** Nicholson, William *see* Beggarstaff Brothers 4.11 Morisot, Berthe: View of Paris from the Trocadéro Matthew's Lily (Raffael) 253, 6.8 103-4, 2.60 Mauve District (Frankenthaler) 89-92, 2.42 Morris, Jane: portraits by Rossetti 286, 8.6, 8.7 niello work 360 Mazzocca, Gus: Haitian Dance Fantasy 'Petwo' Morris, William: (with Edward Burne-Jones): Niépce, Joseph-Nicéphore 285 Nigerian traditional dress 382, 12.9 Nîmes, France: Pont du Gard 400, 13.20 270, 6.32 Works of Geoffrey Chaucer 281, 7.14 mosaics 246, 446, 448, 5.30, 5.31, 15.16 Medallion (Pettway) 372, 11.26 media 206; dry 209-16; liquid 216-19, 221; Moscow: St. Basil's Cathedral (Barma and *Nio* (Unkei) 334, **10.5** Nishat Bagh, India (Asaf Khan) 417–18, **14.**7 Noelker, Frank 297–8; Untitled Iris print 297, mixed 248; printmaking 270-1; paint Posnik) 392, 13.7 224-44; synthetic 242-4 mosques 404 medieval art 448-54 Mouhot, Henri 390 8.19 Melnick, Rick 327 Meninas, Las (Velàzquez) 470-2, **15.33** Mountain Village in a Mist (Yu-Jian) 217, 4.14 Noguchi, Isamu 194; *Red Cube* 38, 494, **1.31**; *Small Torso* 139, **2.112** movement (in artworks): actual 161-3; illusory Mertes, Lorie 50 Merz 19 (Schwitters) 245–6, **5.29** 164 - 8'noise,' digital 297 movies see film(s) nonobjective/nonrepresentational art 21-4, 48, Mesopotamian civilizations 439-43; ziggurats Mr. and Mrs. Andrews (Gainsborough) 185, 3.21 488 398-9, 13.15 Mughal period: gardens 417-18, 14.7; turban Norfolk (Lytle) 211, 4.7 metalwork 358–61 see also bronzes Meta-Matic No. 9 (Tinguely) 162, 2.138 mezzotints 263–4, 6.25 jewel 358, 11.9 see also Taj Mahal North Beach Rocks (Barnes) 370, 11.24 Muhammad, Prophet 62 Nostalgia (Tarkovsky) 306, 8.33 Muirhead, Deborah 506; Water World Voices from Nude Descending a Staircase # 2 (Duchamp) 164-8, 487, 2.141 the Deep 506, **15.68** Mukhina, Vera: Machine Tractor Driver and Michelangelo Buonarroti 335; 'Atlas' Slave 333, 10.4; David 335, 337, 464, 10.6; The Last Judgment 31, 233, 1.23, 5.16; Pietà 335, Nude in a Bathtub (Bonnard) 223, 5.4 Collective Farm Girl 34-5, 1.27 Number 1, 1948 (Pollock) 48, 1.43 458-62, 15.27; Sistine Chapel ceiling multimedia installations 312, 495, 8.39 No. 2 Sea Form Series (Chihuly) 365, 11.18 frescoes 40, 54-6, 57, 207, 208, 232, 462, Munch, Edvard: The Scream 485, 15.45 Nymphs and Satyr (Bouguereau) 48, 67, 1.45 524-30, 1.48, 4.2, 16.13-16.19; Creation of Munsell, Albert: color tree 138, 2.107 Adam 12, 526, 1.1, 16.15 muqarnas 404 Oath of the Horatii, The (J.-L. David) 473, 15.37 Middleton, Wisconsin: 'Solar Hemicycle' house Muqi: Six Persimmons 98-100, 2.52 offset lithography 265-6 (Wright) 416-17, 14.6 Mural with Blue Brushstroke (study) Ofili, Chris: The Holy Virgin Mary 30, 1.22 oil paint/painting 223, 231–7, 5.15, 5.17, 5.19 O'Keeffe, Georgia 22; *Abstraction Blue* 137, 2.108; Mies van der Rohe, Ludwig: 'MR' armchair 375, (Lichtenstein) 494, 15.56 12.2 murals 224-5, 227-8, 5.9 see also frescoes; wall-Migrant Mother (Lange) 288-9, 490, 8.10 Lily-White with Black 22, 1.14 painting Milwaukee Art Museum, Quadracci Pavilion 95, Museo de Arte Contemporaneo de Monterrey, Old Guitarist, The (Picasso) 142, 487, 2.116 Oldenburg, Claes 108; Soft Saxophone: Scale B 15, 2.48 Mexico 508, 15.69 Ming porcelain flask 355, 11.6 Museum Guard (Hanson) 15, 1.4 1.4; Stake Hitch 108, 494, 2.66 miniature paintings: Hindu 83–4, 2.35; Holbein 108–9, 2.67; Persian 122, 2.89 Museum of Jewish Heritage, New York: Garden Olympia (Riefenstahl) 308 of Stones (Goldsworthy) 169, 2.145 Olympic Games: logos: P. Good 274, 7.4; Minimalism 494-5 Muybridge, Eadweard 300-1; Headspring, a Wyman 174, 3.7 one-point perspective 101–2, **2.56** Op Art 152–4, 493 Minkowitz, Norma 369-70, 501; Collected Flying Pigeon Interfering 300-1, 8.23 369-70, **11.23** Misty Bamboo on a Distant Mountain (Zheng Xie) 'Nabis' artists 5.4 open forms 79 119, 2.82 naive art 44 'open-source' artworks 328 mixed media 248; printmaking 270–1 Miyake, Issey 383–5; *Body Sculpture in Rattan* Nakagin Capsule Building, Tokyo (Kurokawa) Orbello, Italy: aircraft hangars (Nervi) 409, 409, 13.37 13.33 383, 12.11 Nakashima, George 362; Altar for Peace 362, orders, Greek 399-400, 13.18 mobiles 138, 161–2, **2.111**, **2.137** *Mod Lang* (J. Blake) 313–14, **9.1** 11.15 Orozco, José Clemente: Zapatistas 172, 3.4, 3.5 Namuth, Hans: Jackson Pollock 15.53 Orpheus (Redon) 92, 152, 2.43 modeling: clay 338; of contours 85; sculpture Nangulay, Dick (attrib.): The Lightning Spirit Otto, Frei: German Pavilion, Montreal 409, 337-40; wax 338-40 97-8, 2.50 13.36 'modern' age 483-5 Nanook of the North (Flaherty) 305, 8.30 Ottoman embroidered envelope 152, 2.128 Modigliani, Amedeo: Head of a Woman 334, Napier, Mark: Shredder 328; The Waiting Room 328, 9.16 outsider art 49, 512 10.8 overlapping 83, 100 modular construction (architecture) 409 Narveno Court, Hawthorn, Melbourne (McBride Charles Ryan) 409, 13.38 Modulation in Sync, 2000 (Paik et al.) 311-12, Pacific (Takaezu) 354-8, 11.8

Nasca hummingbird 346–50, 10.22

Padua, Italy: Arena Chapel frescoes 453, 15.20

8.38

quilting 52, 512; art quilts 501; Pettway 171-2, Paik, Nam June et al.: Modulation in Sync, 2000 pilgrimage churches 452, 472, 15.36 pinching (clay) 353, **11.2** *Pine Trees* (Tohaku) 106–8, **2.65** 311-12, 8.38 175, 3.2 Paikea (Kahukiwa) 280-1, 7.13 Quinlan, Caroline 312 painting 221–5; Aboriginal bark paintings 97–8, 2.50; cave paintings 434–9, **15**.3; computers and 315–19; direct (*alla prima*) 223; indirect 221–3; media 224–44; sand 240, **5**.24; silk Pittsfield, Mass.: Shaker barns 387, 13.2, 13.3 pixels 296, 314 placement 98–100 planishing 358 planographic processes 264–7 plaster, modeling 337–8 2.68 see also acrylics; encaustic; frescoes; gouache; miniature; murals; oil; tempera; plate glass 394 Plato 462 wall painting; watercolor Palau de la Música Catalana, Barcelona (Domènech i Montaner) 246, 5.31 Pliny 224 palettes: limited 158–9; open 158–9 Palladio, Andrea, and Vincenzo Scamozzi: Teatro Olimpico, Vicenza 425, 14.15, 14.16 Poe, Edgar Allen: daguerreotype portrait 285, rangoli 240 8.4 Poet Li Bo, The (Liang Kai) 193, 3.34 Palma (Butterfield) 344-5, 10.18 point of view 104 Pointillism 158, 482 Palos Verdes, California: Wayfarer's Chapel (Wright, Jr.) 394, 13.9 politics, art and 308 Panel for Edward R. Campbell (Kandinsky) 200, Pollaiuolo, Antonio del: Battle of the Ten Nude Men 6.2, 6.3 Pannini, Giovanni: Interior of the Pantheon 93-5, Pollock, Jackson 174, 490-1, 15.53; Number 1, 1948 48, 1.43 2.46 Pantheon, Rome 93-5, 392, 403, 2.46, 13.6, Polshek, James Stewart: Rose Center for Earth and Space, New York 416, 14.5 paper 208-9 Polyclitus (after): Spear Bearer 17, 78-9, 2.28 Papua New Guinea: kaivakuku costume 426, Polydorus see Hagesandrus Pompeii 473 Parisian Boulevard, A (Daguerre) 285, 8.3 Parker, Olivia 283, 290–2; Four Pears 283–4, 8.1 Pont du Gard, Nîmes, France 400, 13.20 Pop Art 268, 494, 6.28 Parthenon, Athens (Ictinus and Callicrates) 196, porcelain 353; Chinese 26-7, 194, 355, 1.19, 445, 3.40, 15.12 3.35, 11.6 pastel drawings 208, 214-15, 4.4, 4.10, 4.11 Porta, Giovanni Battista della 456 Patel, Pierre: Sight of the Castle and Gardens of Versailles ... 37, 1.30 patronage 27, 38, 55 pattern 174, 191–2 porticos 392 Portrait of a Landowner (anon. photograph) 286, Portrait of a Woman (Cranach the Younger) 257, Paxton, Joseph: Crystal Palace 103, 405, **2.57** pediments 400 Portrait of a Young Man (Bronzino) 221, 5.3 pen and ink drawings 207, 216, 4.1, 4.3, 4.16 Pen Argyl Myth, The (Stuart) 116, 2.77 pencil (graphite) drawings 209–10, 4.5 Pendour (Hepworth) 79, 2.30 Penseur, Le (Rodin) 121, 2.86 performance art 429–30, 498 rest Portrait of the Princesse de Broglie (Ingres) 116–18, Portrait of Woody Guthrie (Frasconi) 253, 6.7 portraits 185, 192, 3.34; photographic 285–6, 8.4-8.7 see also above and self-portraits performing arts 424–30 Portuguese, The (Braque) 487, 15.47 Pericles 444, 15.12 positive space 60 post and lintel construction 399, 13.16 postage stamps 276, 7.7 Perkins, Danny: White Square 145, 2.118 Perseus with the Head of Medusa (Cellini) 341, poster art 276; Beggarstaff Brothers 65-6, **2.11**; Cassandre 70-3, **2.19**; Glaser 121-2, **2.87**; Good (P.) 274, **7.4**; Grear 122, **2.88**; 10.13 Persia: carpets 371, 11.25; miniatures 122, 2.89 Persistence of Memory, The (Dali) 490, 15.51 resists 262 Hohlwein 39, 1.33; McNutt 98, 2.51; Rand 273, 7.1; Tomaszewski 93, 2.44; Toulousepersistence of vision 301 perspective: atmospheric 103-4; forced 425; linear 100–3, 188, 455; one-point 101–2, **2.56**; three-point 103, **2.59**; two-point 103, Lautrec 276, 7.6 Post-Impressionism 48, 479-82 Post-modernism 409, 485, 505 Perugino (Pietro Vanucci): The Crucifixion with Post-Painterly Abstraction 491-3 Saints 186, 3.24-3.26 pottery and ceramics 353-8; Acoma ware 25-6, Peterson, Susan 10.11 89, 1.17; ceramic arch (A. Zimmerman) 338 10.11; Greek amphorae 352, 444, 11.1, 15.10; trompe l'oeil 119, 2.81 see also clay; Petipa, Marius: La Bayadère 426, 14.18 Pettway, Loretta: Medallion 372, 11.26 Pettway, Lucy T.: Birds in the Air 171-2, 175, 3.2 porcelain Pfaff, Judy 345-6; 3D 345, 505, 10.20 power, art and 37-9 photocopying/xerox art 168, 268-9, 495, 6.31 Pratibimba I (Mori) 505, 15.66 photograms/photogenic drawings 284, **8.2** photography 283–300; artists and 168, 286–8; prehistoric art 13, 433-9, 1.2, 15.2, 15.3 primary hues 134–5, 2.104–2.106 prints and printmaking 249–52; intaglio 258–64, 6.14; mixed media 270–1; bitmap scanning 315, 9.3; close range 292; daguerreotypes 285; digital 296–7; digital imaging 297–300; documentary 288–9; monotypes 251; photocopy and fax art 268–9; planographic 264–7; relief 252–7, **6.5**; stenciling 267–8 *see also* engravings; high-speed 293-5; landscapes 289-90; 'Pictorialist' movement 286-8; portraits 285–6; and realism 490; and values 120–1; Weston on 294 lithography; woodcuts/woodblock prints propaganda, art and 37–9 proportion 195–8 proscenium 424 photorealism 500 photorealism 500
Picasso, Pablo 244, 433, 480, 487; Bust of a
Woman after Cranach the Younger 256–7, 6.12;
Guernica 56–7, 86, 174, 464, 515–20, 1.50,
3.6, 16.1–16.7; Les Demoiselles d'Avignon
432–3, 487, 15.1; The Old Guitarist 142, 487,
2.116; Three Female Nudes Dancing 206, 216,
4.1; A Woman in White 158–9, 2.136
(Pictorialist' movement 286–8 proscenium arches 426 protection of artworks 464 Protestantism 468, 472 Prueitt, Melvin L 321 Pryde, James *see* Beggarstaff Brothers public art 27–31 pueblo ware *see* Acoma ware puppetry 429, **14.20** 'Pictorialist' movement 286-8 picture planes 101 Piero della Francesca 188; Flagellation of Christ pyramids, Egyptian 443, 15.8 188, 3.27 Pietà (Michelangelo) 335, 458-62, 15.27 Qin Shihuang, terra cotta army 338, 10.10

Qing-de-zhen ware vase 194, 3.35

Queen Charlotte Island: Haida chest 183, 3.18

pigments 135, 221

Pilchuk Glass School, nr. Seattle 11.18

Qur'an 48, 62, 2.8 race, art criticism and 52-3 Radha and Kirshna (miniature) 83–4, 2.35 radial balance 185 Raffael, Joseph: *Matthew's Lily* 253, **6.8** *Raft of the Medusa, The* (Géricault) 475, **15.38**Rand, Paul 273–5; IBM logo/poster 273, 7.1; Picasso show catalog cover 275, 7.5 Raphael 462; The School of Athens 462, 15.28 Rashomon (Kurosawa) 303, 8.27 Ratcliffe, Bill 6.29 Rauschenberg, Robert: 248; *Monogram* 248, 5.32 Ray, Satyajit 305–6; *Apu Trilogy* 306, **8.31** realism 17; and photography 490; 19th century 467-9; 20th century 490, 500 Reality Models—Re/Cycle (Don't Hold Your Breath) (Spitzer) 498–500, **15.62** receding colors 148 Reclining Figure (H. Moore) 113, 2.72 'Reconstruction' (Chiang et al) 312, 8.39 Red Cube (Noguchi) 38, 494, 1.31 Red Studio, The (Matisse) 142, 485, 2.117 Redon, Odilon: Orpheus 92, 152, 2.43 reduction print method 257 reflected color 135, 2.106 reflections 127-31 Reformation, Protestant 468 refracted colors 134-5, 2.104 Reinhardt, Ad 494-5 Relativity (Escher) 112, 2.71 Relativity (ESCNET) 112, 2.71
relief printmaking processes 252-7, 6.5
relief sculpture 73-4, 2.21
Rembrandt van Rijn 13, 433, 472, 511; Danaë
464; Self-Portrait 13, 34, 121, 125, 1.3; Sleeping
Girl 216-19, 4.17; The Three Crosses 262-3, 472, 6.19-6.23 Renaissance art 124–5, 196, 213, 216, 225, 454–5; Italy 455–8; Northern 462–7; theater 425 see also High Renaissance; Michelangelo Renoir, Pierre-Auguste 13, 48, 479; *The Boating Party* 188–9, **3.28** repetition 171-4 repoussé technique 358-61 representational art 17 reproductions of artworks 16 resolution (digital photography) 297 restoration of artworks 228, 232-3, 527-8, 5.10; ephemeral materials 348; Sistine Chapel ceiling frescoes 54-6, 57 Resurrection, The (G. David) 141, 2.114 Resurrection, The (Grünewald) 462-7, 15.29 Rêverie (Rossetti) 286, 8.7 rhythm 181-3 ribbed vaulting 400-3, 452 Riefenstahl, Leni 308; Olympia 308; Triumph of the Will 308, 8.34 Riley, Bridget: Crest 493, 15.55 Rivera, Diego 224–5; *The Agitator* 227–8, **5.9**; *Creation* 225, **5.6**; *Flower Day* 18, **1.9** rocking chair (Thonet) 70, 181, 2.17 Rococo art and architecture 213, 472 Roden Crater project (Turrell) 497, 15.60 Rodin, Auguste 166; The Gates of Hell 24, 56, 74, 184, 520-4, 1.49, 2.22, 16.8-16.12; Monument to Balzac 166, 2.142 Rodin: The Thinker (Steichen) 121, 2.86 Roman Empire 444, 446, 448; aqueducts 400, 13.20; architecture 446 (see also Rome); concrete 403; encaustic painting 224, 5.5; mosaic 246, 5.30; sarcophagus 73, 446, 2.21; sculpture 78–9, 139, 338–40, 446, 2.28, 15.14 Romanesque architecture 400, 452, 15.18 Romantic movement/Romanticism 473, 475 Rome: Arch of Constantine 27, 446, 1.21; Basilica of Maximus (reconst.) 400, 13.21; Colosseum 57; Pantheon 93-5, 392, 403, 2.46, 13.6, 13.24; St. Peter's piazza (Bernini) 420, 14.8 Ronchamp, France: Notre-Dame-du-Haut (Le Corbusier) 131-2, 2.98 Rose Center for Earth and Space (Polshek) 416, 14.5

Rosenberg, Pierre 233 Self-Portrait (Rembrandt) 13, 34, 121, 125, 1.3 Stake Hitch (Oldenburg) 108, 494, 2.66 Rosenquist, James: Iris Lake 266, 6.28 Self-portrait with a Pencil (Kollwitz) 210-11, 4.6 Standard Bearer, The (Prince Rupert) 264, 6.25 Rossetti, Dante Gabriel: Jane Morris 286, 8.6; Senmut with Princess Nefrua 78, 2.27 Standing Woman (Lachaise) 120, 2.84 Rêverie 286, 8.7 'Sensation' exhibition 30 Stapati, Ganapathi 40-1 Rothko, Mark 124, 491; Green on Blue 45, 1.40 serif typefaces 276 Starry Night, The (van Gogh) 45, 223, 1.41 Rouen Cathedral (Monet) 479, 15.41 serigraphs 267-8 Staten Island Institute for Arts and Sciences Rousseau, Henri: The Dream 44, 1.38 serpentinata 179 (Eisenman) 320, 9.8 Royal Ballet Company, London: La Bayadère Serra, Richard: Torqued Ellipses 331-2, 10.3 states (etchings) 262-3, 6.19-6.23 426, 14.18 Set of Six Self-portraits, A (Warhol) 268, 6.30 static forms 79-82 Rubens, Peter Paul 511; The Assumption of the Seurat, Georges-Pierre 48, 158, 479, 482; L'Echo Steakley, Douglas: raised vessels 361, 11.13 Virgin 472, 15.34; Landscape with Rainbow 215, 4.12; Seated Model 158, 2.134; A Sunday steel 358, 11.10 Afternoon on the Island of La Grande Jatte 482, steel engravings 258-62, 6.15, 6.17 steel-frame skyscrapers 405, **13.29** Rune Stone, Jelling, Denmark 114-15, 2.74 15.44 Running Fence (Christo and Jeanne-Claude) 65, Steichen, Edward 288; Moonrise, Mamaroneck, Seventh Seal, The (Bergman) 306, 8.32 208, 2.10 sfumato 213, 233, 458 New York 288, 8.8; Rodin: The Thinker 121, Rupert, Prince: The Standard Bearer 264, 6.25 shading 85 Russia: architecture 392, 13.7; 'Caution! Shaker stone barns 387, 13.2, 13.3 Stella, Frank: Hacilar aceramic la 158, 2.135 stemcup, Ch'ing dynasty 27, **1.19** Stieglitz, Alfred 288, 490; *The Terminal* 288, Religion' exhibition 30-1; film 306; shanshui 195 metalwork 360 shape(s) 73, 85–93; and emotions 93; geometric 89; hard-edged 92; soft-edged 92 She-Ba (Bearden) 100, **2.53** Ruysch, Rachel 17; Still Life with Fruit and a Vase 8.9 Still Life no. 24 (Wesselmann) 15, 1.4 of Flowers 17, 1.7 Still Life with Apples (Cézanne) 482, **15.43** Still Life with Fruit and a Vase of Flowers (Ruysch) Sheep Piece (H. Moore) 80, **2.31** Shen, Lien Fan 312 Ryoanji temple, Kyoto, Japan: rock garden 198, Shinto 422 stippling 206, 216 stone 386, 398; carving 333–7 Shiva as Lord of the Dance 40–1, 1.35 shopping malls 411–12, 13.40 Shredder (Napier) 328 Sabina Mitologica, La (S. Alcorn) 255, 6.10 Safdie, Moshe: Vancouver Library Square 38, 57, 76, 394, **1.32**, **2.24** Stone Breakers, The (Courbet) 476, 15.39 sidewalk drawings 213–14, **4.9**Sight of the Castle and Gardens of Versailles ... Sagrada Familia church, Barcelona (Gaudi) 175, stoneware 353, 11.5, 11.8 Stout, Renée 508; *Trinity* 508–9, **15.70** Saint Christopher (Dürer) 252, 6.6 (Patel) 37, **1.30** Strange Fruit (for David) (Leonard) 348, 10.21 St. Basil's Cathedral, Moscow 392, **13.7** St. Paul's Cathedral, London (Wren) 472, **15.35** silk: banner 152, 2.127; painting 2.68; Stuart, Michelle: The Pen Argyl Myth 116, 2.77 preparation for kimonos 372–3, **11.27** silkscreen printing 267–8, **6.30** studio glass 364-5 Saito, Ryoei 510 stylization 18 Samuel, Cheryl: Kotlean robe 374, 12.1 silverpoint drawings 210 stylobates 400 San Vitale, Ravenna: mosaic 448, 15.16 Simon, Joan 50 Sublimate (Cloud Cover) (Lambert) 162-3, 2.139 Singapore: skyline 405, 13.30 sand paintings: Navajo 240; Tibetan 240, **5.24** 'subtractive hues' 135 Sistine Chapel frescoes (Michelangelo): ceiling 'Sandal' (Muhammad ibn Mubadir Abu Bakr) sugar aquatints 264 62, 2.8 frescoes 40, 54-6, 57, 207, 208, 232, 462, Suger, Abbot 452 sandstone 337 524-30, 1.48, 4.2, 16.13-16.19; Creation of Sumerian art and architecture 439-42 sans serif typefaces 276, 278 Adam 12, 526, 1.1, 16.15; Last Judgment 31, Sun Tunnels (Holt) 124, 2.90, 2.91 Santiago de Compostela Cathedral, Spain 452, 233, 1.23, 5.16 Sunday, Elizabeth: Life's Embrace 295-6, 8.17 15.18 Six Persimmons (Muqi) 98-100, 2.52 Sunday Afternoon on the Island of La Grande Jatte, Saqqara: portrait panel 444, 15.9 sizing 235-6 A (Seurat) 482, 15.44 sarcophagus, Roman 73, 446, 2.21 skene 424 Sunday on the Banks of the Marne (Cartiersaris 384, **12.12** Bresson) 289, 8.12 skyscrapers, steel-frame 405, 13.29, 13.30 Sasaki, Hideo: Greenacre Park, New York 421, 'skyspaces' 133 Suomalainen, Timo and Tuomo: Taivallahti slab building (clay) 353 church, Helsinki 178, 3.11 saturation, color 137, 2.107, 2.109 Sleeping Girl (Rembrandt) 216-19, 4.17 super-realism 500 scale 108-10 Supperclub Roma, Rome (Concrete slip 338 Small, Jane: portrait (Holbein) 108-9, 2.67 Architectural Associates) 150, 2.124 scale change 100 Scamozzi, Vincenzo: proscenium arch 426; Teatro Olimpico, Vicenza 425, 14.15, 14.16 Small Torso (Noguchi) 139, 2.112 supports 221 Suq al-Ainau, Yemen 392–4, 398, **13.8** Smith, W. Eugene: Tomoko in a Bath 35, 1.28 Scarlet Letter, The (J. Alcorn) 59-60, 2.3 Smithson, Robert 497; Spiral Jetty 350-1, 497, Surrealism 490 Schocker, Edward 312 Suzuki, D. T. 422 10.23 School of Athens, The (Raphael) 462, **15.28** Schwartzman, Arnold 308 Snail, The (Matisse) 85, 86, 89, 186, 2.38 Swibold, Professor Richard 387 Swing, The (Fragonard) 168, **2.143** Sydney Opera House (Utzon) 409, **13.34** Symbolist painters 92 Snake (Serra) 10.3 Schwendinger, Leni: Dreaming in Color 496, Snow Storm: Steamboat off a Harbor's Mouth (Turner) 258–62; (engravings) **6.15**, **6.17**; 15.58 Schwitters, Kurt 245; *Merz* 19 245–6, **5.29** *Scream, The* (Munch) 485, **15.45** sculpture 330–1; African 342; assembled 343–6; Assyrian 443; Baroque 472; carving processes symmetrical (formal) balance 183-4, 3.17 (oil) 6.16 Sobol-Wejmen, Anne: *Boyka Fable* 264, **6.26** synthetic media 242–4 Szabó: clock 358, **11.11** sociopolitical content 34-7 *Soft Saxophone: Scale B* (Oldenburg) 15, **1.4** Soriano, Juan: *The Dove* **15.69** 333–7; casting processes 340–3; Chinese 139, 338; closed forms 78–9; and color 139; and T is for Toad (Azarian) 116, 2.78 Southerly Wind and Fine Weather (Hokusai) 249, Ta Prohm, temple of 390, 13.5 338; closed forms /8–9; and color 139; and computers 319, 331–2; Cycladic 439; earthworks 64–5, 79–82, 346–51, 350, 497; Egyptian 78, 443–4; fiber 369–70; and focal points 192; frontal works 74; full round 74; Futurist 487; glass 145, 365; Gothic 453; Greek and Hellenistic 17, 118, 139, 189, 338, 444, 446; kippic 161–2, 405; and light 6.1 Tabriz carpet 371, 11.25 space 93; and form 80; illusion of 83-5, 97-108, Tahiliani, Tarun: zardozi sari 384, 12.12 111–12; negative 60; positive 60; three-dimensional art in 93–7 Taivallahti church, Helsinki (T. and T. Suomalainen) 178, 3.11 Space and Space Forest 91A (Endo) 300, 8.22 Taj Mahal, Agra, India 34, 48, 196, 1.26 Spear Bearer (after Polyclitus) 17, 78-9, 445, 2.28 Takaezu, Toshiko 354-8; Pacific 354-8, 11.8 444, 445, 446; kinetic 161-2, 495; and light spectrum, visible 134, 2.102 Talbot, William Henry Fox 284, 285; Botanical 124; Mannerist 468; maquettes and models Spectrum II (Kelly) 148, 2.122 Specimens 284, 8.2 331-2; Minimalist 494; modeling 337-40; Spiral Jetty (Smithson) 350–1, 497, **10.23** Talman, Donna Hamil 296; Ancestor Portraits open forms 79; planning 331-2; prehistoric Spirit of the Dead Watching, The (Gauguin) 480, 296, 8.18 13, 434; protection of 464; reliefs 73-4; 15.42 Taoism 110, 217 Renaissance (see Michelangelo); Rodin on 166; Roman 78–9, 139, 338–40, 446; and spiritual content of art 40-7 tapestries 369, 11.21 Spitzer, Serge: Reality Models—Re/Cycle (Don't Tarkovsky, Andrei 306; Nostalgia 306, 8.33 scale 108; and space 95, 97; static forms Hold Your Breath) 498-500, 15.62 Tatlin, Vladimir: Monument to the Third 79-82; Sumerian 439-42; and texture 113, Splendor of Red (Anuszkiewicz) 152-4, 2.129 International 322-3 114-16; and value 120, 121; walk-through split fountain technique 268 TBWAChiatDay offices, Los Angeles (Wilkinson) Spores Falling from the Common Horsetail (Dalton) 378, 12.5 scumbling 235 technological art 495-6 Sea Ranch (sketch) (Halprin) 423, 14.12 Spring Thaw on Goose Pond (Lytle) 237, 5.20 television 307-10 tempera 228–31, **5.11–5.14** tensile strength 334, 409, **13.35** seals, Sumerian 439 squinches 404 Seated Boxer (Apollonius) 343, 10.16 Stacks of Wheat (End of Summer) (Monet) 141, Seated Model (Seurat) 158, 2.134 Terminal, The (Stieglitz) 288, 8.9

stained glass 131, 365; Chartres Cathedral

452-3, 15.19; Le Corbusier 131-2, 2.98

terra cotta army, Shaanxi province, China 338,

10.10

secondary hues 135, 2.104-2.106

Self-Portrait (Close) 155, 2.131

'terra sigillata' 352 terre verte 230 tertiary hues 135, 2.105 tesserae 246 texture 113–14; actual 114–16; simulated 116–19 thangka, Tibetan 185, **3.19** theater(s) 424-9, 4.14-4.16; kabuki 426-9, 14.19 see also puppetry Thiebaud, Wayne: Bikini 15, 34, 1.4 Thinker, The (Rodin) 121, 2.86 Thomas, Gwenn 316; AB:47/Untitled 316, 9.5 Thonet, Gebrüder: reclining rocking chair 70, 181, 2.17 Thorn Puller (Hellenistic bronze) 67, 74, 2.13 Thoughts on the Imitation of Greek Works of Art (Winckelmann) 473 Three Crosses, The (Rembrandt) 262-3, 472, 6.19-6.23 Three Female Nudes Dancing (Picasso) 206, 216, 3D (Pfaff) 345, 505, 10.20 three-dimensionality 15, 16; characteristics of 77-82; and computers 319-20, 331-2, 531; degrees of 73-4; and line 69; reliefs 73-4; in space 93–7; static forms 79 see also sculpture three-point perspective 103, 2.59 Tibetan sand paintings 240, 5.24 Tiffany, Louis Comfort 365–9; Flower-form Vase 82, 2.33; Irish Bells and Sentinels 365–9, 11.20 time 161-3; captured moments 168-9; changes in artworks 169 Tinguely, Jean 495; Meta-Matic No. 9 162, 2.138 Tintoretto, Jacopo 179; The Last Supper 467–8, 15.31; Leda and the Swan 178–9, 186, 234, 467–8, 3.12, 3.13 407-0, 3.12, 3.13
Tjupurrula, Johnny Warangkula 512
Tlingit: Moon House post 73, 2.20
Tohaku, Hasegawa: *Pine Trees* 106-8, 2.65 *tokonoma* alcoves 27, 416, 1.20
Tokyo, Japan: Nakagin Capsule Building
(Kurokawa) 409, 13.37 Tolland, Gregg 302 Tomaszewski, Henryk 274; poster 93, **2.44** Tomoko in a Bath (Smith) 35, 1.28 tonal range (digital photography) 297 Torqued Ellipses (Serra) 331–2, 10.3 Toulouse-Lautrec, Henri de 250; Aristide Bruant dans son cabaret 276, 7.6; Equestrienne (At the Circus Fernando): (crayon) 216, 4.13; (oils) 168-9, 2.144 Toutes Uncommon Bowl (Lindquist) 364, 11.16 Trace (Graves) 185-6, 3.22 Traditional Realism 490 transitions 175-8 transparencies 267 *Tree ÎI* (Mondrian) 18, **1.10** Tree of Life Fantasy (Aycock) 330, **10.1** Trent, Council of 31, 54 triad color schemes 152, 2.128 triangles, compositional 186, 462, 3.23 Tribal Spirits (Harvey) 512, 15.74 Trinity (Stout) 508–9, 15.70 Tristan and Isolde (Wagner) 311, 312, 8.36 Triumph of the Will (Riefenstahl) 308, 8.34 Trumph of the Will (Referishan) 306, 8.34 trompe l'oeil 118–19, 421, 2.81, 14.10 Tron (Disney) 320, 9.9 Trundholm, Denmark: bronze horse and sun chariot 79, 2.29 trusses 405, 13.27 trusses 405, 13.27
Turner, Joseph Mallord William 475; Looking out to Sea: A Whale Aground 237, 5.21; Snow Storm: Steamboat off a Harbor's Mouth 258–62; (engraving) 6.16, 6.17; (oil) 6.16
Turrell, James 132–3, 497; Knight Rise 133, 2.101; Roden Crater project 497, 15.60
Twittering Machine (Klee) 41–4, 1.37
Two Nudes (Ingres) 85. 2.36 Two Nudes (Ingres) 85, 2.36
Two River Stones Worked around with Curved Sticks (Goldsworthy) 114, 2.75 two-dimensionality 15–16; and illusion of form 83–5; and illusion of space 97–108, 111–12 two-point perspective 103, 2.58 Two-toned Golf Bag (Levine) 119, 2.81 Tycho advertisement (Hill, Holliday, Connors, Cosmopulos) 277-8, 7.11 typefaces 273, 276-8, 281

Ugolino di Nerio: Last Supper 181, 191, 228, 3.14, 5.12 ukiyo-e prints 250, 253-4 ultramarine 234 underpainting 223, 230, 5.18 Underweisung der Messung (Dürer) 277, 7.9 Unicorn in Captivity (Unicorn Tapestries) 369, Unique Forms of Continuity in Space (Boccioni) 487, **15.48** unity, compositional 171, 186–9 Unkei: *Nio* 334, **10.5** unsized canvases 223 Untitled (Frank) 251, 6.4 Untitled (Gupta) 505, 15.67 Untitled Iris print (Noelker) 297, 8.19 Untitled (Revenge) (Gonzalez-Torres) 348 Untitled X (A. Martin) 495, 15.57 Ur, Iraq: harp soundbox (from tomb of Queen Puabi) 440, 15.5 urban planning 420-3 Urnes, Norway: church door panels 60, 2.4 Utzon, Jorn: Sydney Opera House 409, 13.34 value(s): and color 137, 2.107; and contrast 154–5, **2.130**; interpretive 121–2; and light 119–20; local 120; value scale 119, **2.83** van Eyck *see* Eyck, Jan van van Gogh, Vincent *see* Gogh, Vincent van Vancouver Library Square (Safdie) 38, 57, 76, 394, 1.32, 2.24 vanishing points 100–1 Variable Media Initiative 348 variety 175–9 varnish 232–3 Vastushastra (laws of architecture) 395-7, vault construction 400-3, 13.19 Velázquez, Diego 456; Las Meninas (The Maids of Honor) 470-2, **15.33** vellum 263 veneers 364 Venice Biennale 500, 15.59 Venom Dub Rigonda (Wilkes) 132, 2.99 Venus de Milo 118, 2.80 verdigris 237 Vermeer, Jan: The Art of Painting 83, 456, 2.34; Girl with a Pearl Earring 231-4, 5.15 Versailles, Palace of 37, 1.30 Vicenza, Italy: Teatro Olimpico (Palladio and Scamozzi) 425, 14.15, 14.16 Victoria and Albert Museum extension, London (Libeskind) 409-10, 13.39 Victory of Samothrace 446, 15.13 video art 310-12 video games 322 video graphics 320-1, 9.9 video signals 307 Vierzehnheiligen church, nr. Staffelstein (Neumann) 472, 15.36 Vietnam Veterans' Memorial, Washington DC (Lin) 35-7, 1.29 View of Paris from the Trocadéro (Morisot) 103-4, 2.60 View of Toledo (El Greco) 150, 2.125 Vignelli, Lella and Massimo 377; (with David Law) stoneware dinner set 377, 12.3 Villa d'Este, Tivoli: Water Organ 163, 2.140 Vinci, Leonardo da see Leonardo da Vinci Viola, Bill 310–11; video for *Tristan and Isolde* 311, 312, 8.36 Vir Heroicus Sublimis (Newman) 493, 15.54 Virgin, The (Wyeth) 231, 5.14 Virgin and Child with St. Anne and St. John the Baptist , The (Leonardo) 213, 4.8 Virgin of the Rocks, The (Leonardo) 213, 458, 15.26 virtual reality 322-3, 325, 495-6 Vishkarma 395 visible spectrum 134, 2.102 visual weight 69, 183 Vitiello, Stephen 8.38 vodun culture 508 Voice of Fire (Newman) 29-33, 48, 198, 1.24 Voisard: A Lady of Fashion 380-2, 12.7

von Rydingsvard, Ursula 345; Bowl with Folds

345, 10.19

voussoirs 400 Wachowski, Larry and Andy: Matrix trilogy 304-5, 8.29 Waiting Room, The (Napier) 328, 9.16 Walking Man (Giacometti) 64, 2.9 walk-through works 74-6 Wall Drawing # 1131, 'Whirls and Twirls' (LeWitt) 183, 3.16 wall-painting 221, **5.2** *see also* frescoes; murals wall-painting 221, **5.2** *see also* frescoes; murals wallpaper design 414–16, **14.3** *Wallpaper** (magazine) 279, **7.12** Warhol, Andy 268, 494; *A Set of Six Self-portraits* 268, 6.30 washes, ink 216 Washington, D.C.: Howell home 146, 2.120; Vietnam Veterans' Memorial (Lin) 35–7, water jar, ceramic (L. Lewis) 25–6, 89, 1.17
Water Lilies (Monet) 221, 5.1
Water Organ (Villa d'Este, Tivoli) 163, 2.140
Water World Voices from the Deep (Muirhead) 506, 15.68 watercolor paintings 237–9, **5.20**, **5.21**, **5.22**Watteau, Antoine 472
wax, modeling 338–40
Wayfarers' Chapel, Palos Verdes, California
(Wright, Jr.) 394, **13.9** Webb, Alex: Killed by the Army 289, 8.11 websites, art 325, 326-7 wedging clay 354 Wedgwood, Thomas 284-5 Welles, Orson: Citizen Kane 302-3, 8.26 Wesselmann, Tom: Still Life no. 24 15, 1.4 Weston, Edward 294; Artichoke Halved 292, 8.14; Knees 294, 8.16 Whale Aground, A (Turner) 237, 5.21 Wheel of Life (Tibetian thangka) 185, 3.19 wheel-throwing (clay) 354, 11.4 Whirlwind, The (Malyavin) 152, 2.126 White Square (Perkins) 145, 2.118 Wiene, Robert: The Cabinet of Doctor Caligari 301-2, 485, 8.24 Wilkes, Jonnie: Venom Dub Rigonda 132, 2.99
Wilkinson (Clive) Architects: TBWAChiatDay
offices, Los Angeles 378, 12.5 Willendorf, Woman of 434, 15.2 Winckelmann, J. J.: Thoughts on the Imitation of Greek Works of Art 473 Winokur, Paula 356; Entry I: Sakkara 356, 11.7 Woman from Brassempouy (ivory) 13, 1.2 Woman in White, A (Picasso) 158-9, 2.136 Woman in White, A (Picasso) 158–9, 2.136 Woman of Willendorf 434, 15.2 Woman with the Hat (Matisse) 485, 15.46 women's art 52–3, 505 Wondrous Spring (Csuri) 324, 9.12 wood 361–4, 399; Altar for Peace (Nakashima) 362, 11.15; bowl (Lindquist) 364, 11.16; burls 364, 2xviin 60, 224, franc contexticion 364; carving 60, 334; frame construction 405; laminating 334; sculptures 73, 79, 113, 139, 334, 345, **2.20**, **2.30**, **2.72**, **2.113**, **10.5**, **10.19**; veneers 364 wood engravings 254-6, 6.9, 6.11 woodcuts/woodblock prints 116, 252-3, 254-6, 2.78, 6.6, 6.7; color 249-50, 253-4, 6.1, 6.8 World Trade Center: Libeskind's design for 33, Wren, Sir Christopher: St. Paul's Cathedral 472, 15.35 Wright, Frank Lloyd: Kaufmann House 'Fallingwater'), Bear Run, Pa 203–4, 409, 3.46; 'Solar Hemicycle' house, Middleton, Wisconsin 416–17, **14.6** Wright, Frank Lloyd, Jr.: Wayfarers' Chapel, Palos Verdes, California 394, 13.9 wrought iron 358-61, 11.11 Wyeth, Andrew 490; Christina's World 490, 15.52; The Virgin 231, 5.14 Wyman, Lance: logo for XIX Olympiad 174, xerox art 268-9, 495, 6.31 yantras 240 Yellow House, The (van Gogh) 85, 2.37 Yemen: Suq al-Ainau 392-4, 398, 13.8

Voss, Richard: Changing the Fractal Dimension

316, 9.4

Yoruba people 426; diviner's bag 24, 1.15 Yoshida, Kojiro 416 Yoshida, Ryoichi: dolls 501, 15.64 Young Woman, Goldfish, and Checkered Cloth (Matisse) 262, 6.18 Young Woman with a Gold Pectoral (encaustic) 224, 5.5 Your Colour Memory (Eliasson) 132, 2.100 Yu-Jian (Yu-Chien): Mountain Village in a Mist 217, 4.14 Zagarensky, Pamela: *1895* 316–19, 9.6 *Zapatistas* (Orozco) 172, 3.4, 3.5

Zapf, Hermann: Alphabet with quotations 277, 7.10 *zardozi* work 384, 12.12 *zashiki* 416, 14.4

Zelanski, Ruth 298, 8.20

Zen Buddhism 106, 193, 217; garden 422, 4.11 *Zeno at the Edge of the Known World* (Kosuth) 497, 15.59

Zeri, Federico 17
Zhen, Chen: Jue Chang (50 Strokes to Each) 430, 14.21
Zheng Xie: Misty Bamboo on a Distant Mountain 119, 2.82
ziggurat construction 398–9, 439, 13.15
Zimmerman, Arnold: ceramic arch 338, 10.11
Zimmerman, Elyn: Marabar 74–6, 2.23

zoetropes 301